STUDIES IN MODERN ART 3

Les Demoiselles d'Avignon

Special Issue by

WILLIAM RUBIN

HÉLÈNE SECKEL

JUDITH COUSINS

THE MUSEUM OF MODERN ART

NEW YORK

DISTRIBUTED BY HARRY N. ABRAMS, INC., NEW YORK

Studies in Modern Art is prepared by the Research and Scholarly Publications Program of The Museum of Modern Art, which was initiated with the support of a grant from the Andrew W. Mellon Foundation. Publication is made possible by an endowment fund established by the Andrew W. Mellon Foundation, the Edward John Noble Foundation, Mr. and Mrs. Perry R. Bass, and the National Endowment for the Humanities' Challenge Grant Program.

Produced by the Department of Publications
The Museum of Modern Art, New York
Osa Brown, Director of Publications
Edited by James Leggio
Translations edited with Alexandra Bonfante-Warren
Design and typography by Michael Hentges
Production by Marc Sapir
Printed by Herlin Press Inc., West Haven, Connecticut
Bound by The Riverside Group, Rochester, New York

Studies in Modern Art, no. 3

ISBN 0-87070-162-2 (The Museum of Modern Art and Thames and Hudson)
ISBN 0-8109-6125-3 (Harry N. Abrams, Inc.)
ISSN 1058-997x

Published annually by The Museum of Modern Art,
11 West 53 Street, New York, New York 10019

Distributed in the United States and Canada by
Harry N. Abrams, Inc., New York, A Times Mirror Company

Distributed outside the United States and Canada by
Thames and Hudson Ltd., London

Contents

Dedication

This volume is dedicated to Mr. and Mrs. Perry R. Bass with warm
gratitude for their generosity to the Museum and its publishing program,
including their support for *Studies in Modern Art*.

Preface

Studies in Modern Art is the publishing vehicle of The Museum of Modern Art's Research and Scholarly Publications Program, whose aim is to foster scholarship and publication on works of art in the Museum's collection and on topics related to the Museum's activities. The preface to the first issue of *Studies in Modern Art*, published in 1991, describes the origin of this program and explains more fully the philosophy that guides it. It is worth repeating here, however, that our method of focusing this aspect of research within the Museum is to devote each issue of the publication to a uniform theme. Thus, the first issue explored a specific period, American art of the 1960s; the second, an important technical concept, the art of assemblage. We envisage future issues on individual artists and movements, on specific collections, on particular periods of the Museum's own history, and so forth.

This issue is the first we have devoted to a single work of art, and it seems entirely appropriate that the work is Picasso's *Les Demoiselles d'Avignon*, arguably the most renowned painting in the Museum's collection, if not in the history of modern art itself.

The *Demoiselles* formally entered the collection in 1939, the year of the Museum's tenth anniversary. Although, of course, widely known in avant-garde circles since its creation, the painting had in fact been virtually hidden from public sight for many years, first in Picasso's studio and then, from 1924, in the collection of Jacques Doucet. A. Conger Goodyear summarized the events leading to the Museum's acquisition of the painting, in his *The Museum of Modern Art: The First Ten Years*, published in 1943:

Through a somewhat complicated transaction there was added to the collection early in 1938 the very large Picasso Les Demoiselles d'Avignon, *painted about 1907, and called by Alfred Barr "one of the few pictures in the history of modern art which can be called epoch-making." The eight feet square canvas was purchased from Jacques Seligman[n] & Company, two members of the firm, Germain Seligmann and César de Hauke, making substantial contributions toward its purchase price. The balance required was to be obtained from the sale of* The Race Course *by Degas, one of the pictures included in the Bliss Bequest. This was the first important sale from the permanent collection. Two years later the sale was concluded and as a consequence* Les Demoiselles *actually became the property of the Museum.*[1]

Thus, the *Demoiselles* was the first important work to enter the Museum's collection whose purchase was made possible through what is now called deaccessioning.

After it entered the collection, the painting's fame with the public quickly increased. But given its importance, it has seldom, especially in the past few decades, been allowed to travel to loan exhibitions. A rare recent exception was the major exhibition built around the *Demoiselles* at the Musée Picasso, Paris, and the Museu Picasso, Barcelona, in 1988, an exhibition organized by Hélène Seckel, Conservateur

en Chef at the Musée Picasso.[2] That exhibition was accompanied by a large, two-volume catalogue in French, from which derived a one-volume Spanish-language edition.[3] Unfortunately, no English-language edition was produced (although one of the contributions, Leo Steinberg's "The Philosophical Brothel," originally published in 1972, was republished in English in its revised form later in 1988).[4] We therefore determined that at least the contributions to the two-volume exhibition catalogue by members of the Museum's staff should be made available in English. That was the origin of the present publication.

William Rubin's extended essay, "The Genesis of *Les Demoiselles d'Avignon*," which forms the principal part of this publication, derives from his "La Genèse des *Demoiselles d'Avignon*" in the exhibition catalogue. Already acknowledged as a classic study, it offers not only the fullest account of the evolution of the painting, but also new information and interpretation regarding a multitude of related issues, ranging from the artist's concerns with disease and death as manifested in the work to the importance of El Greco for the picture's realization. In revising the text for the present volume, the author has addressed critical studies of the painting that have been published since 1988, as well as discussing the recently discovered oil sketch for the *Demoiselles*, from early 1907, acquired by the Museum in 1991.

Also derived from the exhibition catalogue is Judith Cousins and Hélène Seckel's Chronology, tracing the fortunes of the *Demoiselles* from 1907 to 1939. This is the only such compendium documenting the history of the work before it entered the Museum's collection. It too has been revised since its original appearance, allowing the addition of new material unearthed as study continues of the vast archive of the artist's papers at the Musée Picasso.

From the remaining contributions to the exhibition catalogue, we have included another important documentary source, Hélène Seckel's Anthology, devoted to early commentary on the *Demoiselles*. This compilation collects the artist's own statements as well as many eyewitness accounts and reminiscences of the work. To the prior version of the Anthology has been added, among other items, a text by Max Jacob, written in 1931, that recounts Picasso's first exposure to African sculpture, at Henri Matisse's. And published here for the first time, the Appendix, by Étienne-Alain Hubert, offers the new suggestion that the *Demoiselles* was exhibited at the Galerie Paul Guillaume in January–February 1918. The updated and revised Bibliography of the painting and a list of exhibitions complete the volume.

A transatlantic project of this scope requires the great generosity and professional skill of a number of colleagues, both here in America and in France. I would like to express special gratitude to Hélène Seckel, who opened to us the vast resources of the Musée Picasso, and who helped to coordinate the various endeavors that had to take place in Paris, including archival research and photography. And I am most grateful to Anne de Margerie, Chef du Département de l'Édition et de l'Image, Réunion des Musées Nationaux, Paris, for her generous assistance in securing and clarifying a number of permissions. Ana Cajal-MacLellen in Paris performed the yeoman's portion of the photograph research and acquisition, accomplishing these tasks with accuracy, speed, and deft diplomatic skill.

At The Museum of Modern Art, a number of individuals have contributed to the success of the Research and Scholarly Publications Program and to this present

issue of *Studies in Modern Art*. Since its inception, Richard E. Oldenburg, Director of the Museum, has been the program's most indefatigable champion. All of the Museum's curatorial department heads have actively helped the program to prosper, and they generously serve, along with other, non-curatorial department heads, on its Advisory Committee. The members of that committee are listed on the copyright page; I am deeply grateful for their counsel and commitment.

To my colleagues on the Editorial Committee, who have worked closely with the contributors to this issue, go my particular thanks. Joseph Ruzicka, until recently Research Coordinator of the program, and James Leggio, Editor in the Department of Publications, were deeply involved in both the preparation of this volume and the organization of the program as a whole.

Many thanks are also due to Michael Hentges, Director of the Department of Graphics, for expertly designing this issue, the most complex and demanding in the series to date; Marc Sapir, Assistant Production Manager in the Department of Publications, for smoothly overseeing a daunting range of production problems; James Leggio, for his characteristically sensitive editing of the publication; and Beverly M. Wolff, General Counsel, and Charles Danziger, Assistant General Counsel, for their judicious legal advice. Other Museum colleagues who were especially helpful deserve to be acknowledged here: Magdalena Dabrowski, Senior Curator, Department of Drawings; James Coddington, Conservator, and Carol Stringari, formerly Associate Conservator in the Department of Conservation; Clive Phillpot, Director, Janis Ekdahl, Assistant Director, and Eumie Imm, Associate Librarian, Reference, of the Museum's Library; Rona Roob, Museum Archivist, Rachel Wild, Archives Technician, Apphia Loo, Archives Assistant, of the Museum Archives; and Mikki Carpenter, Director, Department of Photographic Services and Permissions.

A number of people must be thanked for their roles in preparing specific materials for publication. Judith Cousins, Curator for Research, Department of Painting and Sculpture, oversaw the complex process of updating the different sections of this publication from the original French edition and made essential contributions to every part of it. Christel Hollevoet, Research Assistant, worked on this publication for almost two years, collecting and collating the original source material for the Chronolology, revising all the captions, and preparing the English manuscripts for the revised Essay, Chronology, Anthology, and Bibliography for editing. Judith Daniel assisted in collating the source material for the Anthology. Gregg Clifton and Anne Lampe ably assisted in the complicated preparation of William Rubin's manuscript and in coordinating its illustrations. Veronique Chagnon-Burke, Judith Cousins, Christel Hollevoet, Ritu Pahwa, Navah Perlman, Joseph Ruzicka, and Hélène Seckel all contributed to the revision of the extensive Bibliography. For translating the Anthology and Chronology from the French, we are grateful to Sophie Hawkes. For translations of documents in other languages, we thank Suzanna Halsey, for those from Czech; Scott de Francesco, for those from Danish and Swedish; and Ingeborg von Zitzewitz, for those from German. We also thank Alexandra Bonfante-Warren for her timely help in the editing of the translations, and for herself translating the Appendix from French.

Many colleagues from outside the Museum contributed to the revisions made for this volume by sharing their extensive knowledge of the painting, giving access to

documents in their possession that are related to its history, and generously autho-
rizing us to publish or cite these documents in translation. For their assistance in var-
ious forms, we are indebted to André Bernheim, Laurence Berthon, Yve-Alain Bois,
Elisa Breton, Edward Burns, Stanley B. Burns, Thérèse Burollet, Pierre Caizergues,
Florence Callu, Yveline Cantarel-Besson, François Chapon, Aube Elléouët, Michael
FitzGerald, John Froats, Denise Gazier, Valeria Soffici Giaccai, Catherine Giraudon,
Colette Giraudon, Jacqueline and Jacques Gojard, Ronald J. Grele, Bonnie
Hardwick, Étienne-Alain Hubert, Dr. Stanley Kenneth Jernow, Pepe Karmel, Leon
Katz, Patricia Miller King, Billy Klüver and Julie Martin, Leila Krogh, Rolf Laessøe,
Carlton Lake, Quentin Laurens, Sylvie Maignan, Percy North, Florence Paillon-
Raynal, the late Joseph Pulitzer, Jr., Emily Rauh Pulitzer, Gérard Regnier, John
Richardson, Georges Rodrigues, Jean-François Rodriguez, Jeanne-Yvette Sudour,
Gérard Tilles, Richard J. Wattenmaker, Nicholas Fox Weber, Patricia Willis, and
Gretchen Worden. And we owe a debt of gratitude to the anonymous outside read-
ers who scrutinized each section of the volume and made useful comments.

Of course, our deepest gratitude goes to the individual authors. Their dedica-
tion to the research and writing of their contributions, despite numerous other com-
mitments, is itself exemplary, even before we take into account the addition to
knowledge and understanding that is the result. Those who support this publication
by their own dedication to scholarship are the ones who make it possible at all.

Funding such an ambitious project requires the confidence and generosity of
several organizations and individuals. The Andrew W. Mellon Foundation has
underwritten the costs incurred during the first three years of publishing *Studies in
Modern Art*, and, with typical foresight, also established a challenge grant toward an
endowment to support the program in subsequent years. The Edward John Noble
Foundation responded to the challenge by making an equally generous gift to the
endowment. The National Endowment for the Humanities awarded the project a
significant grant, for which we are most grateful. Finally, our warmest appreciation
goes to Mr. and Mrs. Perry R. Bass for their substantial gift, given by them on the
occasion of their fiftieth wedding anniversary, that successfully completed the
endowment of the program. Thanks to their far-ranging vision, extraordinary gen-
erosity, and understanding of the Museum's mission, Mr. and Mrs. Bass have guar-
anteed that this program will continue.

John Elderfield
Editor, *Studies in Modern Art*

Notes

1. A. Conger Goodyear, *The Museum of Modern Art: The First Ten Years* ([New York]: privately printed,
1943), p. 87. For details of the Lillie P. Bliss Bequest, works deaccessioned from it, and works acquired through
such deaccessioning, see Alfred H. Barr, Jr., *Painting and Sculpture in The Museum of Modern Art, 1929–1967*
(New York: The Museum of Modern Art, 1977), pp. 651–53.
2. "Les Demoiselles d'Avignon," Musée Picasso, Paris, January 26–April 18, 1988; Museu Picasso,
Barcelona, May 10–June 14, 1988.
3. Hélène Seckel, ed., *Les Demoiselles d'Avignon*, 2 vols. (Paris: Réunion des Musées Nationaux, 1988).
Spanish-language edition, 1 vol. (Barcelona: Polígrafa, 1988).
4. Leo Steinberg, "The Philosophical Brothel," *Art News* (New York), vol. 71, no. 5 (September 1972),
pp. 22–29 (part 1); no. 6 (October 1972), pp. 38–47 (part 2). Reprinted with revisions in *October* (New York),
no. 44 (Spring 1988), pp. 17–74. Contributions to the two-volume exhibition catalogue that have not
appeared in English are: "Introduction" by Hélène Seckel; "Catalogue" by Hélène Seckel; "Carnets" by
Brigitte Léal; "Images révélées" by Charles de Couëssin and Thierry Borel (in vol. 1); "L'Historique des
Demoiselles d'Avignon révisé à l'aide des carnets de Picasso" by Pierre Daix (vol. 2).

A Note to Contributors

Studies in Modern Art publishes scholarly articles focusing on works of art in the collection of The Museum of Modern Art and on the Museum's programs. It is issued annually, although additional special numbers may be published from time to time. Each number deals with a particular topic. A list of future topics may be obtained from the journal office.

Contributors should submit proposals to the Editorial Committee of the journal by January 1 of the year preceding publication. Proposals should include the title of the article; a 500-word description of the subject; a critical appraisal of the current state of scholarship on the subject; and a list of works in the Museum's collection or details of the Museum's program that will be discussed. A working draft of the article may be submitted as a proposal. The Editorial Committee will evaluate all proposals and invite selected authors to submit finished manuscripts. (Such an invitation does not constitute acceptance of the article for publication.) Authors of articles published in the journal receive an honorarium and complimentary copies of the issue.

Please address all inquiries to:

Studies in Modern Art
The Museum of Modern Art
11 West 53 Street
New York, New York 10019

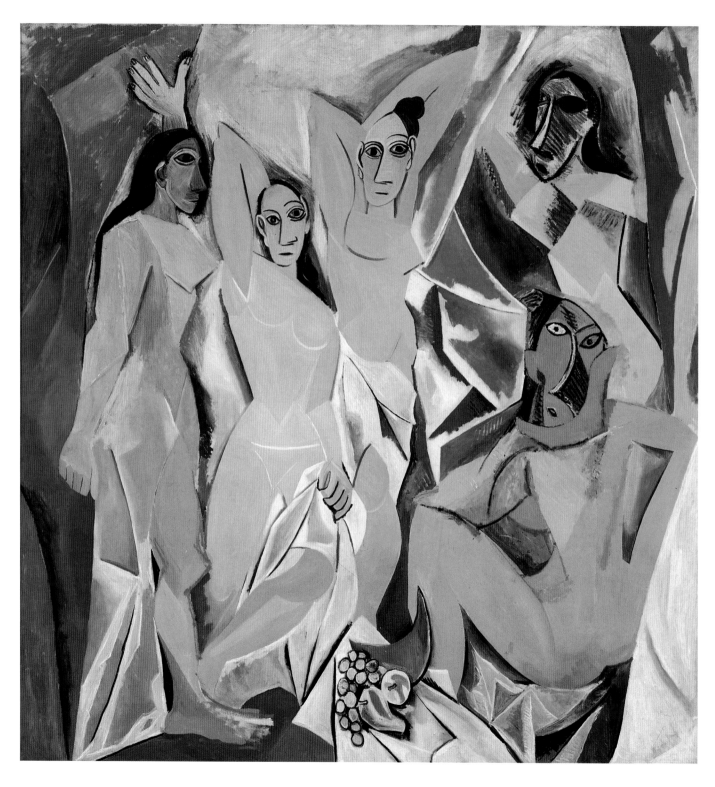

1. *Les Demoiselles d'Avignon*. Paris, June–July 1907. Oil on canvas, 8' x 7' 8" (243.9 x 233.7 cm). Zervos II', 18. Daix 47. The Museum of Modern Art, New York. Acquired through the Lillie P. Bliss Bequest.

The Genesis of
Les Demoiselles d'Avignon

William Rubin

"What had to be avoided was that they should continue to see nothing but 'attractive harmonies' or 'exquisite colors.'"
—Picasso on viewers of the *Demoiselles*

INTRODUCTION

Les Demoiselles d'Avignon created an historical fault-line that makes even the most radical of Fauve paintings look today like the modernism of the late nineteenth century. But the courage and perseverance of Picasso's undertaking cannot be measured by reference to pictorial values alone. Doubtless a competitiveness with Matisse and Derain acted as a spur for Picasso, encouraging him to go beyond even their first post-Fauve innovations in a "masterpiece" that would both summarize and surpass his earlier work.[1] And certainly it took considerable nerve for him to push his picture so far that those very colleagues saw it less as a triumph of artistic daring than as a preposterous and incomprehensible failure.[2] (Even they, however, must have been impressed by Picasso's scorn for received ideas and taste—in other words, by his absolute conviction of his own genius.) Yet the courage of which I speak, which was the motor force that drove the almost six-month-long metamorphosis of the *Demoiselles*,[3] was less a matter of aesthetic endeavor than of relentless self-confrontation—and was in this sense comparable to Freud's solitary self-analysis.

Insofar as Picasso's aims in the *Demoiselles* were artistic, one almost demeans them by invoking the goal of surpassing Matisse's and Derain's daring. For as work on the picture progressed, Picasso's ambition became nothing less than the recovery of the magical function that first led humankind to make images: the power to change life. Picasso understood instinctively that the Western tradition had been losing contact with that primordial, talismanic aim of image-making—indeed, had lost it altogether in the nineteenth-century definitions of art shared by his painter-father, the schools he attended, and the Salons that insured prevailing values. But for Picasso, it was less the nature and conventions of art than those of life—and most important, of his own life—that were at stake.[4]

In the winter of 1906–07, when Picasso began his studies for the *Demoiselles*, vanguard painting was clearly at a crossroads. The inherited Impressionist/Symbolist

This monograph is dedicated to Leo Steinberg, for the daring and originality of his thought and the eloquence of his language.

phase of modernism was coming to an end, and solutions that could seriously redirect the enterprise of painting were not yet visible.[5] But the primary impulse for the terrifying night journey of the soul that Picasso undertook in the *Demoiselles* was a crisis of a personal, psychological order. It became an artistic one, insofar as Picasso needed to forge new tools adequate to excavate the deeper strata of his mind. This exploration induced the astonishing variety of styles that we see in the *Demoiselles* and in the many hundreds of drawings and paintings associated with it[6]—a quantity of preparatory work unique not only in Picasso's career, but without parallel, for a single picture, in the entire history of art. The notebook drawings that form the bulk of these preparations constitute a kind of visual diary. This is what Picasso meant when he transformed the printed cover of one of the *Demoiselles* notebooks (Carnet 8) by adding a handwritten inscription that made the cover read: "Je suis le CAHIER" ("I am the NOTEBOOK").

•

More a symptom than a cause of Picasso's state of mind when he made the *Demoiselles*, and doubtless a function of the erotic crisis embodied in the painting and its studies, was the long-overlooked rupture the artist precipitated at that moment in his affair with Fernande Olivier. This, in turn, might conceivably have been complicated on Picasso's side by an episode of venereal disease.[7] Fernande's letters to Gertrude Stein indicate that the relationship had been deteriorating for some months before she moved out of the Bateau-Lavoir in September 1907, shortly after Picasso had stopped work on the *Demoiselles*. She would have left earlier, Fernande wrote, but for the lack of money needed to help her resettle—money owed to Picasso by Vollard, whose absence from Paris "leaves us in dire poverty and in the difficulties of a situation no less dire."[8]

A year earlier, Picasso had enjoyed a blissful summer idyll with Fernande in the Spanish village of Gósol, where his many studies of her *toilette* provided some of the most intimate and tender works of his career. Now, following presumably tumultuous quarrels, Picasso and Fernande decided, as Gertrude Stein reported, "to separate forever."[9] For months, the painter had been prey to a malaise clearly associated with the making of the *Demoiselles* and the picture's manifold motivations, a period his close friend André Salmon described as one of marked "anxiety."[10] Pierre Daix, who first drew attention to the critical sundering of Picasso's relationship with Fernande, speculates on some possible causes of their quarrel.[11] He notes that Gertrude Stein considered Fernande's sexuality essentially "maternal" in character, and this, Stein believed, finally left Picasso "indifferent." Fernande's putative maternal love might be all the more problematic for a painter whose sexuality Stein

2. *Nude with Drapery*. Paris, summer 1907. Oil on canvas, 59 7/8 x 39 3/4" (152 x 101 cm). Zervos II¹, 47. Daix 95. The Hermitage Museum, Saint Petersburg

classified as "dirty."[12] In *Picasso and His Friends,* Fernande tells us that Picasso was especially jealous during this period, and Daix suspects that Fernande fought Picasso's sexual indifference by feeding his native jealousy.[13]

I am convinced, moreover, that the presence in their *foyer,* during part of the time Picasso worked on the *Demoiselles,* of a young orphan girl, Raymonde, whom Picasso and Fernande had recently adopted, played a profoundly complicating role. Daix saw Fernande's decision in early summer to place the girl elsewhere as sure to have "empoisoned" their personal crisis.[14] André Salmon describes Raymonde as about thirteen years old, and "of a grave and serious beauty … [her] child's hair completed with bangs of sumptuous silk."[15] Drawings of her in one of the notebooks that contains studies for the *Demoiselles* (fig. 3)—identified as Raymonde in Zervos[16]—confirm this description. One can only imagine the ambivalent emotions both Fernande and Picasso would have had as, in their almost claustrophobic Bateau-Lavoir quarters, the former helped this lovely girl with her *toilette.* Could Fernande have begun to suspect a potential rival? The twenty-five-year-old painter's feelings of jealousy in finding himself no longer the sole focus of his mistress's interests, of which Daix speaks, may well have been accompanied, it seems to me, by a physical attraction to Raymonde herself.[17] An intimate study of a girl doing her pedicure (fig. 5), her sex visible through her underwear, whom discretion no doubt prompted Picasso not to identify to Zervos, is also certainly Raymonde—as attested by her age, appearance, and particular hairdo. Indeed we are not surprised to discover that this drawing would subsequently provide the pose for a small oil study (fig. 227) at the origins of the seated demoiselle on the left (later Steinberg's "gisante"). Given Picasso's anarchic sexual mores, it would not be inconsistent to imagine that Fernande sent Raymonde away in part to protect her chastity.[18]

We do not know whether in the winter of 1906–07 Picasso had recourse to brothels in order to satisfy his particular sexual needs—though he had certainly frequented them earlier. However that may be, the family group of the Bateau-Lavoir celebrated in *Man, Woman, and Child* of late 1906 (Zervos II, 587; D./B. XVI, 30)—the last painting of the winter leading to the *Demoiselles* in which a Fernande surrogate appears[19]—is soon succeeded in Picasso's imagery by the *maison close.* The scenes he mounted in the parlor or "showcase" of this imaginary bordello—variations on what a connoisseur of the subject calls "the welcoming scenarios"[20]—constituted a kind of laboratory in which Picasso attempted to discover the deeper nature of his own erotic desire by probing the mysteries of what Freud called the life force, the primal source of procreation, in which sexuality and artistic creativity are as yet undifferentiated. But Picasso soon found that in order to comprehend Eros, he had also to confront Thanatos. He would use the knowledge gained—as he himself later made clear—to overcome anxieties and exorcise personal demons.

The various metamorphoses of *Les Demoiselles d'Avignon* provide visible evidence of Picasso's journey into the recesses of his psyche. This self-analysis, peeling away layers of consciousness, was associated with—and was, indeed, in some ways paralleled by—a search into the origins of man's way of picturing himself, an attempt very selectively to retrace the history of image-making so as to isolate the essentials of the affective visual language. That Ariadne's thread led Picasso to such then "outsiders" or "primitives" within the Western tradition as Cézanne and El Greco; continued outside that tradition to the oldest indigenous art of Picasso's native Iberian

3. *Bust of Raymonde*. Carnet 6, 40V. Paris, May 1907. India ink and graphite pencil on beige paper, 4⅛ x 5⅜" (10.5 x 13.6 cm). Zervos II², 589. Musée Picasso, Paris (MP 1862)

4. *Portrait of Raymonde*. Carnet 7, 39R. Paris, May–June 1907. India ink on white ruled paper, 8¾ x 4⅝" (22 x 11.6 cm). Zervos XXVI, 237. Private collection

5. *Raymonde Doing Pedicure*. 1907. Graphite pencil on paper, 8¾ x 6¾" (22 x 17 cm). Zervos VI, 914. Formerly estate of the artist, no. 1039

peninsula; and ultimately found the Minotaur in imagery from the "womb" of civilization, Africa.

Picasso's prior explorations of archaic art,[21] brought to a head in his fascination with ancient Iberian sculpture, had prepared him, visually and psychologically, for the sudden epiphany that would be produced by the tribal objects in the Musée d'Ethnographie du Trocadéro. The Trocadéro visit triggered the final alterations in the conception of the *Demoiselles*, which resolved Picasso's dissatisfactions with the large canvas's "Iberian" incarnation by informing three of his figures' visages with mysterious "masks" that expressed otherness, savage sexuality, violence, and, finally, horror. The visit to the Musée d'Ethnographie, Picasso later said, had made him "understand what painting was about."[22] In that glimpse into the heart of darkness, he had apprehended the essentially magical nature of art, and the cathartic power that could flow from it. At the Trocadéro, in objects that Picasso associated with the very birth of civilization (his generation mistakenly took the African objects to be even older than those of the Egyptians),[23] Picasso found visual clues to the embodiment of his dark forebodings and private terrors, which brought the *Demoiselles* to a richer and more profound conclusion.

In the first instance, the aesthetic side of the tribal objects mattered less to the deeply superstitious Picasso than did their ritual and psychological function. That he would later call the *Demoiselles* his "first exorcism picture"[24] suggests he saw its execution as analogous to the rituals and the rites of passage associated with the functions of the talismanic masks and "fetishes" in the Trocadéro. No doubt Picasso read some of the lapidary phrases regarding practical function on the labels of the objects. Among those we know to have been visible in 1907 were "Cures the insane," "Cures ailments caused by the deceased," and "Protects against the sorcerer." For anxieties perhaps closer to home, there was a gourd neck in phallic shape provided with mirrors on each end; it was succinctly labeled, "Cures gonorrhea."[25] "For me the [tribal works] were not just sculptures," Picasso would tell André Malraux thirty years later when discussing the *Demoiselles*. "They were magical objects … intercessors … against everything—against unknown, threatening spirits.… They were weapons—to keep people from being ruled by spirits, to help free themselves." To this, Picasso added an argument that explains, I believe, both his impetus to rework the *Demoiselles* and the crucial role the picture played in his psychological life: "If we *give a form* to these spirits, we become free."[26] Picasso's perception here of a visual counterpart to what psychologists call abreaction—the therapy of solving problems by "speaking them out"—had provided him with a key to unlocking the hidden causes of his personal crisis.

The last months of 1907 were, in any case, free of the malaise and frustration identified with the period of the *Demoiselles*. The night journey had reached its end and, like his mythic predecessors, Picasso had returned a changed man. Sketches for what became the monumental and highly resolved *Three Women* (fig. 7) were begun around that time and—no later than November—Fernande and Picasso were once again together.[27] What may have been the final alteration in the *Demoiselles*, the reworking of the head of the demoiselle at the left, was probably made in middle to late summer of 1907.[28] With that change, the painting Salmon would later call "the incandescent crater from which emerged the fire of present art" was finished.[29]

may well have inspired Picasso's later contrary assertion: "Je tente de peindre ce que j'ai trouvé et non ce que je cherche."[63]

However much Salmon's text is skewed by the studio cant of the Cubist years, it does tell us a good deal about the *Demoiselles* and its early reception. This is not surprising for, in the spring and summer of 1907, Salmon was more of a presence in Picasso's studio than was either Jacob or Apollinaire.[64] Salmon's testimony is important especially in view of Picasso's later contradictory statements regarding "art nègre" (to which we will return below). For him, Picasso is "the sorcerer's apprentice" who never failed "to consult the Oceanic and African witch doctors." When painting the big canvas, Picasso was "passionate about the blacks, whom he considered much superior to the Egyptians." Salmon also tells us that the picture "did not long remain in its first state." Picasso soon makes a first set of changes and, sometime later, takes up "le tableau champ de manoeuvres" yet again. What was Picasso's state of mind as he began work on the *Demoiselles?* Salmon tells us that despite recent success ("his canvases had begun to be sought after"), Picasso "experienced anxiety. He turned his paintings to the wall and threw away his brushes. For many long days and nights he did nothing but draw.... Never was hard work less rewarding, and it was quite without his usual youthful enthusiasm that Picasso undertook the large canvas.... " Picasso's circle is shocked by the picture and its accompanying studies ("the human image seemed to us so inhuman ... the monsters of his imagination put us in despair"). But the "distortions" of the figures are not the primary cause ("we were prepared for it by Picasso himself, by Matisse, Derain, Braque, van Dongen and, even earlier, by Cézanne and Gauguin"). It is rather "the ugliness of the faces which froze us half-converts with fear." The artists are dumbfounded; "artist friends began to distance themselves" from Picasso.

Salmon's references to the *Demoiselles*, the earliest published, were not, however, absorbed into the operative literature on the picture until well after World War II.[65] A more determinative role in subsequent writing about the *Demoiselles* was played by the World War I observations of Daniel-Henry Kahnweiler, who had first seen the picture in what was most likely July of 1907,[66] at a stage he remembered (perhaps not entirely correctly) as the condition in which "it remains today."[67] Kahnweiler probably saw the picture once or twice again while it was at the Bateau-Lavoir; he was not, however, an intimate of Picasso's studio, and became the artist's principal dealer only in the late spring of 1908.[68] He may have seen the *Demoiselles* subsequently at the boulevard de Clichy or the rue Schoelcher, though he never mentions this. Kahnweiler was a wartime refugee in Switzerland when the picture left Picasso's studio for its very first public showing, at the Salon d'Antin in 1916.

Kahnweiler's first discussion of the canvas was published in Switzerland that same year (he spent the war largely in Bern). In his article "Der Kubismus" he writes: "At the outset of 1907, [Picasso] began a strange, large picture with women, draperies, and fruit. The nudes stand rigid, like mannequins, with big, silent eyes.... In the foreground, different from the style of the rest, a crouching figure and a bowl of fruit. These are the beginnings of the desperate, boundlessly ambitious undertaking that will follow now. He wants to solve all problems at once."[69] This text is as interesting for what it does not say as for what it does. Kahnweiler does not know, or chooses not to mention (which is more probable), that Picasso's picture is a bordello scene, and he gives no title. Also notably absent from "Der Kubismus" is a notion that

Kahnweiler would subsequently launch and elaborate—and that would become one of the principal myths of the literature—namely, that Picasso abandoned the *Demoiselles* "unfinished." This appeared only when Kahnweiler took up and embroidered "Der Kubismus" to publish it as *Der Weg zum Kubismus* in 1920.

In this later text, the first sentence about the *Demoiselles* begins identically with the 1916 version. (Four years after it was shown publicly as *Les Demoiselles d'Avignon*, Kahnweiler still does not have a name for the picture.) But the period after "draperies and fruit" in the earlier text (altered to "fruit and draperies") is replaced by a comma, and followed by the words: "which remained unfinished."[70] If Kahnweiler had thought the *Demoiselles* "unfinished" in 1916, he evidently had not considered the fact worth mentioning. And when, in *Der Weg zum Kubismus*, he argues that the picture "cannot be called anything but unfinished … because it … never constituted a unified whole," we realize that the putative "unfinishedness" of the *Demoiselles* stems from a personal aesthetic judgment *by Kahnweiler himself* about its anticlassical mixture of styles. For Kahnweiler, this *mélange des genres* is not a function of Picasso's having purposefully reworked the large canvas, but reflects instead the long gestation of the *Demoiselles*: the picture is said (wrongly) to mix Picasso's 1906 and 1907 styles.

Only after World War II did Kahnweiler begin claiming not only that the *Demoiselles* was unfinished, but that *Picasso himself* had considered it unfinished. Reinhold Hohl has pointed out what is probably the first statement of this new position in a 1947 lecture Kahnweiler gave at the University of Freiburg im Breisgau.[71] The thesis was repeated in texts of 1953[72] and 1955,[73] and it became virtually canonical (although Barr never repeated it).[74] In 1973, in his most baroque version of this idea, Kahnweiler put it directly into Picasso's mouth (quoting an imaginary statement that is demonstrably untrue): "He [Picasso] said to me at that moment: the picture is unfinished, it has never been altered."[75] Although Kahnweiler was obviously unaware of them, radiographs made by The Museum of Modern Art in 1950 proved beyond a doubt that some heads in the picture had been radically altered, as Picasso knew better than anyone else. Kahnweiler's thesis would have had more serious implications had the very notion of "finish" as a fixed, *a priori* relationship between motif and picture not earlier been undermined by Cézanne and others. By the time Kahnweiler raised the issue, it was no longer a particularly relevant question.[76]

The second major new thesis about the *Demoiselles* in Kahnweiler's *Der Weg zum Kubismus* was that the crouching nude in the lower right—perhaps the most fiercely expressionist figure in all modern painting—marked the "beginning of Cubism."[77] None of the other early authors make this "Cubist" connection, although Salmon's 1912 discussion of the picture takes place in a chapter called an "anecdotal history" of Cubism. In the text said by Kahnweiler to be based on notes of 1933 (published only in 1952), the dealer was to identify "the birth of Cubism" more broadly with Picasso's second period of work on the *Demoiselles*,[78] and in 1946 he identified Cubism simply with the reworking of the right-hand part.[79] Kahnweiler never explains the contradiction between these remarks and his argument that the picture never changed.

To be sure, Kahnweiler was right to begin his account of Cubism with the *Demoiselles*, insofar as the titanic destructive effort that was part of Picasso's enterprise in painting it would clear the way for Cubism's subsequent development. Moreover, the *Demoiselles* was certainly linked to Cubism by some inevitable threads of continu-

ity (despite the fact that these were far outweighed by crucial differences). But Kahnweiler's fateful decision in *Der Weg zum Kubismus* specifically to hail the expressionist "crouching figure" as the "beginning of Cubism" opened a Pandora's box for subsequent criticism. Of course, the decision as to whether the *Demoiselles* does or does not mark the beginning of Cubism is essentially semantic: it depends upon how one defines Cubism. My own definition, for example, leads me to see the inception of Picasso's Cubism in the equally monumental *Three Women*, a painting totally ignored by Kahnweiler. (Picasso began *Three Women* a few months after finishing the *Demoiselles*, and worked on it for about a year.) The real issue, however, is less whether Kahnweiler's assertion is ultimately right or wrong, historically speaking, than that the notion of Cubist beginnings was for him the signal "fact" about the *Demoiselles*. In much subsequent writing, it remained the principal thing to say about the work, devouring other considerations until it became virtually the picture's definition. The psychosexual content of the canvas remained unmentioned until Leo Steinberg's epochal essay, published sixty-five years after the picture was painted.

That Kahnweiler broached the notion of the *Demoiselles*'s alleged unfinishedness only in the definitive 1920 version of his text, and then in conjunction with his first explicit assertion of the idea that the picture was the "beginning of Cubism," suggests that these two ideas were intended to function *in an interdependent manner*. For Kahnweiler, the *Demoiselles* lacked unity in the form that Picasso painted it, and thus could hardly serve as model for an art as "classical," in his view, as Cubism. His thesis that the picture was "unfinished" at once rationalized and excused its anticlassical mixture of styles, hence making possible its retroactive annexation as the first Cubist painting. In thus imposing upon Picasso's development an aesthetic bias of his own, Kahnweiler was no doubt responding to a widespread new conservatism—later characterized by Cocteau as "the call to order"—which followed World War I. Picasso's own neoclassicism and Severini's reinterpretation of Cubism as a strictly classical art[80] were symptomatic of a mood that had led Kahnweiler to conclude that the work of Juan Gris, "the most classic of the Cubists," represented the fulfillment of the style.

If Kahnweiler's remarks about the *Demoiselles* were primarily formal, André Breton, the most important critic of Picasso's Surrealist years, was to see the picture as "une image sacrée."[81] But while Breton reproduced the *Demoiselles* itself in an issue of *La Révolution surréaliste* (1925), he regrettably published no writings on the picture, despite discussing Picasso often in print. His remarks about the painting are found only in his letters to Jacques Doucet, whom he was trying to convince to buy it. In these, which were published, in part, only in 1984 by François Chapon, he too vaunts the painting as "the origin of Cubism," but his main sense of it lies in its poetry. In the *Demoiselles*, he wrote Doucet in 1923, we enter "directly into Picasso's laboratory ... that is the crux of the play, the center of all the conflicts that Picasso brought to light and that will face us forever, I do believe. Here is a work that, in my opinion, goes peculiarly beyond painting; it provides the theater for everything that has been going on for fifty years; it is the wall in front of which passed Rimbaud, Lautréamont, Jarry, Apollinaire, and all those we still love."[82] The following year, when Doucet wavered about the purchase, Breton wrote again: "... while I generally accord preeminence to the explorations of poets when characterizing an epoch, I cannot avoid seeing in the *Demoiselles d'Avignon* the capital event of the onset of the twentieth century. Here is a picture one could parade through the streets of our cap-

ital as one did in other days the *Virgin* of Cimabue.... I cannot speak other than mystically [about this picture] ... the *Demoiselles d'Avignon* defies analysis, and the laws of its vast composition are in no way formulatable. For me, it is pure symbol, like the Chaldean bull, an intense projection of that modernity of which we catch a sense only in bits and pieces. Speaking mystically still, with the *Demoiselles d'Avignon* it's good-bye to all the art of the past. The phenomenon of pure inspiration, about which for so many years so many bitter disputes have taken place, is seen in such a flagrant form in this picture that there is nothing left but to declare oneself for or against it."[83]

Breton's poetic approach to the *Demoiselles* strikes one as closer to the spirit of the picture than Kahnweiler's more formalistic account. And this same perspective was much later to be elaborated in print by Ron Johnson.[84] Neither the literary nor the formalist approach, however, caught the flavor of the *Demoiselles's* interior psychological and pictorial drama, though they nevertheless added valuable pieces to what remains an ever incomplete puzzle.

Little more was written about the *Demoiselles* from the time of Breton's letter until the later thirties. Gertrude Stein mentioned the picture twice then in her monograph, *Picasso* (1938), composed originally in French and published in Paris. She emphasized that it was painted "under the influence of Negro art." Yet tribal art, she observes, "like the other influences that at one time or another distracted Picasso from his own way of painting, was not so much a help as a hindrance [*trouble*] that veiled his images."[85] For Stein, Picasso gets back on his personal track with his Cubism, which, in her view, begins only with the Horta pictures of 1909 (and is purely Spanish).[86] She says nothing, however, about any Spanish influence in the *Demoiselles*, or any relationship of the picture to Cubism.

In 1939, a year after the appearance of Stein's book in French, The Museum of Modern Art purchased *Les Demoiselles d'Avignon*. In the announcement of the acquisition, Alfred Barr, the Museum's director, described it as "one of the very few paintings in the history of modern art which can justly be called epoch-making." The picture, he continued, "has been considered the first Cubist painting. But it is really a transitional work in which the transformation of Picasso's ideas can be seen taking place right before our eyes. The figures at the left, which were done first, are reminiscent of Picasso's monumental style of 1906. The later figures at the right are more completely under the barbaric inspiration of African Negro masks and fetishes which, together with the art of Cézanne, greatly influenced Cubism in its early stages.... *Les Demoiselles d'Avignon* remains one of Picasso's most formidable achievements ... a composition of dynamic vehemence. In few modern works of art is the arrogance of genius so powerfully asserted."[87]

Shortly afterward, Barr published his epochal *Picasso: Forty Years of His Art*, which served as a catalogue for the Museum's 1939 retrospective exhibition;[88] this text was to be revised and expanded in 1946 as *Picasso: Fifty Years of His Art*, which became, and in many ways remains, the standard reference on the artist.[89] In *Forty Years*, Barr enlarged upon his remarks about Cézanne's influence on the *Demoiselles* printed in the acquisition announcement, identifying that influence particularly with the "late bather pictures in which [Cézanne's] figures and background are fused in a kind of relief without much indication either of deep space or of weight in the forms"; he particularized the influence of African art by identifying the heads of the picture's right-hand figures with the art of "the Ivory Coast or [then] French Congo."

Barr also proposed in *Forty Years* the possibility of an important source that he had not previously mentioned, namely El Greco. To be sure, a number of earlier authors, beginning with Salmon, had invoked El Greco's name in relation to Picasso, but always in the more obvious contexts of the elongated figures of the Blue Period. And the "mythic" role of the Greek-born painter among the Catalan *Modernistes* of Picasso's youth was widely acknowledged.[90] Barr now proposed that, in the *Demoiselles*, El Greco's "compact figure compositions and the angular highlights of his draperies, rocks and skies may have confirmed [for Picasso] the suggestions drawn from Cézanne." Barr also reproduced—their first appearance in print—the three principal compositional studies then known for the *Demoiselles:* the drawing heightened with pastel now in the Kunstmuseum Basel (fig. 40), the tiny lost oil on panel (fig. 39), and the watercolor now in the Philadelphia Museum of Art (fig. 49). He interpreted Picasso's intention in the first two—which are early, seven-figure versions of the image—as having been the "moralistic contrast" of virtue and vice.

The publication of volume two, part one, of Zervos's catalogue in 1942[91] was a capital event, less for the author's text than for his making accessible, if only in black-and-white reproductions, the bulk of the oil paintings and many of the drawings associated with the *Demoiselles*. (Further drawings and paintings would appear in supplemental volumes of Zervos's catalogue, and the repertory of paintings would be completed in Daix's catalogues raisonnés, though a number of related drawings remained unpublished until the Musée Picasso exhibition catalogue of 1988, in which the present text first appeared.) The dominant challenge of Zervos's introduction—directed in particular to statements in Barr's *Forty Years*—was the rejection, apparently at the behest of the artist himself, of an "African" influence in the picture ("the artist has categorically assured me that at the time when he painted the *Demoiselles* he did not know African art")—a statement that could be more or less true *only* for the original (i.e., unaltered) state of the canvas. Zervos also proposed, again in the voice of the painter, that Picasso had "in fact derived his inspiration from the Iberian sculptures in the Louvre collection," which was, of course, perfectly true of the canvas before three of its five figures were altered. Zervos drew special attention to parallels between the heads in Picasso's painting and "the overall construction of the heads, the shape of ears [and the] lines of the eyes" in Iberian sculpture—an observation valid only for the two central demoiselles, who remained unchanged from the canvas's first state. Iberian sculpture, the author stated, gave Picasso "the necessary means [*appui*] to transgress the academic taboos, trespass the established limits, challenge once again all established aesthetic roles." Zervos's text had been seen in proofs by James Johnson Sweeney in 1939 (its publication would be held up by the war), and in 1941 Sweeney enlarged upon, and provided a scholarly context for, the subject of Iberian influence in an article in *The Art Bulletin*,[92] discussed below (p. 37).

Despite having reproduced in his catalogue many of the early studies for the *Demoiselles* that contain male figures of a medical student and a sailor, Zervos said nothing about any narrative or situational implications in the motif of the picture—no doubt because he considered the work's inspiration "much more formal than affective [*sentimental*]" and found its expression more in "the general effect of the whole" than in "the poses and gestures of the figures." The most eccentric of Zervos's observations concerned the color of the *Demoiselles*, in which he curiously found a "restraint" (*sobriété*) that "avoids any extremes." "It is neither heavy nor frivolous,"

he continued, "only slightly more chromatic than [his painting] of the Rose Period, more joyful too, but without turmoil or excessive ostentation." (One wonders how much, if at all, Zervos had actually seen the *Demoiselles*.)

Barr's revised text on the *Demoiselles* in *Fifty Years* may be considered the conclusion of the early literature on the picture. His remarks on Cézanne and El Greco remained unchanged, but much was done to put the painting in the context of Picasso's development. Barr drew attention to the change in the artist's style by comparing the left-hand figures of both the *Demoiselles* and the late 1906 *Two Nudes* (fig. 27), which he described as "clearly related in pose and gesture"; in place of the naturalistic curves and sculptural modeling of *Two Nudes*, we see in the *Demoiselles* "mostly straight lines which form angular overlapping planes and there is scarcely any modeling so that the figure seems flat, almost weightless." Barr also closely described the heads of the two women on the right of the *Demoiselles*, finding the flat-ridged nose, sharp chin, small, oval mouth, and deleted ears of the standing figure "characteristic of certain African Negro masks of the French Congo more than of Iberian sculptures" (he cited, as an example [wrongly], the now celebrated Etoumbi-region mask; see fig. 8 and note 268). Despite Zervos's rejection (in the name of Picasso) of "art nègre" as a source for the picture, Barr concluded, as regards the mask-like faces of the two demoiselles on the right, that "the forms, the coloring [*sic*] and hatched shading seem inspired in a general way by the masks of the Congo or Ivory Coast, more than any other source." He added that "for sheer expressionist violence and barbaric intensity [these heads] surpass the most vehement inventions of the *fauves*." In *Fifty Years*, Barr also elaborated his discussion of the three major early studies. The "moralistic contrast between virtue (the man with the skull) and vice (the man surrounded by food and women)" was now also described as "a kind of *memento mori* allegory or charade." Later, he would describe it as an allegory of "the wages of sin."[93]

Far more important, however, was Barr's conviction that in the final picture, Picasso had "eliminated" this early drama "in favor of a purely formal figure composition," which "as it develops becomes more and more dehumanized and abstract." The postulating of a "purely formal" composition brought the text of *Fifty Years* closer than Barr had earlier been to Kahnweiler's view of the *Demoiselles*. This was reinforced, moreover, by another subtle shift of emphasis: in *Forty Years*,[94] Barr had characterized the picture primarily as "the masterpiece of Picasso's Negro Period," although he added that it "may also be called the first cubist picture" (a Cubism he qualified as "rudimentary"); in *Fifty Years*,[95] however, he dropped the phrase "the masterpiece of Picasso's Negro Period," while restating the picture's role in Cubism. In 1954,[96] Barr set the *Demoiselles* into a symmetrical relationship with *Three Musicians* of 1921, Cubism being envisaged as beginning with the former and culminating in the latter.

The combined authority of Kahnweiler and Barr sufficed for the *Demoiselles* to be considered the first Cubist painting in most scholarly and popular accounts, although a number of early authors—such as Gertrude Stein, André Level, Victor Crastre, and Christian Zervos—considered Cubism to have begun only in late 1908 or the summer of 1909. By the 1960s, however, the Kahnweiler/Barr thesis began being questioned. The earliest of these critiques was that of John Golding, whose article on the *Demoiselles* in 1958 marked a second important phase in the literature on the picture, one in which the critical apparatus of art history was to play an increasing role.

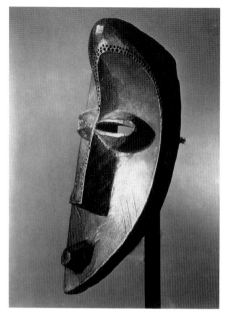

8. Mask. Etoumbi region. Zaire. Wood, 14" (35.5 cm) high. Musée Barbier-Müller, Geneva

SOME LATER LITERATURE

John Golding's text in *The Burlington Magazine*,[97] written a half century after the execution of the *Demoiselles*, was the first article anywhere devoted entirely to this one painting. And although Golding failed to explore the implications of Picasso's preparatory drawings, his text was the first to place the picture in a broad art-historical context. Golding's article was also the first publication to review the early literature on the picture (in particular, to cite and make use of Salmon), to discuss the picture in depth in relation to individual works both of Matisse and Derain (such as the latter's 1907 *Bathers*, fig. 12), as well as to explore particular Bather pictures of Cézanne (fig. 9) as possible influences on Picasso, and to reproduce and recognize the importance of the two Iberian sculptures (the male head in particular) that Picasso had acquired in 1907 (see fig. 19). Golding proposed—rightly, it is now quite evident—that Picasso's crucial visit to the Musée d'Ethnographie du Trocadéro took place before he finished work on the *Demoiselles*, rather than afterward, as had been stated by Zervos.

To be sure, Golding agreed with Kahnweiler that the *Demoiselles* was in certain respects "unsatisfactory" because of "its obvious inconsistencies of style," and he unquestioningly repeated Kahnweiler's fiction that Picasso himself had considered the picture unfinished. Moreover, insofar as Golding assumed that Picasso became "more interested in purely pictorial problems" as the project advanced, he was accepting Barr's version of Kahnweiler's formalist thesis. (This popular view of the *Demoiselles* was reinforced, in the same year as Golding's article appeared, by a text on which Picasso's secretary, Jaime Sabartés, had collaborated; for him and Wilhelm Boeck, "The history of the composition … illustrates the process by which form asserts its supremacy over subject matter.")[98] Although Golding pointed out a few adumbrations of Cubism in the *Demoiselles*, he did not treat the picture primarily within a teleology of Cubism, nor accept the Kahnweiler/Barr thesis that it was the movement's starting point. On the contrary, he insisted:

The Demoiselles d'Avignon *is not, as has been so often said, the first Cubist painting. None of the fundamental qualities of Cubism are found in it. Detachment and intellectual control, objectivity combined with intimacy, an interest in establishing a balance between representation and an abstract pictorial structure—all these features are noticeably absent in the* Demoiselles. *Cubism was an art of realism, and, insofar as it was concerned with reinterpreting the external world in a detached, objective way, a classical art. The impression made by the* Demoiselles, *on the other hand, is one of violence and unrest. Indeed, the savagery of the two figures at the right-hand side (which is accentuated by the lack of expression in the other faces) would justify its classification as one of the most remarkable products of twentieth-century expressionism. But it is incontestable that the painting marks a turning point in the career of Picasso and, furthermore, perhaps the most important single turning point in the evolution of twentieth-century art so far.*

No articles devoted to the *Demoiselles* were to appear in the 1960s, although Robert Rosenblum's *Cubism and Twentieth-Century Art* (1960)[99] and Edward Fry's *Cubism* (1966)[100] contained extended passages on the painting. Rosenblum's superbly evocative text hinted at a contestation of the prevailing negative view of the picture's stylistic multiplicity. "*Les Demoiselles d'Avignon* has often been criticized for its styl-

istic incoherence," he noted. "Yet this very inconsistency is an integral part" of the picture. Rosenblum found the cause of this inconsistency, however, more in "the inexpressible energy behind [the picture's] creation" rather than in any artistic purpose on Picasso's part—a view that coincided with the position taken by Meyer Schapiro in his lectures at Columbia University. Schapiro had described Picasso, working from left to right in the picture, as developing so rapidly and intensely that it was impossible for him to make a homogeneous picture.[101] Rosenblum described the *Demoiselles* with emphasis on its "barbaric, dissonant power," which he related to primitivist music of the following decade such as Bartók's *Allegro Barbaro*, Stravinsky's *Rite of Spring,* and Prokofiev's *Scythian Suite.* He saw the "savagery that dominates the painting" expressed through "jagged planes that lacerate torsos … harsh junctures … [and] the furious energies of … collisive, cutting angles"; the "demonic" eyes of the crouching demoiselle were described as having "magical force." This newly imagined primitivist, almost shamanistic, Picasso presented by Rosenblum was, nevertheless, somewhat two-headed, for he cohabited with a painter whose explorations of "mass and void, line and plane, color and value" were "independent [of] representational ends."

Fry's discussion was the first to compare, however briefly, Picasso's treatment of the brothel theme with those of other painters. "The subject," he wrote, "recalls Picasso's interest, during his previous blue and pink periods, in episodes from the lives of those on the margins of society." But while the brothel was a familiar subject for artists such as Toulouse-Lautrec and Rouault, "Picasso's version is as far removed from the spirit of irony or pathos of his predecessors as it is from the empathy and restrained lyricism of his own earlier painting." Fry was also the first to signal, among Picasso's "sources," the work of Gauguin, "particularly his carved sculpture." Cézanne, however, emerges as the dominant influence for Fry, especially Cézanne's "tentative suggestion of an alternative to Renaissance perspectival space." "In *Les Demoiselles,*" Fry dubiously proposed, "one finds Cézannian '*passage*' linking together foreground and background planes," and there is as much precedent for "Picasso's schematic treatment of human anatomy" in Cézanne as there is in African sculpture. Given the variety of its "sources," the *Demoiselles* is "a crossroads of aesthetic forces." Fry nevertheless concurred with Kahnweiler and Golding in considering that Picasso had fused these contradictory forces "only imperfectly"; *Three Women* (fig. 7), which "bears a symmetrical relation to the *Demoiselles,*" was judged by Fry to be "more successful and unified, though less ambitious."

The 1970s opened with two paradoxically contrasting treatments of the *Demoiselles* by English art historians.[102] Though Douglas Cooper was an eminent scholar who enjoyed unparalleled personal access to Picasso, his 1970 book on Cubism contained only a trite, cliché-ridden discussion of the *Demoiselles;* John Nash, on the other hand, delivered a B.B.C. radio lecture on the painting that was remarkable for the freshness of its approach; regrettably, however, he never published it. In *The Cubist Epoch*, Cooper revealed to an unsuspecting world that Picasso had actually "gone far beyond Cézanne and Gauguin … in his simplifications and wholly new treatment of space." But it is "not easy to appreciate" the *Demoiselles*, Cooper continued, "because it was abandoned as a transitional and often reworked canvas, with many stylistic contradictions unresolved." Except for the mistaken suggestion that the faces of the two central figures (in addition to those at the sides) had been

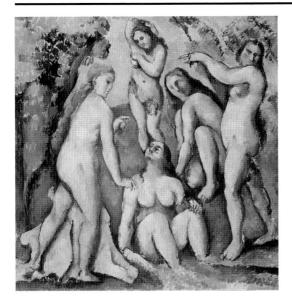

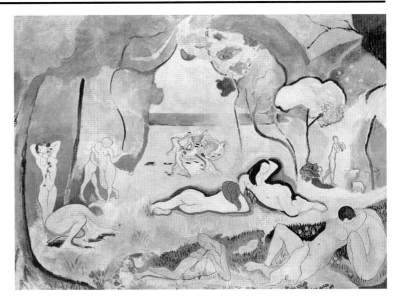

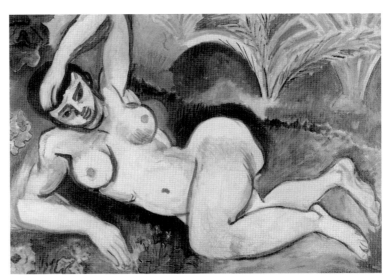

9. Paul Cézanne. *Five Bathers*. 1885–87. Oil on canvas, 25 ¾ x 25 ¾" (65.5 x 65.5 cm). Venturi 542. Öffentliche Kunstsammlung Basel, Kunstmuseum

10. Henri Matisse. *Le Bonheur de vivre*. Paris, autumn— winter 1905–06. Oil on canvas, 68 ½" x 7' 9 ¾" (174 x 238.1 cm). The Barnes Foundation, Merion, Pennsylvania

11. Henri Matisse. *Blue Nude: Memory of Biskra*. Collioure, early 1907. Oil on canvas, 36 ¼ x 55 ¼" (92.1 x 140.4 cm). The Baltimore Museum of Art. The Cone Collection

12. André Derain. *Bathers*. 1907. Oil on canvas, 52" x 6' 4 ¾" (132.1 x 195 cm). The Museum of Modern Art, New York. William S. Paley and Abby Aldrich Rockefeller Funds

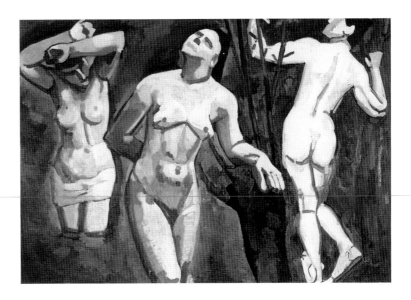

reworked by Picasso,[103] Cooper's text continued as a virtual rehash of Kahnweiler.

Leo Steinberg's brilliant, monograph-length "The Philosophical Brothel"[104] of 1972 fundamentally reoriented discourse about the *Demoiselles* and, in combination with Steinberg's other texts, about Picasso in general. The searching, insistent quality of Steinberg's thought, combined with the precision of his language, produced a text of such density and richness that it is hard to fully absorb even after repeated readings. As I intend to take up many of Steinberg's insights about individual aspects of the *Demoiselles* below, I will limit myself here to a summary of what seem to me the most important general features of his interpretation.

Steinberg was the first writer to come to grips with the sexual subject of the *Demoiselles*. He was the first to deal closely with the studies for the picture and, indeed, the first to deal *at all* with its many preparatory drawings in which the bordello subject is most evident. Steinberg was convinced that in the final work Picasso "did not abandon" his initial idea but discovered "more potent means for its realization." Thus, Steinberg viewed the *Demoiselles* essentially as "a sexual metaphor," whose figures "personify sheer sexual energy as the image of a life force." The stylistic differences between individual personages in the final work constitute Picasso's challenge "to the notion that the coherence of the work of art demands a stylistic consistency among the things represented," and the artist's decision to introduce these differences was characterized as "purposeful." Steinberg saw this stylistic multiplicity as paralleled by a methodological variety in Picasso's means of indicating space, the whole of which was compressed not only from back to front but from its sides: "no terms taken from other art—whether from antecedent paintings or from Picasso's own subsequent Cubism—describe the drama of so much depth under stress." This is not a flattened form of Renaissance space, not a Cubist space, but one "peculiar to Picasso's imagination." Beginning with the raised, pointed edge of the foreground table, "a visual metaphor of penetration,"[105] the space and the figures and objects in it were seen by Steinberg as expressively and symbolically in the service of the sexual content of the picture. The space was "not a visual continuum," but "an interior apprehended on the model of touch and stretch, a nest known by palpation, or by reaching and rolling, by extending oneself within it. Though presented symbolically to the mere sense of sight, Picasso's space insinuates total initiation, like entering a disordered bed." The picture's "inconsistencies" and "discontinuities" were subsumed in a higher expressive and psychological unity that "resides above all in the startled consciousness of a viewer who sees himself seen."

Seven years later Steinberg himself would summarize his many aperçus about the "explosive debut" in the *Demoiselles* of what he called Picasso's "discontinuity principle":[106]

The picture crowds five disconnected figures—not as one group, nor in one ambience, but each singly encapsulated: the lone curtain raiser at left, separated even from her own lifted hand by an unmediated space jump; the second figure stretched forth in reclining position seen from on top—she arrives on the picture plane like a Murphy bed hitting the wall; the straight middle figure adjacent, but with no spatial ties to her sister, seen from below again. Then those curtain folds like packed ice to quarantine the intruding savage at upper right—treated in a menacing "African" mode; and lastly—"crouched for employment"—an exotic jade realized like no other, dorsal and frontal at once.

Comparison with the numerous studies for the Demoiselles *revealed how tenaciously Picasso pursued this end; he was resolved to undo the continuities of form and field which Western art had so long taken for granted. The famous stylistic rupture at right turned out to be merely a consummation. Overnight, the contrived coherences of representational art—the feigned unities of time and place, the stylistic consistencies—all were declared to be fictional. The* Demoiselles *confessed itself a picture conceived in duration and delivered in spasms. In this one work Picasso discovered that the demands of discontinuity could be met on multiple levels: by cleaving depicted flesh; by elision of limbs and abbreviation; by slashing the web of connecting space; by abrupt changes of vantage; and by a sudden stylistic shift at the climax. Finally, the insistent staccato of the presentation was found to intensify the picture's address and symbolic charge: the beholder, instead of observing a roomful of lazing whores, is targeted from all sides. So far from suppressing the subject, the mode of organization heightens its flagrant eroticism.*

"Pygmalion and Medusa," the radio talk given by John Nash in 1970[107]—slivers of which later appeared in that author's *Cubism, Futurism, and Constructivism* in 1974[108]—had anticipated Steinberg's publication by two years. If I deal with it after Steinberg, it is because Nash's failure to publish it kept it out of the ken of scholars; I myself did not become aware of "Pygmalion and Medusa" until 1987. Nash had addressed only a few of the many aspects of the *Demoiselles* treated by Steinberg, but it is clear that he and Steinberg had been thinking along related lines. Nash suggested that Picasso's removal of the sailor in the final studies "turned the dramatic focus of the picture on the relation between the demoiselles and the spectator," and that in the final work the artist had not "lost interest in the original theme" but had developed it, turning to the forms of primitive art specifically to "provide a metaphor for the power of sexuality."

Rejecting the teleology of Cubism within which the *Demoiselles* had traditionally been set, Nash was "sure that we shall understand the *Demoiselles* better by looking at what lay behind it rather than what lay ahead." After Spies,[109] he was among the first to draw attention to Ingres's *Turkish Bath* (fig. 14) as "the true ancestor of the *Demoiselles*," and he invoked as well Delacroix's *Women of Algiers* (fig. 13) in passing. Both were seen as feeding into Picasso's *Harem* of 1906 (fig. 16), which was proposed as a crucial link to the brothel image. Finally, Nash identified two similar small drawings of heads published by Zervos (see figs. 182, 183) as studies for the crouching demoiselle and suggested that they were metamorphosed from the contours of a torso that Picasso had originally drawn on one of the sheets in question. Hence this most radical of all the heads in the *Demoiselles* was interpreted by Nash as a displaced sexual emblem—"an aesthetic indecency which metaphysically transfers the obscene display at first made [by this demoiselle] to the sailor, directly to the spectator." (In a number of Picasso's drawings, throughout his career, the "obscene display" is not displaced symbolically; see figs. 93, 223, 224.)

Rosenblum's "The *Demoiselles d'Avignon* Revisited"[110] of 1973 began with thanks to Steinberg for having "resurrected" Picasso's image as a "startling, unfamiliar painting." Indeed, Steinberg's article would trigger a veritable second literature on the *Demoiselles*. Though Rosenblum and other writers might expand on some of Steinberg's insights, explore some aspects of the picture that Steinberg did not treat, and occasionally take exception to his ideas, everyone writing after 1972 has been

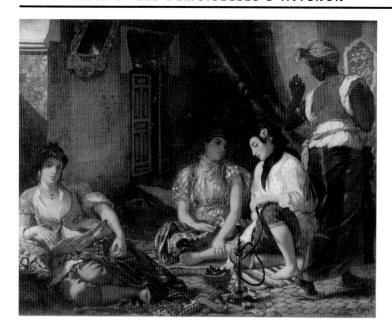

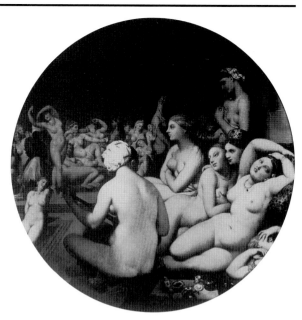

directly or indirectly indebted to "The Philosophical Brothel." As was the case with Rosenblum's text, which explored in detail the relationship of Picasso's image to Manet, Ingres, and Delacroix, entire articles would now be devoted to particular aspects of or perspectives on the painting. In view of this increasing specialization, Rosenblum's text and others of the seventies and eighties will be cited below (rather than summarized here) as individual aspects of the *Demoiselles* are taken up.

Perhaps the only exception to the widespread influence of Steinberg's text was Ron Johnson's "Picasso's *Demoiselles d'Avignon* and the Theatre of the Absurd" of 1980,[111] which made an important contribution to expanding the literary context of Picasso's early work by focusing on his interest in anarchic and proto-Dadaist aspects of Alfred Jarry, Apollinaire, Jacob, and Salmon. With particular attention to Jarry, about whose relationship with Picasso "not enough has been said," Johnson's speculative commentary explored a strain of Paris culture of the *Demoiselles* period that had earlier been celebrated by André Breton and developed critically by Roger Shattuck.[112]

In his enthusiasm, however, Johnson used this particular cultural context as the almost exclusive filter through which he viewed the *Demoiselles*. The gun that Picasso is said (apocryphally) to have received as a gift from Jarry—"an anarchist and phallic weapon of contradiction signifying death of the old mentality and birth of the new"[113]—is for Johnson the key to the painting, which he conceives as a masterpiece of "tragi-comic humour," a shocking and disorienting pictorial *geste* in the spirit of the opening of *Ubu Roi*, where Ubu turns to the audience exclaiming the neologism "merdre." As a bridge, Johnson alludes to the occasion when a bored, probably exasperated Picasso is said to have responded to a request that he explain his aesthetic theories by firing a few shots in the air.[114] For Johnson, "mockery" is the "exploding device" of Picasso's symbolic anarchist's gun: "Mockery is one of the most effective weapons for dealing with threatening and contradictory situations since it can simultaneously accommodate both attraction and revulsion." Johnson's "mockery," which somewhat resembles what Breton described as Surrealist "hilarity," is (rightly, I

13. Eugène Delacroix. *Women of Algiers*. 1834. Oil on canvas, 70⅞" x 7' 6⅛" (180 x 229 cm). Musée du Louvre, Paris

14. Jean-Auguste-Dominique Ingres. *The Turkish Bath*. 1859–63. Oil on canvas (tondo), diameter 42½" (108 cm). Musée du Louvre, Paris

believe) described as a characteristic of Picasso's personality and (wrongly, I think) found at the center of the *Demoiselles*. Johnson describes Picasso's previous "Symbolist" work as having "a private and inward" quality, which would be "externalized" and "shifted to public display" in the *Demoiselles*, whose somewhat "puppet-like" figures and masks related directly to Jarry's conception of theater.

My problem with Johnson's approach is less that its argument is wrong than that it covers but a narrow span of what is right. By treating Jarry as a virtual member of Picasso's circle—though Picasso probably never even met him[115]—by overly insisting on the similarities in interests, personality, and behavior of the two men, Johnson creates a reading of the *Demoiselles* in which anarchic Jarryesque humor crowds out the biographically related problematic (Picasso's personal psychosexual crisis), to say nothing of the symbolic and formal inventions at the heart of Picasso's picture. This, in turn, prejudices Johnson's treatment of its primitivist dimensions.[116]

There hovers over Johnson's exposition the implication that Jarry had an important influence on the *Demoiselles*—impossible to swallow for anyone intimate with the picture's biographical context and, above all, with the details of its incredibly extended artistic development. Unquestionably there were strongly anarchic traits in Picasso's personality (not to be confused with a commitment to anarchism,[117] however much they might have made Picasso sympathetic to anarchist ideas), and his sense of humor was Rabelaisian. (Indeed, given Picasso's robustness in all aspects, he was, to my mind, more Gargantua than Ubu.) But all this was genetically encoded and widely evidenced well before Picasso's contact with Jarry's work. His interest in Jarry's ideas, and his far more profound and personal involvement with those of Apollinaire and Jacob, were by way of being what Goethe called "elective affinities." Had Jarry never existed, the drama of the *Demoiselles*'s realization would not, I am convinced, have been visibly different. No doubt we can savor some overtones of the Picasso/Jarry affinity in the *Demoiselles*, but on a secondary level at best.

What Johnson says about Picasso's colossal and bawdy wit is very true. But you will search unsuccessfully through the hundreds of studies for Picasso's bordello scene for a scrap of Johnson's "ribald humor," which, elsewhere in Picasso's work, was commonly engendered by the theme of sexuality—even in the densest and most contemplative Cubist compositions. But such works flowed from the familiar Picasso, secure and sure of himself. The *crise de conscience* that produced the *Demoiselles*—a picture as different in spirit from what followed it (the reintegrated world of *Three Women*) as from what came before—led to an interior *agon* entirely uncharacteristic of Picasso in its sustained and unrelieved seriousness. When Johnson—attempting to reinforce the humorous side of his tragicomic *Demoiselles* thesis—stresses Picasso's allusion to the jokes he and his intimates made about the "identities" of the five females in the picture, he forgets that these studio jokes were made *after the fact* of what was for Picasso a troubled and even frightening night journey.[118] An early critic such as Burgess might, as Johnson notes, find the *Demoiselles* grotesquely humorous. But that more reflected the differential between Burgess's own definitions of painting and what he saw in Picasso's studio than it did the painting or its related works. Painters and poets more familiar with Picasso's work would find the picture disquieting, frightening, disappointing, or inadmissible. But, whatever their reactions, they were not amused.

Johnson's text is truffled with observations that ring true for Picasso as a whole

but fall short—or, more often, distort—when generalized onto the *Demoiselles*. For example, his extended discussion of the "anti-religious" in Picasso, particularly in its relation to Apollinaire, makes good sense until it is hypertrophied and read into the *Demoiselles*. Thus "the current of religious mockery in Picasso's circle and its appearance in two drawings" (unrelated to the *Demoiselles*) is extrapolated to the point that the "Avignon" in the title becomes an anticlerical allusion to the papal city that, together with "the aggressive sexual and caustic stylistic character" of the picture, "very likely" was "meant to deliver a broadside to the church."

In the process of interpreting Picasso's concerns in the *Demoiselles* as outer-directed social satire or propaganda, Johnson opened the door to the recent predominantly political and social interpretation of the *Demoiselles* as elaborated largely by Patricia Leighten.[119] Johnson's passing remark that the *Demoiselles* whores revealed "the emotional brutalization of the brothel inhabitants"—hardly a pressing concern of Picasso, who exploited them himself and was happy to use some other women as "doormats" (his own word)—is extrapolated by Leighten into an Alice in Wonderland inversion of a feminist tract. Here Picasso, instead of being a simple brutalizer of women (the standard feminist approach),[120] becomes a politically correct proselytizer for their emancipation.[121]

To the extent that Johnson saw the *Demoiselles* as an anarchist-related pictorial tract in the spirit of Jarry, he was obliged to interpret it as a more public, outer-oriented painting than Picasso's previous work. This seems to me the reverse of the truth. Although its figures are not narratively interconnected, and face the spectator "iconically,"[122] the nature and context of the picture's motif are more private than heretofore. Its immediate predecessor among Picasso's large pictures, *Family of Saltimbanques* (fig. 97), was tinged, to be sure, with a Symbolist wistfulness, but was, nevertheless, a public picture: a statement about the artist's relationship to the world. The *Demoiselles* was almost hermetic, in all the meanings of the word; hence, literary references tell us less about its essence than they do about some of his other works.

Picasso clearly considered the *Demoiselles* an extended dialogue with himself—not a public statement, emphatically not a social tract—and perhaps precisely because it plumbed problems at the deepest levels of his psyche, it engendered, over the many months of its development, more radical innovations than any other work in his oeuvre. In it, Picasso mooted many possible new definitions of painting, to some of which he would return only after many years. That the *Demoiselles*'s realization depended on Picasso's confrontation with his inner self—which, as suggested earlier, attested to a courage comparable to that of Freud's self-analysis—cannot be uncoupled from the unique incidence of invention in, nor the hermeticism of, the pictorial language he was forced to develop to implement this interior dialogue. And to the extent that the *Demoiselles* was unquestionably more self-revealing than his other work, we understand the possessive, almost secretive attitude Picasso maintained about it. (The similarly private, though smaller and less crucial *Embrace* of 1925 [fig. 252]—stylistically, a kind of gloss on the *Demoiselles* that issued from his crisis with Olga—was kept even more confidential and was seen only after Picasso's death.)[123] Picasso's attitude, in turn, also explains, though only in part, the strange absence of references to the *Demoiselles* in accounts by his intimates; hardly mentioned by Jacob, it is not mentioned at all by Apollinaire—and it is omitted from Fernande's memoirs.

II. The Picture's Gestation

The profoundly private nature of what Picasso confronted in the *Demoiselles*, and the almost secretive attitude he therefore took toward the painting, return us inevitably to the personal crisis he underwent at the time he painted it. Deeper psychological forces of a kind presumably at work in his affair with Fernande Olivier, especially in the rupture between them which I described at the outset, gradually reveal themselves in the course of the interior journey that Picasso pursued in developing the *Demoiselles*. They make themselves felt both in the painting's extended studies and in the demanding execution of the large canvas itself. Indeed, certain relevant elements surface in his work even before the studies.

THE PREHISTORY OF THE DEMOISELLES IN PICASSO'S WORK

If there is any single point in Picasso's career at which the subjects that eventually filter into the *Demoiselles* clearly begin to germinate, it is during the artist's stay at Gósol in the Spanish Pyrenees in the summer of 1906. Picasso seems to have been remarkably happy in this remote village, whose isolation was conducive to assimilating the many new experiences, artistic and personal, to which he had been exposed in Paris the previous winter. The lyrical images of Fernande painted there—a "great hymn to Fernande's body"[124]—suggest a pleasurable sexual life with a woman with whom Picasso was spending entire days for the first time away from the distractions of his Parisian entourage.

A drawing from the so-called Catalan Sketchbook shows a nude boy amidst trees (fig. 15) with his arms raised behind his head in a pose that looks back to Cézanne and forward to the central demoiselle. But the sketch was probably triggered by a recollection of the standing nude on the left of Matisse's *Le Bonheur de vivre* (fig. 10), which Picasso saw in the 1906 Salon des Indépendants, not long before leaving for Spain.[125] Taken together with other sketches from that summer, in particular one of a seated nude, legs akimbo, it suggests that Picasso gave some thought to a composition of nudes in a pastoral setting à la Matisse. In keeping, however, with the themes related to Fernande's *toilette* that dominate the Gósol stay, he finally opted for an enclosed, more intimate conception: the tentatively realized but nevertheless prophetic *Harem* (fig. 16).

The Harem shows "four nude Fernandes"[126]—bathing, stretching, combing her hair, and regarding herself in the mirror—in the presence of two symbolically important but anachronistic figures. The old procuress crouching in the background corner, a descendant of Picasso's 1903 *Celestina* (fig. 91), gives the first hint that these nude houris might later find themselves in a brothel. The powerful, bareheaded ithyphallic colossus in the foreground of *The Harem* has been explained by some critics as a eunuch; but Steinberg pointed out that eunuchs do not sit about nude in harems. On the contrary, this colossus "lolls like a proud possessor" and—as only Steinberg could have put it—"conveys his velleity by the penchant of his *porrón*."[127] The colossus is thus a surrogate for Fernande's proud possessor. The *porrón*—"characterized by an erect spout"—was an object that had recently begun to intrigue Picasso. Its use here as an attribute of the male figure is important insofar as it would return again, Steinberg observed, as a "sexual surrogate" for the sailor in the early sketches of the *Demoiselles*.[128]

15. *Nude Boy with Raised Arms*. Catalan Carnet, p. 16. Gósol, summer 1906. India ink on paper, 4¾ x 6" (12 x 7.5 cm). Zervos XXII, 406. D./B. XV, 1. Formerly estate of the artist

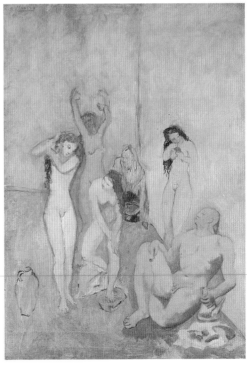

16. *The Harem*. Gósol, summer 1906. Oil on canvas, 60¾ x 43⅛" (154.3 x 109.5 cm). Zervos I, 321. D./B. XV, 40. The Cleveland Museum of Art. Leonard C. Hanna, Jr., Collection

Although inspired primarily by Picasso's fascination with Fernande's *toilette*, *The Harem* is the first echo of the profound impression made on the painter by Ingres's *Turkish Bath* (fig. 14), which Picasso had seen in the Ingres retrospective that formed part of the celebrated Salon d'Automne of 1905. *The Harem* picks up what Rosenblum calls *The Turkish Bath*'s "ambiguous spatial scheme" as well as its exotic setting.[129] Daix also considers the position of the male colossus in the foreground to reflect that of the odalisque at the lower right of Ingres's picture.[130]

If Picasso was inspired by *The Turkish Bath* to create *The Harem* as an interior, "Orientalist" alternative to the Golden Age pastorale of Matisse's *Le Bonheur de vivre* (fig. 10), the results were neither very personal nor, indeed, very good. Moreover, despite the presence of such Western anachronisms as the *porrón* and the procuress, the scene adheres basically to a nineteenth-century tradition of "Turkish" salon pictures in which the erotic is rendered morally acceptable by means of the exotic, that is, by displacing it in time and space. Picasso's Fernande-like houris emerge, in fact, as more casual than erotic in spirit—they could at most be called languorous—and none of them have that insistent, "paint-substantial" sensuousness with which Picasso's handling endowed other images of Fernande at Gósol. To be sure, it is possible, as Daix suggests, that Picasso was consciously thumbing his nose at the tradition represented by *The Turkish Bath* to the extent of including in *The Harem* such trivialities as a "commonplace snack of bread, cold sausage, and red wine which insult the delicacy of the tea served on the low table of the *Bain Turc*."[131] Notwithstanding, the results still leave us very far from the conjunction of actuality and sexuality proposed in the *Demoiselles*.

While *The Harem* thus adumbrates the subject of the *Demoiselles*, two other aspects of Picasso's work at the end of the Gósol stay, both associated with his Spanishness, were to contribute more directly to the great bordello picture. The first is the "Iberian" stylization exemplified by the handling of Fernande's head in *Reclining Nude* (fig. 17)—a sculptural realization that predicts the mask-like face Picasso would give Gertrude Stein when he completed her abandoned portrait (fig. 20) some weeks later.[132] Most critics agree in seeing these reductive and insistently tactile heads as the first results of Picasso's avowed interest in the Iberian carvings from Osuna (fig. 18), installed the previous winter of 1905–06[133] at the Louvre (although, as Leighten points out, Picasso probably had some familiarity with Iberian art in his early Barcelona years).[134]

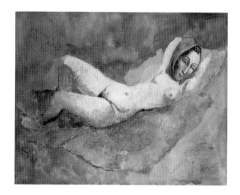

17. *Reclining Nude (Fernande).* Gósol, summer 1906. Gouache on paper, 18 ⅝ x 24 ⅛" (47.3 x 61.3 cm). Zervos I, 317. D./B. XV, 47. The Cleveland Museum of Art. Gift of Mr. and Mrs. Michael Straight, 1954

Very different, and still more prophetic, were the sketches for *The Blind Flower Merchant*, which testified to a renewed—and more profound—confrontation with El Greco. The large canvas (fig. 21) that issued from those sketches was executed in Paris, where Picasso and Fernande had returned precipitously in mid-August when typhoid broke out in Gósol. Given the ways in which *The Blind Flower Merchant* anticipates the *Demoiselles*, it seems to me not insignificant for the meanings of the later picture that this large Grecoesque composition should emerge from an idyll of love between Picasso and Fernande that was interrupted by the threat of disease and death.

While the stylized sculptural "masks" that marked Picasso's autumn 1906 reactions to Iberian sculpture are still a long way from the *Demoiselles*, a continuous thread links them to the features of the first, so-called Iberian version of the large canvas, from which only the two central figures remain. Picasso's autumn 1906 style, as exemplified by Gertrude Stein's repainted head—smooth, hard, and sculptural—had

been provoked primarily by the Osuna sculptures (fig. 18). His approach subse-
quently became looser, more linear, indeed almost caricatural at times, as he re-
focused that style under the pressure of the Iberian carving from Cerro de los Santos
that came into his possession in early 1907 (fig. 19),[135] an elongated male head whose
hairdo, huge ear, and damaged eye fascinated him.

Both Osuna and Cerro were backwater areas of Mediterranean culture and
commerce, where sculptural style had remained essentially provincial, almost indige-
nous. Sweeney described some of the Osuna pieces as reflecting a "synthesis of ori-
ental influences with a provincially degenerate classicism."[136] "Unorthodox in formal
idiom," he continued, "these sculptures gave the impression of a complete disregard
for any refinements of manual dexterity, much less technical virtuosity." This was cer-
tainly crucial to their appeal for Picasso, inasmuch as, beginning with the *Demoiselles*
(and later with collage and construction), his most daring and personal innovations
would derive from working against the grain of his own technical prowess. The
"primitive" dimension of the Iberian sculptures constituted the first of a series of trig-
gers that spurred Picasso into an entirely personal artistic language (as opposed to the
essentially nineteenth-century idioms that he had paraphrased prior to 1906). All the
more did these archaic sculptures recommend themselves to Picasso because they
were widely recognized as the oldest native art of his Spanish homeland. The Osuna
excavations were located not far from his birthplace.

That the impact of the Iberian carvings should only be discernible in Picasso's
art some six months after he first saw them is not surprising. Their implications had
gradually to enter into and become part of his own thinking. Influences of other
artists only manifest themselves in Picasso when his own development is at a point
where it is profitable to cannibalize their work. This may be immediately; but it may
also be years later. He had seen Henri Rousseau's painting, for example, months
before seeing the Louvre's Osuna installation—if not earlier[137]—but Rousseau's
influence would not become evident in Picasso's work until the summer of 1908,
when it could usefully contribute to the "proto-Cubism" of his Rue-des-Bois
landscapes.

Picasso's interest in archaic Iberian statuary marks the initial phase of what is called
his "primitivism." When this word is used today, it rather evokes modern artists'
fascination with the tribal art of Africa and Oceania. But the formal and ideational
assimilation of such tribal art really began only in 1907[138] (in the *Demoiselles* and in

20. *Portrait of Gertrude Stein*. Paris, begun winter 1905–06; partially reworked Paris, autumn 1906. Oil on canvas, 39 ¼ x 32" (99.6 x 81.3 cm). Zervos I, 352. D./B. XVI, 10. The Metropolitan Museum of Art, New York. Bequest of Gertrude Stein

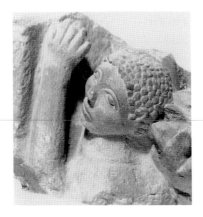

18. *Man Attacked by a Lion*. Iberian; Osuna, 6th–3rd century B.C. Stone (detail of a bas-relief), 16 ⅛" (41 cm) high. Museo Arqueologico Nacional, Madrid

19. *Head of a Man*. Iberian; Cerro de los Santos, 5th–3rd century B.C. Limestone, 18 ⅛ x 10 ⅝ x 6 ¾" (46 x 27 x 17 cm). Musée des Antiquités Nationales, Saint-Germain-en-Laye. In Picasso's possession from March 1907 to September 5, 1911

Matisse's *Blue Nude;* fig. 11) and it marks a later, strictly twentieth-century phase in the development of Western primitivism, which already had a substantial history.

For the bourgeois public of the nineteenth century (though not for a handful of vanguard artists of that time) the adjective "primitive" had a pejorative meaning. Indeed, that public considered any culture outside Europe—any art outside the margins of Renaissance-derived Beaux-Arts styles—inherently inferior. Hence, not surprisingly, all styles outside the tradition of Western European verisimilitude —Egyptian, Asian, Byzantine, and even Western medieval art, for example—were known as "primitive."[139] To the extent that the "fetishes" of tribal peoples were known at all, they were not even considered art, but extravagant artifacts of untutored "barbarians." Even so sophisticated a critic as John Ruskin opined that there was "no art in the whole of Africa, Asia or America."

Yet a more positive, "minority" view of tribal peoples—although *not*, it must be emphasized, of their art—had already begun to form in the eighteenth century, especially in France. But this affirmative attitude, of which Jean-Jacques Rousseau's Noble Savage is the best-known embodiment, involved only a segment of the small educated public, and remained entirely literary and philosophical in character. Antipodal to the popular view, it tended to idealize primitive life, building upon it the image of an earthly paradise—a kind of "myth of the primitive"—inspired primarily by visions of Polynesia, especially Tahiti.[140] If we trace this attitude to its source in Montaigne's essay "On Cannibals," we see that, from the start, the writers in question were interested in the "primitive" primarily as an instrument for criticizing their own societies, which they saw as deforming the innately admirable spirit of humankind that they assumed was still preserved in such island paradises.

This is the ideational context out of which the primitivism of Gauguin developed, and it was precisely Picasso's contacts with the art and ideas of Gauguin that formed the background, if not the precondition, of his interest in archaic Iberian sculpture. Moreover, the shift from a perceptual to a conceptual type of painting— with which Picasso caught up at the end of his Gósol stay—had been initiated by Gauguin (though it had already been signaled by Manet, and was reflected in the *japonisme* that took hold in the 1860s).

If Gauguin has thus been rightly considered the starting point for the study of primitivism in modern art, his role has nevertheless tended to be misunderstood, for his primitivism was ultimately more philosophical than aesthetic, and, actually, hardly involved the tribal art of the Pacific peoples among whom he lived. The few Polynesian works that figured in his painting—a modified Marquesan Tiki on a hill or an enlarged Easter Island "talking board" used as a background for a portrait[141]— functioned more as contextual symbols and decorative devices than as agents of influence on his style. In Gauguin's painting, references to Polynesian tribal art are far fewer and less central to his imagery than are the allusions to non-Western archaic court styles such as the Egyptian, Persian, Cambodian, and Javanese—which arts are, indeed, what everyone including Gauguin thought of as "savage" art in the last decades of the nineteenth century. Gauguin synthesized these diverse interests in an eclectic paradisiacal vision that shows contemporary Tahitian women standing in postures taken from Javanese sculptures (see *We Hail Thee Mary* of 1891 in The Metropolitan Museum of Art, New York) or sitting in those adapted from Egyptian painting (see *Market Day* of 1892 in the Kunstmuseum Basel). However, in view of

the degradation and dissolution of Tahitian life that had already resulted from French colonization, it would not be farfetched to consider Gauguin's visual account of his "island paradise" a somewhat desperate example of life imitating literature—in effect, a mimetic reenactment of the "myth of the primitive."

Picasso's contacts with Gauguin's art began in 1901, when he and Sabartés visited the studio of Paco Durrio, who possessed a number of Gauguin's works. Through Durrio he met Charles Morice, who, in 1902, gave Picasso a copy (now lost) of his publication of Gauguin's *Noa-Noa*, in the margins of which Picasso made at least two drawings. Ron Johnson[142] has traced various influences of Gauguin in Picasso's work from 1901 through 1905, but none of the adduced examples anticipate Picasso's subsequent primitivism. Such influences from Gauguin as feed into Picasso's remarkable stylistic metamorphosis from the summer of 1906 through the spring of 1907 are discernible in the Spanish painter's work only *after* his exposure to the Osuna sculptures in the Louvre early in 1906. The latter prepared him to look with a fresh eye at the wide range of sculpture as well as painting shown in Gauguin's retrospective at the Salon d'Automne of that year. In general, Picasso seems generally not to have been overly impressed by the "soft" primitivism of Gauguin's synthetic vision of an exotic paradise. Iberian sculpture was not accompanied by this sort of Romantic baggage. Cruder and more raw in spirit than the ritualized archaic court art subsumed in Gauguin's painting, the Iberian carvings lent themselves more readily to absorption into an art marked by rough-hewn facture and commitment to present time and place, such as Picasso now wanted.

The Blind Flower Merchant (fig. 21), which was executed concomitantly with Picasso's early Iberian paintings, is "altogether exceptional," as Barr observed, in his art of late 1906.[143] Yet its innovative linear Mannerism marks it, I believe, as even more significant for the *Demoiselles*, stylistically speaking, than such major intervening Iberian works as *Two Nudes* (fig. 27). In *The Blind Flower Merchant*, Picasso extrapolated from El Greco considerably more than the pathetic (indeed, sometimes bathetic) Mannerist elongation he had used to characterize society's "outsiders" during the Blue Period. Its distortions are far more angular and extreme than anything seen in Picasso thus far, indeed, than anything that was to precede the *Demoiselles*. The compression of the interlocking linear web that binds the composition of *The Blind Flower Merchant* anticipates the *Demoiselles* more closely than do the juxtapositions of sculptural forms which characterize Picasso's intervening paintings.

Picasso's renewed interest in El Greco was no doubt sparked by the first Spanish monograph on that painter, published by Picasso's friend Miguel Utrillo in Barcelona shortly before Picasso passed through that city on his way to Gósol. Barr drew attention to the "remarkable resemblance" of Picasso's *Blind Flower Merchant* to El Greco's *Saint Joseph with the Child Jesus*, which was reproduced in Utrillo's book.[144] Indeed, the tilt of the child Jesus' head, his curly hair, and the position of his legs were taken up in Picasso's little girl, as were aspects of the larger compositional configuration, with the baskets of flowers replacing the swarm of flower-bearing angels. Other Grecoesque aspects of *The Blind Flower Merchant* that were even more prophetic for the *Demoiselles* include Picasso's suppression of graduated modeling in favor of highly contrasting shards of light and dark (especially in the "abstract," almost disembodied patterning of the drapery); his spatial compression of figures and animals (they are almost steamrolled together); and his peculiar "vertical" perspective (the

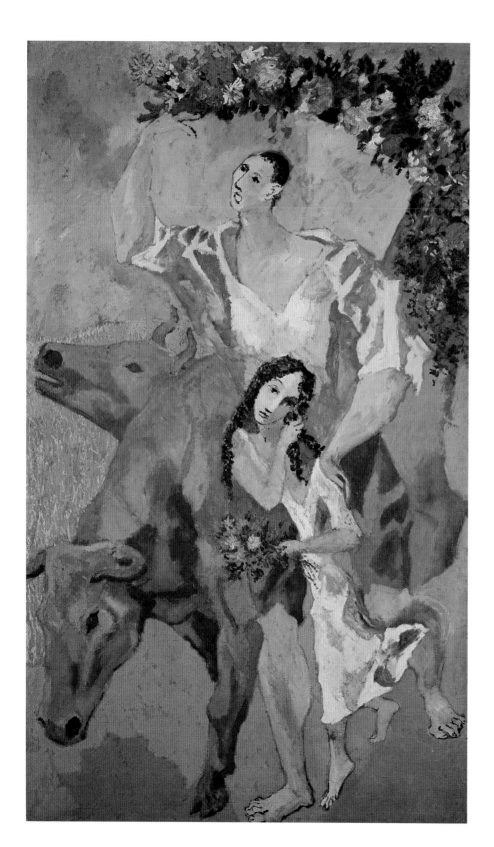

Left:
21. *The Blind Flower Merchant*. Paris, August 1906. Oil on canvas, 7' 2" x 51 ⅝" (218.5 x 129.5 cm). Zervos I, 384. D./B. XV, 62. The Barnes Foundation, Merion, Pennsylvania, Inv. no. 140

Opposite, from top:
22. *Young Girl and Devil*. 1906. Ink on paper. Zervos VI, 804. Private collection

23. *Young Girl Between Devil and Cupid*. 1906. Turpentine painting on paper, 8 ⅜ x 5 ¼" (21.5 x 13.5 cm). Zervos VI, 805. Formerly estate of the artist, no. 578

24. *Nude and Faun*. 1906. Watercolor on paper, 8 x 5 ¼" (20.5 x 13.5 cm). Zervos XXII, 412. The Alex Hillman Family Foundation, New York

forearms of the flower merchant, for example, diminish radically in width, leaving ambiguous whether their contours are to be read simply as distortions or as orthogonal clues to movement through space).

The young girl who leads the blind flower merchant has one of those faces that continue to haunt Picasso's art for some time. Her metamorphoses are such that we can recognize her at some moments only by her long, angular nose or her curly hair; she is most fully realized in the autumn of 1906—now somewhat grown in years— in the large *Woman with a Comb* (Zervos I, 337). Josep Palau i Fabre[145] points out an interesting transformation of this girl in a drawing where, separated from the flower merchant and grown plumper, she is tempted by a top-hatted devil who offers her jewels (fig. 22); grown plumper still, she is torn between a satyr-devil and a cupid (fig. 23); and finally, inflated to the Cézannesque proportions of Picasso's late 1906 nudes, she again confronts a satyr-like devil (fig. 24). Palau considers this "one of the most curious metamorphoses [in] the artist's whole career," and is quite right in seeing this series of works on paper, which links the girl of *The Blind Flower Merchant* to the context of *Two Nudes* (fig. 27), as one of those "separate adventures [that] suddenly converge and combine, like a series of different streams and brooks, to form a mighty river" with the appearance of the *Demoiselles*. Moreover, such themes as beautiful young girls tempted by top-hatted devil-clients, or torn between romantic love (Cupid) and erotic sexuality (satyr-devil), are not without a certain resonance for the sexual problematic of the brothel image that was to come.

We know very little about the chronology of the paired female nudes of late 1906 and early 1907 that led up to and away from the monumental *Two Nudes*, a picture that represents Picasso's Iberianism at its most sculptural. The stylization of the heads in this painting—especially the heavy-lidded, almost lozenge-shaped eye— reflects the continued influence of the Osuna sculptures. But these bulbous, awkward, and semi-hieratic nudes, and especially the drawings that prepare them, also have a kinship with the figure style and proportions of Cézanne, as we see him in such early pictures as *The Temptation of Saint Anthony* (fig. 25) and, later, in *Five Bathers* (fig. 9). As in Cézanne, the shading that models Picasso's nudes is not consistent with any outside source of light and thus seems a property of the monumental forms themselves. Despite the figures' insistent plasticity, which creates a sense of weight and bulk far greater than Cézanne's, they are modeled—like Cézanne's bathers—not in the round but in relief, diminishing to virtual flatness in a few passages.

As far as the *Demoiselles* is concerned, *Two Nudes* is best considered in connection with its many drawings, some of them postscripts, such as the one in which the two female figures from the painting are joined to two others, one standing, the other sitting (fig. 26). Here, compressed in a room hung with a curtain not only in back but in the foreground, something anticipating the "theater" of the *Demoiselles* begins to emerge. Steinberg saw such studies as "shading off" into those for the bordello. Indeed, the earliest study for the *Demoiselles* (fig. 30) is literally back-to-back in the same sketchbook (Carnet 2, 32R and 32V) with a postscript for *Two Nudes* (fig. 100). Moreover, the second demoiselle from the left in Picasso's bordello painting (who was originally seated), and the crouching demoiselle on the lower right (also originally seated), are direct descendants of two seated nudes in a sketchbook drawing that is also a postscript for *Two Nudes* (fig. 101). Steinberg fantasizes that the curtain grasped

by the left-hand figure in the chaste *Two Nudes* conceals a scene of a wholly contrary type of sexuality that Picasso, by a process analogous to a cinematic "jump cut," would reveal in the *Demoiselles*.[146] Thus the curtain in *Two Nudes* is identical with the one opened from behind by the standing demoiselle on the right. The very contrasts of style and meaning between *Two Nudes* and the *Demoiselles* speak for the symmetrical relationship Steinberg posits: *Two Nudes* exemplifies femininity in terms of "primal virginity … ripe and unbreached." On the other side of the curtain await the "eager anatomies of the demoiselles … bodies manipulable and ready for play."[147]

SYMBOLIC THEATER IN THE EARLY STUDIES

When Picasso pursued the vision on "the other side of the curtain" during the early months of 1907 in the sketches for a large brothel picture, he temporarily placed at the center of his art a wholly carnal, unromantic kind of sexuality previously seen only in his minor works or marginalia (such as erotic drawings and caricatures, figs. 79, 223, 224). While never overtly pornographic, the promiscuous and unregenerate sexuality Picasso evoked in his early studies for "my brothel" was not at that time considered acceptable subject matter for serious painting. Indeed, any large brothel picture—even so discreet and sedate a one as Lautrec's 1894 *In the Salon at Rue des Moulins* (fig. 28)—constituted an outright social challenge. Had Picasso carried out the *Demoiselles* in the more realistic, narrative spirit of its early sketches (figs. 30–34), the seductively postured whores would certainly have provoked scandal in a public exhibition. Yet such a painting would have conveyed little of the psychosexual *déchaînement* that characterizes the *Demoiselles* as we know it. The full depth of Picasso's will to transgress was only to be plumbed as the image evolved. Ironically, the relatively private scandal it actually *did* cause had less to do with this exacerbated sexual content than with the radical and expressionistic formal language Picasso had invented to express it.

In the early drawings, Picasso treated his bordello subject as anecdotal theater in an allegorical spirit. All of the sketches for a seven-figure project, and the earliest of those for a six-figure one, contain two men who play symmetrically opposed roles—an "active" medical student and a "passive" sailor[148]—and whose contrast on the narrative level is paralleled in every aspect of their formulations. Surrounded by prostitutes, the mariner client sits before his phallic attribute, the *porrón*, at a table

Below left:
25. Paul Cézanne. *The Temptation of Saint Anthony*. 1869–70. Oil on canvas, 21 1/4 x 28 3/4" (54 x 73 cm). Stiftung Sammlung Bührle, Zurich

Below right:
26. *Four Nudes in an Interior*. Paris, autumn 1906. Graphite pencil on parchment, 5 1/8 x 7 7/8" (13 x 20 cm). Zervos XXII, 461. D./B. XVI, 20. David H. Cogan Foundation, United States

Opposite:
27. *Two Nudes*. Paris, late autumn 1906. Oil on canvas, 59 5/8 x 36 5/8" (151.3 x 93 cm). Zervos I, 366. D./B. XVI, 15. The Museum of Modern Art, New York. Gift of G. David Thompson in honor of Alfred H. Barr, Jr.

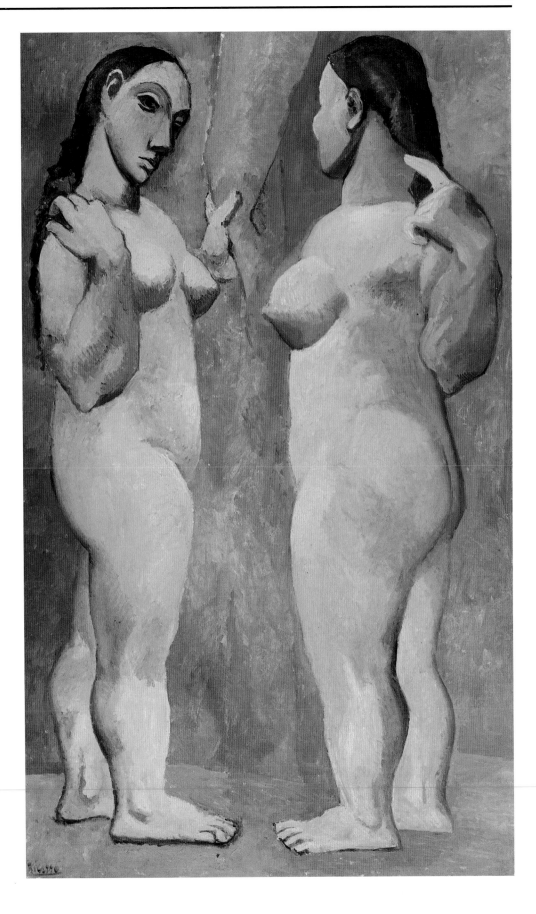

in the center of the brothel's parlor—at the nexus of the picture's surface design and depicted depth;[149] the student is in the margin of the picture, an outsider to its sexual drama. The sailor is disposed frontally and cut off at the waist by the table at which he sits; the student is shown from the side in full figure, standing. In the first sketch for the full composition (fig. 30), the sailor turns his head toward the medical student; later, he will glance down at a cigarette he rolls. Although the carnal display of the whores is directed toward the sailor, Picasso's very first idea was evidently to focus his and their glances—and, in some cases, direct the turning of their heads—toward what was obviously an unexpected interruption by the student.

In what, precisely, does the latter's action consist? The medical student is usually described as entering the stage from the left, drawing open a curtain to reveal a *tableau vivant*—"the sexual exhibitions performed by the inmates to whet the appetites of customers."[150] But Steinberg noticed that, beginning in the six-figure sketches (fig. 29), the student grasps the curtain with both hands, his body tilted in a manner indicating that he is not pulling it away, but drawing it across the room, "as though he had the power, or the intention, to foreclose the act." In fact, he does just that even earlier, in some of the seven-figure sketches (such as fig. 31). These drawings make clear, I believe, that from the very beginning, the role of the student was not to introduce the play, so to speak, by opening the curtain, but to write *finis* by drawing it closed. Such an action is more consistent with the sudden glance of the sailor in the first sketch,[151] and with the nature of at least one of his symbolic attributes, the skull. To this extent, the student is the dramatist—the surrogate of the painter—and thus holds the destinies of the other figures in his hands.

Already in 1939, Picasso was recorded as having identified the figure at the left in the early versions as a man carrying a skull.[152] The skull had to be taken on faith because none of the studies for the *Demoiselles* known at the time (i.e., the pastel in Basel and the lost oil on wood)—and, indeed, none of the many sketches published by Zervos in 1942—showed him carrying anything resembling a skull, though he often carried a book. Later, Picasso explained to Romuald Dor de la Souchère that this man was a student.[153] Only in 1972 did he identify the figure specifically as a medical student,[154] revealing at the time the previously unpublished sketchbook drawings of him holding a skull. These separate studies for the student showed not only that the medical student sometimes carried a skull, but that his facial features, hairstyle, and large "scroll" ear were reminiscent of the male Iberian head from Cerro (fig. 19) that Picasso purchased from Apollinaire's secretary, Géry Pieret, in the spring of 1907.

The narrative identity of the other male protagonist is clear at the start. Consulting my selective "film strip" for the sailor (figs. 65–78), the reader will see that the earliest studies of the figure in isolation from the others also show him with generalized "Iberian" features—a robust young man with crossed arms (fig. 65)—distinctly reminiscent of Picasso's *Self-Portrait* of the previous autumn (fig. 64)—who soon acquires a sailor's cap and blouse (fig. 69). In these drawings, as in the first study for the whole composition, he glances in the direction of the student. Somewhat later, he is sketched in full figure, looking down at the cigarette he rolls (fig. 72), after which he is recast in a series of very different and strangely tender portrait studies that include a wash drawing, a gouache, and an oil (figs. 73–75). In these, the sailor

28. Henri de Toulouse-Lautrec. *In the Salon at Rue des Moulins.* 1894. Oil on canvas, 43¾ x 52" (111 x 132 cm). Musée Toulouse-Lautrec, Albi

appears older, balding, and mustachioed—a seemingly introspective and shy man, the demureness of whose downcast glance is hardly explained by his looking down at his cigarette. Steinberg found this version of the sailor "enigmatic" and, indeed, it is. In the Basel drawing (fig. 40), the lost oil on wood (fig. 39), and the newly discovered oil on canvas (fig. 41), the sailor is totally unresponsive to the sexual playlet enacted for him. Is he preparing a postcoital smoke?[155] Might his expression hint at a certain resignation, given his role of potential victim of the brothel sirens? Or could this passiveness to some degree reflect—as I shall suggest below—the sexual ambiguity of an actual person that Picasso probably came to associate in part to this figure? Whatever the sailor's psychology at this stage, he appears to change yet again in such six-figure studies as fig. 45, and in the oil sketch of that conception recently revealed by infrared photography (fig. 48), to which the oil study of his head and bust (fig. 75) is probably related. Due no doubt to Picasso's elimination of the medical student by that point—through his transformation into a woman in a peignoir—the sailor becomes the undisputed focus of the picture's action as he sits with his left arm confidently propped against the table edge and (in a few versions) with the formerly seated prostitute on his knee.[156] Only in the five-figure Philadelphia watercolor (fig. 49) does the sailor disappear, leaving behind his *porrón* as the lone symbol of masculinity in the picture.

29. *Composition Study with Six Figures for "Les Demoiselles d'Avignon."* Carnet 3, 19V. Paris, March 1907. Graphite pencil on beige paper, 7 5⁄8 x 9 1⁄2" (19.3 x 24.2 cm). Zervos XXVI, 70. Musée Picasso, Paris (MP 1861)

The individual figure studies for the student—largely notebook sketches, plus one gouache—mostly show him holding a skull, although his principal attribute in the full-composition studies is a book. In one sketch (fig. 59), he uncomfortably holds the skull in his right hand and the book under his right arm, closing the curtain with his left hand while a dog leaps excitedly at his feet. Despite the fact that the book is shown more often than the skull, it was the skull that Picasso remembered when he communicated with Barr in 1939[157] about the man entering on the left and when he mentioned him to me in 1972.[158] Now the skull had been treated by Barr, as we have seen, as a *memento mori* object in an image purportedly contrasting virtue and vice— the interpretation most writers subsequently accepted. Not surprisingly, Barr did not demonstrate much conviction about the "wages of sin" dimension of this thesis, admitting that Picasso probably had "no very fervid moral intent."[159] Indeed, anyone familiar with Picasso's anarchic sexual and social attitudes (and uncompromising atheism) would question the likelihood of his embarking on a major picture in the form of a sermon.

Steinberg rejected both the "wages of sin" theory and the notion of the skull as a *memento mori* (or *vanitas*) symbol. Rather, he rationalized the skull's presence by describing the medical student as "the one member of human society who can … look at a skull with thoughts other than that of death—i.e., he looks at it as an object of scientific enquiry." Thus the skull and the book become symbols of "a particular brand of knowledge—non-participatory and theoretical"; together "they herald the chilling approach of analysis." The student-scientist, a "non-participant" who "never looks at the nudes," was contrasted to the sailor with "his Bacchic *porrón*," who is "in the thick of it." In what seems to me the least convincing aspect of Steinberg's interpretation, the meaning of this first act of the *Demoiselles*'s drama was summarized as "an allegory of the involved and the uninvolved in confrontation with the indestructible claims of sex."[160]

Steinberg's dissociation of the medical student and skull from any symbolism

30

31

34

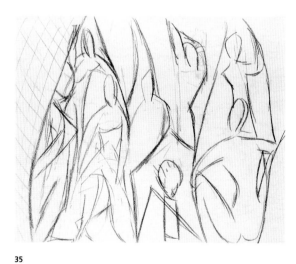

35

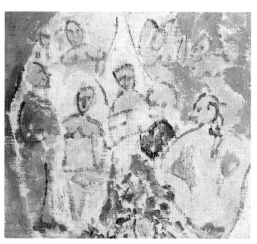

38

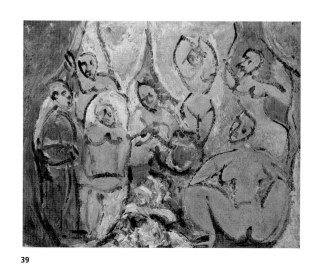

39

32

33

36

37

30. *Composition Study with Seven Figures for "Les Demoiselles d'Avignon."* Carnet 2, 32R. Paris, winter 1906–07. Graphite pencil on beige paper, 5 7/8 x 4 1/8" (14.7 x 10.6 cm). Zervos II², 643. Musée Picasso, Paris (MP 1859)

31. *Composition Study with Seven Figures for "Les Demoiselles d'Avignon."* Carnet 3, 29R. Paris, March 1907. Graphite pencil on beige paper, 7 5/8 x 9 1/2" (19.3 x 24.2 cm). Zervos XXVI, 59. Musée Picasso, Paris (MP 1861)

32. *Composition Study with Seven Figures for "Les Demoiselles d'Avignon"* [infra-red photograph of *Jars with Lemon.* Paris, summer 1907. Oil on canvas, 21 5/8 x 18 1/8" (55 x 46 cm). Daix 65. Collection Dr. Herbert Batliner, Vaduz, Liechtenstein]

33. *Composition Study with Seven Figures for "Les Demoiselles d'Avignon"* (vertical format). Carnet 3, 28R. Paris, March 1907. Graphite pencil on beige paper, 7 5/8 x 9 1/2" (19.3 x 24.2 cm). Musée Picasso, Paris (MP 1861)

34. *Medical Student, Sailor, and Five Nudes in a Bordello (Composition Study for "Les Demoiselles d'Avignon")* (reproduced in color, fig. 40)

35. *Composition Study with Seven Figures for "Les Demoiselles d'Avignon."* Carnet 3, 14V. Paris, March 1907. Graphite pencil on beige paper, 7 5/8 x 9 1/2" (19.3 x 24.2 cm). Zervos XXVI, 82. Musée Picasso, Paris (MP 1861)

36. *Composition Study with Seven Figures for "Les Demoiselles d'Avignon."* Carnet 3, 8V. Paris, March 1907. Graphite pencil on beige paper, 7 5/8 x 9 1/2" (19.3 x 24.2 cm). Zervos XXVI, 91. Musée Picasso, Paris (MP 1861)

37. *Composition Study Showing One Figure for "Les Demoiselles d'Avignon."* Carnet 3, 3R. Paris, March 1907. Graphite pencil on beige paper, 7 5/8 x 9 1/2" (19.3 x 24.2 cm). Musée Picasso, Paris (MP 1861)

38. *Oil Sketch for "Les Demoiselles d'Avignon"* (reproduced in color, fig. 41)

39. *Medical Student, Sailor, and Five Nudes (Oil Sketch for "Les Demoiselles d'Avignon").* Paris, March–April 1907. Oil on wood, 7 1/2 x 9 3/8" (19 x 24 cm). Zervos II¹, 20. Daix 30. Whereabouts unknown

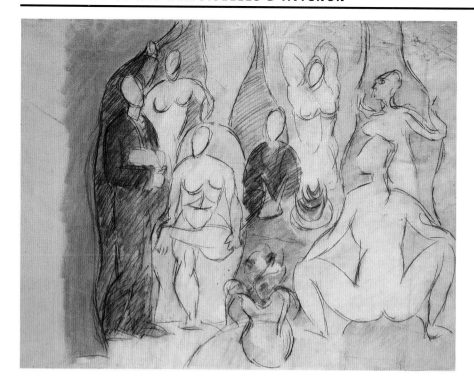

40. *Medical Student, Sailor, and Five Nudes in a Bordello (Composition Study for "Les Demoiselles d'Avignon")*. Paris, March–April 1907. Graphite pencil and pastel on paper, 18 ¾ x 25" (47.7 x 63.5 cm). Zervos II', 19. Daix 29. Öffentliche Kunstsammlung Basel, Kupferstichkabinett. Bequest of the artist to the city of Basel

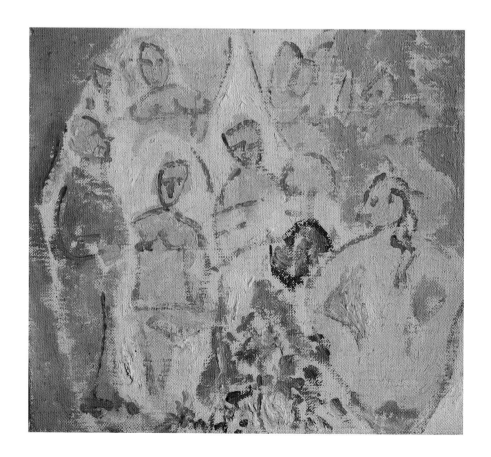

41. *Oil Sketch for "Les Demoiselles d'Avignon."* Paris, early 1907. Oil on canvas, 7 ½ x 8" (18.5 x 20.3 cm) irregular. The Museum of Modern Art, New York. Acquired through the Lillie P. Bliss Bequest

involving disease or death—to my mind, a crucial aspect of the picture from start to finish—is a function of what I consider his overly restricted view of the *Demoiselles* as essentially an image of "orgiastic immersion" and "Dionysian release." But if, as Steinberg rightly insists, the *Demoiselles* was about the "trauma of sexual encounter," then such intimations of castration[161] and death native to the male psyche in the contemplation of the sexual act—intimations distilled in the French characterization of male orgasm as *la petite mort*—should also be present, all the more so within a context implying possible mortal disease. And I think their role *is* significant. Picasso had long been familiar, of course, with the Destroying Woman, the *femme fatale* of that Symbolist art and literature which constituted the culture of his youth. But the menace in the bordello responds to both a deeper level of his consciousness and more immediate anxieties than those occupied by memories of Salomé and Judith—or even Germaine Florentin.[162] Picasso's art had long played host to peculiarly personal images connecting sex with death. Take the drawing on a trade card of 1903 in which a skull floats like a malevolent sun over a couple performing fellatio and cunnilingus (fig. 79), or the lost mural, painted on the studio wall of Sabartés's apartment in Barcelona in 1904, of a couple making love under a tree from which a half-naked Moor has been hanged, his sex shown in erection.[163] In focusing on the "life force"— the robust erotic aspect of the *Demoiselles*—Steinberg dealt with only one side of an equation. For me, the final picture is less a Dionysian orgy than a sexual battleground in which both Eros and Thanatos contend for Picasso's psyche.

Moreover, it may be that the motif of a person holding a skull did first arise in Picasso's mind in a conventional moralizing guise, rather than as a medical student— or any kind of student at all. And the figure may well have been conceived in relation to a *vanitas* allegory. To be sure, the *vanitas* theme has no necessary correlation with the "wages of sin"; it involves no religious judgment, no necessary implications of good or evil, but simply a philosophical recognition of the vanity of human pursuits in the face of ineluctable mortality. In discussing themes of love and death in Picasso's early work,[164] Theodore Reff drew attention to a projection of Picasso's persona that may help us understand the genesis of the medical student: an image of a Hamlet-like Harlequin holding a skull directed toward the gaze of a woman who closely resembles Fernande. Clearly related to Picasso's "self-portrait" as Harlequin at the left of *Family of Saltimbanques* of 1905 (fig. 97), the image Reff cites (fig. 96) is among Picasso's sketches (some are Max Jacob's) on the drypoint *planche de dessins* (fig. 80) of the same year. In this sketch, Reff observes, Picasso is "both the profoundly melancholy Hamlet who laments the death of Yorick—the king's jester, an entertainer like Harlequin—and the bitterly ironic Hamlet who would send Ophelia to a nunnery; both the moralist who reflects on the vanity of all human affairs, and the ascetic who rejects all love as sensual and corrupting."

The early sketches for the *Demoiselles*, Reff suggests later, were "conceived as a kind of *memento mori*, in the spirit of the 1905 drypoint sketch." And it does seem to me that a thread links the drypoint Harlequin-Hamlet to Picasso's early thoughts for the man on the left in the bordello. When one looks at the drypoint image reversed, the way Picasso drew it, the figure's gesture anticipates some early sketches for the student, who, like the Harlequin-Hamlet, was also, as we shall see more clearly below, a surrogate of the artist. Moreover, the location of the medical student within the *Demoiselles* study is comparable to that of the Harlequin-Hamlet's alter ego—

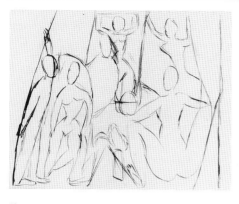

42

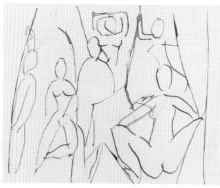

43

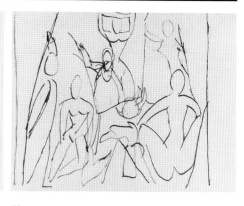

44

45

46

47

42. *First Composition Study with Six Figures for "Les Demoiselles d'Avignon."* Carnet 6, 1R. Paris, May 1907. Pen and India ink on beige paper, 4⅛ x 5⅜" (10.5 x 13.6 cm). Zervos II², 632. Musée Picasso, Paris (MP 1862)

43. *Fourth Composition Study with Six Figures for "Les Demoiselles d'Avignon."* Carnet 6, 4R. Paris, May 1907. Pen and India ink on beige paper, 4⅛ x 5⅜" (10.5 x 13.6 cm). Zervos II², 635. Musée Picasso, Paris (MP 1862)

44. *Fifth Composition Study with Six Figures for "Les Demoiselles d'Avignon."* Carnet 6, 5R. Paris, May 1907. Pen and India ink on beige paper, 4⅛ x 5⅜" (10.5 x 13.6 cm). Zervos II², 636. Musée Picasso, Paris (MP 1862)

45. *Eleventh Composition Study with Six Figures for "Les Demoiselles d'Avignon."* Carnet 6, 11R. Paris, May 1907. Pen and India ink on beige paper, 4⅛ x 5⅜" (10.5 x 13.6 cm). Zervos II², 641. Musée Picasso, Paris (MP 1862)

46. *Twelfth Composition Study with Six Figures for "Les Demoiselles d'Avignon."* Carnet 6, 18R. Paris, May 1907. Pen and India ink on beige paper, 4⅛ x 5⅜" (10.5 x 13.6 cm). Zervos II², 642. Musée Picasso, Paris (MP 1862)

47. *Sailor and Five Nudes (Composition Study for "Les Demoiselles d'Avignon").* Paris, May 1907. Charcoal on paper, 18¾ x 25⅝" (47.6 x 65 cm). Zervos II², 644. Öffentliche Kunstsammlung Basel, Kupferstichkabinett. Douglas Cooper Bequest

48. *Composition Study with Six Figures for "Les Demoiselles d'Avignon"* [infra-red photograph of *Bust of a Woman with Large Ear.* Paris, May–June 1907. Oil on canvas, 23⅞ x 23¼" (60.5 x 59.2 cm). Zervos XXVI, 18; Daix 23. Musée Picasso, Paris (MP 17)]

48

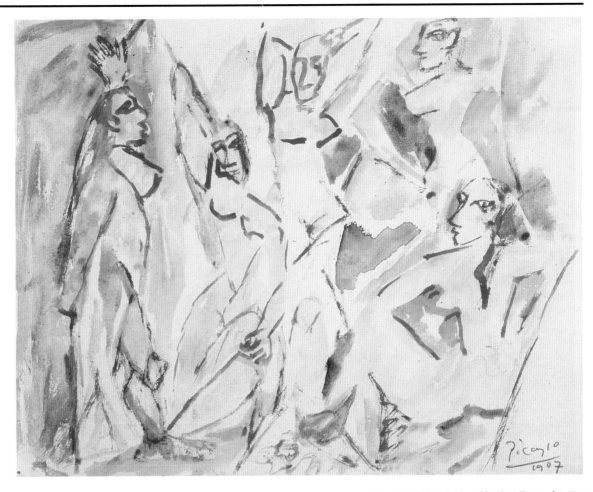

49. *Composition Study with Five Figures for "Les Demoiselles d'Avignon."* Paris, June 1907. Watercolor on paper, 6⅞ x 8⅞" (17.4 x 22.5 cm). Zervos II¹, 21. Daix 31. Philadelphia Museum of Art. A. E. Gallatin Collection

50. *Composition Sketch (or "Brouillon") for the Five-Figure Version,* drawn in charcoal over *Study for the Crouching Demoiselles.* Carnet 3, 12R. Paris, June 1907. Charcoal, pen, and black ink on beige paper, 7⅝ x 9½" (19.3 x 24.2 cm). Zervos XXVI, 83. Musée Picasso, Paris (MP 1861)

51

52

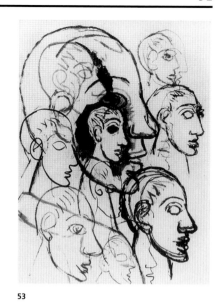

53

51. *Study for the Medical Student*. Carnet 2, 34R. Paris, winter 1906–07. Graphite pencil on beige paper, 5 ⅞ x 4 ⅛" (14.7 x 10.6 cm). Musée Picasso, Paris (MP 1859)

52. *Study for the Medical Student*. Carnet 3, 32V. Paris, March 1907. Graphite pencil on beige paper, 7 ⅝ x 9 ½" (19.3 x 24.2 cm). Zervos XXVI, 55. Musée Picasso, Paris (MP 1861)

53. *Sheet of Studies for the Medical Student*. Paris, March–April 1907. India ink on paper, 25 x 18 ⅞" (63.3 x 48 cm). Zervos XXVI, 14. Estate of the artist, no. 870. Marina Picasso Collection; Jan Krugier Gallery, Geneva

57. *Self-Portrait*. Paris, late 1906. Ink on paper, 12 x 9" (30.5 x 22.8 cm). Collection Margaret Mallory, Santa Barbara, California

58. *Studies for the Medical Student*. Carnet 3, 37V. Paris, March 1907. Graphite pencil on beige paper, 7 ⅝ x 9 ½" (19.3 x 24.2 cm). Zervos XXVI, 45. Musée Picasso, Paris (MP 1861)

59. *Study for the Medical Student*. Carnet 3, 18R. Paris, March 1907. Graphite pencil on beige paper, 7 ⅝ x 9 ½" (19.3 x 24.2 cm). Zervos XXVI, 73. Musée Picasso, Paris (MP 1861)

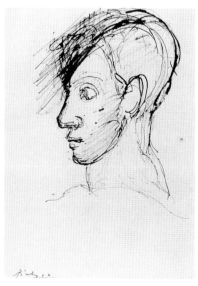

57

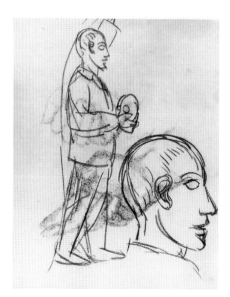

58

59

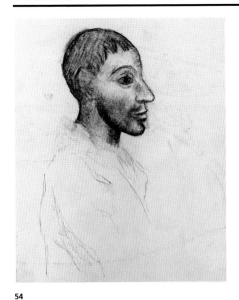

54

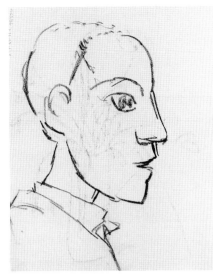

55

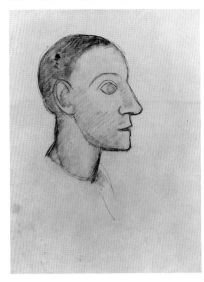

56

54. *Study for the Medical Student.* Carnet 3, 23R. Paris, March 1907. Graphite pencil, pen, and black ink on beige paper, 7 ⅝ x 9 ½" (19.3 x 24.2 cm). Zervos XXVI, 67. Musée Picasso, Paris (MP 1861)

55. *Study for the Medical Student.* Carnet 3, 36R. Paris, March 1907. Graphite pencil on beige paper, 7 ⅝ x 9 ½" (19.3 x 24.2 cm). Zervos XXVI, 48. Musée Picasso, Paris (MP 1861)

56. *Study for the Medical Student.* Paris, March–April 1907. Pastel and charcoal on paper, 24 ⅞ x 18 ¾" (63.1 x 47.6 cm). Zervos XXVI, 16. Daix 10. Musée Picasso, Paris (MP 530)

60. *Study for the Medical Student.* Carnet 3, 17V. Paris, March 1907. Graphite pencil on beige paper, 7 ⅝ x 9 ½" (19.3 x 24.2 cm). Zervos XXVI, 74. Musée Picasso, Paris (MP 1861)

61. Detail of *Medical Student, Sailor, and Five Nudes in a Bordello (Composition Study for "Les Demoiselles d'Avignon")* (fig. 40)

62. *Study for the Medical Student.* Paris, March–April 1907. Gouache on paper, 25 ⅛ x 19 ¼" (64 x 49 cm). Zervos VI, 904. Daix 11. Musée Picasso, Paris (MP 531)

63. Detail of *Medical Student, Sailor, and Five Nudes in a Bordello (Oil Sketch for "Les Demoiselles d'Avignon")* (fig. 39)

60

61

62

63

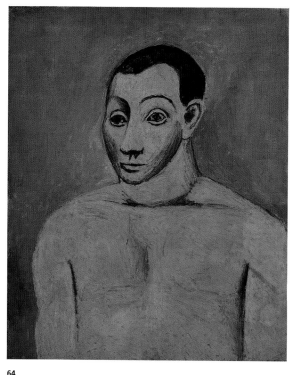

64

65

72. *Study for the Sailor Rolling a Cigarette*. Carnet 3, 5V. Paris, March 1907. Graphite pencil on beige paper, 7 ⅝ x 9 ½" (19.3 x 24.2 cm). Zervos XXVI, 92. Musée Picasso, Paris (MP 1861)

73. *Study for the Sailor*. Paris, winter–spring 1907. India ink wash on paper, 12 ⅝ x 18 ⅞" (32 x 48 cm). Zervos XXVI, 10. Daix 12. Private collection

74. *Study for the Sailor Rolling a Cigarette*. Paris, winter–spring 1907. Gouache and lavis on paper, 24 ⅝ x 18 ½" (62.5 x 47 cm). Zervos II', 7. Daix 14. Private collection, Switzerland

64. *Self-Portrait*. Paris, autumn 1906. Oil on canvas, 25 ⅝ x 21 ¼" (65 x 54 cm). Zervos II', 1. D./B. XVI, 26. Musée Picasso, Paris (MP 8)

65. *Studies for the Sailor*. Carnet 3, 21R. Paris, March 1907. Pen and black ink on beige paper, 7 ⅝ x 9 ½" (19.3 x 24.2 cm). Zervos XXVI, 66. Musée Picasso, Paris (MP 1861)

66. *Study for the Sailor*. Carnet 3, 3V. Paris, March 1907. Graphite pencil on beige paper, 7 ⅝ x 9 ½" (19.3 x 24.2 cm). Zervos XXVI, 93. Musée Picasso, Paris (MP 1861)

67. *Study for the Sailor*. Carnet 3, 44V. Paris, March 1907. Graphite pencil on beige paper, 7 ⅝ x 9 ½" (19.3 x 24.2 cm). Zervos XXVI, 34. Musée Picasso, Paris (MP 1861)

68. *Study for the Sailor*. Carnet 3, 46V. Paris, March 1907. Graphite pencil on beige paper, 7 ⅝ x 9 ½" (19.3 x 24.2 cm). Zervos XXVI, 25. Musée Picasso, Paris (MP 1861)

69. *Studies for the Sailor and the Medical Student*. Carnet 3, 11V. Paris, March 1907. Graphite pencil on beige paper, 7 ⅝ x 9 ½" (19.3 x 24.2 cm). Zervos XXVI, 86. Musée Picasso, Paris (MP 1861)

70. *Studies for the Sailor*. Carnet 3, 1V. Paris, March 1907. Graphite pencil on beige paper, 7 ⅝ x 9 ½" (19.3 x 24.2 cm). Zervos XXVI, 100. Musée Picasso, Paris (MP 1861)

71. Detail of *Medical Student, Sailor, and Five Nudes in a Bordello (Composition Study for "Les Demoiselles d'Avignon")* (fig. 40)

75. *Study for the Sailor*. Paris, winter–spring 1907. Oil on canvas, 15 ¾ x 16 ⅜" (40 x 41.8 cm). Zervos II', 6. Daix 13. Private collection. Formerly collection Leo and Gertrude Stein

76. Detail of *Medical Student, Sailor, and Five Nudes (Oil Sketch for "Les Demoiselles d'Avignon")* (fig. 39)

77. Detail of *Sailor and Five Nudes (Composition Study for "Les Demoiselles d'Avignon")* (fig. 47)

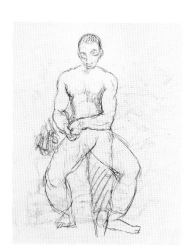

72

73

74

66

67

68

69

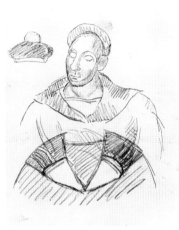

70

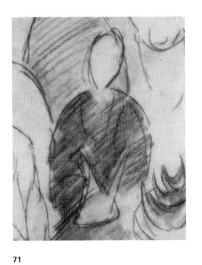

71

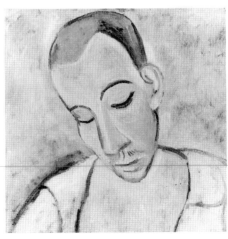

75

76

77

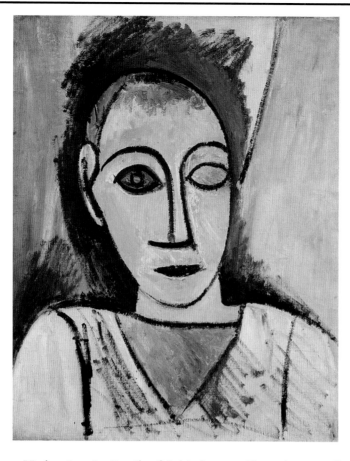

78. *Study for the Sailor.* Paris, April–May 1907. Oil on canvas, 22 x 18¼" (56 x 46.5 cm). Zervos XXVI, 12. Daix 22. Musée Picasso, Paris (MP 14)

Picasso's self-portrait as Harlequin—in *Family of Saltimbanques* (fig. 97). As Reff observed, however, the skull-holding motif in the *Demoiselles* can only be characterized as a "kind of" *memento mori.* The traditional nature of the theme was necessarily altered by the new context in which the figure with a skull found himself, and the fact that, in contrast to the drypoint sketch, he directs the skull more toward a man than a woman.[165]

Of crucial importance to the changing meaning of the skull motif is the fact that brothel sex involved possibilities of physical degeneration and death of a kind not traditionally implied by the *vanitas* symbol, a fate more likely to be in the mind of a medical student than in that of a Harlequin-Hamlet. (Even an artist as happy with the life of *maisons closes* as Toulouse-Lautrec was hardly unaware of this fatal possibility; fig. 81.) Picasso had been a spectator in the world of the circus, but in the brothels he was a participant. There, the skull's connotation becomes, I believe, specific and concrete. In the hands of his alter ego medical student, it serves, like the book, as a symbol of one who knows and cures disease—specifically such venereal disease as may result from the sailor's dalliance.

Trepidation in regard to syphilis and gonorrhea *had* to play some role, I believe, in Picasso's symbolism. After all, his fear of illness and death was legendary, and he had already demonstrated an exceptional concern for and fascination with venereal disease in his visits to both the prison hospital of Saint-Lazare in Paris and the Santa Creu i de Sant Pau hospital in Barcelona, where he also visited the morgue.[166] The Saint-Lazare visit—probably arranged with the institution's director, Dr. Jullien, by Picasso's friend and collector Olivier Sainsère—was no ordinary event, for Saint-

Left:
79. *Sex and Death*. Barcelona, 1903. Ink, crayons, and colored pencils on trade card, approximately 3 ⅝ x 5 ⅛" (9 x 13 cm). Private collection

Right:
80. *Print with Drawings by Max Jacob and Picasso* (detail; reversed reproduction to show the figures as they were drawn). Paris, 1905. Drypoint, 11 ½ x 9 ⅞" (29.2 x 25 cm). Geiser 8. Musée Picasso, Paris (MP 1895)

Lazare "was closed to all but a few doctors on the grounds of decency," and even prominent specialists "obtained entry there only with great difficulty."[167] Indeed, Picasso's curiosity about syphilis and gonorrhea appeared so exaggerated to Palau and Berger that it led them to suggest that he himself had early on contracted some form of venereal disease.[168] Later, Mary Mathews Gedo (citing Françoise Gilot) would write that the skull in the early sketches "may refer to the fact that somewhere, sometime in his youthful amatory career, Picasso ... had contracted a venereal infection."[169] However that may be, it is not necessary for the purposes of this aspect of our interpretation to postulate Picasso's actually having been diseased; it more than suffices that the painter deeply feared such contagion.

Lest we forget, syphilis was still very much a fatal disease at the time Picasso painted the *Demoiselles*. In those early years of the century, he had to think of syphilis somewhat as we today think of AIDS, though the disease in its final stages was perhaps even more terrible.[170] Arsenic-based Salvarsan, itself sometimes fatal, was to be discovered only two years after Picasso's painting; that was the first improvement on the traditional mercury treatment in four centuries. Moreover, the last years of the nineteenth century and the first decade of the twentieth constituted what Alain Corbin termed "the golden age of venereal peril."[171] This period witnessed the height of a then widely discussed struggle between regulationists and abolitionists of prostitution, as well as an immense effort "to spread the notion of a terrifying peril in public opinion, by means of an obsessive propaganda."[172] Though never much of a reader of books, Picasso was an avid reader of newspapers and, in the years leading up to 1907, there was a vast reportage on the horrific consequences of venereal disease. Almost every year, beginning in 1902, a widely reported budget dispute took place concerning funds to remodel the scandalously outmoded Saint-Lazare and improve the dreadful conditions there (which Picasso had personally witnessed). But the aim of most of the press was simply to spread what was called at the time a "salutary terror" (*salutaire terreur*);[173] warning posters about syphilis were even placed on the street urinals—as Picasso himself recorded in a 1901 street scene (fig. 82).

Picasso's choice of a sailor as the client in the *Demoiselles* not only characterized his bordello as the working-class type then known in the vernacular as "slaughterhouses," but implied the theme of venereal disease, insofar as sailors were universally considered transmitters of the pox from insalubrious, primitive regions whence such maladies were popularly believed to have come;[174] the Société de Prophylaxie had formed a special commission to deal with "the venereal peril in the French

81. Henri de Toulouse-Lautrec. *"La Chronique médicale" (First Sketch for the Title of the Periodical)*. 1891. Black chalk on paper, 6 ⅛ x 12 ⅝" (15.5 x 32 cm). Reproduced in *La Chronique médicale*, vol. 9, no. 4 (February 15, 1902)

colonies."[175] Nevertheless, the inclusion of a medical student in the *Demoiselles* to signal sickness and mortality in relation to the sailor—a contrast between he who cures the pox and he who gets it—probably struck Picasso in time as overly anecdotal, and perhaps even too banal. The artist's subsequent elimination of the student—and, somewhat later, the sailor himself—in the interest of concentrating, deepening, and generalizing the image did not, however, imply the disappearance of the themes of disease and death. Picasso became aware that these concerns need not be embodied allegorically, but could be subsumed into the female figures themselves—as is very vividly the case in the figure of the crouching prostitute on the lower right in the final painting.

It was, I believe, in part the absence of any sufficiently clear reference to death and disease in the first, purely Iberian form of the large canvas, which was similar to the Philadelphia watercolor (fig. 49)—the "archaic" head and "fatal" gesture of its curtain-puller being judged inadequate—that probably led Picasso quickly to reject it and subsequently to rework the heads (and parts of the bodies and adjacent draperies) of three of the five figures. The motivations for these changes—usually attributed to self-wound theories of Picasso's formal development, or to the influence of outside agencies (such as tribal art)—are crucial. Picasso now realized that he could convey through contrasts of style what he had earlier bodied forth through symbolic storytelling. The horror that, according to Salmon, "froze" Picasso's acquaintances must have been particularly identified with the Medusa crouching on the right, whose asymmetrical distortions invoke—quite without illustrating—the atrocious structural deformations of *syphilis osseuse,* to which the rotting human head is subject, especially in the advanced congenital form of the disease (figs. 236–40).[176] Like some of the women Picasso unquestionably saw at Saint-Lazare, in the Barcelona hospital and morgue, and perhaps also in some of the popular "museums" of anatomical deformities that were encouraged by the Société de Prophylaxie,[177] the crouching demoiselle implies the living corpse, one of the "images and schemas" Corbin saw at the heart of the widespread official propaganda of the day, in which the "association between the prostitute and cadaverous flesh becomes a leitmotif."[178] And while Picasso could not in 1907 have seen the sort of African "sickness" masks (fig. 225) that, of all tribal art, most resemble the crouching demoiselle's monstrous face, it is not by chance that many of those masks represent the distorted faces of congenital syphilitics.[179]

The cohabitation of Thanatos and Eros in the *Demoiselles*—the contrast between the horrid squatting demoiselle and the comparatively elegant Iberian maidens in the center—recalls a very particular component of Picasso's psychology: his deep-seated fear and loathing of the female body, which existed side by side with his craving for and ecstatic idealization of it. This dichotomous attitude was time and again evidenced in Picasso's art, as it was in his behavior; it is parodied in his admitted treatment of women as "either goddesses or doormats" (read also, whores). To be sure, comparable attraction/repulsion syndromes are commonplace in male psychology, though rarely so hypertrophied as in Picasso. But in the *Demoiselles*, as often in the work of a great artist, such inherently banal material is so amplified by the spirit of genius that it emerges as a new insight—all the more universal for being commonplace.

82. *Street Scene*. c. 1901. Ink on paper, 10⅞ x 7⅞" (27.5 x 20 cm). Private collection

As Picasso was the most autobiographical of artists, the figures in his pictures—whatever narrative identities they might have—were often extensions of his own persona, or were invested with literal and/or symbolic references to members of his entourage. Except, of course, where portraiture was the issue, these identities were generally not conceived in advance, but emerged by association, as it were, in the process of working. It was as if Picasso's hand revealed to him the protagonists of his pictures. Such identities were precarious, sometimes investing Picasso's figures only fleetingly, and they might be iconographically contradictory. The telling visual resemblance or symbolic attribute could disappear; the figure might metamorphose into someone else, or be compounded with other identities (as in the *Demoiselles*, which ended as a kind of palimpsest).

The only documentary evidence we have for such an identity in the *Demoiselles* concerns the medical student as a personification of the painter. This was suggested when Picasso identified to John Richardson *as a self-portrait* a profile sketch (fig. 57)[180] related to the sketches of the student, and later confirmed its relation to those studies.[181] We should not take this to mean, of course, that the medical student "is" Picasso, or lacks a narrative identity of his own. Nor that the identity in question is consistent throughout the studies in which the student appears (on the contrary, he seems distinctively to be another character in the lost oil sketch; fig. 63). Nevertheless, there are so many clues relating the student to Picasso that one might have made a convincing identification even without the artist's confirmation.

To begin with, there is the very fact of the "Iberian" style in which the student is usually represented (figs. 52, 58). As I wrote some years ago,[182] style comes to displace subject matter as a carrier of content for the first time in the *Demoiselles*. We are at that point in Picasso's career where style first ceases to be a fixed, *a priori* language or medium in which the artist tells his story, but rather provides a series of optional representational modes that can in themselves deliver particulars of his message. Picasso felt a deep personal identification with Iberian sculpture because it was the earliest known Spanish art. Not only is the student often drawn in what we recognize as the late form of Picasso's Iberianism (early 1907), but his face is sometimes drawn (as is clearest in fig. 52) so as to suggest the very *Head of a Man* (fig. 19) from the excavations at Cerro that Picasso purchased from Apollinaire's secretary. The forelock of hair falling over the student's forehead in the *Demoiselles* studies (fig. 58) simultaneously echoes not only the Cerro head but Picasso's own hairstyle. (This same Cerro head was also clearly the inspiration for the painted relief [fig. 84], executed in the spring of 1907, in which the sculptural Iberian style of later 1906, characteristic of *Two Nudes* and *Head of a Woman* [figs. 27, 83], gave way more clearly to the flatter, sketchier, and sometimes almost caricatural Iberianism that leads directly into the *Demoiselles*.)[183]

We have already seen that there is little question as to the presence of Picasso's persona in that immediate ancestor of the student, the 1905 Harlequin showing a skull to Fernande. The skull was, of course, a prop in Picasso's own studio at the time, and it appears in some large ink-and-wash drawings that are contemporaneous with the *Demoiselles* (fig. 85). Picasso's persona is further indicated by the fact that in a few of the *Demoiselles* studies (figs. 33, 59), his dog, Fricka—subject of a number of independent sketches in one of the notebooks of the period—leaps up at the medical student in joyful recognition (this is the kind of private, encoded clue that Picasso

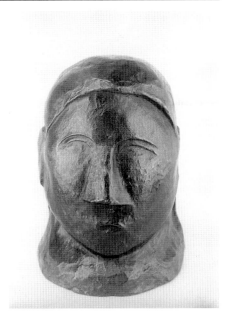

83. *Head of a Woman*. Paris, 1906–07. Bronze, 4¼ x 3⅛ x 3⅝" (11 x 8 x 9 cm). Zervos II², 574. Spies 12. Musée Picasso, Paris (MP 235)

84. *Head*. Paris, spring 1907. Carved and painted wood, 15⅜ x 9⅞ x 4¾" (39 x 25 x 12 cm). Zervos II², 611. Spies 11. Private collection

adored).[184] Finally, the student is, like the artist, something of an outsider to the narrative that is represented; he interrupts it and, in closing the curtain over it, himself functions as a kind of stage director or dramatist—hence, as observed, a surrogate for the artist.

The sailor, originally the central figure of the drama, survives through the picture's various permutations longer than the student; he changes nature more radically in the course of Picasso's work, and is obviously more multi-leveled in his possible associated identities, though these remain relatively speculative in character. Years ago, I had considered the sailor and the student as complementary alter egos of the artist—at least in the early state of the conceit—and the drawings I have come to know since that time only confirm this belief. In some of his early, more Iberian incarnations (fig. 65), as we have seen, the sailor is very reminiscent of Picasso's late 1906 *Self-Portrait* (fig. 64). Moreover, Picasso often painted himself wearing a sailor's striped shirt[185] (de Chirico drew him with an anchor tattooed on his chest),[186] and a case can be made for the sailor as a persona of Picasso that recurs throughout his career. To my early suggestion that the sailor suit in the *Demoiselles* studies referred in part to childhood memories (see below), Mary Mathews Gedo added a reference to a photograph of Picasso wearing such a costume at the age of seven.[187]

The *Demoiselles* sketches show that the artist originally considered the student and sailor as a pair linked through opposition. The student's gesture of proffering the skull was clearly directed at the sailor rather than the whores; in some sketches of the sailor he looks up to see a study of the student's hand (fig. 65) or is juxtaposed on the sheet to the student's figure (fig. 69). In a communication to Steinberg, sent to him prior to the publication of his classic text (and excerpted in his notes),[188] wherein I recounted seeing some of these early, then unpublished, sketches, I suggested that both student and sailor could be considered surrogates of the artist:

The earliest sketch for the student shows a short, stocky man of Picasso's build and hairstyle…. Picasso is here implicitly contrasting and weighing the life of the senses (the sailor is surrounded by flesh, food, [flowers,] and drink) and the mind (the book held by the student), poles between which his own work will oscillate…. The sailor … represents Picasso's instinctual, sensuous side as established during childhood (sailor suit, surrounded by women in the home) … the medical student may be assimilated to that side of Picasso whose "science" will anatomize the visual world.

In the course of developing the six-figure version of the *Demoiselles*, Picasso eventually changed the student into a woman. But so long as the figure remained a man, its prevailing identity was that of the artist himself (nor was this association entirely lost, as we shall see below, even in the sex change). The single exception is the student's appearance in the lost oil on panel (fig. 63), where he is balding, and bears a certain resemblance, as Steinberg observed, to Max Jacob.[189]

The fate of the sailor was very different. At some point late in Picasso's exploration of the seven-figure version, the sailor ceases to sit with arms folded, but rolls a cigarette, toward which he looks down (fig. 72). Soon his previously handsome, and sometimes virile, face (fig. 66) becomes more delicate and demure, and he seems to take on some years as he loses hair on his head while gaining it on his upper lip (fig.

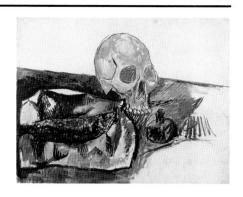

85. *Still Life: Fish, Skull, and Inkwell*. Paris, spring–summer 1908. India ink and tinted wash on paper, 18¾ x 24¾" (47.7 x 63 cm). Zervos XXVI, 193. Musée Picasso, Paris (MP 548)

86. *Portrait of Max Jacob*. Paris, early 1907. Gouache on paper, 24 ½ x 18 ¾" (62 x 47.5 cm). Zervos II¹, 9. Daix 48. Collection Ludwig, Aix-la-Chapelle

73). With the exception of his lingering *porrón*, this second incarnation of the sailor is clearly no longer to be associated with the persona of the artist; for Steinberg, the "mild and shy" personage in question—an "effeminate personality" and a "timid candidate for sexual initiation"—was to remain an enigma.

Speculative as it is, I persist in my view[190] that in this effeminate incarnation, the sailor was identified in Picasso's mind at least in part with Max Jacob. The fact that in one version of the seven-figure picture, it was instead the student who resembled Jacob is no contradiction, given the shifting, volatile nature of these associations and the tendency of Picasso's figures often to compound more than one identity (as in a 1908 gouache study for *Carnival at the Bistro*, where the figure in a Kronstadt hat, representing Cézanne, also becomes associated with Braque).[191] Max Jacob was Picasso's most intimate friend. And the two men contrasted maximally (like the medical student and the sailor), not only as personalities and artists, but sexually as well. Like W. S. Gilbert's operetta protagonists in *Cox and Box*, they at one time literally shared the same bed, Max Jacob sleeping in it at night, Picasso during the day. Picasso must have had a special curiosity about the complicated sexual makeup of this tender, loving man who, though primarily homosexual, also had experiences with women—all the more at a moment when Picasso seems himself to have been profoundly questioning the dichotomy within his own sexual feeling regarding Fernande (affectionate loving as against aggressive eroticism—a modern polarity recalling a

87. Marie Laurencin. *Apollinaire and His Friends (Group of Artists)*. 1908. Oil on canvas, 25 ⅛ x 30" (64 x 76 cm). The Baltimore Museum of Art. The Cone Collection. Formerly collection Gertrude Stein

classic theme, that of sacred and profane love). Indeed, virtually everything Steinberg says about Max Jacob to reinforce his identification with the student in the lost oil on panel is equally applicable to the studies of the sailor we are discussing (figs. 73–75). But there is more: Picasso painted a gouache *Portrait of Max Jacob* (fig. 86) in what clearly resembles a striped sailor's shirt, precisely at the time he was elaborating the studies for the sailor of the *Demoiselles*. Moreover, sailoring was one of Jacob's myths. In 1911, Jacob would describe himself as "born on the shores of Brittany" and as a "sailor for five years" in a fictitious autobiographical sketch intended to be printed as part of the introduction to *Saint Matorel*.[192]

Finally, in relation to Max-the-sailor as a potentially diseased protagonist in Picasso's bordello, we have Picasso's peculiar and terrible insistence on "Fiacre" as a Christian name for Max in 1915, when the artist was to stand as godfather at the poet's baptism. This was an inside joke that I believe throws some reflected light on Jacob's relation to the *Demoiselles*, for Saint Fiacre was nothing less than the patron saint of syphilitics.[193] "Pablo wants to call me Fiacre," Jacob wrote Apollinaire a month earlier. "It is very upsetting."[194] Max preferred the name Cyprien (one of Picasso's own baptismal names), and we are told that "after a debate, Picasso accepted" it (although the painter would always resist calling Max by that name).[195]

As for possible "identities" of the prostitutes in the *Demoiselles*, we have nothing but Picasso's account to Kahnweiler[196] of the studio jokes, cited earlier, in which the whores were variously identified with Fernande, Marie Laurencin, and Max Jacob's grandmother, plus a more abbreviated account by Sabartés, which added Max's sister to the cast.[197] In dealing with the Kahnweiler text, not all critics have chosen to remember that Picasso characterized these associations as "jokes" (though that hardly eliminates their significance), and that Picasso took no responsibility for having invented them himself. To the extent that Picasso was conscious of these associations, they were, I believe—much more than those linked to the student and sailor—attributions after the fact, and the joking itself took place after the picture was finished. This said, I would guess that, given their beauty, Fernande and Marie were at least "officially" associated with the relatively attractive "Iberian" whores in the center of the *Demoiselles*, though given the nature of Picasso's psychosexual crisis, he probably also identified Fernande with the crouching whore as well. In any case, if Fernande got wind of these jokes, she no doubt took them ill,[198] which would further explain the conspicuous lack (mentioned above) of any reference to the *Demoiselles* in her memoirs. As for Laurencin, there seems to me a clear echo of the *Demoiselles* in the group portrait she painted the following year (fig. 87), in which the "Egyptian" profile of Picasso is located on the left, in keeping with its surrogate—if "transvestite"—forerunner in Picasso's picture.[199]

Jacob's "grandmother," mentioned by Picasso, could conceivably have been identified with the clothed woman on the left of the *Demoiselles*, whose head is like an archaic ancestor idol. But given the mordant character of Picasso's humor, I believe she was more likely, simply because of age, identified with the horrifying whore on the lower right, who is, on one level, a personification for the aging "madam" or procuress often shown seated in bordello scenes (as in Degas's *The Madam's Birthday Party*, fig. 88, which Picasso would later own), and who is in *The Harem* (fig. 16), the *Demoiselles*'s 1906 prefiguration.

88. Edgar Degas. *The Madam's Birthday Party* (reversed reproduction to show the composition as it was drawn). c. 1879. Black ink monotype with pastel highlights, 10 ½ x 11 ⅝" (26.6 x 29.6 cm). Musée Picasso, Paris (RF 35791). Formerly collection Pablo Picasso

89. *Degas at the Brothel* (reversed reproduction to show the composition as it was drawn). Mougins, March 16, 1971. Etching, 15 x 19 ½" (37 x 49.5 cm). Bloch, vol. 4, 1942. Galerie Kornfeld, Bern

90. *Degas at the Brothel*. Mougins, April 4, 1971. Etching, 15 x 19 ¾" (37 x 50 cm). Bloch, vol. 4, 1964. Galerie Kornfeld, Bern

Left:
91. *Celestina*. Barcelona, March 1904. Oil on canvas, 31 ⁷⁄₈ x 23 ⁵⁄₈" (81 x 60 cm). Zervos I, 183. D./B. IX, 26. Musée Picasso, Paris (MP 1989.5)

Above:
92. *Old Prostitute*. Mougins, June 3, 1972. India ink on paper, 11 ⁵⁄₈ x 8 ¼" (29.6 x 21 cm). Zervos XXXIII, 406. Private collection

Picasso had, to put it mildly, no sympathy with old age in women. This animus may well have played a role in the metamorphosis of the crouching whore of the *Demoiselles* into a kind of monster who reembodies the squatting procuress of *The Harem*, and more pointedly—especially in view of the displacement of her left eye— the aged, one-eyed whore and procuress of 1903, *Celestina* (fig. 91).[200] In his last years, Picasso drew many "rêveries" that meld associations to *Celestina* and the *Demoiselles*, to Degas's brothel monotypes, and to other bordellos real and imaginary. They function as a kind of retroactive "critique" of his 1907 masterpiece. In some of these (fig. 89), Degas acts as a kind of alter ego of Picasso, entering from the left like the medical student. In others (figs. 90, 92), Picasso depicts quite graphically his horror of the sexuality of old whores in the etymological sense of *putain* as the "putrid woman." Such later images by Picasso help elucidate sentiments that are more violently and imaginatively, though less overtly, expressed in the *Demoiselles*.

The Picasso of the early Paris years had probably viewed the inmates of Saint-Lazare and Santa Creu i de Sant Pau with a certain compassion. He could not, however, have helped being shocked—and was clearly fascinated—by the metamorphoses of the human face that take place in the advanced stages of syphilis (see figs. 235–40), particularly the congenital type. While only one painting (Zervos I, 101) of the time shows a woman with a lesion, another such painting having disappeared under what became the *Portrait of Sabartés*, the malleability of the human visage under the pressure of congenital syphilis no doubt stayed in his mind. It may

93. *Woman's Sex*. Mougins, August 20, 1971. Graphite pencil on cardboard, 5 x 12 ¼" (12.7 x 31.3 cm). Zervos XXXIII, 146. Private collection

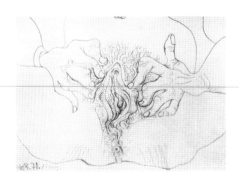

have played a role in the deformed death's-head of such drawings as fig. 94, and it resurfaced, I believe, when Picasso could make use of it, that is, as an association to, or impulse toward—though quite clearly *not* as a literal model for—the deformations of the crouching whore in the definitive state of the *Demoiselles.*

THE DEVELOPMENT OF THE COMPOSITION

The first ensemble sketch for the *Demoiselles* (fig. 30) probably dates from sometime around the very beginning of 1907, though we cannot be sure. Carnet 2, in which it is located, is dated by Daix to early in the winter of 1906–07. But even if we possessed documented dates for the first and last sketches in this carnet, we would not know where to situate this ensemble sketch, for no presumption of chronological order can be made in Picasso's notebooks, except in some cases where he draws the same motif on successive pages with the same pen or pencil. Thus, for example, the fact that this first ensemble study of the *Demoiselles* is back-to-back with a postscript to *Two Nudes*, while underlining the filiality between the two large paintings, in no way indicates that these drawings, the recto and verso of page 32 of Carnet 2 (figs. 30, 100), immediately followed one another. On the contrary, the recto study for the *Demoiselles* obviously follows rather than precedes the verso study, and they were probably executed weeks (and not impossibly months) apart. By contrast, the second ensemble sketch (fig. 31), which is in Carnet 3, is sufficiently close to the one in Carnet 2 that little time probably separates these two (though much else in Carnet 3 indicates that Picasso worked in it at least into the month of March).

We have to imagine Picasso as having had about him a number of sketchbooks at any given time, usually putting one of them away only when it was close to being filled. When he reaches for one, a variety of considerations come into play. The choice will be a function of the size and format of the carnets at hand, the purpose of the intended image, and the particular medium he wants to use (he probably will not take up a sketchbook with good paper for a rough pencil sketch). Carnet 10, for example, which was broken up and hung as separate pictures by Gertrude Stein, was made of relatively fine paper chosen both because it had to support gouache and because Picasso intended these "African" heads as autonomous works. Yet, given Picasso's improvisatory way of working, and his not particularly tidy habits, one suspects that the main motivation for choosing any particular carnet was often accessibility: he must often have simply picked up the carnet nearest to hand. In the absence of a ready carnet, the urge to get the idea down on paper might lead him to draw on a newspaper or any other kind of studio scrap.

A carnet once in hand, Picasso would not methodically seek out the last page he had drawn upon and continue from there. *Any* clean page would do. Sometimes, lacking a clean page, he simply drew on top of another image in order to get down a pressing idea—as is clearly the case with the vigorous little summary sketch (fig. 50) for the large canvas, probably drawn sometime in June 1907, over a study for the crouching demoiselle executed some months earlier when Carnet 3 was in everyday use. Nor is there any reason to suppose that Picasso began with the beginning, so to say, in filling a carnet. It is clear that the first page of Carnet 3 had been empty for months when Picasso drew on it the definitive study (fig. 185) for the head of the crouching demoiselle, probably executed in early July. By the same token, the study of flexing legs on the verso of page four of Carnet 6 (Seckel, p. 190), which contains

94. *Sheet of Studies.* c. 1902. Graphite pencil and colored pencils on paper, 10⅝ x 14¾" (27 x 37.5 cm). Zervos XXII, 17. Formerly estate of the artist, no. 838V

a sequence of six-figure studies for the *Demoiselles*, is obviously a later "insert," as it is a very advanced study associated with the "dancing" figure (Zervos II[1], 35), executed after the definitive reworking of the *Demoiselles*.

Not all Picasso's sketchbooks are carnets in the traditional sense. "Carnet" 5, for example, consists of the blank pages from the catalogue of a Daumier exhibition which ran at the L. and P. Rosenberg gallery from April 15 to May 6, 1907. Picasso probably used it, as Daix suggests,[201] because of the fine quality of the paper (at a time when he was obliged to buy mostly cheap carnets). But it may also be that Picasso had only this catalogue at hand (he might have been on his way home from the show) when he was inspired to explore a new conception of the prostitute with raised arms.

All these considerations function as caveats for those who would reconstruct the chronology of the *Demoiselles* from Picasso's notebooks.[202] We must also remember that when Picasso made his hundreds of studies for the *Demoiselles*, he did not know what we know. That is to say, he did not know where he was going. The sketchbook studies are full of discarded variants, false starts, and backtrackings. And continuity was clearly interrupted when, in the spring of 1907, at some point after the six-figure studies, Picasso temporarily broke off work on the project for about a month.

During the period of the *Demoiselles*'s development, the sketchbooks show—apart from unrelated projects—numerous "spin-offs," such as *Nude with Drapery* (fig. 2), and it is sometimes difficult to decide whether a particular drawing (or painting) is more in the train of the *Demoiselles* or in that of one of its contemporaneous outgrowths. The seated nude with raised arms, for example (Carnet 7, 15V; Seckel, p. 213), might have been considered a variant of the seated demoiselle, but like some drawings in this notebook, it was probably associated with a project for a separate painting. It is therefore best to approach the development of the *Demoiselles* by trying to erase from our minds the crushing and compelling image of the final work and think of the picture's integration as a kind of film that might have ended very differently, and for which much of the footage was left on the cutting-room floor, parts of it to be used along the way or later for "short subjects."

•

The two earliest ensemble studies (figs. 30, 31) are broadly horizontal in format, as befits a narrative scene containing not a little anecdotal activity. With one exception, all the seven-figure ensemble studies maintain more or less these proportions, though the oil sketch discovered by Hélène Seckel[203] under *Jars with Lemon* of 1907 (infra-red photograph, fig. 32), and the Basel pencil and pastel (fig. 40), are less wide, the compression of the composition inward from the sides having already begun; this inward pressure is even more evident in the newly discovered small oil on canvas (fig. 41).

The single exception to this prevailing horizontality among the seven-figure studies is the vertical format of the ensemble study on the recto of page 28 of Carnet 3 (fig. 33). Here the draperies reach much higher and, on the back wall, there is something resembling a window whose shutters are opening (inside of which there is a vague hint of the bust and head of a figure looking in).[204] This is the sole full ensemble study in which the student carries only a skull and is leapt upon by a dog. It is the first to show, in the foreground, not only a segment of a round second table, or low stand, but on it, a pitcher of flowers (which Picasso studied independently, Carnet 3, 26R [Seckel, p. 156], as he did all the still-life components of the picture).[205]

Picasso presumably developed the lower table and its still life here, as he did the shuttered window, to help fill the vertical space of the image. If so, it was a providential decision, given the role this table would subsequently play—its contours changed to straight edges—as a wedge moving into the space of the composition from that of the viewer.

Picasso was obviously displeased with the vertical version of his composition. He tried lowering the top of the field (as indicated by the heavy black bar inscribed horizontally near the top of fig. 33), and he finally crossed the drawing out. I suspect that while he liked the compression from the sides afforded by this format, he found too much of the central axis of his composition devoted to relatively inessential motifs (the tables and window). Nevertheless, Picasso continued to retain the circular foreground table in (what I take to be) his fourth ensemble study (fig. 95), which he also crossed out; such studies as fig. 37 show him exploring the compositional placement of its now wedge-shaped form in relation to the rectangular contours of the larger table.

The vertical format probably remained in the back of Picasso's mind through the rest of the *Demoiselles* studies, though we will see it again—as a blunted vertical—only when he takes up the large canvas. A comparably blunted horizontal format (fig. 42) became standard after Picasso eliminated the whore entering from the rear left, whose left hand grasps the chair of the seated prostitute in the earliest studies (figs. 120, 121); it persists throughout the six-figure studies in Carnet 6 (figs. 42–46), though it becomes a square in the charcoal drawing formerly in the Cooper collection (fig. 47) and in the totally overpainted oil sketch discovered by infra-red photography (under *Bust of a Woman with Large Ear*) in 1987 (fig. 48), which close out the six-figure series.

Aside from the superimposed rough and summary little pencil sketch mentioned above (fig. 50), which, though incomplete, seems clearly to be for a five-figure version (there is no trace of the sailor, nor space for him), the only study we possess that resembles the disposition of the final painting is the Philadelphia watercolor (fig. 49), which was executed in the "second period," when Picasso resumed work on the bordello project. Here he returned to an even wider format than the blunted horizontal fields of Carnet 6. The watercolor's resemblance in terms of figure style to the Iberian version of the large canvas—the center of which we still see and some of the rest of which we can reconstruct through radiographs—suggests that when Picasso stretched his large canvas, probably sometime in early May, he may still have intended to paint the picture as a blunted horizontal. If so, it was probably just before actually laying in his painting that Picasso made the decision to turn the canvas sideways (i.e., ninety degrees) and paint the *Demoiselles* as a slightly vertical picture.[206] It may be that Picasso's experience of El Greco's *Apocalyptic Vision* (which, among other affinities with the *Demoiselles,* has the same unusual format) inspired the new proportions. The decision would not, in any case, have necessitated elaborate new studies, as Picasso's format was already close to square; only the *brouillon*, or summary sketch (fig. 50), seems clearly to have been made in relation to this change.

Picasso's felicitous decision to paint the *Demoiselles* in a vertical format further abbreviated the open space—still evident in the Philadelphia watercolor but gone in the *brouillon*—where the sailor had previously sat. It also increased the tautness of his composition, compressing the figures from the side so much that they fairly burst

95. *Composition Study with Seven Figures for "Les Demoiselles d'Avignon."* Carnet 3, 6R. Paris, March 1907. Graphite pencil on beige paper, 7⅝ x 9½" (19.3 x 24.2 cm). Musée Picasso, Paris (MP 1861)

forward toward the spectator, an effect enhanced by Picasso in many of the changes he made as he overpainted parts of the Iberian version.

The progressive reduction of the cast from seven to five figures, the shift from anecdotal interaction to a more frontal ensemble, and the overarching change from a horizontal to a vertical format—all of which led (though by no means in a straight line) to the final version of the *Demoiselles*—reflect a varied and sometimes contradictory series of intuitive decisions. Nevertheless, I believe that some guiding instinct was leading Picasso in those directions, for it does not seem to me purely accidental that the same process—a progressive disengagement from anecdote, an increased emphasis on frontality, a shift from dispersal to intense concentration in the play of pictorial forces, and a movement toward verticality in the format—should have obtained between the first and final conceptions of four of Picasso's largest compositions of the period 1905 to early 1909: *Family of Saltimbanques*, the *Demoiselles*, *Three Women*, and *Bread and Fruit Dish on a Table*. The consistent pattern of those changes may be summarized, I believe, as a tendency in Picasso's art of those four years to move from a narrative kind of image (best suited to a horizontal format) to an "iconic" one (most natural in a vertical format).[207] Thus, for example, the random activities of the figures in the gouache *Circus Family* (fig. 96)—stage one of *Family of Saltimbanques* (fig. 97)—give way in the final picture to a motionless introspection in which the now comparatively frontal figures appear almost to be posing in a studio. Indeed, it has been suggested that the development of both *Family of Saltimbanques* and the *Demoiselles* in this direction may have been influenced by the frontal character of contemporaneous group photographs, as Theodore Reff proposed was the case with the variant of *Family of Saltimbanques* known as *Group of Saltimbanques* (fig. 98); Michael Leja sees the bordello photographs of the turn of the century (fig. 99) as feeding into the *Demoiselles*.[208] X-rays made several years ago of *Family of Saltimbanques* revealed the earlier composition (close to *Circus Family*) and showed that Picasso had begun moving toward the square format (the underimage has the squarer proportions of the drypoint of *Circus Family* rather than those of the gouache) even before he repainted the picture in its virtually square format with only six figures. (The format looks less square today than when Picasso executed *Family of Saltimbanques* because one of its early owners trimmed off portions of the image.)[209]

•

The five women in the ensemble studies of the *Demoiselles* arrive with varying histories behind them and encounter very different destinies. Two derive directly, and a third indirectly, from studies connected with *Two Nudes;* three boast possible ancestry in works by Cézanne, Matisse, and Derain—to say nothing of Ingres and Michelangelo. By the time Picasso arrived at the Philadelphia watercolor (fig. 49), which is the only developed preparatory study that approximates the image first laid in on the canvas, one whore had radically changed position and another had disappeared entirely, while the other three—despite numerous metamorphoses en route—reemerged largely the same. Along the way, all were studied independently and in subgroupings. Picasso would often make studies of one from different sides, while constantly altering its posture and orientation toward the viewer ever so slightly. Sometimes he would retain a variant motif for his composition; mostly he rejected them.

Throughout the carnets and the independent studies in all mediums right up

96. *Circus Family*. Paris, 1904–05. India ink and gouache on cardboard, 9 ⅜ x 12" (24 x 30.5 cm). Zervos XXII, 159. D./B. XII, 18. The Baltimore Museum of Art. The Cone Collection

97. *Family of Saltimbanques*. Paris, 1905. Oil on canvas, 6' 11¾" x 7' 6 ⅜" (212.8 x 229.6 cm). Zervos I, 285. D./B. XII, 35. National Gallery of Art, Washington, D.C. Chester Dale Collection

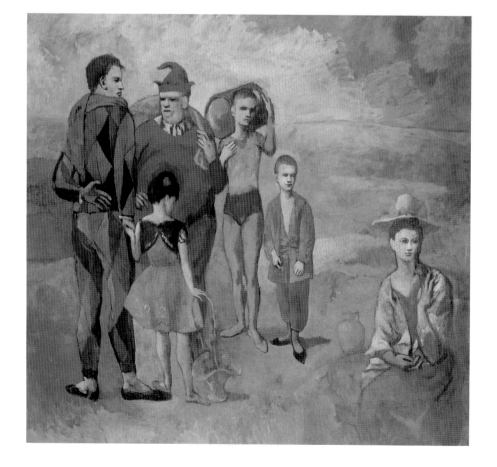

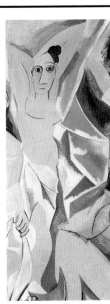

150 151 152 153

seated demoiselle (fig. 164). But the dialogue between nudes here, in keeping with the chaste character of the imagery surrounding *Two Nudes*, suggests nothing of the almost pornographic role she was later to play. Of all the whores in the early ensemble sketches, the one whose torso is seen finally from the back is the only one in an obscene posture: she is shown from the beginning spreading her legs to exhibit her sex to the sailor (figs. 30, 165). As she is the only whore not totally nude in the first ensemble exercise—Picasso endowed her with a belted, filmy peignoir—one might wonder whether he had second thoughts concerning propriety. Was the peignoir intended to mask or cover up a little, so to say, what was transpiring? More probably, he thought that the filmy peignoir would make her more of a tease than the others. Whatever Picasso's intentions, he omitted the figure's peignoir immediately afterward, and, while he would always demonstrate more indecision with regard to this crouching demoiselle than any of the others, his instincts were generally leading him to greater frankness, as witness the front view of this woman in Carnet 3 (fig. 167). This drawing, contemporaneous with the early ensemble projects, is not erotic or lubricious, but Picasso nevertheless appears to have decided that its front view was finally inadmissible; from then on we see the crouching demoiselle only from behind. (The emphatically drawn back view of the figure, inserted somewhat later on one of the pages showing this figure from the front, fig. 168, is underlined as if it were the painter's note to himself that the back view would prevail.)

As the narrative logic of the first ensemble project requires that the whore seen from the back address her sex to the sailor rather than to the painting's viewer, even as her attention is momentarily distracted by the unexpected gesture of the student, it is difficult to see how Picasso could have rationalized a front view of her in narrative terms, short of major compositional changes that would have placed this prostitute well into the illusioned space, *behind* the sailor. Picasso's vexation came from both wanting this whore to show her sex to the viewer (while perhaps having reservations about it) and needing her to show it to the sailor. This equivocation may well have led him to adopt an ambiguous silhouette for the crouching whore (as in figs.

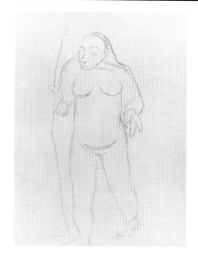

154

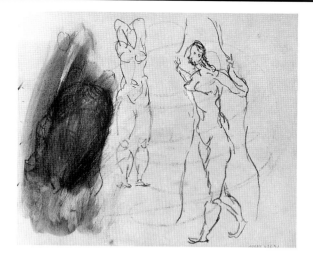

155

156

159

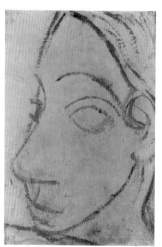

160

161

157

158

162

163

154. *Study for "Two Nudes" (Nude with Curtain).* Carnet 1, 48R. Paris, autumn 1906. Graphite pencil on beige paper, 10¼ x 7⅞" (26 x 20 cm). Zervos VI, 814. Musée Picasso, Paris (MP 185)

155. *Study for the Standing Demoiselle on the Right (the "Curtain-Parter"):* Detail of *Study of Two Demoiselles.* Carnet 3, 5R. Paris, March 1907. Graphite pencil and ink wash on beige paper, 7⅝ x 9½" (19.3 x 24.2 cm). Musée Picasso, Paris (MP 1861)

156. *Study for the Standing Demoiselle on the Right (the "Curtain-Parter").* Carnet 3, 12V. Paris, March 1907. Graphite pencil on beige paper, 7⅝ x 9½" (19.3 x 24.2 cm). Zervos XXVI, 81. Musée Picasso, Paris (MP 1861)

157. Detail of *Medical Student, Sailor, and Five Nudes (Oil Sketch for "Les Demoiselles d'Avignon")* (fig. 39)

158. Detail of *Sailor and Five Nudes (Composition Study for "Les Demoiselles d'Avignon")* (fig. 47)

159. Detail of *Composition Study with Five Figures for "Les Demoiselles d'Avignon"* (fig. 49).

160. *Head of a Woman in Red Paint* (reproduced in color, fig. 174)

161. Detail of *Composition Study for the Two Demoiselles on the Right* (fig. 178)

162. *Bust of a Woman* (reproduced in color, fig. 175)

163. Detail of *Les Demoiselles d'Avignon* (fig. 1)

164

165

166

169

170

171

167

168

172

173

164. *Studies: Two Seated Nudes with Curtain and Hand.* Carnet 2, 27V. Paris, winter 1906–07. Graphite pencil on beige paper, 5 ⅞ x 4 ⅛" (14.7 x 10.6 cm). Musée Picasso, Paris (MP 1859)

165. *Study for the Crouching Demoiselle.* Carnet 2, 33R. Paris, winter 1906–07. Graphite pencil on beige paper, 5 ⅞ x 4 ⅛" (14.7 x 10.6 cm). Musée Picasso, Paris (MP 1859)

166. *Study for the Crouching Demoiselle.* Carnet 3, 13R. Paris, March 1907. Pen and black ink on beige paper, 7 ⅝ x 9 ½" (19.3 x 24.2 cm). Zervos XXVI, 85. Musée Picasso, Paris (MP 1861)

167. *Study for the Crouching Demoiselle.* Carnet 3, 47R. Paris, March 1907. Graphite pencil on beige paper, 7 ⅝ x 9 ½" (19.3 x 24.2 cm). Zervos XXVI, 26. Musée Picasso, Paris (MP 1861)

168. *Studies for the Crouching Demoiselle.* Carnet 3, 46R. Paris, March 1907. Graphite pencil on beige paper, 7 ⅝ x 9 ½" (19.3 x 24.2 cm). Zervos XXVI, 28. Musée Picasso, Paris (MP 1861)

169. *Study for the Crouching Demoiselle.* Carnet 3, 38V. Paris, March 1907. Graphite pencil on beige paper, 7 ⅝ x 9 ½" (19.3 x 24.2 cm). Zervos XXVI, 47. Musée Picasso, Paris (MP 1861)

170. Detail of *Medical Student, Sailor, and Five Nudes* (*Oil Sketch for "Les Demoiselles d'Avignon"*) (fig. 39)

171. Detail of *Sailor and Five Nudes* (*Composition Study for "Les Demoiselles d'Avignon"*) (fig. 47)

172. *Study for the Crouching Demoiselle.* Carnet 3, 7V. Paris, March 1907. Graphite pencil on beige paper, 7 ⅝ x 9 ½" (19.3 x 24.2 cm). Zervos XXVI, 89. Musée Picasso, Paris (MP 1861)

173. Detail of *Composition Study with Five Figures for "Les Demoiselles d'Avignon"* (fig. 49)

169–71), one whose "flattened impress," as Steinberg pointed out, "orients itself simultaneously inward and outward."

The constantly changing orientation of the crouching whore's head is an index to this dilemma. In the first two ensemble projects (figs. 30, 31), she turns in profile toward the student; in the two following, she looks at him in *profil perdu*, as would be the case later in the Basel drawing (fig. 34); in The Museum of Modern Art's small oil on canvas (fig. 41), she is again in absolute profile. In the meantime, there are some studies (figs. 169, 173) that show her head revolved to an almost three-quarter view in the direction of the viewer. The extreme of this rotation (apart, of course, from the repainting of the canvas itself, where the head is entirely frontal) was reached in the lost small oil on panel (fig. 170), which is the final conception of the seven-figure project. Here the head is turned and tilted so much that, in combination with the visibility of both breasts, everted symmetrically to the sides, we are given a virtually simultaneous image of the figure from both front and back. Thereafter, in the six-figure studies, the "squatter's" head hovers between a back view and something just on the viewer's side of a profile—which is the way she is imaged in both the Philadelphia watercolor (fig. 173), and in the composite radiograph of the Iberian state of the canvas, where the ponytail (fig. 220, arrow) confirms the back view of the torso.

The sketchbooks suggest strongly that when Picasso spoke to Kahnweiler of "two periods of work" on the *Demoiselles*, he was thinking not of the two (or more) campaigns of work on the large canvas itself, but rather of two chronologically separate

174. *Head of a Woman in Red Paint*. Paris, March–April 1907. Oil on wood, 10 ⅝ x 7 ½" (27 x 19 cm). Zervos XXVI, 17. Daix 21. Private collection

175. *Bust of a Woman*. Paris, June–July 1907. Oil on canvas, 29 ⅛ x 23 ⅝" (74 x 60 cm). Zervos II¹, 34. Daix 37. Private collection

176. Detail of *Les Demoiselles d'Avignon* (fig. 1)

periods during which he worked on the studies (as well as the painting).[216] The first of these covers the months in which the seven- and six-figure conceptions were elaborated, along with their related studies of individual figures in different mediums. After a hiatus of about a month (or as much as five or six weeks), during which Picasso worked on other projects, such as *Nude with Drapery* (fig. 2), he took up the *Demoiselles* once again, and put it quickly in its definitive five-figure form, thereafter developing the work on the canvas itself.

As compared with the myriad seven- and six-figure versions of the *Demoiselles*—probably no Hollywood director has shot so many "re-takes" of a scene—we have very little in the way of studies that can clearly be associated with the five-figure version, either prior to or contemporaneous with the laying in of the composition on the large canvas. For the ensemble project, there is only the Philadelphia watercolor (fig. 49) and—evidently executed at the last minute—the little *brouillon* (fig. 50); for individual figures, a few oil studies can be identified with some degree of assuredness, and there are a few working drawings in the carnets. How do we explain this relative paucity? First, let us consider that throughout Picasso's career, there are certain projects for which he made numerous studies, and others, sometimes very complex compositions, for which he made none at all. In the latter, Picasso seemed to have had in his mind a clear and detailed image of what he wanted to do at the moment that he attacked the canvas (though he might make significant changes in the course of work). This suggests that Picasso was more than normally capable of composing pictures in his mind, of making mental erasures and additions, and holding even detailed aspects of these images in his memory for long periods.

By the time Picasso arrived at the Philadelphia watercolor (fig. 49), he had been living with the personages of the *Demoiselles* for many months. He knew every twist and turn of their bodies, as well as the exact placement of the furniture, curtains, and props. Despite its tiny size, the watercolor packs in an enormous amount of detailed information. It seems to me to confirm that—except for the scant possibility that some study for the five-figure version has been lost (though Picasso was almost maniacal in the preservation of his work)—the resolved version was composed carefully in Picasso's mind before he set it down on paper in the Philadelphia watercolor. He had never been sufficiently satisfied with either the seven- or six-figure ensembles. The attempt to resolve them satisfactorily may be in part what drove him to make so very many studies, and somewhat explains his putting the project aside for a time. Picasso seems to have immediately recognized the five-figure version as the right solution, for, soon after its execution, he set to work on the large canvas. I can see only one ensemble study, the little *brouillon* (fig. 50), as intervening after the watercolor.

The elimination of the sailor and his high table constituted the main "breakthrough" reflected in the Philadelphia watercolor; not a great deal happened to the poses of the other figures as compared to their incarnations in the former Cooper collection charcoal (fig. 47) and the oil sketch known through infra-red photography (fig. 48). The woman on the left (sometimes called the "curtain-puller"), the "gisante," and the demoiselle entering through the curtain on the right remained substantially unchanged. The crouching whore's legs are splayed wider, but she is in no other way altered. Only the standing whore in the center underwent a major modification between the six- and five-figure versions. Whereas her posture in the former showed her arms raised in a hieratic manner (fig. 141), her hands drop down

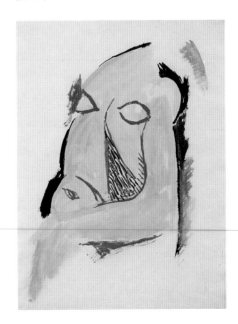

177. *Study for the Head of the Crouching Demoiselle.* Paris, June–July 1907. Gouache on paper, 24 7/8 x 18 7/8" (63 x 48 cm). Zervos XXVI, 276. Daix 45. Musée Picasso, Paris (MP 539)

178

179

180

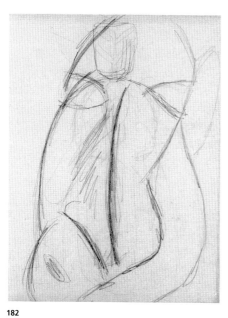

182

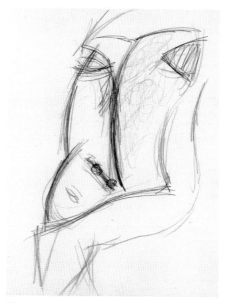

183

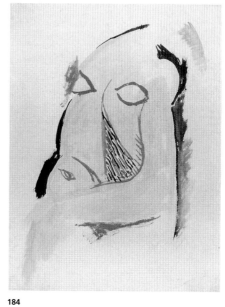

184

178. *Composition Study for the Two Demoiselles on the Right*. Carnet 14, 15V. Paris, July 1907. Graphite pencil on beige paper, 6⅞ x 8⅞" (17.5 x 22.4 cm). Private collection

179. *Study for the Crouching Demoiselle, Drawn over a Study of a Male Nude*. Carnet 14, 16R. Paris, July 1907. Graphite pencil on beige paper, 6⅞ x 8⅞" (17.5 x 22.4 cm). Private collection

180. *Composition Study for the Two Demoiselles on the Right*. Carnet 14, 1V. Paris, July 1907. Graphite pencil on beige paper, 6⅞ x 8⅞" (17.5 x 22.4 cm). Private collection

181. *Study for the Crouching Demoiselle*. Carnet 13, 8V. Paris, late June–early July 1907. Graphite pencil on ecru paper, 12¼ x 9¾" (31.2 x 24.7 cm). Musée Picasso, Paris (MP 1990-96)

182. *Study for the Head of the Crouching Demoiselle, Drawn over an Erased Sketch*. Carnet 13, 10R. Paris, late June–early July 1907. Graphite pencil on rose paper, 12¼ x 9¾" (31.2 x 24.7 cm). Zervos VI, 971. Musée Picasso, Paris (MP 1990-96)

183. *Study for the Head of the Crouching Demoiselle*. Carnet 13, 11R. Paris, late June–early July 1907. Graphite pencil on beige paper, 12¼ x 9¾" (31.2 x 24.7 cm). Zervos VI, 969. Musée Picasso, Paris (MP 1990-96)

184. *Study for the Head of the Crouching Demoiselle* (reproduced in color, fig. 177)

185. *Study for the Crouching Demoiselle*. Carnet 3, 1R. Paris, July 1907. Charcoal on beige paper, 7⅝ x 9½" (19.3 x 24.2 cm). Zervos XXVI, 101. Musée Picasso, Paris (MP 1861)

186. *Bust of a Woman (Study for the Crouching Demoiselle)* (reproduced in color, fig. 188)

187. Detail of *Les Demoiselles d'Avignon* (fig. 1; detail reproduced in color, fig. 189)

181

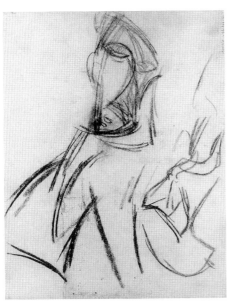

185

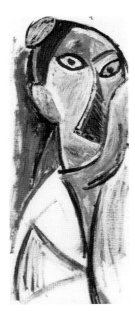

186

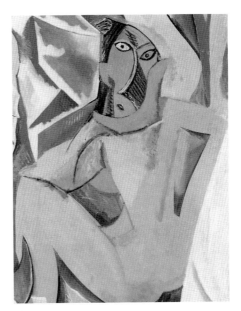

187

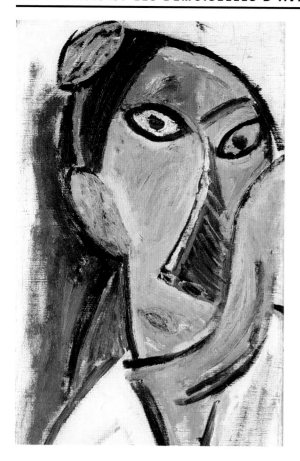 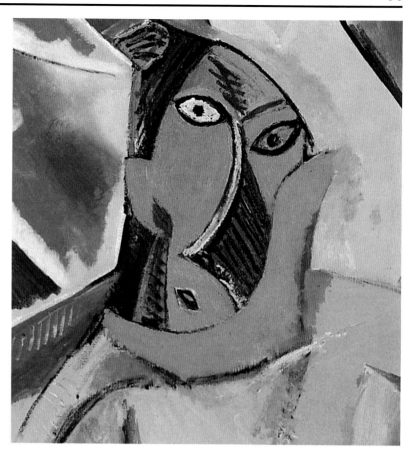

behind her head in the Philadelphia watercolor (fig. 152), as they did in the very earliest sketches, except that the splayed arms are now markedly asymmetrical.

The most important changes between the last six-figure ensembles and the five-figure Philadelphia watercolor have less to do with the surviving figures than with the spaces between them and, as a consequence, the format. One might have thought that, having dropped the sailor and his table, Picasso would use the occasion to further compress his composition laterally (as he ultimately did in the *brouillon* and the canvas). On the contrary, he spreads the whole right side wider. Instead of moving the two right-hand demoiselles into the space left open by the table's departure, he fills that space with the large folds of blue drapery that become so important in the final painting, which motif makes its first appearance at this point. As the central demoiselle slips downward so that she can be paired with her "gisante" sister, the diagonal formed by the edge of the tabletop and the forearm of the sailor in the former Cooper collection charcoal is reconstituted as a fold of drapery that descends diagonally just below the standing demoiselle's crotch. (Her knee has been placed so low in the watercolor that she appears unusually elongated, a situation Picasso would correct in the final painting.)

The sailor having disappeared, Picasso brought the "gisante" much closer to the central demoiselle, laterally as well as vertically. But in so doing, he opened a wider space between her and the "curtain-puller." Add to this the wider segment of curtain along the left border of the image, and we see why Picasso needed a horizontal format for this conceit. This shift back to the horizontal format, after Picasso had

188. Detail of *Bust of a Woman (Study for the Crouching Demoiselle)*. Paris, July 1907. Oil on canvas, 29 ½ x 13" (76 x 33 cm). Zervos II', 22. Daix 46. Private collection

189. Detail of *Les Demoiselles d'Avignon* (fig. 1)

worked the six-figure image into a square, may seem illogical. But Picasso advanced by instinct, not by logic. We must also keep in mind that the two prevailing tendencies—the overall reduction in figures (determined primarily by changes in the image's drama and symbolism) and the tendency to move from horizontality to verticality (basically formal decisions in favor of lateral compression)—were only loosely or secondarily intertwined. And Picasso always answered to the meandering spirit of his genius.

III. The Execution of the Large Canvas

When Picasso sketched in the *Demoiselles* on the large canvas, the conceptions of the five prostitutes differed only in details—such as the frontal eye given the curtain-puller—from their prefigurations in the Philadelphia watercolor. But their adjustment to one another and to the pictorial field as a whole was radically altered. The arms and legs of the crouching whore were splayed less widely, and the formerly billowing curtains on the right margin were reined in so that the two demoiselles on that side felt the pressure of the frame as never before. The distance between this pair and the central figure was somewhat narrowed, which intensified the pressure on—and caused the buckling outward of—the blue and white drapery ("like packed ice," as Steinberg says) and brought the arms of the whore entering on the right into closer proximity with those of the central figure; the latter's lower right leg (adjusted to correct the exaggerated elongation in the watercolor) now almost abutted the crouching figure.

The spatial compression and the interlocking of figures on the left of the canvas was even more intense. The "gisante" was narrowed and made more vertical, the lower part of her left forearm bent toward the picture's central axis rather than away from it, and her hand touching her "sister's" knee. The heads of these two central figures were moved closer together both horizontally and vertically. On the left, the curtain-puller was brought so close to the "gisante" on the lateral surface that their kneecaps overlapped and the former's pointed breast almost touched the latter's armpit. This articulation no longer describes a narrative space in which figures are free to act, but one that proclaims almost *a priori* a quasi-iconic immobility and rigidity.

The two central figures and the still life remain today in the Iberian form in which they were first painted. But the three other prostitutes—their heads in particular—were considerably altered after the canvas had been painted through in its initial form. Originally, all five figures were Iberian in type, as in the Philadelphia watercolor. The radiograph of the head of the standing figure at the right (fig. 190) reveals that it was much less elongated and slightly more in three-quarter view than the "savage" head Picasso would soon paint over it, and that it possessed (as in the watercolor) an unusually large Iberian ear. Albert Albano (formerly senior conservator at The Museum of Modern Art) made for me a schematic overlay of this radiograph in 1987 emphasizing the original Iberian contours (fig. 191). From this we discover that the Iberian head was very like the small panel *Head of a Woman in Red Paint* (fig. 174), except for a slightly different tilt of the head and a larger ear. The boxing off of this standing demoiselle's projecting breast in the picture's definitive state, with its intensely colored striated shading, is also an emendation of what had been a less angular, less "cubic" breast in the Iberian version.

190. Radiograph of the head of the standing demoiselle on the right (the "curtain-parter"), 1987

191. Radiograph and schematic tracing of the head of the standing demoiselle on the right (the "curtain-parter"), 1987

The radiographs of the crouching demoiselle's head give us relatively less knowledge of its Iberian form than does that of her standing neighbor's, in part because its subsequent metamorphoses involved an overlay of at least *two* additional and very distinct projects. Of the fragments of earlier heads made visible in recent radiographs, the clearest elements belonging to the original Iberian head of this figure are an eye, an ear, and the corner of the second eye (which Albert Albano marked in green in fig. 221). Falling below the field of this radiograph, but clear in the second, composite one (fig. 222), are the traces of this prostitute's ponytail, which drops below her left ear, as it did in the Philadelphia watercolor. On the basis of these clues, Albano suggested that the nearest preliminary study to the Iberian state of the squatter's head is the soft pencil sketch Carnet 3, 7V (fig. 172). I would add that as the eyes of the Iberian face in the radiograph are clearly on the same level, the tilt of the painting's original head probably more closely resembled that of the Philadelphia watercolor than of the sketch in Carnet 3.

Sometime after the execution of the watercolor, most probably as Picasso was laying in the canvas, the curtain-puller, on the left, underwent some important changes as regards the positioning of her forward leg (the knee in particular). The watercolor shows the knee somewhat peculiarly as an autonomous triangular form. Picasso took up this problem in working drawings in Carnet 14 (figs. 128, 129), of which the latter provided the formulation he actually set down on the canvas. Here the plane of the thigh descends past the pointed kneecap before giving way to the lighter tone of the lower leg. This angular solution for the lower section of the curtain-puller (which was carried into the drapery fold over the other leg) suggests that there were, significantly, some stylistic differences between her and the other figures even at this early Iberian stage of the image.

As for the alteration of the darkling head of the curtain-puller—a change of no less significance but considerably less radicality than those of the two heads at the right—the radiograph can tell us nothing because the later repainting in brown took place directly over the terra-cotta red profile of the Iberian head originally there. The new contours were more emphatic and stylized and, in combination with the increased chiaroscuro that animated the change in color, produced a head that was

to suggest tribal masks to some critics. In my opinion, the nearest thing we possess to a study for the curtain-puller's original Iberian head is an oil sketch (fig. 131) showing her large nose and ear, weak chin, and protruding lips, and above all, her large frontal eye set within the profile visage. To be sure, the profile in this oil study is facing left rather than right but, as has been seen many times already, it was Picasso's practice to paint his protagonists for the *Demoiselles* not simply as they might appear in the picture, but from other views as well.

•

It should be observed that neither Kahnweiler nor Barr distinguished between the dark, archaic, and almost immobile reworked head of the curtain-puller and those of the two central, unreworked Iberian faces. They treated the picture as having essentially two styles, that of the paired, supposedly "African" figures of the right-hand side, and that of the rest of the picture, a reading accepted by many later writers as well. Nevertheless, as Golding observed in 1958,[217] despite the absence of alien contours in the early set of X-rays he was using, there are clear indications (beyond the remaining traces of overpainted terra-cotta, of which he was unaware) that Picasso had also reworked the curtain-puller's head. Its sculptural edges and harder, dark surface suggested to Golding the possible influence on Picasso of an African mask of the Dan people (fig. 192). And although it turns out that ethnologists insist Dan masks could have been seen neither in the Musée d'Ethnographie du Trocadéro nor in the Paris market in 1907,[218] Golding's association of the curtain-puller's head to a type of African mask was indicative of its more "tribal" than Iberian character; in any case, the comparison is certainly not the kind Golding or anyone else would have made for either of the two Iberian heads in the center.

If I am right that fig. 131 is a study for the Iberian version of the curtain-puller's head, then the motif of a frontal eye in a profile head—clearly absent in the Philadelphia watercolor—became part of the image either just before or during the laying in of the Iberian version of the picture. To be sure, one always speaks of the curtain-puller in the final version of the picture simply as a profile figure. But when looked at carefully, the face reveals a small section in shadow—universally overlooked—that shows a sliver of the figure's left eye (fig. 193). Picasso no doubt added this because, while he wanted to maintain the archaism of his Gauguinesque formulation, he also wanted the figure to function logically in a space that was malleable and not flat. Unlike some of Gauguin's "Egyptian" heads, this detail forcibly reminds us of the five thousand years of art that separate the two formulations. Despite the enormous contraction of space in the *Demoiselles* from back to front, Picasso wanted to obviate any impression of absolute flatness, which he always associated (negatively) with the decorative.

In one sense, the frontal eye in the profile head of the curtain-puller—already present in the Iberian version of the large canvas—simply reverses the formula Picasso used in the central maidens, where the heads are frontal and the noses are in profile. Yet the expressive difference between the two formulas is considerable. Picasso's drawing of the nose in profile is a conceptual simplification ("It had to be put in sideways so that I could name it, so that I could call it 'nose,' " said the artist).[219] Quite apart from its frequency in folk art and children's drawings, it was far from unique to Picasso; it is found, for example, in Matisse (as in the portrait *Marguerite* [fig. 194], which Picasso chose when he and Matisse exchanged pictures in 1907,

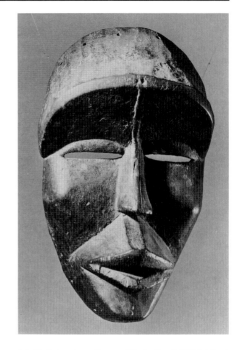

192. Mask. Dan. Ivory Coast or Liberia. Wood, 9⅝" (24.5 cm) high. Musée de l'Homme, Paris

193. Detail of *Les Demoiselles d'Avignon* (fig. 1)

probably for precisely that reason).[220] The frontal eye in the profile head, as in the curtain-puller, has, on the other hand, consciously archaizing overtones. It immediately recalls the "memory-image" formulation of Egyptian painting—a history-laden formulation never found in Matisse. The frontal eye not surprisingly struck Picasso's acquaintances as "Egyptian" and "Assyrian,"[221] and was no doubt responsible for Henri Rousseau's famous remark about Picasso having painted "in the Egyptian style."[222] We must assume then—exceptionally for the Iberian phase of the picture—that the expression of the curtain-puller's face had something archaic and idol-like about it even *before* Picasso covered the terra-cotta pink profile with brown and hardened it into a mask-like form. Such a distinction would have been clearly in keeping with the figure's role from the beginning as an outsider to the body of the narrative, a personage of a different order, in some way associated with determining the other figures' fate.

In the absence of any working drawings for the alteration of this left-hand figure's head, we are left with only one, inadequate clue as to when—in the order of Picasso's changes on the canvas itself—this overpainting might have been executed. The clue in question is the vague and incomplete image of the *Demoiselles* we see in the background of a photograph of Guus and Dolly van Dongen probably made in the summer of 1907 (fig. 232).[223] In this photograph, Picasso focused his camera on Guus and Dolly, with the result that, given the camera's limited depth of field, the image of the *Demoiselles*, propped against the wall behind, is blurred. It is clear that the left part of the painting is also in some way light-struck, and something has definitely gone wrong on the photograph's left margin, where a band of light cuts vertically through the curtain-puller. (Beyond that, of course, large segments of the painting are missing in the photograph along all four of its sides.)

Given all these problems, it becomes virtually impossible to judge accurately the state of the curtain-puller at this time, when the right-hand figures had obviously already been reworked, except to say that the changes in the knee explored in Carnet 14 are clearly already in place. Inasmuch as the changes in the head had largely to do with color, and did not involve a displacing but a "hardening" of contours, the incomplete and unfocused image of the head in this photograph can tell us very little. The light value of the head does, however, seem similar to that of the pink-ocher area of the breast (and the pink-ocher central figures), so that it may well be that the repainting of that head—which would already have had its "frontal" eye—in brown took place *after* the changes on the right side, although this cannot be deduced with any authority from the photograph. The almost universal assumption that this head either remained unchanged or, if repainted, preceded the changes of the right-hand figures, has been based upon the fact that its stylization is less radical. But such assumptions depend upon a "logic" in Picasso's development that is ultimately formal in its assumptions—while Picasso's decisions are usually motivated by expressive needs. (Britta Martensen-Larsen draws more far-reaching conclusions from the van Dongen photograph [fig. 232], and from the photoengraving of Burgess's 1908 photograph of the *Demoiselles* [fig. 244] as regards the order and dating of Picasso's changes of the painting, which she sees as completed much later than generally believed. But her analysis is undermined by a failure to evaluate the photographic properties and peculiarities of the images with which she was working.)[224]

It is clear, in any case, that right from the beginning of work on the large can-

194. Henri Matisse. *Marguerite*. Collioure, winter 1906–07. Oil on canvas, 25½ x 21¼" (65 x 54 cm). Musée Picasso, Paris (RF 1973-77). Formerly collection Pablo Picasso

vas, Picasso wanted a very specific form of primitivism for the "outsider" figure of the curtain-puller—one that would clearly distinguish her from the rest of the cast. Despite the views of Golding and others, I myself see nothing particularly "African" in her head. Indeed, it has always seemed to me to be essentially Gauguinesque in character, and probably, through Gauguin, more intuitively indebted to Oceanic or Egyptian art than to anything African in the tribal sense. What could have been more natural? Picasso certainly used Gauguin as one of his "levers" in getting into primitivism, and there is every evidence that the major Gauguin retrospective of the Salon d'Automne of 1906 left a residue in his art. Gauguin's *Two Figures Flanking a Statue*, for example, which was shown in that retrospective, seems to me to have inspired Picasso's *Two Seated Women*,[225] and the curious, bent, non-supportive legs of Gauguin's maiden, *Oviri* (fig. 195),[226] were certainly relevant to the "vertical perspective" of Picasso's "gisante."

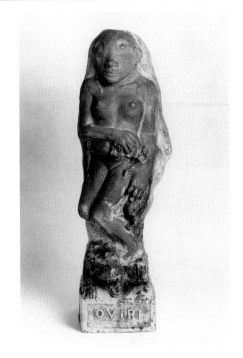

195. Paul Gauguin. *Oviri*. 1894. Stoneware, partially glazed, 29 ½ x 7 ½ x 10 ⅝" (75 x 19 x 27 cm). Musée d'Orsay, Paris

The idol-like head of the curtain-puller is also clearly more "Oceanic" than "African" in spirit than any of the heads on the right, insofar as it is more mysterious than malefic.[227] As I made clear in 1983,[228] I believe this figure may constitute a direct echo of the half-idol, half-human "Tupapau," or female ancestor spirit, in Gauguin's *Spirit of the Dead Watching* (fig. 197), which Picasso certainly knew in lithographic form (its elements are also present in *Noa-Noa*, of which Picasso owned a copy). Indeed, Richardson has recently held that Picasso would have been very familiar with the Gauguin painting itself, "not just from having read the extensive explanation for it in *Noa-Noa*, but from having actually seen it at Vollard's at the time of his 1901 show."[229] In *The Spirit of the Dead Watching*, the ancestor spirit is situated, like Picasso's curtain-puller, on the extreme left of the picture, adjacent to a drapery, and—again like the curtain-puller—is shown in profile facing right, with protruding lips, a receding chin, and, above all, a frontal eye. On the poetic and psychological plane, *The Spirit of the Dead Watching* is still more relevant to the *Demoiselles*, given its pairing of Eros and Thanatos. It shows a troubled young girl at the age of sexual awakening reclining on a bed (Gauguin described this figure as "nearly indecent," and she is not unrelated to the heroine of his loss-of-innocence paraphrase, *Nevermore*). Her "fear" or "dread" (in Gauguin's words) is related to the imagined Tupapau, and hence to death.

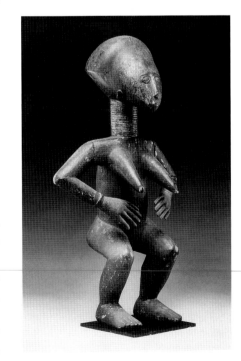

196. Figure. Eastern Akan. Ghana or Ivory Coast. Wood, 24" (61 cm) high. The Detroit Institute of Arts. Founders Society Purchase, Eleanor Caly Ford Fund for African Art

THE ROLE OF "INFLUENCES": CÉZANNE

The attention of critics, beginning with Kahnweiler and Barr, has been focused primarily on the heads of the demoiselles on the right. But even if we limit ourselves to their seemingly less radically conceived draperies and anatomies, we find that those parts of any of the five figures left in the Iberian manner of their first laying in are flatter, simpler, and more economical than in the Picasso paintings that preceded the *Demoiselles*. This may be partially explained by the large size of the pictorial field beckoning Picasso, which almost automatically (as even more markedly in the case of *Guernica*) called forth an "attack" of greater simplicity and somewhat more abandon. But other influences inflecting Picasso's new manner certainly included the renewal of his dialogue with the work of El Greco. And it is *his* example, rather than Cézanne's, which becomes important at the point at which Picasso begins to paint.

If this becomes the case at the moment of the actual execution of the large canvas—and I think it does—we are reminded of how limited has been the role played

197. Paul Gauguin. *The Spirit of the Dead Watching.* 1892. Oil on burlap mounted on canvas, 28 ¾ x 36 ¼" (73 x 92 cm). Albright-Knox Art Gallery, Buffalo. A. Conger Goodyear Collection

198. Detail of *Les Demoiselles d'Avignon* (fig. 1)

by the work of Picasso's predecessors during the generation of the image's hundreds of studies. Indeed, when we parse the *Demoiselles* purely in the light of its many studies, the sense of its relation to the flow of art history changes, and the pivotal role traditionally attributed to Picasso's diverse "sources" seems diminished. The more the final state of each figure—indeed, of the composition as a whole—emerges for us as an extension or conclusion of a development that Picasso has worked through many anterior phases, the less we are wont to see the results as functions of a dialogue between Picasso and other artists.

Taking stock of this issue as of the time of the laying in of the large canvas, I find personally that of the many prototypes or "influences" proposed in the literature, the one that emerges as most exaggerated—precisely because of its absence at this critical juncture—is that canonically attributed to Cézanne. This is certainly not to suggest that the Master of Aix failed to play some role in the early studies, or was without a crucial role in the development of Picasso's subsequent Cubism, but rather that this inspirational role in early Cubism is as yet hardly visible in the *Demoiselles*. The picture is overwhelmingly linear in its figure articulation and space-making devices, and contains but a single area—the blue and white drapery between the right-hand figures—that truly hints at a Cubist conception of picture-making (a simulacrum of a bas-relief modeled with *passage* linking the planes) as it was to be extrapolated by Braque and Picasso in part from Cézanne a year later, but even those blue and white curtain folds in the *Demoiselles* recall El Greco far more than Cézanne.

Notwithstanding all this, the supposed special affinity of the *Demoiselles* with the work of Cézanne has remained unquestioned[230] since the time of Barr's early statements about the picture (even though Barr's description of the nature of the Cézannean low-relief space more closely resembles *Two Nudes* [fig. 27], and other pic-

tures of both late 1906 and of 1908, than it does the *Demoiselles*). It is almost as if Barr
unconsciously forced himself to exaggerate Cézanne's presence in the *Demoiselles*
because without Cézanne he could not envision the picture as the beginning of
Cubism. But Barr never precisely identified the putative Cézannean low relief with-
in the *Demoiselles*. And except in the piling up of icy blue draperies at the right, there
is virtually no illusion of modeled relief at all; moreover, the suggestions of ortho-
gonal movement of forms through space—such as the "contrapposto" of the squat-
ter's head—are communicated in a purely linear way. Nor does Picasso's drawing in
the *Demoiselles* have anything in common with Cézanne's broken, "polyphonic" line,
characterized by its "fleeing" contour. And finally, what could be less Cézannean than
Picasso's compacting and abutting of his whores in a space that is compressed later-
ally as much as it is in depth? Such a formulation has little to do with the compara-
tively relaxed spatial distribution of the figures in pictures such as *Five Bathers* (fig.
9), which has traditionally, since Golding, been identified as the Cézannean proto-
type for the *Demoiselles*.

I am not arguing here that there is *no* influence of Cézanne on the *Demoiselles*,
but rather that, to isolate it, such as it is, we must admit that Picasso's grasp of
Cézanne in early 1906 and early 1907 was more fragmentary—less coherent and inte-
gral—than it was to become in 1908, in part under the influence of Braque's reading
of that artist.[231] Prior to the revisions of *Three Women* (fig. 7)—that is to say, in the
Demoiselles and the work of the two years immediately preceding it—Picasso
responded to Cézanne only in bits and pieces: here some broken contour drawing,
there a Cézannesque posture or figure type. What we do *not* see in the Picasso of those
years—and this was certainly the most crucial aspect of the Cézannean revolution—
is the overall conception of the picture as a simulacrum of a bas-relief: an indivisible,
interlocking, and integral low-relief structure, characterized by *passage* between the
planes.

In the *Demoiselles*, Picasso's painting was less close to Cézanne, structurally,
than it had been in the fall of 1906, when the ideas that fed into his great bordello
image were first being generated. The heavyset nudes of that autumn, usually paint-
ed in low relief rather than illusionistically "in the round," are very reminiscent in
their proportions of Cézanne nudes and bathers, and they often echo Cézanne in
their gestures and postures. But by the time Picasso began his ensemble sketches for
the *Demoiselles*, he had already given up the heavyset anatomies related to Cézanne
(though the drawings for a few of the very earliest elongated figure studies for the
Demoiselles [fig. 156] have reminiscences of the broken "polyphonic" contouring of
the Aix Master). The final echoes of Cézanne are perhaps found in some of the
sketches for the first, seven-figure versions of the *Demoiselles* (fig. 31) that contain
elongated figure types. These drawings may count among their prototypes—and it
is here that El Greco is also briefly glimpsed in the carnets—such comparably "dis-
torted" Cézannes as *Harlequin* (fig. 199).[232]

Whatever Picasso's affinity for Cézanne in the *Demoiselles*, we should seek it
more in the mood than in the formal aspects of Cézanne's bathers and nudes—par-
ticularly in that of such early works as *The Temptation of Saint Anthony* (fig. 25) and
Luncheon on the Grass. Inasmuch as the distress that informs the latter pictures is of
a sexual order, their disquiet—the rumbling anxiety that animates their gloomy
Stimmung—is not unrelated in nature to the conflict-ridden sexual interrogation

199. Paul Cézanne. *Harlequin*. 1888–90. Oil on canvas, 36 ¼
x 25 ⅝" (92 x 65 cm). Private collection

behind what Salmon called Picasso's "anxiety" during work on the *Demoiselles*. I believe Picasso had *this* in mind when he later downplayed the formal advances of Cézanne, and insisted: "What [really] forces our interest is Cézanne's anxiety."[233]

THE ROLE OF "INFLUENCES": EL GRECO

If the influence of Cézanne on the *Demoiselles* has been exaggerated in the literature—as, for example, in Fry, who unaccountably saw examples of Cézannean *passage* throughout the picture[234]—the sway of El Greco has no doubt been counted too little (at least until very recently). Not that the El Greco influence had in any sense gone unnoticed. We have seen that from the time of Barr's early remarks about the *Demoiselles* (above, p. 25), El Greco's influence was envisioned as clearly playing some role in the picture. And in 1980 Ron Johnson, in his imaginative article about Picasso's literary sources, not only also reemphasized the El Greco influence, but pointed directly to El Greco's *Apocalyptic Vision* in The Metropolitan Museum of Art, known since 1908 as *The Opening of the Fifth Seal* (fig. 200),[235] as a possible direct source for the *Demoiselles*.[236] Johnson saw the latter's "segmented blue and white background curtain with its strange broken highlights" as related to El Greco in a general way, but he identified its "strange relationships between the figures and the drapery, the broken angular frames of the drapery, the unusual gestures, and the nearly square canvas without much setting" directly with *Apocalyptic Vision*.

Johnson's observation generated interest in many quarters, although his was not, in fact, the first text to signal the affinity between these two particular pictures. Neither Johnson, nor later scholars writing on the subject appear to have been aware that in 1973 the Spanish poet and art critic Santiago Amón had juxtaposed reproductions of the *Demoiselles* and *Apocalyptic Vision*, whole and in detail, and devoted eleven pages to a comparison of them in a book on Picasso. Amón himself (and, for that matter, Johnson too) may have gotten the cue for this juxtaposition from a 1957 German publication or, more probably, from a 1968 issue of *Life* magazine.[237] Amón's text was never translated, however, and no notice seems to have been taken of it at the time in art-historical circles.

•

By 1986, at least two scholars, clearly unaware of Amón's work and of each other's parallel interests, were independently working to explore the relationship between the *Demoiselles* and *Apocalyptic Vision*. In May of that year, the Danish art historian Rolf Laessøe completed and sent to the *Gazette des beaux-arts* a text titled "A Source in El Greco for Picasso's *Les Demoiselles d'Avignon*"; this text, written in English, would not appear, however, until the October 1987 issue of the magazine.[238] In the meantime, John Richardson was to publish an article on the same subject, in an April 1987 issue of *The New York Review of Books*, titled "Picasso's Apocalyptic Whorehouse."[239]

Though slightly breathless in character, and occasionally prone to overstatement,[240] Richardson's imaginative and ambitious text tends to confirm a direct link, circumstantial though it is, between Picasso's *Demoiselles* and the artist's experience of seeing El Greco's *Apocalyptic Vision*. It fleshes out, as he observes, the remarks regarding El Greco and the *Demoiselles* that Picasso made late in life.[241] In the period leading up to the execution of the *Demoiselles*, El Greco's *Apocalyptic Vision*, Richardson argues, was very likely in Paris, housed in the collection of the Spanish

200. El Greco. *Apocalyptic Vision (The Vision of Saint John).* 1608–14. Oil on canvas, 7' 4½" x 6' 4" (225 x 193 cm). The Metropolitan Museum of Art, New York. Rogers Fund. Formerly collection Ignacio Zuloaga

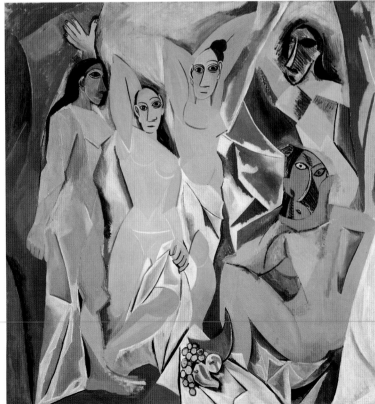

201. *Les Demoiselles d'Avignon* (fig. 1)

painter Ignacio Zuloaga (whom Amón had already mentioned without elaborating on his relationship with Picasso), and that Picasso had visited Zuloaga on a number of occasions, so that he almost surely saw *Apocalyptic Vision* then,[242] if not before.

Laessøe makes a similar assertion, though providing less evidence, but he notes that Picasso might well have seen *Apocalyptic Vision* even earlier, in 1902, when he probably journeyed to Madrid from Barcelona to see the great El Greco exhibition of that year.[243] *Apocalyptic Vision* was not only in that exhibition but was shown, interestingly enough, under the title *Amor divino y amor profano* (*Sacred and Profane Love*), the title, Laessøe points out, by which it was certainly known to Picasso and Zuloaga in 1907. This title brings us back full circle, by implication, to the particulars of Picasso's sexual conflict with Fernande—a chance happening that could certainly have impressed the deeply superstitious painter.

Richardson contends that *The Opening of the Fifth Seal*, a title suggested for the El Greco in a text by Manuel Cossio that appeared only in 1908,[244] was nevertheless the more operative title for Picasso. He admits that Zuloaga and Picasso knew the painting as *Sacred and Profane Love*. But he argues that Picasso, who "would have taken a leading part in the discussions that Zuloaga's great new find triggered," would have been aware that Cossio—"much in Zuloaga's circle"—was going to reinterpret the scene this way. Richardson insists on Picasso's foreknowledge of Cossio's argument because he wants to read the *Demoiselles* as an "Apocalyptic Whorehouse," hence a quasi-religious picture peopled by "Apocalyptic prostitutes who have the psychic energy and the redemptive power of *The Fifth Seal*." "Picasso," Richardson adds, "would have instinctively understood the divine nature of *The Fifth Seal*'s message. And given his chameleon-like spirit, he would have been only too ready to see himself as Saint John, to whom God ordained this vision of the end of the world; equally as the vengeful, omnipotent Lamb of God—divine yet demonic."

As the *Demoiselles* does not strike this writer as a religious (or especially "apocalyptic") picture—except in the ritual or "magical" sense in the spirit of Breton's "image sacrée"[245]—it is easier to sympathize with Laessøe's suggestion that the operative title for Picasso was *Sacred and Profane Love*, and that this appealed to Picasso insofar as the *Demoiselles* "may also be understood as having to do with two opposite kinds of love." Laessøe relates this amatory contrast to the opposition of the student and sailor in the early studies—"a duality" he sees as "strongly akin to that of sacred and profane love." It should be considered, however, that quite without benefit of any title, Picasso would have recognized El Greco's picture as an image of tension and conflict involving groups of male and female nudes. And one may doubt that he was any more interested in this particular picture's title than he was in any other. I would guess that Picasso interpreted this El Greco—as he normally did all pictures—not according to *its* iconography, but in terms of *his* own associations and memories.

If *Apocalyptic Vision* had a direct impact on the *Demoiselles,* and I agree it did, it was less because of the particulars of its subject than the way the subject was presented. First, and probably most important, as both Amón and Johnson had already noted, was the peculiar format, so close both in actual size and in proportions to Picasso's picture. As we have seen, the format of the *Demoiselles*—a blunted vertical—differs from that of any of its sketches (except the last-minute, very summary *brouillon* [fig. 50]). It is therefore not unlikely that El Greco's compressed groups of nudes in this unusual format[246] might have inspired Picasso to change the dimensions of his

project. If, indeed, this was the case, it enhances the probability of Picasso's having seen *Apocalyptic Vision* in May or June 1907 (though almost certainly not for the first time), assuming it was then in Paris. However, we must keep in mind that the proportions of Picasso's canvas are very close to those of some of the six-figure sketches for the *Demoiselles* except that it is vertical, so that it is not impossible that Picasso originally stretched up a blunted horizontal and at the last minute, purely at his own instance, turned his canvas vertically.

El Greco's overall spatial solution was, in any case, familiar to Picasso through many other examples of the Mannerist painter's works; he did not have to have seen *Apocalyptic Vision* for that. It was a solution admirably encapsulated by Jonathan Brown as an ability "to confound the illusion of space, producing a compositional pattern that hovers ambiguously between the second and third dimension—an effect that caused early twentieth-century artists and critics to liken El Greco to Cézanne."[247] It was clearly El Greco (rather than Cézanne) who could best serve Picasso at the moment when the *Demoiselles*, which for months had germinated as drawings and *bozzetti*, was suddenly to become a painting. And El Greco's intervention seems to me to have been rather sudden. Keep in mind that while Picasso's notebooks in earlier years are replete with allusions to El Greco, the Mannerist's influence is notable for its almost total absence (the few early elongated figures may be exceptions) in the hundreds of preparatory drawings for the *Demoiselles*.

The *Demoiselles* sketches, however, by their very nature, left many questions about the space of Picasso's bordello scene unanswered. El Greco's style would serve this ambiguity. Moreover, Picasso's later sketches for the *Demoiselles* were invaded by the kind of expressionistic tensions that could better be communicated in painting by means of a broad, passionate, and painterly approach à la Greco than by building a picture as a meditative mosaic of architectonic accents in the manner of Cézanne.

•

The argument in favor of the influence of El Greco's *Apocalyptic Vision* in the period just before Picasso began executing the *Demoiselles* is reinforced by a number of affinities between the two works, affinities that belong as much, if not more, to Picasso's mode of execution, color, and broader compositional structure than to particulars of the postures and gestures (which had been Amón's emphasis).[248] El Greco's juxtaposition in the picture plane of figures in three different depths of a compressed foreground space, the whole of which was closed in the back by draperies, must certainly have fascinated Picasso. And what draperies! Like Picasso's, they have a life of their own, and are virtually unrelated to the figures who wear or hold them. The remarkable drapery patterning over the knees of El Greco's Saint John is admittedly not the same as—but nevertheless shares a comparable "illogic" with—the folds of a similar color that pile up between the two right-hand demoiselles. And while much of Picasso's color scheme in the *Demoiselles* recalls his work of 1905–06, the *particular* pinks and blues of the *repainted* parts, the drapery especially, have a saturation cooled by chalky whites that recalls El Greco in general and *Apocalyptic Vision* in particular. Of course, Picasso's palette was to change yet again before he completed the *Demoiselles*, as he moved to the still more radical *brut,* or raw, coloring of the two "African" heads on the right.

The affinities between *Apocalyptic Vision* and the *Demoiselles* are many. Apart from the common format, extreme figure distortions, autonomous drapery patterns,

and the vigorous painterly execution shared by the two paintings, passing mention should be made of triangulations in the foregrounds,[249] the unexpected and inconsistent foreshortenings,[250] and a certain androgyny in some of the figures (as exemplified by the standing boy holding the golden drapery on the left of *Apocalyptic Vision* and the drapery-puller of the *Demoiselles*, who is a transsexual mutant of the medical student). What is, however, remarkable about all these Grecoesque attributes in Picasso's picture is the completeness with which they were absorbed into its pictorial fabric. In the eclectic totality of the *Demoiselles*, the El Greco influence is far less noticeable, for example, than the hints taken from tribal art—which perhaps reflects the comparatively greater ease with which historically removed but nevertheless Western pictorial forces (as opposed to alien sculptural ones) could be absorbed into painting.

•

Carnet 14 provides us with a number of working sketches postdating the Philadelphia watercolor (fig. 49) that are associated with the major changes Picasso effected on the right side of the *Demoiselles*, changes already fully in place in the photograph of Dolly van Dongen and her mother (fig. 232).[251] The earliest of these sketches are concerned with establishing the drapery patterns around the space inhabited by the two right-hand figures (for example, figs. 202, 203), and they sometimes contain linear accents or "lines of force" presumably intended to relate to the figures themselves (fig. 204). When Picasso does clearly indicate his two figures within this space (for example, fig. 205), we see that the crouching demoiselle's head is still well to the right of the axis of her standing neighbor, as it is in the watercolor. This obliges us to place these particular drawings at the beginning of the Iberian phase of the canvas, inasmuch as the crouching demoiselle's Iberian head, as shown in the radiographs, had been moved to its definitive position directly under the head of her standing partner and slightly to the left of the axis of the latter's torso. These "drapery" sketches (figs. 202, 203) must be distinguished from another group of working drawings, also in Carnet 14, which clearly postdate the Iberian version of the painting and are concerned with the changes made in the two right-hand figures directly on the canvas.

202. *Study of Space: Curtains.* Carnet 14, 1R. Paris, July 1907. Graphite pencil on beige paper, 6 ⅞ x 8 ⅞" (17.5 x 22.4 cm). Private collection

203. *Study of Space: Curtains.* Carnet 14, 2R. Paris, July 1907. Graphite pencil on beige paper, 6 ⅞ x 8 ⅞" (17.5 x 22.4 cm). Private collection

204. *Study of Space: Curtains.* Carnet 14, 5R. Paris, July 1907. Graphite pencil on beige paper, 6 ⅞ x 8 ⅞" (17.5 x 22.4 cm). Private collection

205. *Composition Study with Two Figures.* Carnet 12, 9R. Paris, end June–early July 1907. Graphite pencil on white paper, 6 ⅞ x 8 ⅞" (17.5 x 22. 4 cm). Zervos VI, 1047, Private collection.

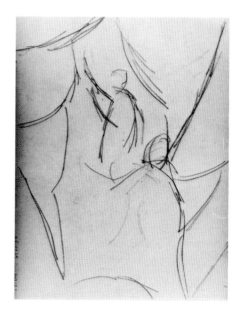

This second group of drawings probably dates from the early days of July. Figure 161 provides us, however sketchily, with an adumbration of the right-hand standing demoiselle's new head. It suggests a physiognomy very different from the Iberian one: the face appears more elongated, and the enlarged eyes, long nose, and small mouth seem to lead downward to a pointed chin. These implications are realized in an oil titled *Bust of a Woman* (fig. 175), which was clearly intended as a study for this standing demoiselle's head. It crystallizes some of the features hinted at in the drawing and leads us toward the definitive image of this demoiselle's head. But this version of the entering whore—unlike her succeeding image—still has ears, and, though her face is distorted, it appears more human than the mask-like face in the final work. There (fig. 176), the combination of animal and human features and the absence of ears point toward tribal masks. The definitive head was executed by Picasso directly on the canvas, apparently without a preparatory drawing, essentially in the form of a transmogrification of fig. 175.

With this definitive "mask" of the standing whore, the El Greco-inflected Iberian style that dominated the first campaign of work on the large canvas gives way to a "savage," violent, and distorted type of imagery that in part reflects the impact on Picasso of his traumatic visit to the Musée d'Ethnographie du Trocadéro sometime in the weeks (or perhaps even days) preceding these alterations. The Trocadéro visit brings us face to face with a major crux in Picasso criticism caused by the artist's statement to Zervos (many years later) that he had become aware of tribal art only on the occasion of that visit, and that the visit had taken place *after* his work on the *Demoiselles*. As the subject is thorny, and as I have treated it at great length elsewhere,[252] I shall simply summarize my views here, reinforcing them with some documentation that was not available to me at the time of my earliest text.

THE VISIT TO THE TROCADÉRO

In the years after 1907, Picasso's position as regards the relation of tribal art to the *Demoiselles* was, to say the least, variable and contradictory. His comments to Florent Fels shortly after World War I suggested that he was already fed up with the constant association of his work of 1907–08 with "art nègre."[253] But his denials that a rapport existed between the *Demoiselles* and tribal art began only during, or just before, World War II, at the time of his statement to Zervos (cited above, p. 25).

Against this, however, must be set a considerable amount of evidence to the contrary, some of it from the artist himself. Four major witnesses of the period of the *Demoiselles*—André Salmon,[254] Gertrude Stein,[255] Max Jacob,[256] and Wilhelm Uhde[257]—specifically refer to Picasso's contacts at that time with "art nègre" (which term referred to Oceanic as well as African Art). Moreover, Picasso himself recounted to Malraux in 1937 that *Les Demoiselles d'Avignon* "must have come to me that very day" (the day of his visit to the Trocadéro).[258] Burgess's much earlier association of Picasso's paintings—the *Demoiselles* amongst them—with primitive art[259] probably reflects some conversations with the painter about tribal art or about the Musée d'Ethnographie. The same is probably true of a comment about the Trocadéro museum by Augustus John, who visited Picasso's studio in late July or early August 1907,[260] at a time when the artist had recently completed (or was just finishing) the *Demoiselles*. John saw "a large canvas [that] contained a group of figures which reminded one a little of the strange monoliths of Easter Island." Picasso, he wrote,

"is steeped in the past and no stranger to the *Musée Ethnographique*. His explorations ... at first sight disturb or even horrify, but ... on analysis, reveal elements derived from remote antiquity or the art-forms of primitive peoples."[261]

Picasso's admittedly revelatory visit to the Trocadéro was surely not, in any case, his very first contact with tribal art. A variety of different accounts make it clear that in the fall of 1906 Matisse showed him an African piece he had recently acquired.[262] And as both Derain and Vlaminck had both begun collecting "art nègre" at that time, it is highly probable that Picasso saw at least a few masks and figure sculptures during visits to their studios well before he began work on the *Demoiselles* the following winter. Yet there is not the slightest trace of any interest in tribal objects in Picasso's art of the autumn, winter, and spring of 1906–07 that precedes his actual execution of the large canvas. Only in the *revisions* of the painting's Iberian figures (of June or early July) and their accompanying studies, do we see an awareness of tribal art. And it arrives suddenly, in part *as a solution to the search for plastic correlatives to express feelings about sexuality and fate* with which Picasso had wanted to invest the *Demoiselles* from the beginning, and which he obviously felt to be beyond the expressive capabilities of the Iberian-Grecoesque figuration of the early state. All this speaks virtually incontrovertibly for the Trocadéro visit as a turning point.

The Trocadéro not only offered Picasso a much larger number of more stylistically varied tribal works than he could see in his fellow artists' incipient collections but, more important, presented them in a different context. To see a few tribal sculptures in an artist's studio is to see them in a situation of aesthetic delectation (which was precisely Matisse's and Braque's approach to "art nègre"—and one that Picasso would later belittle).[263] Viewed this way, tribal art clearly did not impress Picasso between the autumn of 1906 and June 1907. Then we suddenly find him regarding these masks and "fetishes" in a compelling new light that is relevant to what he is trying to get at in the *Demoiselles*. He now begins to think in terms of "exorcism," "intercession," and "magic." What could be more logical than that this "revelation" should have taken place in an ethnographic museum, where the isolated masks and statuettes of the artists' studios give way to mannequin figures in full ceremonial regalia surrounded by artifacts evoking their cultures and accompanied by labels that declare their ritual function? Labels which, moreover, would have piqued Picasso's deep native superstitiousness (objects that protect against malicious spirits) and even touched on more practical concerns related to his bordello project (fetishes that "cure gonorrhea").[264] Is it any wonder that Picasso would insist to Malraux that it was the exorcistic rather than the formal aspect of these objects that gripped him?

It is precisely because Picasso was looking for new solutions to the direct communication of deepening fears touching his own humanity—not unrelated to the sights that revealed "the horror" to Kurtz in Conrad's *Heart of Darkness*—that he seized upon tribal art at that particular moment as a source of inspiration,[265] and not because it supposedly offered some sort of proto-Cubist morphology. A visit to the Trocadéro a year earlier or later would not have had the same effect. To the extent, therefore, that at least two of the demoiselles were influenced by ideas about tribal art prompted by Picasso's Trocadéro visit, their images open outward toward the collective implications of masking as elucidated by Claude Lévi-Strauss. Insofar, however, as those visages were in fact arrived at by Picasso's search for plastic correlatives in exorcising his private psychological demons, they constitute, as I suggested above

in my Introduction (p. 13), a form of visual abreaction, and lead us inward to the other, Freudian sense of masking, in which emotions too painful to confront directly (here the artist's conflicted feelings triggered by the inherent savagery of sex and fear of death) are dealt with by substituting "cover" images.

Although the magical, exorcistic roots of art constituted the central feature of Picasso's Trocadéro "revelation," there is another aspect of the reworked, so-called "African" figures on the right of the *Demoiselles* that leads me to relate them to his visit there—and that is, paradoxically, their "Oceanic" coloring. (African objects are most frequently unpainted and when colored tend to be muted in hue—except for the folkloristic palette of the Yoruba. This is consistent with their fundamentally sculptural plasticity, as against the essentially pictorial character of most Oceanic sculpture.) While the tactility and morphology of the upper right-hand demoiselle's mask-like face is clearly, if only elliptically, reminiscent of Africa, the highly saturated colors of *both* right-hand demoiselles, juxtaposed in brash—even brutal—combinations, strongly suggest the raw and often grating juxtapositions of orange, blue, white, and yellow in many Oceanic objects. These color combinations are not, however, found in objects from Tahiti, the Marquesas, or New Caledonia—which Parisian artists *could* have acquired in 1906–07—but in objects from other Melanesian areas such as the New Hebrides (a joint British-French protectorate) and New Guinea, whence a number of such intensely colored pieces had entered the Trocadéro in the nineteenth century, despite the fact that comparable pieces remained commercially unavailable in France.[266] Impetus for sudden stylistic change is often associated in Picasso with seeing a challenging, unfamiliar art that speaks directly to his thinking and feeling at the moment. Given the sudden rupture in his development represented by the right-hand figures of the *Demoiselles*, whose color is unprecedented in Picasso's (or any other Western) art, a trigger can readily be assumed—and there is no better candidate for this than the Trocadéro visit, which the artist himself called a "shock" and a "revelation."

The unprecedented *brut* or raw coloring and the slashing painterly attack of the right side of the *Demoiselles* (and studies related to it) have sometimes been wrongly associated with Fauvism. But the latter style remained throughout its development essentially decorative in its color harmonies, which were consistently anchored to the triad of the primary hues. Moreover, the manner in which this color was applied—even at its most "wild" (as in Vlaminck, for example)—was a far cry from the slashing boldness, the almost bodily physicality, of some brushwork in the *Demoiselles*, certain of its oil studies, and succeeding pictures. Picasso's "attack" in 1907 more closely adumbrates Pollock's of 1942–46, and de Kooning's after 1945, than do the Fauvists (or German Expressionists). Both New York painters affirmed their debt to Picasso, and the work that most visibly influenced them—even more than *Guernica*—was the *Demoiselles*.

Picasso's new color schemes in the repainted sections cannot be associated with Gauguin's decorative palette, nor with the more Expressionist chromatics of Brücke painters such as Emil Nolde and Ernst-Ludwig Kirchner, whose characteristic color gamuts in any case postdate the *Demoiselles* by more than a year (though it is probable that a certain rawness in *their* color too was inspired by South Seas sources). The Expressionists favored remote tertiary and quaternary hues, while Picasso's robust new "primitive" coloring of 1907 stays closer to the primaries and secondaries. Yet the

206. Mask (detail). Oba, Vanuatu (formerly the New Hebrides). Painted tree bark and fiber, 33½ x 9" (85 x 23 x 25 cm). Musée de l'Homme, Paris. Acquired 1894

particular oranges, blues, reds, yellow, and whites he used in the *Demoiselles* and related studies are utterly unlike those of the Fauve painters. Not only are they more saturated, but the chromatic intervals separating adjoining colors have a brutal dissonance that is entirely antidecorative.

There is no model for this palette in Western art. But it was to be seen in some of the Oceanic art in the Trocadéro collection at the time of Picasso's visit. Nor was Picasso's interest in Oceanic art limited to color.[267] The New Hebrides mask illustrated here (fig. 206), for example, is made up of raw oranges, blues, and whites close to those of the *Demoiselles*, while its exaggerated nose and grimacing "caricatural" grin—though far from having been imitated by Picasso—accord with a kind of "horrific" expressionism he initiated. It was this Picassoesque expressionism (which he would himself revive intermittently beginning in 1925) rather than German Expressionism (as was often mistakenly assumed) that would lead directly to the grimacing "smile" on the face of de Kooning's *Woman I*.

THE HEAD OF THE "CURTAIN-PARTER"

The head of the standing demoiselle on the right is the closest of the three reworked heads to the masks of the tribal peoples, and it is primarily with respect to this head that any claim to a formal or morphological influence of "art nègre" in the *Demoiselles* resides. The still more radical head of the crouching figure has an asymmetry fundamentally alien to tribal masks, and it came into being, as we shall see, as a metamor-

phosis of an already highly distorted intermediary stage of the image which was neither mask-like nor tribal in character. The head of the curtain-puller, on the left (fig. 198), insofar as it shows a frontal eye in a profile head, is a pictorial rather than a sculptural formulation and relates more to Egyptian painting and to Gauguin's pictorial paraphrases of both Egyptian painting and Oceanic subject matter than to tribal sculpture. If we go beyond the popular tendency simply to ascribe the more challenging aspects of the *Demoiselles* to "African" or tribal influences, we find that those serious arguments made for a relation of Picasso's visages to particular tribal objects—or even whole typologies of tribal objects—have unfailingly proven specious, as I have demonstrated at length elsewhere.[268] Indeed, not one of the types of masks that art historians have through the years proposed as possible models for Picasso could, in fact, have been seen in the Trocadéro or—experts insist—found on the Parisian market as early as 1907.

Despite the fact that Picasso experienced a kind of epiphany on the occasion of his visit to the Trocadéro, and became not long afterward an assiduous collector of tribal works,[269] unlike Matisse, Klee, Giacometti, Moore, and a host of other artists, he never made, so far as we know, even a single verbatim sketch of a tribal object. The bits and pieces he might find useful or stimulating from a formal point of view were so totally assimilated, so entirely fused with his own ideas that it is difficult—

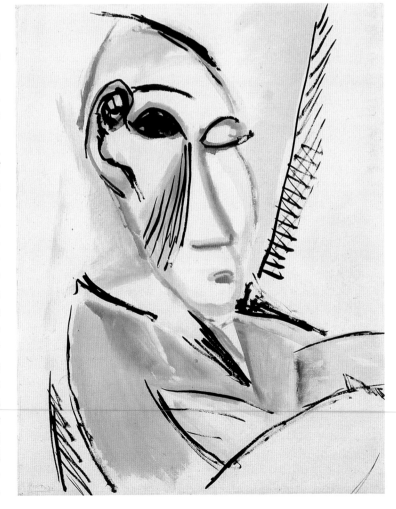

207. *Head of the Medical Student (Study for "Les Demoiselles d'Avignon").* Paris, June 1907. Gouache and watercolor on paper, 23¾ x 18½" (60.3 x 47 cm). Zervos VI, 977. Daix 44. The Museum of Modern Art, New York. A. Conger Goodyear Fund

and in most cases impossible—to identify specific inspirations or "sources." The "African" head of the standing demoiselle on the right (fig. 176) is not directly inspired by any one particular African type, but is a kind of gloss—the symmetry, suppression of the ears, and the elongated, snout-like animalistic face being generalized from a number of African typologies visible at the Trocadéro in 1907. The *front bombé,* or bulging brow, and elongated *museau,* or snout, of Picasso's woman probably come closest to some masks and *bieri* figures of the Fang people,[270] but these, however, do not have the parallel scarification markings that are sometimes suggested as the source of Picasso's striated red and green shading. In any event, this patterning, which resulted essentially from Picasso's "primitivizing" of the traditional linear shading known as hatching, had already been established in the later phases of his Iberianism. We see it—though not yet in alternating colors—in the gouache and watercolor (fig. 207) directly inspired by the carving from Cerro in Picasso's collection (fig. 19).[271] Here, in combination with the large scroll ear and the asymmetry of the eyes—both indebted to the Iberian head—Picasso uses long striations extrapolated as a graphic shorthand from linear hatching for the shadow of the nose. Although this patterning becomes conflated with recollections of African scarification markings and Oceanic color in the *Demoiselles* and Picasso's subsequent work, it can hardly be argued that such "primi-

tivist" shading was simply and solely adopted from tribal art. Is it perhaps "correct-ness" that has impelled some writers to insist on referring to the styles and mor-phologies of the three repainted demoiselles purely and simply as "African"? To be sure, this makes possible the parallel insistence that these figures carry "unavoidable" political and social "associations of white cruelty and exploitation" of black Africa.[272]

CARICATURE

Picasso's undoubted absorption of elements from African morphologies for the head of the standing demoiselle appears to me to have been suggested, however racist this may sound today, in part by their expressive appropriateness for investing his picture with what must have seemed to him an allusion to total sexual *déchaînement*—a primal physicality so enveloping and so instinctual that it overcomes the inhibitions and controls that inhere to the Western psyche, thus tending to erase the distinction between human and animal. The combination of human and animal features com-mon to many tribal masks provided Picasso with admirably expressive prototypes that served as ways of materializing at the center of his art (and thus in "high" art) an "associational" sentiment he had long explored on the margins of his work in the "low" art of erotic caricature. Take, for example, the ribald sheet of 1905 (fig. 208), where the face of the prostitute lasciviously feeding on her colleague's sex has become caricaturally distorted into an almost pig-like snout. Is it any accident that Picasso shows pigs fornicating at the bottom of the sheet? (One wonders if the standing demoiselle could not have been an inspiration for Salmon's heroine Cora—*The Black Venus* of the Sacré-Coeur—"a real savage, sister of the beast that eats and snorts after the repast of love"?)[273]

To be sure, the transmogrification of the human physiognomy was hardly a new idea. We see it notably in drawings by Leonardo, whose so-called caricatures espe-cially appealed to Picasso.[274] Picasso's association of the prostitute with a pig is, after all, a commonplace and is in the line of his frequent permutations of women and beasts. The "popular" side of the syndrome is typified by the cartoon of the simian denizens of a house of prostitution that appeared (in the very year of Picasso's draw-ing) in *L'Assiette au beurre* (fig. 209), in a special number devoted to venereal disease. (Daix notes that Picasso contributed illustrations early on[275] to this anarchist-oriented magazine, in which two texts by Salmon appeared in 1904, and Palau says that the publishers later proposed to Picasso that he provide the visual contents of an entire issue.)[276]

What separated the standing demoiselle's "African" head from caricature—apart from the sheer force of its plasticity—was the organic nature of Picasso's fusion of the human and bestial, and the absence of any "rationale" through humor for doing this. It was precisely the mordant image of the prostitute as something ani-mal[277] that would appeal to Picasso in Degas's bordello monotypes, which he could conceivably have seen, Rosenblum speculates, during the preparation of the *Demoiselles*.[278] Degas frequently contoured or silhouetted his female figures so as to create analogies with animal forms, and the attitudes of certain of his whores (figs. 210, 211) foreshadow the mantis-like women that people Picasso's paintings in the late twenties and the thirties. Whether Picasso saw these extraordinary Degas monotypes in 1907 or, as is more probable, later on, when Vollard acquired a group of them, they certainly fascinated him as prototypes of females whose aggressiveness, animality, and

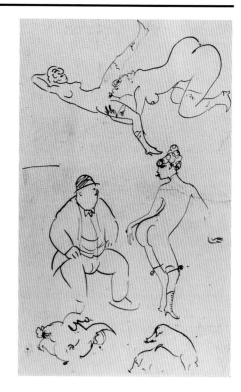

208. *Sheet of Studies*. c. 1905. Ink on paper, 17 1/8 x 10 7/8" (43.5 x 27.5 cm). Private collection

209. Anonymous. *The Best Guarantee*. Caption: "I can't say that all these ladies have their degree [*brevet supérieur*], but they all went to the Institut Pasteur." Sign on the wall: "All our ladies have been vaccinated." Drawing published in *L'Assiette au beurre* (Paris), no. 207 (March 18, 1905)

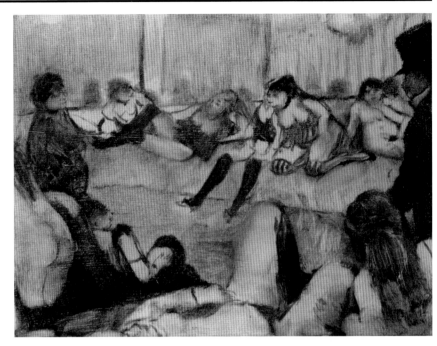

Left:
210. Edgar Degas. *Two Girls*. c. 1879. Monotype in black ink on China paper, 6¼ x 4¾" (16 x 12 cm).

Right:
211. Edgar Degas. *In the Salon*. c. 1879. Monotype in black ink, 6⅜ x 8⅜" (16.4 x 21.5 cm). Musée Picasso, Paris (RF 35785). Formerly collection Pablo Picasso

frightening ugliness went far beyond anything Western art had ever proposed before Degas. Picasso acquired eleven of these monotypes beginning in 1958 and—following a discussion about Degas and brothels with this author—they triggered a series of bordello engravings that included the surrogate figure of Degas himself (beginning in March 1970).[279]

That the revolutionary figuration of the *Demoiselles* incorporated something of the expressive exaggeration, distortion, and displacement at the heart of caricature is attested to by some of the first critics to have viewed the picture. Burgess saw Picasso's women less as borrowings from African sculpture than as "caricatures" of them.[280] The vanguard critic Félix Fénéon, later to become a noted collector of tribal art, was dumbfounded by the *Demoiselles* when he went to see it with Apollinaire in the late spring or early summer of 1907. Nevertheless, he saw something in its drawing that led him to recommend to Picasso that he "devote himself to caricature."[281] Of course, Fénéon had no idea how much caricatural drawing Picasso had already done, nor how much these caricatures anticipated certain plastic liberties (as in the monstrous metamorphic death's-head of fig. 94 or the displacement of sexual parts in fig. 224) that would become fundamental to much of Picasso's work from that point on. Picasso would later remark to Penrose that Fénéon's advice "was not so dumb, because all good portraits are, in a certain sense, caricatures."[282] If we extrapolate Picasso's *aperçu* into "all expressive representation requires something of the selectiveness and distortion of caricature," we understand the how and why of its contribution to Picasso's new way of drawing. But it remains a contribution. What made Picasso's serious drawing of 1907 great is precisely what separates it from real caricature.

We have seen that a schematic, simplified kind of drawing was present among the earliest sketches for the *Demoiselles*, as in the head of the medical student (fig. 57) with its associations of self-portraiture, and that this differed from true caricature, among other ways, in not aiming at humor or parody. We are fortunate in having an excellent index to the contribution of caricature to Picasso's drawing in a series of

images that date around the time of the changes in style associated with the "second campaign" of work on the *Demoiselles*[283]—namely, the portrait of the painting's first critic admirer, André Salmon. It is not by chance, I think, that the caricatural yet magisterial portrait (fig. 215) of the first writer to speak of Picasso's debt to "les enchanteurs océaniens et africains" should be on the reverse of a sheet in which we have one of the artist's earliest images of his own hand functioning with the thaumaturgic power of the shaman (fig. 212).[284] The metamorphoses that the image of Salmon—"imperturbable evangelist of primitivism"[285]—would undergo in subsequent sheets of drawings (fig. 217) confirm that writer's recollection that his portrait "was a preparatory study for a small wood sculpture."[286] The final sketches for this (fig. 219) show Salmon as "the primitivist primitivized."

The caricatural drawing of Salmon (fig. 215) that is the starting point of this series of images shows him holding a book (like something of a stand-in for Picasso's medical student/self-portrait in the early studies for the *Demoiselles*) and a pipe, his head turned in three-quarter view so as to better expose his long nose and prominent jaw. In one extraordinary sheet (fig. 217)—"the art-historical equivalent," as Adam Gopnik observes, "of the intermediate fossil which is the dream and despair of the paleontologist"—the caricature of Salmon is "caught forever in transition from caricature to primitivized image, caught in transit between *Charivari* and the Congo."[287] As usual, Picasso considers his figure from the back and the side as well as front. The hatched shading of the caricature becomes the "fishbone" pattern of Salmon's spine, and points in the direction of primitivist scarification. The wave of Salmon's hair is simplified into a jutting crest which, given the elongation of both the cranium and the face, creates something like a Pharaonic profile. This crest would drop down, as Picasso proceeded, to become a jutting brow. Add this brow, and Salmon's lantern jaw and generous nose, to the protruding cheekbones of a face that had obsessed Picasso since Gósol—that of the innkeeper, old Josep Fontdevila, whose image is present in the *Demoiselles* sketchbooks as well (figs. 213, 214)—and we have a classic example of another typical Picasso syndrome, that of conflation. The wooden sculpture, sketched definitively in fig. 219, was to have been an amalgamation of Salmon and "the old man of Gósol,"[288] the two male faces that dominate the beginning and end of the almost year-long period of the gestation and execution of the *Demoiselles*.

As Gopnik points out in his brilliant study of caricature, the affinities between Picasso's caricatures and his primitivist and Cubist figuration are easier to grasp when we realize that, as studies in perception have recently demonstrated:

> [C]aricature's external forms in some way mirror the internal structure of our mental representations, the idealized and schematized internal imagery that our minds use to "presort" and structure perception. The "mind's eye" … in effect sees caricatures, not portraits.… Our conceptual system knows *that* it uses exaggerations, simplifications, and generalizations to encode our knowledge of appearances, and can recognize these deviations when confronted with a cartoon or caricature.[289]

Not surprisingly, we discover that the "low art" of Picasso's caricatures started fusing with his "high art" precisely when his primitivism began: with the repainting of Gertrude Stein's face in the Iberian manner on his return from Gósol. Gopnik further observes:

212. *Sheet of Studies* (verso of fig. 215). 1907. Charcoal on paper, 33⅝ x 15¾" (60 x 40 cm). Private collection

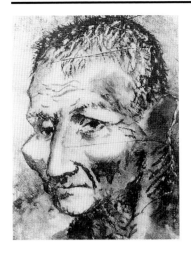

213

214

215

216

217

218

219

213. *Head of a Man: Josep Fontdevila* (detail). Gósol, summer 1906. Watercolor and gouache on paper, 16 x 13¾" (40.7 x 35 cm). Zervos I, 346. D./B. XV, 52. Private collection

214. *Josep Fontdevila Nude.* Gósol, summer 1906. India ink on paper, 18⅞ x 12⅜" (48 x 31.5 cm). Formerly estate of the artist, no. 877R

215. *Portrait of André Salmon.* 1907. Charcoal on paper, 23⅝ x 15¾" (60 x 40 cm). Private collection

216. Detail of a photograph of André Salmon published as the frontispiece to his *Propos d'atelier* (1922)

217. *Sheet of Studies for "Portrait of André Salmon."* 1907. India ink on paper, 12⅞ x 15¾" (32.5 x 40 cm). Zervos XXVI, 179. Private collection

218. *Caricature of André Salmon.* 1905. Black lead on cardboard, 4⅛ x 28⅜" (10.4 x 7.2 cm). Private collection

219. *Portrait of André Salmon* (final state). 1907. India ink on paper, 24¼ x 19⅞" (63 x 48 cm). Zervos XXVI, 284. Private collection

A likeness [the Stein portrait] that began … in the grand manner, is transformed through the use of primitive forms into a study in physiognomic identification through distortion. Even the particular forms Picasso selects from the vocabulary of Iberian art—the over-sized eyes, the magnified and thrust-out brows—are precisely those physiognomic features which any "how-to" book still encourages the beginning caricaturist to emphasize. What Picasso has done is to invent a kind of creole, a language which assimilates an alien vocabulary to a familiar syntax.… *The move from low to high, the victory of the note-book over the easel, is accomplished through the Trojan horse of primitivism.*[290]

THE HEAD OF THE CROUCHING DEMOISELLE

By far the most challenging motif in the *Demoiselles* is the head of the squatting whore, which, following many mutations in the early notebooks, underwent a more extensive metamorphosis in the actual working drawings and on the canvas than any other passage in the picture. In its final form, this figure's head directly faces the view-er and is held by a boomerang-like hand attached to an impossibly twisted arm.[291] But it is clear from the squatter's buttocks, which have been left in their original Iberian position (i.e., shown from behind), and her left breast (still seen only frag-mentarily through her armpit), that the torso was drawn as seen from behind (its sil-houette suggesting less front/back ambiguity than many of the studies). Picasso could easily have changed all this, completing the rotation of the body by adding indica-tions of frontal breasts and a *mons veneris*. As he did not, we must accept that he ful-ly willed the resultant anatomical incongruity. Indeed, such changes would have meant eliminating the painting's greatest violence—the aggressive, wrenching, 180-degree turn of the squatter's head, whereby Picasso wrings the whore's neck like a chicken's. The agonizing torsion of this last motif is further exacerbated by the turn-ing of the axe-blade nose and the manner in which the figure's left eye has horrify-ingly popped from its socket.

The radiograph of the crouching whore's head (fig. 220), aside from revealing some fragments of the Iberian version, also shows bits and pieces of contours from at least one intermediate state. The fragments of those two now overpainted heads (Iberian and intermediate) have been identified in red and green respectively in the overlay of the radiograph by the Museum's former conservator, Albert Albano (fig. 221). He notes that Picasso appears to have reemployed some contours and features from the early states in his successive changes. "As a result of some of these features being shared, we can see only two sets of eyes, for example, because their position and form could serve two faces with only minor alteration."[292]

The earliest suggestion of the intermediate head can be seen in the same work-ing drawing on the verso of page 15 of Carnet 14 (fig. 178) that contained the first inti-mations of the change in the head of her standing neighbor. Here the squatter's head, almost—but not yet fully—frontal, is supported by the arm and hand, but on a tilt more reminiscent of its position in the small, lost, seven-figure oil (fig. 170) than as it would subsequently develop. The somewhat awkward study of the squatter by her-self, made just before or after, on the recto of page 16 (fig. 179), tells little more, except to make clear that—in contrast to the left profile noses of the two central maidens— the nose of the squatter would be in profile to the right.

The details of the squatter's intermediate head become clearer in two drawings (figs. 182, 183) from a carnet published by Zervos, recently rediscovered in a private

collection, and first recognized as heads of the squatter by John Nash.[293] These make evident a new twist, so to say: an unusual elongation of the mouth and chin, which together shift left now to set off the rightward movement of the nose in a kind of facial contrapposto.[294] The definitive study of this intermediate head is the gouache and India ink drawing (fig. 184), which shows the axis of the face still turned slightly away from the picture plane. The contour of this face's foreshortened right eye, mouth, and chin can clearly be made out in the radiograph. As the style of the head in this gouache study is very close to that of fig. 207, especially as regards the shading, and as its color is not yet saturated or strident, it is very likely that this was the intermediate head that Picasso painted onto his canvas prior to reworking—into its present form—the more violent "African" head of the standing figure above it.

Only two studies appear to intervene between the intermediate head and the execution of the definitive, ferociously contorted one, with which Picasso overpainted it. The first of these studies is the powerful sketch (fig. 185), which was a late insertion in Carnet 3. This drawing points to most of the essentials of the more elaborate but somewhat less taut oil study that succeeded it, namely the narrow full-scale panel (fig. 186). The latter is one of the first examples of the saturated, strident color that erupts into Picasso's work during the period of his alterations on the large canvas. Though the yellow in this head is less saturated than the orange of the definitive one, the palette of this study is more raw and brutal than anything visible in earlier Western art, and marks a total break with Picasso's Iberian manner.

Four important changes that distinguish the squatter's head in the final painting are confirmed in this oil study. As in the drawing in Carnet 3, the nose—now more of an axe-blade curve than before—swings to the whore's right rather than to her left; the head is so fully frontal that, as in the drawing, the demoiselle's right ear has become visible; the contour of the right jowl descends straight down, eliminating the angular displacement of the chin that had been characteristic of the inter-

Left:
220. Radiograph of the head of the crouching demoiselle, 1987

Center:
221. Radiograph and schematic tracing of the head of the crouching demoiselle, 1987

Right:
222. Recomposed radiograph of the head of the crouching demoiselle, 1987

mediate version; and perhaps most dramatic of all, the torsion of the head and consequent asymmetry of the face are enhanced by the derangement of the contrastingly colored eyes. The figure's blue left eye, more skewed than in the drawing, drops well below the eyebrow and tilts at a forty-five-degree angle. Finally, this oil study shows us the squatter's new coiffure—only vaguely suggested in the drawing—which is characterized by a bun or knot atop the head.

All these decisions are refined in the final painting. The face gains power through greater width, and its light and shadow are no longer expressed through yellow and blue but by the maximally saturated complementaries of orange and blue. These changes, together with the axe-like hatching of the shadow patterns, heighten the effect of indescribable violence and monstrousness in this head. Our eyes have gotten somewhat accustomed over the years to the violence of de Kooning's and Dubuffet's women, but the awe produced by this crouching figure remains undiminished. Next to it, de Kooning's *Women* seem sympathetic.

Some of the earliest witnesses to the *Demoiselles* caught this frightening dimension of the picture, which was later on largely forgotten as the Kahnweiler/Barr formalist view took hold. Salmon spoke of "the hideousness of the faces"; of "an image of the human being ... that inspires in us a sort of fright"; of "fearful and grimacing nudes worthy of being held in abomination"; and he tells us that "the ugliness of [Picasso's] faces ... unleashed universal anger."[295] A few months later Alice Toklas saw the *Demoiselles* side by side with the first ("African") version of *Three Women*. She considered it (in Gertrude Stein's words) as something "oppressive but imprisoned."[296] Both these adjectives have a certain relevance to Picasso's bordello. And Toklas would have more clearly apprehended the "something oppressive" if she had been privy to such 1903 Picasso drawings as fig. 223. Some six months later, the sophisticated watercolorist/cartoonist Burgess visited Picasso's studio and was taken with the artist, in whom he recognized a kind of demonic genius "colossal in his audacity." Nevertheless, even for him, Picasso's women are "monstrous," "ogresses," "abominable," and "they outrage nature"; they are "frightful," "appalling," and provoke "nightmares" and "profanities."[297]

Such deeply emotional, subjective reactions to the *Demoiselles* are not seen again until 1972, when Steinberg redirects attention to the psychodrama of sexuality that was obviously central for Picasso himself. And it is precisely because of the importance of Steinberg's accomplishment that one feels faintly embarrassed in raising the question of whether, in fact, he went far enough, inasmuch as Steinberg's essentially Dionysian reading of the picture sidestepped some of the implications suggested by the words of Salmon, Stein, and Burgess. While Steinberg's orgiastic reading of the "trauma" of Picasso's sexuality makes room for "savagery," "aggression," and (very marginally) "danger," it has no place for monstrousness, horror, disease, or death. And though Steinberg distinguishes in many important ways between each of Picasso's five whores, he nevertheless views all of them as objects of erotic play—which the squatter and the curtain-puller, in my opinion, surely are not. One wonders, for example, whether such words of Steinberg's as "strumpets" and "doxies" satisfactorily characterize the three reworked figures; or whether Steinberg really closes in on the nature of the terrifying crouching figure by calling her a "trollop."[298]

In 1983, when I suggested emending Steinberg's epochal interpretation so as to cast the picture's psychodrama less as a paean to Eros than as an *agon* between Eros

and Thanatos,[299] I felt that the head of the squatting whore embodied for Picasso everything about women that roused his hate, fear, anger, and disgust. I had concluded that the artist meant this particular visage also to subsume associations with disfiguring sexual disease and with death. At that time, I was unaware of a fascinating and not unrelated reading of the squatter by Nash, whose unpublished radio lecture of 1970 had characterized her head as Medusa—a "gorgon" who turns her "petrifying stare" on the viewer. Medusa had once been beautiful, Nash observed, but because she broke a taboo in having sexual intercourse in one of Athena's temples, she was turned into a hideous monster. The mirror, which was the only means by which Perseus could look upon Medusa without dying, becomes the relevant metaphor for the squatter's head, insofar as Nash wonders aloud whether it was not precisely Picasso's own savage aggressiveness toward women that entailed "a profound fear of a comparable aggressiveness in the female."[300]

223. *Phallic Domination*. 1903. Ink and colored pencils on trade card, 5 ⅛ x 3 ⅝" (13 x 9 cm). Private collection

Nash had also noticed that at least one of the two studies for the intermediate form of the crouching whore's head (fig. 182) had been in part derived from a study of a back over which it was drawn;[301] the other version of the head (fig. 183), Nash implied, could even be read as a kind of torso-face. This sexual emblem is then put to its logical expressive end when Picasso puts it directly over the loins of the standing whore. As we, the viewers, have replaced the sailor—to whom she originally exhibited her sex—as the object of the crouching figure's attention, we now become the focus of the Medusa-headed whore's "obscene display." This displacement is consistent, as Nash observes, with Freud's view of Medusa, whose head he considered a symbol for female genitalia. "What a powerful and terrible metaphor for the genitals the [croucher's] mask is," Nash asserts. "A figleaf far more revealing than a representation of the mere organs could ever have been."[302] More recently, Yve-Alain Bois has reemphasized the Medusa image in its relation to Freud's "castration complex," which Bois considers as being even more deeply related to Picasso's anxieties in the *Demoiselles* than the fear associated with a mortal disease.[303]

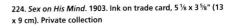

224. *Sex on His Mind*. 1903. Ink on trade card, 5 ⅛ x 3 ⅝" (13 x 9 cm). Private collection

Whether or not the drawing of what Nash takes to be a torso (fig. 182) played an essential role in the integration of the croucher's intermediate head, the principle of metaphorical displacement invoked here by Nash is entirely consistent with Picasso's way of associating forms. An early erotic drawing (fig. 224) shows such a sexual displacement in a prosaic though whimsical manner; the woman's vagina is literally on her bald client's mind. Picasso's painting and sculpture of the twenties and thirties particularly is replete with "genital heads," often having—as in the case of the croucher's mask—suggestions of both male and female sexuality. During the Surrealist period, this "double reading" of the face as genitalia became a commonplace, and one of the Surrealist glosses of the suite of Picassoid heads that begins with the squatter and goes on to those of *The Dance* of 1925 and the *Seated Bather* of 1930 is the female face reimagined as the *vagina dentata*.[304]

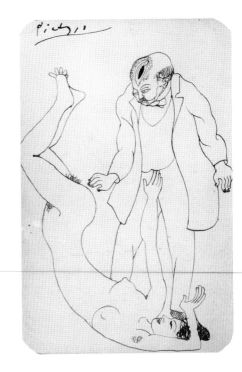

Where does Africa (or any other tribal source) fit morphologically into this crouching figure's head? Nowhere, I am now convinced, especially as we can follow its autonomous step-by-step genesis in the studies and X-rays. Yet nearly every historian willing to admit tribal influences in the *Demoiselles* at all has seen the squatter's head as the epitome of "African" influence. Some have even suggested particular sources, such as the stylized, contorted masks of the Songye people.[305] But apart from the fact that such masks were not visible in France prior to World War I, they are,

like virtually all other tribal art, consistently symmetrical in character, whereas the croucher's head is nothing if not asymmetrical. Comparable asymmetry is seen only very marginally in primitive art: in certain Eskimo masks of a type unknown in Paris early in the century, and in the so-called "sickness masks" made by two African peoples,[306] the very earliest example of which to come to France seems to have arrived during World War I.[307]

During the five years I studied the latter masks in museums and private collections where they could be found, I saw only one, buried in a drawer of the reserves of the Royal Museum of Central Africa in Tervuren, Belgium (fig. 225), that provided a close analogy to the squatter's face. Ironically, this was a mask that was almost certainly carved after the *Demoiselles* was painted (though its carver did not, of course, know Picasso's art any more than Picasso knew the carver's).[308] If the resemblance between such a "sickness mask" and the crouching whore's face tells us anything—and I think it does—it is that there was probably some commonality in the inspiration of the distortions both artists used. As Picasso plumbed his unconscious and searched his memory for the most terrifying faces he had ever seen, he certainly must have recalled the ravaged and distorted heads of some congenital syphilitics he had seen in Saint-Lazare. Such syphilitics are, in fact, the *models* for the Pende masks in question (as well as a large portion of other so-called sickness masks).

The distorted axe-blade features of the crouching demoiselle were arrived at intuitionally through an extended incremental metamorphosis of Picasso's drawings for her face. And while these drawings in no way indicate the intervention of African or any other masks, the freedom and inventiveness of tribal art in general probably sanctioned for Picasso the extremes of his liberties. The African artist who carved the mask reproduced here arrived at its formulation by adding an increment of personal inspiration to a Pende stylistic language that traditionally emphasized sharp, abstract curves. That Pende style, however, was public, collective, traditional. Picasso's point of departure had been his *own* vanguard style. And his solution—which opened an enormous space between this demoiselle's head and the syntax of anything he or anyone else had ever done before—constituted both a singular and a private act.

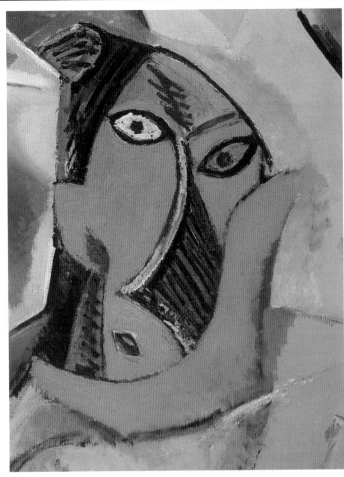

225. Mbuya (sickness) mask. Pende. Zaire. Painted wood, fibers, and fabric, 10 ½ x 8 ⅞ x 10 ⅜" (26.6 x 22.4 x 26.5 cm). Musée Royal de l'Afrique Centrale, Tervuren, Belgium

226. Detail of *Les Demoiselles d'Avignon*, head of squatter (as in fig. 201)

Notes to the Text

This first appearance in English of a monograph written for the Musée Picasso, Paris, in the summer of 1987 has been somewhat revised, mostly in the notes, in order to draw the reader's attention to material published since the initial writing. Due to the paucity of literature available in French in 1987, those passages reviewing early art-historical texts (see pp. 19 ff.) on the *Demoiselles* (including some of my own) are perhaps fuller than I might have made them had the manuscript been directed toward an English-speaking audience. As deleting these passages would now disrupt the continuity of the argument, I can only hope that present readers will find them useful as a review.

In writing this text, and many others published during my quarter century at The Museum of Modern Art, I have been deeply indebted to Judith Cousins, Curator for Documentation and Research in the Department of Painting and Sculpture, for her generous help. Her passionate and unending searches through publications and archival sources of all kinds, relentlessly tracking down ideas, angles, or leads suggested to her—to say nothing of her own often inspired hunches—and even more, the dialogue between us to which this research has given rise, have made her an invaluable colleague with whom it is an honor to have been associated.

1. By the time Picasso began painting the *Demoiselles*, he was familiar not only with Fauve works of the two preceding years, but also with Matisse's *Le Bonheur de vivre* (autumn–winter 1905–06; fig. 10) and *Blue Nude: Memory of Biskra* (January–February 1907; fig. 11). The latter was shown in the Salon des Indépendants in March 1907, while Picasso was at work on his picture, but Picasso probably saw it in one of his visits to Matisse's Paris studio between the time when *Blue Nude* was brought back from Collioure to Paris (February 27 or 28, 1907) and when it went on view at the Indépendants on March 20. Picasso had also visited the studio of Derain where, among other things, he doubtless saw the *Bathers* (fig. 12), which, in any case, was also exhibited in the 1907 Indépendants.

2. The censure of the *Demoiselles* by Picasso's friends was recapitulated by Roland Penrose in his biography of the artist (*Picasso: His Life and Work* [London: Victor Gollancz, 1958], pp. 125–26): "Among the surprised visitors [Picasso] could hear Leo Stein and Matisse discussing [the *Demoiselles*] together. The only explanation they could find amid their guffaws was that he was trying to create a fourth dimension. In reality, Matisse was angry. His immediate reaction was that the picture was an outrage, an attempt to ridicule the modern movement. He vowed he would find some means to 'sink' Picasso and make him sorry for his audacious hoax. Even Georges Braque … was no more appreciative"; the Russian collector Sergei Shchukin exclaimed in sorrow, "What a loss to French art!"; Apollinaire "watched the revolution that was going on not only in the great painting but also in Picasso himself, with consternation." Derain—no doubt in a reference to the failed hero of Balzac's *Chef-d'oeuvre inconnu*, Frenhofer, who sanctions his failure with death and the destruction of his canvases (he commits suicide in the night after burning his canvases)—remarked to his new friend Kahnweiler, "One fine morning we shall find Picasso has hanged himself behind his great canvas" (see the section devoted to Kahnweiler in the Anthology, pp. 234 ff.). For earlier accounts of the disapproval of Picasso's friends, see the texts by Fernande Olivier—whose remarks have been associated with the *Demoiselles* even though she never referred directly to the picture.

3. We cannot precisely date any of the phases of Picasso's work on the *Demoiselles*, and the meager chronological documentation that exists is often contradictory. Even when not, it is open to conflicting interpretations (see the commentary by Hélène Seckel on the testimony of eyewitnesses printed in the Anthology, below, pp. 226 ff.). I have opted for a chronology essentially similar to that proposed by Pierre Daix in the French edition of the *Demoiselles* catalogue (Pierre Daix, "L'Historique des *Demoiselles d'Avignon* révisé à l'aide des carnets de Picasso," in Hélène Seckel, ed., *Les Demoiselles d'Avignon* [Paris: Réunion des Musées Nationaux, 1988]). I believe the first ensemble sketches were made in the winter of 1906–07, probably toward the very beginning of the year, and that Picasso worked into the summer on the large canvas. What may have been the last of his alterations, the repainting of the head of the left-hand demoiselle (see p. 94), was almost certainly completed by the late summer of 1907, although it has been unconvincingly argued (see below, pp. 94–95 and note 224) that the picture was completed later.

4. While this sentence makes clear, to my mind, that the *Demoiselles* involves an implicit critique of "the nature and conventions of life" and, more centrally, a critique of a more purely autobiographical nature (see below, pp. 59–60 and note 181), I have specifically avoided any suggestion that Picasso painted the picture as an act of focused social criticism. This has, nevertheless, been the burden of some recent interpretation. Among the significant scholarly texts concerning the *Demoiselles* to have appeared since this monograph was first published is Patricia Leighten's "The White Peril and *L'Art Nègre*: Picasso, Primitivism, and Anticolonialism" (*The Art Bulletin* [New York], vol. 72, no. 4 [December 1990], pp. 609–30), which argues that, for Picasso, the absorption and use of so-called primitive art in the *Demoiselles* was "as much an act of social criticism as a search for a new art."

This equating of the importance of social criticism with that of the search for new means of expression in Picasso's art seems to me extremely misleading, certainly as regards Picasso in 1907. However well-intentioned, it not only directs us away from the picture itself, and from what Picasso—as well as the virtual totality of scholarship—has had to say about it, but leads to such misguided constructions as a Picasso purportedly in deep sympathy with the plight of prostitutes: "The alliance of Africa … and these prostitutes, in Picasso's oeuvre among the most cruelly exploited and spiritually damaged in European society," Leighten writes, "indicts not only the old artistic order but also the old political and moral order as well. The overlay of African masks—evocative of economic exploitation and forced labor [*sic*]—on white female 'slaves' is strongly reminiscent of the strategy of anarchist critique-by-inversion so familiar in the work of Jarry, Picasso, Kupka, and van Dongen. By 'masking' his figures, Picasso identifies an exploited group external to Western society [African forced laborers] with one of the most exploited groups within it…."

Had Picasso aimed to communicate such a social or political critique, he would hardly have invented for the *Demoiselles* an artistic language so personal and so arcane that neither close friends nor other vanguard painters could understand it. Nor would he have painted a work which, when first shown publicly, almost a decade later, was not even recognized as a bordello scene. He would surely have made a quite legible painting in the more sentimental manner he had used until then. In contrast to such clearly political pictures as the willfully banal *Massacre in Korea* of 1951 (Zervos XV, 173), which is easily read, the *Demoiselles* is a private work—probably the artist's most private (and problematic)—and he always treated it that way. No doubt, like other great and challenging masterpieces, it has implications for social criticism. But these are certainly secondary to issues of individual feeling and self-discovery, and any attempt to particularize them depends upon a highly speculative kind of historical/contextual *hineinlesen* that risks telling more about our own agendas than Picasso's. A Picasso who sympathized with the plight of prostitutes would be admirable, but would no longer be Picasso, who was in every sense, good as well as bad, an exploiter.

If, indeed, we are going to abstract Picasso from his turn-of-the-century context, and press for a social critique in the *Demoiselles* according to our contemporary values—especially those of the prevailing Marxist and feminist-based art history—it seems to me inevitable that we will find Picasso wanting. This is precisely the position of Hal Foster ("The 'Primitive' Unconscious of Modern Art," *October*, no. 34 [Autumn 1985], pp. 45–70), who "wonders if [the] aesthetic breakthrough [of the *Demoiselles*] is not also a breakdown, psychologically regressive, politically reactionary…. Figured here, to be sure, are both fear and desire of the other, but is it not desire for mastery and fear of its frustration?" Picasso, Foster concludes, "conveys the shock of [his] encounter [with the other] as well as the euphoria of his solution, an extraordinary psychoaesthetic move by which otherness was used to ward away others (woman, death, the primitive) and by which, finally, a crisis in phallocentric culture was turned into one of its greatest monuments."

5. Fauvism, the last vanguard movement previous to Picasso's undertaking of the *Demoiselles*,

appears to me to have represented essentially a consolidation and elaboration of late nineteenth-century conceptions of picture-making—Neo-Impressionism and Synthetism particularly. Aside from Picasso's radical departures of 1907–09 (and with them, Braque's contributions to the language of Cubism), only Matisse's post-Fauve painting, which began in 1907, was to provide a major alternative solution to the impasse of the century's opening decade.

6. It is not possible to specify the precise number of studies Picasso made for the *Demoiselles*, due to the way in which his various projects grow into and out of one another. *Nude with Drapery* (fig. 2), for example, developed out of the artist's studies for the seated demoiselle; thus there are a number of drawings and paintings that might be characterized either as variants of the seated demoiselle *or* as preparations for *Nude with Drapery*. By the same token, there are studies for nudes dating from late 1906 in postures used early the following year by Picasso in his first ensemble studies for the *Demoiselles*—drawings that were probably executed even before the artist began mentally planning his large bordello picture. One can say with certainty, nevertheless, that there are at least some four to five hundred studies in all mediums *associated* in one way or another with the genesis and execution of the *Demoiselles*.

7. For remarks on Picasso's possible brush with venereal disease, see below, pp. 57–58.

8. Letter to Gertrude Stein, dated September 2, 1907, signed "Fernande Belval[l]é."

In three successive letters written to Gertrude Stein in September 1907 (the letter cited here, the other two dated the 16th and 19th respectively—all in the Collection of American Literature, The Beinecke Rare Book and Manuscript Library, Yale University, New Haven, Connecticut), Fernande signed herself "Fernande Belvallé," as if, perhaps, to emphasize her dissociation from Picasso as a result of their breakup. See the Chronology, under these dates.

In fact, "Fernande Olivier" was not, any more than was "Fernande Belvallé," her real name. We are indebted to Gilbert Krill, her godson, for providing us (in conversation and written communications, October 1987) with biographical facts helping to dispel some of the underlying confusion in conflicting accounts of Fernande Olivier's early years, such as those by Pierre Cabanne, Josep Palau i Fabre, and Pierre Daix:

Cabanne (in *Pablo Picasso: His Life and Times* [New York: William Morrow, 1977], translated from *Le Siècle de Picasso* [Paris: Denoël, 1975], pp. 92–94) identifies Fernande as "born Fernande Bellevallée [an obvious Gallicization of 'Schoenfeld'] … to a family of Jewish craftsmen…. She claimed to be the ex-wife of an obscure sculptor named Olivier, but in fact her husband was a shop clerk named Paul-Émile Percheron, who married her on August 8, 1889, five months after the birth of their son, never again heard of. Dead? Put out for nursing? We do not know."

Palau i Fabre (in *Picasso: The Early Years, 1881–1907* [1980; New York: Rizzoli, 1981], pp. 372, 380–81, 417, 436) believes the date of Picasso and Fernande's encounter to have been "probably on 4th August [1904]"—Fernande being at the time the "young wife" of a sculptor named Gaston de Labaume—and that "over a year had passed [before] she and Picasso were able to live together. Fernande had to comply with certain formalities on account of her married state and so, though their relations were frequent, they were not altogether uninterrupted either." When asked by Palau why Fernande did not accompany him to Holland in the summer of 1905, Picasso replied that "Fernande at that time was a married woman, who had certain obligations." Picasso himself wrote for Palau the name of her husband: Gaston de Labaume. (Picasso was wrong here.) "On hearing this," Palau continues, "I finally realized why Picasso and Fernande had not lived together as man and wife until a fairly long time after their first meeting." Palau then concludes, incorrectly, that the moment Fernande began to live with Picasso "must have been very shortly before the departure for Gósol."

Daix (in *Picasso créateur: La Vie intime et l'oeuvre* [Paris: Seuil, 1987], pp. 51, 53, 397, note 5—recently published in a revised and augmented form in an unworthy English translation as *Picasso: Life and Art* [New York: HarperCollins, 1993]) writes: "Fernande, who also lived in the Bateau-Lavoir, met [Picasso] in the summer of 1904 and shared his existence in earnest toward the end of the year 1905…. In the summer of 1905 she did not accompany Picasso to Holland and really moved into his place only at the end of the year. If, as she says, she made at seventeen an 'unhappy marriage'—Pierre Cabanne has rediscovered that she had married a shop clerk named Percheron; after having given him five months earlier a son, since vanished—she then bore the name of a sculptor, Gaston de La Baume. It's under the name of Mme de La Baume that she lived in one of the studios of the Bateau-lavoir. And her comportment, at least until the autumn of 1905, is that of a woman bound to diverse precautions, being on the point of divorce proceedings."

We know now through documentation provided by Krill that Fernande was born in Paris, June 6, 1881, the illegitimate child of Clara Lang; that she was given the name Amélie Lang, after her mother, and that she grew up in the care of a couple named Belvallé (her father's half-sister and her husband), who ran a shop selling artificial flowers and feathers. Forced by her aunt and uncle Belvallé into marrying a man who had seduced her—Paul Percheron, whom she married August 8, 1899—she left him following a pregnancy that resulted in the loss of her child through miscarriage in the winter of 1899–1900, an event that left her unable to bear children in the future. (Percheron brutalized her incessantly.) In the spring of 1900 she met a sculptor, whose name she gave as Laurent Debienne, and with him moved into the Bateau-Lavoir in 1901, sharing his atelier until 1905. She had begun to work as an artists' model around 1900, when she met

Debienne, at which time in all likelihood she adopted "Fernande Olivier" as a *nom de guerre*. While Fernande had met and known Picasso during 1904 (Palau i Fabre believes he moved into the Bateau-Lavoir on or soon after arriving in Paris, April 13), Sunday, September 3, 1905, marked the date of what Gilbert Krill calls "the very beginning of her life together with Pablo Picasso"—a day that coincided, as she recalled for Krill, with the inauguration of the monument to the Chevalier de la Barre situated in back of the Sacré-Coeur. She never divorced Percheron, and thus when she died, on January 29, 1966, in Neuilly, her name was registered as "Madame Percheron dite Fernande Olivier." We have so far found no traces of Laurent Debienne and only one of Gaston de la Baume, an intriguing photograph published by Ron Johnson (*The Early Sculpture of Picasso, 1901–1914* [Ph.D. dissertation, University of California, Berkeley, 1971; New York and London: Garland, 1976], fig. 34, p. 205). This is designated as "Photo of Gaston de Labaume sculpting a bust of Fernande in 1903"; Johnson regrettably does not specify the origin of the photograph or his source for establishing the identity of the sculptor).

As for "Mme de La Baume," she was no myth. But neither was she Fernande. Her name appears on the floor plan rendering of the "first level" of the Bateau-Lavoir—which includes names of various occupants of ateliers both before and after the period of Fernande and Picasso—proposed by Jeanine Warnod (in *Le Bateau-Lavoir*, [rev. ed.], Paris: Mayer, 1986], p. 8). Warnod herself observed that "All these considerably impecunious artists were constantly changing studios…. Thus, it is very difficult to know exactly who occupied an atelier at a precise date" [ibid., p. 11]). Who was she? According to Warnod, an old-time, eccentric resident of the Bateau-Lavoir. Jean-Paul Crespelle, who described the inhabitants of the Bateau-Lavoir at the time of the fire that reduced it to ashes in a matter of minutes on May 12, 1970, says: "There were still worthy artists living there among the picturesque characters that you find only in Montmartre, like Jeanne de la Baume, who nearly died in the fire, trying to save the thirty dogs and cats she kept in her studio" (*La Vie quotidienne à Montmartre au temps de Picasso, 1900–1910* [Paris: Hachette, 1978], p. 82).

For a recent account of the life of Fernande and Picasso during these early years at the Bateau-Lavoir, see John Richardson, *A Life of Picasso*, vol. 1: *1881–1906* (New York: Random House, 1991), pp. 309–25.

9. Gertrude Stein, *The Autobiography of Alice B. Toklas* (1933; New York: Vintage, 1961), p. 19. This may be a reflection of Fernande's letter to Gertrude, dated August 24, 1907, in which she writes "It is finished, our life together, for Pablo and me. We are separating forever next month" (Collection of American Literature, The Beinecke Rare Book and Manuscript Library, Yale University, New Haven, Connecticut). See the Chronology.

10. André Salmon, "Histoire anecdotique du cubisme," in *La Jeune Peinture française* (Paris: Société des Trente, 1912), p. 42.

11. Daix, *Picasso créateur*, pp. 75–76.

12. In Gertrude Stein's notebooks: written notes and comments from which she worked directly for most of her writings from 1902–1911, transcribed by Leon Katz, a sampling of which was first published in *Gertrude Stein on Picasso*, ed. Edward Burns, Afterword by Leon Katz and Edward Burns (New York: Liveright, in cooperation with The Museum of Modern Art, 1970), pp. 95–105. Stein's discernment of Picasso is "subtle and various," to quote Katz and Burns (p. 111), and she thought of him as a "Basarof" (from Turgenev's *Fathers and Sons*), and individuals of the Basarof type, "no matter how genial, possess a *sale* sexuality.... It was Gertrude's prayer that this extreme of sexuality would counterbalance his Basarofian aesthetic mysticism" (ibid.). Thus, she wrote in her notebooks: "Pablo so much dirtier than Raymond [Duncan] or Hutch[ins] Hapgood]. they cleaner[:] sexual tabby goes to weakness, dirtier goes to pathology ... dirty Bazarof. Pablo most genial Bazarof and dirtier" (ibid., p. 95).

13. Olivier, *Picasso and His Friends* (New York: Appleton-Century, 1965), p. 17: "Out of a sort of morbid jealousy [Picasso] forced me to live like a recluse." Fernande appears nude in a painting by their former neighbor Kees van Dongen that Daix ascribes to this period (see Daix, *Picasso créateur*, pp. 75, 401, note 2). The fact that Fernande was portrayed nude by van Dongen is, perhaps, not so extraordinary when one considers that she had been posing for artists since around 1900, in order to earn a living. Moreover, Fernande remembered Laurent Debienne encouraging her to pose for a painter who had asked if she would pose for him as an Eve. "'Of course!' Laurent said when I spoke to him about it. 'For an artist, a nude woman is less indecent than a woman dressed in nothing but her shirt.'" (Fernande Olivier, *Souvenirs intimes: Écrits pour Picasso* [Paris: Calmann-Lévy, 1988], p. 107). Fernande's memoirs were published posthumously by her godson, Gilbert Krill, who very kindly brought the text to our attention in manuscript form a year before publication. In these memoirs, Fernande tells us that she posed in turn for Cormon, Carolus Duran, Henner, Boldini, Rochegrosse, Roll, Mac Ewen, Deyrolles, Dubuffe: "I went to Degas's studio with Benedetta Canals, who was his model" (p. 170).

14. Daix, *Picasso créateur*, note 3, p. 401.

15. André Salmon, *La Négresse du Sacré-Coeur* (Paris: Nouvelle Revue Française, 1920); translated from the French by Slater Brown as *The Black Venus* (New York: Macaulay, 1929), pp. 32, 207. This is a *roman à clef* in which Raymonde appears under the name of Léontine, described as "a pretty girl of about thirteen [p. 32].... The girl was beautiful, of a grave and serious beauty ... a little Montmartrois Diana [p. 33] ... [a] too beautiful, too serious and too mature child [p. 34]." In his memoirs (published subsequently, under the title *Souvenirs sans fin: Deuxième époque, 1908–1920* [Paris: Gallimard, 1956], pp. 328–29), Salmon identified some of the characters in his novel: "... the painter Sorgue is Picasso. Septime Fébur, the saint of the Traînée culde-sac, is Max Jacob, of the rue Ravignan. O'Brian

is Mac Orlan. That much one sees right away. Léontine, the chaste young girl ... is far from an invented character.... The arrival of the girl I call Léontine was an actual event at the Bateau-Lavoir.... We were all very fond of Léontine...."

16. Zervos could not have gotten the name of Raymonde as the subject of these portrait studies except from Picasso himself. That Raymonde played a profoundly affective, if relatively brief, role in Picasso's life is reflected in the fact that he identified these sketches with her correct name some thirty-five years after she had disappeared into a second orphanage; Salmon, who had written about her decades earlier (see note 15, above) apparently could not remember her real name.

17. Salmon further comments on Raymonde's presence at the Bateau-Lavoir (*Souvenirs sans fin: Deuxième époque*, p. 329): "Fernande treated Léontine [Raymonde] like her own daughter. She washed her, coiffed her hair, dressed her up. She could find no ribbons that were pretty enough to tie up the child's blond hair ... but Léontine was beginning to be a nuisance, and it was Fernande's fault. She was such an attentive surrogate mother that Picasso had even to leave his studio, out of delicacy, because Fernande was having Léontine try on even finer underclothing than the poor kid had learned to make at the convent."

18. The theme of Raymonde as an inadvertent temptress appears several times in *La Négresse du Sacré-Coeur*, where Salmon has one character draw Sorgue's (Picasso's) attention to Léontine (Raymonde): "Can't you see the way she's sitting and showing everything she's got?" (p. 72). She is also mentioned as a rival to a mature woman (p. 72); it is recommended that the "poor kitten" be gotten rid of because "a person can be vicious without being wicked ..." (p. 151); "Those young animals, you know, are so vicious that they do harm innocently" (p. 155). The impression made by Raymonde on Salmon (who promoted her to a major character in his novel) suggests that her presence in the Bateau-Lavoir, which corresponded roughly to the period of the execution of the large canvas, was more likely a question of months than of weeks. Apollinaire, who apparently was away from Picasso's studio for much of Raymonde's stay, though he was with Picasso on the day she was sent away, mentions her only briefly (in his diary for April 16, 1907). For a description of her final day, see Henri Hertz, "Contribution à la figure de Max Jacob," *Europe* (Paris), no. 489 (1970), pp. 137–41. (My thanks to Hélène Seckel for bringing this text to my attention.) Theodore Reff ("Harlequins, Saltimbanques, Clowns, and Fools," *Artforum* [New York], vol. 10, no. 2 [October 1971], p. 37), Ronald Johnson ("Picasso's Parisian Family and the 'Saltimbanques,'" *Arts* [New York], vol. 51, no. 5 [January 1977], p. 94), and E. A. Carmean (*Picasso: The Saltimbanques* [Washington, D.C.: National Gallery of Art, 1980], pp. 52–53) each identified Raymonde wrongly with a young girl in some of Picasso's 1905 paintings. But we know now that she was adopted only in 1907. Jacob, though he evidently knew Raymonde well, is, as ever, discreet.

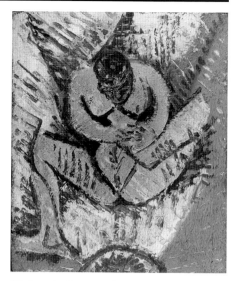

227. *Squatting Woman*. Paris, summer 1907. Oil on wood, 7 x 5⅞" (17.6 x 15 cm). ZXXVI, 262. Daix 71. Musée Picasso (MP 20)

The provocative sketch of Raymonde's pedicure (fig. 5) was used sometime later, Daix notes, as the basis for the pose of the mature nude, *Squatting Woman* (no longer Raymonde), who is in the train of the *Demoiselles* studies (fig. 227). The pedicure posture makes it possible, in this nude version of the pose, for the woman's sex to be fully visible. The sketches of Raymonde are thus demonstrably at the origins—along with drawings for *Two Women*—of that most complex and enigmatic of Picasso's demoiselles, the "gisante" (figs. 102–18), whose posture, as modified in fig. 106, has also been identified with the antique *Spinario*, or *Thorn-Puller* (Alexandra Parigoris, lecture at The Royal Academy, London, November 1988, as cited in Lomas, "A Canon of Deformity: *Les Demoiselles d'Avignon* and Physical Anthropology"). The two "prototypes" for Picasso's pose (the real-life autobiographical one and the antique) are not mutually exclusive; indeed, Picasso's "associational" method of linking such allusions leads to the maximal enrichment of his images. Nevertheless, it seems to me that the *Squatting Woman* (fig. 227) is clearly a metamorphosis of the Raymonde pedicure and, as it certainly precedes the *Seated Demoiselle* (fig. 106), which has been compared with the *Spinario*, I am forced to conclude that, in this case, the autobiographical, erotic association was more seminal for Picasso than the possible secondary reference to a classical prototype, even one with which Picasso was surely very familiar.

19. Daix, *Picasso créateur*, p. 75.

20. Félicien Davray, *Les Maisons closes* (Paris: Pygmalion, Gérard Watelet, 1980), p. 81.

21. Picasso had been studying Egyptian art at the Louvre since 1903, according to Salmon. Carnet 4, which focuses on studies for the *Demoiselles*'s central, standing figure in an intermediate incarnation, also contains exceptional studies after a particular Egyptian statue (figs. 228–31) of a striding woman, in the Louvre (related even more directly to the contemporary *Harvesters*; Zervos II¹, 2), whose archaic

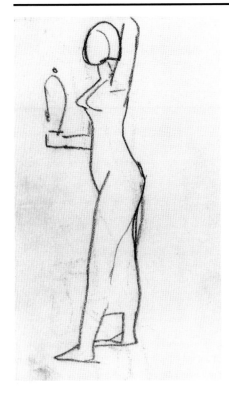

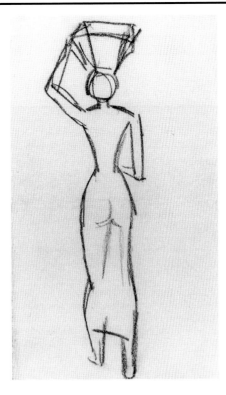

228. *Woman Carrying Offerings* (left profile): Study for *Harvesters*. Sheet inserted in Carnet 4. Paris, March–April 1907. Graphite pencil on paper, 6¼ x 3¾" (16 x 9.6 cm). Private collection

229. *Woman Carrying Offerings; Canephoros* (back): Study for *Harvesters*. Sheet inserted in Carnet 4. Paris, March–April 1907. Graphite pencil on paper, 6¼ x 3¾" (16 x 9.6 cm). Private collection

230. *Woman Carrying Offerings; Canephoros* (left profile). Egyptian; Middle Empire. Stuccoed and painted wood, 42¾" (108.5 cm) high. Musée du Louvre, Paris. Département des Antiquités Égyptiennes. Purchased 1899

231. *Woman Carrying Offerings; Canephoros* (back; see fig. 230)

rigidity of pose, frontality, and hieratic demeanor are in the same spirit as the frontal and rigidly geometrical studies for this central demoiselle. (My thanks to Mmes Letellier and Abbo, for their help in providing photographs of this Egyptian work.) These drawings are exceptional in the sense that, unlike many other modern artists, Picasso hardly ever made verbatim sketches after art objects he saw.

Picasso's interest in archaic (i.e., pre-Classic) Greek *kouroi* is suggested by such figures as *Boy Leading a Horse* of 1905–06 (see Rubin, *Picasso in the Collection of The Museum of Modern Art* [New York: The Museum of Modern Art, 1972], p. 35). Beginning in the late nineteenth century, the interest of vanguard artists in the highly stylized art of archaic court cultures constituted the early phase of a primitivism that—starting in 1907—would refocus on the sculpture of tribal societies (see this author's "Modernist Primitivism: An Introduction," in *"Primitivism" in Twentieth-Century Art: Affinity of the Tribal and the Modern*, ed. Rubin [New York: The Museum of Modern Art, 1984], pp. 2–3, 7, 10, 29–32, 74–75 (notes 10–17), 76 (note 33).

22. The full sentence, taken from Françoise Gilot and Carlton Lake (*Life with Picasso* [New York, Toronto, and London: McGraw-Hill, 1964], p. 226), runs: "At that moment I realized that this was what painting was all about." I have chosen this version of Picasso's account as coming closer to my notes of my own conversation with him (in which he covered the same ground) than does the version of André Malraux (in *La Tête d'obsidienne* [Paris: Gallimard, 1974], p. 18; translated and annotated by June Guicharnaud, with Jacques Guicharnaud, as *Picasso's Mask* [New York: Holt, Rinehart & Winston, 1976], p. 11), in which Picasso says, "I understood why I was a painter."

23. There were no historians of African art early in this century, and ethnologists did not concern themselves with the dates of tribal sculpture, which were looked upon, in any case, only as artifacts. Among the earliest critics to laud "art nègre" was Salmon who, as late as 1920, could write, mistakenly, that "a number of the most beautiful pieces [of African art] that have come down to us are much older than the Christian era." He even thought he discerned an "influence of the carvers of 'fetishes'" *upon* Egyptian art (and, through it, on archaic Greek art). Given their concern with fundamental principles of artistic construction, Salmon concluded, the modern artists were fated "to pass from the Egyptians [back] to the Negroes" ("L'Art nègre," published in English in *The Burlington Magazine* [London] in 1920, emphasis added; reprinted in *Propos d'ateliers* [Paris: G. Crès, 1922], pp. 116, 123, 128).

24. Malraux, *La Tête d'obsidienne*, pp. 18–19 (*Picasso's Mask*, pp. 10–11). Later "exorcism pictures" include *The Dance* (Zervos V, 426) and *The Embrace* (fig. 252), both of 1925, the year of the key turning point of Picasso's relations with Olga, and of his encounter with Marie-Thérèse Walter.

25. During my researches for *"Primitivism" in Twentieth-Century Art*, the curators of what is today

the Musée de l'Homme (and was in Picasso's day the Musée d'Ethnographie du Trocadéro) told me that there were explanatory labels on some of the works in 1907, and in my text (ibid., p. 255) I suggested that Picasso had probably read some of these. Since that time, one of my collaborators on that book, Jean-Louis Paudrat, has confirmed the fact of the labels and discovered some of the label texts. His report on this question is cited below, note 264.

26. Malraux, *La Tête d'obsidienne*, p. 18 (emphasis added).

27. This is almost certainly the import of the card addressed by Picasso to Gertrude Stein on November 20, 1907, in which he uses the plural "we" to accept a dinner invitation (Collection of American Literature, The Beinecke Rare Book and Manuscript Library, Yale University, New Haven, Connecticut).

28. For the reasons why this change (an even later date for it has been suggested) may have been the last of the alterations of the *Demoiselles*, see below, pp. 94–95 and note 224.

29. André Salmon, "Picasso," *L'Esprit nouveau* (Paris), vol. 1, no. 1 (October 1920), p. 64.

30. Picasso referred to *Guernica* by that name in a document concerning the picture's disposition; a few titles for other paintings, such as *The Charnel House*, crystallized in the course of the artist's studio conversations with friends, but such instances are relatively rare. With the present author, Picasso usually referred to the *Demoiselles* as "my bordello." In general he decried "the mania of art dealers, art critics, and collectors for christening pictures" (see below, note 197). Picasso's 1933 (?) recollection (cited in D.-H. Kahnweiler's notes from a conversation with Picasso at 29 bis, rue d'Astorg, December 2, 1933, published in "Huit Entretiens avec Picasso," *Le Point* [Souillac and Mullhouse], vol. 42, no. 7 [October 1952], p. 24) that the *Demoiselles* was called "Le Bordel d'Avignon" at the beginning ("au début") contradicts Salmon's 1912 and 1922 references to "Le B [...] philosophique," which he characterized as "the work's first title." As both Picasso and Salmon contradict themselves more than once on this and other subjects, it is impossible to clarify this matter fully on the basis of documentation now available. That Picasso may also have referred to his picture as "Les Filles d'Avignon" is suggested by the accounts of both Soffici and Salto (see below, note 41, and the sections devoted to Salto [p. 250] and Soffici [pp. 251–52] in the Anthology).

31. Gelett Burgess, "The Wild Men of Paris," *The Architectural Record* (New York), vol. 27, no. 5 (May 1910), pp. 400–14; the "Study by Picasso" was reproduced on p. 408. There are no "ultramarine" figures in Picasso's paintings of the period, but the most "contorted" of Picasso's demoiselles is next to a blue curtain and her saturated orange face and black hair contain ultramarine linear accents and shadows, hence, probably, the "ultramarine ogresses" of Burgess's text. It cannot be ruled out that he may have been using "ultramarine" in its secondary meaning of "beyond the sea," hence "exotic" (as Steinberg considers possible, in conversation with

this author).

32. Salmon, "Histoire anecdotique du cubisme," pp. 43–44. See the section devoted to Salmon in the Anthology, pp. 244–46.

33. Salmon, *Propos d'atelier*, p. 16. See the section devoted to Salmon in the Anthology, p. 248.

34. Warnod, *Le Bateau-Lavoir*, p. 109.

35. Considering Apollinaire's fondness for and inexhaustible curiosity about rare books, strange cults and customs, and erotica, and his considerable knowledge of pornography and the so-called "limbo" of literatures (to quote from Roger Shattuck in *The Banquet Years* [1955; New York: Vintage, 1968], pp. 258, 269), it is not surprising that the poet was to accept commissions to write pornographic works, beginning in 1901 with *Mirely, ou le petit trou pas cher*, to supplement his meager income as art and literary critic. Thus, in 1907, finding himself in difficult financial straits, Apollinaire turned out two pieces of pornography, *Les Onze Mille Verges* (see below, note 199) and *Les Exploits amoureux d'un jeune Don Juan*. In the following year he accepted a contract to edit texts, both old and new, of obscene and erotic writings, published by the Éditions Briffaut under the rubric "Bibliothèque des curieux," in two series named respectively "Les Maîtres de l'amour" and "Le Coffret du bibliophile." Beginning in 1909 with selections from de Sade and Aretino, Apollinaire produced erudite introductions, annotations, translations in part, and bibliographies for some twenty-seven licentious texts, such as the work of John Cleland, *Mémoires de Fanny Hill, femme de plaisir* in 1910; *Le Joujou des demoiselles* in 1910; *Tariffa delle puttane di Venezia* (Aretinian poems) in 1911; and *L'Oeuvre des conteurs allemands: Les Mémoires d'une chanteuse* in 1913. Apollinaire also compiled, in collaboration with Fernand Fleuret and Louis Perceau, a clandestine catalogue of "the so-called 'Enfer,' the locked collection of erotica and sexology in the Bibliothèque Nationale" (Francis Steegmuller, *Apollinaire, Poet among the Painters* [New York: Farrar, Straus, 1963], p. 167), which was published by Mercure de France in 1913.

36. Such aggression against the female figure as exists in the final version of the *Demoiselles*—primarily a matter of the two women on the right and, secondarily, the one on the left—is identified with the figures' angular, difficult postures, style, and mask-like faces rather than their represented action, about which—with the exception of the twisted neck of the crouching demoiselle—there is nothing sadistic or, for that matter, visibly indecent.

37. André Salmon, "Picasso" (May 1920), *L'Esprit nouveau* (Paris), vol. 1, no. 1 (October 1920), p. 62.

38. This exhibition, and the fact that the *Demoiselles* was first publicly shown in it, was for many years overlooked. When citing it for the first time, in 1966, Edward Fry (in *Cubism* [London: Thames & Hudson, 1966; New York: Oxford University Press, 1978, p. 185]) listed "Cubist Exhibitions ... 1916 *Paris*. Salon d'Antin ... (no catalogue)," and evidently had no knowledge of the catalogue's existence. It was, nevertheless, he who

later discovered the catalogue as well, in the summer of 1973, while rummaging through archives and libraries in Paris. The first published reference to Fry's discovery appeared in Pierre Daix's *Aragon: Une Vie à changer* (Paris: Seuil, 1975), p. 56, note 2: "It has recently been established, thanks to Edward Fry's researches, that *Les Demoiselles d'Avignon* was exhibited for the first time in July 1916 in the Salon d'Antin, organized by André Salmon." The realization of the exhibition depended upon the patronage of the couturier Paul Poiret. It was held at the Galerie Barbazanges (established in 1911 on the premises of Paul Poiret's Hôtel d'Antin, situated at the corner of avenue d'Antin and rue du Faubourg-Saint-Honoré, and so named after the man who had charge of the gallery, M. Barbazanges; see the Chronology, under July 1916). The *Demoiselles* was no. 129 of a catalogue printed in the form of a folded leaflet.

While this catalogue does not indicate the dates of the exhibition itself—though it does list dates of related literary and musical events held at the Salon d'Antin on July 18, 21, 25, and 28—the invitation card sent by the journal *Sic* to its subscribers gives them as July 16 to 31, 1916 (see fig. 8 in the Chronology, and the section "Contemporary Accounts of the Salon d'Antin," pp. 165ff).

39. Over time, Picasso sold a few of the studies associated with late phases of work on the *Demoiselles*, but he never sold any of those connected with the early, seven-figure version (containing the sailor and medical student), which revealed the origins of his idea. He evidently gave Maurice Raynal, a friend and early defender of his work, the recently discovered tiny oil sketch of the seven-figure version now in The Museum of Modern Art (fig. 41) and, toward the end of his life, he donated a larger seven-figure drawing heightened with pastel to the Kunstmuseum Basel (fig. 40). Alfred Barr had much earlier (in 1944) sought in vain to purchase the latter from Picasso, along with a now lost oil study on wood (fig. 39), for The Museum of Modern Art (see the Chronology, note 3 of the entry for November 15, 1939–January 7, 1940). Mary Mathews Gedo ("Art as Exorcism: Picasso's *Demoiselles d'Avignon*," *Arts Magazine* [New York], vol. 55, no. 2 [October 15, 1980], pp. 70–83) somewhat exaggerates the degree of Picasso's possessiveness in this matter, characterizing it as a conscious plot to foil his critics and biographers, and keep them off the trail. Nevertheless, her main point—that Picasso considered the early studies for the *Demoiselles* very personal and treated them in a very private manner—is well taken.

40. The possibility of scandal resulting from showing a picture of a bordello scene, clearly designated as such by the use of the word *filles* in the title, would have existed under any conditions. However, the situation in wartime Paris (excellently described in Kenneth E. Silver's dissertation, "Esprit de Corps: The Great War and French Art 1914–1925" [Yale University, 1981], published as *Esprit de Corps: The Art of the Parisian Avant-Garde and the First World War, 1914–1925* [Princeton, N.J.: Princeton Univer-

sity Press, 1989]) involved a new wave of conservative and traditional French rightist sentiment. Modern art, and especially modern art made by foreign painters, found a less congenial reception than had been the case in the immediate prewar years, and the prevalence of these forces no doubt played a role in Salmon's desire to finesse the title. There is some irony in the fact that Picasso's challenging and unnerving style in this picture was pushed so far that the public and press could not—and evidently *did not*—recognize the picture's real subject, in the absence of a descriptive title. See Vauxcelles's review in *L'Événement* of July 28, 1916; in the Chronology, p. 169.

41. The reference by Salto is in "Pablo Picasso," *Klingen* (Copenhagen), no. 2 (November 1917), n.p.; first published in English translation in Marilyn McCully, ed., *A Picasso Anthology: Documents, Criticism, Reminiscences* (London: Arts Council of Great Britain, 1981), pp. 125–26. Salto describes the picture as a canvas the size of a wall, somewhat higher than broad, and showing four [*sic*] figures. In the translation of Salto's text published by McCully, the picture is referred to throughout as the *Demoiselles d'Avignon*, but Salto in fact used a Danish equivalent of "Filles d'Avignon" that can denote prostitutes (see the section devoted to Salto in the Anthology, p. 250, note 4).

42. Kahnweiler, notes from a conversation with Picasso, "Huit Entretiens avec Picasso."

43. Picasso was never one to mince words on the subject of sexuality. Characteristic was his inscription on a 1902 drawing of a nude woman: "When you want to fuck, fuck" ("Cuando tengas ganas de joder, jode"); pencil and watercolor drawing in the collection of the artist when exhibited at the Petit Palais, Paris, in 1966, no. 10 in the catalogue; now collection Marina Picasso, Geneva (Zervos XXI, 343).

44. Kahnweiler, notes from a conversation with Picasso, "Huit Entretiens avec Picasso."

45. From an unpublished letter by Kahnweiler to Alfred Barr dated December, 7, 1939, in the Alfred H. Barr, Jr. Papers of the Archives of The Museum of Modern Art, New York, and first brought to my attention by Edward Burns. My thanks to Rona Roob, Museum Archivist at The Museum of Modern Art, for her help in this and other aspects of my Picasso research. For me, the mystery of this 1939 communication is that in it Kahnweiler seems totally to have forgotten the conversation with Picasso he later published as having taken place in 1933 ("Huit Entretiens avec Picasso"), a conversation about which Kahnweiler tells us he made detailed notes at the time (even though these were not published until 1952). In view of the difficulty that everyone had in getting Picasso to speak about his own work, it seems nothing short of amazing to me that Kahnweiler would have made notes on Picasso's fascinating remarks regarding the *Demoiselles* in 1933 only to have entirely overlooked their existence and content when writing to Barr just six years later. Among the things Picasso tells Kahnweiler (purportedly in 1933) is that Salmon gave the picture its

present name: "It was Salmon who invented it." Yet in his 1939 letter to Barr, Kahnweiler suggests that the author of the title *Les Demoiselles d'Avignon* might have been Aragon (whom Picasso did not even know in 1916). Is it possible that the Picasso/Kahnweiler conversation in question took place after World War II and that Kahnweiler used an earlier date to enhance its, or his, authority?

46. Christian Zervos, *Pablo Picasso*, vol. II¹: *Oeuvres de 1906 à 1912* (Paris: Cahiers d'Art, 1942), p. 10. Zervos also specified that "The work's title did not come from the artist.... Picasso believes he remembers it was André Salmon who gave the painting its title" (ibid.).

47. Alfred H. Barr, Jr., *Picasso: Fifty Years of His Art* (1st ed., New York: The Museum of Modern Art, 1946), p. 57; hereafter cited as *Fifty Years*. Handwritten notes from the Alfred H. Barr, Jr. Papers indicate that Barr had gotten the proper Catalan spelling of what Zervos called "rue d'Avignon" as well as the Castilian spelling from his friend the architect José Luis Sert.

48. If we accept at face value Picasso's remark to Kahnweiler that the *Demoiselles* had been "called 'Le Bordel d'Avignon' at the beginning," we obviate any possibility that "Avignon" was added to the title by Salmon at the time of the Salon d'Antin. In this text, I have remained within those parameters, but not without certain misgivings. Consider first that "Avignon" is never heard of prior to the year 1916, in which its current name was established in the catalogue of the Salon d'Antin. It strikes me as a bit strange that Salmon had nothing to say about it in his note about the title "Le Bordel philosophique" in 1912. But mostly, I find rather strained Picasso's explanation to Kahnweiler (purportedly in 1933) as to why Avignon was in the title. It has something of the air of a rationalization after the fact. (This goes as well for Kahnweiler's presumably secondhand—and clearly forgetful—remarks to Barr in 1939 about a brothel in Avignon.)

Picasso mentions two unrelated points (that he bought his supplies in the calle d'Avignon in Barcelona, and that Jacob's grandmother came from Avignon), neither of which seems really important enough to have propelled "Avignon" into a title made up by Picasso's friends, or even into a studio "handle" used by the artist himself. But most important is the fact that Picasso says nothing in 1933 about any whorehouse in the calle d'Avignon. He could hardly have forgotten such a neighborhood bordello in Barcelona, and this, logically, should have been at the center of his explanation.

There exist two versions of the origin of the name of the calle Avinyó (*el carrer Avinyó*), one linking it with a celebrated Barcelona family named Avinyó—and thus without implications for the Bordello theme—the other with the French papal city of Avignon. None of the guidebooks or histories of Barcelona streets from early in the century (to be found in the Archivo del Instituto Municipal de Historia, in Barcelona) give any references to a possible house of carnal pleasure (*locales de diversión*) having been situated on that street, although such

houses are mentioned elsewhere. On the contrary, they emphasize on the calle Avinyó a number of artistically notable buildings such as the "casa de Hércules," or the monumental edifice of the "Borsí" dating from the end of the nineteenth century. (I am much indebted to Maria Teresa Ocaña, director of the Museu Picasso, Barcelona, for providing historical documentation on the calle Avinyó in Barcelona.) The evidence that the calle Avinyó was anything but a red-light district at the turn of the century has been reinforced by Daix, whose inquiries with aged male residents of the area produced only denials that there had ever been a bordello in that street.

The sole exception to this testimony, and it is a dubious one, is a passage in a fairly recent guidebook titled *Barcelona Step by Step*, by Alexandre Cirici, an author of several texts on Picasso. Cirici speaks of the transformation of some seignorial houses in the carrer de l'Avinyó into *maisons de tolérance*, one of which has "great importance for the history of art because it inspired Pablo Picasso to paint his famous picture titled 'Les Demoiselles d'Avignon,' the starting point of Cubism" (Alexandre Cirici, *Barcelona pam a pam* [Barcelona: Teide S.A., 1976], p. 275). Cirici gives no documentation or information beyond repeating the by then conventional story, which was probably inspired by what had been repeated by Barr and others from Picasso's explanation to Zervos. Picasso's change from his 1933 explanation to Kahnweiler (his art-supply shop, and Max Jacob's grandmother) to what sounded like a more convincing rationale (that there was a bordello on the calle d'Avignon) in his conversations with Zervos—who hears nothing about the art supplier or about Max's grandmother—seems *faute de mieux* to have settled the question art-historically. But it leaves distressing contradictions, and an alternative scenario, admittedly entirely speculative, is at least thinkable.

Let us suppose that the word "Avignon" did *not* in fact figure in any early titles or studio nicknames, Max's "grandmother" notwithstanding. Aside from "Le Bordel philosophique" (which one can hardly imagine Picasso himself using), there were references to "le bordel" and "les filles." Faced with inventing a public title early in 1916, Salmon realizes the dangers of one that would give the game away through the use of either "bordel" or "filles." He proposes "Demoiselles," but knows Picasso isn't going to like that very proper term, so he will "compensate" for its blandness. At this point, Salmon, who was an *amateur* of Petrarch, explains to Picasso the "troubadour" implications of the word "Avignon." It will be a private joke, a double entendre of the type Picasso loves. He goes along, although he still might use the variant "Filles d'Avignon" in private. But in 1933 (or perhaps later), he doesn't want to bother with the literary/historical rationale that lay behind Salmon's title so, when questioned by Kahnweiler, he mentions the art supplier on the calle d'Avignon and Max's grandmother. Still later, considering his earlier explanations inadequate, he simplifies everything by inventing

for Zervos the bordello of Avignon Street. In all this, one should keep in mind how utterly trivial Picasso considered this sort of art-historical question.

49. Abbé de Sade, *Mémoires pour la vie de Pétrarque* (Amsterdam, 1764), vol. 1, p. 27, and vol. 2, pp. 37, 97, as quoted in Georges Cartoux, *Condition des courtisanes à Avignon du XIIème au XIXème siècle* (Lyons: Thèse, 1925), p. 13.

50. I want to acknowledge here the help of my correspondent in Rome, Ester Coen, in elucidating the use of the vernacular "going to Avignon street" (*andare agli avignonesi*) for going to any street with a bordello. Without furnishing a source, one author has gone so far as to state that "The most famous Roman brothel was called 'the Avignonese'" (Davray, *Les Maisons closes*, p. 71).

51. Dr. Léon Bizard and Jane Chapon, *Histoire de la prison Saint-Lazare du moyen âge à nos jours* (Paris: de Boccard, 1925), p. 234.

52. While Max Jacob referred to *Les Demoiselles d'Avignon* by name only once, he alluded in three instances to the preparatory drawings and painted studies for the large painting: in 1927 ("Souvenirs sur Picasso contés par Max Jacob," *Cahiers d'art* [Paris], vol. 2, no. 6 [1927], p. 202); in a 1931 text not published until 1964 ("Fox" [1931], *Les Lettres françaises* [Paris], no. 1051 [October 22–28 , 1964], pp. 1, 11); and in 1932 ("Naissance du cubisme et autres," in *Les Nouvelles Littéraires* [Paris], April 30, 1932, p. 7). It was in this 1932 text that he made his single reference to *Les Demoiselles d'Avignon* by name, mentioned in passing as being "large as a wall." In each of these texts Jacob described Matisse as the first to introduce Picasso to African art. My thanks to Raymond Josué Seckel for ascertaining the correct date of publication of Jacob's 1932 article; and to Étienne-Alain Hubert and Hélène Seckel for making Jacob's 1931/1964 article available. For Jacob's explanation of his discretion, see the section devoted to him in the Anthology, p. 232.

As regards Apollinaire, Scott Bates (*Guillaume Apollinaire* [New York: Twayne, 1967], p. 115) observes: "It is significant that after the lyrical article of May 1905 about the Blue and Rose period[s] … Apollinaire only rarely referred to specific later works of Picasso; and he never mentioned the *Demoiselles of Avignon*. In his summaries of the painter's output after that date [1905] … there was a noticeable diminution of enthusiasm."

In a notebook serving as his private diary from 1898 to 1918 (first published in 1991 by Michel Décaudin), Apollinaire noted for February 27, 1907, that he dined at Picasso's and saw his new painting. The succinct references to the works seen suggest that these were probably preparatory studies—heads of men and women—for the *Demoiselles* (see the Chronology, under that date).

53. "Kahnweiler reproached him for not appreciating the *Demoiselles d'Avignon* at the time, and for not having given support to Picasso, who was in need of it then" (in the exhibition catalogue *Apollinaire* [Paris: Bibliothèque Nationale, in collaboration with la Direction Générale des Arts et des Lettres, 1969], p. 71). The authorship of this passage

is in some doubt, though it was probably written by Jean Adhémar, under whose supervision the catalogue was prepared. As Adhémar knew Kahnweiler, the latter was almost certainly the source of this passage. It is difficult to imagine why Adhémar, or anyone else, would have gratuitously invented this account. Moreover, the critical attitude toward Apollinaire's appreciation of painting expressed in this passage is congruent with Kahnweiler's view of the poet expressed elsewhere: "This, like much of what Apollinaire wrote about the arts, is completely untrue. Apollinaire … knew nothing about painting" (Kahnweiler, with Francis Crémieux, *My Galleries and Painters*, trans. Helen Weaver [1961; New York: The Viking Press, 1971], p. 41). Indeed, there exists a transcript of a taped 1973 interview by Claude de Givray (Société Française de Production, Paris; never published or broadcast) in which Kahnweiler is more specific: "One must always note [that at the moment of *Les Demoiselles d'Avignon*] … Picasso had been abandoned by everyone [*sic*] … notably Apollinaire" (typescript, p. 7). My thanks to Orde Levinson and Hélène Seckel for generously making this text available to me.

54. See above, p. 14 and note 9.

55. Leo Stein, *Appreciation: Painting, Poetry, and Prose* (New York: Crown, 1947), p. 175. See note 206, below, for an account of the Steins' travels in 1907; see also the Chronology, p. 149.

56. Gertrude Stein, *Picasso* (Paris: Floury, 1938), p. 64: "When Picasso, under the influence of 'l'art nègre' painted the *Demoiselles d'Avignon* (1906–07) [*sic*], it was a veritable cataclysm."

57. Stein, *Picasso*, p. 68.

58. It has usually been said, and I took this position myself in the past, that Braque's *Large Nude*, finished in the spring of 1908, was directly influenced by his experience of the *Demoiselles*. Pierre Daix (in *Picasso créateur*, pp. 91–92; and in "Les Trois Périodes de travail de Picasso sur *Les Trois Femmes* [automne 1907–automne 1908], les rapports avec Braque et les débuts du cubisme," *Gazette des beaux-arts* [Paris], series 6, vol. 111, nos. 1428–29 [January–February 1988], pp. 141–54) has strongly argued that *Three Women*, in its early "African" form, was visible to Braque in Picasso's studio as early as the autumn of 1907, and that it was *this* picture rather than the *Demoiselles* which lay behind Braque's *Large Nude* as well as his drawing (preserved only in reproduction) and large painting (lost) of three nudes. The drawing, which was more intimately related to *Three Women* than was the *Large Nude*, was given by Braque to Burgess, who reproduced it in his 1910 article in *The Architectural Record*.

59. Salmon, *La Jeune Peinture française*. See the section devoted to Salmon in the Anthology, p. 244.

60. The *Demoiselles* is partially visible, covered by a cloth, in a photograph of Salmon taken by Picasso probably early in 1908, as well as in other of Picasso's studio photos of that year (see figs. 2–4 in the Chronology and fig. 232 in the present essay). It was photographed by Burgess (fig. 244) sometime during his stay in Paris between March 31 and July 28,

1908, or even perhaps prior to June 13. (On the subject of Gelett Burgess, see the Chronology, pp. 155–58.) We know this from a letter of that date written to his mother from Les Beaux (see the Chronology, p. 156), saying he had sent "The Wild Men of Paris" to the journal *Collier's*.

The sole references we have to the *Demoiselles* being seen in Picasso's studio between 1909 and 1915 are by the Italian painter-critic Ardengo Soffici (in a chapter titled "Gli Studi di Picasso" in *Ricordi di vita artistica e letteraria* [Florence: Vallecchi, 1942], pp. 366–71—a text discovered by Jean-François Rodriguez to have been first published in *Gazzetta del popolo* [Turin], February 9, 1939, p. 3, and also reprinted in *Trenta Artisti moderni italiani e stranieri* [Florence: Vallecchi, 1950], pp. 17–22). The *Demoiselles* was a special favorite of Soffici's and he tells us that whenever he visited Picasso, the artist showed him the picture. When he visited the studio in the rue Schoelcher, in 1914, he saw the *Demoiselles* "hanging in a corner" (see fig. 7 in the Chronology). Soffici had also seen the picture at boulevard de Clichy in 1910 (he was in Paris from February to May of that year), according to a later autobiographical text, *Fine di un mondo—Virilità* (Florence: Vallecchi, 1955), fourth of a four-volume book of memoirs that appeared under the general heading *Autoritratto d'artista italiano nel quadro del suo tempo*, published from 1951 to 1955; *Fine di un mondo—Virilità* was subsequently incorporated into *Opere*, an edition of the collected writing of Soffici, brought out by Vallecchi in 1968, to which we refer here (vol. 7, part 2, p. 707). While reiterating his description of the rue Schoelcher studio, he amplifies his recollections of seeing the *Demoiselles* (see the section devoted to Soffici in the Anthology, p. 252). It may be worth noting here that Soffici, cofounder and editor of the Futurist bi-weekly periodical *Lacerba* (the first issue appeared January 1, 1913), made a reference in his column "Giornale di bordo" to initiating "the publication of *Bordello spirituale*, a journal of pure poetry and high culture" (*Lacerba* [Florence], vol. 1, no. 11 [June 1, 1913], p. 116; I am indebted to Ester Coen for bringing this to my attention, as well as to Luigi Cavallo for providing the specific reference in *Lacerba*). Given the provocative and satirical intent of Soffici's column, it is probable that the idea of the magazine *Bordello spirituale* was meant to be no more than a joke on the part of Soffici; however, it was certainly also an oblique tribute to the painting he so admired.

61. Picasso did explore the use of geometrical forms in some notebook sketches of 1907–08 in the interest of simplifying his configurations, reducing them to notational essentials. Though he used circles and rectangles occasionally, he never focused upon them as integral symbolic shapes in themselves, any more than he was interested in the "golden section." When Salmon tells us that Picasso "meditated on geometry," he implies (at least to my mind) that the painter—in common with some Parisian Cubists—thought such forms had autonomous value in themselves. Salmon's thinking here seems to me to reflect that of some Parisian

Cubists with whom he was very friendly in 1912.

62. Daix, "Les Trois Périodes de travail de Picasso sur *Les Trois Femmes*," demonstrates convincingly that Salmon recollectively confused aspects of *Three Women* with the *Demoiselles* in parts of his discussion. The "geometry at once infinitesimal and cinematic" could conceivably refer to passages vaguely resembling proto-Cubist "sprays" of Neo-Impressionist brushwork found in some parts of *Three Women*, though not in the *Demoiselles*. (See the section devoted to Salmon in the Anthology, p. 245.)

63. Florent Fels, "Chronique artistique: Propos d'artistes—Picasso," *Les Nouvelles littéraires* (Paris) vol. 2, no. 42 (August 4, 1923), p. 2. The English translation, "I try to paint what I found and not what I sought," gives no sense of Picasso's probable negative allusion to Salmon's word *recherche* as a term used in connection with Picasso's painting.

64. During the time Picasso worked on the large canvas, parts of June and July, Apollinaire was apparently out of Paris some of the time; he wrote to Picasso from Anvers on July 15 (see *Picasso/Apollinaire: Correspondance,* ed. Pierre Caizergues and Hélène Seckel [Paris: Gallimard, 1992], p. 20). Jacob seems also to have left Paris for the summer. Of the members of the "Picasso gang," only Salmon is definitely known to have visited the studio during work on the large canvas.

65. The earliest references would seem to be in John Golding, "The *Demoiselles d'Avignon*," *The Burlington Magazine* (London), vol. 100, no. 662 (May 1958), p. 155–63—but only, of course, if one excepts the unpublished Ph.D. dissertation by Herschel B. Chipp, "Cubism, 1907–1914," (Columbia University, New York, 1955). In the course of his study, Chipp had the opportunity to consult André Salmon, then still living, whose passages concerning the *Demoiselles* in *La Jeune Peinture française* (1912) he cites at some length in his own discussion of the picture, and whose writings figure prominently in the bibliography included in the dissertation.

66. In his many different accounts of his first visit to Picasso's studio, Kahnweiler dated the event variously, ranging from the spring to the early summer of 1907. As I am in agreement with the overall chronology for the *Demoiselles* proposed by Daix (in "L'Historique des *Demoiselles d'Avignon* révisé à l'aide des carnets de Picasso"), which generally best fits the facts we know and the order and development of the studies and related works, I would choose from among the options Kahnweiler provided a dating "quite early in summer 1907," which was, anyway, Kahnweiler's earliest (1933) recollection of the event (in "Huit Entretiens avec Picasso").

67. Kahnweiler had always insisted that when he first saw the *Demoiselles* in 1907, it was in its definitive form. Yet in certain of his accounts he says he first saw it in the spring—at which time it was certainly not finished, if even begun. In his earliest (1933) account Kahnweiler speaks of early July. Depending, however, on one's reading of Picasso's photograph of Guus and Dolly van Dongen (fig.

232. Mrs. Guus van Dongen with her daughter Dolly, in front of *Les Demoiselles d'Avignon* at the Bateau-Lavoir, probably summer 1907. Archives Dolly van Dongen. See figs. 3 and 4 in the Chronology.

232), one might date the repainting of the head of the left-hand demoiselle *after* that of the heads shown already clearly repainted in the photograph—that is, sometime later in the summer of 1907 than the July date given by Kahnweiler. Britta Martensen-Larsen in fact opts for a much later date (see below, pp. 94–95 and note 224). As Kahnweiler failed in his writings to distinguish between the head of this left-hand figure and those of the two center demoiselles, despite differences in style (admittedly less marked than between the middle figures and those on the right, but significant nonetheless), he probably would not have noticed the change, even in the event that Picasso had overpainted this head at a later date.

68. Except during the spring and summer of 1912, when he was helping with the move to boulevard Raspail during Picasso's absence, Kahnweiler visited the studio only occasionally. Picasso maintained a long (if somewhat discontinuous) and usually cordial (but never very close) relationship even with this most important of his many dealers. As in the case of the money Kahnweiler owed the artist at the outbreak of World War I—when, as the property of a German national, Kahnweiler's bank account was frozen—Picasso might treat him quite meanly. Picasso was also extremely cautious as to what he chose to let dealers see on studio visits, for which he prepared carefully, partly to stage fitting put-downs for members of a race of which he was suspicious. Daix suggested to me in conversation, and I am inclined to agree, that Kahnweiler—though he no doubt returned once or twice to the Bateau-Lavoir—probably saw very little of the *Demoiselles* in the period immediately following its execution.

Kahnweiler became a dealer of Picasso no earlier than in the late spring of 1908, by which time the *Demoiselles* was stacked behind *Three Women*, covered with a piece of cloth and stretchers (see figs. 3 and 4 in the Chronology) and was entirely visible only on special occasions, as when it was photographed by Burgess or when Soffici visited.

69. Daniel Henry [Kahnweiler], "Der Kubismus," *Die Weissen Blätter* (Zurich and Leipzig), vol. 3, no. 9 (September 23, 1916), p. 212. See the Anthology, pp. 234 ff., for Kahnweiler's texts on the *Demoiselles*.

70. The entire passage runs: "Anfangs 1907 beginnt Picasso ein seltsames, grosses Gemälde mit Frauen, Früchten und Vorhängen, das unvollendet blieb. *Unvollendet ist es zu nennen,* obzwar in ihm gar lange Arbeit steckt, *weil es im Geiste der Werke des Jahres 1906 begonnen, in einem Teile die Bestrebungen des Jahres 1907 enthält, und so kein geschlossenes Ganzes aus ihm geworden ist*" (Daniel Henry [Kahnweiler], *Der Weg zum Kubismus* [Munich: Delphin, 1920], p. 17 [emphasis added]).

71. Letter from Reinhold Hohl to William Rubin, October 15, 1982. "Picasso then considered *Les Demoiselles* as unfinished" ("Picasso damals *Les Demoiselles* für unvollendet hielt") (in "Ursprung und Entwicklung des Kubismus," text compiled from a lecture by Kahnweiler of October 23, 1947, at the University of Freiburg im Breisgau, by Maurice Jardot and Kurt Martin [1948]; and published in French translation as "Naissance et développement du cubisme," in *Les Maîtres de la peinture française contemporaine* [Baden-Baden: Woldemar Klein, 1949], p. 15).

72. Daniel-Henry Kahnweiler, "Picasso et le cubisme," in the exhibition catalogue *Picasso* (Lyons: Musée de Lyon, 1953), n.p.

73. Daniel-Henry Kahnweiler, "Cubism: The Creative Years," *Art News Annual* (New York), vol. 24 (1955), p. 107.

74. One might argue that, as director of the Museum that purchased the *Demoiselles*, Barr had a vested interest in not considering it unfinished. But Barr had too much intellectual integrity for that. He surely would have somewhere mentioned its purported incompleteness had he at all credited Kahnweiler's idea (and it was understood as *only* Kahnweiler's idea until after World War II, when the latter attributed it to Picasso himself). Perhaps Picasso had himself dismissed the notion of its being "unfinished" in his chats with Barr, as he had with me (see the present author's "From Narrative to 'Iconic' in Picasso: The Buried Allegory in *Bread and Fruitdish on a Table* and the Role of *Les Demoiselles d'Avignon*," *The Art Bulletin* [New York], vol. 65, no. 4 [December 1983], pp. 615–49).

75. This statement is in the unpublished radio interview with Claude de Givray (see note 53, above). In having Picasso say that the picture had never changed, Kahnweiler was reinforcing his historico/formal reasoning for the differences in style, which, instead of following from some expressive purpose on Picasso's part, are explained by the fact that the picture contains the styles of both 1906

and 1907 (see above, note 6). At the time I wrote my article "From Narrative to 'Iconic' in Picasso," I believed that Salmon had also, by 1920, in his text in *L'Esprit nouveau* begun to believe that the *Demoiselles* was unfinished. And I associated this with possible contacts between Salmon and Kahnweiler. In looking again at Salmon's text, I have become convinced that in fact the observation that Picasso "abandonne ce grand ouvrage *Les Demoiselles* d'Avignon" refers only to Picasso's having stopped work on it at the end of the first period of work. Salmon follows this observation by noting that the picture was "par la suite pris et repris" (p. 64). See the Anthology, p. 247.

76. See my discussion of finish in "From Narrative to 'Iconic' in Picasso," Appendix XI: "The Supposed Unfinishedness of the *Demoiselles*," pp. 647–48.

77. "Der Beginn des Kubismus: Der erste Anlauf." Daniel Henry [Kahnweiler], *Der Weg zum Kubismus*, p. 18. These words are not to be found in the earlier (1916) version of the text, though the section on the *Demoiselles* there is found under the rubric "Beginnings of Cubism." See the Anthology, pp. 235.

78. "This second period which marks, properly speaking, the birth of Cubism … " (Daniel-Henry Kahnweiler, interview with Picasso at 29 bis, rue d'Astorg, Paris on December 2, 1933; published in "Huits Entretiens avec Picasso," p. 24). See the Anthology, p. 235, for an English translation.

79. "C'est proprement cette partie droite des Demoiselles d'Avignon qui constitue le début du cubisme" (Daniel-Henry Kahnweiler, *Juan Gris: Sa Vie, son oeuvre, ses écrits* [Paris: Gallimard, 1946], p. 145). "The foundations of Cubism were laid in this right-hand section of *Les Demoiselles d'Avignon*" (see the Anthology, p. 236).

80. Gino Severini, *Du Cubisme au classicisme: Esthétique du compas et du nombre* (Paris: J. Povolozky, 1921).

81. Letter from André Breton to Jacques Doucet, December 12, 1924. Bibliothèque Littéraire Jacques Doucet, Paris, B-IV-6, 7210.65; printed in part in François Chapon, *Mystère et splendeurs de Jacques Doucet, 1853–1929* (Paris: Jean-Claude Lattès, 1984), p. 300, and published in its entirety in the Chronology in the present volume. In associating the *Demoiselles* with the mysteries of rite and ritual—the symbol of the "Chaldean bull"—Breton came closer to Picasso's own feelings about the painting than did Kahnweiler.

82. Letter from André Breton to Jacques Doucet, November 6, 1923. Bibliothèque Littéraire Jacques Doucet, Paris, B-IV-6, 7210.40; printed in part in Chapon, *Mystère et splendeurs de Jacques Doucet*, p. 294, and in its entirety in the Chronology in the present volume.

83. Letter from André Breton to Jacques Doucet, December 12, 1924, as in note 81, above.

84. In "Picasso's *Demoiselles d'Avignon* and the Theatre of the Absurd," *Arts Magazine* (New York), vol. 55, no. 2 (October 1980), pp. 102–13. In this text Johnson expressed concepts very kindred in spirit to those in André Breton's letters to Jacques Doucet (unpublished at the time).

Breton's letters of December 3, [1921], November 6, 1923, December 2, 1924, and December 12, 1924, to Jacques Doucet (given, with the rest of Breton's correspondence to Doucet, to the Bibliothèque Littéraire Jacques Doucet by Elisa Breton) were first published in part by Chapon in *Mystère et splendeurs de Jacques Doucet*, pp. 267–68, 293–94, 298, 299–300). See the Chronology.

85. Gertrude Stein, *Picasso* (Paris: Floury, 1938), p. 67. To anyone who reads both the French and English editions of Stein's *Picasso*, it quickly becomes apparent that we are in the presence of two separate books. For this reason we asked Edward Burns to check the manuscripts and related materials in The Beinecke Rare Book and Manuscript Library at Yale University. See the section devoted to Gertrude Stein in the Anthology, p. 253, note 4, for his letter on this subject dated March 18, 1993, to Judith Cousins.

86. Ibid., pp. 71–72. The notion of Cubism as intrinsically Spanish had already been expressed by Stein in 1933 when she wrote "… cubism is a purely spanish conception and only spaniards can be cubists and … the only real cubism is that of Picasso and Juan Gris" (*The Autobiography of Alice B. Toklas*, p. 91).

87. The Museum of Modern Art, Press Release of January 20, 1939, announcing the Museum's forthcoming exhibition of the work of Pablo Picasso (to open in November 1939), and at the same time announcing its acquisition of *Les Demoiselles d'Avignon*. See the Chronology.

The wording of the press release is somewhat misleading: in fact it was not the "monumental style" of late 1906, but rather the low-relief, schematic "Iberianism" of late spring 1907, that formed the earliest layer of imagery in the canvas.

88. Alfred H. Barr, Jr., *Picasso: Forty Years of His Art* (New York: The Museum of Modern Art, 1939), hereafter cited as *Forty Years*. The volume went through the following editions: 1st ed., November 1939; 2nd ed., rev., December 1939; 3rd ed., rev., March 1940; 4th ed., rev., March 1941.

89. Barr, *Fifty Years*. A 2nd ed. was published in 1951.

90. That "mythic" influence was largely literary and social rather than pictorial. As Robert Lubar observes in "Picasso, El Greco, and the Body of the Nation" (in *Picasso and the Spanish Tradition* [New Haven, Conn.: Yale University Press, to appear 1994–95]):

What mattered was not the work of El Greco, historically tied to the Castilian rather than the Catalan milieu, but the model of an unbroken chain between past and present—the linkage of tradition with progress and modernity. The El Greco "myth" provided highly mediated symbols that affirmed the interests of the Catalan industrial bourgeoisie within a broad process of social engineering, cultural retrieval, and national identity formation. To this end, the idea of El Greco's timeless appeal as an innovator—and thus his modernity—was ideological; lifted outside of a precise histor-

ical moment, El Greco's art—or rather the El Greco myth — articulated the political and social aspirations of a particular class actively engaged in the process of constructing a hegemonic Catalan cultural nationalism.

Whatever the role of El Greco's painting itself for other artists, Picasso had absorbed the broader figural aspects of El Greco's Mannerism in the Blue Period, and by 1907, he was poised for a new exploitation of El Greco which would go to the heart of that painter's style.

91. Christian Zervos, *Pablo Picasso*, vol. II¹.

92. James Johnson Sweeney, "Picasso and Iberian Sculpture," *The Art Bulletin* (New York), vol. 23, no. 3 (September 1941), pp. 191–98.

93. Alfred H. Barr, Jr., ed., *Masters of Modern Art* (New York: The Museum of Modern Art, 1954), p. 68.

94. Barr, *Forty Years*, p. 60.

95. Barr, *Fifty Years*, p. 56.

96. Barr, ed., *Masters of Modern Art*, p. 82.

97. Golding, "The *Demoiselles d'Avignon*," pp. 155–63.

98. Wilhelm Boeck and Jaime Sabartés, *Picasso* (New York and Amsterdam: Abrams, 1955), p. 142.

99. Robert Rosenblum, *Cubism and Twentieth-Century Art* (New York: Abrams, 1960), pp. 10–12, 25–28, 30, 32.

100. Edward F. Fry, *Cubism* (London: Thames & Hudson, 1966), pp. 12–17, 18, 24, 35, 47–48.

101. Meyer Schapiro, lectures in the course "Modern Painting," Columbia University, Department of Fine Arts, 1950–51. In fact, Picasso could easily have repainted the two "Iberian" demoiselles in the center of the painting in styles matching those of the outer figures in a day or two, had he wished to do so.

102. Douglas Cooper, *The Cubist Epoch* (London: Phaidon; Los Angeles: The Los Angeles County Museum of Art; New York: The Metropolitan Museum of Art, 1970), pp. 17–25, 26–27, 30; John M. Nash, "Pygmalion and Medusa," twenty-one-minute talk on B.B.C. Radio 3, London, first broadcast at 10:05 P.M., Wednesday, June 24, 1970. John Nash has provided me with a much elaborated though still unpublished version of this talk, as it was given at the Tate Gallery, London, on April 27, 1983, which I will cite in the closing section of my text (p. 115).

103. Cooper, *The Cubist Epoch*, p. 22.

104. Leo Steinberg, "The Philosophical Brothel," published in two parts in *Art News* (New York), vol. 71, no. 5 (September 1972), pp. 22–29, and no. 6 (October 1972), pp. 38–47. Subsequently reprinted, with revisions, in *October* (New York), no. 44 (Spring 1988), pp. 7–74.

105. Ibid. In a short memo of suggestions regarding the interpretation of the *Demoiselles* that I gave Steinberg (along with some then unpublished photographs of *Demoiselles* studies) prior to the initial appearance of his essay, was an admittedly highly speculative idea (omitted in the partial citation Steinberg generously made of that text) that is perhaps worth mentioning at this point, in relation to

Steinberg's reference to the small table entering the picture at the bottom as "a visual metaphor of penetration" (see Steinberg, "The Philosophical Brothel" [part 2], *Art News* [New York], vol. 71, no. 6 [October 1972], p. 47, note 32). My memo, written before Steinberg completed his text, suggested that the closed, illusioned space of the *Demoiselles*, its contours characterized by curtains, might have been felt, at least unconsciously, by Picasso as a kind of counterpart of, or metaphor for, a vaginal space. Given the soft, membranous nature of these *tissus* and their folds, as well as their prevailing rose tonality (at least in the earlier state of the painting), this does not appear to me so farfetched, especially in the

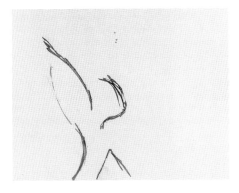

233. *Composition Study.* Carnet 6, 12R. Paris, May 1907. Pen and India ink on beige paper, 4⅛ x 5⅜" (10.5 x 13.6 cm). Musée Picasso, Paris (MP 1862)

234. *Vaginal Environment.* Barcelona, 1903. Ink and crayon on trade card, approximately 5⅛ x 3⅛" (13 x 9 cm). Private collection

light of such previous erotic spatial fantasies of Picasso as that of *Vaginal Environment* (fig. 234). Indeed, certain of the composition studies, especially fig. 233, endow the curtains anthropomorphically with contours that suggest feminine torsos, toward which the "arrow" of the penetrating table seems directed.

106. Leo Steinberg, "Resisting Cézanne, Part 2: The Polemical Part," *Art in America* (New York), vol. 67, no. 2 (March–April 1979), pp. 123–24.

107. Nash, "Pygmalion and Medusa," as in note 102, above.

108. John M. Nash, *Cubism, Futurism, and Constructivism* (1974; Woodbury, N.Y.: Barron's, 1978), pp. 4–17.

109. Werner Spies was the first to explore the filiation of Picasso's *Demoiselles* to Ingres's *Turkish Bath* (fig. 14; shown in the Salon d'Automne of 1905), in a review of the 1968 exhibition of Picasso's 347 engravings at the Galerie Louise Leiris in Paris ("Picassos Herausforderung: Graphik von 1968 in der Galerie Leiris," *Frankfurter allgemeine Zeitung* [Frankfurt am Main], no. 5 [January 7, 1969], p. 18). Many of the prints in the show had struck him as proof of a renewed encounter on the part of the artist with the oeuvre of Ingres, an association Spies felt should be viewed as a lifelong homage to Ingres, beginning with the liberating effect produced by his *Turkish Bath*—which surfaced in Paris shortly before the period of work preliminary to the *Demoiselles*—thanks to which Picasso was able to overcome the moods of the Blue and Rose periods. This view, to which he assimilated a widening frame of reference, remained the nucleus of Spies's subsequent writings on the subject of the genesis of *Les Demoiselles d'Avignon*. In *Sculpture by Picasso, with a Catalogue of the Works* (New York: Abrams, 1971), pp. 20–21, 266, notes 22–27, which contains an expanded discussion of Ingres's *Turkish Bath* as a source of inspiration, Spies noted that the picture "almost certainly had a decisive influence on Matisse's composition *Bonheur de vivre*" [fig. 10] and that it was "also crucial to Picasso's figurative and compositional style," as reflected in the works created in late 1905. Spies observed that the "direct influence of Ingres is most readily discernible in *The Harem* [fig. 16]. One of the central figures, the woman with her hands above her head, also occurs in Matisse's *Bonheur de vivre*, which was likewise begun in November 1905, after an encounter with *The Turkish Bath*." Spies concluded: "It is certain that this picture was one of the factors which stimulated Picasso to work on *Les Demoiselles d'Avignon* a year later" (ibid., pp. 20, 226, note 27). While Spies's text on the *Demoiselles* in his *Picasso: Das plastische Werk* (Stuttgart: Gerd Hatje, 1983), pp. 26–27, is essentially a *reprise* of that which appeared in 1971, he had offered in another text, published a year earlier and titled "Picasso: L'Histoire dans l'atelier" (*Cahiers du Musée National d'Art Moderne* [Paris], no. 9 [1982], pp. 63–65), a more complex reading of the genesis of the *Demoiselles*, which he considered as "the reply to a challenge." Viewing the *Demoiselles* as a response to Ingres's *Turkish Bath*—described as

feeding into the former through *The Harem*—and at the same time as a meditation upon the Ingres, on the Bathers of Cézanne (see fig. 9), and on the idea of a Golden Age such as represented by Matisse in his *Bonheur de vivre*, Spies proposed as its point of departure the famous allegory of Zeuxis painting the portrait of Helena for the temple of Hera at Croton, known to us through the description of Alberti, "one of the *topoi* of pictorial betterment, on the improvement of reality, with an eye toward achieving purely artistic Beauty, the *topos* that had challenged painting since Antiquity" (p. 65).

110. Robert Rosenblum, "The *Demoiselles d'Avignon* Revisited," *Art News* (New York), vol. 72, no. 4 (April 1973), p. 45.

111. See note 84, above.

112. Shattuck, *The Banquet Years*, pp. 218–19, 228.

113. Johnson, "Picasso's *Demoiselles d'Avignon* and the Theater of the Absurd," p. 108. It seems to me self-evident from the intentionally preposterous tone and content of the passage by Jacob cited in Johnson that the statement was a meaningful fiction, as, indeed, the reference to Jarry's gun would have had to have been, had—as seems to be the case—Picasso and Jarry never met. (See note 115, below.)

114. André Salmon, *L'Air de la Butte* (Paris: La Nouvelle France, 1945), p. 36. Also cited in Penrose, *Picasso: His Life and Work*, p. 113.

115. The question of possible direct personal contacts between Picasso and Jarry has become something of an issue in recent criticism. Inasmuch, however, as every serious scholar would agree that Picasso evinced considerable sympathy for Jarry's ideas—identifying personally in certain respects with the author of *Ubu Roi* (though obviously not with his sometimes reactionary politics and anti-Semitism)—the question of whether the two men actually knew each other may have been blown out of proportion. This notwithstanding, if one were to accept the views of such critics as Johnson and Leighten, who describe Jarry as nothing less than a member of "la bande Picasso," one would have to imagine that the proto-Dada playwright was far more a presence in Picasso's studio and on his mind during the elaboration of the *Demoiselles* than was surely the case.

That key members of "la bande Picasso," such as Apollinaire and Salmon, were friends of Jarry, naturally leads one to suspect that Picasso knew him too. This, even though Jarry died in the autumn of 1907, only three years after Picasso might first have met him through Apollinaire, during which time Jarry suffered—beyond his chronic alcoholism—a variety of lingering illnesses. The frequent assertion that Picasso and Jarry were friends rests, however, on but a single piece of (seemingly) direct evidence namely, an account of a dinner in the memoirs of Max Jacob (*Chronique des temps héroiques* [Paris: Louis Broder, 1956], pp. 48–49):
At the end of a supper, Alfred Jarry gave up his revolver to Picasso and made a gift of it to him.... At that time it was recognized:
1) That the tiara of the psychic Pope Jarry was

loading [the] revolver, [the] new distinguishing mark of [the] papacy.

2) That the gift of this emblem was the enthronement of the new psychic Picasso.

3) That the revolver sought its natural owner.

4) That the revolver was really the harbinger comet of the century.

This is a slender reed to support the purported friendship, especially given the manifestly fantastic nature of the text. On the other hand, there is serious evidence to suggest that the playwright and painter never even met. Nowhere in the Picasso archives is there any trace of contact between the two men. Indeed, Hélène Parmelin (*Picasso Plain* [London: Secker & Warburg, 1963, p. 215; translated from *Picasso sur la place* [Paris: René Julliard, 1959], p. 242) recounts that Picasso had expressed to her his regret at never having met Jarry. More recently John Richardson, who knew Picasso well, has insisted that "when Jarry's name came up in conversation, the artist would try to correct this misapprehension [that he knew Jarry], but people persisted in believing otherwise" (Richardson, *A Life of Picasso*, vol. 1: *1881–1906* [New York: Random House, 1991], p. 362).

None of Jarry's biographers give any evidence of a meeting with Picasso. On the contrary, their chronicles of Jarry's last years show him moving in quite other circles (to the extent that his deteriorating physical condition permitted mobility). The playwright was frequently bedridden when in Paris, and he spent an increasing portion of his time in his birthplace, Laval, where his sister attended him; he was there, for example, throughout the months during which Picasso worked on his large canvas.

Given the results of Jarry's alcoholism and the debility caused by the mounting virulence of what was later diagnosed as tubercular meningitis, one should hardly be surprised if the two men never met—especially in the light of Picasso's legendary nervousness about being in the presence of sick people. Hélène Seckel, who is preparing a scholarly catalogue for an exhibition on the subject of Picasso and Max Jacob, believes that Picasso may in fact have met Jarry on a single occasion, but she wonders whether something like the ritual passing of the revolver described by Jacob would have taken place at such a first and only contact.

Jarry's biographers, moreover, describe his deep and mystical attachment to his obviously symbolic revolver, of which he was bereft, according to them, only once late in life—following the scandalous firing of it during a dinner at Maurice Raynal's. It is difficult to imagine Jarry "passing" his gun to anyone, especially Picasso. Consider that if he knew Picasso's work at all, his familiarity would have been limited to the pictures of the Blue and Rose periods. These hardly conform with Jarry's anarchic and vanguard tastes, either as a writer or sometime draftsman. The kind of in-your-face daring that might well have pleased Jarry developed in Picasso's work only in late 1906 and 1907. None of those works were exhibited before Jarry died, and nobody claims he ever visited Picasso's studio.

My own guess is that the tale told by Jacob was a fantasy extrapolated from accounts of the Raynal dinner (which was also attended by Apollinaire—though not Picasso—who left a report of it). In the course of that evening, the intoxicated Jarry became unaccountably angry at the Spanish artist Manolo, and fired his revolver wildly. The revolver was left behind as he was hurried out by friends, though it was returned to him some months later through the good offices of Apollinaire. The latter may himself have retrieved it following Jarry's death and given it to Picasso (if, indeed, *that* is the very revolver the painter possessed).

During Jarry's lifetime, he was a much more celebrated vanguard hero than Picasso. Jacob may have transformed the actual event into a symbol of his perfectly defensible notion that Picasso was the natural heir to Jarry in the following artistic generation. As in the case of some of Picasso's celebrated "lies" (for example, that he knew no tribal art before painting the *Demoiselles*), Jacob is here using his art to get to a higher truth. Had not Picasso himself called art "a lie that helps us understand the truth"?

116. See my essay "Picasso" in *"Primitivism" in Twentieth-Century Art*, p. 264.

117. In Johnson ("The *Demoiselles d'Avignon* and Dionysian Destruction," *Arts Magazine* [New York], vol. 55, no. 2 [October 1980], pp. 94–101, and "Picasso's *Demoiselles d'Avignon* and the Theatre of the Absurd") and in Leighten (*Re-Ordering the Universe: Picasso and Anarchism, 1897–1914* [Princeton, N.J.: Princeton University Press, 1989]; and "The White Peril and *L'Art Nègre*"), there is a slippery tendency to confound anarchic personal behavior (especially Picasso's) with anarchism. This "sleight-of-word" is put in the service of reinforcing, even exaggerating, Picasso's youthful brush with anarchist ideas—and the sympathy of some members of "the Picasso gang" for them—so as to propel anarchism into a major source and cause of Picasso's art. For a critique of Leighten's ideas in this regard, see Robert S. Lubar's review of Leighten's *Re-Ordering the Universe* in *The Art Bulletin* (New York), vol. 72 (September 1990), pp. 505–10. Leighten's overall argument in these texts, Lubar observes, "hinges precisely on a direct relationship between aesthetic radicalism and political radicalism." He argues, rightly, however, that "the aesthetic radicalism of *la bande Picasso*—their modernist idiom—exists in a deeply problematical relationship to … political developments, and cannot be reduced to a simple causative model."

118. While both Apollinaire and Jacob had seen sketches for the *Demoiselles,* they appear to have seen the altered large canvas only when it was finished. During the summer months of 1907, when Picasso was making the changes on the large canvas, the only documented visitor to the studio among Picasso's intimates was André Salmon (see note 64, above, and the Chronology entry under August 8, 1907). The studio jokes with *la bande Picasso*, to which the artist alluded, might have been related to the first, entirely "Iberian" version of the picture, in which the demoiselles all look the same, but more

logically dated from the autumn of 1907, by which time the picture was in its final state and Picasso's life had returned to normal (including the reconciliation with Fernande).

119. Leighten, "The White Peril and *L'Art Nègre*," pp. 609–30. See note 4, above.

120. See Arianna Stassinopoulos Huffington, *Picasso: Creator and Destroyer* (New York: Simon & Schuster, 1988), passim, and Carol Duncan, "The MoMA's Hot Mamas," *Art Journal* (New York), vol. 48, no. 2 (Summer 1989), pp. 171–78.

121. See above, note 4.

122. James D. Herbert (in *Fauve Painting: The Making of Cultural Politics* [New Haven, Conn., and London: Yale University Press, 1992], p. 176) makes an important qualification as regards the mentioned "address" of the prostitutes to the picture's viewer: "… while the direct gazes of the two central figures suggest reciprocal attention between viewer and depicted women, the impermeability of the mask-like heads at the edges close off all regular channels of human address."

123. Though this picture was reproduced in Zervos (V, 460), under the misleading title *Seated Woman*, it had never been seen publicly, nor was it known to friends of Picasso's alive at the time of his decease.

124. Palau i Fabre, *Picasso: The Early Years, 1881–1907*, p. 454.

125. During the winter of 1905–06, Matisse worked on *Le Bonheur de vivre* (fig. 10)—begun in all probability after the opening of the Salon d'Automne on October 18, 1905—in a space he had rented in the former Couvent des Oiseaux on the rue de Sèvres. He sent *Le Bonheur de vivre* as his "single submission" to the 1906 Salon des Indépendants, which opened on March 20 and closed on April 30 (see John Elderfield, *Matisse in the Collection of The Museum of Modern Art* [New York: The Museum of Modern Art, 1978], pp. 44, 180), where "because of its size, originality and brilliance of color, it created a furor" (Alfred H. Barr, Jr., *Matisse: His Art and His Public* [New York: The Museum of Modern Art, 1951], p. 82). Several weeks after the opening of the exhibition, Leo Stein, who had disliked the painting at first, but returned again and again to study it, announced to Maurice Sterne that "the big painting was the most important done in our time and proceeded to buy it" (ibid.). The exact date Picasso and Matisse met (they were introduced by the Steins) has not been fully established, but probably took place in April 1906, prior to Matisse's departure for Perpignan in early May, from there going to Algeria (May 10–26) and returning to Paris (at the end of May), and from there departing for Collioure (at the end of June), where he remained for the rest of the summer and early fall, until the beginning of October (see Claude Laugier and Isabelle Monod-Fontaine, "Élements de chronologie, 1904–1917," in Dominique Fourcade et al., *Henri Matisse, 1904–1917* [Paris: Musée National d'Art Moderne, Centre Georges Pompidou, 1993], p. 76). If Picasso did not see *Le Bonheur de vivre* in Matisse's studio, he unquestionably saw it at the Indépendants, for he

assured this author (as well as Daix) that he saw every Indépendants and Salon d'Automne that took place in Paris during his sojourns there until World War I (see Rubin, "From Narrative to 'Iconic' in Picasso," p. 621). Picasso remained in Paris until the beginning of May, when he left, together with Fernande, for Barcelona. In any case, he would see *Le Bonheur de vivre* again and again at the rue de Fleurus the following autumn and winter.

126.　Daix, *Picasso créateur*, p. 70.

127.　Steinberg, "The Philosophical Brothel" (part 1), p. 25.

128.　Steinberg (ibid., pp. 25–26, notes 22, 23) considers extensively the genealogy of the *porrón* in Picasso's work, and its function as a sexual symbol.

129.　Rosenblum, "The *Demoiselles d'Avignon* Revisited," p. 46. See also Spies on *The Turkish Bath* (note 109, above).

130.　Daix, *Picasso créateur*, p. 70.

131.　Ibid.

132.　Picasso had left Gertrude Stein's head unfinished—in fact, had painted it out—when he left for Gósol. Despite what Stein remembered as eighty or ninety sittings, he could not seem to catch her character and expression to his satisfaction. On his return from Gósol, without again consulting his model, Picasso painted Gertrude's head in the same sculptural Iberian style that we see in some of the last works executed in Gósol. While most of the picture remained a somewhat Redonesque version of Picasso's later Rose Period—still rooted in direct perception—the simplified head reflected the more purely conceptual way of working which Picasso adopted in the autumn of 1906. This depended on isolating a few telling essentials of the expression and—in a process not unrelated to caricature, of which Picasso was already a master—rebuilding the visage entirely from those, at the cost of the kind of detail we see elsewhere in the painting.

133.　Richardson, *A Life of Picasso*, vol. 1: *1881–1906*, p. 517, note 24, indicates that this was not an exhibition, but an installation in the Louvre of the newly acquired Iberian sculptures; and while the spring of 1906 is the date traditionally given for the installation, these objects may have been displayed as early as 1905 or even as soon as they arrived from Spain following their excavation at the Cerro de los Santos, Osuna, and Córdoba in 1902, 1903, and 1904; some were acquired from Pierre Paris.

134.　Leighten (*Re-Ordering the Universe*) notes that articles on the indigenous art of Catalonia were published in *Hispania* and *La Ilustració llevantina*, both revues that were accessible for perusal at Els Quatre Gats. More than offering models of simplified form, Leighten observes, "the Iberian images offered expressions of the earliest, most 'primitive' Spanish people about whom anything was known. Thought to have come to the peninsula from Africa beginning in about 3000 B.C., they were described by Roman writers as typically dark-complexioned, small-framed, hardy, wiry, alert and savage. (If Picasso was aware of this description, he would probably not have been displeased with its similarity to his own appearance.) Up to about the

fourth century B.C. the Iberians were settled in the southeast corner of Spain, centering in Andalusia and Murcia, but by the third century B.C., their culture had shifted in part to the valley of the Ebro river (corruption of Iberus), encompassing the lower part of Aragon and Catalonia. Thus Catalonia could claim ancestry back to the original Iberians, whose art expressed the purest Spanish or Catalonian spirit before the corruption of modern times" (pp. 79–80).

135.　By March 1907, Picasso had in his studio two Iberian sculpted heads (male and female) from Cerro de los Santos that he had purchased for a small sum from a man called Géry Pieret. What Picasso seemingly did not know at the time was that Géry Pieret, a Belgian adventurer and one-time secretary to Apollinaire, had stolen these heads (on two successive days that same month) from the Salle des Antiquités Ibériques at the Louvre, where they were on display with other Iberian pieces, and had first offered them to Apollinaire, who suggested Picasso might be interested in them. Four years later, when (on August 21, 1911) the *Mona Lisa* disappeared from the Louvre, the theft of the Iberian heads assumed a new importance, as Géry Pieret, who had just stolen another Iberian sculpture from the Louvre, brought it to the newspaper *Paris-Journal* to prove that anyone could burglarize the Louvre. The affair was made a sensation (Géry Pieret boasting about his thefts in *Paris-Journal* of September 6, 1911, in which he declared that he had chosen the male head [fig. 19]—subsequently sold to Picasso—because of its enormous ear, "a detail that seduced me"). Picasso, realizing the danger of keeping the heads and desperately afraid of being implicated, set about with Apollinaire to dispose of them by dropping them into the Seine. But failing to do so from fear of being followed, they finally restituted the sculptures through *Paris-Journal*, where, happily, Salmon worked as an art critic. Unfortunately for Apollinaire, Géry Pieret—who by that time was operating in Belgium under the name Baron Ignace d'Ormessan—wrote to the Louvre confessing to the theft of the *Mona Lisa* (which he had not committed), and the poet was arrested on the charge of complicity. He was released a few days later, after Géry Pieret wrote the Louvre yet another letter clearing Apollinaire of any culpability (see John Golding, *Cubism: A History and an Analysis, 1907–1914* [London: Faber & Faber, 1959], pp. 53–54; Daix, *Picasso créateur*, pp. 75, 100, 113; Daix, *La Vie de peintre de Pablo Picasso* [Paris: Seuil, 1977], p. 92, note 20; and Richardson, "Picasso Among Thieves," *Vanity Fair* [New York], vol. 56, no. 12 [December 1993], pp. 198–205, 224–27).

136.　Sweeney, "Picasso and Iberian Sculpture," p. 193.

137.　For a discussion of Picasso's possible early contacts with Rousseau's work, see my article "From Narrative to 'Iconic' in Picasso," pp. 620–22.

138.　I find no indications of any influence on Matisse of the tribal objects he began to collect in late 1906 prior to *Blue Nude* (fig. 11). The unfinished painting in which he illustrates what is probably the

first of these objects (see Jack Flam, "Matisse and the Fauves," in *"Primitivism" in Twentieth-Century Art*, pp. 214, 220–25) was probably executed late in 1906. Golding (*Cubism: A History and an Analysis 1907–1914*, pp. 139–40) sees the influence of African masks in the head of at least one figure in Derain's *Bathers* (now in The Museum of Modern Art; fig. 12), probably completed toward the end of 1906, though I find this argument unconvincing.

139.　Picasso had used that word with me to describe the plaster casts of Romanesque sculpture he had gone to see at the Musée de Sculpture Comparée on the occasion of his famous visit to the Musée d'Ethnographie du Trocadéro. He had been to the Musée de Sculpture Comparée before, and the fact that he was drawn back to an art considered "primitive" in those years is indicative of his predisposition to seek objects relevant to his needs (see my "Picasso," in *"Primitivism" in Twentieth-Century Art*, p. 254).

140.　For a discussion of this view of Polynesia, especially Tahiti, see my "Modernist Primitivism: An Introduction," in *"Primitivism" in Twentieth-Century Art*, pp. 6, 75, note 27.

141.　*There Is the Marae* of 1892 and *Tehamana Has Many Parents* of 1893; reproduced in Kirk Varnedoe, "Gauguin," in *"Primitivism" in Twentieth-Century Art*, pp. 193 and 188, respectively.

142.　Ron Johnson, "Primitivism in the Early Sculpture of Picasso," *Arts Magazine* (New York), vol. 49, no. 10 (June 1975), pp. 64–68.

143.　Barr, *Fifty Years*, p. 48.

144.　Ibid., pp. 48, 255, 256 (note to p. 48).

145.　Palau i Fabre, *Picasso: The Early Years, 1881–1907*, pp. 466–67.

146.　Steinberg, "The Philosophical Brothel" (part 2), p. 42.

147.　As I shall argue later, the robust eroticism that Steinberg sees at the heart of the *Demoiselles* seems to me a possible reading for the *Demoiselles* only as regards the first (Iberian) version of that large canvas. The changes Picasso subsequently made in three of the five figures belong in part, I believe, to a much darker view of sexuality, which is shadowed over by a concern with sickness and death.

148.　The student draws the curtain over the scene, proffers a skull, and carries a book, sometimes doing all three at once. The sailor is the passive receptor of the blandishments of the whores; he first looks at the student, later looks down at the cigarette he rolls, and finally—looking straight ahead—drapes his arm across the table.

149.　In the first sketch, the sailor is just slightly left of the vertical axis of the field and in the middle distance. Three of the prostitutes, and the draperies that close the space, are behind him; two prostitutes and the student (as well as the curtain he pulls) are in the foreground.

150.　Jill Harsin, *Policing Prostitution in Nineteenth-Century Paris* (Princeton, N.J.: Princeton University Press, 1985), p. 302.

151.　The glance of the sailor is more consistent with the sudden interruption of the scene by the student tugging the drapery closed than if we were to

imagine the latter as having already traversed the entire "stage" from right to left, as would have been the case were he opening it. Moreover, as observed below, the various gestures of the student, first with his left arm—and especially when he later uses both—make it clear that he is pulling the curtain from (our) left to right.

152. Barr, *Forty Years*, p. 60; text accompanying No. 68, Study for *Les Demoiselles d'Avignon* (Zervos II', 19), Kunstmuseum, Basel, then in the possession of the artist.

153. Romuald Dor de la Souchère, *Picasso à Antibes* (Paris: Fernand Hazan, 1960); English ed., *Picasso in Antibes* (New York: Pantheon Books, 1960, p. 19). This concurs with the statement made by Picasso in conversation with Kahnweiler on December 2, 1933, but not published by Kahnweiler until 1952 (in "Huit Entretiens avec Picasso," p. 24); see the section devoted to Kahnweiler in the Anthology, p. 235: "There must have been, according to my original idea, some men—in fact, you've seen the drawings. There was a student holding a skull. And a sailor...." As this is posterior to Barr's statement to the same effect in *Fifty Years*, Steinberg has suggested ("The Philosophical Brothel" [part 1], p. 28, note 5) that "the gist of Picasso's statement must have been known before its late publication in 1952." Barr may have gleaned this information from Picasso when he visited him in 1935 in connection with the exhibition "Cubism and Abstract Art," or, perhaps more likely, during the early summer of 1939, when Barr was in Paris to plan the exhibition "Picasso: Forty Years of His Art." This time, Picasso submitted "to a long interrogation together with Sabartés" (see Margaret Scolari Barr, "'Our Campaigns': 1930–1944," *The New Criterion* (New York), special number (Summer 1987), pp. 42, 56. See the Chronology in the present volume, pp. 191, 203–04.

154. In conversation with this author, who communicated the information to Steinberg, June 1, 1972 (incorporated into the latter's "The Philosophical Brothel" [part 2], pp. 38–39, and notes 29–32).

155. The lack of interest of the sailor in the temptresses that surround him was first discussed by Steinberg ("The Philosophical Brothel"). One possible explanation that suggests itself is that the scene is meant to take place *after* the sailor's sexual activity, as his subsequent rolling of a cigarette might hint at. But such a rationale is somewhat inconsistent with the efforts of the whores to arouse him and, as I propose below, there is a more logical motivation for his passivity.

156. The reading of the whore immediately to the sailor's right as seated on the sailor's knee was first suggested, to my knowledge, by Michael Leja ("'Le Vieux Marcheur' and 'Les Deux Risques': Picasso, Prostitution, Venereal Disease, and Maternity, 1899–1907," *Art History* [Oxford], vol. 8, no. 1 [March 1985], p. 75). It is consistent with a small number of Picasso's studies of the composition as a whole (such as fig. 48), all of them associated with the third (and last) incarnation of the sailor (in certain of the six-figure versions). Leja gives an amus-

ing imaginary account of the seven-figure ensemble studies as read in the light of "what we know of the operation of brothels ca. 1906": "A sailor is seated at a table in the principal room of the brothel; the women of the house have just entered and are competing for the account. The fact that the client is a sailor and that the women are entirely undressed marks this as a brothel of the lower strata. The women have surrounded the sailor, and each has assumed her favorite seductive posture in hopes of striking his fancy. One squats open-kneed before him, one sits at his side, later on his knee, another raises both elbows behind him, a fourth is just entering, a fifth stands at the right. At the same time, the agent of the *brigade des moeurs*, in the person of the medical student, is entering to conduct the weekly examinations of the women. He carries his record book.... A dog, the usual pet of the *maisons closes*, leaps at his feet." As Leja himself observes: "It would be foolish to press this realistic reading too hard."

157. As above, note 153.

158. As above, note 154.

159. Barr, *Fifty Years*, p. 57; in *Forty Years*, p. 60, the Basel study was described solely as "a scene of carnal pleasure."

160. Steinberg, "The Philosophical Brothel" (part 2), p. 59.

161. See below, p. 114 and note 303

162. Germaine Florentin (née Gargallo), who married Ramon Pichot in 1906 or 1907 (Richardson, *A Life of Picasso*, vol. 1: *1881–1906*, pp. 120, 161, 162, 214), was the girlfriend of Picasso's chum Carlos Casagemas and the ostensible cause of the latter's suicide, in February 1901; she was probably the nearest thing to a real-life *femme fatale* as Picasso would know. A notable tease (see Daix, *Picasso créateur*, pp. 39–40, 44, 198–99), Germaine was also one of Picasso's lovers and would remain associated in his mind with sexual exacerbation. She is evoked indirectly, by association with her husband, in *The Dance* of 1925 (Zervos V, 426), the nearest thing to a sequel of the *Demoiselles* in Picasso's oeuvre. In 1925, at the inception of the crisis in his relations with his wife, Olga, Picasso made two "exorcism" paintings, *The Embrace* (fig. 252) and *The Dance*, both of which recall the expressionist drawing and raw coloring of the *Demoiselles*. The three violently ecstatic women of *The Dance* are haunted by a mysterious black profile that Picasso identified to Roland Penrose as the image of Germaine's husband. (From notes about *The Three Dancers* made by Penrose after conversations with Picasso at Mougins January 29, 30, and 31, 1965, which were first published in *The Tate Gallery Report, 1964–65* [London, 1966], pp. 49–50.)

163. This lost mural is described by Sabartés in *Picasso: An Intimate Portrait*, translated from the Spanish (New York: Prentice-Hall, 1948), pp. 93–94.

164. Theodore Reff, "Themes of Love and Death in Picasso's Early Work," in John Golding and Roland Penrose, eds., *Picasso in Retrospect* (New York and Washington, D.C.: Praeger Publishers, 1973), p. 42.

165. See below, pp. 57–59, and notes 168, 169, 181.

166. Picasso's visit or visits to the hospital of Saint-

Lazare prison have frequently been cited. Some authors, for example, Palau i Fabre (*Picasso: The Early Years, 1881–1907*, p. 277), place it in 1901; others, such as Patrick O'Brian (*Pablo Ruiz Picasso* [New York: Putnam, 1976], p. 113), in 1902. Though Picasso remembered the name of Dr. Jullien, the syphilologist who oversaw his visit, it is unlikely that this doctor was a friend, as is often said. Pierre Daix (in conversation with this author) believes that the appointment was probably arranged through the good offices of an acquaintance of Jullien's, Olivier Sainsère, who was an early collector of Picasso. The Barcelona hospital visits are recounted by Palau (*Picasso i els seus amics catalans* [Barcelona: Editorial Aedes, 1971], pp. 126–27). They were arranged by Picasso's friend Dr. Cinto Reventós, brother of Ramón, who was an intern in gynecology in the Hospital de la Santa Creu i de Sant Pau, and who gave Picasso free run of the wards and morgue.

The prison of Saint-Lazare had had a hospital devoted to venereal diseases since 1836 (it was reorganized and enlarged in 1886). Almost half of the prison's inmates were prostitutes, many of whom were syphilitics, a substantial number of them congenital. In the early twentieth century, the hospital normally treated over one thousand of these each year (Eugène Pottet, *Histoire de Saint-Lazare, 1122–1912* [Paris, 1912], p. 52)—a small percentage of the approximately one million contagious syphilitics in France (a figure given for 1902 by the Institut Pasteur, see Alain Corbin, *Les Filles de noces: Misère sexuelle et prostitution—XIXème et XXème siècles* [Paris, 1978], p. 388). Among the incarcerated prostitutes, tertiary, bone-deforming syphilis was most visible in those serving long sentences for serious crimes.

167. Harsin, *Policing Prostitution*, pp. 257–58.

168. To the best of my knowledge, this possibility was first suggested by John Berger in 1965 (in *The Success and Failure of Picasso* [1965; New York: Pantheon, 1980], p. 43); Palau i Fabre proposes it in *Picasso: The Early Years, 1881–1907*, pp. 290–91. Berger also proposes, concerning the man with the skull: "It seems as likely to have been another private reference to Picasso's own recent fears about venereal disease."

169. Gedo, "Art as Exorcism," pp. 70–83. Gedo recounts (p. 77) a recollection by Françoise Gilot (from an interview of September 3, 1977) in which Gilot says Picasso mentioned to her having caught some sort of venereal disease, but that it had been cured before his marriage to Olga Khoklova in 1918. Gedo presumes (p. 83, note 55) that Picasso caught syphilis rather than gonorrhea "since the latter is a self-limiting disease," and the cure presumably followed the discovery of Salvarsan by Paul Ehrlich in 1909 (rather than 1910 as stated by Gedo). If, indeed, Picasso contracted any venereal disease, it was more likely to have been gonorrhea, which was treated as a local infection through cauterization or acid, and responded more readily than did syphilis to Salvarsan. The discovery of penicillin by Alexander Fleming in 1929 provided the basis of truly effective cures for both diseases.

235. "Acquired ulcerated syphilis in conjunction with tuber-culosis condition of the face." Colored wax model of a woman aged 37 years old, cast by Baretta, 1872. Courtesy the Musée de l'Hôpital Saint-Louis in Paris

236. "Acquired syphilis, destruction of the nose: this was an easily recognized and well-known stigmata of syphilis. Its social consequences were further accentuated, as many of these patients had an infection in the nasal tissue that result-ed in a malodorous breath so offensive that it was unbear-able to be in the same room with the patient. The condition was called 'Ozena,' meaning 'to stink.'" Photograph 1880. Courtesy the Burns Archives

237. "Congenital syphilis, hydrocephalic girl: syphilitic destruction of brain tissue occasionally caused blockage of cerebral-spinal fluid flow channels resulting in the classic pic-ture of hydrocephalus. Most of these syphilitic children ulti-mately died as the syphilitic gummas destroyed brain tissue. Mental retardation frequently accompanied congenital syphilis." Photograph c. 1890. Courtesy the Burns Archives

238. "Congenital syphilis, monocular blindness, and loss of nose: this case of *Syphiloderma Hereditaria* was halted by the liberal use of mercury compounds, but not before the girl had lost her nose, one eye, and part of her lip." Photograph 1901. Courtesy the Burns Archives

239. "Congenital syphilis, loss of lower face: most syphilitic babies suffer from 'snuffles,' a nasal inflammation that can progress to syphilitic destruction of the soft palate and nasal structure. Syphilitic gummas, chronic ulcerative nodules, and secondary infection continually eat away the face, resulting in the classic picture of hereditary facial syphilis." Photograph 1884. Courtesy the Burns Archives

240. "Congenital syphilis, destruction of central face: the most devastating result of congenital syphilis is the total destruction of the central face. Blindness and deafness usu-ally accompany the condition to (fortunately) spare the afflicted the reaction to their plight. It also spares them the awareness of further degeneration. Death results from infection in such cases." Photograph 1870. Courtesy the Burns Archives

170. I am indebted to David Lomas's challenging though seriously flawed "A Canon of Deformity: *Les Demoiselles d'Avignon* and Physical Anthropology" (*Art History* [Oxford], vol. 16, no. 3 [September 1993]) for pointing out an error in the identification of photographs of deforming skin lesions in my "Genèse des *Demoiselles d'Avignon*" (Musée Picasso, 1988) in time to correct these photographs in this updated English version. This time around, I have been able to clarify my discussion of the kind of syphilitic deformations of the head Picasso would have been able to see in his visits to Saint-Lazare (Paris) and Santa Creu i de Sant Pau (Barcelona), with the help in particular of Dr. Stanley Burns, possessor of what is widely recognized as the world's most comprehensive historical collection of medical photography of the nineteenth and early twentieth centuries.

In pointing out my error, Mr. Lomas—citing an 1889 book by the physical anthropologist Tarnowsky—made much of the "fact" that acquired syphilis "plays no role in the malformations of the head." Yet apart from the reality that acquired (as opposed to congenital) syphilis *did* in some cases involve such deformations (figs. 235, 236), gross distortions of the cranial anatomy were entirely characteristic of the advanced stages of congenital syphilis, of which there were numerous examples among the prostitutes (sometimes incarcerated with their children) in the hospitals Picasso visited. I cannot, therefore, see that the photography error undermined in the least my thesis that these cranial horrors were an active constituent of Picasso's memory bank at the moment that—in the head of the squatting demoiselle on the painting's right—the artist wished to express feelings of horror and revulsion. That particular demoiselle's (definitive) form "invokes" (as I held), quite without illustrating, the atrocious deformations which Picasso had seen.

Dr. Burns, whose archive numbers over 35,000 original medical photographs of 1839-1939, is the author of one of the rare attempts to frustrate the loss and destruction of this medical photographic heritage (The College of Physicians of Philadelphia is another, and we are beholden to Gretchen Worden, its Director). The photographs reproduced here (figs. 236–40) are from the corpus that Dr. Burns has taken a lead in salvaging—in this case, images of syphilitic deformations that have disappeared from pathology since the work of doctors Ehrlich and Fleming. In addition to the captions, I asked Dr. Burns to write a short summary of the syphilitic disfigurements, in particular of the head, at the turn of the century:

Syphilis was known as the "great mimicker" because its signs and symptoms could be confused with every known disease from cancer to nutritional deficiencies. In advanced cases, symptoms might involve cutaneous, oral, skeletal, cardiovascular, neural, and visceral organs. In the congenital form of the disease about a quarter of the fetuses died in utero, another quarter died shortly after birth. Common symptoms of congenital syphilis included rhinitis, which would develop into a serious destructive process of the nose and face.

The classic picture of the "saddle nose" and, at times, complete destruction of the central face resulted [fig. 240]. Other symptoms included paralysis of the facial nerves and corneal inflammation advancing at times to blindness [fig. 238]. Deafness was common. Bony head deformities involving asymmetry and irregular development were present in over three-quarters of congenital-type cases; a thickened prominent forehead was produced by bony overgrowth ("parrot bossings"); mandibular protuberance is evident in about a quarter of the cases. Hydrocephalus and other gruesome head deformities were not uncommon [fig. 237]. Gumma nodular inflammatory response ate into bones causing cavities and major deformities [figs. 236, 239, 240]. Other classic symptoms—skin rashes, foot ulcerations, notched teeth, "sabre shins," and dozens of other defects—were noted. Prior to chemotherapeutic treatment (Salvarsan 1909) and antibiotics (Penicillin 1944), advanced congenital syphilis cases were very common.

Several methods of visual representation were available to physicians studying disease in the nineteenth century. Three-dimensional works included actual preserved pathological specimens (heads were particularly popular), wax and papier-mâché models, and painted cast moldings called "moulages" [see fig. 242]. Two-dimensional portrayal by artists, print makers, and engravers allowed for book reproductions. Photography, introduced in 1839, being the most inherently credible evidence, gradually became the standard of medical documentation. For centuries before that, "medical museums" containing specimens as well as art and artisanal reproductions had been the backbone and pride of institutions and private physicians. Little of this survives today. Thousands of medical specimens and "art works" were destroyed as educational methods changed and diseases were conquered. Photography had allowed every physician to make his own case documentation. But as with the "medical museum" specimens, photographs were destroyed, as conventions changed, especially as modern ideas of social consciousness about patient privacy ascended. But more importantly, as diseases were conquered, photographs of the diseased and deformed — not considered aesthetically pleasing, and thus not worth saving — were thrown out, given away, and sold cheaply, having become, medically speaking, impractical excess baggage. Some of the rarest medical photographs I have retrieved were purchased from flea markets.

171. Corbin, *Les Filles de noces*, p. 386.

172. Ibid.

173. Ibid., p. 395.

174. The mythology of the source of syphilis—as opposed to other venereal diseases known already in the ancient world (for example, what is translated from Aristotle as "the pox")—is, as might be expected, contradictory. Some thought it was brought from the New World by Columbus; others blamed the early traders and explorers of Africa. Syphilis was called "the Spanish disease" by Italians, "the Naples illness" by the French, and "the malady of France" by Shakespeare. While many French blamed Africa, others, critical of colonialism, considered that the French themselves were responsible for spreading the disease through much of Africa.

175. Corbin, *Les Filles de noces*, p. 389.

176. See note 170, above.

177. No study exists on the subject of these "museums," some of which were admonitory in purpose, and which relied largely on photographs, hand-drawn illustrations, color plates, and in some cases, colored wax or tinted plaster casts, and projected images. The most extensive syphilogical museum in France was the so-called Musée Anatomo-Pathologique of the Hôpital Saint-Louis in Paris. This museum was founded in 1865 as a teaching instrument, and was available only to professionals. Its most impressive collection was a series of more than 1,800 tinted wax casts of dermatological and syphilitic conditions made from patients between 1867 and 1894 by the official *mouleur* and first curator of the museum, Jules Baretta (see fig. 235). Some of Baretta's work evidently found its way into the popular museums. Perhaps the most ambitious of the popular museums was the "Grand Musée d'Anatomie et d'Hygiène" of one "Doctor" Pierre Spitzner, which opened on what is now the place de la République in 1856, and which boasted a number of casts by Baretta, as well as other well-known *mouleurs*, such as Vasseur and Zeller. Something of a cross between a freak show (fig. 241) and a hospital museum (it contained, aside from its models of venereal infections, fig. 242, casts of Siamese twins, heads of celebrated *guillotinés*, and "ethnological molds"), Doctor Spitzner's museum became itinerant following a fire in its building sometime in the 1880s. It is known to have been a feature of fairs in many major European cities and ceased to circulate only in 1940. The section devoted to venereal deformities was considerable. According to George Achten (in the exhibition catalogue *Grand Musée anatomique du docteur Spitzner* [Brussels: Musée d'Ixelles, June 28–September 16, 1979], p. 19): "From the scientific point of view, the reproduction of the lesions is so realistic that this collection could still today be used for objective courses on venereal diseases.… Hence their historical meaning, even for a specialized doctor who could observe, in the case of syphilis, certain lesions which have today disappeared from the pathological domain." I am extremely grateful to Hélène Seckel for having called my attention to Spitzner and his museum.

178. Alain Corbin, "Commercial Sexuality in Nineteenth-Century France: A System of Images and Regulations," *Representations* (Berkeley), no. 14 (Spring 1986), p. 211.

179. See below, pp. 115–16.

180. First reproduced in the exhibition catalogue *Picasso: An American Tribute*, ed. John Richardson (New York: Public Education Association of the City of New York; Chanticleer Press, 1962), no. 8.

181. The statement of mine excerpted by Steinberg was the fruit of the first occasion when I was able to speak of the *Demoiselles* with Picasso. On a later occasion I showed him a photocopy of *Self-Portrait* and asked Picasso if it was not very similar to the drawings of the medical student in the carnet he had earlier shown me. According to my notes,

Museum of Modern Art (fig. 41), and the lost seven-figure oil (fig. 39), where the *porrón* has a very long spout, and they remain in their places in those six-figure studies in which still-life indications are given (the summary form of the pitcher throughout is a kind of cylinder). When the higher table disappears, along with the sailor, in the five-figure Philadelphia version (fig. 49), the *porrón* is shifted to the low table, which also contains some small fruits, the pitcher of flowers disappearing in order to make room. In the large canvas, the slices of watermelon replace the *porrón* (did Picasso think the latter motif was too obvious?) though their sharply pointed forms satisfy some of the same compositional and symbolic purposes.

206. If we accept the 1947 account of Leo Stein, Picasso had to have mounted his canvas prior to June 9, the date at which "all four Steins" (Gertrude, Michael, Sarah, and presumably Leo, according to Mary Berenson's diary for June 9, 1907, though she does not mention Leo by name) were in Florence—Gertrude and presumably Leo having left Paris on or just before May 24 for Florence to stay at Casa Ricci for the summer; she would return to Paris sometime between September 2 and 7. The first mention of Leo actually in residence in Florence in the summer of 1907 is in Mary Berenson's diary, June 14, 1907.

Leo Stein recounts seeing Picasso at a time when the large canvas was stretched but not yet painted upon. He ridicules the artist for treating the picture as a "classic" by "relining" a canvas that he had not yet even painted. "Picasso was pleasantly childlike at times. I had some pictures relined, and Picasso decided that he would have one of his pictures too treated like a classic, though in reverse order—he would have the canvas lined first and paint on it afterwards. This he did on a large scale, and painted a composition of nudes of the pink period, and then he repainted it again and again and finally left it as the horrible mess which was called, for reasons I never heard, the Demoiselles d'Avignon" (Leo Stein, *Appreciation*, p. 175).

As there is no way Stein could have known that Picasso reinforced this large canvas with an extra lining, except through the artist himself—if, indeed, that was the case—the procedure would obviously have had to be discussed at the rue Ravignan sometime before Leo's and Gertrude's departure. Albert Albano, The Museum of Modern Art's painting conservator in 1987, pointed out to me that the term "relining" is frequently used incorrectly in that it often means not that the picture is being *re*lined but that it is being lined for the first time "by means of a fabric attached to the back of the original canvas." Albano had found no physical evidence *in the canvas's present state* to confirm Leo Stein's statement that Picasso lined his canvas prior to painting on it. There is, however, no report available of work done by restorers when the painting, rolled at the time, was mounted on a stretcher following its sale to Jacques Doucet. It seems to me very probable that Picasso had stretched his canvas with another canvas doubling it, but *not* adhered to it as in lining or relining. This would have been done

to protect and stiffen, in the sense of reinforcing, the large primary canvas. Leo Stein, not wise in the ways of painters, may well have misunderstood what Picasso was about.

207. See my "From Narrative to 'Iconic' in Picasso," pp. 623–27.

208. In a study written in 1971 examining Picasso's enthusiasm for the circus in the Rose Period, Theodore Reff ("Picasso and the Circus," in *Essays in Archaeology and the Humanities: In Memoriam Otto J. Brendel* [Mainz: Philipp von Zabern, 1976], pp. 237–48) observed that the type of compositional study showing frontal, stiff, compressed figures caught in motionless introspection, as in *Family of Saltimbanques* of 1905 (fig. 97), derived from popular commercial photographs of members of circus "families" assembled for a group portrait, such studio portraits of celebrated circus troupes being widely reproduced at the time (p. 245). See also Carmean, *Picasso: The Saltimbanques*, pp. 65–69; and my "From Narrative to 'Iconic' in Picasso," pp. 626–27.

Michael Leja proposed that the presentation adopted by Picasso in his final version of the *Demoiselles*—"a group of prostitutes in poses signifying solicitation directly addressing the viewer"—was a common one in contemporary erotic and pornographic photography, and he reproduced two examples drawn from the turn of the century, portraying what he terms the "encounter motif" in which the "(male) viewer functions as the patron of the brothel" (Leja, "'Le Vieux Marcheur' and 'Les Deux Risques,'" pp. 76–77, pls. 37, 38). I have chosen a different but comparable photograph (fig. 99), one of several taken by Toulouse-Lautrec's friend François Gauzi in the 1890s, showing a group of six prostitutes, seated or standing in seductive postures in the principal room of rue des Moulins—one of the brothels frequented by Toulouse-Lautrec and in which he spent periods of residence. Mireille, one of the painter's models, is seated on the extreme left. Of the two photographs selected by Leja (both by unknown photographers, c. 1900, one reproduced from *Le Nu* of 1900 by Philippe Julian, the other from *Victorian Erotic Photography* by Graham Ovenden), the latter example illustrates a tendency in this genre which, he believes, "may relate to the *Demoiselles*," namely the titillation "through coupling sexuality with bestiality and death in a distinctly Decadent manner" (five nude women cavorting in a lavishly furnished *cabinet* decorated with trophies of the hunt). "While the photograph celebrates cavalier gaiety in the face of death and decay," Leja observes, there is on the other hand "no frivolity in the *Demoiselles* to temper the deadly seriousness of the threats, real and imminent, which the women symbolize.... Its [the painting's] thrust is diametrically opposed to that of the photograph. Unlike the latter, where the emphasis is on titillation, the *Demoiselles* concentrates upon evocation of the reality of danger, danger not contextual but inherent" (ibid., p. 77). I am indebted to Peter Galassi for bringing the photograph by François Gauzi to my attention, and to Beth Gates-Warren

for providing a print.

209. The radiograph is published in Carmean, *Picasso: The Saltimbanques*, pp. 66–73, figs. 85, 88, 89, 90, 91, 93. Carmean (p. 74 and fig. 102) points out that a photograph of *Family of Saltimbanques* (fig. 97) made prior to the reduction in size of the work and reproduced on the cover of *Art News* for February 21, 1931, shows the painting in its initial larger size as having been more nearly square. See my "From Narrative to 'Iconic' in Picasso," pp. 626–27, for a detailed review of the shift in format toward the vertical.

210. The photograph of André Derain in his studio at 22, rue Tourlaque, in Montmartre (see fig. 5 in the Chronology), in which the reproduction of Cézanne's *Five Bathers* (fig. 9) may be seen on the wall, was taken by Gelett Burgess in the spring of 1908 for his article on Picasso and the Fauves, "The Wild Men of Paris," published in the May 1910 issue of *The Architectural Record*, where it is reproduced on p. 414.

211. In an interesting, if finally inconclusive discussion of the sexual ambiguity that sometimes characterizes this demoiselle—the masculine appearance in fig. 102 for example—David Lomas ("A Canon of Deformity: *Les Demoiselles d'Avignon* and Physical Anthropology") connects, correctly, I believe, the choice of Michelangelo as a source with the masculinity in Michelangelo of even women. Since the *Dying Slave* was a favorite of Cézanne, it may be that the theme of sexual ambiguity throws some light on Picasso's seemingly cryptic remark about Cézanne (see p. 98).

212. See Rubin, *Picasso in the Collection of The Museum of Modern Art*, p. 221, note 2: reference to Robert Rosenblum, who drew my attention to this particular interior profile, which Picasso was subsequently to isolate and stylize as the "double head."

213. See note 21, above.

214. Rosenblum, "The *Demoiselles d'Avignon* Revisited," p. 47.

215. See ill. 12 in Daix, "L'Historique des *Demoiselles d'Avignon* révisé à l'aide des carnets de Picasso," p. 498. See also Werner Spies, "Picasso: L'Histoire dans l'atelier."

216. See Daix, "L'Historique des *Demoiselles d'Avignon* révisé à l'aide des carnets de Picasso," pp. 536–37.

217. Golding, "The *Demoiselles d'Avignon*," p. 161. The radiographs mentioned by Golding, were taken in April 1950 for The Museum of Modern Art at the instigation of Alfred Barr for a proposed revised edition of *Picasso: Fifty Years of His Art*, a revision on which he worked during the early 1950s but never completed.

218. Golding's association (in his article "The *Demoiselles d'Avignon*") of the curtain-puller's head at the left with a Dan mask (fig. 192) that he called a "characteristic form of Negro mask, found particularly on the Ivory Coast," was put to question in my essay "Picasso" (in *"Primitivism" in Twentieth-Century Art*, p. 263). Golding did not, of course, imply that the particular mask he illustrated was the mask Picasso saw. But apart from the fact that the

piece in question did not enter the Musée de l'Homme's collection until 1952, *no* such masks are known to have reached Paris until the period of the inter-war years (1918–39); the earliest to enter the collection of the Musée de l'Homme (then known as the Musée d'Ethnographie du Trocadéro) arrived only in 1931.

219. To Malraux, who cited the statement in *La Tête d'obsidienne*, pp. 116–17: "Il fallait bien le mettre de travers ["sideways"], pour le nommer, l'appeler: nez." This association of the profile nose with the *Demoiselles*, was also reported by Kahnweiler (in *Mes Galeries et mes peintres: Entretiens avec Francis Crémieux* [Paris: Gallimard, 1961], p. 83), who quoted the artist as saying: "In those days people said that I made the noses sideways, even in *Les Demoiselles d'Avignon*, but I had to make the nose sideways so they would see that it was a nose." The assimilation of the nose with a "signe plastique" intended to stand for it ideographically was a recurring subject in Picasso's conversation. See, for instance, Leo Stein, *Appreciation*, p. 205: "Picasso thought it a fault that Cézanne and Renoir made use of real noses, when in truth, only unreal noses were really real." Kahnweiler (in his *Confessions esthétiques* [Paris: Gallimard, 1963], pp. 125–26), recalled a conversation of November 9, 1944, in which Picasso told him: "But I did that oblique nose [i.e., profile nose in a frontal face] that way on purpose. You understand, I did it in such a way that [people] would be obliged to see a nose. Later, they saw, or they will see, that it is not oblique. What had to be avoided was that they should continue to see nothing but 'attractive harmonies' or 'exquisite colors.'"

220. For earlier remarks concerning Matisse's *Marguerite* (fig. 194) as an "agent of simplification" as best illustrating "Matisse's generalized primitivism" (in explanation of Picasso's choice of this portrait), see "Picasso" (in *"Primitivism" in Twentieth-Century Art*, pp. 291, 338, note 130); and "From Narrative to 'Iconic' in Picasso," p. 619, note 16.

According to Pierre Daix (*Picasso créateur*, pp. 81, 402, note 12), the exchange between Picasso—selecting the portrait *Marguerite*—and Matisse, choosing the still life *Pitcher, Bowl, and Lemon* of 1907 (Zervos XXVI, 267), took place in the autumn of 1907. Gertrude Stein maliciously (and wrong-headedly, as concerns motivations) described the exchange (in *The Autobiography of Alice B. Toklas*, p. 64): "They exchanged pictures as was the habit in those days. Each painter chose the one of the other one that presumably interested him the most. Matisse and Picasso chose each one of the other one the picture that was undoubtedly the least interesting either of them had done. Later each one used it as an example, the picture he had chosen, of the weaknesses of the other one."

221. While Wilhelm Uhde did not, to our knowledge, utilize the terms "Egyptian" or "Assyrian" in his own writing about the *Demoiselles* (1928 and 1938), he was quoted by Kahnweiler, on several occasions, as having spoken to him about the picture in precisely those terms. Kahnweiler was not always consistent in his recollections, as we shall see. In a

lecture he delivered October 23, 1947, at the University of Freiburg im Breisgau (printed in French in *Les Maîtres de la peinture française contemporaine*, ed. Maurice Jardot and Kurt Martins [Baden-Baden: Woldemar Klein, 1949], p. 14), Kahnweiler recalled: "In March 1907, my good friend Wilhelm Uhde, who died in the summer of 1947, told me he had seen in Picasso's studio a recent, large painting that he found astonishing. He found it strange, a bit Egyptian, he said, to give me some idea of it" (see the Anthology, pp. 237, 255). Subsequently, however, Kahnweiler was to substitute "Assyrian" for "Egyptian." He told Georges Bernier in 1955 ("Du temps que les cubistes étaient jeunes: Un Entretien au magnétophone avec Daniel-Henry Kahnweiler," an interview by Georges Bernier published in *L'Oeil* [Paris and Lausanne], no. 1 [January 15, 1955], p. 28): "Shortly after the opening of my gallery, I made the acquaintance of Wilhelm Uhde, who already knew Picasso. He told me that the latter had just painted an entirely strange picture, 'something of the Assyrian in it'" (see the Anthology, p. 238). In an article published that same year ("Cubism: The Creative Years," p. 108), Kahnweiler retained the "Assyrian" attribute: "… Picasso, [Uhde] said, was at work on a strange, huge picture which, he added, had an 'Assyrian' look"; as he also did in his subsequent *My Galleries and Painters*, pp. 37–38, "… it was he [Uhde] who first told me about a strange picture that the painter Picasso was working on. A picture, he said, that looked Assyrian…" Nevertheless, when he was interviewed by Brassaï, some time during the 1960s (published in Brassaï, *The Artists of My Life*, translated from the French by Richard Miller [New York: Viking, 1982], p. 206), Kahnweiler told him: "I didn't find the canvas 'Assyrian' at all, but monstrous, horrid!" (Understandable, of course, but contrary to Kahnweiler's claims elsewhere to have been a champion of the *Demoiselles* from the beginning; see the Anthology, p. 240.) The interchangeability of "Egyptian" and "Assyrian" and their use as a surrogate for "primitive"—or as applicable to any art tending to the exotic, highly static, geometrical, frontal art of the Egyptians—is characteristic of late nineteenth-century critical vocabulary of form. It is the "memory-image" aspect of archaic court painting that is being brought into play here by Uhde and Kahnweiler.

222. Rousseau's often quoted remark was first reported by Fernande Olivier (*Picasso et ses amis* [Paris: Stock, 1933], p. 113; English ed., *Picasso and His Friends* [New York: Appleton-Century, 1965], p. 92): "He [Rousseau] used to say to Picasso, 'We are the two great painters of the age; you paint in the "Egyptian" style, I in the modern.'" Rousseau probably had in mind the frontal eye in the profile head of the Egyptianizing left-hand demoiselle. Moreover, Rousseau's association of Picasso's "Africanism" or "primitivizing" in general to Egyptian art is not illogical when considered in the context of late nineteenth-century connotations of the term *primitif*, for the word "Egyptian" had become a surrogate for "primitive" in the critical jar-

gon (and remained so until the latter took on its tribal connotation in the years just prior to World War I). For a discussion of the friendship between Rousseau and Picasso, Rousseau's influence on Picasso, and the latter's celebration of Rousseau, see my "Picasso" (in *"Primitivism" in Twentieth-Century Art*, pp. 290–95, 338 notes 128–36); and "From Narrative to 'Iconic' in Picasso," pp. 620–22; and Carolyn Lanchner and Rubin, "Henri Rousseau and Modernism" (in *Henri Rousseau* [Paris: Réunion des Musées Nationaux, 1984; New York: The Museum of Modern Art, 1985]).

223. In order to date the photograph accurately it would be necessary to know Dolly's precise age at the time. Mlle van Dongen died on September 4, 1987. Mme van der Klip, Dolly's companion in old age, informed us that she was born in Paris on April 18, 1905. If Picasso took the photograph in the summer of 1907, she would have been a little over two years old.

224. In her article "When Did Picasso Complete *Les Demoiselles d'Avignon*?" (*Zeitschrift für Kunstgeschichte* [Munich], vol. 48, no. 1 [1985], pp. 256–64), Britta Martensen-Larsen argues for a range of much later dates than ever previously proposed for the various changes made by Picasso in the Iberian laying in of the large canvas (see note 67, above). Her different theses not only contradict (by years) the dating on the carnets (to which she had no access) but repose on a reading of two photographs reproduced here. First, a photograph in which we see young Dolly van Dongen and her mother, Guus, standing before the *Demoiselles* (fig. 232), which was taken by Picasso (a print of which was preserved by Mlle van Dongen). Martensen-Larsen dates this photograph 1907 and asserts that it is our earliest such document of the *Demoiselles*. This may be, but everything depends on one's reading of a very inadequate image. It is also possible that Picasso made this photo late in 1907, after stopping work on the picture—or even in early 1908—the date of the earliest other studio photographs made by Picasso, who is thought by some (incorrectly, I believe) to have acquired his camera only early that year. The second image on which Martensen-Larsen's text depends is the halftone reproduction in Burgess's article in *The Architectural Record* (fig. 244), made from a photograph taken by the American in Picasso's studio in the spring of 1908, as we now know (see note 60, above, and the Chronology, pp. 155–56).

Apart from her problems in relation to the carnets, not one of Martensen-Larsen's seemingly revolutionary conclusions about dating can survive a critique of the photographic documents on which she based them—to whose limitations she is seemingly oblivious in her text. For the van Dongen photograph, she worked from a halftone reproduction (published in Michel Hoog, "*Les Demoiselles d'Avignon* et la peinture à Paris en 1907–08," *Gazette des beaux-arts* [Paris], vol. 82 [October 1973], p. 212, fig. 5)—with all the loss of definition this implies—which was furthermore incomplete (compare her reproduction of the photograph with that illustrated here). But far more important, she failed to note

Rosenberg," *L'Europe nouvelle* (Paris), vol. 2, no. 3 (January 18, 1919), p. 139: "At the same period [that of the *Demoiselles*], Picasso executed a portrait of me in charcoal which was a preparatory study for a statuette in wood that he was yet to carve. [This was never executed.] This work, together with the large painting in question [the *Demoiselles*], is at the foundation of Cubism."

287. Gopnik, "High and Low: Caricature, Primitivism, and the Cubist Portrait," p. 375.

288. During his stay at Gósol with Fernande, in the spring and summer of 1906, Picasso made a number of studies of the innkeeper Josep Fontdevila, whom Fernande Olivier described as follows: "An old man of ninety, who had once been a smuggler, wanted very much to follow Picasso to Paris. A proud old man, extraordinarily beautiful in a strange, wild way, he still had all his hair and his teeth, which were worn right away but still brilliantly white. Mean and cantankerous with everybody, he was never in a good humor except when he was with Picasso, who did a drawing of him which is an excellent likeness" (*Picasso and His Friends*, p. 94). The most notable characteristics of his face were prominent cheekbones, "exaggeratedly accentuated by Picasso, as though he were trying to make the face explode from within" (Palau i Fabre, *Picasso: The Early Years, 1881–1907*, p. 426; Palau reproduces seven works relating to the innkeeper). The image of the old man was to follow Picasso, to haunt him after he returned to Paris straight through the period of the *Demoiselles,* and gradually become amalgamated with that of Salmon. See Daix ("L'Historique des *Demoiselles d'Avignon* révisé à l'aide des carnets de Picasso," pp. 517, 532), who discusses the fusion of Fontdevila with Salmon.

289. Gopnik, "High and Low: Caricature, Primitivism, and the Cubist Portrait," p. 373.

290. Ibid., p. 374 (emphasis added).

291. That this is the proper reading for the form I take to be the arm is confirmed by a gouache study for that demoiselle as a "dancing" figure (fig. 250).

292. Albert Albano, memorandum to the present author, May 7, 1987, p. 1. Collection files, Department of Painting and Sculpture, The Museum of Modern Art, New York.

293. John Nash, "Pygmalion and Medusa," pp. 11–12: "They were interesting and unmistakable studies for the uncouth mask Picasso abruptly gave this squatting figure after the picture was half finished …"; the drawings were subsequently reproduced and discussed by him as part of his published book (*Cubism, Futurism, and Constructivism,* pp. 12–15).

294. Anatoli Podoksik (in *Picasso: Enquête continuelle*, French translation by Georges Krassovski from the Russian [Leningrad: Aurora, 1989], p. 162) wrongly suggests a filiation of these drawings from the heads (such as Zervos VI, 966) related to the figure of an old man that emerged from a fusion of studies for the portrait of Salmon (fig. 217) and recollections of the old Gósol innkeeper Josep Fontdevila (figs. 213, 214). But heads like Zervos VI, 966, while containing the salient cheeks of

250. *Study for Female Figure.* Paris, 1907. Watercolor and gouache on paper, 24⅞ x 18⅞" (63 x 48 cm). Collection Mr. and Mrs. Rolf Weinberg, Zurich

Fontdevila, have much more of the elongated lantern jaw and pronounced brow of the Salmon variations and, of all these qualities, *only* the elongation is shared with the heads of the squatter (figs. 188, 189). Moreover, the dominant element there is the novel shift of the nose in contrapposto to the head, a decision which moves these studies a great distance away from any of the Fontdevila/Salmon material.

295. In "Histoire anecdotique du cubisme," pp. 48, 51; and in "Mouvement des idées: Origines et intentions du cubisme," *Demain* (Paris), no. 68 (April 26, 1919), p. 489 (reprinted in Salmon, *L'Art vivant* [Paris: G. Crès, 1920], p. 119). See the section devoted to Salmon in the Anthology, pp. 245, 247.

296. Stein, *The Autobiography of Alice B. Toklas,* p. 22. See the section devoted to Gertrude Stein in the Anthology, p. 252.

297. Burgess, "The Wild Men of Paris," p. 408. See the section devoted to Burgess in the Anthology, p. 230. The appearance of this text in 1910 is the *only* occasion I know where Picasso reacted *at all* to a critical text—the artist bringing the article to the attention of his friends. In a postcard of June 19, 1910, addressed to Leo Stein in Fiesole, Picasso informs him about the May issue of the American review *The Architectural Record*, which has published the portraits of the Fauves: "I think you could find it in Italy; they will make you laugh awhile." He also advises Leo Stein that if he is unable to find it there, he should write the author—"Gelett Burgess. The Players' Club, New York City U.S.A."—for a copy (Collection of American Literature, The Beinecke Rare Book and Manuscript Library, Yale University, New Haven, Connecticut). See the Chronology under June 19, 1910, pp. 159–60. And Fernande Olivier, two days earlier, June 17, 1910, had written

to Gertrude: "Pablo has received that review from America, for which there came two years ago a reporter who made his portrait and reproductions…. There is a very long *very american* article." See the Chronology, p. 159, for a more extensive citation of this letter.

298. Steinberg, "The Philosophical Brothel" (part 2), p. 43.

299. Rubin, "From Narrative to 'Iconic' in Picasso," p. 635.

300. The statement, which Nash included in the first draft for his 1970 B.B.C. Radio 3 talk, but did not utilize in the "as broadcast" version ("Pygmalion and Medusa"), reads as follows: "The violence and savagery of the *Demoiselles d'Avignon* springs from a savage aggression grappling with a profound fear of a comparative aggressiveness in the female. Woman is destroyed, made hideous and reconstructed in a controllable medium."

301. Nash, 1970 B.B.C. Radio 3 Talk, "as broadcast" script ("Pygmalion and Medusa"), pp. 11–12; and *Cubism, Futurism, and Constructivism*, p. 13.

302. Nash, essay version of 1983 of his "Pygmalion and Medusa" lecture, p. 22.

303. Bois's long and penetrating article ("Painting as Trauma," *Art in America* [New York], vol. 76, no. 6 [June 1988], pp. 130–41, 172–73) was by far the most serious review engendered by the Musée Picasso's exhibition and catalogue. Elaborating on my reference to fear of castration in relation to the *Demoiselles*, Bois developed his discussion of the "castration complex" in the context of Freud's text on the Medusa head, which had been seized upon earlier by Nash. "The Medusa (castration) metaphor is, in fact," Bois concluded, "the one that, in the evolution of the *Demoiselles*, best accounts for the suppression of allegory, on one hand, and, on the other, the apotropaic brutality of the finished picture" (p. 138).

At about the same time as Bois's review, Jean Clair (pen name of Gérard Régnier, presently director of the Musée Picasso, Paris) published an arresting and provocative short book, titled *Klimt et Picasso en 1907* (Paris: Gallimard, 1988), in which he compared a range of Klimt's relatively explicit confrontations of the Medusa myth with Picasso's implicit one in the *Demoiselles*. Clair analyzed Klimt's *Portrait of Adele Bloch-Bauer I* (fig. 251)— "the model of the mutilated woman and [the artist's] own mistress"—in whom he sees Klimt discovering "a possible incarnation of the Gorgon, the deadly woman who could not only petrify/paralyse [*méduser*] but cut off a man's head…" (p. 98). Klimt, Clair suggested, turned all Adele's hypnotic force back on her. "And without doubt," he continued, "all the difference between Klimt and Picasso lies there. The former uses all the normative powers of a style, all the Secessionist willingness to tolerate the multiplication of decorative aggregates, in order to ward off the malefic spell, the 'malocchio' [evil eye], the 'gettatrice' [curse-throwing] aspect of his model, to whom he is tied by close but secret links. He paints her so that only her face emerges, disengaging itself from the abstract-decorative apparatus, so that

251. Gustav Klimt. *Adele Bloch-Bauer I.* 1907. Oil and gold on canvas, 54 ¼ x 54 ¼" (138 x 138 cm). Österreichische Galerie, Vienna

the entire picture becomes, in effect, a mimetic shield, a reflection of the conjuring Medusa. Picasso, however, in confronting the same peril, looking upon a scene of banal prostitution, dislocates the whole of the system of representation, abandons the recourse to any style, rejects the resources of an abstract apparatus…. In contrast to the Klimt, it is precisely the faces [in the *Demoiselles*] which cease to be visages of flesh, denuded as they are, bare, stripped to the quick: Picasso makes *masks* of them, hiding the real faces of flesh of these effigies, whose features will be forever fixed in the expression, the grin, the rictus, the caricature—the expressive overload demanded by the ritual of exorcism" (p. 106). (Translated by Christel Hollevoet.)

In 1989, Clair also published *Medusa:*

Contribution à une anthropologie des arts du visuel, an extraordinary iconological study of the Medusa's image throughout history, viewed from the psychological, sociological, and philosophic—as well as art-historical—points of view. (For an entry on that book, see note 200, above.)

304. See the present author's *Picasso in the Collection of The Museum of Modern Art,* p. 132, for a reference to the themes of sexuality and aggression—the praying mantis who devours her mate as the climax of the sexual act—as epitomized in the *Seated Bather* of early 1930. The years 1929–31 saw the culmination of a variety of conceptions that portray Olga (as a result of the deteriorating relations between her and Picasso) as a kind of bone-hard, sharp-edged predatory monster, a violence that began in 1925 with *The Embrace* (fig. 252) and was summarized in the *Seated Bather* of 1930. See also Robert Rosenblum, "Picasso and the Anatomy of Eroticism" (in Theodore Bowie and Cornelia V. Christenson, eds., *Studies in Erotic Art* [New York and London: Basic Books, 1970], pp. 337–50) for a study of the image "of female sexuality as a monstrous threat" dominating Picasso's work of the late 1920s. The image of "woman as predatory monster" is also discussed by John Golding in his essay "Picasso and Surrealism," (in Golding and Penrose, eds., *Picasso in Retrospect,* pp. 94–108, 269 [notes]). Examples of Picasso's versions of the *vagina dentata* include Zervos VII, 71, 325; VII, 149.

305. See note 268, above, referring to this author's discussion of the masks wrongly associated with the *Demoiselles.*

306. This mask was first discussed by me in "From Narrative to 'Iconic' in Picasso," pp. 634–35, repr. p. 639, fig. 25.

307. A much less Picasso-like Ivory Coast sickness

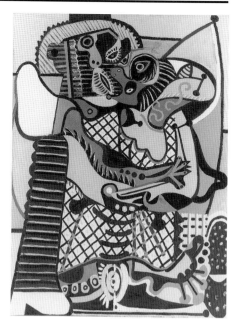

252. *The Embrace.* Juan-les-Pins, summer 1925. Oil on canvas, 53 ⅛ x 38 ⅜" (103.5 x 97.7 cm). Zervos V, 460. Musée Picasso, Paris (MP 85)

mask (misconstrued as a "war mask") did, however, figure in the collection of André Level in 1917.

308. According to the authorities of the Tervuren museum, this mask (fig. 225) was collected in 1954. They estimate that it would not have existed for more than twenty or thirty years before the date of its collection. One has difficulty imagining carvers in Pende country being aware of Picasso in the 1920s. (See "Picasso," in *"Primitivism" in Twentieth-Century Art,* pp. 265, 337, note 83.)

Chronology of *Les Demoiselles d'Avignon,* 1907 to 1939

Judith Cousins
Hélène Seckel

Prefatory Note

The essay by William Rubin in this volume analyzes the sequence of events in the creation of *Les Demoiselles d'Avignon.* Much, however, remains to be told regarding the subsequent history of the work—the story of the essentially private life it led (except for two brief public appearances, in 1916, and, probably, in 1918) from its birth in Picasso's studio in 1907 to its arrival in 1924 at the home of Jacques Doucet, where it would remain until 1937, after which it was acquired by The Museum of Modern Art. Many of the years in this three-decade span remain obscure.

Of course, certain events in this history have already been carefully examined. It is nevertheless astonishing that as recently as 1973, Edward F. Fry, having found at a secondhand bookseller's kiosk the catalogue of the 1916 Salon d'Antin, discovered that the *Demoiselles* was included in that exhibition.[1] This was a startling revelation, which Étienne-Alain Hubert helped elaborate in 1979 by republishing the press review that had reported the event in its day.[2] And even more recently, thanks to the discovery of certain archival documents, the catalogue of the exhibition held in 1987 to commemorate the 1937 show "Les Maîtres de l'art indépendant"[3] finally put an end to the mistaken idea (stemming from an error in the 1937 show's catalogue) that the *Demoiselles* was exhibited in 1937; we now know that it was in fact a pastel, belonging to Georges Salles, and not the large painting, which was shown to the public. (The painting was at that very moment being sold by Mme Doucet to the Seligmann gallery.) Not until after the 1988 exhibitions in Paris and Barcelona devoted to the *Demoiselles* did the Archives Picasso provide, from a small notebook of graph paper, the precise date of the painting's sale to Jacques Doucet—February 20, 1924—an event previously documented in large part in 1984, in François Chapon's book on Doucet.[4] (Chapon disclosed the role played by André Breton in the purchase, a fact made clear by the publication in the book of part of Breton's correspondence with Doucet.) And not until May 6, 1989, on the occasion of a sale at Sotheby's in New York, was a photograph published showing the *Demoiselles* installed on the landing of the stair-

case to the studio that Doucet had had built to house his collection at 33, rue Saint-James, Neuilly-sur-Seine, in 1928.[5] The most recent revelation occurred in 1992, when Étienne-Alain Hubert brought to our attention the intriguing possibility that the *Demoiselles* might have been exhibited at Paul Guillaume's gallery in January and February of 1918.[6]

Primarily we have sought, with the help of documentation that was unpublished until 1988, and with a few items that have come to light since then, to establish more firmly certain historical facts surrounding such events. For example, we now know a little more about the Salon d'Antin, thanks to some letters from Picasso to Gertrude Stein and from Doucet to René-Jean; to information Troels Andersen provided concerning the attendance of Axel Salto and Jens Adolf Jerichau at that exhibition; and to the invitation card for the exhibition, which Jacques and Jacqueline Gojard pulled out of a drawer for us.

It has been possible to learn more about Breton and Doucet regarding the *Demoiselles,* thanks to the erudition and generosity of François Chapon, chief curator of the Bibliothèque Littéraire Jacques Doucet, Paris, who facilitated our access to rare documents; to information provided by Marguerite Bonnet, Suzanne Lemas, and Sylvie Maignan; and to the understanding of Elisa Breton, who permitted us to publish for the first time certain passages from André Breton's correspondence that were not included in Chapon's 1984 book. These sources enriched the information from the unpublished notes of Alfred H. Barr, Jr., in the Archives of The Museum of Modern Art, New York.

Still other events are presented here in a clearer light: for example, Gelett Burgess's visit to Picasso in the spring of 1908. Here, too, Edward Fry blazed the trail, when studying, in 1966, the circumstances of this visit and the firsthand information presented by Burgess in the article "The Wild Men of Paris," published in 1910 in *The Architectural Record.*[7] Through the disinterested good will of Dr. Stanley K. Jernow, who showed us his own unpublished notes on the subject, we came to know of the existence of letters by Burgess and

of the diary of one of his friends, Inez Haynes Irwin;[8] these pinpointed the dates of Burgess's stay in Paris, and told of the circumstances in which he had paid a call on Picasso and himself taken the remarkable photographs of Picasso and four of his works used to illustrate his article,[9] one of them being the very first photograph of the *Demoiselles* to be published.

And yet many questions still remain unanswered. For example, there are a number of questions about who actually saw the painting in the various studios Picasso used during these years. Who saw it at the Bateau-Lavoir, and when? To what extent was it visible at boulevard de Clichy, where only Ardengo Soffici remembers seeing it? So far, no evidence has been found confirming the presence of the painting at boulevard Raspail. One photograph and two accounts attest to its presence at rue Schoelcher. But what became of it after the 1916 Salon d'Antin? Was it rolled up during the Montrouge period? (If we accept the hypothesis of Étienne-Alain Hubert [whose conclusions are here published in the Appendix] that the *Demoiselles* was shown in early 1918 in the "Matisse et Picasso" exhibition organized by Paul Guillaume, and was listed in the catalogue by Apollinaire as "no. 13: Tableau"—and that it was therefore the painting described by Max Jacob as having been displayed on the sidewalk, since it was too large to enter Guillaume's gallery—then the canvas would not have been rolled up during the Montrouge period, since only a stretched canvas would not have fit through the door of Guillaume's gallery.) Was it rolled up at rue La Boétie? Did Doucet see the painting, or see it again, when he decided to buy it; and where did he store it when he resided at avenue du Bois in Neuilly from 1924 to 1928 (that is, until its installation at the Saint-James studio)? There is not a single photograph showing the *Demoiselles* on display during this period, nor has any written account been found. Why, and how, did the frame that Doucet commissioned from Pierre Legrain for the *Demoiselles* disappear after the painting's entry into The Museum of Modern Art in the spring of 1939? Responses to many such questions remain in the realm of conjecture.

In preparing this Chronology, therefore, we had to be prudent, making sure not to confuse information confirmed by primary documents (such as letters) with information known only through later or secondhand accounts, which should always be handled with caution. Similarly, it was necessary to distinguish between a document itself and the interpretation that could be given of it, however careful and well supported the latter might be. A typographical artifice is used to distinguish between the text of an original document or account (printed in italic type) and the interpretation or the inferences that might be drawn from it (printed in roman type). In interpreting documents, it is important to keep in mind one of the four precepts that Descartes imposed on himself as the method he was striving to define: "The first [precept] was never to accept anything as true if I did not have evident knowledge of its truth: that is, carefully to avoid precipitate conclusions and preconceptions, and to include nothing more in my judgments than what presented itself to my mind so clearly and so distinctly that I had no occasion to doubt it."[10]

A number of institutions and archives greatly facilitated our research: the Archives Picasso, which could be only cursorily examined while they were still being organized;[11] the archives of the Stein Bequest at The Beinecke Rare Book and Manuscript Library at Yale;[12] in matters concerning Doucet, the Archives des Musées Nationaux at the Louvre,[13] and of the Département des Manuscrits at the Bibliothèque Nationale; and concerning the purchase of the *Demoiselles* by the Seligmann gallery and its acquisition by The Museum of Modern Art, the New York gallery's records, kept in the Archives of American Art in Washington, D.C.,[14] and the Archives of The Museum of Modern Art.[15] This project would not have been possible without the understanding of those holding the copyrights to the unpublished documents here presented, who kindly permitted us to publish them. We are deeply grateful to them, as we are, in advance, to those individuals we were unable to track down.

To give a sense of the people around the protagonists of this story and the milieu in which the events took place, we have included, for example, a letter from Soffici suggesting that in April 1910 he went to see Picasso; a letter from Picasso to Gertrude Stein that in the autumn of 1916 speaks of Jacques Doucet; a letter from Doucet, in early 1917, attesting to the consideration and friendship the collector felt toward the painter, and giving a better idea of the context in which Breton intervened to convince Doucet to buy the *Demoiselles*. Obviously we were unable to document what must have been numerous visits to Picasso's various studios by all those who could not have failed to see the *Demoiselles* there—whether close friends or people passing through Paris, especially before the outbreak of World War I in 1914. We have, in any case, sought to follow each path that opened up to us, especially those originating in the Archives Picasso. Our sometimes fragmentary information will perhaps provide other researchers with missing links, helping to reconstruct aspects of history of which we were previously unaware. This Chronology, submitted for examination as a work-in-progress, remains open, ready for the contributions of others. As our incomplete knowledge led us into risk of error, we kept in mind the words of Alfred Barr, who was the first, after all, to pursue this history, and who, discouraged at being unable to get any information from Picasso concerning the *Demoiselles*, wrote to Zervos in 1945 that "Perhaps ...I shall have to publish certain errors and speculations so that Picasso may be aroused to deny or clarify."[16] We hope that our efforts will trigger further research.

The goal of this project was to construct a history, rather than merely to publish archival documents. Thus excerpts from letters and unpublished diaries are quoted without strictly reproducing the orthography or punctuation of the manuscripts, while nevertheless making it clear whether a given text has been abridged. For letters, the places of dispatch or receipt are indicated only when not self-evident, or when they seemed of particular importance. Dates given on postmarks are indicated as such. The texts themselves are printed without observing the original paragraph breaks, unless quoted at length.

Bibliographical citations given here in abbreviated form refer to the Bibliography, pp. 258 ff.

Unless otherwise indicated, primary materials in the Chronology come from the following sources: all correspondence to Pablo Picasso is from the Archives Picasso, Musée Picasso, Paris. All correspondence to René-Jean is from the Département des Manuscrits, Bibliothèque Nationale, Paris, or from the Archives René-Jean. All correspondence to Jacques Doucet, Francis Picabia, and André Suarès is from the Bibliothèque Littéraire Jacques Doucet, Paris. Documents pertaining to the Salon d'Antin are from the Fonds Jacques Doucet, Bibliothèque d'Art et d'Archéologie, Paris. All correspondence and documents pertaining to Jacques Doucet's bequest to the Louvre are from the Archives des Musées Nationaux, Musée du Louvre, Paris. All correspondence to Maurice Raynal is from the Archives Maurice Raynal. All correspondence to Gertrude Stein, Leo Stein, and Alice B. Toklas is from the Yale Collection of American Literature, The Beinecke Rare Book and Manuscript Library, Yale University, New Haven, Connecticut. The papers of Inez Haynes Irwin are also in the Yale Collection of American Literature. Inez Haynes Irwin's diary of March 27–May 3, 1908, is in the Inez Haynes Irwin Papers, The Arthur and Elizabeth Schlesinger Library on the History of Women in America, Radcliffe College, Cambridge, Massachusetts. All correspondence to Daniel-Henry Kahnweiler is from the Galerie Louise Leiris Archives, Paris. All correspondence and documents pertaining to the Jacques Seligmann gallery are drawn from The Jacques Seligmann & Co. Records, Archives of American Art, Smithsonian Institution, Washington, D.C. The Gelett Burgess Papers, and The Annette Rosenshine Papers are in the Manuscripts Division, The Bancroft Library, University of California at Berkeley. All correspondence to Edith Willumsen is from the J. F. Willumsens Museum, Frederikssund, Denmark. All correspondence and documents pertaining to The Museum of Modern Art and the *Demoiselles* are drawn from the Archives of The Museum of Modern Art, New York.

1. In 1966, Fry wrote that the Salon d'Antin, organized by André Salmon, had taken place in Paris in 1916 (Fry 1966a, p. 185). Fry's subsequent discovery, in 1973, of the catalogue of the 1916 Salon d'Antin exhibition revealed that the *Demoiselles* was shown in that exhibition. Fry communicated this information to William Rubin and to Pierre Daix, who apparently was the first to publish it (see Daix 1975a, p. 56, note 2).
 In the summer of 1993, Clive Phillpot, director of the Library of The Museum of Modern Art, acquired from the Estate of Edward Fry (who had died on April 17, 1992) the copy of the 1916 Salon d'Antin exhibition catalogue that Fry had owned, for the Library's Special Collections.
2. Hubert 1979, p. 61 and note 26, p. 66. See also Daix 1979, p. 199; Gee 1981, pp. 222–23; Klüver 1986, p. 104; and Klüver 1993, pp. 68–70.
3. Contensou/Molinari 1987. We thank Catherine Amidon-Kayoun of the Musée d'Art Moderne de la Ville de Paris, co-curator of the exhibition "Paris 1937: L'Art indépendant," for assisting us in our research.
4. Chapon 1984.
5. Sotheby's 1989; photographs included in Lot 37A, repr., n.p. Three photographs from the group included in Lot 37A are reproduced in the present Chronology (figs. 22–24).
6. While Étienne-Alain Hubert's thesis is to some degree speculative, we nevertheless felt it imperative that his findings be published, in the form of an Appendix, which follows the present Chronology.
7. Fry 1966b. Alfred H. Barr, Jr. (1946, pp. 257–58) was the first to mention Burgess's article.
8. We also thank the institutions where these documents are on deposit: The Beinecke Rare Book and Manuscript Library, Yale University, New Haven, Connecticut; The Bancroft Library, University of California at Berkeley (our thanks to Bonnie Hardwick, head, and Nicole Bouché, assistant head, Manuscripts Division); The Arthur and Elizabeth Schlesinger Library on the History of Women in America, Radcliffe College, Cambridge, Massachusetts (our thanks to Patricia Miller King, director).

9. In "The Wild Men of Paris," Gelett Burgess indicated that he "hired a man …to photograph a few of these miracles" (examples of the "new art"), also observing that "In line and composition, the reproductions will bear me out perhaps; but unfortunately (or is it fortunately?) the savagery of color escapes the camera. The color is indescribable" (Burgess 1910, pp. 401–02). This statement no doubt is what led Edward Fry to assert that when Burgess visited the seven painters whose names had been furnished by Matisse, he brought to "several of the interviews a photographer, whose work resulted in the invaluable and unique visual documentation accompanying [his] article" and to speak of "Burgess's foresight in hiring a photographer to accompany him on his visits to the artists' studios" (see Fry 1966b, pp. 70, 72).
 While some of the photographs reproduced in Burgess's article may have been taken by the hired photographer, there is strong evidence that a number of photographs, in addition to those of Picasso and his work, were taken by Burgess himself. We know that he photographed Braque and Herbin when he visited their respective studios (noted by Inez Haynes Irwin in her diary entry for April 27, 1908), and that he photographed Picasso several times during successive visits, along with Fernande Olivier and Othon Friesz (reported in Burgess's letters of May 29, July 12 (in which he also observed, "I find I have a fine camera—almost all my photographs are fine"), and July 28, 1908, to Inez Haynes Irwin (see below, under those dates). And two years later, Fernande Olivier's letter of June 17, 1910, to Gertrude Stein will confirm that Burgess came to photograph Picasso and several canvases, and that his "portraits" of Braque, Derain, Friesz, Herbin, and Picasso, as well as photographs of paintings, have been reproduced in *The Architectural Record*, a copy of which Picasso has received from America (see below).
10. René Descartes, "Discourse on Method" (1637), in *The Philosophical Writings of Descartes*, vol. 1, trans. John Cottingham, Robert Stoothoff, and Dugald Murdoch (Cambridge, London, and New York: Cambridge University Press, 1985), p. 120.
11. We thank Laurence Berthon, former documentaliste at the Musée Picasso, Paris, for her assistance.
12. We are grateful for the help of Christa Sammons, acting curator, and Patricia Willis, curator of American Literature at The Beinecke Rare Book and Manuscript Library, Yale University.
13. Yveline Cantarel-Besson, chargée du service des Archives des Musées Nationaux at the Louvre, was a great help in our research.
14. Our thanks to Judith Throm, collections manager, and Darcy Tell, reference assistant at the Archives of American Art, Washington, D.C., for their help.
15. We thank Rona Roob, Museum archivist, and Janis Ekdahl, assistant director of the Library, at The Museum of Modern Art, New York, for their cooperation.
16. See the Anthology, p. 223.

FEBRUARY 27, 1907

In a notebook, Guillaume Apollinaire writes:

Feb. 27, 1907 … Evening, dinner with Picasso, saw his new painting: even colors, pinks of flowers, of flesh, etc., women's heads similar and simple heads of men too. Wonderful language that no literature can express, for our words are already made. Alas.
(APOLLINAIRE 1991A, pp. 42 [facsimile], 142 [transcript])

As Apollinaire's words indicate, even this most modern of writers was at a loss to describe a new kind of painting that, at the time, was clearly unprecedented. It is likely that in his shorthand way, he is referring to several paintings, preparatory studies of heads—of both men and women—for the *Demoiselles*. This notebook, to which access was limited until 1989, is in the Département des Manuscrits at the Bibliothèque Nationale.

EARLY IN THE YEAR TO EARLY SUMMER 1907:
VISITORS TO THE BATEAU-LAVOIR

An attempt to write the history of the painting's discovery, at the Bateau-Lavoir studio, by those close to Picasso—using their various personal accounts, which are often vague and contradictory, and making no claim to extract from them a "true," or definitive history—might begin as follows:

Wilhelm Uhde writes in 1938: "In early 1907 I received a desperate note from Picasso asking me to come see him at once. He was troubled about the new work; Vollard and Fénéon had paid him a visit but had left without understanding a thing."[1] Intrigued by this, Uhde goes to the Bateau-Lavoir and there sees the *Demoiselles*. In 1948, Daniel-Henry Kahnweiler gives a more precise date for Uhde's visit (and, indirectly, for Vollard and Fénéon's visit as well): "In March 1907 my good friend Wilhelm Uhde …told me he had seen in Picasso's studio a recent, large painting that he found astonishing."[2] Kahnweiler goes on to confirm that this is indeed the *Demoiselles*, which he says he saw for himself at the Bateau-Lavoir, probably shortly thereafter.[3] But he tells us that before he had a chance to go to Montmartre, André Derain too gave him his opinion: "Derain had also spoken to me about it, adding that one day we would find Picasso hanged behind that painting."[4] Lastly, Kahnweiler tells us, still in 1948, that during this same spring of 1907 Georges Braque met Picasso, through Guillaume Apollinaire, and that upon seeing the *Demoiselles* at the Bateau-Lavoir, Braque "was disturbed by the large painting."[5]

In addition, Leo Stein explained that before his departure for Italy, in the spring of 1907, he had witnessed the lining of the canvas on which Picasso would later paint the *Demoiselles*,[6] and before leaving for Tuscany in the summer of 1907, Ardengo Soffici saw Picasso working on the *Demoiselles*.[7] But the foregoing accounts exhaust the list of visits that can be securely dated.

The information available from other accounts, especially concerning dates, is often less precise: Fernande Olivier mentions the less than favorable reactions of Braque[8] and Matisse,[9] but without explicitly relating them to the *Demoiselles*. Picasso, without mentioning a date, told Édouard Pignon that Matisse and Fénéon made jokes when they saw the painting,[10] and he told Hélène Parmelin that Fénéon, who may or may not have been accompanied on that occasion, advised him to take up caricature.[11] According to Roland Penrose, who very likely got his information from conversations with Picasso, Fénéon was with Apollinaire when he saw the *Demoiselles* (here there is also some talk of caricature);[12] and Matisse was with Leo Stein—and the latter two, in a fit of laughter, supposedly invoked the fourth dimension.[13] Antonina Vallentin, too, mentions the episode—Picasso recounted the story to her—but in this version Leo Stein appears to be alone.[14] For his part, Leo Stein does not himself say when he first saw the painting, nor whether any other visitor was with him at the time.[15] Max Jacob gives no date for his own confrontation with the *Demoiselles*, which he mentions just three times,

only once by name,[16] nor is there a date for Sergei Shchukin's, which was related by Gertrude Stein.[17] Moreover, we do not know when Stein herself saw the painting for the first time, or what she thought of it. It is known, however, that before mid-October she went to the Bateau-Lavoir with Alice Toklas.[18] Mention could also be made of Henri Mahaut, who wrote of his visits to the Bateau-Lavoir that Picasso's studio was then becoming "a kind of laboratory."[19]

For the texts of the early accounts of the *Demoiselles* mentioned here, see the Anthology, which begins on p. 213.

1. Uhde 1938, p. 142. The episode had already been recounted in Uhde 1929 (p. 22) without clear reference being made to the *Demoiselles*; see the section devoted to Uhde in the Anthology, p. 255. The *petit bleu* (Uhde 1929, p. 22), an express letter conveyed by pneumatic tube, sent from Picasso to Uhde, like the postcard the painter sent Leo Stein on April 27, 1907, suggests that Picasso was in the habit of inviting his friends to the studio to see his work. On this matter, see also Salmon 1912, p. 43 ("When [Picasso] allowed [his friends] to judge the first stage of his new work …"); Salmon 1926, p. 445 ("One morning Picasso showed his friends the *Demoiselles d'Avignon* stripped of their 'rose period' grace and enlarged to a geometrical monstrousness"); and Georges-Michel 1954, p. 88 ("The evening of the famous day in 1907 when the unveiling of the *Demoiselles d'Avignon* took place …"). See also Fernande Olivier (1965, p. 135): "Picasso …worked in a large, airy studio, which no one could enter without permission"; this, however, is the later studio on boulevard de Clichy. But did the layout of the Bateau-Lavoir also allow for such closing off of one part of the studio? The partition dividing it in two was probably equipped with a door (see the plan devised by Jeanine Warnod [1986, p. 8], and also the small plan drawn up by Salmon "sixty years later," as he noted [published in Pontoise 1979, p. 64], showing Picasso's studio and an adjoining room, which, according to Salmon's handwritten caption, was a "small room called 'the maid's room' until Fernande's arrival"). In her unpublished memoirs, "Life's Not a Paragraph," Annette Rosenshine, who was a friend of Alice Toklas's and was in Paris from December 1906 to December 1908, implies that there were two separate rooms to the studio, which was at once a studio, bedroom, kitchen, and "dog kennel" (for Fricka, Picasso's dog): "It was a formidable ménage, a difficult atmosphere for an artist to work in. Gertrude and Leo were well aware of how harassed Picasso was at times in these cramped quarters. They were responsible, I believe, for the acquisition of a second room where he could work undisturbed" (Rosenshine c. 1964, p. 115). In Soffici's memoirs, *Autoritratto d'artista italiano nel quadro del suo tempo*, one learns that Picasso lived in two rooms that were not on the same floor as the Bateau-Lavoir studio (Soffici 1968, pp. 414–16). This is confirmed by Max Jacob in a text written in 1931 (first published in Jacob 1964, pp. I, II, and reprinted in 1973, pp. 47–49), titled "Fox." According to Jacob, when Picasso returned to Paris from Spain in 1904, "he settled in the shack on the rue Ravignan [i.e., the Bateau-Lavoir], a kind of old attic, awkwardly perched over cellars"; at the time that Matisse introduced him, at quai Saint-Michel, to his first "African" sculpture ("bois nègre")—that is to say in 1906 or the beginning of 1907—Picasso "had rented one of the dark rooms beneath the floor of the shack."

2. Kahnweiler 1949a (first published 1948), p. 14.

3. Ibid., p. 15.

4. Ibid., p. 14.

5. Ibid., p. 16 (this episode appears only in the French edition of Kahnweiler's text). When, in 1916, Kahnweiler mentions for the first time Braque's visit to the Bateau-Lavoir, he gives no date but associates the visit with the *Demoiselles* (Kahnweiler 1916, p. 214). As for his own first visit, Kahnweiler generally assigns it to the spring of 1907 (1953b, n.p., where he states specifically: "it was in the spring of 1907 that I saw the *Demoiselles d'Avignon* for the first time"; 1955a,

p. 28; 1955b, p. 108; 1961, p. 33). It is not certain whether the dealer, in writing his commentary on the interview he had with Picasso in 1933 (published in 1952), actually meant his first visit, but we learn that "rather early in the summer of 1907" he saw the *Demoiselles*, unchanged since (Kahnweiler 1952, p. 24). That Kahnweiler, in this text, seems not to know about what happened in April or May could lead one to believe that he did not yet know Picasso during that time. See the section devoted to Kahnweiler in the Anthology, p. 235.

6. L. Stein 1947, p. 175.

7. Soffici 1942, p. 369. On Soffici's return to Italy, see Rodriguez 1984–85, pp. 27, 31; and 1993 edition, pp. 7–8.

8. Olivier 1965, p. 98. Some authors, based on this account, situate the episode in early 1908 (Daix 1987, p. 91).

9. Ibid., p. 88.

10. Related in Parmelin 1980, p. 69.

11. Parmelin 1966, p. 37.

12. Penrose 1973, p. 134.

13. Ibid., p. 133. This version may perhaps be put in a new light if looked at in relation to a letter of June 12, 1912, from Picasso to Kahnweiler, mentioning a "Shchukin-style painting" before which Matisse and Leo Stein had spoken, laughing, of the fourth dimension. The "Shchukin-style painting" is in all likelihood *Woman with a Fan* (Paris, early spring 1909; Zervos II¹, 137; Daix 263), purchased by Shchukin in 1909 (see Richardson 1991, p. 392).

14. Vallentin 1957, p. 150.

15. L. Stein 1947, p. 150.

16. Jacob 1927, p. 202; Jacob 1932, p. 7; Jacob 1964, pp. 1, 11.

17. G. Stein 1938 (Paris: Floury, p. 64; London: Batsford, p. 18). Alfred Barr writes that Matisse did not take Shchukin to Picasso's place until 1908 (Barr 1951a, p. 85). This has been disputed by Richardson (1991, pp. 392–93), who argues for Shchukin's having already met Picasso in the spring of 1906.

18. G. Stein 1961, p. 22.

19. Mahaut 1930, p. 10.

LEO AND GERTRUDE STEIN,

EARLY WINTER 1906–07 TO LATE SUMMER 1907

When did Leo and Gertrude Stein see the *Demoiselles* in Picasso's studio, and at what stage was the painting when they saw it? Our attempt to determine when brother and sister were in Paris brought the following to light:[1]

From the beginning of the year until April, both are in Paris.

[March–April] 1907: An inscription in Picasso's hand on the final page of a sketchbook for the *Demoiselles* [dated March–April 1907] states: "Stein will be at home all of next week except for Monday and Tuesday," attesting to the presence in Paris at the time of at least one of the Steins (see below, [March–April] 1907).

April 24–26: Gertrude spends three days (Wednesday to Friday) in Epernon with Jeanne Boiffard.[2]

April 27: Picasso sends Leo a card inviting him and Gertrude ("mes chers amis") to come by the studio the following day, Sunday, April 28, to see "the painting" ("le tableau")[3] (see fig. 1). The painting in question is probably the *Demoiselles*, then in a preliminary state, and we know Leo and Gertrude were both in Paris on that day.

Before or on May 24: The Steins (Gertrude, Michael, Sarah, Allen, and probably Leo) leave Paris for Florence, where they spend the summer.[4]

June 9 and 14: Leo, Gertrude, Michael, and Sarah Stein are all in Florence.[5]

September 2: Gertrude is still in Florence.[6]

September 7: Leo is not yet in Paris.[7] Gertrude has by now returned to Paris, since on this date she meets Alice Toklas, at the home of Michael and Sarah Stein.[8]

1. We are grateful to Leon Katz for sharing his archival documents and his research on this subject with us. We also thank Edward Burns for helping us with research on the Steins.

2. April 17 letter from Jeanne Boiffard to Gertrude Stein, where Gertrude Stein is invited to come to Epernon around April 23 or 24. Gertrude Stein scribbled her reply in English on that letter: "I will come by the Wednesday [24] morning train and come back Friday [26] afternoon train."

3. Postcard from Picasso to Leo Stein, April 27, 1907 (see this date, below): "My dear friends, do you want to come see my painting tomorrow Sunday. Picasso."

4. Letter from Jeanne Boiffard in Epernon to Gertrude Stein in Florence, May 31, 1907, saying that she went to Paris but the Steins had left for Italy two days before she arrived. Assuming that Boiffard wrote this letter as soon as she got back to Epernon from Paris, we can deduce that since Jeanne Boiffard spent five days in Paris, and the Steins had left Paris two days before she arrived in the city (both pieces of information Boiffard gives in her letter), the Steins must have left before or on May 24.

5. Mary Berenson diaries, Library of Villa I Tatti, Settignano. Mary Berenson's diary entry of June 9, 1907, mentions that "all the Steins" are in Florence, but does not actually mention Leo by name (we know Gertrude, Michael, Sarah, and Allen Stein were there). As Leon Katz pointed out, "The first mention I have of Leo actually in residence in Florence in summer 1907 is in Mary Berenson's diaries, June 14, 1907, when he was at B[ernard] B[erenson]'s for dinner. But it is more than likely that he was in Florence much earlier" (letter to J. Cousins, October 4, 1993).

6. Letter from Fernande Olivier in Paris to Gertrude Stein in Florence, dated September 2, 1907 (see below under that date).

7. Letter from Félix Fénéon in Paris to Leo Stein [in Italy] dated September 7, 1907, asking Leo to give his opinion to Thomas Whittemore about a Matisse painting Whittemore considers purchasing from the Bernheim gallery (*The Red Madras Headdress*, Barnes Foundation, Inv. no. 878). Fénéon asks Leo to do so before he returns to Paris, an indication that Leo was still in Italy at that time.

8. Alice Toklas, interview by Leon Katz (see below, under September 16, 1907).

BEFORE SUMMER 1907

Leo Stein is witness to the preparations for the execution of the *Demoiselles*;[1] unfortunately he does not specify the date, but we know it was before his departure for Italy, where he spent the summer: "I had some pictures relined, and [Picasso] decided that he would have one of his pictures too treated like a classic, though in reverse order—he would have the canvas lined first and paint on it afterwards." The paragraph that follows this passage tells us that the painting in question is the *Demoiselles*.[2] Fernande Olivier recounts that Picasso "liked a fine, tight canvas, with a very smooth grain, less absorbent than the others," and that he prepared his own canvases: "To prepare his canvases, he had rented a building—since destroyed—at the bottom of an old garden on rue Cortot, in Montmartre. He could leave the prepared canvas there for as long as necessary for it to dry."[3] However, she does not give a date for this; it may refer only to the end of the Bateau-Lavoir period.

1. L. Stein 1947, p. 175; see the section devoted to Leo Stein in the Anthology, p. 254.
2. Regarding the accuracy of Leo Stein's statement, Carol Stringari, former Associate Conservator, and James Coddington, Conservator, The Museum of Modern Art, find no visual evidence that the painting was executed on a lined canvas. But it was undoubtedly rolled and stretched several times. Because the *Demoiselles* went to the reliner Charles Chapuis at the time of its acquisition by Doucet (see below, under April 15, 1924), it is not unreasonable to believe that the present lining of the painting was applied at that time.
3. Olivier 1965, p. 129.

SPRING 1907

Kahnweiler mentions that in the spring of 1907 Apollinaire introduced Braque to Picasso and that Braque later saw the *Demoiselles* in the studio (see Kahnweiler 1949a p. 16; and see the section devoted to Kahnweiler in the Anthology, p. 237. This episode is not mentioned in the German edition of Kahnweiler's text).

[END OF MARCH OR APRIL 1907]

In an undated letter from Paris, Ardengo Soffici writes to his friend Giovanni Papini (then editor of the journal *Leonardo*):

I have exhibited five paintings at the Indépendants [held March 20–April 30] but for the time being no one understands a thing and they laugh! I went back to see Picasso some time ago and this time he was most cordial and told me (an unheard-of thing for him!) that he wished to know me better. I will therefore be going to see him in a few days and we will probably spend the day together.
(PAPINI/SOFFICI 1991, pp. 124–25, letter 105; Papini Archives, Fondazione Conti, Fiesole)

This excerpt (first published in Richter 1969, p. 95, where it is dated "certainly March 1907") was redated by Richter in Papini/Soffici 1991, p. 124, as "certainly March 24 or March 25, 1907." Rodriguez 1984–85 (1993 edition), p. 11, note 6, opts for the date "end of March 1907."

As this declaration of budding friendship suggests, it was not Soffici's first visit to Picasso, in this spring of 1907, nor was it his last. In his memoirs, Soffici recalls having seen the *Demoiselles* at the time, which he "had liked so much at the moment when Picasso painted it" (Soffici 1942, p. 369). For Soffici's subsequent visits to Picasso's studio, see below, under April 6 and 7, 1910, May 7 and 8, 1912, and May 24, 1914. We thank Jean-François Rodriguez for bringing this excerpt to our attention, and Valeria Soffici Giaccai for kindly authorizing us to quote it.

MARCH 30, 1907

Eugène Rouart, one of the sons of the collector Henri Rouart, writes from Bagnols-de-Grenade to Picasso in Paris:

Dear M. Picasso, I would very much have liked to have something of yours at Bagnols. Would you be willing to part with your canvas representing the large red clown and the little harlequin—with a little flower

pot in the background; …I'm sorry to have left you in such haste the other day, but I had to leave that same evening.… Please remember me to your excellent friend Max Jacob. The canvas I am speaking of was in your studio at the time of my last visit.

This is on a sheet of letterhead paper that reads:
Eugène Rouart. Bagnols-de-Grenade par Saint-Jory. Haute-Garonne. Adresse télégraphique: Rouart-Capy-St-Jory.
(ARCHIVES PICASSO)

The letter attests to a very recent visit by Rouart to Picasso's studio. Olivier Rouart, Eugène's son, wrote to the present authors that "as for my father's visits to Paris, they were rather frequent, and we even had a pied-à-terre on rue Boissière" (letter of October 7, 1987). The painting in question is the *Comedians (Acrobat and Young Harlequin)* (Zervos I, 301; D./B. XII, 25), which Olivier Rouart informed us was sold to Paul Guillaume after Rouart had owned it. (Colette Giraudon, documentaliste at the Musée de l'Orangerie and author of a Paul Guillaume exhibition catalogue and a book [Giraudon 1993a and b], confirms that the painting did indeed pass through that dealer's collection before being acquired by Dr. Barnes in 1924.) Rodriguez (1984–85, pp. 43–44) notes that Fernande Olivier, in her memoirs (Olivier 1965, p. 28), mentions the "large red harlequin in fool's cap that was later to become part of the Rouart collection." The exact wording of the letterhead was written down by Picasso in one of the preparatory sketchbooks for the *Demoiselles* (see the next entry), along with a lunch appointment with Rouart at Foyot, a restaurant situated at the top of rue Tournon and now defunct, though its name remains attached to a famous dish, "côte de veau Foyot."

[MARCH–APRIL] 1907

A sketchbook of Picasso's, in which he executes primarily studies of one of the figures in the six-figure sketch (Zervos II², 644) for the *Demoiselles*, the woman with arms raised, bears, in Picasso's hand, on the inside front cover, the following inscription: "Eugene Rouart Bagnols-de-Grenade par St Jory Haute Garonne Adresse télégraphique Rouart-Capy-St-Jory;" and on the inside back cover: "Jueves a las 12 au restaurant Foyot Eugène Rouart."
(CARNET No. 4; Seckel, pp. 170, 175)

The entry is directly related to the two letters from Eugène Rouart (see March 30 and April 27). The lunch, on a Thursday, may have taken place in March (we know that Picasso and Rouart saw each other before the 30th); the April 27 letter (see below) does not indicate whether they had seen each other again since March 30.

The final page of the same sketchbook bears the note: "Escribir à Braque / Stein estará en su casa / toda la semana próxima / menos el lunes y el martes." On the inside back cover: "Braque El viernes." On the inside front cover, along with Rouart's address, "Salle 11."
(CARNET No. 4; Seckel, pp. 170, 175)

Picasso has to write to Braque. Are they supposed to meet on a

Friday? Have they already made each other's acquaintance, and if so, where? The reference to "Stein" confirms the presence of either Leo or Gertrude in Paris at the time. Does "Salle 11" refer to a room in the Salon des Indépendants (March 20–April 30)?

APRIL 27, 1907

Eugène Rouart writes from Bagnols-de-Grenade to Picasso ("My dear friend") in Paris concerning payment for the painting he is buying from him (*Comedians [Acrobat and Young Harlequin])*, which he anxiously awaits.

(ARCHIVES PICASSO)

This, again, we know because of Rouart's letter of March 30, expressing his desire to acquire the painting.

1. Postcard from Picasso to Leo Stein, April 27, 1907. Yale Collection of American Literature, The Beinecke Rare Book and Manuscript Library, Yale University, New Haven, Connecticut

A postcard, postmarked April 27, 1907 (fig. 1), and addressed by Picasso to Leo Stein at his Paris address, 27, rue de Fleurus, bears only the following words:

My dear friends
please come Sunday tomorrow to see the painting
 Picasso.

(Yale Collection of American Literature, The Beinecke Rare Book and Manuscript Library, Yale University, New Haven, Connecticut [hereafter abbreviated as BEINECKE LIBRARY])

Both Gertrude and Leo being in Paris at the time, it is fair to assume that they did go to Picasso's studio on April 28, at a time when Picasso was working on preparatory drawings and sketches for the *Demoiselles* (see the chronology of the Steins' movements, p. 149, above). Golding (1958, p. 160) was tempted to believe that the painting in question was the *Demoiselles* in its early stages. In his book (1988a), Golding had originally maintained that assumption (in the 1959 and 1968 editions, p. 54), but it was edited out in 1988. Daix for his part thinks it is *Head and Shoulders of a Sailor* (Seckel 1988, cat. 45, p. 56); see Daix 1979, p. 18; Daix 1987a, p. 76 and note 5, p. 402; and Daix 1988a, p. 504.

JUNE 11, 1907

Victor Gastilleur, a friend of both Picasso and Eugène Rouart, writes from Carcassonne to the painter in Paris. He closes with:

We are still expecting you here, this summer.
(ARCHIVES PICASSO)

We are told by André Salmon (who calls him "Tartarin de Carcassonne"; Salmon 1955, p. 208) that Victor Gastilleur frequented the circle of *Vers et prose*, the review founded in 1905 by Paul Fort with Salmon as its secretary. Fernande Olivier says that "on Tuesdays the Picasso gang went to the Closerie des Lilas, for the poetry and prose evenings that had been started and were run by Paul Fort" (OLIVIER 1965, p. 44).

JUNE 14, 1907

Ignacio Zuloaga writes from his Paris residence at 54, rue Caulaincourt, to Paul Lafond, curator of the Musée des Beaux-Arts de Pau, who is preparing an article on his collection:

… I am delighted that you are doing the article on my collection, and I thank you very much for it. My collection is divided in two. The best things are here in Paris, and the rest are in Eibar.… I also think it is important for you to mention that I was one of the first to create interest in El Greco.

(J. P. LAFOND ARCHIVES, Musée des Beaux-Arts de Pau; published in MILHOU 1981, p. 269, no. 50. We are indebted to Ghislaine Plessier for having brought this document to our attention.)

Unfortunately, neither Zuloaga's letter nor Paul Lafond's article (published in *Les Arts*, February 1908, with a reproduction of El Gre-

co's *Apocalyptic Vision* but without mention of the work's exact location) confirms whether the painting, acquired by Zuloaga in Córdoba in mid-June 1905, was already in Paris by June 1907, where Picasso could have seen it during the period immediately preceding the execution of the *Demoiselles*. The title *Apocalyptic Vision* has been adopted by recent scholarship to replace such former ones as *The Fifth Seal of the Apocalypse* or (the title still used at The Metropolitan Museum of Art) *The Vision of Saint John*. See William Rubin's essay in the present volume, p. 138, note 235.

JULY 3, 1907

The painter Francisco Iturrino writes from Córdoba to Picasso in Paris:

Friend Pablo, I was very happy to receive your letter you don't know how much it pleased me to know that you have been working for months on a large painting this painting will be quite different from the ones that I know and undoubtedly it is one of the things that makes me think and my imagination gets carried away and I think of the work of art.
(ARCHIVES PICASSO)

It is possible that the large painting on which Picasso had been working for months was the *Demoiselles*. When a painting occupied his thoughts, Picasso would never fail to tell his friends about it (as, for example, in the letter he sent to Max Jacob on July 13, 1902, from Barcelona, in which he speaks of the *Two Sisters* [D./B. VII, 22]). The letter from Eugène Rouart, below, also bears witness to the painter's need to talk about what he is working on.

JULY 10, 1907

Eugène Rouart writes from Bagnols-de-Grenade to Picasso in Paris:

My dear friend …I am going to Toulouse and will see if your large painting has arrived. My friend André Gide is with me, and I shall be happy to show it to him…. It will be a real pleasure to see your large painting when I come to Paris; I expect much from your temperament and your tremendous efforts. It is very satisfying to know you are working hard and courageously on a large painting…. If you come to the south, let me know; I would like to see you and will welcome you with great pleasure.
(ARCHIVES PICASSO)

The first large painting mentioned is *Comedians (Acrobat and Young Harlequin)*, which Rouart is in the process of buying (see above, under March 30 and April 27, 1907), and there is every reason to believe that the second—the one Picasso is still working on, and which he has probably discussed with Rouart, and written to Iturrino about (see above, under July 3), in a letter that we have not been able to examine—is the *Demoiselles*. Certainly Picasso is expected in the south (Rouart had invited him in his April 27 letter, and Gastilleur was expecting him on June 11). Did he go? He did go, eventually, since Olivier Rouart recalls: "My father's relations with Picasso must have been rather close, and I remember very well several of Picasso's stays at Bagnols, our estate in the south" (letter of October 7, 1987). However, it would be interesting to know whether Picasso left Paris that summer, since Salmon's text of 1912 is ambiguous (see the section devoted to Salmon in the Anthology, p. 245). We are grateful to Olivier Rouart for information concerning his father.

AUGUST 5, 1907

The English painter Augustus John writes to Henry Lamb:

I saw a young artist called Picasso whose work is wonderful in Paris. (HOLROYD 1975, p. 273)

Michael Holroyd also says (pp. 209–74, passim) that Augustus John left England for France in late September 1905. He stayed in Paris intermittently, moving into a studio in cour de Rohan in February 1907, and seeing the Salon des Indépendants; in April he was in Normandy. He probably remained in France until mid-August. We know that on September 25, after passing through Ireland, he was back in London. Holroyd is convinced that John saw the *Demoiselles* in Paris during the summer of 1907 and that he quite likely visited Picasso two or three times, at close intervals (letter to the authors, September 24, 1987). John in his memoirs tells of a visit to the Bateau-Lavoir studio, where he saw a painting Picasso was working on, "an immense canvas bearing a number of figures based, it would seem, on a recent acquaintance with the monstrous images of Easter Island" (John 1941, p. 127; see also the section devoted to Augustus John in the Anthology, p. 234). André Salmon (1955, pp. 225–26) confirms the presence of his "friend Augustus John" in Paris.

AUGUST 8, 1907

Fernande Olivier writes from Paris to Gertrude Stein, who is in Fiesole, Italy:

You should know that the Salon d'Automne begins October 1 this year. Will you be there for the opening, I don't think I will…. Pablo is working…. I will write to you at greater length soon; at the moment Salmon is with us together with another friend, and I am prevented from writing to you as I would like to.
(BEINECKE LIBRARY)

Fernande Olivier and Salmon are therefore at the studio on this day in the month of August. Who is the other friend? In any case, this confirms the presence at the Bateau-Lavoir of André Salmon, whose "Histoire anecdotique du cubisme" (Salmon 1912) clearly gives one to understand that he witnessed the execution of the large painting.

AUGUST 24, 1907

Fernande writes from Paris to Gertrude Stein in Fiesole:

My dear Gertrude, Would you like to hear some major news? Pablo's and my life together is over. We are splitting up for good next month….

Monsieur, I shall venture to visit you once more in your studio on Monday, 11 o'clock.
(ARCHIVES PICASSO)

AUTUMN 1911

Picasso, while still living at boulevard de Clichy, moves his studio back into the Bateau-Lavoir (see Daix 1987a, p. 120). Gertrude Stein mentions this move in *The Autobiography of Alice B. Toklas* but without giving a date:

Not long after this, Picasso came one day [to rue de Fleurus] and told Gertrude Stein that he had decided to take an atelier in the rue Ravignan. He could work better there. He could not get back his old one but he took one on the lower floor.
(G. STEIN 1961, p. 111)

We do not know, after this date, where the *Demoiselles* might be, until Picasso's move to rue Schoelcher in the autumn of 1913, where the painting's presence is documented by Soffici (see below, under May 25, 1914).

NOVEMBER 3, 1911

From Poggio a Caiano, Soffici sends to Picasso in Paris, at boulevard de Clichy, a parcel (dated by postmark) of photographs of several of Soffici's recent works, among them *Donne che si lavano (Women at Their Toilette)* of 1911.
(ARCHIVES PICASSO)

This canvas is no. 21 in the catalogue Richter 1975. The crouching figure seen from behind, in the painting's foreground, is a direct quotation of the *Demoiselles*.

APRIL 10, 1912

The Danish painter Jens Ferdinand Willumsen writes from the Hôtel Voltaire, Paris, to Edith Willumsen, his second wife, that he has been to visit Zuloaga the day before:

Yesterday I went to see the Spanish painter Zuloaga, who has a large collection of El Grecos.—They were very interesting. I was confirmed in my belief that my picture is an El Greco. He was very friendly.... We saw none of his own pictures. He seemed to live in rather empty rooms. He was offered, he said, for his largest and most interesting picture 450 thousand [Danish kroner], but he would never part with it, even if he ran short of money. He was very proud of his El Grecos, which were the finest, the best in the world, and he was envious of others who had El Grecos. I have ordered a few photos of his pictures, which will be sent directly home in about a week.
(J. F. WILLUMSENS MUSEUM ARCHIVES, Frederikssund, Denmark)

It seems likely that the "largest and most interesting picture" referred to by Willumsen is El Greco's *Apocalyptic Vision*, which would make this one of the very few contemporary references to the painting's presence at Zuloaga's in Paris.

J. F. Willumsen was an ardent admirer of El Greco's work,

which had considerable influence on his own, and he wrote a two-volume biography of the painter, published in Paris in 1927. We are most grateful to Vibeke Petersen, former curator of the J. F. Willumsens Museum, for making available the letter just cited and translating the excerpt quoted, and to Leila Krogh, curator of the J. F. Willumsens Museum, for help with research. We also thank Rolf Laessøe, for alerting us to the existence of correspondence in the J. F. Willumsens Museum pertaining to Zuloaga.

APRIL 30, 1912

Picasso draws a map to show Vincenc Kramář how to get to the Bateau-Lavoir from place Pigalle (fig. 6).

Jirí Kotalík brought to our attention this visit (and the dated map that documents it), as well as another visit between the two, on May 3, at rue Ravignan and boulevard de Clichy, during a trip by Kramář to Paris from April 25 to May 5.

6. Plan drawn by Picasso for Kramář the day of his visit to the Bateau-Lavoir, April 30, 1912, indicating the route from place Pigalle to rue Ravignan. Private collection

MAY 7, 1912

Picasso and Ardengo Soffici see each other in the evening (see the next entry).

[MAY 8, 1912]

That Wednesday, Ardengo Soffici writes from Paris to Giuseppe Prezzolini, who is also in Paris:

I saw Picasso yesterday evening.
(PREZZOLINI/SOFFICI 1977, pp. 227–28)

This was perhaps another visit by Soffici to Picasso's boulevard de Clichy studio (if indeed that was where they met on the evening of May 7); Soffici saw the *Demoiselles* in that same studio in the spring of 1910 and perhaps in 1911 (see above, under April 6, 1910; see also the section devoted to Soffici in the Anthology, pp. 251–52). Many thanks to Jean-François Rodriguez for directing us to this letter.

MAY–AUGUST 1912

A series of letters sent by Picasso from Céret and from Sorgues to Kahnweiler in Paris between May and August confirms that the painter had two addresses, one on boulevard de Clichy, the other at the Bateau-Lavoir (published in Monod-Fontaine 1984a, pp. 165–69).

JUNE 23 TO THE END OF SEPTEMBER 1912

Picasso, after leaving Céret on June 21, goes to Avignon and rents a house in Sorgues, a town in the northern suburbs of that city. (COUSINS 1989, pp. 396–97)

This is Picasso's earliest proven stay in Avignon. (See the sections devoted to Kahnweiler and Salmon in the Anthology, pp. 236, 249.) For the dates of his stay at Sorgues, see Monod-Fontaine 1984a, pp. 169–70; and Cousins 1989, pp. 391–96.

SEPTEMBER 17, 1912

From Sorgues, Picasso writes to Kahnweiler in Paris:

[A]sk the concierge if everything is arranged so I can move out right away. I would then come to Paris and look around some more and inevitably find something because this can't go on much longer.
(ARCHIVES KAHNWEILER-LEIRIS)

Picasso, who has just made a quick trip to Paris to arrange to move out of the apartment on boulevard de Clichy, is back in Sorgues, apparently without having managed to find a new apartment. This will be taken care of in the week to follow, when he leaves Avignon for Paris and moves into 242, boulevard Raspail. No accounts have been found of the *Demoiselles* being at this address. (Concerning the date of departure from Avignon, see Cousins 1989, p. 404.)

AUTUMN 1912

Publication of André Salmon's book *La Jeune Peinture française*, one chapter of which, the "Histoire anecdotique du cubisme" (Salmon 1912, p. 43), contains a long description of Picasso's work on a large canvas, representing "six large female nudes," which a friend of the painter christened "The Philosophical Brothel."

At the end of the last of the texts published in *La Jeune Peinture française*, the date March–April 1912 appears. Edward Fry found an advertisement announcing its publication in the October 14 issue of *Gil Blas* (Fry 1966a, pp. 90 and 195 [note 1 of Text 18]). Guillaume Apollinaire, in the November 29 issue of *L'Intransigeant*, reviews this "charming book," this "witty, well-written work," and says that an

entire chapter of it, devoted to paintings by women, is largely inspired by his own ideas (Apollinaire 1972, p. 261; see also the Anthology, pp. 244–46).

MAY 7–JUNE 25, 1913

Kramář is in Paris again, and meets with Picasso. A letter from Kramář to Picasso, dated January 29, 1922 (see below, under that date), refers to their meetings nine years earlier.

Again we thank J. Kotalík and J. Brunclík for providing the dates of this visit by Kramář.

AUGUST 19, 1913

From Paris, Picasso writes to Kahnweiler:

We've found a studio with apartment, very large and full of sunlight, near our place, 5 bis, rue Schoelcher.
(MONOD-FONTAINE 1984a, p. 170)

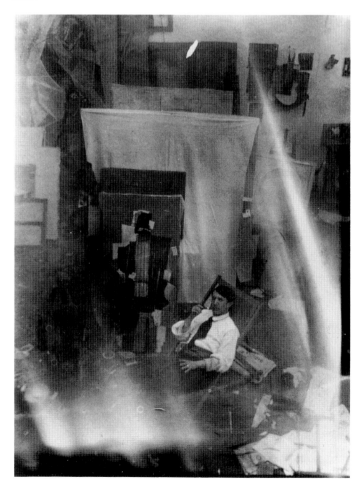

7. Picasso in his studio at 5 bis, rue Schoelcher, Paris, 1914–16. Behind him can be seen *Man with a Pipe* (Zervos II², 470). *Les Demoiselles d'Avignon* can be seen in the upper left. Archives Picasso

SEPTEMBER 20, 1913

In a letter to Apollinaire, Picasso proposes a luncheon appointment at the boulevard Raspail address.

(PICASSO/APOLLINAIRE 1992; photograph, p. 109; original letter no longer extant)

At this date, Picasso has not yet moved into the rue Schoelcher studio.

AUTUMN 1913

After selling his collection of eighteenth-century paintings, with the intention to replace it with contemporary art, the couturier Jacques Doucet moves to 46, avenue du Bois, where he will reside until August 1928. This is his residence when he buys the *Demoiselles,* in 1924.

(CHAPON 1984, pp. 157, 332)

1914

According to Henri-Pierre Roché, Doucet visited Picasso around this time:

Roché took Doucet to see Picasso on rue Schoelcher—maybe 1914—for first time. They talked for hours—Doucet at first very skeptical, feeling Picasso was not sincere, was fooling public. Picasso very courteous, patient and persuasive: "Was Michelangelo sincere when he painted the Sistine frescoes?"

(Archives of The Museum of Modern Art, New York [hereafter abbreviated as MoMA ARCHIVES], Alfred H. Barr, Jr. Papers)

These are handwritten notes taken by Alfred Barr during or after a conversation with Roché on July 29, 1946, in Paris.

EARLY 1914

A March 31, 1919, letter from André Level to Picasso (see below, under that date) mentions a first visit to the studio by André Lefèvre, with Level, in early 1914; no doubt Lefèvre saw the *Demoiselles* there. On July 4, 1922, at the third Kahnweiler sale, Lefèvre will buy *Yellow Nude* (Daix 39; Zervos XXVI, 281), which he considers to be a study for the *Demoiselles.* He will also purchase *Bust of a Woman* (Daix 38; Zervos II¹, 23, generally believed to be a preparatory study for the large painting).

MAY 25 [1914]

From Paris, Ardengo Soffici writes to Giuseppe Prezzolini in Florence: *I went to see Picasso, who found my recent works to be very good.* (PREZZOLINI/SOFFICI 1977, p. 253)

Here is a documented visit by Soffici to Picasso's rue Schoelcher studio. There, Soffici saw the *Demoiselles* again (fig. 7)—"hanging in a corner," as he later reported (SOFFICI 1942, p. 371)—having already seen the painting at the time of its birth at the Bateau-Lavoir, and again at Picasso's place on boulevard de Clichy (see above, under April 6–7, 1910, and May 8, 1912; see also the section devoted to

Soffici in the Anthology, pp. 251–52).

Our thanks to Jean-François Rodriguez for calling this letter to our attention and for determining the dates of Soffici's two sojourns in Paris in 1914: from before March 15 to the first half of April (before the 12th); and from early May (before the 5th) to June 14.

During one of these two sojourns, Soffici is invited to Picasso's place, together with Henri Matisse, at which time Matisse presumably saw the *Demoiselles* again (SOFFICI 1942, p. 372).

1914–16

A text by Albert Dreyfus published in 1923, in which he recounts a visit to Picasso the previous summer, indicates that he had gone to see him at rue Schoelcher during the war, thus between August 1914 and the autumn of 1916, when Picasso moved to Montrouge.

In the midst of war I saw Picasso in his studio on rue Schoelcher drawing again with an entirely Ingres-like precision.

(DREYFUS 1923, p. 58; see also the section devoted to Dreyfus in the Anthology, p. 232)

Dreyfus does not say here that he saw the *Demoiselles;* he does not mention the painting until his visit to Picasso in 1922. From André Salmon (1955, p. 225) we learn that Dreyfus and his wife Hilma Graff (who was a painter) frequented the Closerie des Lilas at the time of the *Vers et prose* Tuesday-night gatherings, hence after 1905. It is not impossible that Dreyfus knew Picasso at an early date.

DECEMBER 1915

The Swedish painter Arvid Fougstedt pays a visit to Picasso in the "new studio building" on rue Schoelcher, in the company of Adolphe Basler and Max Jacob. Picasso tells Fougstedt that he does not see much of anyone, seldom goes out, and that all his friends are in the war, with the exception of Matisse, who visited him a few days earlier (Fougstedt 1916).

It is probable that during December 1915, Fougstedt, Basler, Jacob, and Matisse saw, or saw again, the *Demoiselles,* which was, as is known from a photograph (fig. 7), conspicuous, leaning against a wall of the studio. We also know that by December 2, 1915, Matisse was in Marseille (P. Schneider 1984, p. 735).

This document was kindly provided by Julie Martin and Billy Klüver, who translated it.

APRIL 29, 1916

The Norwegian painter Edvard Dieriks sends a postcard to Danish friends, the painter Axel Salto and Salto's wife, Kamma, in Paris, telling them they can pay a call on Picasso whenever they like, except Mondays.

The existence of this postcard, which remains impossible to find, was reported to us by Troels Andersen (letter of April 6, 1987). In 1965–66, he had the opportunity to talk with Mrs. Salto about her stay in Paris in 1916. See, on this matter, his book on the Danish painter Jens Adolf Jerichau (Andersen 1983, pp. 126–29): Jerichau had

not yet arrived in Paris when the Saltos visited Picasso, after receiving Dieriks's card. Salmon mentions the presence of Dieriks (he spells it "Diriks," as does Apollinaire in *Chroniques d'art*), and of his wife, at the *Vers et prose* gatherings at the Closerie des Lilas (see Salmon 1955, pp. 214–16). Fernande Olivier also mentions the presence of the "Didricks" at those Tuesday evenings (Olivier 1965, p. 44).

AFTER APRIL 29, 1916

Axel Salto and his wife, Kamma, pay a visit to Picasso at rue Schoelcher. Salto mentions the event in an article published in the review *Klingen* a year later:

In the studio there hung a painting from a more recent period, "Les Filles d'Avignon." It is a canvas as large as a wall, a little bit higher than it is wide. It shows three standing female figures and one sitting (with her back to us), who is closest to some fruit on her left.

(SALTO 1917; see also the section devoted to Salto in the Anthology, p. 250)

JULY 1916: THE SALON D'ANTIN

In *L'Europe nouvelle* of April 6, 1918, Salmon will recount the events of two years before:

It would be wrong not to recall here that in July 1916, M. Paul Poiret put his avenue d'Antin gallery at my disposal, with the cooperation of M. Barbazanges, to organize the Salon d'Antin, the only group exhibition available, since the start of the war, to the revolutionary artists whom unfortunately I cannot all name here.[1]

The exact location and dates of the Salon d'Antin can now be clearly established, as follows.

The address: the July 1916 events took place at two different addresses, the first, given in the catalogue of the Salon (see fig. 10), being 26, avenue d'Antin (now avenue Franklin-Roosevelt), and the second, given in *Sic*, being 109, rue du Faubourg-Saint-Honoré.

The place: on the ground floor of one of the adjoining outbuildings of the three-story eighteenth-century mansion that Paul Poiret lived in from 1909 to 1924, at 109, rue du Faubourg-Saint-Honoré, there was a gallery of modern art, which the great couturier had rented to his friend Barbazanges since 1911. This gallery was also accessible through a rear entrance door situated in the back of a courtyard that one entered at 26, avenue d'Antin; therefore, at the time, the press spoke of the "salons Poiret," the "Galerie Poiret," the "Salon d'Antin," or even "chez Barbazanges" (after the dealer in charge).[2]

The dates: the admission card indicates July 16 to 31, 1916 (see fig. 8). Numerous reviews bear witness to the importance and resonance of the event in a time of war.[3] This political context clearly explains the generally xenophobic tone of critics, who did not fail to point out the large number of foreigners who at the time were the makers of "Modern art in France" (see below, p. 169, July 23 and 28, 1916).

Some of the visitors who saw the exhibition: Axel Salto's wife, Kamma, said that she and her husband, together with their friend Jerichau, had been invited by Picasso himself to the Salon d'Antin, where the *Demoiselles* was hung on a wall by itself, and that Picasso had commented on his painting for them.[4]

Gino Severini, who participated in the exhibition with four paintings, recalls the Salon d'Antin:

After Madame Bongard's exhibition, André Salmon organized another, much more important show in a gallery called Galerie Barbazanges, at 26 avenue d'Antin. At the time it was called the Salon d'Antin; later it was managed by Marcel Bernheim. Participating in this exhibition were practically all the avant-garde painters of some worth. Picasso submitted his large painting "Les Demoiselles d'Avignon," which, in addition to its artistic value, also has a historical value, being one of the works that marked the beginning of Cubism.[5]

One can assume that Gertrude Stein, who was invited to the opening by Picasso, did attend.[6] We can also surmise that René-Jean, who advised Jacques Doucet to go see the exhibition, had seen it himself, and that Doucet, who claimed he would be delighted to see the avenue d'Antin show, actually did go see it.[7] (Roché, probably mistaken as to the date, told Alfred Barr in July 1946 that Doucet had seen the *Demoiselles* at Poiret's house.)[8]

Paul Valéry writes to André Breton on July 31, 1916:

In the meantime I have had a son, who is fourteen days old today. This event, though it is of minor consequence to you, did not prevent me from going to see a cubic [sic] exhibition where your company would have been most valuable to me. I do not know what you do, but this was well worth an ambulance. There is something positively new about this art, but what is it?[9]

Georges Auric, one of the composers of the Groupe des Six, will later write an account in which he confuses the Salon d'Antin with an event organized by the Lyre et Palette association at rue Huyghens:

On rue Huyghens, near boulevard Raspail, close to the very heart of Montparnasse, there was quite a vast studio in which a series of rather sensational exhibitions took place. Matisse, Picasso (I believe I saw his famous Demoiselles d'Avignon *there) and everyone else whom it was possible to discover at that time were hung on those walls.[10]*

Most likely those artists showing at the Salon d'Antin who were in Paris at the time also saw the exhibition,[11] as did Poiret,[12] of course, as well as Apollinaire, who was responsible for the literary matinee of July 21.[13]

1. Salmon 1918a, p. 631. Several weeks later, on June 22, Salmon again recalls the Salon d'Antin: "With the help of a few friends who had returned with me from armed service, I organized the Salon at Poiret's, that much-maligned, generous man" (Salmon 1918b, p. 1155).
2. Hubert 1979, p. 61. For a description of the premises, see also Yvonne Des-

landres, *Poiret* (Paris: Regard, 1986), p. 42; and *Paul Poiret et Nicole Groult* (Paris: Palais Galliera, 1986), pp. 179–80.

Given the discrepant references to the Salon d'Antin being held at Poiret's art gallery at 26, avenue d'Antin, or 109, rue du Faubourg Saint-Honoré, Billy Klüver has sought to establish exactly where the Salon d'Antin was held within the complex of buildings Poiret owned in a large triangular block between avenue d'Antin, rue du Faubourg-Saint-Honoré, and rue du Colisée. The results of his investigation (which he generously shared with us in manuscript form) appeared in a revised and expanded version of his article "A Day with Picasso" (Klüver 1986) published in German in November 1993 (Klüver 1993) and French in 1994 by Hazan; they include a ground plan based on a 1900 map of Paris, showing the space occupied by Poiret's mansion and the Barbazanges gallery.

Poiret's premises included the three-story late eighteenth-century mansion at 26, avenue d'Antin—which he found abandoned, and bought and completely restored in 1909—set back from the street and reached by a driveway into a formal garden; the adjoining buildings at 107 and 109, rue du Faubourg-Saint-Honoré (the former on the same lot as the mansion, the latter on a separate lot at the side of the building); and a fourth building, which fronted on 39, rue du Colisée.

Around 1911, the space on the ground floor facing the street at no. 109 was leased by Poiret to an art dealer, thus becoming the Galerie Barbazanges, and consisting of a large front room and several smaller rooms that led to a large back room with a glass ceiling. "Barbazanges agreed that Poiret could organize exhibitions of his own choosing in the gallery from time to time. Poiret also broke through the wall and made a door leading from the mansion to one of the rooms of the gallery" (Klüver 1993, p. 72). The couturier exercised his prerogative to hold Salmon's exhibition in Barbazanges's gallery space, which, owing to the large number of works, may have been extended to include the mezzanine above the front room. Klüver proposes that "since the large room of the gallery could be reached from the mansion at No. 26, Avenue d'Antin, Salmon used '26 Avenue d'Antin' as the address, and gave the exhibition the more classical title 'Salon d'Antin,' both to underscore Poiret's sponsorship and to separate his exhibition from the activities of the gallery (Klüver 1993, pp. 72–73; quotations are from the English-language manuscript).

3. Hubert 1979, p. 66, note 26.
4. Troels Andersen has published information on this subject in his book on Jerichau (Andersen 1983, p. 126): "[The Saltos] and Jerichau received an invitation from Picasso to an exhibition at the Salon d'Antin, arranged by the art critic André Salmon. This exhibition took place in July. Here Picasso exhibited for the very first time his major work, painted in 1907, *Les Demoiselles d'Avignon*. It was hung by itself, alone on a wall. Picasso showed it himself to Jerichau and Salto, and seemed to attach great importance to it." Many thanks to Jonas Storsve for calling our attention to this text, and to Scott de Francesco for translating it into English. Troels Andersen clarified a few points for us in a letter of April 6, 1987: the invitation the Saltos received from Picasso may well have been a handwritten note; and the show was "intimate in character."
5. Severini 1946, pp. 249–50; see also the section devoted to Severini in the Anthology, p. 251.
6. See Picasso's express letter of July 16, 1916, below, p. 166.
7. See July 20, 1916, below, p. 168. It should also be mentioned that the catalogue of the exhibition can be found in the Fonds Doucet at the Bibliothèque d'Art et d'Archéologie, Paris.
8. See the passage from Barr's notes, quoted below, p. 168.
9. Quoted in Breton 1970, p. 14. We thank Étienne-Alain Hubert for pointing this text out to us. Paul Valéry's son, François, was born July 17. Breton was at the time an orderly in the medical corps at Nantes (hence the allusion to the ambulance [*automobile chirurgicale*]). We are unaware of Breton having made any visit to the Salon d'Antin.
10. Auric 1979, p. 132. The first exhibition of Lyre et Palette at rue Huyghens took place November 19–December 15, 1916; according to the catalogue, Picasso exhibited a *Violin* (no. 34) and a *Guitar* (no. 35). But literary events were very likely held there as early as April of that year (Chapon 1984, p. 240). Since Auric speaks of the *Demoiselles*, one might surmise that he saw it at the Salon d'Antin (indeed, he was on the program of the musical performance of July 18 at the

Salon d'Antin), but apparently he is confusing two shows that took place at about the same time—the 1916 Lyre et Palette exhibition and the Salon d'Antin. Étienne-Alain Hubert, to whom we are indebted for directing us to Auric's text, firmly rules out that the *Demoiselles* was ever exhibited at Lyre et Palette. He conjectures that Auric's allusion to seeing the *Demoiselles* someplace other than the Salon d'Antin during the war is a possible indication that he saw it at the Matisse/Picasso exhibition at Paul Guillaume's gallery in January–February 1918 (see the Appendix, p. 207).
11. It would be interesting to investigate, in archives and published memoirs, whether any of the exhibiting artists mention the Salon and the *Demoiselles*. The unpublished memoirs of Marie Vassilieff, "La Bohème du XXème siècle" (Claude Bernés collection), written in 1929, unfortunately say nothing on this point.
12. By this time Poiret has in fact been called up for service, but was assigned to the Archives du Ministère de la Guerre in Paris (see *Paul Poiret et Nicole Groult*, p. 184). Poiret had known Picasso since the days of the Bateau-Lavoir. Fernande Olivier recounts with irony the couturier's first visit to the studio (Olivier 1965, p. 115). He may have seen the *Demoiselles* at that time.
13. See below, p. 170, Apollinaire's letter to Soffici of August 27, 1916. The poets and composers who may have attended and the readers and performers whom we know were present at the literary and musical events should also be taken into account.

CONTEMPORARY ACCOUNTS OF THE SALON D'ANTIN

The review *Sic* announces an exhibition to take place at 109, rue du Faubourg-Saint-Honoré:

Painting, poetry, music (Sounds, Ideas, Colors). We are happy to announce to our readers that an avant-garde exhibition-recital will take place at 109, Faubourg-Saint-Honoré from July 10 to 30. This assortment will constitute the first of the art events that Sic *has long been promising to produce. All* Sic *subscribers will receive a personal card assuring them 2 places at the literary and musical matinées.*
(*Sic*, July 1916, p. 54)

In the event, the dates announced in the review were changed.

Imprinted on an admission card (fig. 8)—for two persons, valid for the exhibition, the two musical performances, and the two literary matinees—are the precise dates of the painting exhibition (July 16–31) and the name of its organizer, André Salmon.

This is the card—black with orange lettering, and measuring 10.1 x 13.2 cm—that was distributed to the subscribers to *Sic* (it is stamped five times with the review's title). Four detachable coupons gave admission to the literary and musical events. As for the dates shown on the card, the one for the opening, the 16th, is most likely correct. As regards the closing date, it should be noted that news articles on the exhibition appeared until August 6, although it is possible, of course, for reviews to appear after the closing of an exhibition. Based on the documents available at the time, Billy Klüver in 1986 believed that the Salon d'Antin opened on July 15 and closed on August 12, 1916 (Klüver 1986, p. 104). Following the publication of the admission card giving the precise dates of the Salon d'Antin (in Cousins/Seckel 1988, vol. 2, p. 572), Klüver now accepts the dates July 16 and July 31 for the opening and closing of the exhibition (Klüver/Martin 1989, p. 76; and Klüver 1993, p. 68).

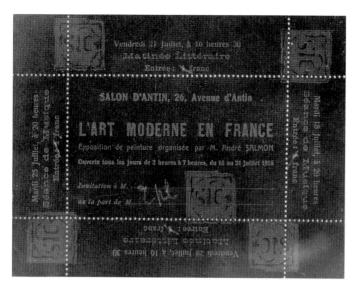

8. Invitation card for the exhibition "L'Art moderne en France" (the Salon d'Antin), mailed by the periodical *Sic* to its subscribers. Collection Jacqueline Gojard, Paris

This document, which to our knowledge had not been published prior to 1988, was kindly provided by Jacqueline and Jacques Gojard.

•

Picasso addresses an express letter (fig. 9) to Gertrude Stein (posted 7 a.m., Sunday, July 16, at the avenue d'Orléans post office, and received at 9:25 a.m., at rue Littré):

My dear Gertrude:
Tomorrow (Sunday) opening at Poiret's, come around 3:30
This letter serves as your invitation
Yours truly,
Picasso
(BEINECKE LIBRARY)

This note, which is undated, must have been written Saturday, July 15 (since it mentions that "tomorrow" is Sunday), but it was not posted until the following morning, the day of the opening. Avenue d'Orléans is today avenue du Général-Leclerc.

•

The catalogue of the exhibition "L'Art moderne en France" (at the "Salon d'Antin, 26 avenue d'Antin"), which does not indicate the dates of the show, cites the following: "Picasso (Espagnol). no. 129 *Les Demoiselles d'Avignon*" (figs. 10, 11). On the cover are announcements for two musical performances, on Tuesdays (July 18 and 25), and two literary performances, on Fridays (July 21 and 28). On the reverse of the cover there is an advertisement for Rosine perfumes (created by Poiret and named after his daughter).

This is the first time the title *Les Demoiselles d'Avignon* appears in print (see fig. 11), and the first time the work is shown to the public. Maurizio Fagiolo dell'Arco has pointed out to us (letter of September 1987) that in the Severini archives there is a typewritten list of participating artists and the works exhibited which bears the annotation, in

Severini's hand: "organisé p. Salmon." Fagiolo dell'Arco suggests that Paul Guillaume may have instigated the project, considering the number of his gallery's artists represented in that exhibition and the fact that a recent work by Giorgio de Chirico was also shown there, after being sent from Ferrara to Paul Guillaume.

The copy of the catalogue that we consulted is in the Fonds Doucet at the Bibliothèque d'Art et d'Archéologie, Paris. It is accompanied by a press clipping about the exhibition, taken from the July 23, 1916, issue of *L'Excelsior* (see below, pp. 168–69).

•

L'Intransigeant of July 16, in its column "Nos échos …On dit que …" (p. 2), comments, under the pen name "Wattman":

At the opening of the Salon d'Antin:
"Who would ever have thought we would see an opening in wartime?"
"You will agree, Madame, that this feast of color is rather austere in tone…."
"That Picasso!"
"Did you prefer his harlequins?"
"Yes, but this large picture holds my attention; you could say it's overwhelming."

The "large picture" is the *Demoiselles*. This article was pointed out by Billy Klüver (1986, p. 104), who thinks its author was probably André Salmon. (Pierre Caizergues confirms that by this time, it was no longer Guillaume Apollinaire hiding behind the name of

9. Express letter from Picasso to Gertrude Stein, July 16, 1916. Yale Collection of American Literature, The Beinecke Rare Book and Manuscript Library, Yale University, New Haven, Connecticut

Salon d'Antin
26, Avenue d'Antin

L'ART MODERNE
EN FRANCE

1916

DEUX SÉANCES DE MUSIQUE :
Les Mardi 18 et 25 Juillet à 10 h. 30
DEUX SÉANCES LITTÉRAIRES :
Les Vendredi 21 et 28 Juillet à 16 h. 30

11463

DAGOUSSIA MOUAT (Anglaise)
116. *Toile: " Table et chaises ".*
117. » *" Etude ".*
ANNA ORLOFF (Russe)
118. *Sculpture : " Les Danseuses ".*
119. » *" Portrait d'homme ".*
120. » *" Le baiser " (bois).*
121. » *" Portrait du Comte Vilgorsky "*
122. » *" Petite esquisse en bois "*
HÉLÈNE PERDRIAT (Française)
123. *Portrait de mes sœurs.* 126. *La Dame rouge.*
124. *Tiarka.* 127. *Saintonge.*
125. *Créole.* 128. *Sept pointes sèches.*
PICASSO (Espagnol)
129. *Les Demoiselles d'Avignon.*
GEORGES ROUAULT (Français)
130. *Von Luther.* 133. *Von Krapôte.*
131. *Sacrée Union.* 134. *Vénus Germanique.*
132. *Herr Rouquin.* 135. *Frau Krapôte.*
PIERRE ROY (Français)
136. *Deux coiffes.*
DE SEGONZAC (Français)
137. *Nature morte.*
138. *Paysage (App. à M. P.)*
139.
GINO SEVERINI (Italien)
140. *Femme et enfant.* 142. *Nature Morte.*
141. *Nature morte.* 143. »
ROBERT TILLET (Français)
144. *Trois dessins au fusain.*
145. *La Sulamite (bois gravé).*
146. *Les roses de Pestum (bois gravé).*
147. *Esquisse pour une Passion de la Vierge.*
VAN DONGEN (Hollandais)
148. *Madame la France.*
MARIE WASSILIEFF (Russe)
149. *Nature morte : Poupées* 154. *Pierrette.*
150. *Portrait de M. M.* 155. *Paysage.*
151. *Tableau d'enfant.* 156. *Paysage à Poigny.*
152. *Fleurs.* 157. *Cimetière du Mont-*
153. *parnasse.*
DE WAROQUIER (Français)
158. *L'orage.*
159. *Paysage au rocher.*
MADEMOISELLE YORKE (Américaine)
160. *Le Métro.*
161. *2 rideaux.*
162. *Dessin.*
ORTIZ DE ZARATE (Espagnol)
163. *Figure : Homme.* 165. *Nature morte.*
164. » *Femme.* 166.

10. Cover of the catalogue for the exhibition "L'Art moderne en France" (the Salon d'Antin), organized by André Salmon and held at Paul Poiret's Galerie Barbazanges, 126, avenue d'Antin, Paris, July 16–31, 1916. Bibliothèque d'Art et d'Archéologie, Fonds Jacques Doucet, Paris

11. Page from the catalogue of the exhibition "L'Art moderne en France" (the Salon d'Antin). *Les Demoiselles d'Avignon* is listed as no. 129. Bibliothèque d'Art et d'Archéologie, Fonds Jacques Doucet, Paris

"Wattman.") Klüver also surmises that the opening took place the evening before, Saturday, July 15. However, to the present writers the July 16 date seems incontestable, Picasso's handwritten note being the best evidence of all. Moreover, R. Josué Seckel has ascertained that *L'Intransigeant*, which was an evening daily, and generally appeared the evening *before* the printed date it bears, did nonetheless during wartime appear on the same day, as would be the case here. A box in the paper (in the "Édition de Paris") specifies: "Sunday evening, July 16, 1916." Several news items are datelined the 16th, notably the official bulletins on the military situation (e.g., "July 16, 1500 hours"). It is reasonable to assume, therefore, that the piece on the opening of the Salon d'Antin is likewise reporting an event of the same day.

On July 18, 1916, a musical performance is given at the Salon d'Antin. (It is attended by Misia Sert, who describes it the next day in a letter to Igor Stravinsky; see below.) On the program are *Gymnopédie* and *Sarabande* by Erik Satie and works by Henri Cliquet, Roger de Fontenay, Darius Milhaud, and Georges Auric. The performance concludes with Stravinsky's *Three Pieces for String Quartet*, performed by Yvonne Astruc, Darius Milhaud, Arthur Honegger, and Félix Delgrange.
(GOLD/FIZDALE 1980, p. 174)

•

In a letter probably written on July 19, 1916, Misia Sert writes to Stravinsky:

Yesterday I spent an atrocious evening, in which you were involved, my dear Igor, and that is why I am writing to you....

Well then, yesterday afternoon I heard there was a concert at Poiret's art gallery, where they were to play Satie, then your quartets. You can imagine that I dropped everything and threw on my clothes to get there in time to hear some of it. You see the sad truth in the enclosed program. When they got to you, my poor ears had been subjected to every possible nightmare—and my eyes, too.
(GOLD/FIZDALE 1980, pp. 174–75)

Might the "nightmare" for her eyes have been *Les Demoiselles d'Avignon*?

•

In *Le Bonnet rouge* of July 19 (p. 2), an article titled "Une Exposition: L'Art moderne en France," signed M.S. (Marcel Serano), says:

In Poiret's rooms, which one reaches through a little shop on faubourg Saint-Honoré bearing the sign Modernists, *no doubt to scare off the peaceful bourgeois fond of photography, our colleague and friend* André Salmon *has organized an exhibition of modern art.*
A description of the show follows.
There is yet another big daub by Picasso.

(This press excerpt, like all those that follow, was cited by Étienne-Alain Hubert [1979, p. 66, note 26], who led us to these texts and other information concerning the Salon d'Antin.)

Salmon, in his *Propos d'atelier* (1922, pp. 39–40), launches an attack against the "witty chronicler of the *Bonnet rouge*" and more generally against the "critics from the red press [who] as a rule refuse to accept anything beyond a benign Impressionism, the likes of which can only be tolerated by a certain kind of proletarian dauber." He concludes: "A curious disagreement with Moscow."

•

On July 20, from the Savoy Hôtel at Fontainebleau, Jacques Doucet writes a letter (postmarked Dijon) to René-Jean, curator in charge of Doucet's library (at the time located at 44, rue des Perchamps, Paris):

I am returning to Paris Tuesday, during the day. Please come see me, if possible, Thursday morning around 9 o'clock. We'll talk. I know nothing about the Salon of av. d'Antin, nor about Poiret. I shall be delighted to see [it]. Yours sincerely, Jacques Doucet.
(DÉPARTEMENT DES MANUSCRITS [NaFr. 13124 no. 62], Bibliothèque Nationale, Paris)

The French is ambiguous here and could mean either "delighted to see him" or "delighted to see it." One may assume, however, that it is the Salon d'Antin that Doucet will be delighted to see, because, according to François Chapon (1984, pp. 53–54), Doucet's relations with Poiret had been cool since the beginning of the century. Why then does Suzanne Lemas (1980, p. 16), who brought this letter to our attention, conclude that Doucet missed the Salon d'Antin? The letter is dated "Thursday" and postmarked July 20 (the same day). Doucet therefore expected to return Tuesday, July 25, six days before the exhibition closed.

•

In Alfred Barr's hasty notes, written in Paris in July 1946, one reads:

P. Roché to Barr (July 1946)—Demoiselles d'Avignon c. 1918–19 shown at Galerie? (owned by Paul Poiret)—seen there by Doucet who later visited Picasso— …
(MoMA ARCHIVES, Alfred H. Barr, Jr. Papers)

These notes are rather imprecise but they may attest to Doucet's having visited the Salon d'Antin, which his letter of Thursday, July 20, might suggest. See the continuation of these notes below, under "Before 1924."

•

In *L'Opinion* of July 22, in the column "Beaux-Arts et Curiosité" (pp. 95–96), Roger Bissière writes an article headed "La Logique et les expositions":

I had on several occasions deplored here the lack of cohesion characteristic of most exhibitions of modern art.… Consequently M. André Salmon deserves our unequivocal praise for having at last organized a truly coherent exhibition of French art the general meaning of which is clearly apparent.

The *Demoiselles* is not mentioned; only Picasso's name. Pierre Daix (1979, p. 199) was the first to point out this reference.

•

In *Le Cri de Paris* of July 23 (fig. 12), in the column "Lettres et Art" (p. 10), under the headline "Cubistes," the following appears:

The Cubists are not waiting for the war to end to recommence hostilities against good sense. They are exhibiting at the Galerie Poiret naked women whose scattered parts are represented in all four corners of the canvas: here an eye, there an ear, over there a hand, a foot on top, a mouth below. M. Picasso, their leader, is possibly the least dishevelled of the lot. He has painted, or rather daubed, five women who are, if the truth be told, all hacked up, and yet their limbs somehow manage to hold together. They have, moreover, piggish faces with eyes wandering negligently above their ears.
An enthusiastic art-lover offered the artist 20,000 francs for this masterpiece. M. Picasso wanted more. The art-lover did not insist.…

Who was this art-lover? The amount offered is less than what Doucet probably paid eight years later (30,000 francs); see below, under February 20, 1924.

•

In *L'Excelsior* of July 23, Michel Georges-Michel devotes an article to "L'Art 'Montparnasse,' ou une peinture trop 'moderne'":

In the rooms of a futurist (and one would hope clever) couturier, alongside Picasso, Matisse, Marquet, Othon Friecz [sic], Derain, Marchand, de Waroquier, de Segonzac, Mme Agutte, Dufrêne, Dufy, Boussingault, Van Dongen, all true artists and, in any case, painters whose effort has at least been original, this foreign riffraff—ah! so now we're saying it forthrightly—follow on one another's heels, jostling, crowding: Scandinavians, Americans, Poles and the rest, floundering in the most ludicrous

for Kunst, Copenhagen, who has made a close study of the Tetzen-Lund collection), is now impossible to verify because it has been mounted on a new canvas. Regarding the Picasso/Salto encounter, see above, under "After April 29, 1916," and November 1917.

JANUARY 23–FEBRUARY 15, 1918

A Matisse and Picasso exhibition is presented at the Galerie Paul Guillaume, 108, rue du Faubourg-Saint-Honoré, Paris. Matisse is represented by twelve works (nos. 1 through 12 in the catalogue), Picasso by thirteen (nos. 13 through 25), of which no. 13 is titled simply *Tableau*. For the catalogue, Apollinaire has written two brief texts, one on each painter. The exhibition elicits numerous commentaries in the press, excerpts of which are later reprinted in the first number of the review founded by Guillaume, *Les Arts à Paris*, issued on March 15, 1918.

On the possibility that the *Demoiselles* was shown in this exhibition, see the Appendix by Étienne-Alain Hubert, in the present volume, p. 206 ff.

JULY 16, 1918

Apollinaire writes to Picasso at Montrouge.
(ARCHIVES PICASSO)

This is the last of Apollinaire's letters addressed to Picasso at Montrouge before the painter left for his honeymoon in Biarritz.

JULY 25, 1918

Max Jacob writes to Picasso at Montrouge.
(ARCHIVES PICASSO)

This is the last of Jacob's letters addressed to Picasso at Montrouge before the painter left for his honeymoon. This letter and the one cited above, under July 16, 1918, confirm that Picasso had kept his place in Montrouge.

OCTOBER 16, 1918

In a notebook, Apollinaire writes:

October 16, 1918 …—Visited the large new apartment Picasso has rented on rue de la Boétie.
(DÉPARTEMENT DES MANUSCRITS, Bibliothèque Nationale, Paris; published in APOLLINAIRE 1991A, pp. 72, 161)

Picasso had not yet moved in at this point; see below, under December 20, 1918. Picasso in fact took two apartments at rue La Boétie.

NOVEMBER 1, 1918

André Breton pays a visit to Picasso and reports this event in two letters, both written the same day, to Louis Aragon (see Beaumelle 1991, p. 93).

This is close to Picasso's following account of the circumstances of his first meeting with Breton, as reported by Roberto Otero (from a conversation with Picasso, October 4, 1966):

I think it was the day [actually the week] before Apollinaire's death [on November 9, 1918]. I remember I was introduced to [Breton] in the passageway of Guillaume's house on the boulevard Saint-Germain. Breton, a young man in uniform—a military doctor, I think—was extremely courteous. He talked about Apollinaire's health, and he couldn't conceal his grief.
(OTERO 1974, p. 82; cited in Cowling 1985, p. 82)

NOVEMBER 13, 1918

Picasso, Max Jacob, and André Breton participate in the funeral procession bearing Apollinaire's remains to the Père Lachaise cemetery (see Beaumelle 1991, p. 93).

DECEMBER 20, 1918

Picasso's final bill from the Hôtel Lutétia, which runs from December 16 to 19, is paid.
(ARCHIVES PICASSO)

Up until this date, therefore, Picasso was living at the Lutétia. He thus did not move into rue La Boétie until the very end of the year, and it must have been at that moment that his studio, and therefore the *Demoiselles*, was transferred from Montrouge to Paris.

JANUARY 18, 1919

In *L'Europe nouvelle*, André Salmon writes:

Picasso one day placed before our eyes a large, beautiful canvas of several nudes, powerful in construction and the natural outcome of the series of paintings that make up what the studio jargon calls the Rose Period. *Picasso had upset the economy of this canvas by retouchings bound to elicit our comments.*
(SALMON 1919A, p. 139)

The *Demoiselles* is not named here. It is only by comparing this passage with Salmon's texts of the period where the *Demoiselles* is described or alluded to that one realizes he is indeed talking about that painting. See below, under April 26, 1919; see also the section devoted to Salmon in the Anthology, p. 247.

MARCH 31, 1919

André Level writes to Picasso:

Dear friend, One of my friends, A. Lefèvre, who came with me in early 1914 to your studio and then to Mlle Stein's, is burning with the desire to see you again.
(ARCHIVES PICASSO)

See above, under "Early 1914."

APRIL 26, 1919

In the journal *Demain*, Salmon writes:

At the time of his first experiments, …Picasso began to transform half-

14. *Portrait of André Breton.* 1923. Drypoint on copper, 5⅞ x 3¹⁵⁄₁₆ " (15 x 10 cm). Frontispiece for the deluxe edition of Breton's book *Clair de terre* (1923). G./B. I, 110. Musée Picasso, Paris (M.P. 2086)

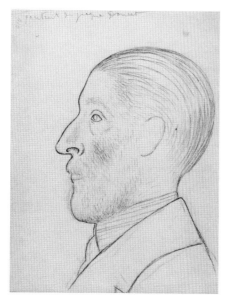

15. *Portrait of Jacques Doucet.* 1915. Graphite, 12⅜ x 9½" (31.3 x 24.3 cm). Zervos XXIX, 162. Musée Picasso, Paris (M.P. 771R)

finished, half-conceived figures, large nudes still related to the style of the "Rose Period."
(SALMON 1919B, p. 485; see the Anthology, p. 247)

1920

Publication of *L'Art vivant* by André Salmon (Salmon 1920a). Pages 118–19 allude to the *Demoiselles* (though it is not named), in a pas-

sage identical to the one that had previously appeared in the April 26, 1919, issue of *Demain*. See the section devoted to Salmon in the Anthology, p. 247.

•

Publication in Munich of Daniel-Henry Kahnweiler's book *Der Weg zum Kubismus* (a revised version of his 1916 text). It mentions:

In early 1907, Picasso starts work on a strange, large painting, with women, fruit, and curtains, which was never finished.... In the foreground, however, inconsistent in style with the rest, a figure is crouching....
(KAHNWEILER 1920B, pp. 17–18)

The *Demoiselles* is not named. See the section devoted to Kahnweiler in the Anthology, p. 235.

•

FEBRUARY 10, 1920
Kahnweiler writes from Bern to Picasso:

I, as you perhaps already know, have written a book on the genesis of Cubism, which will soon be out. I shall send it to you. I have also undertaken to write a book on you alone. I have already started it; it will be published at the end of the year.
(ARCHIVES PICASSO)

The first book is *Der Weg zum Kubismus* (Kahnweiler 1920b), in which the *Demoiselles* is described.

[FEBRUARY] 1920
In the magazine *Die Freude,* Kahnweiler publishes, under the name "Daniel Henry," the article "Werkstätten" (Kahnweiler 1920a, p. 154), in which he describes, among other artists' studios, Picasso's, where he discovered "that mighty painting, never completed, that is the origin of Cubism."

The *Demoiselles* is not named. The publication date of February is suggested in Monod-Fontaine 1984b, p. 128. See the section devoted to Kahnweiler in the Anthology, p. 235.

BEFORE APRIL 1920
Florent Fels, co-editor of the review *Action,* writes to Picasso, on his calling card:

Dear sir, In the upcoming issue of Action, *I am doing an inquiry on African art and would be delighted if you could send me immediately 10 to 15 lines on this subject.*
Thank you beforehand. Sincerely yours, Fels.
(ARCHIVES PICASSO)

The replies to Florent Fels's inquiry on African art are published under the heading "Opinions sur l'art nègre" (Fels 1920) in the April 1920 issue of *Action* (p. 25). The only response from Picasso is the famous: "African art? Never heard of it!"

APRIL 22, 1920

Paul Dermée writes to Picasso, on *L'Esprit nouveau* letterhead, to announce the forthcoming publication of the first issue of this review, of which he is the editor:

In my first issue, I am keen on there being something said about you, and in such a manner that you will find fully satisfying, that is, which truly expresses your intentions and the true facts.

(ARCHIVES PICASSO)

OCTOBER 1920

The first issue of *L'Esprit nouveau* includes a text by Salmon titled "Picasso," dated May 1920. One reads:

[Picasso] turns his canvases to the wall, abandons the large work "Les Demoiselles d'Avignon."

(SALMON 1920B, pp. 63–64)

The *Demoiselles*, here called by name for the first time by Salmon, is again named on p. 78. See longer excerpts from this text in the section devoted to Salmon in the Anthology, pp. 247–48.

1921

In Brno, Vincenc Kramář publishes *Kubismus*. A passage reads:

At that time, a large, curious painting was created, one of the most interesting of all Picasso's oeuvre, even though it was never finished. It portrays female nudes painted in the style of late 1906; that is, the angular forms modeled by chiaroscuro, and next to them we see another figure and a bowl of fruit painted in pure colors of blue, yellow, red, and white—according to the author [Kahnweiler], that represents the true beginning of Cubism.

(KRAMÀŘ 1921, pp. 11–12)

The *Demoiselles* is not named. See the section devoted to Kramář in the Anthology, p. 242. We thank Suzanna Halsey for translating this text from the Czech.

MARCH 31, 1921

According to a written report of the Comité Consultatif des Musées Nationaux, in charge of new acquisitions, in the meeting of March 31, 1921:

M. Guiffrey [curator of the department of paintings] has, among other things, advised the committee of two possible bequests; M. Jacques Doucet has stated his intention of bequeathing twenty-one modern paintings to the Louvre.

(Musée du Louvre, Archives des Musées Nationaux, Paris; hereafter abbreviated as ARCHIVES DES MUSÉES NATIONAUX)

Doucet did not yet own *The Snake Charmer* by Rousseau, which he would purchase from Delaunay in 1922 (Chapon 1984, p. 283), nor Seurat's sketch for *Circus*, which he would acquire at the beginning of 1924 (ibid., p. 296) and which would in fact be left to

the Musées Nationaux, nor of course did he yet own the *Demoiselles*, purchased in 1924. He seems to have forgotten the exasperation evident in his letter to René-Jean (see above, under March 6, 1917).

We warmly thank Yveline Cantarel-Besson for having found this document for us, as well as all of those, below, that concern the relations between Doucet and the Musées Nationaux.

DECEMBER 3, [1921]

André Breton (residing on rue Delambre, Paris, at this time), who has been Jacques Doucet's art adviser since June or July 1921, writes to Doucet to try to convince him to buy an important work by Picasso (and not a small painting, as Henri-Pierre Roché has advised him):

[T]here is no reason, I believe, to represent Picasso in your collection with such tiny pieces. You are aware, especially with an eye toward your future home, that I somewhat regret the fact that you have not acquired one of Picasso's major works (by this I mean something whose historical importance is absolutely undeniable, such as, for example, those Demoiselles d'Avignon which mark the origin of Cubism and which it would be a shame to see end up abroad). Please excuse my frankness, sir, but it has always seemed to me that you almost owe it to yourself, above and beyond your tastes, which are undeniable, to collect in your home the distinguished work of two or three of the greatest artists of the day. This spirit seems to me in any case the only one that conforms to that in which you conceived your library and which I, for my part, cannot help but take into account each time I suggest a painting to you.

(B.L.J.D., B-IV-6, 7210.16)

This is the first of a series of letters attesting to the history of the acquisition of *Demoiselles*, correctly established by François Chapon (who published this excerpt; see Chapon 1984, pp. 267–68). Doucet, as will be seen in a letter he writes to Suarès on March 9, 1924, was touched by Breton's argument concerning the danger that a work as important as the *Demoiselles* might go abroad.

LATE 1921

An undated note from André Breton (at rue Delambre; his address figures in the note) to Picasso (whom he still addresses respectfully as "Dear sir") says:

I had hoped to see you again about the little matter we discussed. Unfortunately Doucet is prepared to acquire not a pastel, but again one of those little things that you brought back this summer (the nudes). He has entrusted me with asking you the price and, if possible, to make an appointment for him to meet with you at the beginning of next week.

(ARCHIVES PICASSO; also in Beaumelle 1991, p. 108)

This note demonstrates the role of intermediary that Breton played between Doucet and Picasso. It is probably contemporary with the letter from Breton to Doucet cited above (which also concerns "tiny pieces" that Roché wants Doucet to buy). For the Picassos in Doucet's collection, see Chapon, 1984, note 92, p. 386.

Marguerite Bonnet confirmed for us that Breton must have moved to rue Fontaine at the end of 1921 or at the beginning of 1922.

1922
André Salmon's *Propos d'atelier* is published. He mentions *Les Demoiselles d'Avignon* by name, and recalls its initial title: "Le B— philosophique."
(SALMON 1922, pp. 16, 180; and see the section devoted to Salmon in the Anthology, p. 248)

JANUARY 29, 1922
Kramář writes to Picasso, from Prague (the letter is postmarked the 30th):

Monsieur, I took the liberty several months ago of sending you, through M. Kahnweiler, a copy of my book on Cubism,...I often recall with pleasure the hours I spent in your company nine years ago at your place and at M. Kahnweiler's.
(ARCHIVES PICASSO)

This again confirms the meetings between Picasso and Kramář, who speaks about the *Demoiselles* in the book he mentions here, *Kubismus*.

MARCH 29, 1922
From Paris, Albert Dreyfus writes to Picasso:

Dear Monsieur; my plan to publish a book on you with a hundred or so first-rate reproductions and a commentary in three languages has aroused the keen interest of a publisher in Dresden. I would like to speak with you about this as soon as possible, since I am leaving for Germany in a few days. I shall therefore try to call on you tomorrow morning at 11 o'clock (Thursday).
With great admiration and friendship,
Albert Dreyfus
(ARCHIVES PICASSO)

In the summer of 1923, in the review *Der Querschnitt*, Dreyfus publishes an article on Picasso in which he tells of his visit to the studio on rue La Boétie in 1922 (see below, under summer 1923).

SPRING–SUMMER 1922
Breton, who will play an important role in Doucet's purchase of major works for his collection of modern art, accompanies Doucet on visits to Man Ray, Francis Picabia, and Picasso; also to Robert Delaunay, with whom negotiations for the purchase of Henri Rousseau's *The Snake Charmer* are concluded on May 22, 1922.

Most probably the purpose of these visits was prospective purchases, because we know from Chapon (1984, pp. 280, 282) that Doucet was introduced by Breton to Picabia and Man Ray during this period, and began buying their work in October. With regard to Picasso, one might ask if the visit may have been related to Doucet's eventual purchase of the *Demoiselles* in 1924—an acquisition that

Breton had been advocating since December of the preceding year (see above, under December 3, 1921).

[JUNE] 9, 1922
Dreyfus writes to Picasso, again from Paris, to complain of the difficulties he is having in obtaining from Paul Rosenberg, Picasso's dealer, eighty photographs that he needs for his book.
(ARCHIVES PICASSO)

The date of the postmark is unclear. This letter and the one of March 29, 1922, document Dreyfus's visit to Paris in 1922 and his contacts with Picasso.

[1923–24]
An undated letter from Doucet to Picasso brought by messenger (the envelope bears the notation "To be hand-delivered") says:

My dear Picasso
May I come to see you next Tuesday around 11 o'clock. I would like first of all to see you, then to talk to you about Les Demoiselles d'Avignon. *my telephone Passy 73-82.*
Fondly,
Jacques Doucet
On the envelope, in Picasso's hand, is written "1923–24."
(ARCHIVES PICASSO)

MAY 1, 1923
Florent Fels writes to Picasso:

My Dear Friend,
Could you please let me know if you could receive me sometime soon and grant me an interview of just fifteen minutes?
Most cordially yours,
Fels
(ARCHIVES PICASSO)

Three months later, in *Les Nouvelles littéraires* of August 4, 1923, an article on Picasso appears in which Fels relates some remarks made by the painter, including "African art? Never heard of it!" (Fels 1923, p. 2; and see above, under "Before April 1920"). In *L'Air de la Butte* (Salmon 1945, p. 23), Salmon speaks of "the only serious interview he [Picasso] ever granted [to Florent Fels]," but mentions in this connection some statements made by Picasso that are found neither in *Les Nouvelles littéraires* nor in Fels's *Propos d'artistes*, published in 1925. Perhaps Fels had shown Salmon a text more complete than the one he published.

MAY 30, 1923
Dreyfus, from Paris, writes an express letter to Picasso dated by postmark:

My review "Le Querschnitt" has gone to press; I have included in it a part of the book I wrote on you, which is still waiting for an opportunity to come out.
(ARCHIVES PICASSO)

Dreyfus has known Picasso a long time (see above, under 1914–16). The reference to the article in *Der Querschnitt* (Dreyfus 1923) will appear below. We were unable to find Dreyfus's monograph on Picasso.

JULY 22, 1923
Dreyfus, from Frankfurt, writes to Picasso in Paris:

Dear M. Picasso, I am sending you herewith a copy of the "Querschnitt," of which I have assumed control of the publishing and editing. You will find several pages on you in it; I hope you will find them amusing.
(ARCHIVES PICASSO)

SUMMER 1923
Albert Dreyfus publishes in *Der Querschnitt* a piece, "Picasso," in which he recounts a visit to the painter's studio on rue La Boétie the previous year:

Picasso brought out his large canvas, "Les Femmes d'Avignon," and unrolled it for me on the floor.
(DREYFUS 1923, p. 57)

The title of the painting is in French in the text. See the section devoted to Dreyfus in the Anthology, pp. 231–32.

NOVEMBER 6, 1923
Writing to Jacques Doucet, Breton elaborates on the reasons for his enthusiasm for the *Demoiselles*. After mentioning several painters who in his judgment should be well represented in Doucet's collection, he comes to Picasso:

Much more difficult. I am quite certain that one is never done with Picasso and yet it seems to me that he is, today, the touchstone for any collection. What there is of Picasso will determine the nature of the collection, whether it is exciting or not, rich or poor. It is an extremely arduous choice; I know that here alone I should find myself at a loss. One sure thing: "Les Demoiselles d'Avignon," because through it one penetrates right into the core of Picasso's laboratory and because it is the crux of the drama, the center of all the conflicts that Picasso has given rise to and that will last forever, in my opinion. It is a work which to my mind transcends painting; it is the theater of everything that has happened in the last fifty years; it is the wall before which have passed Rimbaud, Lautréamont, Jarry, Apollinaire and all those we still love. If it were to disappear, it would take with it the largest part of our secret.
(B.L.J.D., B-IV-6, 7210.40; this excerpt previously published in Chapon 1984, pp. 293–94)

BETWEEN DECEMBER 31, 1923, AND JANUARY 27, 1924
An entry in a notebook of André Breton, undated but appearing between two events dated, respectively, December 31, 1923, and January 27, 1924: "*Les Demoiselles d'Avignon*, 2,42 m x 2,33 m, restauration de tableaux. Chapuis 4 rue Crétet."

This is related to information contained in the April 15, 1924, letter from Doucet to Picasso, below. We thank Marguerite Bonnet for having pointed this out to us. This notebook was published in volume 1 of Breton 1988, pp. 455–72.

BEFORE 1924
In the handwritten notes taken by Alfred Barr during (or after) an interview with Henri-Pierre Roché in July 1946, one finds, in connection with a visit by Doucet to Picasso after the Salon d'Antin:

…saw canvas rolled in corner of studio—bought it without seeing it unrolled—Picasso later regretful at sale and Doucet very proud of having bought it having seen it only once several years before. At Doucet's, Roché often saw Louis Aragon …taken seriously by Doucet who may well have been advised by him in this purchase.
(MoMA ARCHIVES, Alfred H. Barr, Jr. Papers)

The passage preceding this excerpt can be found above, p. 168.

1924: HOW JACQUES DOUCET BOUGHT THE *DEMOISELLES*
In the early 1950s Breton told André Parinaud:

For several years I had taken on the role of librarian for the couturier-collector Jacques Doucet. I was also asked to take charge of guiding the choice of paintings and sculpture for what would become the expansion of his collection of modern art. I do not think myself unequal to this last task, because the acquisitions for which I was responsible included "The Snake Charmer" by Henri Rousseau, a sketch for "Circus" by Seurat, "les Demoiselles d'Avignon" and "la Femme dite au 'sorbet'" by Picasso, "The Disquieting Muses" by de Chirico, "Glider Containing a Water Mill in Neighboring Metals" and "Rotary Demisphere (Precision Optics)" by Duchamp, important works by Picabia, Miró.… Strange man, when I think of it, this Jacques Doucet, then seventy years old, who undoubtedly at times proved himself to be a man of taste and who was considered, not without some just claim to this appellation, to be a patron of the arts; he had already donated a library of art and archeology to the City of Paris, and he was preparing to bequeath to it the collection of works and manuscripts of which I was in charge and which today may be consulted at the Sainte-Geneviève Library. To convince him to buy a painting was a no less laborious undertaking. Not only was it necessary to praise emphatically, and many times, its exceptional qualities, but also to continue thus to entreat him over the course of many letters. Needless to say, this very quickly turned into mere verbiage.[1]

In 1961, when Jean-François Revel asked him to recount the history of Doucet's collection of modern art and the role he played in its making, Breton answered:

Let's take Les Demoiselles d'Avignon. *I remember the day he bought this painting from Picasso, who, strange as it may seem, appeared to be intimidated by Doucet and even he offered no resistance when the price was set at 25,000 francs. "Well, then, it's agreed, M. Picasso," Doucet then said. "You shall receive 2,000 francs per month, beginning next month, until the sum of 25,000 is reached."*[2]

The relatively modest sum for which Picasso sold the painting is shocking (considering that in 1916 he had refused to sell it for 20,000 francs).[3] In this account to Revel, Breton quotes Doucet, followed by his own comments:

"After my death, my whole collection shall go to the Louvre and I shall be the only collector whose authority compels the Louvre to accept avant-garde paintings." He said that to all the painters, even though an important part of his collection was not left to the Louvre.[4]

What impressed Picasso and made him accept the price thus was less the rich collector than the glorious future he foresaw for his masterpiece, in the Louvre.[5] In all likelihood he came to regret the sale.[6] It seems that in bargaining, Doucet had used the risqué subject matter of the painting as a ploy. François Chapon reports the statements of a member of Doucet's immediate circle, according to whom the collector said to the painter, "It's that, you see, M. Picasso, the subject of the painting is a little … well, peculiar, and I cannot in all decency show it in Mme Doucet's living room."[7] In 1946 Roché told Alfred Barr that "Doucet after buying *Demoiselles* wanted to buy *Three Dancers* from P[icasso] but P[icasso] wouldn't sell—because Doucet had got the *Dem[oiselles]* at such a good bargain."[8]

1. Breton 1969, p. 97. This explains the long series of letters to Doucet aimed at convincing him of the reasons for acquiring the *Demoiselles*. Breton had to play along, which somewhat minimizes the authenticity of the overwhelming conviction that in his letters he had skillfully communicated to Jacques Doucet.

2. Revel 1961, p. 51. We know that the price may have been 30,000 francs. See below, under February 20, 1924.

3. See *Le Cri de Paris* of July 23, 1916, above, p. 168.

4. Revel 1961, p. 51.

5. Chapon 1984, pp. 297–98. Two years later, in 1926, Henri-Pierre Roché appraised the painting at between 200,000 and 300,000 francs (ibid., p. 312; letter from Roché to Doucet, January 12, 1926; B.L.J.D., B-IV-1, 7204.197).

6. See Chapon 1984, p. 312.

7. Ibid., pp. 298–99. No one knows where the painting was displayed in Doucet's residence at avenue du Bois. Speaking of the *Demoiselles* to Sabartés, Picasso said, "You know, it is a bit much for a collector to have a brothel in his home" (Sabartés 1946, p. 158).

8. MoMA Archives. Notes taken by Alfred Barr during (or after) a conversation with Henri-Pierre Roché on July 29, 1946 (on the conversation between Barr and Roché, see above, under 1914, "After July 25, 1916," and "Before 1924"). This confirms François Chapon's conclusions about the reasons Picasso did not wish to sell *Dance (The Three Dancers)* (Zervos V, 426) to Doucet: "[R]egretting having given up *Les Demoiselles d'Avignon* for such a low price, Picasso rejects one of those deals in which the collector liked to pay by installments" (Chapon 1984, p. 312). Picasso in fact did not part with *Dance (The Three Dancers)* until January 1965, when he sold it to the Tate Gallery, whose purchase of the picture was negotiated by Roland Penrose (Alley 1986, p. 7).

FEBRUARY 20, 1924

A small black notebook of graph paper (in a handwriting that is not Picasso's but may be Olga Khokhlova's) in which sales between August 1918 and May 1924 are listed (fig. 16), includes this entry:

20 février 1924
30,000 frs 'Les demoiselles d'Avignon'
Doucet
(ARCHIVES PICASSO)

16. Page from one of Picasso's notebooks, with amounts received for works or rights, listing 30,000 francs for *Les Demoiselles d'Avignon*, sold to Jacques Doucet, February 20, 1924. Archives Picasso.

Michael FitzGerald, who has verified the prices listed in the notebook, observed (in conversation with Judith Cousins, August 1992) that some of the figures are inaccurate, although this does not necessarily hold true for the *Demoiselles*. It is to be noted, nevertheless, that the sum of 30,000 francs, recorded in the notebook, does not correspond to the price recalled by André Breton when interviewed by Jean-François Revel in 1961; Breton at that time says the price was settled by Doucet at 25,000 francs. See above, under "1924: How Jacques Doucet Bought the *Demoiselles*."

While the number of francs listed in the notebook may be debatable, it is probable that February 20, 1924, reflects the date of Doucet's agreement to buy the *Demoiselles,* which he began to pay for the following month in installments of 2,000 francs each, according to Breton's account to Revel (see Revel 1961, p. 51; see also below, under March–April 1924). In any event, payments appear to have been completed in November, for in early December the painting was delivered to Doucet's home (see below, under December 2, 1924).

MARCH 9, 1924

Doucet writes from Paris (fig. 17) to André Suarès at Kermès à Carqueiranne in the Var (letter posted the 10th):

28. Receipt signed by Mme Jacques Doucet on September 15, 1937, for the sale of six paintings by Picasso to Jacques Seligmann & Co., among which is *Les Demoiselles d'Avignon*. Seligmann Records, Archives of American Art, Smithsonian Institution, Washington, D.C.

Picasso exhibition: Will you start working on this show at once, upon receipt of these lines, by: a) getting in touch with Gallatin, and see if he will loan the large picture "The musicians," he bought last year. b) Note that René has written to Pullitzer [sic], in order to obtain the loan of his Picasso…. c) If you have an opportunity to see Paley, ask him if he would loan his large one…. d) Write Wertheim…. e) Call up the Harriman gallery…. f) Write to the Carnegie Institution….

P.S. FOR HEAVENS SAKE [sic], do not mention to anyone, especially not to Gallatin, or McIlhenny, or any other people, any details regarding the Doucet pictures. Do not show photographs to anyone, and do not mention pictures to anyone. Germain and myself insist upon that.

The only thing you can do is to use the Doucet name in your publicity regarding the exhibition we plan….

You will see that the Picasso pictures brought from the Doucet coll. have been framed by Pierre Legrain. It adds quite an artistic value, from

the publicity angle, to this group and the pictures will be shown as they were in the Doucet house.
(A.A.A., SELIGMANN RECORDS)

Note de Hauke's insistence on the need to keep the paintings from the Doucet collection a secret, and the importance given to Pierre Legrain's frames.

OCTOBER 6, 1937
The customs declaration on the stationery of the consulate general of the United States in Paris mentions the shipment, from the Galerie Jacques Seligmann et Fils, at 9, rue de la Paix, Paris, to the Galerie Jacques Seligmann and Co., 3 East Fifty-first Street, New York, of a group of paintings including *Les Demoiselles d'Avignon*. The paintings cross the ocean on the *Normandie*, which leaves Le Havre on October 9. The register accompanying the customs form mentions, under number G.S. 93/458: "Painting by Picasso, 'Les demoiselles d'Avignon,' with modern second hand frame (see value at foot). French work of beginning of 20th cent. Purchased from Mme Doucet, Paris, 21/9/37 … 100,000 fr." Further on, one reads also: "modern frame of 458 … 100 fr."
(A.A.A., SELIGMANN RECORDS)

One notes that the value declared at customs is less than the amount paid to Mme Doucet, and that the frame was declared separately (most likely, it was dismantled) without any mention of its creator, whose importance was evident in the September 5 letter and, as will be seen, in the catalogue of the exhibition at Seligmann's gallery in New York; it did not escape the prospective buyer's attention.

OCTOBER 9, 1937
A Western Union cablegram to the Seligmann gallery in New York mentions:

Germain left on Normandie René Washington.
(A.A.A., SELIGMANN RECORDS)

OCTOBER 11, 1937
A Western Union cablegram from César M. de Hauke to the Seligmann gallery in New York contains the following instructions:

Immediately upon arrival Picasso Avignon have about six photographs made showing all details stop rush Zervos Cahiers d'art Paris.
(A.A.A., SELIGMANN RECORDS)

Six photographs will be made, one of the entire painting and five details of the five figures. In January 1938, Germain Seligmann will make a gift to Alfred Barr for The Museum of Modern Art of the six negatives of these photographs (see below, under January 15, 1938).

The volume of Zervos in which the *Demoiselles* would be reproduced (Zervos II¹, 18, 25–29) did not come out until 1942, during World War II. It is interesting to note that the reproductions there

consist of six photographs—one full view of the painting and one detail for each of the five figures—in full-page format.

NOVEMBER 1937

Rudi Blesh will touch on the events of November 1937 when he writes a chronicle for The Museum of Modern Art, titled "Fifty Years of Modern Art in America," in 1955; in connection with the *Demoiselles*, he recounts an interview with A. Conger Goodyear (of November 19, 1954):

A. Conger Goodyear tells of Barr's excited urgency as he came to the Trustees with news that this great painting could be had. Cornelius J. Sullivan, excited, wanted to see the picture forthwith. "It's at Seligman[n]'s," Goodyear told him. Sullivan set out. It happened that the great Seligman[n] had a more obscure neighbor close by name, Arnold Seligman [and] Rey, who were antiquarians. In his excitement, it was into this latter shop that Sullivan dashed, to be met ceremoniously by a frock-coated gentleman, who wished to ascertain the visitor's wishes. Cheeks red and eyes glowing, Sullivan came to the point without ceremony: "Show me the demoiselles!" The impressive frock coat stepped back a pace, and, shocked, but still deferential, said: "Surely the gentleman has come to the wrong place."
(MoMA Archives, typewritten text, pp. 122–23; a slightly different version appears in Blesh 1956, pp. 173–74)

NOVEMBER 1–29, 1937

The exhibition "Twenty Years in the Evolution of Picasso, 1903–1923" is held at Jacques Seligmann & Co., Inc., 3 East Fifty-first Street in New York. The catalogue says:

The present exhibition has a two-fold purpose. It is intended as a successor to the Picasso exhibition of the "Blue" and "Rose" Periods which was shown in this gallery last year and which aroused tremendous interest at the time. Whereas last year's exhibition covered a period of five years, the present one shows the evolution of the painter over a period of twenty years, from 1903 to 1923; an evolution through the Negroid, Cubist, and Classical or Monumental Periods....

The second purpose is to exhibit to the American public a selected group of paintings from one of the most famous of all sources, the distinguished Jacques Doucet Collection. These pictures have never before been seen in America and have seldom, if ever, been in European exhibitions. It is, therefore, with great pride and pleasure that we are able to include them at this time.

Regarding the Doucet Collection and the house, the late Mr. Jacques Doucet had, at one time, one of the greatest of all French eighteenth century collections which was dispersed before the war. Today, most visitors to the house know only the celebrated group of French nineteenth century paintings. However, the "Studio," or Gallery on the top floor of the house was specially constructed to house the equally famous collection of twentieth century art where Mr. Doucet, realizing the importance and significance of much of the contemporary painting of the day, added outstanding examples to the collection, amongst which were the Picassos shown here.

To reach the "Studio," one climbs a beautiful stairway to the top floor. Given the place of honor and at the entrance to the studio proper, was the famous "Les Demoiselles d'Avignon" which had been set into the wall. This canvas, painted in 1907 and measuring approximately eight feet square, is one of the largest that Picasso has ever painted, with the exception of the recently completed canvas which he executed this year for the Spanish Pavilion of the Paris Exposition. Its importance is comparable to its size, as it is by far the most outstanding picture of the Negroid Period and one of the greatest pictures that the artist has ever painted regardless of period. It is, indeed, a veritable landmark in the history of twentieth century art and has had a profound effect on much of the painting that followed it. It further marks the disappearance of the blue and pink tones and forms a glowing introduction to the Cubist periods to follow.

The frames, as well, of the pictures from the Doucet Collection are worthy of note. These were, for the most part, designed and executed by the late Pierre Legrain, probably the most famous artistic craftsman that France has produced in over a hundred years. Legrain's genius as a designer and craftsman was not only limited to bookbinding, for which he is perhaps best known, but reached its highest level as well in almost every phase of the decorative arts.
(Levy 1937, pp. 3–4)

The *Demoiselles* appears in the catalogue on p. 7, no. 5. The caption specifies "frame by Legrain."

Among the American collectors cited as having lent works to the exhibition is Joseph Pulitzer, Jr., whose *Harlequin* of 1923 is no. 16 in the catalogue. It will be seen further on (under December 6, 1937) that he was given the opportunity to buy the *Demoiselles* but did not have the necessary funds.

•

The articles published in the American press—some twenty of them—on the exhibition at the Seligmann gallery highlight the remarkable presence of the *Demoiselles* in the show; some of the more significant reviews are quoted below. (There are in addition two other articles, which could not be obtained, that most likely concern the exhibition at the Seligmann gallery: one in the *New Bedford [Mass.] Mercury* of November 3, and the other in the November issue of *Parnassus*.)

•

The Art Digest of November 1 (vol. 12, no. 3, p. 10) carries an article titled "Picasso in Dual New York Exhibitions":

[The Seligmann] gallery is presenting to the American public for the first time a selection of the famous group of Picassos from the Jacques Doucet Collection. The outstanding picture in this group is the well-known Les Demoiselles d'Avignon.

A reproduction of the painting accompanies the article. The other Picasso exhibition discussed in the article, and on view at the same time in New York, is "Twenty Paintings by Picasso through 1937" at the Valentine Gallery.

•

have entirely hidden, and although it is more likely that the work was something with a theatrical theme, such as *Harlequin and Woman with Necklace* (Rome, 1917; Zervos III, 23), a large square, two meters on each side, the mention of nudes that had to be exhibited on the sidewalk ties in with Max Jacob's observation, and by and large confirms the "Pinturrichio" item.

Having arrived at the end of this somewhat disappointing meander through only approximately correct news items and careless reviews, readers will perhaps be reinforced in the conviction that it is imperative to thoroughly reconstruct, as far as possible, the content of watershed exhibitions. Readers may also wish to take the opportunity to ask themselves about Apollinaire's relationship to the *Demoiselles*—whose (alleged) presence at the Paul Guillaume gallery the poet could hardly have been unaware of—and to examine the fine text on Picasso (reprinted below) that he contributed to the catalogue, for a clue to the mysterious number 13, *Tableau*.

THE CATALOGUE TEXTS

Printed here are translations of Guillaume Apollinaire's two prefaces to *Catalogue des oeuvres de Matisse et de Picasso exposées a Galerie Paul Guillaume, 108, Faubourg Saint-Honoré à Paris du 23 janvier au 15 février 1918.*

HENRI-MATISSE

Every painting, every drawing by Henri-Matisse possesses a certain virtue that one cannot always define but that always strikes one as an authentic force. It is the artist's strength that he does not attempt to oppose this force but allows it to act as it will.

If one were to compare Henri Matisse's work to something, it would have to be an orange. Like the orange, Matisse's work is a fruit bursting with light.

Inspired by a total good faith and by a genuine desire to know and to realize himself, this painter has never ceased following his instinct. He allows his instinct to choose among his emotions, to judge and delimit his fantasy, and to look searchingly into the depths of light, nothing but light.

With the years, his art has perceptibly stripped itself of everything that was nonessential; yet its ever-increasing simplicity has not prevented it from becoming more and more sumptuous.

1. Texts on Matisse and Picasso written by Apollinaire for the catalogue of the exhibition at Paul Guillaume's gallery, January 23–February 15, 1918. © Éditions Gallimard

HENRI-MATISSE

↑ ↑ ↑ ↑ ↑

Tout tableau, tout dessin d'Henri-Matisse possède une vertu qu'on ne peut toujours définir, mais qui est une force véritable. Et c'est la force de l'artiste de ne point la contrarier, de la laisser agir.

Si l'on devait comparer l'œuvre d'Henri-Matisse à quelque chose, il faudrait choisir l'orange. Comme elle, l'œuvre d'Henri-Matisse est un fruit de lumière éclatante.

Avec une entière bonne foi et un pur souci de se connaître et de se réaliser, ce peintre n'a cessé de suivre son instinct. Il lui laisse le soin de choisir entre les émotions, de juger et de limiter la fantaisie et celui de scruter profondément la lumière, rien que la lumière.

A vue d'œil, son art s'est dépouillé et malgré sa simplicité toujours plus grande, il n'a pas manqué de devenir plus somptueux.

Ce n'est pas l'habileté qui rend ainsi cet art plus simple et l'œuvre plus lisible. Mais, la beauté de la lumière se confondant chaque jour davantage avec la vertu de l'instinct auquel l'artiste se fie entièrement, tout ce qui contrariait cette union disparaît comme il arrive aux souvenirs de se fondre dans les brouillards du passé.

GUILLAUME APOLLINAIRE.

PICASSO

↑ ↑ ↑ ↑ ↑

Picasso est l'hoir de tous les grands artistes, et, soudain éveillé à la vie, il s'engage dans une direction que l'on n'a pas encore prise.

Il change de direction, revient sur ses pas, repart d'un pied plus ferme, grandissant sans cesse, se fortifiant au contact de la nature inconnue ou par l'épreuve de la comparaison avec ses pairs du passé.

Dans chaque art, il y a un lyrisme. Picasso est souvent un peintre lyrique. Il offre encore à la méditation mille prétextes qu'animent la vie et la pensée et que colore avec netteté une lumière intérieure au fond de laquelle gît pourtant un gouffre de mystérieuses ténèbres.

Ici le talent se multiplie par la volonté et par la patience. Les expériences aboutissent toutes à dégager l'art de ses entraves.

Ne serait-ce pas le plus grand effort esthétique que l'on connaisse? Il a grandement étendu le domaine de l'art et dans les directions les plus inattendues, là même où s'agite la surprise comme un lapin d'ouate qui bat le tambour au milieu du chemin.

Et les proportions de cet art deviennent de plus en plus majestueuses sans qu'il perde rien de sa grâce.

Vous pensez à une belle perle.

Cléopâtre, ne la jetez pas dans du vinaigre!

GUILLAUME APOLLINAIRE.

It is not mere skill that has made his art simpler and his works more intelligible. Rather, as the beauty of light has gradually become merged with the power of the artist's instinct—an instinct in which he trusts implicitly—all the obstacles to this union have disappeared, the way memories sometimes melt into the mists of the past.[28]

Guillaume Apollinaire

PICASSO

Picasso is heir to all the great artists, and, suddenly awakened to life, he is pursuing a direction that no one has yet taken.

He changes direction, retraces his steps, starts off again on a surer footing, growing ever greater, gaining strength from contact with unknown nature or by the test of comparison with his peers of the past.

Every art has its lyricism. Picasso is often a lyrical painter. He offers a thousand opportunities for meditation that are quickened by life and thought and sharply colored by an inner light in the depths of which there yet remains an abyss of mysterious shadows.

Here, talent is multiplied by will and patience. In the end, all experiences free art from its trammels.

Might this not be the greatest aesthetic effort that we have known? He has greatly extended art's domain and in the most unexpected directions, to the very places where surprise pops up like a plush rabbit beating a drum in the middle of the road.

And the size of this art becomes more and more majestic, while losing none of its grace.

It reminds you of a fine pearl.

Cleopatra, don't toss it into vinegar![29]

Guillaume Apollinaire

[Catalogue of the exhibition at Paul Guillaume's Gallery]

LIST OF EXHIBITED WORKS
MATISSE

1. *Intérieur d'atelier [Studio interior]*
2. *Portrait de deux femmes [Portrait of two women]*
3. *Paysage du Maroc [Moroccan landscape]*
4. *"La coupe aux oranges" [Bowl with oranges]*
5. *Portrait de femme [Portrait of a woman]*
6. *Tête de femme [Woman's head]*
7. *Le jardinier [The gardener]*
8. *Femme lisant [Woman reading]*
9. *La femme au divan [Woman and sofa]*
10. *L'Algérienne [The Algerian (f.)]*
11. *La femme à la chaise [Woman and chair]*
12. *La belle Bédouine [The beautiful Bedouin (f.)]*

PICASSO

13. *Tableau [Painting]*
14. *Femme en vert [Woman in green]*
15. *Nature-morte [Still life]*
16. *Un arlequin et une femme [Harlequin and woman]*
17. *Nature-morte [Still life]*
18. *La mansarde [The garret]*
19. *Le pauvre à l'enfant [The poor man and his child]*
20. *Tête d'homme [Man's head]*
21. *Nature-morte [Still life]*
22. *Tête [Head]*
23. *Tête [Head]*
24. *Tête [Head]*
25. *Les amants enlacés [Lovers entwined]*
26. *Tête [Head]*
27. *Portrait d'un homme assis [Portrait of seated man]*
28. *Tête [Head]*

And several watercolors and drawings by each Artist.

2. List of works by Matisse and Picasso in the catalogue of the exhibition at Paul Guillaume's gallery January 23–February 15, 1918. © Éditions Gallimard

LISTE DES OEUVRES EXPOSÉES

MATISSE

1. — Intérieur d'atelier.
2. — Portrait de deux femmes
3. — Paysage du Maroc.
4. — "La coupe aux oranges".
5. — Portrait de femme.
6. — Tête de femme.
7. — Le jardinier.
8. — Femme lisant.
9. — La femme au divan.
10. — L'Algérienne.
11. — La femme à la chaise.
12. — La belle Bédouine.

PICASSO

13. — Tableau.
14. — Femme en vert.
15. — Nature-morte.
16. — Un arlequin et une femme.
17. — Nature-morte.
18. — La mansarde.
19. — Le pauvre à l'enfant.
20. — Tête d'homme.
21. — Nature-morte.
22. — Tête.
23. — Tête.
24. — Tête.
25. — Les amants enlacés.
26. — Tête.
27. — Portrait d'un homme assis.
28. — Tête.

Et plusieurs aquarelles et dessins de chaque Artiste.

Imp. de Vaugirard, Paris

Notes to the Appendix

1. Guillaume had previously operated his art gallery from a studio attached to his apartment, at 16, avenue de Villiers. Located in a more advantageous neighborhood, the site at 108, rue du Faubourg-Saint-Honoré was fairly modest; earlier, it had been an annex of the Galerie Druet (established in 1903 by the photographer and dealer Eugène Druet, and located since 1908 at 20, rue Royale), where photographic reproductions were sold, as well as the albums that the dealer had made his specialty.

2. One of these posters is reproduced in Daix 1982b, p. 139.

3. Max Jacob is surely exaggerating when he writes that Apollinaire "made [Paul Guillaume's] fortune" (letter to Mme Aurel, in Jacob 1989, p. 274). We can assess the role played by the poet through the correspondence published by Jean Bouret (1970, pp. 373–99). I am grateful here to Judith Cousins, who reminded me of the importance of this article.

Apollinaire puts forward a first draft of the press release in a letter of January 14, 1918 (Bouret 1970, pp. 391–92); the letter is reproduced from *Les Nouvelles littéraires* (Paris) of January 20, 1966, in Apollinaire 1991b, p. 1650.

The wording retained for the newspapers is slightly different, and also varies depending on whether its publication preceded or accompanied the exhibition. At times the text is followed by the signature of the newspaper's usual columnist (for example, Marcel Serano in *L'Heure* of January 19). We have found this text in *L'Information* of January 19; *La Bataille: Organe quotidien du syndicalisme* of January 19; *Le Journal du peuple* of January 21; and *La Vérité* of February 10. (However, *Le Petit Bleu* of January 19 and *L'Éveil* of January 22 limited themselves to summary announcements.) The basic text appears as follows:

Someone has just had a perfectly extraordinary and unexpected idea: to join, in a single exhibition, the two most famous masters, those who best represent the two great, opposite trends of great contemporary art. The brilliant work of the former opens new directions for Impressionism, and one feels clearly that this vein of great French painting is far from being exhausted. The latter, on the contrary, demonstrates that this rich perspective is not the only

one open to the artist and the art lover, and that the concentrated art which produced Cubism, that eminently contemporary aesthetic, reaches back through Degas and Ingres to the highest traditions of art. This will be a sensational exhibition and a watershed in the artistic history of our time. The idea came to M. Paul Guillaume, whose taste is once more validated; this fine event will take place at his Galerie du 108, faubourg Saint-Honoré, from January 23 to February 15.

4. The catalogue is an unpaginated, four-page booklet titled *Catalogue des oeuvres de Matisse et de Picasso exposées Galerie Paul Guillaume 108, Faubourg Saint-Honoré à Paris du 23 janvier au 15 février 1918*. There exists as well a poorly produced edition on thin paper, with a slightly different title (*"chez Paul Guillaume"* instead of "Galerie Paul Guillaume"). The two texts, "Henri-Matisse" and "Picasso," each signed by Apollinaire, are on pages [2] and [3] (fig. 1), and are reprinted in translation in the present Appendix (pp. 209–10). There is a plate of a drawing by Picasso (*Harlequin Playing a Guitar*). An exhibition list is printed on page [4] (fig. 2). At the foot of the list there is the annotation: "And several watercolors and drawings by each Artist."

The two texts by Apollinaire also appear in Apollinaire 1972, pp. 457–58; and Apollinaire 1991b, pp. 874–75.

5. Louis Vauxcelles's papers were donated to the Bibliothèque d'Art et d'Archéologie, Paris.

6. See Pliny's *Natural History*, Book 9, chapter 58. After wagering with Antony that she could spend ten million sesterces on a single meal, Cleopatra dissolved one of her two pearls in vinegar and swallowed the liquid. The significance of this reference at the end of Apollinaire's text on Picasso is obscure.

Another baffling passage: the comparison of surprise (a notion essential to Apollinaire's aesthetic), with the leaping up of a "plush rabbit beating a drum in the middle of the road." This very popular children's toy, carried by toy shops and street-vendors' stalls for New Year's, would seem to place the passage among a set of Apollinaire's musings of 1914–18 that exalt this very humble wind-up toy.

7. The following are excerpts from the article in *Le Pays*, titled "Matisse and Picasso":
Though both are sometimes done a disservice by indiscreet and childish devotees, Picasso and Matisse are nonetheless two fine and powerful painters, considered by their generation and their juniors to be at the highest rank. . . . I cannot help finding, in these last (or next-to-

last) formidably Cubist paintings of Picasso's, the original, extraordinary, pure colorist that the young Andalusian master was and is. Whether they are keen-lined drawings, blue harmonies of the so-called "Harlequin" period, nudes, or portraits, Picasso, freed from the Spanish influence (Goya, Greco) and from that of our Lautrec, takes on the most complex problems with swagger. . . . Only a detailed study could and must follow his thought; I am limiting myself here to the most cursory remarks, and I refer the reader to all the writing that has attached itself to Picasso, like ivy to a poplar. . . . Go see this double and fascinating exhibition.

Needless to say, Apollinaire, toward whom Vauxcelles always maintained a snide attitude, is the target of the phrase "childish devotees." Salmon, however, whom Vauxcelles invited to contribute to his *Carnet des artistes* in 1917, is certainly excluded from the critic's condemnation.

8. The notice by "Le Veilleur" in the "Pont des arts" column in *L'Excelsior* of January 24 gives an idea of the opening's success: "Lots of people. Severini and his wife, Paul Fort's daughter, can't get in, having forgotten their invitations. They're very strict: you have to show your credentials."

9. Bouret 1970, p. 391.

10. Ibid., p. 393.

11. For example, *L'Intransigeant* of January 17, 1918: "Second Lieutenant Guillaume Apollinaire, who was stricken with a serious lung congestion, is better now." See also *Le Petit Bleu* of January 19.

12. At this time, André Salmon had returned to journalism after a hiatus, but as court reporter for *L'Éveil*, where his signature appeared on January 21. There is, from his pen, a mention of the exhibition after the fact in the article of March 2, 1918, which inaugurates his column on art in the weekly *L'Europe nouvelle*, a very recent creation: "Except for Picasso and Henri-Matisse's joint exhibition at Paul Guillaume's, few important exhibitions held our attention in February."

13. In a program by Georges Léon, "À propos du *Coq et l'Arlequin*," broadcast on France-Culture on October 22, 1973, Georges Auric maintained that *Les Demoiselles d'Avignon* had been shown more than once during the war, and thought he had seen the painting in rue Huyghens, at Lyre et Palette. The fairly ample documentation I have on Lyre et Palette negates this hypothesis, which was to be taken up again by the author in his memoirs (Auric 1979, p. 132). Perhaps Auric confused Lyre et Palette with the Galerie Paul Guillaume.

14. The item is certainly not by Vauxcelles, whose style is more nimble. A former contributor to *Courrier français* who was among Verlaine's and Jean Lorrain's intimates, Delphi Fabrice was the author of very forgettable plays and novels. There is nothing surprising about his presence at an exhibition of Matisse and Picasso: this picturesque, stone-broke, alcoholic figure was a regular dinner companion of the Cubists in the little Montmartre restaurants such as Bouscarat's or Azon's. For Hermann-Paul, a painter but primarily a draftsman and caricaturist, we are obliged to consult specialized reference volumes. In 1918 this former Dreyfusard, ferocious painter of the bourgeoisie, collaborated with Gustave Hervé on *La Victoire* and recanted his earlier rebellions, which necessarily sharpened his sarcasm toward Cubism.

15. Dated March 15, 1918, the first issue of this magazine—founded and edited by Paul Guillaume as a news bulletin chronicling the activities of his gallery as well as newsworthy artistic events in Paris and elsewhere (see Giraudon 1993a and b)—offered on pages 9 through 11 excerpts of articles by M. Dons (*La Revue*, March 1–15, 1918, pp. 608–09), Louis Vauxcelles (*Le Pays*, January 26, 1918), Bissière (*L'Opinion*, February 16, 1918, pp. 132–33), Bissière again (*Paris-Midi*, February 20, 1918), "Les Éphémères" (*L'Éclair*, January 26, 1918), Charles Chinet (*L'Éventail* 4, February 15, 1918, p. 135), and by an anonymous staff writer for *La Veu de Catalunya*, published in Barcelona. Absent from the magazine, because of the date of publication, is Gustave Kahn's article for the *Mercure de France* of March 16, 1918 (p. 324); in the article, Kahn insists on the "hermetic," "enigmatic" quality of Picasso's contributions.

16. "Exposition Matisse-Picasso," in the February 16 issue. The only clue to a possible allusion to the *Demoiselles* (to be considered with caution): as he reaches his peroration, Bissière deplores the divorce perpetrated for four centuries between art and the heart of the masses. "Those times are long gone when the people carried Cimabue's works in triumph through the streets of Florence." As it happens, André Breton, with his eye for the press and concern for subtle allusion, uses the same reference when, in order to convince Jacques Doucet to buy the *Demoiselles*, he presents the painting as a principal event of the twentieth century: "This is the painting that we would be carrying through the streets of our capital, as with Cimabue's Virgin in times past. . . ." (quoted in Chapon 1984, pp. 299–300). This provocative comparison between a religious representation from the late thirteenth century and a violent, modern image of femaleness is supported by the large size of the two works and perhaps reinforced by the memory of the article in *L'Opinion*, with regard to which the letter to Doucet might be a kind of corrective.

17. The evidence is often contradictory. The note in *L'Éclair* suggests that the Blue Period was represented only by drawings. Bissière, in *Paris-Midi*, speaks of some drawings and a canvas of this period. In order to praise the earlier Picasso, Charles Chinet mentions *Un Arlequin et une femme* (which precludes its being *Arlequin et femme au collier* of 1917; Zervos III, 23) and *Les Amants enlacés*, a work that is probably *The Embrace* (Zervos I, 161; D./B. IX, 12), the pastel long owned by Vollard and purchased shortly before 1930 by Paul Guillaume (see Geneviève Allemand's catalogue entry in Lemoyne de Forges 1966, no. 92, p. 195). Only documents from the gallery's archives would permit full identifications.

18. *Femme en vert* of 1909 (Zervos II2, 197).

19. Also titled *Femme assise dans un fauteuil devant la cheminée* (Zervos II2, 528). See Daix 1982b, p. 158 (note to p. 138).

20. *La Vie* was a colonialist propaganda publication, directed by Marius and Ary Leblond, in which art held pride of place. Jean Paulhan, whom we believe to have been the author of the item, played an increasingly important part in this publication.

21. Hubert 1968, pp. 217–18.

22. Mugnier 1985, p. 329.

23. See Cousins/Seckel 1988, pp. 570–74; see also the Chronology in the present volume, under July 1916.

24. This is clearly the case on page 325, where he tells of his visit to the Villa Molière on January 5, 1918, the occasion on which he meets Apollinaire, who is there for treatment. In the course of the conversation, Abbé Mugnier notes, "Apollinaire was telling us about Stanislas's dwarf, whose name was Ferry and who was wicked." Apollinaire, however, whose erudition was marginal but very precise, evoked this dwarf in a few lines, emphasizing that he was "charming" (Apollinaire 1991b, p. 1360).

25. Zervos II1, 35; Daix 53. Like *The Embrace*, the work passed from Vollard's collection to Paul Guillaume's (see Daix/Rosselet 1979, p. 200).

26. This document, made up of five sheets and classified number 2250, is cited in Jacob 1986, p. 22. Neal Oxenhandler's study (1964) reproduces correspondence of the poet that allows certain stages of his work to be assessed. Max Jacob's text on Paul Guillaume, going beyond its subject, becomes a fragmentary history of the literary and artistic life. One version would appear in the magazine *Les Feux de Paris*. Another version would be put out in 1956 by the publisher Louis Broder under the title *Chronique des temps héroïques* (Jacob 1956).

27. Bouret 1970, p. 389.

28. Apollinaire 1972, p. 457.

29. Translated by Alexandra Bonfante-Warren. See also Apollinaire 1972, p. 458.

Anthology of Early Commentary on *Les Demoiselles d'Avignon*

Hélène Seckel

PREFATORY NOTE

This collection brings together statements made about *Les Demoiselles d'Avignon*, first those made by Picasso himself, then those made by his contemporaries.

First of all, then, "The Artist's Statements," but a word of caution is appropriate here, for it is by no means certain that Picasso always meant what he said. Moreover, these are all, we shall see, statements of his as recounted by others—interlocutors who always, invariably, report the painter's words as filtered through their own sensibilities. Thus we shall read Picasso under the various signatures of Daniel-Henry Kahnweiler, André Malraux, Christian Zervos, Alfred Barr, Françoise Gilot, Romuald Dor de la Souchère, Antonina Vallentin, Roland Penrose, Pierre Daix, William Rubin, and many others.

That section will be followed by "Eyewitness Accounts and Reminiscences" by people of many and of few words, writing without foreknowledge of what would concern us today. Juxtaposing their points of view will reveal, through their inaccuracies and mutual contradictions, just how difficult it is to glean the truth from this kind of testimony.

Indeed I shall refrain from trying to do so. Instead, everything that follows, Picasso's statements as well as the eyewitness accounts of those close to him, is presented to the reader primarily as information, as raw material that I have merely tried to bring to the surface, without any claim to refining the pure metal.

Citations given in abbreviated form refer to the Bibliography, which begins on p. 258.

The Artist's Statements

Picasso said relatively little about his art, especially to irksome inquisitors. And heaven knows how many inquiries the *Demoiselles* has provoked. Indeed, anyone who sees the painting for the first time without knowing anything about it in advance will be amazed by its appearance, especially by the two astonishing women on the right (some will ask themselves whether these two have been influenced

by so-called "art nègre").[1] They will also wonder about the title (who are these "demoiselles"? what has Avignon got to do with any of this?), and about how the title relates to what is depicted (who are these naked women in a room, whose appearance presents nothing by which we might know more about them, at least nothing vulgar or indecent that would identify them as the prostitutes the well-informed know them to be?). The gradual revelation, fragmented and chaotic, of the sketches and notebook pages published between 1942 and 1973 by Christian Zervos in his catalogue of Picasso's oeuvre[2] bit by bit made it possible to know the work's genesis, and raised further questions: Who are the two men present in the early studies, in which it is quite clear that the setting is indeed a brothel? Who, in particular, is the one carrying first a skull and then a book? Why were these figures eliminated from the final painting? The number of sketches and preparatory drawings attests to the great length of time spent on the work, but precisely when? When did Picasso start to paint it and when did he stop? And is it even finished?

Critics and art historians have attempted to get to the bottom of these issues by questioning the painter. But the painter did not like questions, and so revealed very little on the subject. In addition, his words, though precious because of their rarity, have often been elevated to a kind of gospel truth by some—while others have cast doubt on specific points, thereby calling into question the reliability of all the information given by the artist.

For should we, after all, believe Picasso? Let us hear what his contemporaries, André Salmon and Leo Stein, have to say. Salmon often stressed Picasso's extreme dislike for speaking about his work and his distaste for theoretical discourse, attributing these to the painter's modesty: "Modesty led Picasso, after so many questions and so many demands that he justify himself, to answer facetiously";[3] Leo Stein, having become scathing about the painter he had once so greatly appreciated, does not beat around the bush: he finds the opinions that Picasso began to express at the time of *Les Demoiselles d'Avignon* to be downright stupid.[4] More recently

William Rubin, who supports his arguments with remarks gathered from Picasso himself, prudently notes (on the subject of Cézanne, though thus formulated, his remarks take on a general validity) that it is wise to keep a certain distance from the words of an artist: "Art historians are often too prompt in taking painters at their own word."[5] He himself maintains this distance with respect to what, for example, Picasso says about the influence of African art on him: "What artists talk about is not necessarily to be equated with what they do."[6]

What exactly did Picasso say? Things wrung out of him with a great deal of effort—and reported secondhand, in any case. In 1923, in an article published in *Der Querschnitt*, Albert Dreyfus describes how difficult it is to make Picasso talk:

… I did not go to Picasso on order to find out whether he was buying his shoes ready-made. … Nor did I see [Picasso] for an interview. That would have been futile. Unlike Rodin, Picasso will not have any opinions on art dictated into his pen. Whatever statements he is known to have made would—in terms of the above paragraph [by the editors of Der Querschnitt*]—earn him the note "inadequate." I can only confirm Picasso's reluctance (or inability?) to state something "essential" about his art.*[7]

Daniel-Henry Kahnweiler, whose 1933 interview with the painter can be found further ahead in this volume, was no doubt himself subjected to the harsh law that Picasso imposed on those who would interview him: that they listen without taking notes, and write things down later, from memory.[8] In 1935, Zervos, in turn, in "Conversation avec Picasso," published in *Cahiers d'art*, testifies to what an interview with the painter was like:

Picasso spoke to me simply, but with the emotion that he is capable of putting into his words when speaking about art (he rarely speaks about it), and which gives each word a sense of immediacy that my transcription cannot preserve.

I am presenting his ideas here as faithfully as my memory allowed me to do, the same evening of my visit to Boisgeloup. Picasso has not read them. When I suggested that he look at my notes, he replied: "You don't have to show them to me."[9]

When she met Picasso in 1954, while preparing her book, Antonina Vallentin knew the going would be rough: "Picasso had the fearsome reputation of bullying the curious, of closing up like a hedgehog in the face of any prying into his private life." She also knew that the painter, understandably, did not care for others to remember things for him:

In fact, all that is known about him, his childhood for example, has been recounted by him, and in the accounts of others he meets back up with his own words, now colored to varying degrees by the temperament of his confidant. If the coloring, or distortion, is too much in evidence, he gets angry, for his memory faithfully furnishes his own account.[10]

Pierre Daix, in 1973, provides further information:

I had to learn how to put the questions to him that preoccupied me. If my hypothesis was deficient—if I proposed a mistaken idea about the development of his work—he would change the subject. But if I hit the mark, it would set off his prodigious memory and, suddenly, we would be back in the Bateau-Lavoir, in Céret, at Sorgues, or the boulevard Raspail.[11]

And Rubin states clearly that except for a few specifically remembered words, which he puts in quotation marks, the remarks of Picasso that he cites are paraphrases jotted down on paper after a visit with the painter (as Zervos had done). He stresses the fact that all of Picasso's reported comments are the reconstructions of writers (as we shall see):

Picasso never, to my knowledge, brooked note-taking or the presence of recording devices; even less did he stand for being interviewed (he particularly disliked "art-historical" interrogation). Virtually the only mode of discourse with him was casual and spontaneous.[12]

Hence the difficulty of obtaining the desired information.

Be that as it may, Picasso's comments have frequently been used by biographers and art historians to buttress their theses. The use of quotations becomes complicated, however, when the painter's assertions contradict one another. Is it right to ignore some in favor of others? This issue arises particularly with respect to African art. The statement Zervos reports in 1942, in the second volume of his catalogue—Picasso denying the influence of African art on the *Demoiselles*, while acknowledging that of Iberian art[13]—clearly contradicts the words André Malraux attributes to Picasso in *La Tête d'obsidienne* in 1974 (where the story of the *Demoiselles* is closely tied to a visit Picasso made to the Musée d'Ethnographie du Trocadéro in 1907).[14] We must therefore carefully consider the degree of legitimacy we grant to comments reported secondhand, and to art historians who rely on them.

Last, a word on the careful use one should make of Picasso's remarks (however seductive) on his painting, or on painting in general, remarks that are not directly related to the *Demoiselles*, but nonetheless often cited on the subject of this work. The source most often mined is Zervos's "Conversation avec Picasso," mentioned earlier. In reading it, one sees that in many respects it could be related to the *Demoiselles*, though art historians often quote it without mentioning that it consists mostly of aphorisms of a more general order, and thus falsify its implications. Let us quote some of the better-known of these: "A painting is a sum of destructions"; "The painting is not thought out and determined beforehand; as it is being made, it follows the mobility of thought"; "When you begin a painting, you often come up with pretty things; you should beware of this, destroy the picture, remake it several times." There is also a well-known longer passage:

female heads that had been in Picasso's hands were at the Louvre (Golding 1958, p. 158, figs. 21, 23, 24), in 1959 (figs. 95a, 96a) published the male head as being in the Museo Arqueológico, Madrid; in the 1968 French translation of his *Cubism*, a photograph of the male head bears the caption "Formerly Musée du Louvre, Paris" (*Le Cubisme* [Paris: Livre de Poche, 1968, p. 78, figs. 6, 7).

20. Géry Pieret, quoted in *Paris-Journal*, August 29, 1911, p. 1. This is the head now in the Musée des Antiquités de Saint-Germain-en-Laye (reproduced in the present volume, fig. 19, p. 37). Laude (1968, p. 277, note 32) mentioned in this connection the so-called *"oneilles"* of Alfred Jarry's Père Ubu. And Katia Samaltanos (1984, p. 25) quotes Apollinaire, as we do; however, we are not as convinced as she was about a possible reference to the *Demoiselles* in this passage: "… the art of the new painters takes the infinite universe as its ideal, and it is to this ideal that we owe a new norm of the perfect, one which permits the painter to proportion objects in accordance with the degree of plasticity he desires them to have. Nietzsche divined the possibility of such an art: 'O divine Dionysus, why do you pull my ears?,' Ariadne asks her philosophical lover in one of the celebrated dialogues on the Isle of Naxos. 'I find something pleasant and delightful in your ears, Ariadne; why are they not even longer?'" (Guillaume Apollinaire, *The Cubist Painters: Aesthetic Meditations,* trans. Lionel Abel [New York: Wittenborn, 1944], p. 12).

21. Jacob 1956, p. 65.

THE VISIT TO THE TROCADÉRO

To avoid being limited to the thesis of exclusive Iberian influence advanced by Zervos's 1942 text, a number of authors have taken the following position: even if Picasso went to see the ethnographic collections at the Trocadéro only after having finished the *Demoiselles,* it is nevertheless clear that he was already familiar with primitive art, having seen examples thereof at the homes and studios of his friends Vlaminck, Derain, and Matisse,[1] and having quite probably bought some himself, as early as 1907.[2] This familiarity therefore would justify asserting the existence of African influence.[3]

In 1974, in *La Tête d'obsidienne,* André Malraux relates a conversation he had with Picasso "at the time he was finishing *Guernica*" in 1937—"the most revealing disclosure I ever heard from him"—which not only confirms the connection between the *Demoiselles* and the visit to the Trocadéro but raises the discussion of the painting from the level of formal influences to the level of meanings. What Picasso discovered on that day—with the force of a revelation, at the massive unveiling of the vast collection of the Musée d'Ethnographie,[4] the effect of the objects intensified by their dense, often theatrical presentation, as they seemed to rise out of the dust—was the magical power of these objects. He tells Malraux:

Everybody always talks about the influences that the Negroes had on me. What can I do? We all of us loved fetishes. Van Gogh once said, "Japanese art—we all had that in common." For us it's the Negroes. Their forms had no more influence on me than they had on Matisse. Or on Derain. But for them the masks were just like any other pieces of sculpture. When Matisse showed me his first Negro head, he talked to me about Egyptian art.

When I went to the old Trocadéro, it was disgusting. The Flea Market. The smell. I was all alone. I wanted to get away. But I didn't leave. I stayed. I stayed. I understood that it was very important: something

was happening to me, right?

The masks weren't just like any other pieces of sculpture. Not at all. They were magic things. But why weren't the Egyptian pieces or the Chaldean? We hadn't realized it. Those were primitives, not magic things. The Negro pieces were intercesseurs, *mediators; ever since then I've known the word in French. They were against everything—against unknown, threatening spirits. I always looked at fetishes. I understood; I too am against everything. I too believe that everything is unknown, that everything is an enemy! Everything! Not the details—women, children, babies, tobacco, playing—but the whole of it! I understood what the Negroes used their sculpture for. Why sculpt like that and not some other way? After all, they weren't Cubists! Since Cubism didn't exist. It was clear that some guys had invented the models, and others had imitated them, right? Isn't that what we call tradition? But all the fetishes were used for the same thing. They were weapons. To help people avoid coming under the influence of spirits again, to help them become independent. They're tools. If we give spirits a form, we become independent. Spirits, the unconscious (people still weren't talking about that very much), emotion—they're all the same thing. I understood why I was a painter. All alone in that awful museum, with masks, dolls made by the redskins, dusty manikins. Les Demoiselles d'Avignon must have come to me that very day, but not at all because of the forms; because it was my first exorcism painting—yes absolutely!*

That's also what separated me from Braque. He loved the Negro pieces, but as I told you: because they were good sculptures. He was never at all afraid of them. Exorcism didn't interest him. Because he wasn't affected by what I called "the whole of it," or life, or—I don't know— the earth?— everything that surrounds us, everything that is not us—he didn't find all of that hostile. And imagine—not even foreign to him! He was always at home … Even now … He doesn't understand these things at all: he's not superstitious![5]

Here we see Picasso the "sorcerer's apprentice," as Salmon called him.[6] A little further on, Picasso clearly says there is no "similarity" [*ressemblance*] between the *Demoiselles* and African sculpture:

Similarities! In Les Demoiselles d'Avignon *I painted a nose in profile within a full-view face. (It had to be put in sideways so that I could name it, so that I could call it "nose.") Then everybody talked about the Negroes. Have you ever seen any piece of Negro sculpture—any one at all—with a nose in profile within a full-face mask?*[7]

A nearly identical disclosure, but without any specific mention of the *Demoiselles,* was made to Françoise Gilot, at the end of a visit that she and Picasso paid to Matisse at Cimiez. During the visit, Matisse had made Picasso a gift of an imposing figure, an "ogress from the New Hebrides," a "New Guinea thing" that frightened Picasso and which Matisse had called "a full-size human figure that's completely savage. It's just right for you."[8] Picasso said:

When I became interested, forty years ago, in Negro art and I made what they refer to as the Negro Period in my painting, it was because at

that time I was against what was called beauty in the museums. At that time, for most people a negro mask was an ethnographic object. When I went for the first time, at Derain's urging, to the Trocadéro museum, the smell of dampness and rot there stuck in my throat. It depressed me so much that I wanted to get out fast, but I stayed and studied. Men had made those masks and other objects for a sacred purpose, a magic purpose, as a kind of mediation between themselves and the unknown hostile forces that surrounded them, in order to overcome their fear and horror by giving it a form and an image. At that moment I realized that this was what painting was about. Painting isn't an aesthetic operation; it's a form of magic designed to be a mediator between this strange, hostile world and us, a way of seizing the power by giving form to our terrors as well as our desires. When I came to that realization, I knew I had found my way.

Then people began looking at those objects in terms of aesthetics, and now that everyone says there's nothing handsomer, they don't interest me any longer. If they're just another kind of aesthetic object, then I prefer something Chinese. Besides, that New Guinea thing frightens me. I think it probably frightens Matisse too and that's why he's eager to get rid of it. He thinks I'll be able to exorcise it better than he can.[9]

One may add here what Picasso said to Apollinaire on the subject of African art:

I have felt my strongest artistic emotions when suddenly confronted with the sublime beauty of sculptures executed by the anonymous artists of Africa. These works of a religious, passionate, and rigorously logical art are the most powerful and most beautiful things the human imagination has ever produced. I hasten to add that, nevertheless, I detest exoticism.[10]

Only the notion of religious art connects this with Picasso's words to Malraux; the rest simply shows an enthusiasm—probably Apollinaire's—for the primitive objects which at the time were in the process of being raised to the rank of art objects.

An earlier remark seems to run counter to the statements recorded by Malraux: the reference made by Vladimir Markov, in his 1919 text, to the words of the Russian critic Jakov Tugendhol'd: "When I went into Picasso's studio and I saw the black fetishes of the Congo, writes Tugendhol'd (in *Apollon*, 1914), I asked the painter if it was the mystical character of these fetishes that interested him. He replied: 'Absolutely not; what interests me is their geometrical simplicity.'"[11]

Otherwise, those texts on primitive art published in the first quarter of this century that accord with the statements quoted by Malraux most often emphasize the ritual power of primitive objects, whereas art-lovers and dealers see in them a primarily aesthetic interest.[12] Thus Carl Einstein insists, as early as 1915, in *Negerplastik*, on the appropriate power exercised on forces external to man through these ritual objects, especially through masks:

… the Negro, who is less intimidated by the subjective ego and worships objective powers, must transform himself into those powers, if he wants to stand his ground beside them, particularly at a point when the veneration reaches a climax. Through this metamorphosis he establishes an equilibrium with the destructive adoration: he prays to the god, his ecstatic dancing is directed toward the tribe, and with the mask he turns himself into the tribe and into the god. This metamorphosis gives him the most powerful perception of the objective which he incarnates in himself. Thus he himself becomes this objectivity, inside of which all individual matter is eliminated.

Therefore: The mask is meaningless unless it is inhuman, impersonal; in other words, unless it is a construction, free of the experience of the individual. Conceivably, he venerates the mask as a deity, when he is not wearing it.[13]

The exorcistic power of primitive objects is also emphasized by Henri Clouzot and André Level in 1919, in their introductory text to the catalogue of the exhibition "L'Art nègre et l'art océanien," organized by Paul Guillaume at the Galerie Devambez:

The figures belong to the realm of religion. Art for art's sake is unknown to primitive peoples. Their works traditionally have a ritual and magical function. The art of uncivilized tribes is defensive, more a conjurer of evil spirits than an appeaser of good spirits.[14]

Even Zervos himself—who, respecting Picasso's confidence, takes care to situate the African influence after the *Demoiselles*—insists in 1942 that the formal plane is not where one should look for such influence. On the "primitives" and Picasso, Zervos says: "It is the feeling arising from their works that impressed him the most, and the magical effect of this feeling on the appearances of reality." He had earlier stressed the fact that the "preeminently instinctive and irrational creations" of "primitive" man had opened up to "civilized" man—who holds an "excessive interest in reason"—the paths to the unconscious, for which Picasso had a true "penchant."

I insist, at the risk of repeating myself, that the art of primitive peoples truly had impact on Picasso only insofar as it afforded him a vision of the world fit to modify the aspect and character of his aesthetic experience and to propose to him a new representation of the world, in which the supernatural and experience overlap and interact to produce a new and unique reality.[15]

Let us return, after this digression, to the statements of Picasso recorded by Malraux. William Rubin, making use of testimony he obtained from Picasso, has enriched them with additional information, published in 1983, in an article on the painting at the Basel Kunstmuseum, *Bread and Fruit Dish on a Table,* that includes much discussion of the *Demoiselles,* and then in 1984 in the catalogue of the exhibition "'Primitivism' in Twentieth-Century Art."[16] Thus from the notes Rubin took following his conversations with the painter,[17] we learn that Picasso said he entered the Trocadéro museum by chance—rather than on the advice of Derain[18]—having opened the

wrong door (instead of going, as was his custom, to visit the Musée de Sculpture Comparée);[19] that he was alone on this first visit, but did return several times later in the company of friends;[20] and that it was in fact upon leaving the museum, when he found himself outside, that he realized, in all its violence, the "revelation" he had experienced.[21] But most important, Rubin insists on the fact that the notes he managed to put down on paper shortly after his conversations with Picasso are very close to what Malraux writes so eloquently—which helps confirm the reliability of the text of *La Tête d'obsidienne*.[22] Upon this book, which he takes care to corroborate with the testimony he himself gathered from Picasso, Rubin can therefore rest his convictions:[23] Picasso went to the Trocadéro sometime between the "Iberian" state and the final state of the *Demoiselles* ("surely in June" 1907),[24] as evidenced both by formal concerns—the colors of the two women on the right are supposedly from Oceanic art—and, above all, by the profound meaning of the painting, since Picasso was seeking, through the demoniacal masks with which he endowed the figures on the right, to exorcise the anguish he keenly felt about the link between love and death.[25] Which leads to the conclusion—by way of identifying what triggered the formal and conceptual break that the two demoiselles brought with them—that "there is not only no better but *no other* candidate for this than the Trocadéro visit that the artist himself called a 'shock' and a 'revelation.'"[26]

1. The various approaches to the question of who was the first to discover African art, and when, are explored in Laude 1968, pp. 83–121, and in several essays included in Rubin 1984, especially "From Africa" by Jean-Louis Paudrat and "Matisse and the Fauves," by Jack D. Flam. In different variations of this confused story, pieced together from conflicting, not always reliable testimony, Picasso's "initiation" into African art was effected either by Matisse—whether at a dinner at Matisse's home (see the Max Jacob section, below, in the present Anthology, pp. 232–33) or at the home of Gertrude Stein (see p. 253)—or by Vlaminck (see the Kahnweiler section, p. 237), and this in 1906, if we are to keep to the latest date given.

2. As Kahnweiler states in 1946 (see below, p. 236), and Salmon too, as early as 1912 (see p. 245). Nevertheless, when William Rubin questioned the painter on this, Picasso asserted that he had not begun collecting African art until after having completed the *Demoiselles* (Rubin 1984, pp. 262, 336, note 74). Based on the descriptions given him by Picasso, Rubin thinks that the first primitive objects the artists liked, if not acquired, were Kota reliquary guardian figures from Gabon or the Congo and Nimba masks of the Baga from Guinea (ibid., p. 337, note 86).

3. But, as Rubin has shown, this does not extend to the existence of similarities between any specific masks and the *Demoiselles* (see Rubin 1983, pp. 632–33; and 1984, pp. 262–65). He renders null and void the most famous comparisons, specifically those made by Barr (1946, p. 257) between the *Demoiselles* and an Etoumbi mask, which Laude (1968, figs. 57, 58) reproduced together with a Dogon shutter; Golding's comparison with a Dan mask (Golding 1958, pp. 157, 161, fig. 19); Ron Johnson's comparison with a mask from the Torres Strait (Johnson 1980b, pp. 105–06, 109, fig. 8), a mask that—as Picasso's friends told Pierre Daix, who passed the information on to Rubin—the artist did not acquire until the twenties (see Rubin 1984, pp. 264, 336, note 80); and Warren Robbins's 1982 comparison, in lectures, with a Kifwebe mask (cited in Rubin 1984, p. 265, where the mask is reproduced). Those objects could not have been accessible to Picasso (either at the Trocadéro or through dealers or friends) in 1907.

4. The circumstances of this visit have been studied very closely by Rubin

(1984, pp. 254–56).

5. Malraux 1974, pp. 17–19, quoted here from the English edition, 1976, pp. 10–13. Convinced that Picasso had something to hide here (exorcising, through the female demons that would be the demoiselles, the power his mother had had over him), Mary Mathews Gedo believes that discretion led Malraux to postpone making this disclosure until after the artist's death (see Gedo 1980b, p. 80). Braque does not appear to have focused as exclusively on the formal aspects of primitive art as Picasso makes it seem; to judge from what Braque said to Dora Vallier: "The African masks also opened up a new horizon to me. They enabled me to come into contact with instinctual things, direct manifestations that went against the false tradition I abhorred" (in Vallier 1954, p. 14). As for Matisse, Picasso confided scoffingly to Rubin that Matisse was not interested in the same works of primitive art as he, nor for the same reasons. In particular, Picasso believed that Matisse's correlation between Egyptian art and African art was wrongheaded (Rubin 1984, p. 337, note 86).

The state of neglect of the Trocadéro museum was denounced many times by Apollinaire. For example, in *Le Journal du soir* of October 3, 1909, p. 1, in an article titled "Sur les musées," he wrote: "The Trocadéro museum is not becoming too small; since its collections are shrinking instead of growing, the museum is becoming too vast. Visitors are rare, guards even rarer, and the days one can visit it are rarer than public holidays." Or later, in the *Paris-Journal* of September 10, 1912, p. 1, in an article titled "Les Arts exotiques et l'ethnographie": "The Trocadéro museum, which contains a large number of masterpieces by African and Oceanic artists, has been almost entirely abandoned by its own administration. Open only three days a week, it has no guards of its own; municipal guards have to stand on duty there. The collections are mixed together in such a manner as to satisfy only ethnic curiosity and not aesthetic sensibility." For an ethnographic museum, this is not scandalous, but Apollinaire is here speaking on behalf of a new breed of lovers of primitive art—artists, collectors, and dealers for whom the ethnographic object was also, and indeed above all, an art object. He adds: "The Trocadéro museum is rarely frequented except on Sundays, and the only people who do go there are soldiers on leave and nannies taking babies for a stroll." Another article appeared in *Paris-Journal* of July 18, 1914, p. 3, a short piece titled "Le Musée du Trocadéro." Many thanks to Pierre Caizergues for calling my attention to the first and third of these articles, which are reprinted in his thesis (Caizergues 1979, pp. 121–23, 525). Katia Samaltanos (1984, p. 27) makes reference to the second. These texts are reprinted in Apollinaire 1991b, pp. 122–24, 473–76, 833–34. A brief text on African art (probably written by Paul Guillaume), published in the catalogue of the first exhibition organized by the Lyre et Palette association (held at 6, rue Huyghens in Paris from November 19 to December 5, 1916), in which African art, shown for the first time under the auspices of a non-ethnographic exhibition, was presented alongside works by Kisling, Matisse, Modigliani, Ortiz de Zarate, and Picasso—also denounces the fact that the Trocadéro, being "exclusively" ethnographic, puts no emphasis on "the beauty of the works it exhibits."

6. Salmon 1912, p. 44. See the Salmon section, below, p. 245.

7. Malraux 1974, pp. 116–17, quoted here from the English edition (1976), p. 125. On the subject of the nose in profile, see Salmon 1912, p. 44 (and below, p. 245), and Raynal 1952, p. 13 (and below, p. 229). See also what Picasso said to Kahnweiler in 1951 (quoted in "Le Sujet chez Picasso," in *Verve* [Paris], vol. 7, nos. 25–26 [1951]; reprinted in Kahnweiler 1963, pp. 125–26): "In the figures, people see the nose sideways, whereas nothing shocks them about a bridge. But I made that 'sideways nose' on purpose. You see: I made it so that they would be *forced* to see a nose. Later they saw, or they would see, that it is *not* sideways. What I did not want was for them to continue to see only the 'pretty harmonies,' the 'exquisite colors.'" He says to Kahnweiler on another occasion, in reference to the *Demoiselles* (Kahnweiler 1971a, p. 59): "In those days people said that I made the noses crooked, even in 'Les Demoiselles d'Avignon,' but I had to make the nose crooked so that they would see that it was a nose. I was sure that later they would see that it wasn't crooked." (Note that the portrait *Marguerite*, which Picasso obtained as part of an exchange with Matisse, precisely in 1907, also has a "sideways nose.") Malraux again quotes Picasso talking about the *Demoiselles*: "People have always felt like destroying paintings they hate. And they're right. Funny they didn't do anything against *Les Demoiselles d'Avignon*" (Malraux 1974,

p. 108; quoted from the English edition, 1976, p. 117).
8. Gilot/Lake 1964, p. 265.
9. Ibid., p. 266. See Rubin 1984, p. 334, note 8. To the phrasing reported by Malraux—*"J'ai compris pourquoi j'étais peintre"* ("I understood why I was a painter")—Rubin prefers that quoted by Françoise Gilot—*"J'ai compris que c'était le sens même de la peinture"* ("I realized that this was what painting was all about" [Gilot/Lake 1964, p. 266])—which is to say, giving color and form to the demons of the unconscious and thus liberating oneself from them. An error appears in the French translation of the Gilot/Lake text (first published in English): it was not "with Derain" (as the French edition has it) but "at Derain's urging" that Picasso would have gone to the Trocadéro for the first time (Gilot/Lake 1964, p. 266). However, Edward Fry (1966a, p. 194, note 19) says, without explanation, that the Gilot text is unreliable. Maurice de Vlaminck (1943, p. 106) insinuates that before 1905 he and Derain were regular visitors to the Trocadéro museum and that, as opposed to Picasso, it was *not* at the Trocadéro—before its great gathering of objects, which they saw as nothing more than "barbaric fetishes"—but rather in a bistro in Argenteuil, upon discovering, on a shelf, three African sculptures, that he had his great revelation of African art: "Those three sculptures struck me. I had an intuition of the power they contained. They revealed African art to me."
10. From a two-page manuscript by Apollinaire, in the Doucet archives (7540, B'II²), quoted by Caizergues (1979, pp. 596–98; see above, note 5). The text is reprinted in Apollinaire 1991b, pp. 875–77. Caizergues stresses that these comments by Picasso "belong both to the painter and to the poet, perhaps more to the latter than the former" (p. 1125).
11. Markov 1919, p. 37 (and *Cahiers du Musée National d'Art Moderne* translation, p. 324). The article by Tugendhol'd referred to, "The French Collection of S. I. Shchukin," indeed contains the following sentence: "When I was in the studio of Picasso and saw there black fetishes of the Congo, I was suddenly reminded of the words by A. N. Benois concerning the 'underlying analogy' between the art of Picasso and 'religious art of African fetishes,' and I asked the artist whether the mystical side of these sculptures was of any interest to him. In fact, he answered, I am interested in their geometric simplicity" (Tugendhol'd 1914, p. 33). I am grateful to Magdalena Dabrowski for locating and translating this excerpt of the text. This passage does not appear in the French translation of *Cahiers du Musée National d'Art Moderne*, no. 4 (1980), pp. 313–18. It might be said that this comment by Picasso attests not so much to his taste for contradiction as to the reality of his perception of African art—as an art of exorcism, and rich in plastic qualities.
12. See note 5, above, for Apollinaire's opinions, or see his comments in the introduction ("À propos de l'art des noirs") to the album titled *Sculptures nègres,* published in 1917 by Paul Guillaume (Apollinaire 1917). (This text was republished, with a few changes, in *La Vie anecdotique* of April 1, 1917, under the title "Mélanophilie ou mélanomanie"; see Apollinaire 1993, pp. 252–55.) As defender of aesthetics against ethnography, Apollinaire falls in with those who, he writes, "believed they could take an interest in the idols of Oceania and Africa from a purely artistic point of view, setting aside the supernatural character given them by the artists who sculpted them and the believers who rendered homage to them."
13. Einstein 1915. Translated by Ingeborg von Zitzewitz. There is a French translation by Liliane Meffre of the second edition (1920), in *Travaux et mémoires du CRHRAEC* (see note 11, above), pp. 9–20; the passage quoted here appears on p. 19.
14. Clouzot/Level 1919b, pp. 1–2.
15. Zervos II¹ 1942, pp. xlvi–xlix passim.
16. Rubin 1983 and Rubin 1984, respectively, and the notes below for specific pagination.
17. In 1970–72, as he told me.
18. See Gilot, note 9, above.
19. Rubin 1984, pp. 254, 335, note 46. See also Zervos, above, in "Iberianism vs. African Art," where it is supposedly curiosity that led Picasso to the Musée d'Ethnographie.
20. Rubin 1984, p. 335, note 50. Salmon (1961, p. 253) mentions the "funny old Trocadéro … a museum of anthropology where Picasso, Apollinaire, Max Jacob,

and I discovered African art." On the question of the discovery of African art, Salmon tells Fry more specifically in 1963: "I retain the memory of a first visit with Picasso (Max Jacob was also there, if I remember correctly) to the former Trocadéro museum" (quoted in Laude 1968, pp. 101–02). It may have been Salmon's first visit, but not necessarily Picasso's. Kahnweiler had pointed out to Goldwater (1938, page 129, note 14) that Picasso went often to the Trocadéro.
21. Rubin 1984, p. 335, note 51, where "revelation" is put in quotation marks, indicating that it is Picasso's own word. William Rubin reminds me that Zervos mentions the same word, which suggests that Picasso used it in the confidential statements he made to Zervos (see above, under "Iberianism vs. African Art," p. 216).
22. Rubin 1984, p. 335, note 45. This also corroborates statements recorded by Françoise Gilot. Rubin points out, however, that in the context of these conversations, Picasso's remark could as well have referred in general to the "African" pictures of 1907–08 as to the *Demoiselles* in particular. In 1983 (p. 632, note 56), Rubin notes that Picasso had clearly stated that it was the spirit, not the style, of the figures he called "fetishes" that had overwhelmed him.
23. See Rubin 1983, p. 632, note 56; and Rubin 1984, p. 335, note 45.
24. Rubin 1984, p. 254. Assuming that the painting was completed "rather early in the summer of 1907," to use Kahnweiler's words, the visit is thus correctly situated in the chronology of the execution of the *Demoiselles* as Rubin had established it. "Surely in June" does not reappear in the 1987 French edition of *"Primitivism" in Twentieth-Century Art* (Rubin 1984).
25. I have summarized here in simplistic fashion the theories proposed by Rubin in 1983 and 1984. From Picasso's frequent (and often humorous) allusions, in conversation, to venereal disease, Rubin deduces that the artist's anguish revolved around this (Rubin 1983, pp. 630–31, note 52; Rubin 1984, p. 335, note 43; and his essay in the present volume).
26. Rubin 1984, p. 256; and see above, note 21, and p. 216.

A PAINTING'S IDENTITY

Picasso resisted his questioners, who found him reticent and indifferent. They complain of the imprecision of his answers, sometimes even his total neglect, when he quite simply refuses to answer at all. Nevertheless, to D.-H. Kahnweiler in 1933, Alfred Barr in 1945, Antonina Vallentin during the three years leading up to the publication of her book in 1957, Roland Penrose during the same period, Pierre Daix in the early 1960s, and William Rubin in the 1970s, bits of information were parsimoniously disclosed.

On December 2, 1933, at the Simon gallery,[1] on rue d'Astorg, Kahnweiler and Picasso discuss the *Demoiselles,* a conversation later published in *Le Point* in 1952:

Picasso: "'Les Demoiselles d'Avignon'—how irritating that name is to me sometimes! It was Salmon[I] who came up with it. As you know, it was first called "The Bordello of Avignon." Do you know why? Avignon has always been a familiar name to me, a name closely connected to my life. I used to live just a stone's throw from the calle d'Avignon. That was where I used to buy my paper and watercolors. And as you know, Max's[II] grandmother was originally from Avignon. We used to make a lot of jokes about that painting. One of the women was Max's grandmother, another was Fernande,[III] another Marie Laurencin, all in an Avignon brothel.

"There were also supposed to be men—according to my original idea—in fact you've seen the drawings. There was a student holding a

skull. There was a sailor, too. The women were eating, hence the fruit basket, which remained. Then it changed, and became what it is now."

A few days later Picasso had told me he had not started the painting until 1907, rather than 1906, since, he said, he had begun it in the spring. He confirmed to me that there had been two different periods of work in the painting. I saw the painting in its current state at rue Ravignan, therefore after the second period of work, rather early in the summer of 1907. Since Picasso spoke of the spring, he is remembering something precise and could not be mistaken. The second period of work must have therefore occurred rather soon after the first. This second period, which effectively marks the birth of Cubism, should therefore be situated in April or May of 1907.

Returning to the painting's name, Picasso added: "You see it was no accident that after the incidents at Céret(IV) *I went to Avignon."*[2]

The questioner has done a good job, gathering important information on a number of topics: on the two titles, the first approved by Picasso, the second given by Salmon;[3] on the double connotation of the name Avignon, being both a city (supposedly where Max Jacob's grandmother was originally from—could this be serious?),[4] which Picasso did not visit until 1912, when drawn there—he says with a wink—by some fate connected with the *Demoiselles*, and a street in Barcelona on which, he says, was located the shop where he used to buy his colors (while not mentioning that there were also brothels there);[5] on the keys (perhaps made up?) identifying the figures in the painting; on the disappearance of the student with the skull and the sailor; and on the famous chronology of the painting's execution, in two phases, from the spring to the early summer of 1907.

This 1933 text, the first to gather so much information (but, we should remember, not published until 1952), can be compared with Picasso's statements, on various points, subsequently collected by other interviewers.

In 1939, in the catalogue accompanying The Museum of Modern Art's exhibition "Picasso: Forty Years of His Art," Alfred Barr devotes three pages to the *Demoiselles* (under the heading "The 'Negro' Period"). In the comment accompanying one of the sketches for the painting (reproduced in the present volume, fig. 40, p. 48), Barr mentions: "The figure at the left, Picasso says (1939), is a man with a skull in his hand entering a scene of carnal pleasure."[6] Two observations here: first, Barr does not specify to whom Picasso divulged this information. Did Barr have any way of knowing what Kahnweiler knew, or more likely, did he have occasion to talk about it with Picasso during their 1939 encounter? And second: in the sketch Barr reproduced (now in the Basel Kunstmuseum), the man is holding a book, not a skull.[7] Seven years later, in his book *Picasso: Fifty Years of His Art*, Barr devotes five pages to the *Demoiselles*, this time under the heading "Toward Cubism: 1906–1908."[8] Barr resumes his description of the figures, but completes it this time—his account again vouched for by Picasso's word, though there is

some question as to how reliable that may be: "Picasso explained, in 1939, that the central figure of the early study is a sailor seated and surrounded by nude women, food and flowers. Entering this gay company from the left is a man with a skull in his hand. Picasso originally conceived the picture as a kind of *memento mori* allegory or charade though probably with no fervid moral intent."[9] In 1952, the tireless Barr writes to Picasso and talks about a drawing of a man in three-quarter view, in The Museum of Modern Art's collection (*Head of the Medical Student*, fig. 207, p. 107); he surmises it is a study "for the man who is part of the early sketches for the *Demoiselles*," and adds: "I have a question to ask you about this: what is the figure holding? Is it a palette, a skull, or something else?"[10] A touching question.

Next comes the thorny question of the chronology of the painting's execution. The inquiry pursued by Barr grows more and more intense before the publication of his *Fifty Years* book in 1946: "Quite recently … Picasso has assured us that the two right-hand figures of *Les Demoiselles* were completed some time after the rest of the composition."[11] It was from a telegram dated July 17, 1945, and addressed to the Rosenberg gallery in New York by Paul Rosenberg, the Parisian art dealer, whom Barr had asked to question Picasso on the matter, that Barr learned that "… two heads right Avignon painting painted later 1907."[12] Concurrently, Barr had also questioned Zervos, to whom he wrote on April 9, 1945: "Would you ask Picasso if the faces of the two right-hand figures in the *Demoiselles d'Avignon* were painted after he saw Negro masks. They seem so different in style and so unrelated to Iberian sculpture."[13] Zervos wrote back to him on July 7: "Excuse me for not having answered your letter with the questionnaire for Picasso sooner. Unfortunately M. Picasso has in recent weeks become absolutely impossible to approach. Every time I have gone to see him, it has been impossible to speak to him for two minutes alone, as he is surrounded by mobs of people coming from God knows where.… His studio has become a hell that I can only flee." Zervos advises Barr to address himself to Picasso's secretary, Jaime Sabartés, but doubts that he will get any results from this, since "lately [Picasso] has acquired the habit of no longer answering anyone."[14] The only thing left for Barr to do is to trust his intuition; he hopes that if he does publish a mistake, at least the painter may be shaken out of his silence (though Picasso seemed utterly indifferent to what people wrote about his work): on July 17 Barr writes back to Zervos, saying, "Perhaps, as in the case of 'Les Demoiselles d'Avignon,' I shall have to publish certain errors and speculations so that Picasso may be aroused to deny or clarify. It is indeed harder to discover the truth about Picasso's early work than about the work of Manet, Poussin, or Velazquez."[15] However, in September 1945, following Zervos's advice, Barr does draft a questionnaire in French, which he addresses to Picasso, via Commander James Plaut, director of the Boston Institute of Modern Art, and with the help of Sabartés. Question number 10 is as follows: "Were the two figures on the right painted before or after the summer of 1907?" The answer: "10. Demoiselles d'Avignon … (?)"[16] Barr com-

ments: "Later when asked whether he had painted the two figures before or after the summer of 1907, Picasso was noncommittal (questionnaire, October 1945)."[17]

For her part Antonina Vallentin inquires into the stylistic break that she too notices in the painting. She relates a conversation with the painter:

I had done half the painting, Picasso explains. And I felt: It's not right! I did the other [half]; I wondered if perhaps I should redo the whole thing. Then I said to myself: "No, people will understand what I was trying to do."[18]

Picasso also talks about his isolation—"Yes, I was alone, very much alone"[19]—about the lack of understanding from his close friends, Leo Stein and Braque,[20] and about the necessity that drove him nevertheless to continue his quest: "Yes, I knew the risks I was running." Vallentin then asks him, "But how can anyone be so sure about what he is doing? How can he know that he is right and everyone else is wrong?" The painter replies, "I didn't know, but I could not do otherwise."[21]

Who is the man with the skull? This question was answered by Leo Steinberg in 1972, when relating the testimony obtained by William Rubin: Picasso, "after sixty-five years of negligence or perversity," releasing an unpublished "carnet d'esquisses" (Carnet 3), revealed the man's identity, saying he was a "medical student."[22] Pierre Daix's inquiry led to the same result, enriched by a specific word: "the man entering on the left is a student carrying a death's-head, a medico [*carabin*], Picasso told me one day."[23] As for the sailor, who is hardly an issue: when Daix remarked that the painter had given the Barcelona sailor the Iberian traits of Picasso's ancestors (since at that time he was asserting the Iberian influence), the painter replied, "There's some of that."[24]

Other, final queries: Is the painting finished? Daix recounts being told the following by Picasso: "Picasso clearly confirmed Zervos's account [that the *Demoiselles* was marked by Iberianism and not by the African art 'revealed' to him later at the Trocadéro], further answering my question by saying that, when he had previously spoken on this subject with respect to *Les Demoiselles d'Avignon*, he was referring to the final version of the painting [*la toile définitive*], such as it is today."[25] It would seem clear, therefore, that the resumption of work on the painting affected only the figures on the right,[26] and could not have been done after returning from a summer vacation in 1907 (as might be inferred from what Salmon says),[27] since Picasso did not leave Paris that summer.[28] Upon asking Picasso whether the *Demoiselles* was completed, Rubin writes: "To my surprise, Picasso simply did not accept the idea that the *Demoiselles* was unfinished. Whatever he said to me then—it began with something on the order of 'C'est pas du tout ça'—left me very confused, and it was clear that he did not want to be pressed."[29]

Questions of African and Iberian art aside, it would seem that few references, especially to painting, were made in Picasso's presence that would elicit comment on the sources that the *Demoiselles* drew from, except perhaps by Daix: "In the conversations I had with him in 1970 on the subject of the *Demoiselles*, Picasso admitted he might have been thinking of [Manet's] *Déjeuner sur l'herbe*, but claimed that he had his sights on *Women of Algiers* of Delacroix (fig. 13, p. 32): 'I too, at the beginning, placed naked women next to clothed men,' he said to me. Afterward, the men disappeared, but that's the way it is in a brothel, isn't it?'"[30] Though it only remotely concerns the *Demoiselles*, mention should also be made of what Picasso told Brassaï at Cannes in 1960, about a tapestry, based on the painting, that had been made in 1959 and which was hanging on the wall of the studio at La Californie:

Shortly afterward, he reveals to me the secret of Les Demoiselles d'Avignon, *which dominates the studio. Picasso: "Come over here and look at them closely. It's a tapestry. An old chap in Toulon took it into his head to do it, copying it from an ordinary postcard. A lot of my visitors think it's horrible and talk about sacrilege.... It's the change in colors that shocks them ... but it's precisely that that fascinates me. The colors of the original were completely different, even in the reproduction, and then the Sunday painter who did this invented still others.... It's almost another picture, even though it reminds you of* Les Demoiselles d'Avignon."[31]

And Picasso concludes with what "Bigfoot" says behind the scenes in *Desire Caught by the Tail*: "The Demoiselles d'Avignon have already been earning their living for thirty-three long years!"[32]

1. Kahnweiler had opened his new gallery, at 29 bis, rue d'Astorg, on September 1, 1920.

2. See Kahnweiler 1952, p. 24. I have printed here the original text (notes taken on December 2, 1933), including the last paragraph (in which Picasso speaks of Avignon), which was not included in the 1952 published text. The latter is otherwise identical to the original, except for the verb *situer* ("the second period ... should therefore be situated ..."), which was replaced in 1952 with *placer*. The original text (with *situer*) had likely been transcribed shortly after the conversation and preserved, along with other interviews, with a view toward eventual publication, though only a few excerpts were finally published. The numerals within the text refer to following footnotes, which were printed at the bottom of the page: "(I) André Salmon, the poet and art critic. (II) Max Jacob. (III) Fernande Olivier. (IV) An altercation with the painter Pichot's wife (a friend of Fernande Olivier, from whom Picasso had just separated), who was not getting along with Picasso."

I am grateful to Maurice Jardot for passing this complete text along to me, and to Louise Leiris for authorizing its publication. William Rubin pointed out to me that when Kahnweiler wrote to Alfred Barr in 1939 about Avignon (see the Kahnweiler section, below, p. 236), he left out the mention of Barcelona. To Sabartés, Picasso must have said things quite similar to what Kahnweiler reports. In late 1938, Sabartés says: "While I'm at it, I always forget to ask you about what I thought I heard you say once about *Les Demoiselles d'Avignon*. I can't remember." Picasso replies: "That's an idea of S: actually, that painting, for me, is a bordello in Avignon.... When I was working on it, I was thinking: this one is M's sister ... this other one ... But you see, for a collector, it's a bit much to have a brothel in his house.... Yes, I think it was S who gave it its current name"

(Sabartés 1946, p. 158). S, of course, is Salmon, M's sister is possibly Max's, and the collector is Jacques Doucet. My thanks to Judith Cousins for pointing out this text to me.

3. Zervos II[1] 1942, p. 10, gives the same information (see above, "Iberianism vs. African Art," p. 215). For his part Salmon (1922, p. 16, note 1) also claims, with Apollinaire and Jacob, to have proposed the first baptismal name "The Philosophical B[rothel]" for the *Demoiselles* (see the Salmon section, below, p. 248). Salmon even claims to have been the only one to suggest it, as he recalled in a November 17, 1960, letter addressed to Euro Civis: "The *Demoiselles d'Avignon*: yes, I gave the painting its title, which lasted half a day: The Philosophical Brothel" (collection of The Getty Center for the History of Art and the Humanities, Santa Monica). See also Salmon's unpublished text "Véritable clé d'un domaine imaginaire," p. 247. If we are to believe Picasso, Avignon figured in the original title. Kahnweiler, in his December 7, 1939, letter addressed to Alfred Barr (see note 2, above, and Barr 1946, p. 258, which dates this letter as 1940), writes that the painting was given its definitive title shortly after the end of World War I, perhaps by Louis Aragon (see below, p. 236). However, the catalogue of the Salon d'Antin, where the painting was shown in 1916, proves that in July of that year it was already called *Les Demoiselles d'Avignon*. It is not clear from what source Pierre Cabanne (1979, p. 232) got the notion that Picasso "had come up with the title *'The Wages of Sin'* (*Les Gages du péché*)." It may be a misinterpretation of Roland Penrose (1958, p. 127), who refers to the famous phrase from the Epistle to the Romans (6:23), but certainly does not put it in Picasso's mouth.

4. "Readers will recall that Matorel had a mad aunt. Reliable documents enable us to say with assurance that this demoiselle Matorel was confined to the asylum in Avignon" (Henry 1970, p. 198). My thanks to Judith Cousins for bringing this text to my attention. In his December 7, 1939, letter to Alfred Barr (see note 3 above, and p. 236, below, where the following passage is quoted at length), Kahnweiler directly implicates Jacob in the matter: "Max Jacob—who's [*sic*] maternal family draws its origin from Avignon—had told Picasso that a certain brothel at Avignon was a most splendid place, with women, curtains, flowers, fruits." I thank William Rubin and Judith Cousins for passing this letter along to me. It should be mentioned here that certain authors have thought they recognized Jacob in the sailor in the preparatory drawings: thus LeRoy C. Breunig (1957, p. 589) notes a resemblance between Picasso's portrait of Jacob (Zervos II[1], 9) and the sailor of the *Demoiselles*, taking also into account the rather unlikely stories that Jacob used to tell about himself, such as those that appeared in the autobiographical sketch he had planned to insert in the introduction to *Saint-Matorel*: "Born in the far reaches of Brittany, on the ocean, M. Max Jacob was a sailor for five years" (Jacob 1953, p. 54; undated letter to Kahnweiler). William Rubin (1983, p. 637, note 74) also associates the *Demoiselles* sailor with Jacob; he had previously believed, as Leo Steinberg mentions (see Steinberg 1988, pp. 43–45, and note 33), that the sailor might also be Picasso. Steinberg thought perhaps he recognized Jacob in the bald man entering from the left in the oil sketch (reproduced in the present volume, fig. 39, p. 46) and thinks it plausible that Picasso had specific persons in mind when working on the painting. Concerning this 1933 interview, Pierre Daix (1987, p. 402, note 6) says that "Kahnweiler faithfully recorded Picasso's discussion of the *Demoiselles*," but that "none of it should be taken seriously."

5. On this point, compare Kahnweiler's account with the one published by Zervos (see above, under "Iberianism vs. African Art," p. 215): can we assume it was Picasso himself who said to Zervos that "he had depicted here a recollection of a brothel in Barcelona on Avignon Street"? (Later in the text Zervos is explicit, using such expressions as "Picasso confided to me" and "Picasso assured me.")

6. Barr, 1939a, p. 60. See the Chronology, under November 15, 1939.

7. May we conclude that originally the man was in fact holding a skull? (The figure holding a skull appears only as an autonomous figure in the preparatory studies. In studies of the whole composition, he is always carrying a book.) Rubin (1984, p. 334, note 36) confirms that Picasso told him too that in an initial phase the student was holding a skull. On the meeting between Alfred Barr and Picasso in the early summer of 1939, see the memoirs of Mrs. Barr (Scolari Barr 1987, p. 56, and in the Chronology, under "Early Summer 1939").

8. Zervos's text was published in the interim, and perhaps for this reason, it became difficult to place the *Demoiselles* so explicitly under the heading of "The

'Negro' Period," as in Barr 1939b.

9. Barr 1946, p. 57. In 1939 Barr had said nothing about the sailor. But the 1946 text is still ambiguous, it being somewhat unclear where the paraphrases of Picasso's statements end and Barr's interpretations begin: from the wording of the text it seems that Picasso himself said he had "conceived the picture as a kind of *memento mori*," though the word "probably" prompts one to wonder who doubts the "moral intent." These statements recorded by Barr held authority for later generations of art historians. Steinberg (1988, p. 10, note 5) points out that Barr did not clearly specify his sources on this matter. On the other hand, why does Penrose, who nevertheless cites Barr's 1946 text, say that there are seven figures in the early studies, "two of which appear to be sailors visiting a brothel" (Penrose 1973, p. 135)?

10. Alfred H. Barr, Jr., letter, in French, to Picasso, October 16, 1952. Archives of The Museum of Modern Art, New York.

11. Barr 1946, p. 56. Barr's attempt to justify his 1936 heading, "The 'Negro' Period," is worth noting; after reporting this statement as gospel truth, Barr again calls into question, with all due caution, Picasso's account to Zervos of the antecedence of the *Demoiselles* to the visit to the Trocadéro by asserting that it "seems possible therefore that Picasso's memory is incomplete and that he may well have painted or repainted the astonishing heads of these figures after his discovery of African sculpture" (ibid.).

12. Ibid., p. 257, in a note: "At the request of the writer, Paul Rosenberg asked Picasso whether the two right-hand figures had not been completed some time after the rest of *Les Demoiselles d'Avignon*. Picasso said yes they had (July 1945)." The text of the telegram is from the Alfred Barr Papers, Archives of The Museum of Modern Art, New York.

13. Alfred H. Barr, Jr., letter to Christian Zervos, April 9, 1945. Alfred H. Barr, Jr. Papers, Archives of The Museum of Modern Art, New York.

14. Christian Zervos, letter to Alfred H. Barr, Jr., July 7, 1945. Alfred H. Barr, Jr. Papers, Archives of The Museum of Modern Art, New York.

15. Alfred H. Barr, Jr., letter to Christian Zervos, July 17, 1945. Alfred H. Barr, Jr. Papers, Archives of The Museum of Modern Art, New York.

16. Alfred H. Barr, Jr., questionnaire, in French, sent to Jaime Sabartés, with Sabartés's answer. Alfred H. Barr, Jr. Papers, Archives of The Museum of Modern Art, New York. My thanks to Judith Cousins for locating these documents and to William Rubin for giving me authorization to quote them.

17. Barr 1946, p. 257.

18. Vallentin 1957, p. 144. Steinberg (1979, p. 123) insists that Picasso "forced his pictures to acknowledge the undertow of disorder," and quotes a beautiful statement made by James Joyce to a hopeful beginner: "Young man, you have not enough chaos in you to create a world."

19. Vallentin 1957, p. 150.

20. See the Braque and Leo Stein sections, below, pp. 228–29, 254–55.

21. Vallentin 1957, p. 151.

22. Steinberg 1988 (first published 1972), pp. 38–40, notes 28, 29 (this information was communicated by Rubin to Steinberg on June 1, 1972).

23. Daix 1975b, p. 10. We learn that this was confirmed on April 14, 1972 (Daix 1979, pp. 15, 185, note 17). Concerning the medical student's being a personification of the painter, see also William Rubin's essay in the present volume, p. 59.

24. Daix 1973, p. 48.

25. Daix 1977, p. 94.

26. See Daix 1979, pp. 18, 185, note 26: "In conversation with the author, 24 January 1970 and 7 February 1972."

27. See p. 249 of this volume.

28. Daix 1979, p. 185, note 28.

29. Rubin 1983, p. 647.

30. Daix 1977, p. 91, note 12. When Daix published this account, Rosenblum had already made his contrary opinion known (Rosenblum 1973, p. 47).

31. Brassaï 1966, p. 243 (conversation of May 18, 1960); the tapestry was made in 1959 by the Dürrbachs, weavers who had located in Cavalaire (Var). My thanks to Marie-Laure Bernadac for bringing this text to my attention.

32. Picasso 1948, pp. 51–52; the text was written between January 14 and 17, 1941.

In subsequent sections of this Anthology will be found what Picasso said to

Vallentin about Braque (p. 229); to Penrose about Fénéon (p. 232); to Kahn-weiler about the unfinishedness of the painting (p. 240); to Pignon about Matisse's reaction (p. 244); to Rubin about the episode of the African statuette brought to Gertrude Stein's house by Matisse (p. 253 and note 8, p. 254); and to Vallentin about Leo Stein's visit (p. 254).

Eyewitness Accounts and Reminiscences

These remembrances are not from yesterday and are not written from the sort of notes that punctilious people set down every night before going to bed as if they were taking a sleeping-pill or medication. I abhor the idea of keeping an account of what I have done or what might have happened during the day. If what happened to me was amusing or of interest, there is no point in putting it down on paper; my recollection of it is more or less accurate, and that matters little: so much the better if I embellish it a bit, since that means I have a fond memory of it....

I cannot give exact dates for all these stories; when it all happened everything was confused, we lived like madmen, and now it is difficult to situate all these adventures and give them an order. But that has no importance whatsoever as long as they are told, and for me it's well worth the trouble, for it was quite a time we lived in.[1]

Here and at several other points in his *Mémoires*, Baron Mollet cautions us against giving undue credence to the recollections he has recorded. An honest precaution, but how ironic it is, coming from a personage whose real life was imbued with fiction.

A degree of uncertainty, confusion, and risk of omission always accompanies the attempt to record one's memories. The necessarily subjective interest of the writer, the fact that his unconscious, like anyone's, might be picking and choosing, enhancing some events or effacing others, adds to the inevitable distortions that time may bring. Moreover, human weakness may lead the writer to be carried away and let the pen embellish the facts, or at the very least make the facts conform to current trends and obey the imperatives of history. These are things always to be borne in mind by anyone who would make use of firsthand accounts.

Testimony of this kind played an essential role in the way *Les Demoiselles d'Avignon* has been approached for half a century. From the artist's contemporaries, art historians have sought to learn the secrets that study of the painting has not fully disclosed. Most often these are people very close to Picasso, or people considered to be such. From some of them we have an abundance of texts, while others wrote nothing relevant or left barely a statement recorded by others. For example, Fernande Olivier, Picasso's erstwhile companion, who lived with him at the Bateau-Lavoir from 1904, says nothing in her book *Picasso et ses amis* (1933) about activity at the studio during the spring and summer of 1907.[2] Max Jacob, a friend from Picasso's early days in Paris, took a vow of silence and apparently mentioned the *Demoiselles* by name only once.[3] Guillaume Apollinaire, a close friend if anyone was, and a generous art critic, would leave but a few notes jotted down in a personal and long-inaccessible notebook, and

even these might concern only the studies of female and male busts preparatory to the *Demoiselles*.[4] From Georges Braque, André Derain, and Henri Matisse, Picasso's *confrères* and the leading figures of the avant-garde in 1907, can be gathered only immediate reactions to the *Demoiselles*, reported by third parties. Jean Cocteau, an eloquent admirer, on his first visit to Picasso in 1915 at the rue Schoelcher studio said nothing about the *Demoiselles* (or made only the most oblique allusion to it), though we know, from a photograph and two eyewitness accounts, that the painting was visible in the studio:

The frieze of the Parthenon adorned the staircase of the building in which I first met Picasso, on rue Schoelcher. How hurriedly I climbed those stairs, heart racing, not casting even a glance at that bas-relief.

Upstairs ... I didn't like the African statues much better, but I did like the use of their oddity by the least odd of civilized men.[5]

And André Breton, who wrote such wonderful letters to Jacques Doucet persuading him to buy the *Demoiselles*,[6] apparently does not mention the work in any of his published writings, although he does say a few words about it in his published interviews with André Parinaud.[7]

On the other hand, André Salmon, a close friend during the Bateau-Lavoir period, and D.-H.Kahnweiler, who became Picasso's dealer, did, throughout their lives, tell and retell their remembrances. Salmon, however, when talking for the first time about the painting, describes it as including six female nudes, instead of five.[8] Kahnweiler, for his part, wavers as to the date when he first saw the painting (between March and the beginning of the summer of 1907); sometimes he shares the astonishment and reserve that seem to have been the common reaction, and sometimes he presents himself as immediately convinced and enthusiastic.[9] From Gertrude Stein one might have expected more than her few vague words on "an enormous picture, a strange picture of light and dark colors, that is all I can say, of a group, an enormous group."[10]

No doubt there is a wide gulf between the motives that led certain people to record their memories of what they had seen and lived, and the motives which today drive art-historical research. In 1912, Salmon noted that Picasso had worked his canvas in several phases, but did not reveal what we would so love to know: when, how, and how many times. And on the question of whether the painting was ever completed, Kahnweiler shifted from being totally oblivious of the question to putting an affirmation of unfinishedness in Picasso's own mouth. In the accounts to follow, the reader will find comments on this point, as well as on the cultural fabric of the era, on the multiple influences the painter absorbed (El Greco, Cézanne, African art), which critics have stressed to varying degrees at different times, and on the relationship of the painting to Cubism. Yet there is a point that remains generally ignored: was its subject taboo? Was it not mentioned in conversation at the time, by the people who knew the painting? What does the painting mean, beyond the indication Salmon gave by invoking the title "The Philosophical

Brothel"? Picasso's indifference toward what was written on these various questions does not help matters; most of the time the painter did not react to published accounts, either to refute or to confirm them.

Gathered below are a good number of accounts, which either bear the signatures of their authors or were reported by others. Emphasis has been placed on comments made before the painting's definitive entry into "public life" when it was bought by The Museum of Modern Art in 1937, thereby to gain a better knowledge of the work's "private life" in Picasso's studios and then in Jacques Doucet's collection. Other comments exist beyond those cited here. Certain avenues for further research were glimpsed but, for want of time, could not be followed. Indeed so many people came to Paris in those days, especially before World War I, that it would be all but impossible to investigate all their published writings, not to mention unpublished writings such as their correspondence. Those meriting further research include, for example, Jakov Tugendhol'd, the Russian critic who went to see Picasso at his studio; Vladimir Markov, who while writing his *Iskusstvo Negrov* came to Paris several times; and numerous American artists, such as Max Weber, Morgan Russell, and Elie Nadelman, and all the many others who were drawn to France at the time. Moreover, one could also investigate the writings of the German critics and art historians of the time, as well as the Czechs.

For each account, the reader is given citations of its various published versions, which are here analyzed and compared but without offering a definitive interpretation, since that was not our purpose. The editorial commentaries usually aim only at drawing the reader's attention to the contents of an account, but cannot for the most part confirm the reality of the facts therein. All that can be obtained from these texts are scraps of history (for example, the fact that in 1916 the painting can be seen at rue Schoelcher, while in 1922 it is rolled up at rue La Boétie) or, even more elusive, a sense of the artistic milieu of the time. But whom should one believe? And what? Are we justified in putting more faith in one account than another? Or in what someone says at a given moment over what the same person says at another time? These are serious questions, involving the standards of evidence in art history as a discipline, but the nature of the present Anthology allows its compiler to keep a certain distance from them. When faced with so many accounts, saying too much or not enough, with the vain babblers or the overly discreet, those whose memory fails them or the unrepentant authors of "Memoirs" and "Remembrances," the example of Roland Topor's *Mémoires d'un vieux con* may be instructive:

The dinner at Gertrude Stein's is one of my favorite memories. It was there that I met Picasso. [At the end of the evening], when I was taking my leave, they made me swear I would come back. I did not object. Picasso was keen on accompanying me. He wanted to know everything about me and my past, how I worked, what influences I had absorbed,

as well as a whole lot of other things. The Catalan was armed with a revolver, a gift from Jarry, and in jest he pointed it at the back of my neck. When we arrived at my front door, I asked him to come upstairs for one last drink. He accepted.

I showed him Les Demoiselles d'Orange.... *He seemed crushed. I felt a little pang in my heart when, several days later, I discovered* Les Demoiselles d'Avignon *in his studio. Try as he might to assure me that his painting had nothing to do with Provence and that the title merely referred to a brothel in Barcelona, I wasn't taken in. To be perfectly frank, I had to stay in bed for a fortnight after that.*[11]

1. Mollet 1963, pp. 45,144. Baron Mollet does not mention the *Demoiselles* in this book, but does in an article (Mollet 1947). See the Baron Mollet section, below, p. 244.
2. We know from her correspondence with Gertrude Stein (in The Beinecke Rare Book and Manuscript Library at Yale) that, after a stormy summer, Fernande Olivier separated from Picasso for a while, in mid-September, and moved to rue Caulaincourt—a stone's throw from the Bateau-Lavoir (letters of August 24 and September 2 and 16, 1907; see the entries under those dates in the Chronology). She was therefore at the studio when Picasso was painting the *Demoiselles* (and complains about her life being "outwardly the same as before" in the eyes of those unaware of their dispute).
3. See the Jacob section, below, p. 233.
4. See the Apollinaire section, below, pp. 227–28; see also the Chronology, under February 27, 1907.
5. Cocteau 1923, pp. 28–29.
6. See the entries from late 1921 through 1924 in the Chronology.
7. See Breton 1969, p. 97. The few words mentioning the *Demoiselles* in a notebook of Breton's published in part in 1924 can hardly be considered "testimony." At best those few words recall Breton's active efforts to convince Doucet to acquire the painting; see the entry under December 31, 1923–January 17, 1924, in the Chronology.
8. See the Salmon section, below, p. 245.
9. Compare the accounts in Kahnweiler 1949b and 1961; see the Kahnweiler section, below, pp. 234–35, 239.
10. G. Stein 1961, p. 22.
11. Topor 1975, pp. 54–56.

GUILLAUME APOLLINAIRE

It is difficult to interpret Apollinaire's surprising silence on the *Demoiselles*. How could someone whose friendship with Picasso and career as an art critic made him doubly likely to talk about it, have so little to say on the subject? There are these few words, now well known and overvalued because they are the only ones that might even remotely concern what was happening:

February 27, 1907. Evening, had dinner with Picasso, saw his new painting: even colors, flesh pinks, flowers, etc.... Women's heads, all the same and simple, and men's heads too. A wonderful language that no literature can express because our words are defined beforehand. Alas.[1]

That is all there is, and it has been interpreted as written proof of the discovery, at the studio, in February 1907, of busts of men and women of a different stamp than what came before and which are supposed to be the studies for the different characters of the *Demoi-*

selles. It is not very much. Was it discretion that commanded him to remain silent, when, later in 1907, he quite likely discovered the painting itself in the private domain of the studio? Or was it repudiation? In any case, in 1916 Kahnweiler tells us that it was Apollinaire who had brought Braque to the Bateau-Lavoir, and mentions the latter's dismay at the sight of the painting.[2] Penrose, who probably heard this from Picasso, says that Apollinaire came to see the *Demoiselles* accompanied by Fénéon.[3] And Salmon suggests to what degree Apollinaire is involved in the painting's history, since Salmon counts him among those who originally christened it "Le B… philosophique."[4] Some authors, without naming their sources, claim that during the Bateau-Lavoir period, Apollinaire used the term "revolution" in reference to the *Demoiselles*.[5] And John Golding suggests that a poem Apollinaire wrote November 5, 1907, "Lul de Faltenin," contains a commemoration of the painting.[6]

There is another enigma. Though he was convalescing, of course, from his war wound and subsequent trepanation, Apollinaire not only knew about the Salon d'Antin (since he returned to the Parisian literary and art scenes during the summer of 1916), but was a paid participant in it: on July 21, 1916, he presented the work of a number of poets at the literary matinee held in conjunction with the Salon (the announcement with dates is in the Salon's catalogue). In writing about this event to Soffici on August 27 of the same year, he said:

We organized an exhibition at Poiret's that was much talked about. I gave a lecture to show that there have been no Krauts in our avant-garde arts in France, Italy, and Spain. It is a remarkable fact.[7]

Why does he say nothing about what could be seen at this exhibition, which included the *Demoiselles*, even though he seems to imply that he had a part in its organization?

1. The notebook containing these comments—which is in the manuscripts department of the Bibliothèque Nationale and was not available until after February 1989, when Bernard Poissonnier, who had donated it, lifted the ban on its consultation—was published by Michel Décaudin under the title *Journal intime, 1898–1918* (Apollinaire 1991a); see the Chronology, page 147. The paintings Apollinaire alludes to might be the busts of women (Seckel 69–72) and the studies for the sailor (Seckel 45, 46).
2. Kahnweiler 1916, p. 214. In a 1973 interview (see the Kahnweiler section, below, p. 240), he mentions Apollinaire's incomprehension, and seems to show, in this regard, a slight animosity toward the poet.
3. Penrose 1958, p. 126. On this point it seems difficult to second Katia Samaltanos, who interprets the fact that Apollinaire brought Fénéon to the studio to see the *Demoiselles* as proof of the poet's enthusiasm for the painting (Samaltanos 1984, p. 21).
4. Salmon 1922, p. 16, note 1; see the Salmon section, below, p. 248.
5. Cabanne 1979, p. 241; Warnod 1986, p. 108.
6. Golding 1963, p. 12. My thanks to Judith Cousins for pointing out this text to me. "Lul de Faltenin" was first published in *La Phalange*, no. 17 (November 15, 1907), and reprinted in *Alcools*.
7. Apollinaire, letter to Ardengo Soffici, August 27, 1916; quoted in Adéma 1968, p. 289. See the entry under August 27, 1916, in the Chronology in the present volume.

ADOLPHE BASLER

Basler was a Polish art critic who lived in Paris and knew everyone in Montmartre. He clearly had little liking for Picasso, seeing him as a "pirate" who plundered all the arts, and who, by cleverly blending Cézanne ("the principles of Cézanne's art determined Picasso's success") and African art (made popular by "wags wishing to establish a black archaeology"), created a new art that appealed to a public ready to pounce on the slightest novelty—in this case, meaning Cubism and its dirty trick, the *Demoiselles*:

After practicing his piracy everywhere and squandering his rich booty, one day he fell prey, like so many others, to the lure of African and Oceanic sculpture, brought into fashion by someone, Gauguin, perhaps, or Derain, or Vlaminck. Black beauty very quickly became popular…. Picasso thus took it upon himself to plunder the Black Man, as he had already plundered the Egyptians and Phoenicians, and as he would later plunder the decorators of Pompeii, the Coptic tapestry-makers, and every other art-producing people of the world.

African symbolism revealed to him not so much the magical concept of form as the spicy novelty of a barbaric Cubism…. Primitivism … launched Picasso into a new manner. From that point on, angular heads, faces reduced to a single plane with protuberant bridges on triangular noses, prominent eyebrows, elliptical eyes, cylindrical necks and torsos, and crooked legs in awkward foreshortenings tending toward a crouch under the weight of a brutal geometry, appeared in his painting. Thus did Picasso interpret African art: he substituted dimensions of flat projection for real dimensions and discovered a bizarre beauty with which to thrill those waiting at his door for a new miracle.

Here Basler mentions the Cézannian influence and then concludes:

These are the foundations of Cubism. With them Picasso would kick up his storm and come up with the "philosophical brothel" in painting, a metaphor sprung from the minds of a handful of painters, poets, and fantasists of Montmartre who, in 1907 and 1908, held their discussions at place Ravignan.[1]

1. Basler 1926, pp. 46–47. Even at this late date he calls the painting by its original name, "The Philosophical Brothel."

GEORGES BRAQUE

Those who either witnessed Braque's encounter with the *Demoiselles* or, at least, knew about it at the time all agree that the artist who would collaborate with Picasso in inventing Cubism was far from enthusiastic when he saw the painting for the first time, and even reproving, apparently taken aback by the violence of the work. Various versions of a statement about swallowing tow and kerosene, about burning and destruction, but also about something that "won't go down," run through many accounts, sometimes in direct connection with the *Demoiselles*, sometimes in relation to Cubism in general.[1]

The earliest mention of Braque's statement is from Kahnweiler in 1916. He describes Braque's first visit to the studio, when he no doubt discovered the *Demoiselles,* which Kahnweiler has been talking about in his text: "Braque, who did not know Picasso yet when Guillaume Apollinaire took him to his studio, declared openly that, in his view, painting like that was tantamount to guzzling kerosene."[2] On the subject of Braque and his role in the evolution of Cubism (with no mention here of the *Demoiselles*), Salmon writes in 1920: "Georges Braque never needed to be anyone's disciple"; in a note, he adds: "Moreover, he was undecided about Picasso's Cubist experiments, telling him: 'It's as if you were drinking kerosene and eating flaming tow.'"[3] Carlo Carrà, the Italian Futurist painter, in a 1920 article devoted to Picasso, though not specifically to the *Demoiselles,* says: "It has been written that Picasso's art is a liquor that burns the palate of ordinary people."[4] Braque's statement reappears under the pen of Fernande Olivier, Picasso's companion at the time, but again without reference to the *Demoiselles* and in a rather vague chronological context:

I remember a discussion about cubism which took place in Picasso's studio when, despite all Picasso's arguments, which were put with great reasonableness and clarity on that occasion, Braque refused to be convinced.

"But in spite of your explanations," he answered finally, "you paint as if you wanted to force us to eat rope or drink paraffin."

What made him change his mind after this declaration? How was he so rapidly convinced? How was it that he suddenly came to believe in the future of cubism? I don't know; but some time after this he exhibited a huge canvas of cubist construction at the Independents, which he had apparently painted in secret. He had not spoken about it with anybody, not even Picasso, his source of inspiration.[5]

This episode is recounted again in the published French translation of the lecture Kahnweiler gave in Freiburg in 1947; he mentions that it was in the spring of 1907 that Braque met Picasso:

Through the poet Apollinaire, a friend of Picasso's, he [Braque] met the painter in the spring of 1907. He too was initially disturbed by the great painting: It seemed to him, he said, like drinking kerosene in order to spit fire.[6]

In 1955, Kahnweiler is more concise about Braque's feelings:

When Braque saw the painting, he did not like it.[7]

Two other reactions attributed to Braque could be mentioned here: Maurice Raynal writes in 1952 that Braque was supposedly surprised by the "high-bridged proboscis [*proboscide arquée*] of one of the Demoiselles d'Avignon," and that in response to this, Picasso was supposed to have said: "But that's what a nose is like!"[8] On the other hand, Picasso, in answer to Antonina Vallentin's query about the *Demoiselles* (concerning the necessity that drives the artist to cre-

ate with no regard for the incomprehension of others) told her he "did not know but could not help it"; and Picasso added that Braque, ultimately, when the painting was completed, told him that "it had to be that way." Convinced at last.

1. Rubin (1977, pp. 154, 196, note 25) suspected that Picasso repeated the remark himself and was largely responsible for its dissemination. (Apollinaire who was present, said nothing about it.) The comments attributed to Braque do not put him in a very flattering light, since if accurate they would imply that, as a "reticent Norman," he had to be dragged along in the beginning by his more adventurous colleague.

2. Kahnweiler 1916, p. 214; for longer excerpts, see the Kahnweiler section, below, p. 234.

3. Salmon 1920a, p. 123.

4. Carrà 1920, p. 107.

5. Olivier 1965, pp. 97–98. This episode used to be assigned to the late autumn of 1907, and the "large painting" by Braque (supposedly exhibited at the March 1908 Salon des Indépendants, but not listed in the Salon's catalogue) was considered to be *Large Nude* (usually dated September 1907–June 1908; collection Alex Maguy); see Rubin 1977, pp. 154, 196, 199, notes 25–26, 109. Recently, the episode recounted by Fernande has been redated by some authors—including Daix (1987, p. 91)—to 1908; and the "large painting" by Braque apparently exhibited at the 1908 Indépendants but not listed in the catalogue is now thought to be the multi-figure *Woman* (now lost), supposedly completed in mid-March 1908, shortly before the *vernissage* of the Salon. *Large Nude,* formerly thought to have been exhibited at the Salon, is now known to have remained in Braque's studio during the exhibition (see Cousins 1989, p. 349).

6. Kahnweiler 1949a, p. 16. This passage does not appear in the German version of the text. See below, p. 237.

One wonders at what stage of its development Braque saw the painting, for it to have disturbed him so much: was it before the revision of the two women on the right, or after? (And what precisely does Kahnweiler mean by "spring"?) There is some evidence to support the hypothesis that the two artists met earlier than the time (autumn 1907) traditionally given. In a notebook of Picasso's that can be dated March–April 1907 there are two handwritten notes: "Escribir à Braque" [sic] ("write to Braque") on the last page and "Braque El viernes" ("Braque, Friday") on the inside back cover (reproduced in Seckel 1988, p. 175). There is also, in the Archives Picasso, a postcard from Braque to Picasso the postmark of which, though difficult to decipher, points to a date of August or September 1907 (see the entry under [September] 1907 in the Chronology). Also in the Archives Picasso are two of Braque's calling cards, undated, but possibly left at Picasso's studio during the time of the 1907 Salon des Indépendants (see Cousins 1989, pp. 343–45).

7. Kahnweiler 1955b, p. 111. "… it was as if one drank gasoline so as to be able to spit fire" also appears the same year in Kahnweiler's interview with Georges Bernier published in *L'Oeil* (Bernier 1955, p. 122; English translation of "Du temps que les cubistes étaient jeunes," *L'Oeil* [Paris], no. 1 [January 15, 1955], p. 28) and in the 1961 conversations with Francis Crémieux (see Kahnweiler 1971a, p. 39); Kahnweiler confirmed this statement to Rubin in 1976 (see Rubin 1977, p. 198, note 76).

Patricia Leighten (1989, pp. 80–91) proposed that "'l'étoupe' means not 'rope,' but 'tow' in the sense of 'fuse' or 'wick,' which with gasoline constitutes a Molotov cocktail, an anarchist bomb, affirmed by the common phrase 'mettre le feu aux étoupes' ('to light the fuses')." According to Leighten (who translates *pétrole* as "gasoline"), "This reading of Braque's statement is the only one that makes sense of the combination of these two particular ingredients" (i.e., gasoline and flaming wick).

8. Raynal 1952, p. 13. See above, "The Visit to the Trocadéro," p. 219 and note 7, p. 221.

9. Vallentin 1957, p. 145.

GELETT BURGESS

Cited by Alfred Barr in 1946[1] and analyzed at great length by Edward Fry in 1966,[2] an article by Gelett Burgess, "The Wild Men of Paris," is extraordinary for the discoveries it made at an early date. The article appeared in May 1910 and was based on information obtained firsthand from members of the avant-garde in Paris during 1908, from April through July.[3] In a facetious and deliberately naïve tone (the author, an American humorist, illustrator, and writer is not nearly so uninformed as he would have us believe), Burgess recounts his visits with the "Fauves," the "wild men," at the studios of Matisse, Braque, Derain, and Picasso, among others, relating his impressions, describing the works he sees, and recording his conversations with the painters. Here he is on Picasso at the Bateau-Lavoir:

Picasso is colossal in his audacity. Picasso is the doubly distilled ultimate. His canvases fairly reek with the insolence of youth; they outrage nature, tradition, decency. They are abominable. You ask him if he uses models, and he turns to you a dancing eye. "Where would I get them?" grins Picasso, as he winks at his ultramarine ogresses.

The terrible pictures loom through the chaos. Monstrous, monolithic women, creatures like Alaskan totem poles, hacked out of solid, brutal colors, frightful, appalling! How little Picasso, with his sense of humor, with his youth and deviltry, seems to glory in his crimes! How he lights up like a torch when he speaks of his work!

I doubt if Picasso ever finishes his paintings. The nightmares are too barbaric to last; to carry out such profanities would be impossible. So we gaze at his pyramidal women, his sub-African caricatures, figures with eyes askew, with contorted legs and—things unmentionably worse, and patch together whatever idea we may....[4]

It is not certain whether this description refers to the *Demoiselles*,[5] although "ultramarine" might allude to the painting's curtain, while the technique mentioned by Burgess (with figures "hacked out of solid, brutal colors") might correspond to that of the two demoiselles on the right. The chromatic violence of these two figures is also comparable to that of the Alaskan totem poles he mentions.

Two aspects of Burgess's remarks are rather troubling: the allusion he makes to primitive art (totem poles, the element of caricature in African art) and the question he raises as to the completion of the paintings (a question that, as we know, has long exercised critics concerning the *Demoiselles*), which to him seems an unlikely thing, since it really is not possible for the painter to transpose his nightmares onto the canvas.[6]

Of equal or perhaps even greater importance than the text itself are the illustrations it presents: indeed, Burgess's article includes the very first photographic reproduction of *Les Demoiselles d'Avignon*, generically captioned "Study by Picasso" (his illustration is reproduced in the present volume, fig. 244, p. 137). Does this again imply the idea of incompletion?[7] Or does it merely mean the *Demoiselles* had not yet been named? Other photographs accompanying the article are also important: one shows Picasso in his studio with two New

Caledonian wood sculptures behind him, and gives an indication of his collection of primitive objects in the spring of 1908;[8] another (reproduced in the Chronology, fig. 5, p. 159) shows Derain at home,[9] and, on the wall, a reproduction of one of Cézanne's Bather paintings,[10] works that are often cited in connection with the *Demoiselles*, with that photograph as justification.

The information in the article and especially the photographs illustrating it—taken in all likelihood by Burgess himself[11]—gain further interest when the dates of his stay in Paris are fixed more accurately. Fry originally suggested situating the visit in the fall of 1908 or perhaps in the winter that followed, and definitely before the fall of 1909, at which time Picasso left the Bateau-Lavoir.[12] Daix supports Fry's suggestion.[13] New information makes it possible to date his visit precisely to April–July 1908.[14]

Picasso seems to have been pleased with the publication of Burgess's article, since during the summer of 1910 he wrote to Leo Stein, who was in Italy at the time, to recommend that he read it, telling him also that it will give him a good laugh. Fernande Olivier, for her part, wrote about it to Gertrude Stein on June 17, 1910, recalling the visit of the "petit Américain" two years earlier.[15]

1. Barr 1946, in a note on p. 257. Surprisingly, however, the article is not listed in the book's remarkable bibliography.

2. Fry 1966b.

3. See the entries under March 31 through July 28, 1908, in the Chronology.

4. Burgess 1910, pp. 408.

5. Daix (1987a, pp. 407–08, note 16) thinks that Burgess is actually describing *Three Women*. Since both this work and the *Demoiselles* are reproduced in the article, and since the description in the text is not specific, doubts will inevitably remain. The idea that Picasso works without a model is confirmed by a statement the painter made to Daix (1970, p. 267): "I hadn't been using a model since Gósol. And precisely during that period [1907] I was working entirely without any model at all." From this Daix in 1970 concluded that there was no model at this time either. Later, Daix changed his mind significantly and admitted the existence of African "models."

6. Did Burgess sense that the *Demoiselles*—if that is indeed the work in question here—is a "painting of exorcism," as Picasso would later say to Malraux? See above, "The Visit to the Trocadéro," p. 219.

7. That is the view of Martensen-Larsen (1985, p. 262). Moreover, she compares the photograph published by Burgess with a recent plate and, from the numerous differences she claims to find between the two, draws the conclusion that the painting reproduced by Burgess does not represent the final state. (See the discussion in Rubin, "The Genesis of *Les Demoiselles d'Avignon*," in the present volume, p. 94 and note 224, pp. 136–38.)

8. Burgess 1910, p. 407. See also Cousins 1989, p. 353. Rubin (1983, p. 639) has published a slightly different photograph taken at the same time but showing more of the surrounding studio (also reproduced in Seckel 1988, p. 541, illus. 63).

9. Burgess 1910, p. 414.

10. Venturi 542; reproduced in the present volume, fig. 9, p. 29.

11. See the entries under July 12 and 28, 1908, in the Chronology.

12. Fry 1966b, p. 70, note 8.

13. Daix 1987a, p. 407, note 16.

14. See note 3, above.

15. Picasso, postcard to Leo Stein, June 19, 1910; Fernande Olivier, letter to Gertrude Stein, June 17, 1910. Yale Collection of American Literature, The Beinecke Rare Book and Manuscript Library, Yale University, New Haven, Connecticut. Both are printed, in part, under their respective dates, in the Chronology.

does not mention here as being in direct relation with the *Demoiselles*, even though, by virtue of the heading of the section where it is discussed, it is situated at the origin of Cubism.[3] The *Demoiselles* and related works (which, we learn, are numerous) are, Kahnweiler concludes, "not entirely successful." This notion of their "lack of success" will be developed in Kahnweiler's later texts, in conjunction with the idea of incompletion, which is not yet formulated here.

What follows next is a short text—the first anecdotal piece, the previous one being purely critical—that appeared in February 1920 in *Die Freude*, a magazine published by Wilhelm Uhde, signed "Daniel Henry." Titled "Werkstätten," it describes Matisse's studio at the former Couvent des Oiseaux on rue de Sèvres in 1905; the studio of the "chap Derain" (*gars Derain*) at rue Bonaparte in 1913; Braque's studio on rue Caulaincourt in 1914; and Picasso's studio on rue Ravignan in 1907. After describing the ramshackle wooden lodgings at the Bateau-Lavoir, the notes covering the door on which he knocks, and Picasso, who answers the door dressed only "in a shirt," he goes on to describe the studio itself:

The small shed was illuminated by a window and a skylight. Shreds of old wallpaper were sticking to the walls. In front of the iron stove a mountain of lava, a pile of ashes, higher than the stove itself. Pictures, pictures, countless pictures, stretched, rolled up, were lying around in the dust. Negro sculptures in between, in somber nobility. And that mighty painting, never completed, that is the origin of Cubism.[4]

To be noted here: the primitive objects in the studio as early as 1907,[5] and the unnamed *Demoiselles*, which Kahnweiler explicitly deems unfinished and equally explicitly places at the origin of Cubism.

Der Weg zum Kubismus came out in 1920, being a revised and corrected edition of the 1916 text. A work of aesthetics, it is the "document of an age" whose "theoretical investigations bear witness to very recent, new conversations with the painters" (as Kahnweiler tells us in the preface to the new German edition of 1958):

Toward the end of 1906, the soft, round contours in Picasso's paintings are now giving way to hard, angular shapes. Instead of the delicate pink, light yellow and light green, a leaden white, grey and black is descending onto weighty figures.

In early 1907, Picasso starts work on a strange large painting with women, fruit and curtains which was never finished. It can be called unfinished, although it contains a long period of work, because it was started in the spirit of the works of 1906, contains in part the trends of 1907, and thus has not developed into a unified whole.

Rigid like jointed dolls, nudes are standing with big, tranquil eyes. The inflexible bodies modelled with strict roundness. Flesh, white and black are their colors. This is 1906.

In the foreground, however, inconsistent in style with the rest, a figure is crouching, a bowl of fruit is standing. The forms are not modelled in the round with chiaroscuro, but angularly drawn. The colors are a

luscious blue, shrieking yellow, in addition to pure black and white. The beginning of Cubism! The first endeavor. A desperate, high-flying wrestling with all problems at once.

With what problems? With the primary problems of painting: the presentation of three-dimensionality and color on a flat surface and their integration into the unity of this surface. And yet, "presentation" and "integration" in the strictest and highest meaning of the words. Not an illusion achieved by means of chiaroscuro, but a presentation of the three-dimensional element by drawing it on the plane surface. Not an appealing "composition," but a strict, structured order. Then there is the problem of color, and finally, as the most difficult point, the amalgamation, the reconciliation of the whole.

Boldly Picasso attacks all problems at once. He now places hard-edged shapes on the canvas, primarily heads and nudes, in the most vivid colors, yellow, red, blue, black. The colors are applied in a thread-like manner, in order to serve as direction indicators and—in unison with the drawing—to create the plastic effect. After months of the most strenuous searching, Picasso realizes that this is not the way to find a perfect solution to this problem.[6]

Two important points are more firmly asserted here than in the earlier texts: the incompleteness of the painting as seen in the stylistic incoherence it presents (evident in the comparison between the figures related to the 1906 style and the one that inaugurates the 1907 style—the crouching demoiselle);[7] and the role of the painting as the beginning of Cubism. The *Demoiselles*, however, is still not named.[8]

On December 2, 1933, Kahnweiler interviews Picasso on the subject of the *Demoiselles*. This is the famous interview (not published until 1952) in which Picasso discusses the question of the title, the subject of the painting, and the chronology of its execution. The painter's revelations and Kahnweiler own testimony reinforce each other. Picasso tells Kahnweiler that he began work on the painting in the spring of 1907 and that there were two periods of work. To this Kahnweiler adds:

I saw the painting in its current state *at rue Ravignan, therefore after the second period of work, rather early in the summer of 1907. Since Picasso speaks of the spring [earlier in the interview], he is remembering something precise and could not be mistaken. The second period of work must have therefore occurred rather soon after the first. This second period, which effectively marks the* birth of Cubism, *should therefore be situated in April or May of 1907.[9]*

All the wording is important here, for its peremptory precision, almost like a deposition on the witness stand (even when only dealing with suppositions, to which Kahnweiler is nonetheless reduced, since Picasso did not give him, or anyone else, information that dispels all doubt). He puts two phrases in italics, for emphasis: "in *its current state*" (which means that, whether the painting is finished or not—a question not broached here—no further work was done on it after the beginning of the summer of 1907; and "the *birth of*

Cubism," associated by Kahnweiler in 1920 with one of the two figures on the right, which gave birth to a new order. The chronology is precisely stated (compared to his previous texts): the painting was begun in the spring of 1907, resumed after a very brief period of time, and in any case brought to its current, definitive state rather early in the summer of 1907. Kahnweiler bases this chronology on the statements Picasso has made to him, which he would not dream of doubting: "Picasso … could not be mistaken." Kahnweiler demonstrates this by punctuating his account with three imperious "therefores" (*donc*) that permit no dissent.[10]

On December 7, 1939, Kahnweiler writes in English to Alfred Barr to thank him and congratulate him for the catalogue of the exhibition "Picasso: Forty Years of His Art"; in it the *Demoiselles* is given a place of honor, having just entered the Museum's collection. On this occasion, Kahnweiler makes a clarification about the painting:

Picasso has not [yet] been at Avignon in 1907. He was too poor and too worried by his art to leave Paris. "The Demoiselles d'Avignon," no doubt, gave you this idea. Let me tell the history of this name, as the Museum has got the picture.

When Picasso painted it, his idea was what you call a scene of carnal pleasure. Max Jacob—who's [sic] maternal family draws its origin from Avignon—had told Picasso that a certain brothel at Avignon was a most splendid place, with women, curtains, flowers, fruits. So Picasso and his friends spoke about the picture as being this "place of carnal pleasure."

Nevertheless the name was given much later, in fact after the war [of] 1914–1918 only, I believe, perhaps by someone like Aragon who was Doucet's friend and adviser. As you are well aware, very few of Picasso's titles are given by himself. This one is very good, in spite of its not very serious origin.[11]

Long passages of the chapter on the "birth of Cubism" in Kahnweiler's monograph on Juan Gris, first published in 1946, are devoted to the *Demoiselles*. He comes back to the painting in more explicit fashion when discussing the connection—essential to him—between the *two* demoiselles on the right and Cubism:

When, during the winter of 1906–07, Picasso painted the large canvas later known as Les Demoiselles d'Avignon, *he seems no longer to have been unconscious of the problem which so deeply preoccupied all those around him. For in this picture he tackled the problem of color as well as that of form. The three female figures on the left of the picture are still in the manner of the Pink Period, and are painted in pinkish camaïeu. But they are no longer coloured drawings and their appearance is not classical. The forms are firmly modelled and the bodies, as the first bewildered spectators said, are "hewn with hatchet-strokes." On the other hand the two female figures on the right, the one standing and the other crouching, show that he was engaged in far more daring experiments. They are painted in violent colors, not applied in broad areas but laid on in parallel strokes, so that the form is not created (as on the left) by*

chiaroscuro but by drawing, by the direction of the brushstrokes. The foundations of Cubism were laid in this right-hand section of Les Demoiselles d'Avignon.

I have said that Cubism was born on the right half of Les Demoiselles d'Avignon, *and in so doing I have indicated another of this movement's primary objectives. I mean the attempt to avoid the imitation of light. Light was mistrusted. Had not the Impressionists fallen under its spell? By disregarding it, the Cubists hoped also to dispel from their representation of objects most of what was accidental. For, was not the constantly changing appearance of the outer world caused by variations of light?*

Admittedly this first attack miscarried, and after attempting, in the right half of Les Demoiselles d'Avignon, *to solve the problem of representing forms by means other than chiaroscuro, Picasso was for a while forced to revert to using effects of light to emphasize them.*[12]

This is followed by an explicit discussion of the influence of African art on the *Demoiselles*, an influence which he denies:

The years 1907–09 have been called Picasso's "Negro Period." This name is regrettable because it suggests an imitation of African sculpture, whereas in reality there was merely an affinity between the aims of negro sculpture and those of Picasso and Braque at one stage of their personal evolution. The artists certainly collected negro sculpture, but only later. As with the Italian artists of the Quattrocento and Greco-Roman sculpture, the Impressionists and Japanese prints, creation came first, and it was only subsequently that ancestors and collaterals were discovered.

Somewhat later still, the aesthetic and technique of these forebears were investigated. There is no doubt that their study of African and Pacific sculpture was invaluable for the Cubist painters, but the results of it only appeared years later. Gris's reply to a questionnaire about Negro Art in 1920 shows that he understood its aesthetic and was aware of a close relationship with his own. As for technique I shall quote only one example, to which I have already referred in Der Weg zum Kubismus. *In Picasso's sculptures of 1913 the hole of the guitar is represented by a cylinder or cone in relief; this was unquestionably inspired by the eyes in certain Ivory Coast masks. So it is obvious that the real influence only showed itself long after what is wrongly called the "Negro Period." What in fact inspired this name was merely the crude simplification of forms and color of Picasso's figures at that time. People thought they were looking at negroes.*[13]

In a note relating to this passage, he denounces the naïve myth that some people had created about the discovery of African art, and shows that if there is any later affinity between African art and Cubism, it is one of spirit and not outward appearance:

Confusing art history with legend, ingenuous journalists have given credence to Vlaminck's story of how he was the first to purchase an African object. And so the tale of this painter's "discovery" of Negro Art, and of how he imparted it to his friends, who were amazed, has spread.

There had always been curio-mongers who bought the ornaments,

Picasso's formal borrowings from African statuary. Kahnweiler, according to Bois, described a specific method of borrowing in which Picasso, at first with *Les Demoiselles d'Avignon*, and throughout the following years, employed certain formal characteristics taken from African objects, "within the kind of morphological relation initiated by Gauguin." But it was the artist's discovery of the Grebo mask in August 1912 that initiated his "true" discovery of African art. "This is what Kahnweiler meant when he affirmed that the *true* influence of African art in Picasso's work did not occur during the 'Negro' period, but began in 1912, after his [discovery of Grebo art].... From Grebo art, Picasso received simultaneously the principle of semiological arbitrariness and the nonsubstantial character of the sign" (Bois 1990, pp. 72–74; see also pp. 68–69, 79–80, 288, note 59).

2. Kahnweiler 1916, pp. 212–14. Translated by Ingeborg von Zitzewitz. Kahnweiler, writing in Bern, does not know that the painting has just been shown, during the summer of 1916, at the Salon d'Antin, under its definitive title. By the time he could have found this out, his article would no doubt have already been completed. In the albums of press clippings that Kahnweiler kept (now at the Galerie Louise Leiris Archives) we found no articles on the Salon d'Antin. Although at the time his friends were sending him information about what was happening in Paris, it is quite likely that in the midst of war, some things were lost.

3. Rubin has pointed out (see, in particular, 1983, p. 644, Appendix V) that, in the 1916 text, Kahnweiler does not quite say that the *Demoiselles* is the beginning of Cubism. True enough. Nevertheless, the very heading of the section, "Die Anfänge des Kubismus" ("The Beginnings of Cubism") is clear, and obviously situates the *Demoiselles* at the beginning of the movement, an assertion that Kahnweiler would later make more categorically. Rubin, who rejects the idea that the *Demoiselles* is the first formulation of Cubism, has consistently pointed to Kahnweiler's responsibility for this conception and has demonstrated the concatenation of ideas through which the notion commanded attention in the first place: a perceived interdependence between the painting's stylistic inconsistency and its supposed unfinishedness made the two qualities seem the constituent elements of an anti-classicism that invested the *Demoiselles* with the revolutionary virtues of the new movement, Cubism (ibid., pp. 647–48).

4. Kahnweiler 1920a, p. 154. Translated by Ingeborg von Zitzewitz. Partially translated in French in Monod-Fontaine 1984b, p. 97. Orde Levinson tells me that quite probably these were old notes, written at the time of the visit, and published here.

5. This is of some importance, considering the long debate among art historians on the question of the relationship between African art and the *Demoiselles*.

6. Kahnweiler 1920b, pp. 17–19. Translated by Ingeborg von Zitzewitz. As Yve-Alain Bois observes, Kahnweiler, in *Der Weg zum Kubismus* "was able to give Cubism its first theoretical account of some interest, one that in many respects remains unequaled today" (Bois 1990, p. 67). Further along, Bois indicates that "The first seeds of this text on Cubism date from 1915, when Kahnweiler wrote the manuscript of *Der Gegenstand der Ästhetik*, not published until 1971 (Kahnweiler 1971b), and which bears the trace of his theoretical 'apprenticeship' at Bern. The three last chapters of the book are dedicated to Cubism and include a good section of what became *The Rise of Cubism*" (Bois 1990, p. 280, note 3; Orde Levinson is here acknowledged for having acquainted Bois with this text).

7. Of the figure on the right, Kahnweiler does not say that she has been redone, but only implies that she was done last. There is no mention here of an earlier state of the painting as a whole. One should note that in 1920 Kahnweiler discusses only the crouching figure in its difference from the other figures.

8. Did Kahnweiler know anything about the Salon d'Antin, where the *Demoiselles* is presented with its definitive title? He did not return to Paris until February 1920. See note 2, above.

9. Kahnweiler 1952, p. 24. The complete text of this interview appears above, in "A Painting's Identity," pp. 222–23. See William Rubin's essay in the present volume, p. 17, and note 30, p. 122, which raises doubts concerning the accuracy of the 1933 date assigned by Kahnweiler to this interview with Picasso.

10. Martensen-Larsen (1985) calls this "canonical" text into question.

11. Alfred H. Barr, Jr. Papers, Archives of The Museum of Modern Art, New York. My thanks to William Rubin and Judith Cousins for passing this letter along to me.

The information Kahnweiler gives here concerning the title appears in the caption accompanying a reproduction of the painting in a third edition of the catalogue (Barr 1939b), published March 1940, p. 61: "Mr. Kahnweiler states that the title was not given to the painting until some time after the war of 1914–1918, possibly by Louis Aragon who at that time was advising the collector Jacques Doucet, who bought the painting from Picasso." Compare this with Kahnweiler's interview with Picasso in 1933, where, on the subject of Avignon, there is mention of Barcelona, which Kahnweiler seems to have forgotten (see "A Painting's Identity," above, pp. 222–23). As concerns Aragon, Roché, too, in 1946, says to Barr that possibly it was Aragon who advised Jacques Doucet (see the Chronology, under "Before 1924").

12. Kahnweiler 1969, pp. 108, 110.

13. Ibid., p. 113. One may recall that, all the same, in 1920, in *Der Weg zum Kubismus*, Kahnweiler wrote: "Thus Picasso painted figures [in 1908] resembling Congo sculptures" (Kahnweiler 1949b, p. 8). The idea put forth by Kahnweiler, that one creates first and finds one's 'forbears' later, was formulated by Carl Einstein in 1915 in his famous work *Negerplastik*: "Certain problems arising for the 'new' art have resulted in a less thoughtless approach than before toward the art of the African peoples. Here too, as always, a current historical process has created its own history: and at its center African art has emerged." Yve-Alain Bois (1990, p. 75) refers to "Carl Einstein's famous text *Negerplastik*, published in 1915, which Kahnweiler read during his stay in Bern and cited in 'Negro Art and Cubism' [1948b, p. 413, note 1]." (My thanks to Yve-Alain Bois for additional evidence—based on the Carl Einstein/D.-H. Kahnweiler *Correspondance*, published in 1993—in corroboration of Kahnweiler's having read the 1915 edition of *Negerplastik* in Bern.) Maurice Raynal (1922, p. 64) goes a few steps in the same direction when he speaks of the "way African art confirmed the inclinations of Picasso's sensibility." Reverdy, as we have seen, is as categorical as Kahnweiler and thinks that the role African art supposedly played in the origins of Cubism has been exaggerated. See note 5, p. 218.

14. Kahnweiler 1969, note 107, pp. 210–11. The story of Vlaminck's "discovery" of African art in a bistro at Argenteuil or Bougival, and/or his "discovery" of a Fang mask that he sold to Derain (Seckel 1988, p. 12, cat. 9) is told, with variants from one text to the next, by Francis Carco (1927, p. 36); by Vlaminck himself (1929, pp. 88–89; 1931, pp. 129–30; and 1943, pp. 105–07); and by Roland Dorgelès (1947, p. 137).

15. Kahnweiler 1949a, pp. 14–16. The last paragraph, devoted to Braque, did not appear in the German edition of 1948.

16. See Rubin 1983, p. 648.

17. Kahnweiler 1948, pp. 412–13.

18. Kahnweiler 1953b.

19. Kahnweiler 1955a, p. 28. The same text was published, in translation, in Bernier 1955, p. 122.

20. Kahnweiler 1955b, p. 111. If we compare this text to the others, it becomes clear that at the beginning of this text, there is a mistranslation; he is in fact talking about Fernande Olivier and the dog Fricka, and not about paintings.

21. Vallentin 1957, p. 151.

22. This text was published in French, accompanied by a translation of the preface to the new German edition of 1958, in the collection *Confessions esthétiques* (Kahnweiler 1963), pp. 9–60; for the text of concern here, see pp. 22–23.

23. Kahnweiler, quoted in Dor de la Souchère 1960, p. 16.

24. Kahnweiler 1971a, pp. 38–39; on p. 56, Kahnweiler once again says, "When I say the cubists, of course you must understand always that it was Picasso who began, with his *Demoiselles d'Avignon*. As I have already said, the right half of *Les Demoiselles d'Avignon* is an absolutely heroic first attempt to solve all these problems at once, for the cubists wanted to give not only the exact form of objects, but also their exact color."

25. Kahnweiler 1961, pp. 33–34. In a program of Paule Chavasse devoted to "Picasso and *Les Demoiselles d'Avignon*," broadcast on the France III channel of the R.T.F. on November 14, 1961 (third in the series *Le Cubisme et son temps*), Kahnweiler again mentions, on the subject of the *Demoiselles*, the reactions of Picasso's entourage (Uhde, Braque, Derain, Vollard), his own reaction ("at first dumbfounded, later dazzled"), the break in style, the question of unfinishedness, and the fact that Picasso did not want to sell the painting. My thanks to Pierre Assouline for bringing this program to my attention.

26. Kahnweiler, quoted in Brassaï 1966, p. 268. See also this Brassaï text as cited in the Chronology under "The *Demoiselles* in Jacques Doucet's Home, 1924–37". My thanks to Marie-Laure Bernadac for bringing this text to my attention.

27. Brassaï 1982, pp. 206, 208.

28. "Conversations avec Daniel-Henry Kahnweiler" (1973), unpublished tape-recorded interview with Claude de Givray (a document of the Société Française de Production). My thanks to Orde Levinson for obtaining a typewritten transcription of this passage of the interview.

29. Kahnweiler revised the English text. My heartfelt thanks to Orde Levinson for obtaining this interview for me, and more generally, for his generous assistance to my research, allowing me to benefit from his prodigious bibliographical knowledge and his familiarity with the writings of Kahnweiler. Levinson, frequently cited by Bois (1990, pp. 65–97), is described as "preparing an anthology of Kahnweiler's writings in English."

30. Daix 1970, p. 256; Daix at the time used Kahnweiler's statements to show that "there is no 'African art' in *Les Demoiselles d'Avignon*."

VINCENC KRAMÁŘ

Kramář, a Czech art historian who in 1919 was named director of the Museum of Paintings of the Society of Patriotic Friends of Art (now the National Gallery, Prague), went to Paris several times between 1911 and 1913, sojourns during which he gathered a remarkable collection of paintings (later bequeathed to the National Gallery), including some by Picasso. He bought from Sagot, from Vollard, and from Kahnweiler, forming a friendship with the latter, whose 1916 and 1920 writings on Cubism were not unrelated to Kramář's own work, *Kubismus*, begun before the war and published in 1921:

By the end of the year 1906, the fine harmonious contours of these beautiful nudes gave way to hard, angular forms, and instead of exquisitely soft rose, yellow, and green tones, the black, broken lines are filled with gray, robust white, and dry flesh-color. However, the true transformation does not appear until the spring of 1907. At that time, a large, curious painting was created, one of the most interesting of Picasso's oeuvre, even though it was never finished. It portrays female nudes painted in the style of late 1906; that is, angular forms modeled by chiaroscuro, and next to them we see another figure and a bowl of fruit painted in pure colors of blue, yellow, red, and white—according to the author [Kahnweiler], that represents the true beginnings of Cubism. There is no trace of an attempt to deceive, to create an illusion of form by means of chiaroscuro; instead, the perspective is rendered by lines on the flat surface of the picture plane. Also, eye-pleasing composition, as understood until now, is missing here, replaced by the rigorous structuring of the painting.

Kramář then comes to the 1908 works:

Thus, works of immense simplicity were created, granting monumentality to the most ordinary objects or figures, which in their primitive style were reminiscent of small African figures. (And incidentally, this internal connection awakened Picasso's interest in, and later deeper understanding of, the artistic value of these wood sculptures from overseas—which were until now erroneously, under the influence of a materialistic approach to art, considered as having an essential influence on Picasso's style of 1908. Nevertheless, it is not entirely inconceivable that

Picasso later embraced some of the traits of these artifacts.

Here there is a note at the bottom of the page:

Among the first buyers of African statuettes, Matisse and Picasso should be mentioned. They bought them at a shop, Au Vieu Rouet, on rue de Rennes. Later, their main source was an antique dealer and sculptor, Brummer, located on boulevard Raspail.[1]

The similarity is striking between this text and Kahnweiler's articles, to which Kramář makes explicit reference.[2] Kramář points out in the painting—which, like Kahnweiler, he does not name—the break in style effected by the crouching woman (and only her, as in Kahnweiler's 1916 text and in the original 1920 edition of *Der Weg zum Kubismus*), and also mentions that the painting was left unfinished in the spring of 1907 (as Kahnweiler wrote in 1920). Concerning African art and its alleged influence on Picasso's work in 1908, Kramář suggests a sort of inner resemblance between the two (which Kahnweiler called a "convergence"), Picasso's experimentation having preceded his grasp of primitive art.

1. Kramář 1921, pp. 11–13. My thanks to Jana Claverie for reading this book for me and finding these passages, and to Suzanna Halsey for translating them from the Czech. The similarity between this text and Kahnweiler's 1916 and 1920 texts was intentional. Jiří Kotalik, in a June 30, 1987, letter, points out that in the introduction to *Kubismus*, Kramář makes reference to Kahnweiler and that the passage discussing the *Demoiselles* is in fact a paraphrase of Kahnweiler, not an appreciation born of Kramář's own experience.

 Kotalik and Dr. Kramář's son-in-law, J. Brunclik, have specified for me the dates of Kramář's sojourns in Paris during which he met Picasso either at the studio or at Kahnweiler's: April 24–May 31, 1911; November 25–December 9, 1911; April 25–May 5, 1912 (on April 30 Kramář sees Picasso at the Bateau-Lavoir; on May 3, at the Bateau-Lavoir and on boulevard de Clichy); and May 7–June 25, 1913. Kramář resumed his trips to Paris after the war. A 1922 letter from Kramář to Picasso mentions their prewar encounters (see the entry under January 29, 1922, in the Chronology). It is not unreasonable to think that he saw the *Demoiselles*, even though the description he gives here shows no sign of personal appreciation. My thanks to Jiří Kotalik and J. Brunclik for the information they so kindly provided.

2. Although he is mentioned in the introduction, Kahnweiler's name does not appear in the passage quoted here. But since he is indeed the "author" who is cited as believing that the *Demoiselles* is the origin of Cubism, his name has been added in editorial brackets. Here again I am indebted to Jiří Kotalik for clarifying this matter.

ANDRÉ LEVEL

Fascinated by *Family of Saltimbanques*—which in 1908 (perhaps his first visit with Picasso) he bought for the society of art lovers he had founded, called La Peau de l'Ours ("The Bearskin")—Level says very little about the *Demoiselles* in his 1928 book, *Picasso*, even though in all likelihood he saw the latter painting in Picasso's studio. He places the work at the beginnings of Cubism and points out that it entailed numerous studies:

As with the period of the Saltimbanques, *the period of Picasso's Cubist*

beginnings, in its goal of re-creating the human figure based on new rhythms, leads, after numerous studies, in color or simply in black, to a large painting that, like the Saltimbanques, *has remained famous: the* Demoiselles d'Avignon.[1]

This comes immediately after a discussion of the relationship between Cubism and African art (an art Level admired greatly, having allegedly discovered it at Matisse's house in 1904);[2] in that discussion, Level rejects the notion of imitation, even while recognizing that primitive art opened up a whole new field of investigation:

About his first attempts, which later were given the label of Cubist, to recreate human figures according to new rhythms, it was said they showed the influence of African or Oceanic sculpture. At no time during his long Cubist phase, which in no way is over, can one find the trace of an imitation of those ritual figures now duly classified according to their provenances, if not always according to their historical periods. For Picasso, that art merely evoked the breadth of creative freedom the African sculptors had enjoyed in its realization, which no other ethnic art had ever surpassed or even equaled.... It was an invitation to a greater freedom of reconstruction—not to a transposition, into the domain of painting, of the sculptural types imagined by the Africans.[3]

1. Level 1928, pp. 31–32.
2. Level (1959, p. 59) gives ambiguous information at this point: a probable misprint in the text makes it unclear whether this discovery took place in 1904 or in 1914. Statements he made to Robert Goldwater, however, on June 4, 1934 (see Goldwater 1938, p. 85, note 3), confirm the earlier date, which Rubin (1984, p. 336, note 83) points out has been questioned. It should be noted that Matisse did not own any African sculpture until the autumn of 1906 (see Elderfield 1992, p. 135).
3. Level 1928, pp. 30–31.

MANOLO

To the sculptor Manuel Hugué, known by the diminutive Manolo (his professional name), have been attributed statements he supposedly made "in front of the *Demoiselles* or some similar painting,"[1] according to Daix. Kahnweiler refers to it:

There is a famous remark by him, which he really made to Picasso in front of one of his paintings: "What would you do if your parents met you at the station in Barcelona looking like that?"[2]

Dorgelès's picturesque version of the statement purports that, whereas most of the Cubists had ignored portrait painting, Picasso:

... feeling strong, had immediately launched into figures and compositions. The first time he asked Manolo for his opinion, the sculptor replied gravely: "Look, Pablo, if you went to meet some relatives at the train station and they arrived with faces like that, you wouldn't be very happy...."[3]

Dorgelès approves:

Some, no doubt, will find this argument childish, but I have never heard anything about Cubism that better expresses my own feelings.[4]

Kahnweiler is upset but resigned:

This is childish; there is this common confusion between the sign and the thing signified.[5]

Caused, no doubt, by the sideways noses.[6]

1. Daix 1977, p. 98, note 7.
2. Kahnweiler 1972, p. 48.
3. Dorgelès 1947, p. 230.
4. Ibid., pp. 230–31.
5. Kahnweiler 1971a, p. 48.
6. On sideways noses, see above, "The Visit to the Trocadéro," p. 219, and note 7, p. 221. See also the Braque section, above, p. 229.

HENRI MAHAUT

A friend of Salmon, Apollinaire, and Max Jacob, Mahaut met Picasso at the Bateau-Lavoir when the painter was still in his Blue Period. He witnesses the birth of the *Saltimbanques*, and the discovery of primitive art:

Picasso came upon African or Polynesian sculptures. Previously they had been considered only objects of curiosity. Our young artist saw them in a different light. They troubled him; they moved him aesthetically as admirably spontaneous representations— synthetic and free—of primitive, profound, essential sentiments.[1]

Mahaut may also have seen the *Demoiselles* at the studio, in 1907:

Picasso is once again back at work. His studio becomes a kind of laboratory in which, bravely, patiently, he conducts his research, constructing, creating beings that at first, while still identifiable, look like monsters.[2]

1. Mahaut 1930, pp. 9–10.
2. Ibid., p. 10.

HENRI MATISSE

Fernande Olivier, who is often imprecise, does not mention the *Demoiselles* when she relates Matisse's reaction to Picasso's Cubist works. Nonetheless, many writers, when repeating her account, have not hesitated to connect it specifically with the large painting, although the dispute between the two artists centered in a more general way on Cubism:

Picasso and Matisse, who were quite friendly with one another, clashed over the birth of cubism; a subject which managed to startle Matisse out of his normal calm. He lost his temper and talked of getting even with Picasso, of making him beg for mercy.[1]

Picasso in a way confirmed this episode, except that, instead of getting angry, Matisse makes jokes. Hélène Parmelin relates:

"How were you with other painters, when you were young?" Pignon asked one day. "Horrible," said Picasso; "and they were horrible too. Didn't Matisse make jokes with Fénéon in front of the Demoiselles d'Avignon?"[2]

No doubt neither was very delicate with the other. Roland Penrose recounts (incorrectly associating the anecdote with the *Demoiselles*, when it actually has to do with *Woman with a Fan* [1909]):

Among the surprised visitors trying to understand what had happened he could hear Leo Stein and Matisse discussing it together. The only explanation they could find amid their guffaws was that he was trying to create a fourth dimension. In reality, Matisse was angry. His immediate reaction was that the picture was an outrage, an attempt to ridicule the modern movement. He vowed he would find some means to "sink" Picasso and make him sorry for his audacious hoax.[3]

1. Olivier 1965, p. 88. Here, as with the statements of Braque related by Olivier, Daix suggests situating the scene in 1908; see Daix 1987. pp. 91 ff.
2. Parmelin 1980, p. 69.
3. Penrose 1973, p. 130. Compare the first part of this account with a letter from Picasso to Kahnweiler, dated June 12, 1912: "You tell me that you like very much the Shchukin-style painting [*Woman with a Fan*, Daix 263]; I remember when I was working on it, one day Matisse and [Leo] Stein came by and joked openly in front of me. Stein said to me (I was saying something, trying to explain it to him): 'But it's the fourth dimension,' and he started to laugh. That's for history and to tell to Kramář." (published in Monod-Fontaine 1984a, p. 168). The latter part of Penrose's account is similar to Olivier's.

BARON MOLLET

Baron Jean Mollet, who was Apollinaire's secretary, was never a baron, nor a secretary, for that matter. Apollinaire alone, by a decree of his poetic fancy, conferred on him the first of these two distinctions.

So writes Raymond Queneau in his preface to the *Mémoires du baron Mollet*.[1] Jean Mollet, who arrived in Paris from his native province at the beginning of the century, quickly got to know everyone. He frequented the Bateau-Lavoir in 1907 and probably witnessed the birth of the *Demoiselles*, which he discusses not in his *Mémoires*, but in a piece published in *Les Lettres françaises* in 1947:

Picasso was at the end of his Blue Period, and Braque, coming to a close in his study of Impressionism, was beginning to feel the influence of Cézanne and was already talking about construction. Everyone began to work in that direction: it was the Cézannian period. One day, one of them brought an African statuette. (I don't know which of them; each of them takes credit for it. All I can say is that the statuette was there and was to prompt the discovery of a new mode of expression.) This little piece of sculpted wood unveiled a whole new world of possibilities.... Dating from this period is a whole series of astonishing paintings by

Picasso: I am thinking above all of Les Demoiselles d'Avignon. *Inevitably, these studies of Cézanne and African art would lead our two painters [Braque and Picasso] to investigate construction and thereby to become more interested in drawing than in color. From this, Cubism was born.*[2]

Cézanne, African art, the *Demoiselles*, and Cubism—all the traditional elements are here.

1. Mollet 1963, p. 9.
2. Mollet 1947, p. 7.

ANDRÉ SALMON

The poet and art critic André Salmon belonged to the inner circle of friends of Picasso, whom he knew from 1904. He had a front-row seat from which to witness the creation of the *Demoiselles* and, unlike Apollinaire, who left no record of the event in his writings, Salmon wrote copiously on the subject, though, as will become evident, his approach is very literary, often lyrical, and sometimes confused and mysterious, a headache for today's critic. He makes a few glaring errors (for example, in the first description he gives of the painting, in 1912, he speaks of "six large female nudes" when there are only five (suggesting, perhaps, that it had been a while since he had seen the painting) and these cast some doubt on the reliability of his writings as a whole. On the other hand, how can we not give the greatest credence to one of the "sponsors" of the *Demoiselles*, since he was among those to whom the idea for christening it "The Philosophical Brothel" can be attributed?

A first text appears in 1912, an essay that is also, chronologically, the first published account by an eyewitness of the painting's genesis. (Gelett Burgess, although he refers to the *Demoiselles* in his 1910 article, did not witness its creation, not having arrived in Paris until the spring of 1908.[1] Salmon's essay, published in *La Jeune Peinture française*,[2] is the "Histoire anecdotique du cubisme," devoted for the most part to Picasso and recounting the slow, difficult, painful birth of the *Demoiselles* in great detail, but also with countless inaccuracies and obscure formulations (despite an admirable declaration of intent: "it is necessary to follow step by step the man whose fatal inquisitiveness was to give rise to Cubism"). Some excerpts follow. In section I, he tells us that in the midst of the Rose Period, when success was at last beginning to reward the painter's talent:

I

... Picasso became uneasy. He turned his canvases to the wall and threw down his paintbrushes.

For many long days and nights, he drew, concretizing the abstract and reducing the concrete to essentials. Never was labor less rewarded with joy, and without his former youthful enthusiasm Picasso undertook a large canvas that was intended to be the first fruit of his experiments.

Already the artist had conceived a passion for the blacks, whom he placed well above the Egyptians. His enthusiasm did not arise from some vain taste for the picturesque. The Polynesian and Dahoman images seemed "sensible" to him. In renewing his work, Picasso was inevitably to show us an aspect of the world that did not conform to the way we had learned to see it.

The regulars at the strange studio on rue Ravignan, who had put their trust in the young master, were generally disappointed when he allowed them to assess the first state of his new work.

This canvas has never been shown to the public. It features six large female nudes, delineated with rather rough accents. For the first time in Picasso's work, the expression of the faces is neither tragic nor passionate. These are masks, almost entirely freed from humanity. Yet these people are not gods, nor are they Titans or heroes; not even allegorical or symbolic figures. They are naked problems, white ciphers on the blackboard.

This is the principle of the painting-as-equation.

A friend of the artist spontaneously christened Picasso's new painting "The Philosophical B[rothel]." That, I believe, was the last studio joke to cheer the world of the innovative young painters. Painting henceforth became a science, and one of the more austere at that.

II

The large canvas with the severe figures and no lighting did not long remain in its first state.

Soon Picasso attacked the faces, most of whose noses were rendered from the front, in the form of isosceles triangles. The sorcerer's apprentice continued to consult the Oceanic and African enchanters.

Shortly thereafter, these noses became white and yellow; touches of blue and yellow added relief to some of the bodies. Picasso settled on a limited palette of concise colors corresponding rigorously to the schematic design.

Lastly, dissatisfied with his initial experiments, he set upon other nudes—spared until then, held in reserve by this Neronian—seeking a new equilibrium and composing his palette with pinks, whites and grays.

For a rather brief period, Picasso seemed satisfied with this achievement; "The Philosophical B[rothel]" was turned to the wall, and at this moment were painted those pictures so beautifully harmonious in tone, so supple in design, mostly nudes, which made up Picasso's last exhibition, in 1910.

This painter, the first to have been able to restore a measure of nobility to a discredited subject, returned to the "study" [étude], and to the studies of his early manner, Woman at Her Toilette *and* Woman Combing Her Hair. *He seemed thereby to suspend for a while the more recondite experiments for which he had sacrificed his original gift of immediate seductiveness.*

It is necessary to follow step by step the man whose fatal inquisitiveness was to give rise to Cubism. A holiday interrupted the painful experiments. Upon his return, Picasso resumed work on the large test-canvas, which, as I have said, lived only through its figures.

He created its atmosphere through a dynamic decomposition of the

powers of light—well surpassing the efforts of Neo-Impressionism and Divisionism. Geometric signs—of a geometry at once infinitesimal and cinematic—emerged as the principal element of a kind of painting whose growth, from that moment on, could not be stopped.

Never again would Picasso—his fate prevented him—become the fertile, direct, and ingenious creator of works of human poetry.

III

Those who were inclined to look upon the Cubists as impudent jokers or as shrewd businessmen should deign to take notice of the very real drama surrounding the birth of this art. Picasso, too, had "meditated on geometry," and in choosing primitive artists as his guides he was in no way unaware of their barbarity. Only, his way of thinking led him to believe that their goal was the actual representation of a being, and not the realization of the idea, usually sentimental, that we have of it.

Those who see in Picasso's work the mark of the occult, of the symbol or of the mystic, are in danger of never understanding it. Instead, he wants to give us a total representation of man and things. Such was the goal of the primitive sculptors [imagiers barbares]. *But here we are concerned with painting, an art of surface, and that is why Picasso is obliged to create something new, in his turn, by placing those balanced figures—which are beyond the laws of academicism and the anatomical system—in a space rigorously consistent with the unexpected freedom of movement.*

The will toward such a creation suffices to make the one it animates the foremost artist of his age—though he may know only the bitter joys of his quest without gathering its fruits.

The results of the primitive experiments were disconcerting. No concern for grace; and taste rejected as too limited a standard!

Nudes were born whose distortion came as no surprise, prepared for it as we were by Picasso himself, by Matisse, Derain, Braque, van Dongen, and earlier by Cézanne and Gauguin. It was the hideousness of the faces that froze the half-converts with horror.

Deprived of the Smile, all we could recognize was the Grimace.

The smile of the Mona Lisa was perhaps too long the Sun of Art.

Its worship corresponds to some decadent Christianity that is particularly depressing and supremely demoralizing. One might say, paraphrasing Arthur Rimbaud, that the Mona Lisa, the eternal Mona Lisa, was an eternal thief of energies.

It is difficult not to reflect favorably upon the innovator when we put side by side one of the nudes and one of the still lifes from this moment of Picassism (Cubism had not yet been invented).

While the human effigy seems so inhuman to us and inspires a sort of dread in us, we are ready to submit our sensibility to the conspicuous and entirely new beauties of representation of this bread, this violin, this cup, painted as they never have been before.

This is because the accepted appearance of these objects is less precious to us than our own representation, our reflection distorted in the mirror of intelligence. Thus with a desperate trust we let ourselves be carried along in the search for what underlies the work of Picasso or some other painter of his kind.

Will this all be a waste of time? That's the question!

Could anyone demonstrate the necessity, the higher aesthetic reason, for painting creatures and things as they are, rather than as our eye has seen them to be, perhaps not always but since men like us have meditated on their image? Is that not art itself?

Is not science the sole guide for these seekers anxious to subject us to every angle of the prism at once, mingling touch and sight, which are the agents of such different delights?

No one has yet been able to answer this question conclusively.

Besides, the concern for making us sense an object in the totality of its being is not in itself absurd. The world's appearance changes; we do not wear the mask of our fathers, and our sons will not resemble us. Nietzsche wrote: "We have made the world very small, say the last men, blinking." Terrible prophecy! Doesn't the soul's salvation on earth lie in an utterly new art?

I do not intend to answer that question today, having only set out to prove that some artists, unjustly burdened, obey ineluctable laws for which anonymous genius is responsible.

This chapter is nothing more than an anecdotal history of Cubism.

There is nothing daring in what I am putting forward here. M. Jean Metzinger, in 1910, confided to a reporter: "We never had the curiosity to touch the objects we painted."

IV

Meanwhile, Picasso returned to his field-maneuvers painting. He had to test the pitch of a new palette. The artist found himself in a truly tragic position. He had no disciples yet (later, when he did, several would become disaffected); his painter friends were turning away from him (a less scrupulous man than I might give their names), aware of their weakness and fearing the example he set, hating the beautiful snares of Intelligence. The rue Ravignan studio no longer was the "rendezvous of Poets." The new ideal divided the men who were beginning to look at each other "from all angles at once" and thus developing mutual disdain.

Forsaken, Picasso was left in the company of the African soothsayers. He composed a palette rich in all the hues dear to the old academicians—ocher, bitumen, and sepia—and painted several formidable nudes, grimacing and perfectly deserving of execration.

But what singular nobility Picasso gives to everything he touches!

The monsters of his mind distress us; but never will they shake the biggest boors out of the democratic laughter that makes the Sunday crowds invade the Indépendants.

Already the Alchemist-Prince, this Picasso who calls to mind Goethe, Rimbaud, Claudel, was no longer alone.

Jean Metzinger, Robert Delaunay, Georges Braque were singularly interested in his work....[3]

What do we learn from this text? For one thing, the original name of the painting, "The Philosophical Brothel," given at its birth by a "friend" who remains unnamed. We also learn a good deal about the work's gestation: the numerous preparatory drawings feverishly executed and leading to a painting that is an experiment, a "large test-

canvas" (*grande toile aux essais*), which raises a problem and attempts to resolve it, but which is also a place to try out strategies, a "field-maneuvers painting" (*tableau champ de manoeuvres*). We are told that the work was taken up again several times: Salmon clearly refers to a "first state" (*premier état*) followed by at least three, perhaps four, periods of work—the second having two phases, with precise descriptions given of the retouchings of form and color—all of this occurring within the atmosphere of isolation and anguish created by the incomprehension and disappointment of his close friends. Then there is the clear designation of those who were the neighbors, witnesses, and virtual partners in this story, the "primitive sculptors," whose works, Salmon implies, were known to Picasso and aroused his interest either beforehand or at least concurrently with this drama. Salmon here is the first to connect explicitly the *Demoiselles* with primitive art, specifically African and Polynesian art. Lastly, there is the question of Cubism, its origins and early development: "Cubism had not yet been invented," says Salmon, but soon it would be born, the fruit of the stubborn experimentation, the "fatal inquisitiveness" (*tragique curiosité*) of its begetter; a perilous enterprise—tolling the knell of the lost innocence of the Rose Period and leading to consequences which were not perhaps without dangers ("no concern for grace," "taste rejected")—conducted by an "Alchemist-Prince," Balthasar Claes or another new Faust (note that Salmon invokes Goethe) who would come to terms with the unknown ("he was in no way unaware of their barbarity"). In the disagreement that divides art historians, some of them situating the *Demoiselles* if not at the apogee at least at the inception of Cubism, and others situating it before the movement, the former group has found many phrases in Salmon's text useful in supporting its conviction—"naked problems" (*problèmes nus*), "white ciphers on the blackboard" (*chiffres blancs au tableau noir*), "painting-as-equation" (*peinture-équation*)—phrases they have interpreted in connection with the "sensible" (*raisonnable*) nature of primitive art as manifest indications of a conceptualization of art. It is by refuting these ideas, which Leo Steinberg thinks reveal an error in Salmon's interpretation, that Steinberg begins his 1972 essay "The Philosophical Brothel," going on to analyze the "humanity" contained in the painting Salmon said was "almost entirely freed from humanity."[4]

Some enigmas remain: one of them, one of the most famous and irritating, concerns the chronology of the painting's completion: what is this "holiday" (*vacances*) that interrupts Picasso's work? In 1958, John Golding noted that there was no evidence of any vacation Picasso might have spent away from Paris during the summer of 1907.[5] Pierre Daix, in 1979, settled the matter by publishing that Picasso "explicitly denied taking the slightest time off at that period."[6] This resolves the contradiction between Kahnweiler's compelling affirmation that the painting was completed "rather early in the summer,"[7] and the supposed resumption of work after a summer holiday, related by Salmon. (Martensen-Larsen would resolve the contradiction by [erroneously] pushing the completion of the *Demoiselles* into the autumn of 1908, after the late-summer holiday

known to have been spent at La Rue-des-Bois.)[8]
A few lines by Salmon, at the end of his article "Pour les absents," (for the column "La Semaine artistique"), published in 1918 in *L'Europe nouvelle* at the end of the war, refer to the Salon d'Antin of 1916:

It would be unfair not to recall here that in July 1916, M. Paul Poiret put his avenue d'Antin gallery at my disposal, through the courtesy of M. Barbazanges, to organize the Salon d'Antin, the only group exhibition authorized, since the start of the war, for the revolutionary artists whom unfortunately I cannot all name here.[9]

Meager information from the pen of the man who had organized this exhibition about which so little is known, and nothing at all on the *Demoiselles*, which was exhibited for the first time there. Nor do we find out any more than this, again from Salmon and in *L'Europe nouvelle*, several weeks later:

With the help of a few friends who had returned with me from armed service, I organized the Salon at Poiret's, that much-maligned, generous man.[10]

Writing a review of a Metzinger exhibition in January 1919, Salmon resumes his history of the origins of Cubism; discussing the continuity between the *Demoiselles* and the Rose Period, the upheaval wrought by a few retouchings (only in this text does Salmon so clearly state that it was through the reworking of the painting that Picasso broke away from the past, giving it a seminal role in making the future), and the influence of African art:

Cubism was born from the works and experiments of Pablo Picasso, just after 1906, in his Montmartre studio, which was frequented by the painters André Derain and Maurice de Wlaminck [sic], the curious onlookers, by the indifferent van Dongen, and by Henri Matisse, who was too idiosyncratic to accept anything but too intelligent not to be sensitive. Also there were Guillaume Apollinaire, Max Jacob, the mathematician Maurice Princet, and myself. Picasso one day placed before our eyes a large, beautiful canvas of several nudes, powerful in construction and the natural outcome of the series of paintings that make up what the studio jargon calls the Rose Period. Picasso had upset the economy of this canvas by retouchings bound to elicit our comments.

His discoveries may have had their source in the study of the sort of African statuettes which, at the same time as Picasso, André Derain and Henri Matisse were passionately collecting, though beyond any concern for exoticism.

At the same time Picasso executed, as a preparatory study for a statuette in wood that was yet to be cut, a portrait of myself in charcoal which, together with the large painting in question, is at the origin of Cubism.[11]

In a few words in *Demain*, of the same year, he alludes to the *Demoiselles* again:

At the time of his first experiments, as I said in 1912 in my book La Jeune

Peinture française, Picasso began to transform half-finished, half-conceived figures, large nudes still related to the style of the "Rose Period."

Anxious only about the sense of volume in space, and led by this concern to violent distortions, he at first disdained all the grace of which he was master. Now men who make God in their own image worship that image like barbarians. Hence the hideousness of Picasso's figures unleashed universal wrath.[12]

A full chapter of his book *L'Art vivant*, published in 1920, is devoted to "Cubisme," and another chapter, titled "L'Animateur," has a section devoted to Picasso. Over a number of pages there are observations of interest in connection with the *Demoiselles*, some with a clear relevance, and others more remote: "It is thus around 1908 that we must situate the revelation of Cubism"; to this is appended a footnote: "Picasso was already preparing for it by 1906, without quite realizing it."[13] As in his earlier texts, Salmon seems to be implying that 1907 may be the year of germination. He then alludes to Picasso's liking for Egyptian art; to the discovery of African art by Derain and Vlaminck, then by Matisse, followed by Picasso; and to the tutelary figures of Cubism:

The students of Barrès, docile devotees of El Greco, must have loathed the pre-Cubists who discovered El Greco before Barrès got involved. But to Greco the Cubists added Ingres. Yes, Monsieur Ingres. Even today, in almost all the Cubist studios, you will see the Odalisque *or the* Turkish Bath *next to* Saint Francis Receiving the Stigmata *or* Julian Romero de las Azanas at Prayer, *and not far from the* Chahut *of Seurat, the lone 1885 master to find favor among the Cubists.*

To recapitulate: Cézanne, the Africans, the Douanier Rousseau, El Greco, Ingres, Seurat.[14]

Then, without naming the *Demoiselles*, he alludes to the painting:

Picasso nevertheless becomes tormented. He turns his canvases to the wall and throws down his paintbrushes. For many long days and nights, he draws, concretizing the abstract and reducing the concrete to the essential. Never was labor less rewarded with manifest joy, and without his former youthful enthusiasm Picasso undertakes the first application of his experiments. He has bent his genius to cold Reason.

Once he gives it [genius] back its wings, Picasso finds himself in the midst of a transfigured universe.[15]

The first issue of the journal *L'Esprit nouveau* is published in October 1920, featuring an article devoted to Picasso, dated May. One new development: the painting bears its name, *Les Demoiselles d'Avignon* (the title under which it had been listed in the catalogue of the Salon d'Antin in 1916). To what we learned from Salmon's 1912 text, this one adds a further detail: the painting, in 1920, has not yet left the studio, and "still may not be able to leave yet":

He turns his canvases to the wall, abandons the large work, Les Demoiselles d'Avignon, *a document fit to confound impostors and their incredulous yet gullible clients; a vast painting later worked and*

reworked, which has not yet left the studio and still may not be able to leave yet, and which is at the center of his oeuvre, the still-incandescent crater whence burst the fire of current art. He turns his canvases to the wall and throws down his paintbrushes.

For long days and nights, he draws, concretizing the abstract and reducing the concrete to essentials, while enriching it. Never was labor less rewarded with manifest joy, and without his former youthful enthusiasm Picasso undertakes—returning to the large nudes of the Demoiselles d'Avignon *begun in the spirit of the Rose Period—the first application of his experiments; experiments tyrannically dictated by a lucid examination of everything that came before. In Picasso's oeuvre, an oeuvre a single moment of which marks and commands the start of the Cubist revolution, a true revolution, there is never any concern for continuity.*

He has bent his genius to cold Reason.

Once he gives it [genius] back its wings, suddenly Picasso, immortal, finds himself in the midst of a transfigured universe.[16]

Later on Salmon makes a statement asserting that the revelation of African art occurred right in the middle of the work on the *Demoiselles* and broke the continuity of his work:

I stated that there has never been a concern for continuity in Picasso's oeuvre. Such a concern for continuity would be an obvious fact, a flagrant accident, if the revelation of African art had caused Pablo to turn the demoiselles' noses [i.e., the canvas] to the wall. He did not make them stand in the corner.[17]

Salmon's *Propos d'atelier*, published in 1922, presents several chapters—"L'Ordre nouveau," "La Révélation de Seurat," and "Divagation sur Émile Bourdelle"—in which can be found here and there a few remarks of interest, and a long text, "L'Art nègre," written on the occasion of the exhibition organized by Paul Guillaume at the Devambez gallery in May 1919.[18] Salmon indisputably possesses a talent for reusing the same ideas, from one occasion to the next (he is not alone in this: Kahnweiler does the same thing), but he often adds a few supplementary notations and asides that are not without interest. We already know that Salmon does not accept the idea of a concern for continuity in Picasso's oeuvre:

Such a concern for continuity would be an obvious fact, a flagrant accident, if the revelation of African art had caused Pablo to turn the demoiselles' noses to the wall.[I] *He did not make them stand in the corner.*[II] [19]

The superscript roman numerals refer to footnotes:

(I) The very same vast painting, jealously guarded by the artist, the original title of which has been forgotten little by little, a title suggested, revised and adopted by Picasso's good friends: Guillaume Apollinaire, Max Jacob and myself: The Philosophical B[rothel], *a work I wrote about in my* Jeune Peinture française *in 1912.*

The "friend" said in 1912 to have invented the name has now become

three people,[20] three of Picasso's closest friends, one of whom, Apollinaire, wrote nothing on the *Demoiselles,* while another, Max Jacob, with his great discretion, wrote very little.

And the second note:

(II) The concern for African art only arose from a sum of other concerns and preceded by some time the abandonment of that fine moment of the Rose Period, which had begun to vanish spiritually, if a "period" can ever be fixed and no longer evolve.

A bit further on,[21] talking about the Salon d'Antin, which he organized, Salmon limits himself to quoting, and castigating, an excerpt from a review written on that occasion. He says nothing more about this important event (when the *Demoiselles* was first exhibited to the public), though fuller information might have been hoped for.[22]

Still further on, he says about Bourdelle:

Concerned with lofty construction, he treated Greek art a bit the way we later saw Picasso treat the "surrealist" nudes of those Demoiselles d'Avignon *(still captive in the studio) when he was beginning to be concerned with Cubism, which at the time still had no name.*[23]

Picasso does not want to part with his painting;[24] the *Demoiselles* contains Cubism in embryo; the movement about to be born as yet has no name.

The *Demoiselles* is at center stage in "L'Anniversaire du cubisme," an article Salmon publishes in 1926 in *L'Art vivant.* He says that Cubism issued from the picture, and presiding over its birth were the great masters of Western painting:

Everyone by now knows that Cubism was christened by Matisse when he saw cubic "structures" in a landscape in which they were no longer mere ornaments. We all know that one morning Picasso showed his friends the Demoiselles d'Avignon *stripped of their "rose period" grace and enlarged to a geometrical monstrousness. Such was the first impression. Then we quickly fell in with the new order—so as eventually to go beyond formal Cubism—accepting the need to consider a painting as a plastic fact in itself.*

The [art] object's triumph no longer came from its striving for resemblance. Rather, as Metzinger put it, we finally ventured to touch the object to be painted. We began to consider it from all angles.

Later, speaking of the "revolutionaries of 1906," he writes:

They placed the plastic element, in its entirety, above all emotional content. This is what Cézanne, without whom the Cubist Picasso would be inconceivable, had taken to its final conclusion.

It is what El Greco had done, whom our generation has brought back to his rightful place of honor, with the help of Barrès, who situated him among the princes of the human spirit. It is what Poussin had done.... It is what Chardin had done.... It is what Ingres had done in his preoccupation with processes loftier than the most likeable of Turk-

ish Baths, *one will readily admit. It is what Géricault had done. It is what Delacroix had done, and it is what the divisionist Seurat had done in claiming his lineage from the master of the Croisés [Delacroix].*[25]

One notes in this passage the specific reference to *The Turkish Bath*; also, the reference to the "christening" of Cubism by Matisse, when the jury of the 1908 Salon d'Automne rejected some of Braque's paintings, comes just before the mention of the *Demoiselles*. (Should we see this as a coincidence?)[26]

In 1931, in *Les Nouvelles littéraires*, a few rather obscure lines again mention the *Demoiselles*: Salmon points out that Picasso does not like to talk about his painting ("Picasso wasted no energy commenting on his work," says Salmon of the first time Manolo took him to the Bateau-Lavoir), and that he is anything but a theoretician:

Doctrine did not show its face to any greater extent when Picasso was in his Saltimbanques Period or Rose Period. In fact he was laughing when he showed us his first Cubist work. Return from Sorgue [retour de Sorgue], Les Demoiselles d'Avignon *revised and transformed by an illumination that emerged from a meditation.*[27]

Then again, Picasso might be a theoretician, but if he is, he is very careful not to let it show. In the sentence "*Les Demoiselles d'Avignon, retour de Sorgue et corrigées,...*" what is the meaning of the word "Sorgue"? Are we supposed to read this as "Sorgues" (with a letter *s* at the end), the place where Picasso spent his summer vacation in 1912, not far from Avignon, which he then visited for the first time?[28] What does "retour de Sorgue" signify, and why the untranslatable grammatical breakdown?

This passage is all the more troubling because, in an unpublished text by Salmon from the fifties, titled "Véritable clé d'un domaine imaginaire," the author discloses keys to interpret his 1920 novel *La Négresse du Sacré-Coeur*, in which Picasso is called "Sorgue," and where the name appears in connection with the *Demoiselles* again:

I gave Sorgue that name because Picasso, at the time he invented Cubism, had come back from Vaucluse, where, not far from Avignon, he had been working for several months in a modest house in Isle-sur-Sorgue. It was from there that he brought back the large painting, reproductions of which have multiplied all over the world: a long procession of naked women, figures he transformed (some say in a single night), giving them the first geometric shapes with which we are now familiar. I gave the painting its definitive title: Les Demoiselles d'Avignon.

The Sorgue is a river whose source is the Fontaine-de-Vaucluse. The waters delighted Petrarch. I might also point out that in slang, the language of those the novelist Pierre Mac Orlan, whom we'll talk about shortly, calls the "dangerous classes," Sorgue means night. And Death is "the Great Sorgue." I dwell on this only to show again the large place given to dream in my novel of observed reality.[29]

Earlier, some sibylline lines in a poem titled "Moulins d'antan" mention the painting by name:

On rue Ravignan, Jacob set down his Matorel
Picasso contemplated a metamorphosis
Of the Demoiselles d'Avignon,
For me ... Oh, for me alone![30]

In *L'Air de la Butte*, in 1945, Salmon suggested that the birth of the *Demoiselles* at the Bateau-Lavoir be commemorated in marble:

[T]he old wooden house ... would become a marble palace if covered with all the appropriate commemorative and informative plaques: "Here the nights of the Blue Period were spent.... Here the days of the Rose Period flourished.... Here the demoiselles from Avignon broke up their dance to form another procession according to the golden number and the secret of the fourth dimension...."[31]

1. On Burgess's sojourn in Paris, see the entries under March 31 through September 13, 1908, in the Chronology.

2. The last chapter of *La Jeune Peinture française* is followed by the date March–April 1912 (Salmon 1912, p. 122). Edward Fry (1966a, pp. 90, 195, note 1 to Text 18) says it was not published until October 1912 (there was an advertisement in the *Gil Blas* of October 14, 1912). Fry reproduces *in extenso* the text of the "Anecdotal History of Cubism" in translation (Fry 1966a, pp. 81–90; see also Chipp 1968, pp. 199–206).

3. Salmon 1912, pp. 42–52.

4. Steinberg 1988, p. 7 (first published 1972). It is not clear what Salmon means by absence of humanity: is it the figures' geometrization that distances the *Demoiselles* from the world of humans, or is it their monstrosity?

5. Golding 1958, p. 161 note 28. He assumes that Picasso did, all the same, take a rest that summer, and then finished working on the painting in the fall.

6. Daix 1979, p. 185, note 28. Daix mentions "the artist's almighty fury with Salmon" as a result of these inaccuracies when he read him the critic's 1912 text. Daix also wonders about the exhibition of nudes in 1910 mentioned by Salmon. Regarding the two Picasso exhibitions in Paris in 1910, see ibid., pp. 247 and 259. There was an exhibition in May 1910 at the Notre-Dame-des-Champs gallery and another from December 21, 1910, to the end of February 1911 at Ambroise Vollard's gallery. Apollinaire's commentary on this latter exhibition, in *L'Intransigeant* of December 21, 1911, tells us nothing about its content (see Apollinaire 1991b, p. 244).

7. Kahnweiler 1952, p. 24. See the excerpt from this 1933 interview printed above, in the Kahnweiler section, p. 235.

8. Martensen-Larsen 1985, pp. 261–62.

9. Salmon 1918a, p. 631. My thanks to Étienne-Alain Hubert for bringing this text to my attention.

10. Salmon 1918b, p. 1155; quoted by Malcolm Gee (1981, p. 222, note 2).

11. Salmon 1919a, p. 139. About Picasso's portrait drawing of Salmon, which involves Salmon very closely in the history of the *Demoiselles*, see Rubin 1984, pp. 284–85; and Daix 1988b, p. 532.

12. Salmon 1919b, p. 489. My thanks to Jacqueline Gojard for directing me to this text, which was partially reprinted in the special issue of the *Cahiers d'art* of June 1932, p. 20.

13. Salmon 1920a, p. 112.

14. Ibid., p. 115. Regarding paintings by El Greco, one might add to this list the work in The Metropolitan Museum of Art, New York, *Apocalyptic Vision* (also known as *The Vision of Saint John* and as *The Fifth Seal of the Apocalypse*), which Zuloaga had in his Paris studio perhaps by 1905 (see in particular Amón 1973, pp. 44–54; Johnson 1980b, p. 110; Laessøe 1987; Richardson 1987 and 1991, pp. 430–31; and, in the present Anthology, "Iberianism vs. African Art," p. 216, and

note 2, p. 217, as well as the essay by William Rubin, above, pp. 98–102). A bit further on (Salmon 1920a, p. 145), Salmon says: "Picasso keeps the *Odalisque* of M. Ingres as an icon." He also reprints a passage (Salmon 1920a, pp. 118–19) we have already quoted: "At the time of his first experiments … universal wrath" (from Salmon 1919b, as cited above, in note 12).

15. Salmon 1920a, p. 170.

16. Salmon 1920b, pp. 63–64; another passage (p. 68) refers perhaps to the Picasso of the *Demoiselles*: "the adolescent who painted the Saltimbanques as he was ordering a drastic retreat from the exalted incantation behind veils, heavy as storms, of the Blue Period, and tying the ribbons of the Rose Period to the rigorously calculated columns of the only true sky."

17. Ibid., p. 78.

18. Salmon 1922. A shorter version of "L'Art nègre" appeared in English in *The Burlington Magazine* (London), vol. 36, no. 205 (April 1920), pp. 164–72, under the title "Negro Art," translated by D. Brinton.

19. Salmon 1922, p. 16.

20. In 1960, in a letter to Euro Civis, he once again claims sole credit; see above, "A Painting's Identity," note 3, p. 225.

21. Salmon 1922, p. 39.

22. We learn, however (ibid., pp. 172–73), that Salmon did not have permission to exhibit at the Salon d'Antin Brancusi's *Princess X*, which had in the censors' eyes "characteristics of the gravest indecency." This suggests that the subject of *Les Demoiselles d'Avignon* (thus dissimulated behind this respectable title—which Barr [1946, p. 57] called "the painting's rather romantically troubadour title"—and which Picasso himself may not have used, preferring, apparently, the more explicit *Filles* or *Femmes d'Avignon*) fortunately escaped the censors' notice, as it did that of everyone else, who, unaware of the subject, was shocked only by the purely formal violence done to the bodies of women whose profession is not betrayed by any lewdness whatsoever. Concerning the title, see Adam Fischer's letter, under January 22, 1918, in the Chronology; and see also the Dreyfus and Salto sections in the present Anthology, p. 231, above, and on this page below.

23. Salmon 1922, p. 180.

24. It should be pointed out that before the publication in 1984 of François Chapon's book on Jacques Doucet, from which one learns that it was not until 1924 that the painting left Picasso's studio—except for one exhibition (or possibly two; see the Appendix in the present volume, pp. 206 ff.)—to join Doucet's collection, most writers on the subject situated this famous event in 1920.

25. Salmon 1926, p. 445. On Picasso's showing his friends the *Demoiselles*, see the Chronology, under "Early in the Year to Early Summer 1907: Visitors to the Bateau-Lavoir," p. 148.

26. On this matter, see, for example, Fry 1966a, pp. 50–51. Salmon's text could lead one to believe that Matisse's statement before the opening of the Salon d'Automne of 1908 and the presentation of the *Demoiselles* occurred at the same time.

27. Salmon 1931, p. 8. My thanks to Jonas Storsve for finding this text.

28. Zervos dwells on the fact that Picasso went to Sorgues for the first time in the summer of 1912. See above, "Iberianism vs. African Art," p. 215.

29. Salmon, unpublished typescript, Jacqueline Gojard collection. I thank Mme Gojard for directing me to this text and Mme André Salmon for authorizing its publication. The text speaks of the death of Max Jacob in 1944 and of the recent republication of the book by Fernande Olivier published "about twenty years ago" (i.e., 1933); it can therefore be placed around the early fifties. In it, one notes the idea of Picasso's frenzied revision ("in a single night") of the painting.

30. Salmon 1944, pp. 170–71. My thanks to Jacqueline Gojard for bringing this text to my attention.

31. Salmon 1945, pp. 149–50. Curiously, *Souvenirs sans fin* does not seem to disclose anything about the *Demoiselles*.

AXEL SALTO

In the spring of 1916, probably in early May,[1] the Danish painter Axel Salto visits Picasso at the rue Schoelcher studio:

Pablo Picasso lives in Paris on rue Schoelcher, overlooking the Montparnasse cemetery. He is the High Priest of the latest gospel on Art, Creativity, and Progress. I visited him during the spring of 1916. He greeted me wearing a grass-green colored sweater and brown corduroy pants, those wide pants that the French artists still like to go around in. Picasso is small in stature, but his demeanor is like a bullfighter. His skin appears somewhat yellow, and his black, evil eyes sit close together; the mouth is strong yet delicately drawn. He is reminiscent of a racehorse, an Arabian with a finely arched neck. It is said that he has secret powers and that he can see right through people, and even see the dead. Other curious things have also been said about him. He was the height of super-naturalness.[2]

Salto sees some works from Picasso's youth, from the Blue Period, and from the Saltimbanques period. Then,

In the studio also hung "The Girls from Avignon," from a later period. It is a canvas as large as a wall, a bit higher than it is wide. It presents three standing female figures and one sitting (with her back to us), who is closest to some fruit on her left. Cobalt blue, brown, black, and white placed next to one another make up the composition of the work, the same pure scale of color one finds, for example, in some primitive Peruvian clay pottery. The form is simple without appearing inorganic or thinned out in arabesques. "The Girls from Avignon" is also reminiscent of Javanese stone reliefs and African sculpture. Modern French art (Maillol, Matisse) has turned to these new forms. Other modern art comes to them in a circuitous manner—through the French.[3]

Salto is in error as to the number of women (he published his article barely a year after seeing the painting), and he gives the painting's title as "The Girls from Avignon" (*Pigerne fra Avignon*).[4]

1. Troels Andersen recounts this visit in his monograph on Jens Adolf Jerichau, the Danish painter and a friend of Salto's (see Andersen 1983, p. 126). Andersen wrote to me that Mrs. Kamma Salto had kept a card, sent to her and her husband by the Norwegian painter Edvard Diriks on April 29, 1916, telling them they could go to visit Picasso whenever they wanted, except on Mondays (letter of April 6, 1987). My thanks to Troels Andersen for this, and for information on the Salon d'Antin, which the Saltos attended in the company of Jerichau (see the entries under "After April 29, 1916," and "July 1916: The Salon d'Antin" in the Chronology).

2. Salto 1917, n.p. Translated from the Danish by Scott de Francesco. This text was previously translated into English in McCully 1982, pp. 125–26. Salto's characterization of Picasso reminds one, of course, of the "sorcerer's apprentice" and the "Alchemist-Prince" invoked by André Salmon (see the Salmon section, above, pp. 245–46).

3. Ibid. There is a photograph of the rue Schoelcher studio in which *Les Demoiselles d'Avignon* is visible (reproduced in the Chronology, fig. 7, p. 162). It is difficult to say whether the painting is hanging on the wall, as in Salto's account, or resting on the floor. See also the Soffici section, below, pp. 251–52.

4. The title "The Girls from Avignon" also appears, but in French ("Les Filles d'Avignon"), in a letter of Adam Fischer (see the entry under January 22, 1918, in the Chronology), and the title "Les Femmes d'Avignon" in Albert Dreyfus's text (see the Dreyfus section, above, p. 231). This could lead one to conclude that it was under these titles, and not the title *Les Demoiselles d'Avignon*, that Picasso presented the painting to his visitors. In his text, Salto gives the title in Danish only, omitting the French: "Pigerne fra Avignon," using the word *pige*, which has

the same meaning as *fille* in French—"girl," as opposed to "boy," though it might also, like the French *fille*, imply a woman of ill repute, or *fille de mauvaise vie*.

GINO SEVERINI

In his memoirs, which he collected in *Tutta la vita di un pittore*, Severini mentions the Salon d'Antin and the presentation there of the *Demoiselles*, which he places at the origins of Cubism:

After Madame Bongard's exhibition, André Salmon organized another, much more important show in a gallery called Galerie Barbazanges, at 26, avenue d'Antin. At the time it was also called the Salon d'Antin; later it [the gallery] was managed by Marcel Bernheim. Participating in this exhibition were practically all the avant-garde painters of some worth.

Picasso submitted his large painting "Les Demoiselles d'Avignon," which, in addition to its artistic value, also has a historical value, being one of the works that marked the beginning of Cubism.[1]

In an earlier passage, discussing the origins of Cubism, Severini contests the notion of a causal link between African art and Cubism, and opposes this with the idea of Cézannian influence:

I had already heard talk in Montmartre of African idols for some time, but no one had ever seen them; at the very most we had glimpsed them in a bric-à-brac shop on rue de Rennes, where later I too bought a very fine African mask. Nevertheless it was known that Matisse and Picasso had used such art, each in his own way, as a source of stylistic and poetic reference, which was why it was later said—and Max Jacob endorsed this idea—that African art was the source of Cubism. This is incorrect.

When, much later, I had a chance to see Picasso's paintings of that period [i.e., Cubism], I was convinced that they could not have been done without Cézanne either. African art did, of course, help to stretch the limits of Cézannian possibilities and intentions, and did contribute to the rediscovery of the true poetic spirit, indicating to artists precisely that it could be born only from direct contact with a renewed and, so to speak, virgin reality. But Cubism ... was the result of a whole set of circumstances.... To understand it, one need only look at the history of French art from Ingres up to that time.... The lesson of the Africans was first understood by Matisse, then by Picasso, Braque, and by the best artists of that period.[2]

1. Severini 1946, pp. 249–50. Criticism at the time was often mitigated. Severini insists here that the Salon d'Antin was an avant-garde exhibition.
 Étienne-Alain Hubert (1979, pp. 61, 66, note 24) discusses the exhibitions organized by Mme Germaine Bongard at her fashion salon, at 5, rue de Penthièvre, where, in late 1915 and in 1916, Cubist works were shown for the first time since the start of the war. In the present excerpt, Severini alludes to the third of these exhibitions, held May 29–June 15, 1916.
 The painting's title is in French in the original Italian text. Severini is in a good position to know the work, since he too exhibited at the Salon d'Antin.
2. Severini 1946, pp. 81–82; "bric-à-brac" is in French in the original text.

SERGEI SHCHUKIN

The anecdote recounted by Gertrude Stein in 1938 is still surprising:

I remember, Tschoukine who had so much liked the painting of Picasso, was at my house and said almost in tears, what a loss for French art.[1]

This, from the great Russian collector who several years later did not hesitate to buy back from the Steins an almost equally formidable painting, *Three Women*. Antonina Vallentin attributes different words to him (which perhaps he had written): "Is it true that Picasso has gone mad?"[2] This would seem to be a response to what Kahnweiler wrote: "People were calling him mad," without specifying what all the clamor was about.[3]

Noting that according to Alfred Barr,[4] Matisse did not take the collector to Picasso's studio until 1908, Golding doubts that Shchukin ever made that statement.[5] Nonetheless, these words are consistent with all the other statements, true or false, which bear witness to the incomprehension of those close to Picasso, friends and art-lovers, an incomprehension too often mentioned to be doubted.

1. G. Stein 1938, p. 64.
2. Vallentin 1957, p. 145.
3. Kahnweiler 1953b, n.p.
4. Barr 1951a, p. 85.
5. Golding 1988, p. 33, note 2.

ARDENGO SOFFICI

The Italian Futurist painter Soffici knew Picasso from the beginning of the century.[1] Their friendship apparently became closer precisely at the time of the birth of the *Demoiselles*, in the spring of 1907.[2] (Soffici's friendship for Picasso was "patriotic"—since Soffici was a champion of *italianità* and Picasso's mother had Genoese origins.)[3] Having lived in Paris since 1900, Soffici then returned to Italy (he was at Poggio a Caiano during the summer of 1907).[4] He made trips back to France in 1910, 1911, 1912, and 1914, each time in the spring.[5] These points of reference make it possible to date his visits to Picasso's various studios: to the Bateau-Lavoir in 1907; to boulevard de Clichy in the spring of 1910, of 1911, and of 1912; and to rue Schoelcher in the spring of 1914. And each time, Soffici would later recall, the *Demoiselles* was there, though for the boulevard de Clichy period we do not know whether it was actually on view (Soffici being the only witness to mention it specifically in that context). We learn that at the Bateau-Lavoir Picasso took care to show the painting to his friend (even while he was probably still working on it), and that at rue Schoelcher it was hung in a corner:

If truth be told, what was later called "Cubism" had already been invented by 1906, in certain [pictures of] women's heads that are reminiscent of those of African fetishes, and developed in 1907 in the Demoiselles d'Avignon, *which I liked a great deal the moment Picasso painted it (among other reasons, because there was a nice slice of watermelon in the picture, much like the ones I was doing myself at the time, which*

reminded me of Italy). Picasso, who knew this, showed me the painting each time with pleasure and to be nice to me. But full-fledged Cubism could not be seen until later, in his living room at boulevard de Clichy.

At that later time, as this manner became established and fashionable, these first attempts took on increased importance. In fact Picasso, in addition to the Demoiselles, *still had some works dating from the same period mixed in with more recent ones. I remember one day, when I was in Picasso's studio with Braque, Picasso showed to me and his friend, who had seen it before, an old drawing with Derain-like strokes depicting a village all squared and geometrized: apparently this was the very first attempt at Cubism. The last studio at which I saw him while I was in Paris was a vast white space on rue Schoelcher alongside the cemetery of Montparnasse, the district to which Picasso, following women problems and personal difficulties, had emigrated after Montmartre, to live there....*

In addition to the studio—which was stuffed like the others, but even more so, with canvases painted and blank, with colors, easels, etc., and where I again saw, hanging in a corner, my cherished Avignonese Demoiselles with their watermelon—the place had a real apartment, where Picasso could allow himself the luxury of inviting this or that friend to dinner.[6]

The same account, with a few differences, reappears in *Fine di un mondo*, where Soffici describes the rue Schoelcher studio:

Hung high in a corner in this sort of laboratory reigned the large painting of the Filles d'Avignon, *which I had seen years before in the boulevard de Clichy atelier; as I was looking at it with my old admiration, Picasso, noticing this, said to me: "I see you like it as much as before, when I had just done it. That makes me very happy."*[7]

1. That is, since 1900, as Soffici wrote in 1939; or perhaps since 1901, as Rodriguez suggests (1984–85, pp. 28–29, note 5). My thanks to Jean-François Rodriguez for information on relations between Soffici and Picasso.
2. Rodriguez 1984–85, p. 29, note 5, citing a letter of March 1907 from Soffici to Giovanni Papini, from March 1907, in which Picasso had told the Italian painter he wished to know him better: "I went back to see Picasso some time ago and this time he was very cordial and told me (an unheard-of thing, for him) that he wished to know me more closely!"
3. Ibid., p. 29, note 6. Discussing "Soffici's annexation of Picasso," Rodriguez notes that the friendship between the Spanish and the Tuscan painters had been facilitated, as Soffici liked to emphasize, by their common Italian origin, which made them feel like "blood brothers." Some of Picasso's letters to Soffici (September 1911, July 1914, April 1915) half-jokingly proclaim his Genoese origin on his mother's side, even if he was later to deny it. Soffici in his writings several times returned to the subject of Picasso's *italianità*. The concept of *italianità* was a lifelong preoccupation of Soffici's; the project of a *restaurazione artistica nazionale* ("national artistic restoration") that he began toying with early on in Paris has been seen as the origin of his "annexation" of Picasso. Picasso's disdainful detachment from French culture, his scorn of the French spirit, earned Soffici's approval, in the same way that French artists of the time (Cézanne, Renoir, Degas) were admired by him for what they had absorbed from Italy's great painting of the past.
4. Ibid., p. 27.
5. Jean-François Rodriguez and Mario Richter have determined the exact

dates of Soffici's Paris sojourns at that time, based on Soffici's correspondence with Giuseppe Prezzolini (Prezzolini/Soffici 1977, pp. 81, 82, 103–04, 106, 161, 183–84, 221, 227–28, 229, 253) and from that with Papini (Richter 1969, pp. 135, 172, 196, 252, 254–55): February 18–April 11, 1910; March 11–May 31, 1911; March 18–mid-June 1912; from the first half of March to the first days of April (before the 12th); and from early May (before the 5th) to June 14, 1914. See the Chronology under the following dates: April 6 and 7, 1910; May 7 and 8, 1912; and May 25, 1914.
6. Soffici 1942, pp. 369–71. Soffici, like Salto (see the Salto section, above, p. 250), says that the painting is hanging. He translates the painting's title into Italian, speaking sometimes of the "Damigelle d'Avignone" and sometimes of the "Signorine avignonesi."
7. Soffici 1968, p. 707. This time Soffici translates the title as "Ragazze d'Avignone." The Italian word *ragazza* means "girl" (as opposed to "boy").

GERTRUDE STEIN

Although Gertrude Stein was close to Picasso at the time of the birth of the *Demoiselles*, she wrote very little about it. Did she, too, hesitate before the newness of the work? The very brief description she has Alice Toklas give of it in the *Autobiography* (1933) evinces a sense of shock that seems almost to prevent her speaking about the painting. The occasion is around mid-October 1907, at the Bateau-Lavoir, the first time Alice goes to see Picasso at his studio.[1] Is this the first time Gertrude sees the *Demoiselles* herself? Perhaps she has seen the preparatory studies.

Against the wall was an enormous picture, a strange picture of light and dark colours, that is all I can say, of a group, an enormous group, and next to it another in a sort of red brown, of three women, square and posturing, all of it rather frightening. Picasso and Gertrude stood together talking. I stood back and looked. I cannot say I realized anything but I felt that there was something painful and beautiful there and oppressive but imprisoned.[2]

The two works, side by side, are the *Demoiselles* and *Three Women*.[3]

In her 1938 book *Picasso*, Gertrude Stein mentions the painting as if in passing, and unhesitatingly asserts the influence of African art:

When Picasso, under the influence of African art, painted the Demoiselles d'Avignon *(1906–07),(1) it was a veritable cataclysm. I remember once at my house Stchoukine, who really loved Picasso's painting, said to me in tears: "What a loss for French painting!"*

In this period Picasso wanted to express by means of heads and bodies, not the way everyone sees them, which was the problem of other painters, but the way he saw them; he tended to paint in blocks like a sculptor, or in profile, the way children paint.

African art was beginning to play a role in Picasso's creation. But in fact, African art, like all the other influences which at one moment or another led Picasso away from his way of painting, was not so much a help as a disturbance that veiled the images.

African art, French Cubism and later the Italian and Russian influences were like Sancho Panza keeping up with Don Quixote. They turned Picasso away from his true vision, which was purely Spanish.

Picasso used African art like a crutch. Later, he used other things....

It was Matisse who, in 1906, got him interested in African sculpture. It should never be forgotten that African art is not a naïf art, not at all, it is a very conventional art, based on a tradition well established by Arab culture. The Arabs created civilization and culture for the Blacks, and thus African art, which for Matisse was something exotic and naïf, became for Picasso, the Spaniard, something natural, direct and civilized. It was therefore normal for his vision to be reinforced by it and for his studies of African art to lead him to create the painting, Les Demoiselles d'Avignon, in 1907.

The note (1) in this passage says:

Vlaminck was the first to discover African sculptures; he gave Derain a taste for them at the time when Picasso (1906–1907) painted the Demoiselles d'Avignon. *Matisse already had a veritable "collection" of them.*[4]

The influence of African art is presented here in a curious light, and in contradictory terms: both as a disturbance of the painter's vision and as a "crutch" that would have helped him to progress. The terms that Stein uses against the "exotic and naïf" value of primitive art and in favor of its "natural, direct and civilized" value, are consistent with Salmon's famous description of this art as "sensible" (*raisonnable*),[5] and Picasso's distaste for exoticism, which he expressed to Apollinaire.[6]

Matisse's role as initiator—in autumn 1906—is more clearly outlined in *The Autobiography of Alice B. Toklas:*

At that time negro sculpture had been well known to curio hunters but not to artists. Who first recognised its potential value for the modern artist I am sure I do not know. Perhaps it was Maillol who came from the Perpignan region and knew Matisse in the south and called his attention to it. There is a tradition that it was Derain. It is also very possible that it was Matisse himself because for many years there was a curio-dealer in the rue de Rennes who always had a great many things of this kind in his window and Matisse often went up the rue de Rennes to go to one of the sketch classes.

In any case it was Matisse who first was influenced, not so much in his painting but in his sculpture, by the African statues and it was Matisse who drew Picasso's attention to it just after Picasso had finished painting Gertrude Stein's portrait.[7]

The fact that Matisse brought African art to Picasso's attention one night at the Steins' home is reported by Matisse himself, several times. The account that seems most reliable is an interview Matisse gave Pierre Courthion in 1941:

I used to pass very often through the rue de Rennes in front of a curio shop called Le Père Sauvage, and I saw a variety of things in the display case. There was a whole corner of little wooden statues of Negro origin. I was astonished to see how they were conceived from the point of view

of sculptural language, how it was close to the Egyptians. That is to say that compared to European sculpture, which always took its point of departure from musculature and started from the description of the object, these Negro statues were made in terms of their material, and according to invented planes and proportions.

I often looked at them, stopping each time I went past, without any intention of buying one, and then one fine day I went in and bought one for fifty francs.

I went to Gertrude Stein's house on rue de Fleurus. I showed her the statue, then Picasso arrived. We chatted. It was then that Picasso became aware of Negro sculpture. That's why Gertrude Stein speaks of it.

Derain bought a large mask. It became of interest to the group of advanced painters.[8]

1. G. Stein 1961, pp. 20–22. On this episode, see the entries for September 16 through October 9 or 10, 1907, in the Chronology. It was "ten days" after the opening of the Salon d'Automne, described in the *Autobiography*, that Toklas went to Montmartre. Stein's account is likely to create confusion in people's minds, for the exhibition she is actually referring to is the Salon des Indépendants of 1907 (and that of 1908) rather than the Salon d'Automne.

2. Ibid., p. 22.

3. The presence of *Three Women* next to the *Demoiselles* in the autumn of 1907 would confirm the early date of the painting's first state. It must not have been easy to see the *Demoiselles* and *Three Women* at the same time at the Bateau-Lavoir. In the old photographs in which the two paintings can be seen, the *Demoiselles* is resting on the ground behind the easel bearing *Three Women* (see the Chronology, figs. 2–4, pp. 154–55) or to the side, and concealed by a large piece of floral fabric (only the bottom part of the *Demoiselles* can be seen). See also figs. A–E in Seckel 1988, pp. 178–79.

4. G. Stein 1938, pp. 64–68. This was the first time a reproduction of the *Demoiselles* was published in a monograph on Picasso. The work is given an erroneous date: 1906 (p. 65). Judith Cousins has alerted me to the fact that the French and English editions of Stein's *Picasso* are two separate books. For this reason, she asked Edward Burns to check the manuscripts and related materials in The Beinecke Rare Book and Manuscript Library at Yale. The following information is excerpted from Mr. Burns's letter of March 18, 1993, to Judith Cousins.

The French edition of *Picasso* (Paris: Floury, March 12, 1938) includes a manuscript text (in French) and four typescripts. TS-1 and TS-2 were prepared by Toklas and include various changes and improvements made by Stein and Toklas; however, TS-2 contains changes in the French by an unknown hand. TS-3 is an exact copy of TS-2, but more substantive changes have been made than in TS-2. TS-4 is radically different from the MS and TS-1, TS-2, and TS-3. "It is this typescript, TS-4, that, with a few minor changes, is what the printed French text follows. By comparing this typescript with the other typescripts, it is apparent that the entire text underwent a final revision and rewrite.... How this final revision was made, and whether it was made by Stein herself, remains a mystery."

The English version of *Picasso* (London: B. T. Batsford, Ltd., October 1938; New York: Charles Scribner's Sons, February 1939) was prepared by Toklas. She did the translation, which she and Stein went over together; two typescripts exist of this translation. For her text Toklas ("presumably with Stein's authority") used some version of TS-2 or TS-3—"that is to say, Toklas used Stein's original typescript before it was reworked and revised." This explains the discrepancy between the French and English versions. Burns has not been able to determine if this was done because Toklas did not have a copy of the corrected French typescript or whether it was a conscious decision on Stein and Toklas's part. "What we are left with, then, are two different books, each having its own authority."

I am deeply indebted to Judith Cousins and Edward Burns for their help.

5. See the Salmon section, above, p. 246.

6. See above, "The Visit to the Trocadéro," p. 220.

7. G. Stein 1933, p. 63. Fernande Olivier (1965, p. 137) also says Matisse "was the first to discover what was to be the accepted value of African sculpture as art."

8. Quoted in Flam 1984a, pp. 216–17. In the same book (*"Primitivism" in Twentieth-Century Art* [Rubin 1984]), Jean-Louis Paudrat (1984, p. 139) and William Rubin (1984, p. 338, note 138) agree that this version of history is the most correct. It also appears, with some differences, in the interview published by André Warnod (1945, p. 1) and in an interview with Tériade (1952, p. 121). Laude (1968, p. 111) quotes a letter written to him by Georges Duthuit in 1958 recounting the episode as Max Jacob had told it to him: "We are in 1907 and Matisse notices in the display window of a dealer in exotic curios, called Le Père Sauvage, some statuettes from Africa. One evening he goes in and comes back out with a little seated man sticking his tongue out. Then he goes to Gertrude Stein's. Picasso arrives, and they talk about it." Picasso, when asked by Rubin about this meeting with Matisse, apparently did not attach great importance to it (Rubin 1984, pp. 295–96, 338, notes 138–39). Jean Vinchon (who is mentioned in Samaltanos 1984, p. 17) told this story quite differently: "The shops of savages' weapons, until now, displayed their fetishes, their masks and calabashes, lightly veiled in gray dust, only to the rare ethnographer. Then one day Picasso and Apollinaire stopped in front of one such shop, and the taste for African art began to spread" (Vinchon 1924, pp. 49–50). For his part, Michel Georges-Michel (1942, p. 13) writes: "One visit to an exhibit of African art with his friend Apollinaire sufficed for Picasso, who at first was greatly amused by them, to fall violently in love with these rough and barbarous forms." Such are the ways "history" is written.

LEO STEIN

After the initial enthusiasm that led Leo Stein (with his sister Gertrude) to buy his first Picasso in 1905 at Clovis Sagot's, the American collector began little by little to distance himself from the painter. No doubt the *Demoiselles* had something to do with his reservations. In his book on literature and the fine arts titled *Appreciation: Painting, Poetry, and Prose*, a work largely autobiographical in nature, he describes in not terribly sympathetic terms the care that Picasso, who was about to produce his masterpiece, devoted to the execution of the painting (the artist took the precaution of having the canvas lined before beginning to paint);[1] Stein tells of the transformations that, from the initial composition, led to a final result he deems hardly satisfying. He draws a parallel between this and the long-awaited production, by the "failed" master of Balzac's story *Le Chef-d'oeuvre inconnu*, Frenhofer, of an "unknown masterpiece," which Frenhofer ultimately destroys:

Picasso was pleasantly childlike at times. I had some pictures relined, and Picasso decided that he would have one of his pictures too treated like a classic, though in reverse order—he would have the canvas lined first and paint on it afterwards. This he did on a large scale, and painted a composition of nudes of the pink period, and then he repainted it again and again and finally left it as the horrible mess which was called, for reasons never heard, the Demoiselles d'Avignon.[2] *... Picasso, when he worked a long time, was busy with a remaking. The* Demoiselles d'Avignon *began as one thing and went through many phases, ending as a mixture of all sorts of things.*[3]

In these final words, Stein is comparing Picasso's working methods, which he suggests could only lead to chaos, with those of Matisse (described a few lines earlier), who was much more resolute, conducting an intensive study of form while nevertheless respecting the original unity of the project.

The problem with Picasso supposedly arises from a lack in the formal vocabulary available to him, which then led him to look outside—to African art—for what he could not find within himself:

Picasso's interior resources were too small for his then needs, and he had to have support from the outside. He found it in Negro art, which was a kind of substitute for an illustrative subject. With this he managed to "finish" Gertrude's portrait while we were away in Fiesole; though, as he left all except the mask as it had been before, the picture as a whole is incoherent. An artist, like a business man, needs a working capital; and if he can't make it by his own exertions, he has to borrow it. Picasso now borrowed it from the Negroes and it kept him going for a while. His forms grew bigger and in intention more powerful, but the reality was less than the appearance. I was not seriously interested in this stuff, but I was in his talent. Nor did I trust his morale. I often said that I had complete confidence in Matisse, who would give all that was possible for him to give, but that the future of Picasso was unpredictable, as there was no assured center. His present way was a makeshift, and to it there was no future that was inevitable. Of course with his talent he could make something of it as he could of anything, and in hopes of something better I bought a few of these Negroid things.[4]

Antonina Vallentin described Leo Stein's visit to the Bateau-Lavoir and his reaction upon seeing the *Demoiselles*, as recounted to her by Picasso:

One day, Leo Stein comes to his studio. He looks dumbfounded at the large painting. He understands nothing about it. It can't be a serious work, he says to himself. He nevertheless makes an effort, and suddenly he bursts out laughing: "Ah, now I know what you were trying to do— I see! I see!—You were trying to paint the fourth dimension. How funny!"

While recounting this scene, Picasso mimics the loud laughter [of Stein's] that echoed in his studio: "He was doubled over, holding his sides. He too thought I was mad, like the others...."[5]

Roland Penrose completes the scene by mentioning that Matisse as well was present that day:

Among the surprised visitors trying to understand what had happened he could hear Leo Stein and Matisse discussing it together. The only explanation they could find amid their guffaws was that he was trying to create a fourth dimension. In reality, Matisse was angry. His immediate reaction was that the picture was an outrage, an attempt to ridicule the modern movement. He vowed that he would find some means to "sink" Picasso and make him sorry for his audacious hoax.[6]

1. Lining is generally a restoration procedure, carried out when the canvas on which a work was painted proves too fragile. It is highly unusual for this to be

done before the execution of a work. See the entry in the Chronology under "Before Summer 1907."

2. L. Stein 1947, p. 175. Leo Stein used the expression "Godalmighty rubbish" in a letter to Mabel Weeks of February 7, 1912, to characterize hermetic Cubist works of 1911 and Gertrude's "Portrait of Mabel Dodge," written in mid-September 1911. The letter is published in L. Stein 1950, p. 53.

Barr, writing the following year (Barr 1951b, p. 166) of Leo Stein's waning enthusiasm for Matisse and Picasso, incorporated Stein's expression (without citing its source) in his own text to show Stein's disaffection with Cubism and, by extension, with the *Demoiselles*, although Stein made no reference to the picture in his letter to Mabel Weeks. Thus we read in Barr: "Picasso was painting his big *Demoiselles d'Avignon*, which initiated cubism—and cubism Leo was later to condemn as 'godalmighty rubbish.'" Barr (1954, p. 68) also tells the story of the lining, which he places in autumn 1906. Steinberg 1988, p. 63, note 50, shows that this is unlikely. In the text of Leo Stein quoted here, no date is indicated. In any case, the episode took place before his departure for Italy, where he spent the summer of 1907. See "Early in the Year to Early Summer 1907: Visitors to the Bateau-Lavoir," in the Chronology. See also Penrose 1958, p. 124: "After months of work on drawings and studies, Picasso painted with determination and in the space of a few days a large picture measuring nearly eight feet square. He took unusual care in the preparation of the canvas. The smooth type of canvas that he liked to paint on would not have been strong enough for so large a surface."

3. L. Stein 1947, p. 181.

4. Ibid., pp. 174–75. These are quite likely some sheets from a broken-up sketchbook (see Daix, 1988b, pp. 521–22). Uhde (1938, p. 142) notes that Stein was the first to acquire works by Picasso marked by the influence of primitive art. But this supposedly was "to prove that Picasso was traveling along a wrong track" (Uhde 1929, p. 23).

5. Vallentin 1957, p. 150.

6. Penrose 1973, p. 130 (1958 edition, p. 125). This may be put in relation to a letter from Picasso to Kahnweiler dated June 12, 1912, mentioning that Matisse and Stein had joked about a "Shchukin-style painting" and that Leo Stein had invoked the fourth dimension. However, the "Shchukin-style painting" is in all likelihood *Woman with a Fan* of 1909 (see Richardson 1991, p. 392). Parmelin (1980, p. 69) says it was with Félix Fénéon that Matisse joked about this work.

WILHELM UHDE

Kahnweiler recounts:

In March 1907, my good friend Wilhelm Uhde, who died in the summer of 1947, told me he had seen in Picasso's studio a recent, large painting that astonished him. He found it strange, a bit Egyptian, he said, to give me some idea of it.[1]

Elsewhere, Kahnweiler writes that Uhde had used the word "Assyrian."[2] Uhde, a German critic and collector living in Paris, had been invited, through an express letter sent by Picasso, to come to the artist's studio (he had made Picasso's acquaintance by chance at the café Le Lapin Agile in 1905, just after having bought one of his paintings).[3] In 1928 Uhde writes:

I remember the pneumatique I received one day from Picasso; he begged me to come at once to see him and to examine some of his recent paintings before which such sensitive men as Fénéon and Vollard, without understanding them, had shaken their heads. Somehow he expected a quicker comprehension from me; unfortunately he was disappointed in this hope. Several months of reflection were needed before I was able fully to seize these first plastic experiments influenced by negro art.[4]

Uhde mentions the incomprehension of Vollard and Fénéon, and his own difficulty in understanding what had just been revealed to him. But exactly what had he seen?

Ten years later, Uhde is somewhat more explicit: the "immense canvas with women and fruits," which he saw again at Jacques Doucet's, is indeed the *Demoiselles*:

In early 1907 I received a desperate note from Picasso asking me to come see him at once. He was troubled about the new things; Vollard and Fénéon had paid him a visit but had left without understanding anything. At his place I found that immense canvas with women and fruits (which I would later see again at Doucet's, a few weeks before the famous collector's death) as wells as several smaller paintings, all influenced by African sculpture. At the time, I left in the same state as the two others had; I needed weeks in order to be able to revive within myself the feeling that had led Picasso on that track. But once I understood this new language, I faithfully accompanied Picasso down that road, because he was fighting for great things, to give meaning and formal reality, on the human and artistic level, to a new sensibility and to new aspirations, and because he was mocked and ridiculed by the very people who worship him today.[5]

Further on he recounts how he was received by Doucet, a few weeks before the death of the collector, who seems to have left a vivid impression on him:

… as an old man, suddenly and with youthful enthusiasm, [Doucet] started collecting Cubist pictures of Picasso, Braque, as well as works of Rousseau and of the young school. He had the demeanor of a grand seigneur and received me in the salon of his beautiful adobe like a head of state would receive a foreign ambassador. With emotion in his voice he told me how happy he was to welcome the man to his home, who has been his role model as a collector, and that he now wanted to hear from the horse's mouth whether he was a worthy successor and represented the fame of the artists to my approval. He spoke those words, which put me to shame and confused me, in a manner befitting a king in the process of bestowing a high honor. I demurely intimated how happy it made me to see, so perfectly preserved, the pictures I loved, such as the "Arlésiennes" by Picasso and the "Charmeuse de Serpents" by Rousseau, which brought back beautiful memories of the past and were to be willed to the Louvre. In this collection of a distinguished old gentleman, there was no reflection, no philosophical thought, just a heart that had remained young, a sensuality that had survived over the years. I did not know at that time, that this life was to end only a few weeks later.[6]

In his great emotion Uhde has apparently confused Avignon with Arles.

1. Kahnweiler 1949a, p. 14.

2. As in Kahnweiler 1971a, p. 38 (1961 edition, p. 44).

3. See Uhde 1938, pp. 140–41.

4. Uhde 1929, pp. 22–23.

5. Uhde 1938, p. 142.
6. Ibid., p. 256. Translated by Ingeborg von Zitzewitz. "Arlésiennes" can only
be a reference to *Les Demoiselles d'Avignon*. There are two paintings by Picasso
called *Arlésienne* (Zervos II¹, 356; II², 361) but they never belonged to Doucet. For
the Picassos owned by Doucet, see Chapon 1984, p. 386, note 92.

AMBROISE VOLLARD

This famous art dealer, closely associated with Picasso's beginnings
in Paris, did not record his thoughts about the *Demoiselles* when he
saw the work at the Bateau-Lavoir. We can only rely on that which
other witnesses reported. Picasso told Uhde that before "some of his
recent paintings … such sensitive men as Fénéon and Vollard, with-
out understanding them, had shaken their heads."[1]

And Kahnweiler said:

*I know that at that time Vollard did not appreciate what Picasso was
doing, since he did not buy from him anymore, which is the best proof
that he didn't like his work. Vollard had certainly seen the "Demoiselles
d'Avignon," which he must have disliked excessively, as did everyone else
at the time.*[2]

1. Uhde 1929, p. 22; and Uhde 1938, p. 142, where the same story refers to the
Demoiselles specifically.
2. Kahnweiler 1971a, p. 39.

References for Works of Art

The following books are cited, in abbreviated form, in the captions in this volume. When cited in the text, they document works that are mentioned but not reproduced.

BLOCH
Georges Bloch. *Pablo Picasso: Catalogue de l'oeuvre gravé et lithographié.* 4 vols. Bern: Kornfeld & Klipstein, 1968–79.

DAIX
Pierre Daix and Joan Rosselet. *Picasso: The Cubist Years, 1907–1916—A Catalogue Raisonné of the Paintings and Related Works.* Boston: New York Graphic Society; London: Thames & Hudson, 1979.

D./B.
Pierre Daix and Georges Boudaille, with Joan Rosselet. *Picasso: The Blue and Rose Periods—A Catalogue Raisonné of the Paintings.* Greenwich, Conn.: New York Graphic Society, 1966.

GEISER/BAER
Picasso, peintre-graveur. Vol. 1, by Bernhard Geiser (Bern: B. Geiser, 1933). Vol. 2, by Geiser, in collaboration with Alfred Scheidegger (Bern: Kornfeld & Klipstein, 1968). Vols. 3–5, by Brigitte Baer (Bern: Éditions Kornfeld, 1989).

SECKEL
Hélène Seckel, ed. *Les Demoiselles d'Avignon.* 2 vols. Paris: Réunion des Musées Nationaux, 1988.

SPIES
Werner Spies. *Picasso: Das plastsiche Werk.* Stuttgart: Gerd Hatje, 1983.

ZERVOS
Christian Zervos. *Pablo Picasso.* 33 vols. Paris: Cahiers d'Art, 1932–78.

Bibliography

ADÉMA 1968
Marcel Adéma. *Guillaume Apollinaire*. Paris: La Table Ronde, 1968.

ALLEY 1986
Ronald Alley. *Picasso: The Three Dancers.* London: Tate Gallery, 1986.

AMÓN 1973
Santiago Amón. *Picasso*. Madrid: Diágolo, 1973.

AMÓN 1980
Santiago Amón. *"Les Demoiselles d'Avignon:* Une Révolution du regard." *Le Courrier de l'Unesco* (Paris), vol. 33 (December 1980), pp. 13–14.

ANDERSEN 1983
Troels Andersen. *Jens Adolf Jerichau (1890–1916).* Copenhagen: Borgen, 1983.

ANONYMOUS 1916A
[Signed "Le Wattmann"]. "Nos Échos." *L'Intransigeant* (Paris), July 16, 1916, p. 2.

ANONYMOUS 1916B
"Lettres et art: Cubistes." *Le Cri de Paris* (Paris), vol. 20, no. 1008 (July 23, 1916), p. 10.

ANONYMOUS 1923
"Picasso Speaks." *The Arts* (New York), no. 5 (May 1923), pp. 315–26. Reprinted in Barr 1939b and Barr 1946 as an interview conducted by Marius de Zayas. Reprinted in German in Westheim [n.d.], without identification of interviewer.

ANONYMOUS 1925
"Un Temple de l'art moderne, l'appartement de M.J.D." *Fémina*, January 1925, pp. 29–32.

ANONYMOUS 1930
"Notice documentaire." *Documents* (Paris), vol. 2, no. 3 (1930), p. 180.

ANONYMOUS 1937A
"Picasso in Dual New York Exhibitions." *The Art Digest* (New York), vol. 12, no. 3 (November 1, 1937), p. 10.

ANONYMOUS 1937B
"Art Notes." *Brooklyn Daily Eagle* (New York), November 7, 1937, section C, p. 11.

ANONYMOUS 1937C
"Picasso, Pro and Con." *The Art Digest* (New York), vol. 12, no. 4 (November 15, 1937), p. 13.

ANONYMOUS 1937D
"Spanish Demoiselles." *Time* (New York), vol. 30, no. 22 (November 29, 1937), p. 26.

ANONYMOUS 1939A
"Pablo Picasso, Exhibited, Sold and Honored." *The Art Digest* (New York), vol. 8, no. 9 (February 1, 1939), p. 12.

ANONYMOUS 1939B
"*Life* Goes to the Opening of the New, $2,000,000 Glass-Front Building of New York's Famed Museum of Modern Art." *Life* (New York), vol. 6, no. 21 (May 22, 1939), p. 82.

ANONYMOUS 1988
"Les Demoiselles d'Avignon." *Revue du Louvre et des Musées de France* (Paris), vol. 38, no. 1 (1988), pp. 67–68.

APOLLINAIRE 1917
Guillaume Apollinaire. "À propos de l'art des noirs." In *Sculptures nègres*. Paris: Paul Guillaume, 1917. Also published as "Mélano-philie ou mélanomanie," in *La Vie anecdotique* (April 1, 1917); and in Clouzot/Level 1919a, pp. 5–8.

APOLLINAIRE 1962
Guillaume Apollinaire. *Tendre comme le souvenir*. Paris: Gallimard, 1962. First published in 1952.

APOLLINAIRE 1972
Guillaume Apollinaire. *Apollinaire on Art: Essays and Reviews, 1902–1918.* Edited by LeRoy C. Breunig. New York: Viking, 1972. Translation by Susan Suleiman of *Guillaume Apollinaire: Chroniques d'art, 1902–1918.* Edited by Breunig. Paris: Gallimard, 1960.

APOLLINAIRE 1991A
Guillaume Apollinaire. *Guillaume Apollinaire: Journal intime, 1898–1918.* Edited by Michel Décaudin. Paris: Limon, 1991.

APOLLINAIRE 1991B
Guillaume Apollinaire. *Oeuvres en prose complètes*, vol. 2. Edited by Pierre Caizergues and Michel Décaudin. Paris: Gallimard, 1991.

APOLLINAIRE 1992
Guillaume Apollinaire. *I. Corrispondenza con F. T. Marinetti, A. Soffici, U. Boccioni, G. Severini, U. Brunelleschi, G. Papini, S. Aleramo, C. Carrà.* Edited by Lucia Bonato. Introductory texts by

Michel Décaudin and Sergio Zoppi. Rome: Bulzoni, 1992.

APOLLINAIRE 1993
Guillaume Apollinaire. *Oeuvres en prose complètes*, vol. 3. Edited by Pierre Caizergues and Michel Décaudin. Paris: Gallimard, 1993.

AURIC 1979
Georges Auric. *Quand j'étais là*. Paris: Bernard Grasset, 1979.

BANDMANN 1965
Günter Bandmann. *Pablo Picasso: "Les Demoiselles d'Avignon."* Stuttgart: Philipp Reclam Jun, 1965.

BARR 1936
Alfred H. Barr, Jr. *Cubism and Abstract Art.* New York: The Museum of Modern Art, 1936. Reprinted, New York: Arno Press, 1966; Boston: New York Graphic Society, 1974; Cambridge, Mass.: Belknap Press of Harvard University Press, 1986.

BARR 1939A
Alfred H. Barr, Jr. *Art in Our Time: An Exhibition to Celebrate the Tenth Anniversary of The Museum of Modern Art and the Opening of Its New Building.* New York: The Museum of Modern Art, 1939.

BARR 1939B
Alfred H. Barr, Jr. *Picasso: Forty Years of His Art.* New York: The Museum of Modern Art, 1939. 3rd ed., revised and corrected, 1940.

BARR 1943
Alfred H. Barr, Jr. *What Is Modern Painting?* New York: The Museum of Modern Art, 1943.

BARR 1946
Alfred H. Barr, Jr. *Picasso: Fifty Years of His Art.* New York: The Museum of Modern Art, 1946. Reprinted, 1974.

BARR 1951A
Alfred H. Barr, Jr. *Matisse: His Art and His Public.* New York: The Museum of Modern Art, 1951. Reprinted, 1974.

BARR 1951B
Alfred H. Barr, Jr. "Matisse, Picasso, and the Crisis of 1907." *Magazine of Art* (New York), vol. 44, no. 5 (May 1951), pp. 163–70.

BARR 1954
Alfred H. Barr, Jr., ed. *Masters of Modern Art.*
New York: The Museum of Modern Art, 1954.

BASLER 1926
Adolphe Basler. *La Peinture, religion nouvelle.*
Paris: Librairie de France, 1926.

BAURET 1982
Gabriel Bauret. "*Les Demoiselles d'Avignon:*
Manifeste du cubisme?" *Europe* (Paris), vol. 60,
nos. 638–39 (June–July 1982), pp. 26–31.

BEAUMELLE 1991
Agnès Angliviel de la Beaumelle, Isabelle
Monod-Fontaine, and Claude Schweisgut, eds.
André Breton: La Beauté convulsive. Paris: Musée
National d'Art Moderne, Centre Georges
Pompidou, 1991.

BEER 1934
Richard Beer. "Art Collectors in America: Frank
Crowninshield." *Art News* (New York), vol. 32,
no. 18 (February 3, 1934), p. 13.

BERGER 1965
John Berger. *The Success and Failure of Picasso.*
Harmondsworth: Penguin, 1965.

BERNIER 1955
Georges and Rosamond Bernier, eds. *The
Selective Eye: An Anthology of the Best from
"L'Oeil," the European Art Magazine.* Foreword
by Alfred H. Barr, Jr. New York: Random
House, 1955.

BERSWORDT-WALLRABE 1985
Kornelia von Berswordt-Wallrabe. "Zur
Interpretation von Picassos Bild *Les Demoiselles
d'Avignon.*" *Pantheon* (Munich), vol. 43 (1985),
pp. 155–65.

BLESH 1956
Rudi Blesh. *Modern Art USA: Men, Rebellion,
Conquest, 1900–1956.* New York: Knopf, 1956.

BLUNT / POOL 1962
Anthony Blunt and Phoebe Pool.
*Picasso: The Formative Years—A Study of His
Sources.* London: Studio Books, 1962.

BOECK / SABARTÉS 1955
Wilhelm Boeck and Jaime Sabartés. *Picasso.*
Translated by J.-E. de Lago. New York and
Amsterdam: Abrams, 1955. Paris: Flammarion,
[1955].

BOGGS 1992
Jean Sutherland Boggs. *Picasso and Things.*
With essays by Marie-Laure Bernadac and
Brigitte Léal. Cleveland: The Cleveland
Museum of Art, 1992.

BOIS 1985
Yve-Alain Bois. "La Pensée sauvage." *Art in
America* (New York), vol. 73, no. 4 (April 1985),
pp. 178–88.

BOIS 1987
Yve-Alain Bois. "Kahnweiler's Lesson."
Representations (Berkeley), no. 18 (Spring 1987),
pp. 33–68. Revised text published in Bois 1990
(Painting as Model). Published in French as "La
Leçon de Kahnweiler." *Les Cahiers du Musée
National d'Art Moderne* (Paris), no. 23 (Spring
1988), pp. 29–56.

BOIS 1988A
Yve-Alain Bois. "Painting as Trauma." *Art in
America* (New York), vol. 76, no. 6 (June 1988),
pp. 130–40, 172–73. Published in French as "Le
Trauma des Demoiselles." *Critique* (Paris), no.
497 (October 1988), pp. 834–57.

BOIS 1988B
Yve-Alain Bois. "Letter to the Editor." *Art in
America* (New York), vol. 76, no. 10 (October
1988), p. 23.

BOIS 1989
Yve-Alain Bois. "Exposition: Musée Picasso—
Les Demoiselles d'Avignon." Encyclopaedia
Universalis: *Universalia 1989* , pp. 487–88.

BOIS 1990
Yve-Alain Bois. *Painting as Model.* Cambridge,
Mass.: MIT Press, 1990.

BOLANDER 1938
Carl-August Bolander. "Flickorna i Avignon."
Dagens Nyheter (Stockholm), April 17, 1938, pp.
9, 13.

BOURET 1970
Jean Bouret. "Une Amitié esthétique au début
du siècle: Apollinaire et Paul Guillaume
(1911–1918) d'après une correspondance inédite."
Gazette des Beaux-Arts (Paris), vol. 76, no. 1223
(December 1970), pp. 373–99.

BRASSAÏ 1966
Brassaï. *Picasso and Company.* Translated by
Francis Price. Garden City, N.Y.: Doubleday,
1966. Originally published as *Conversations avec
Picasso.* Paris: Gallimard, 1964.

BRASSAÏ 1982
Brassaï. *The Artists of My Life.* Translated by
Richard Miller. New York: Viking, 1982.
Originally published as *Les Artistes de ma vie.*
Paris: Denoël, 1982.

BREERETTE 1988
Geneviève Breerette. "La Genèse d'un tableau."
Le Monde (Paris), January 30, 1988, p. 17.

BRENSON 1988
Michael Brenson. "Art: Picasso's *Demoiselles.*"
New York Times, February 8, 1988, p. C13.

BRETON 1969
André Breton. *Entretiens (1913–1952) avec André
Parinaud.* Rev. ed., Paris: Gallimard, 1969. First
published 1952.

BRETON 1970
André Breton. "C'est à vous de parler, jeune
voyant des choses . . ." In *Perspective cavalière.*
Paris: Gallimard, 1970. Reprint of *XXᵉ Siècle*
(Paris), n.s., no. 3 (June 1952), pp. 27–30.

BRETON 1988
André Breton. *Oeuvres complètes*, 2 vols. Edited
by Marguerite Bonnet et al. Paris: Gallimard,
1988.

BREUNIG 1957
LeRoy C. Breunig. "Max Jacob et Picasso."
Mercure de France (Paris), no. 1132 (December
1957), pp. 581–96.

BRODSKY 1986
Joyce Brodsky. "Delacroix's *Le Lever*, Cézanne's
Interior with Nude, Picasso's *Les Demoiselles
d'Avignon* and the Genre of the Erotic Nude."
Artibus et historiae (Vienna), vol. 7, no. 13
(1986), pp. 127–51.

BRUYNOGHE 1979
Margo Bruynoghe, ed. *Grand Musée anatomique
du docteur Spitzner.* Brussels: Musée d'Ixelles,
1979.

BUCKLEY 1981
Harry E. Buckley. *Guillaume Apollinaire as an
Art Critic.* Ann Arbor, Mich.: UMI Research
Press, 1981. Revised edition of a thesis submitted
to the University of Iowa, Iowa City, 1969.

BURGESS 1910
Gelett Burgess. "The Wild Men of Paris." *The
Architectural Record* (New York), vol. 27, no. 5
(May 1910), pp. 400–14. Written 1908. The
Demoiselles is reproduced.

BURNS 1970
Edward Burns, ed. *Gertrude Stein on Picasso.*
Afterword by Leon Katz and Edward Burns.
New York: Liveright, in cooperation with The
Museum of Modern Art, 1970.

CABANNE 1979
Pierre Cabanne. *Le Siècle de Picasso*, vol. 1:
(1881–1912) La Naissance du cubisme. Paris:
Denoël/Gonthier, 1979. 1st ed., vol. 1: *La
Jeunesse, le cubisme, le théâtre, l'amour
(1881–1937).* Paris: Denoël, 1975.

CACHIN / MINERVINO 1977
Françoise Cachin (Introduction) and Fiorella
Minervino (Catalogue). *Tout l'Oeuvre peint de
Picasso, 1907–1916.* Paris: Flammarion, 1977.
Translation by Claire Braunschvig of *L'Opera
completa di Picasso cubista*, Milan: Rizzoli, 1972.

CAHIERS D'ART 1927
Cahiers d'art (Paris), vol. 2, nos. 7–8 (1927), p. 254. The *Demoiselles* is reproduced.

CAHIERS D'ART 1932
Picasso. Special issue of *Cahiers d'art* (Paris), vol. 7, nos. 3–5 (1932), pp. 85–196; the *Demoiselles* is reproduced p. 101. Contributions by Christian Zervos, Félicien Fagus, Adrien Farge, Guillaume Apollinaire, Igor Stravinsky, André Salmon, Jacques-Émile Blanche, Jean Metzinger, Henri Mahaut, Régis Gignoux, Louis Vauxcelles, Pierre Guéguen, Georges Hugnet, Ramón Gomez de la Serna, Jean Cocteau, James Johnson Sweeney, H. S. Ede, Carl Einstein, Pierre Reverdy, Maurice Raynal, Amédée Ozenfant, Oskar Schürer, André Breton, Paul Éluard, Will Grohmann, Maud Dale, Vicente Huidobro, Adolphe Basler, Jacques Maritain, Pablo Picasso, Marius de Zayas, Arthur Jerome Eddy, Giovanni Scheiwiller.

CAHIERS D'ART 1935
Picasso, 1930–1935. Special issue of *Cahiers d'art* (Paris), vol. 10, nos. 7–10 (1935), pp. 143–262. Contributions by Christian Zervos, Paul Éluard, André Breton, Benjamin Péret, Man Ray, Salvador Dalí, Georges Hugnet, Jaime Sabartés, Luis Fernandez, Julio Gonzales, and Joan Miró.

CAIZERGUES 1979
Pierre Caizergues. "Apollinaire journaliste." Thesis, Université de Lille, 1979.

CARANDENTE 1981
Giovanni Carandente. *Picasso: Opere dal 1895 al 1971 dalla collezione Marina Picasso.* Florence: Sansoni, 1981.

CARCO 1924
Francis Carco. *Le Nu dans la peinture moderne, 1863–1920.* Paris: G. Crès, 1924.

CARCO 1927
Francis Carco. *De Montmartre au Quartier latin.* Paris: Albin Michel, 1927.

CARRÀ 1920
Carlo Carrà. "Picasso." *Valori plastici* (Rome), vol. 2, nos. 9–12 (1920), pp. 101–07.

CAUMAN 1991
John Cauman. "Henri Matisse's Letters to Walter Pach." *Archives of American Art Journal* (Washington, D.C.), vol. 31, no. 3 (1991), pp. 2–14.

CHABANNE 1988
Thierry Chabanne. "Étude de tableau: *Les Demoiselles d'Avignon.*" *Beaux-Arts Magazine* (Paris), no. 54 (February 1988), pp. 38–43.

CHANIN 1951
Abraham Levick Chanin. "Les Demoiselles de Picasso." *New York Times Magazine,* August 18, 1951.

CHANIN 1952
Abraham Levick Chanin. "Picasso's Historic Cubist Work, the Striking *Les Demoiselles.*" *The Compass* (New York), July 20, 1952, p. 26.

CHANIN 1957
Abraham Levick Chanin. "Les Demoiselles de Picasso." *New York Times Magazine,* August 18, 1957, pp. 16, 20.

CHAPON 1984
François Chapon. *Mystère et splendeurs de Jacques Doucet, 1853–1929.* Paris: Jean-Claude Lattès, 1984.

CHIPP 1955
Herschel B. Chipp. "Cubism, 1907–1914." Ph.D. dissertation, Columbia University, New York, 1955. Facsimile, Ann Arbor, Mich.: University Microfilms International, 1986.

CHIPP 1968
Herschel B. Chipp, with Peter Selz and Joshua C. Taylor. *Theories of Modern Art: A Source Book for Artists and Critics.* Berkeley and London: University of California Press, 1968.

CHONEZ 1938
Claudine Chonez. "New York et l'amour de l'art." *Marianne* (Paris), vol. 6, no. 280 (March 2, 1938), p. 11. The *Demoiselles* is reproduced.

CLAIR 1988A
Jean Clair. *Le Nu et la norme: Klimt et Picasso en 1907.* Paris: Gallimard, 1988.

CLAIR 1988B
Jean Clair. "The Eye of Disorder and Desire." *Art International* (Paris), Summer 1988, pp. 7–19.

CLOUZOT / LEVEL 1919A
Henri Clouzot and André Level. "L'Art sauvage: Océanie–Afrique." In: *Première Exposition d'art nègre et d'art océanien, organisée par M. Paul Guillaume.* Paris: Galerie Devambez, 1919.

CLOUZOT / LEVEL 1919B
Henri Clouzot and André Level. *L'Art nègre et l'art océanien.* Paris: Galerie Devambez, 1919.

COATES 1937
Robert M. Coates. "The Art Galleries: Picasso Everywhere—Stieglitziana." *The New Yorker* (New York), November 20, 1937, p. 39.

COCTEAU 1923
Jean Cocteau. *Picasso.* Paris: Stock, 1923.

COGNIAT 1935
Raymond Cogniat. "Notes chronologiques." In *Les Créateurs du cubisme.* Paris: Beaux-Arts & Gazette des Beaux-Arts, 1935.

CONTENSOU / MOLINARI 1987
Bernadette Contensou, Danielle Molinari, et al. *Paris 1937: L'Art indépendant.* Paris: Musée d'Art Moderne de la Ville de Paris, 1987.

COOPER 1971
Douglas Cooper. *The Cubist Epoch.* London: Phaidon; Los Angeles: The Los Angeles County Museum of Art; New York: The Metropolitan Museum of Art, 1971.

CORTISSOZ 1937
Royal Cortissoz. "The Evolution of Picasso." *New York Herald Tribune,* November 7, 1937, section 7, p. 8.

COSSIO 1908
Manuel B. Cossio. *El Greco.* Madrid: Victoriano Suárez, 1908.

COURCELLES 1988
Pierre Courcelles. "La Révolution Picasso." *Révolution* (Paris), no. 417 (February 26, 1988), pp. 11–14.

COUSINS 1989
Judith Cousins. "Documentary Chronology," with the collaboration of Pierre Daix. In Rubin 1989 (*Picasso and Braque: Pioneering Cubism,* New York: The Museum of Modern Art, 1989).

COUSINS / SECKEL 1988
Judith Cousins and Hélène Seckel. "Éléments pour une chronologie de l'histoire des *Demoiselles d'Avignon.*" In Seckel 1988 (*Les Demoiselles d'Avignon,* 2 vols., Paris: Réunion des Musées Nationaux, 1988).

COWLING 1985
Elizabeth Cowling. "'Proudly We Claim Him as One of Us': Breton, Picasso, and the Surrealist Movement." *Art History* (Oxford), vol. 8, no. 1 (March 1985), pp. 82–104.

CRASTRE 1947
Victor Crastre. *La Naissance du cubisme: Céret, 1910.* [Paris:] Ophrys, [1947].

CREPAX 1985
Guido Crepax. "Vive Trotsky!" In Crepax, *Le Journal de Valentina.* Paris: Futuropolis, 1985. Translation by Dominique Grange of the Italian edition, 1974. Previously published in *Charlie mensuel* (Paris), no. 72 (January 1975), pp. 64–96.

DAIX 1964
Pierre Daix. *Picasso.* Paris: Aimery Somogy, 1964.

DAIX 1970
Pierre Daix. "Il n'y a pas 'd'art nègre' dans *Les Demoiselles d'Avignon.*" *Gazette des beaux-arts* (Paris), series 6, vol. 76, no. 1221 (October 1970), pp. 247–70. Translated and reprinted as "There Is No African Art in the *Demoiselles*

d'Avignon." In Gert Schiff, ed., *Picasso in Perspective*. Englewood Cliffs, N.J.: Prentice Hall, 1976.

DAIX 1973
Pierre Daix. "For Picasso, Truth Was Art; and Falsity, the Death of Art." *Art News* (New York), vol. 72, no. 6 (Summer 1973), pp. 47–49.

DAIX 1975A
Pierre Daix. *Aragon: Une Vie à changer*. Paris: Seuil, 1975.

DAIX 1975B
Pierre Daix. "Picasso et l'art nègre." In *Art nègre et civilisation de l'universel*. Dakar-Abidjan: Les Nouvelles Éditions Africaines, 1975. Proceedings of a colloquium held in Dakar, May 1972.

DAIX 1977
Pierre Daix. *La Vie de peintre de Pablo Picasso*. Paris: Seuil, 1977.

DAIX 1979
Pierre Daix. "The Conception of *Les Demoiselles d'Avignon*: Autumn 1906–March 1907" and "The Second Period of Work on *Les Demoiselles d'Avignon*: The Transition from Matter-of-Factness to Violence, Spring 1907." In Daix/Rosselet 1979 (*Picasso: The Cubist Years, 1907–1916—A Catalogue Raisonné of the Paintings*, Boston: New York Graphic Society; London: Thames & Hudson, 1979).

DAIX 1982A
Pierre Daix. "La Révolution du cubisme: Du Salon des Indépendants de 1907 aux *Demoiselles d'Avignon*." In *Le Temps des révolutions: Fauvisme, Expressionnisme, Cubisme, Futurisme, 1900–1914*. Geneva: Skira, 1982.

DAIX 1982B
Pierre Daix. *Cubists and Cubism*. New York: Rizzoli, 1982. Translated by R. F. M. Dexter from *Journal du cubisme*. Geneva: Skira, 1982.

DAIX 1987A
Pierre Daix. *Picasso créateur: La Vie intime et l'oeuvre*. Paris: Seuil, 1987. English ed., *Picasso: Life and Art*. Translated by Olivia Emmet. New York: HarperCollins, Icon Editions, 1993.

DAIX 1987B
Pierre Daix. "Picasso's Time of Decisive Encounters." *Art News* (New York), vol. 86, no. 4 (April 1987), pp. 136–41.

DAIX 1987C
Pierre Daix. *Picasso: Cubist Works from the Marina Picasso Collection*. New York: Jan Krugier Gallery, 1987.

DAIX 1988A
Pierre Daix. "L'Historique des *Demoiselles d'Avignon* révisé à l'aide des carnets de Picasso."

In Seckel 1988 (*Les Demoiselles d'Avignon*, 2 vols., Paris: Réunion des Musées Nationaux, 1988).

DAIX 1988B
Pierre Daix. "Les Trois Périodes de travail de Picasso sur *Les trois femmes* (automne 1907–automne 1908), les rapports avec Braque et les débuts du cubisme." *Gazette des beaux-arts* (Paris), series 6, vol. III, nos. 1428–29 (January–February 1988), pp. 141–54.

DAIX 1988C
Pierre Daix. "La Nouvelle Virginité des *Demoiselles d'Avignon*." *Le Quotidien de Paris*, January 28, 1988, p. 7.

DAIX 1988D
Pierre Daix. "Picasso: Confrontation entre les debuts de sa modernité et les derniers messages de son art." In "La Chronique des arts." *Gazette des beaux-arts* (Paris), series 6, vol. III, nos. 1432–33 (May–June 1988), pp. 1–2.

DAIX 1988E
Pierre Daix. "Dread, Desire, and the *Demoiselles*." Translated by Matthew Ward. *Art News* (New York), vol. 87, no. 6 (Summer 1988), pp. 133–37.

DAIX 1990
Pierre Daix. *Picasso*. Paris: Éditions du Chêne (Profils de l'art), 1990. German ed., Cologne: DuMont, 1991.

DAIX 1991
Pierre Daix. "Maurice Raynal et le cubisme" (with description of a sketch for *Les Demoiselles d'Avignon*). In *Ancienne collection Maurice Raynal* (auction catalogue). Paris: Drouot Montaigne, November 28, 1991, pp. 5–7, 8–10.

DAIX 1992A
Pierre Daix. "The Chronology of Proto-Cubism: New Data on the Opening of the Picasso-Braque Dialogue." In *Picasso and Braque: A Symposium*. New York: The Museum of Modern Art, 1992.

DAIX 1992B
Pierre Daix. "The Years of the Great Transformation." In M. Teresa Ocaña and Hans Christoph von Tavel, *Picasso, 1905–1906*. Barcelona: Electa España, 1992.

DAIX / BOUDAILLE 1966
Pierre Daix and Georges Boudaille, with Joan Rosselet. *Picasso: The Blue and Rose Periods—A Catalogue Raisonné of the Paintings, 1900–1906*. Translated by Phoebe Pool. Greenwich, Conn.: New York Graphic Society, 1966. French ed., *Picasso 1900–1906: Catalogue raisonné de l'oeuvre peint*. 1966; Neuchâtel: Ides & Calendes, 1988.

DAIX / ROSSELET 1979
Pierre Daix and Joan Rosselet. *Picasso: The Cubist Years, 1907–1916—A Catalogue Raisonné of the Paintings and Related Works*. Translated by Dorothy S. Blair. Boston: New York Graphic Society; London: Thames & Hudson, 1979. French edition, *Le Cubisme de Picasso: Catalogue raisonné de l'oeuvre peint, 1907–1916*. Neuchâtel: Ides & Calendes, 1979.

DALE 1930
Maud Dale. *Modern Art: Picasso*. New York: Knopf, 1930.

DAVIDSON 1937
Martha Davidson. "Second Annual Picasso Festival: Dual Exhibitions Again of the Hispano-French Master." *The Art News* (New York), vol. 36, no. 6 (November 6, 1937), pp. 10–11, 22.

DÉCAUDIN 1981
Michel Décaudin. *La Crise des valeurs symbolistes: Vingt Ans de poésie française, 1895–1914*. 1960; Geneva and Paris: Slatkine, 1981.

DENTI 1986
Mario Denti. "Due Demoiselles di tradizione ellenistica: Sul ruolo dell'arte antica nella formazione del cubismo." *Prospettiva* (Florence), no. 47 (October 1986), pp. 75–87.

DISPOT 1988
Laurent Dispot. "Les Coincidences: Michel-Ange, Zurbarán, donc Picasso!" *L'Officiel de la Couture* (Paris), March 1988, pp. 337, 352.

DONNE 1978
John B. Donne. "African Art and Paris Studios, 1905–1920." In Michael Greenhalgh and Vincent Megaw, eds., *Art and Society: Studies in Style, Culture, and Aesthetics*. London: Duckworth, 1978. Published in French as "L'Art nègre dans les ateliers de l'école de Paris, 1905–1920." *Arts d'Afrique noire* (Arnouville), no. 71 (Autumn 1989), pp. 21–28.

DOR DE LA SOUCHÈRE 1960
Romuald Dor de la Souchère. *Picasso à Antibes*. Paris: Fernand Hazan, 1960. English ed., *Picasso in Antibes*. New York: Pantheon; London: Percy Lund, Humphries, 1960.

DORGELÈS 1947
Roland Dorgelès. *Bouquet de Bohème*. Paris: Albin Michel, 1947.

DREYFUS 1923
Albert Dreyfus. "Picasso (1922)." *Der Querschnitt* (Frankfurt am Main), vol. 3, nos. 1–2 (Summer 1923), pp. 56–59.

DUBOIS 1973
André Dubois. "Cubisme et cubismes." In *Le Cubisme*. Saint-Étienne: Université de Saint-

Étienne, C.I.E.R.E.C., 1973. Proceedings of a colloquium held November 19–21, 1971.

DUNCAN 1982
Carol Duncan. "Virility and Domination in Early Twentieth-Century Vanguard Painting." In Norma Broude and Mary D. Garrard, eds., *Feminism and Art History: Questioning the Litany*. New York: Harper & Row; Toronto: Fitzhenry & Whiteside, 1982. Originally published in *Artforum* (New York), vol. 12, no. 4 (December 1973), pp. 30–39.

DUNCAN 1989
Carol Duncan. "The MoMA's Hot Mamas." *Art Journal* (New York), vol. 48, no. 2 (Summer 1989), pp. 171–78.

DUNCAN 1990
Carol Duncan. "Letter to the Editor." *Art Journal* (New York), vol. 49, no. 2 (Summer 1990), p. 207.

DURAN I RIU / BAYÉS 1981
Fina Duran i Riu and Pilarín Bayés. *Picasso: Centenari 1881–1981*. Barcelona: Caixa de Pensiones, 1981.

EINSTEIN 1915
Carl Einstein. *Negerplastik*. Leipzig: Weissen Bücher, 1915. Reprinted in *Carl Einstein: Werke—Band I, 1908–1918*. Edited by Rolf-Peter Baacke, with the collaboration of Jens Kwasny. Berlin: Medusa Verlag Wölk und Schmid, 1980.

EINSTEIN 1926
Carl Einstein. *Die Kunst des 20. Jahrhunderts*. 1st ed., Berlin: Propyläen, 1926. The *Demoiselles* is unmentioned in the first edition.

EINSTEIN 1931
Carl Einstein. *Die Kunst des 20. Jahrhunderts*. 3rd ed., Berlin: Propyläen, 1931.

ELDERFIELD 1992
John Elderfield. *Henri Matisse: A Retrospective*. New York: The Museum of Modern Art, 1992.

ESCHOLIER 1937A
Raymond Escholier. *La Peinture française: XXᵉ siècle*. Paris: Floury, 1937.

ESCHOLIER 1937B
Raymond Escholier et al. *Les Maîtres de l'art indépendant, 1895–1937*. Paris: Arts et Métiers Graphiques, 1937.

FABIANI 1989
Enzo Fabiani. "Picasso e *Les Demoiselles d'Avignon*." *Arte* (Milan), vol. 19, no. 200 (October 1989), pp. 94–101.

FAGAN-KING 1988
Julia Fagan-King. "United on the Threshold of the Twentieth-Century Mystical Ideal: Marie Laurencin's Integral Involvement with Guillaume Apollinaire and the Inmates of the Bateau Lavoir." *Art History* (Oxford), vol. 11, no. 1 (March 1988), pp. 88–114.

FELS 1920
Florent Fels, ed. "Opinions sur l'art nègre." *Action* (Paris), vol. 3 (April 1920), pp. 23–27.

FELS 1923
Florent Fels. "Chronique artistique: Propos d'artistes—Picasso." *Les Nouvelles littéraires* (Paris), vol. 2, no. 42 (August 4, 1923), p. 2.

FELS 1925
Florent Fels. *Propos d'artistes*. Paris: La Renaissance du Livre, 1925.

FELS 1959
Florent Fels. *Le Roman de l'art vivant*. Paris: Fayard, 1959.

FERMIGIER 1967
André Fermigier. "La Révolution cubiste." In *Picasso*. Paris: Hachette, 1967.

FERMIGIER 1969
André Fermigier. *Picasso*. Paris: Le Livre de Poche, 1969.

FERRIER 1988
Jean-Louis Ferrier. "*Les Demoiselles* en visite à Paris." *Le Point* (Paris), no. 801 (January 25, 1988), pp. 78–79.

FITZGERALD 1992
Michael Cowan FitzGerald. "Skin Games." *Art in America* (New York) vol. 80, no. 2 (February 1992), pp. 70–82, 139–41.

FLAM 1973
Jack D. Flam, ed. *Matisse on Art*. New York: Phaidon, 1973.

FLAM 1984A
Jack D. Flam. "Matisse and the Fauves." In William Rubin, ed., *"Primitivism" in Twentieth-Century Art: Affinity of the Tribal and the Modern*, vol. 1. New York: The Museum of Modern Art, 1984.

FLAM 1984B
Jack D. Flam. "The Spell of the Primitive: In Africa and Oceania Artists Found a New Vocabulary." *Connoisseur* (New York), vol. 214, no. 871 (September 1984), pp. 124–31.

FORT 1944
Paul Fort. *Mes Mémoires: Toute la vie d'un poète, 1872–1943*. Paris: Flammarion, 1944.

FOSTER 1985
Hal Foster. "The 'Primitive' Unconscious of Modern Art." *October* (New York), no. 34 (Autumn 1985), pp. 45–70. Reprinted in Francis Frascina and Jonathan Harris, eds., *Art in Modern Culture: An Anthology of Critical Texts*. New York: HarperCollins, 1992.

FOUGSTEDT 1916
Arvid Fougstedt. "En visit hos Pablo Picasso." *Svenska Dagbladet* (Stockholm), January 9, 1916, p. 10.

FRASCINA 1987
Francis Frascina. "Picasso's Art: A Biographic Fact?" (review of *Je suis le cahier: The Sketchbooks of Picasso*, ed. Arnold Glimcher and Marc Glimcher). *Art History* (Oxford), vol. 10, no. 3 (September 1987), pp. 401–15.

FRONTISI 1988
Claude Frontisi. "Les Demoiselles à Paris." *Vingtième Siècle* (Paris), no. 19 (July–September 1988), p. 91.

FRY 1966A
Edward F. Fry. *Cubism*. London: Thames & Hudson; New York: McGraw-Hill, 1966. Republished, New York: Oxford University Press, 1978.

FRY 1966B
Edward F. Fry. "Cubism, 1907–1908: An Early Eyewitness Account." *The Art Bulletin* (New York), vol. 48, no. 1 (March 1966), pp. 70–73.

GAGNEBIN 1987
Laurent Gagnebin. *Du Golgotha à Guernica: Foi et création artistique*. Paris: Les Bergers et les Mages, 1987.

GALLATIN 1930
Albert Eugene Gallatin. *Gallery of Living Art, New York University*. New York: [Gallery of Living Art], 1930.

GARCIA-HERRAIZ 1985
E. Garcia-Herraiz. "Primitivismo y arte del siglo XX." *Goya* (Madrid), no. 185 (March–April 1985), pp. 305–06.

GEDO 1972
Mary Mathews Gedo. "Picasso's Self-Image: A Psycho-iconographic Study of the Artist's Life and Works." Ph.D. dissertation, Northwestern University, Evanston, Ill., 1972. Facsimile, Ann Arbor, Mich.: University Microfilms International, 1986.

GEDO 1980A
Mary Mathews Gedo. *Art as Autobiography*. Chicago and London: University of Chicago Press, 1980.

GEDO 1980B
Mary Mathews Gedo. "Art as Exorcism: Picasso's *Demoiselles d'Avignon*." *Arts Magazine* (New York), vol. 55, no. 2 (October 15, 1980), pp. 70–83.

GEE 1981
Malcolm Gee. *Dealers, Critics, and Collectors of Modern Painting: Aspects of the Parisian Art Market Between 1910 and 1930*. New York and London: Garland, 1981. (Ph.D. dissertation, Courtauld Institute, London, September 1977).

GEELHAAR 1993
Christian Geelhaar. *Picasso: Wegbereiter und Förderer seines Aufstiegs, 1899–1939*. Zurich: Palladion/ABC Verlag, 1993.

GENAUER 1937
Emily Genauer. "More Than Fifty Exhibitions: Picasso One of the 'Musts.'" *New York World-Telegram*, November 6, 1937, p. 30.

GEORGES-MICHEL 1942
Michel Georges-Michel. *Peintres et sculpteurs que j'ai connus, 1900–1942*. New York: Brentano's, 1942.

GEORGES-MICHEL 1954
Michel Georges-Michel. *De Renoir à Picasso: Les Peintres que j'ai connus*. Paris: Arthème Fayard, 1954.

GERSH-NEŠIĆ 1991
Beth S. Gersh-Nešić. *The Early Criticism of André Salmon: A Study of His Thoughts on Cubism*. New York and London: Garland, 1991. (Ph.D. dissertation, City University of New York, 1989).

GILOT / LAKE 1964
Françoise Gilot and Carlton Lake. *Life with Picasso*. New York: McGraw-Hill, 1964.

GIMPEL 1966
René Gimpel. *Diary of an Art Dealer*. Introducton by Herbert Read. New York: Farrar, Straus & Giroux, 1966. Translated by John Rosenberg from *Journal d'un collectionneur marchand de tableaux*. Paris: Calmann-Lévy, 1963.

GIRAUDON 1993A
Colette Giraudon. *Paul Guillaume et les peintres du XXᵉ siècle: De l'art nègre à l'avant-garde*. Preface by Michel Hoog. Paris: Bibliothèque des Arts, 1993.

GIRAUDON 1993B
Colette Giraudon. *Les Arts à Paris chez Paul Guillaume, 1918–1935*. Paris: Réunion des Musées Nationaux, 1993.

GIRY 1968
Marcel Giry. "Observations sur la période fauve et la période précubiste de Picasso, 1901–1907." *Bulletin de la Faculté des Lettres de Strasbourg*, vol. 46, nos. 8–9 (May–June 1968), pp. 779–786.

GOLD / FIZDALE 1980
Arthur Gold and Robert Fizdale. *Misia: The Life of Misia Sert*. New York: Morrow, 1980.

GOLDING 1958
John Golding. "The *Demoiselles d'Avignon*." *The Burlington Magazine* (London), vol. 100, no. 662 (May 1958), pp. 155–63.

GOLDING 1963
John Golding. "Guillaume Apollinaire and the Art of the Twentieth Century." *The Baltimore Museum of Art News*, double issue: vol. 26, no. 4 (Summer 1963); vol. 27, no. 1 (Autumn 1963), pp. 3–31. Reprinted with revisions in Golding, *Visions of the Modern* (London: Thames & Hudson, 1994), pp. 11–27.

GOLDING 1964
John Golding. "Picasso, the *Demoiselles d'Avignon*, and Cubism." In Jean Sutherland Boggs, *Picasso and Man*. Toronto: The Art Gallery of Toronto; Montreal: The Montreal Museum of Fine Arts, 1964.

GOLDING 1980
John Golding. "Picasso's Cubist Years." *The Burlington Magazine* (London), vol. 122, no. 928 (July 1980), pp. 507–09.

GOLDING 1988A
John Golding. *Cubism: A History and an Analysis, 1907–1914*. 3rd ed., Cambridge, Mass.: Harvard University Press, 1988. First published, London: Faber & Faber, 1959.

GOLDING 1988B
John Golding. "The Triumph of Picasso." *The New York Review of Books*, vol. 30, no. 12 (July 21, 1988), pp. 19–26. Reprinted with revisions in Golding, *Visions of the Modern* (London: Thames & Hudson, 1994), pp. 101–18.

GOLDING 1990
John Golding. "Two Who Made a Revolution." *The New York Review of Books*, vol. 37, no. 9 (May 31, 1990), pp. 8–11.

GOLDWATER 1938
Robert J. Goldwater. *Primitivism in Modern Painting*. New York and London: Harper & Brothers, 1938.

GOLDWATER 1967
Robert J. Goldwater. *Primitivism in Modern Art*. New York: Random House, 1967. Revised edition of Goldwater 1938.

GOLDWATER 1986
Robert Goldwater. *Primitivism in Modern Art*. Cambridge, Mass., and London: The Belknap Press of Harvard University, 1986. Enlarged edition of Goldwater 1938.

GOMBRICH 1954
Ernst H. Gombrich. "Psycho-analysis and History of Art." *The International Journal of Psycho-Analysis* (London), vol. 35 (1954), part 4, pp. 1–11.

GOMBRICH 1987
Ernst Gombrich. "From Careggi to Montmartre: A Footnote to Erwin Panofsky's *Idea*." In *"Il se rendit en Italie": Études offertes à André Chastel*. Preface by Giuliano Briganti. Roma: Edizioni dell'Elefante; Paris: Flammarion, 1987.

GOODYEAR 1943
A. Conger Goodyear. *The Museum of Modern Art: The First Ten Years*. New York: [privately printed], 1943.

GOPNIK 1983
Adam Gopnik. "High and Low: Caricature, Primitivism, and the Cubist Portrait." *Art Journal* (New York), vol. 43, no. 4 (Winter 1983), pp. 371–76.

GREEN 1988
Christopher Green. "Paris, Musée Picasso, *Les Demoiselles d'Avignon*." *The Burlington Magazine* (London), vol. 130, no. 1022 (May 1988) pp. 391–92.

GRUNDBACHER 1988
François Grundbacher. "Avignon oder das Rätsel des Bordells." *Du* (Zurich), no. 4 (1988), pp. 66–71, 101.

GUILLAUME 1916
Paul Guillaume. *Lyre et Palette: 1ʳᵉ Exposition—Art nègre et Matisse, Picasso, Ortiz de Zarate, Modigliani, Kisling*. Paris: Lyre et Palette, 1916.

HAESSLY 1983
Gaile Ann Haessly. "Picasso on Androgyny: From Symbolism Through Surrealism." Ph.D. dissertation, Syracuse University, 1983.

HARRISON / FRASCINA / PERRY 1993
Charles Harrison, Francis Frascina, and Gill Perry. *Primitivism, Cubism, Abstraction: The Early Twentieth Century*. New Haven, Conn.: Yale University Press; London: Open University, 1993.

HAXTHAUSEN 1985
Charles W. Haxthausen. "Primitivism in Twentieth-Century Art." *The Burlington Magazine* (London), vol. 127, no. 986 (May 1985), pp. 325–27.

HENRY 1970
Hélène Henry. "Max Jacob et Picasso: Jalons chronologiques pour une amitié, 1901–1944." *Europe* (Paris), vol. 48, nos. 492–93 (April–May 1970), pp. 191–210.

HERBERT 1992
James D. Herbert. "Figures of Innovation and Tradition." In *Fauve Painting: The Making of Cultural Politics*. New Haven, Conn., and London: Yale University Press, 1992.

HERDING 1992
Klaus Herding. *Pablo Picasso, "Les Demoiselles d'Avignon": Die Herausforderung der Avantgarde*. Frankfurt am Main: Fischer Taschenbuch, 1992.

HILTON 1981
Timothy Hilton. Introduction to *Picasso's Picassos*. London: Hayward Gallery, 1981.

HOCKE 1957
Gustav René Hocke. *Die Welt als Labyrinth: Manier und Manie in der europäischen Kunst, von 1520 bis 1650 und in der Gegenwart*. Hamburg: Rowohlt Taschenbuch, 1957. French ed., Paris: Gonthier, 1967.

HOFMANN 1986
Werner Hofmann. "Réflexions sur l'Iconisation' à propos des *Demoiselles d'Avignon*." *Revue de l'art* (Paris), no. 71 (1986), pp. 33–42.

HOHL 1986
Reinhold Hohl. *Picasso: Oeuvres cubistes de la collection Marina Picasso*. Geneva: Galerie Jan Krugier, 1986.

HOLLIER 1989
Denis Hollier. "Portrait de l'artiste en son absence." *Les Cahiers du Musée National d'Art Moderne* (Paris), no. 30 (Winter 1989), pp. 5–22.

HOLROYD 1975
Michael Holroyd. *Augustus John: A Biography*. New York: Holt Rinehart & Winston, 1975.

HOOG 1973
Michel Hoog. "Les *Demoiselles d'Avignon* et la peinture à Paris en 1907–1908." *Gazette des beaux-arts* (Paris), vol. 82 (October 1973), pp. 209–16.

HUBERT 1968
Étienne-Alain Hubert. "Apollinaire filmé?" *La Revue des lettres modernes* (Paris), nos. 183–88 (1968), pp. 217–18.

HUBERT 1979
Étienne-Alain Hubert. "Pierre Reverdy et le cubisme en mars 1917." *Revue de l'art* (Paris), no. 43 (1979), pp. 59–66.

HUYGE / BAZIN 1939
René Huyge and Germain Bazin. *La Peinture française: Les Contemporains*. Paris: Pierre Tisné, 1939.

JACOB 1911
Max Jacob. *Saint Matorel*. Aquatints by P. Picasso. Paris: Éditeur Henry Kahnweiler, 1911.

JACOB 1927
Max Jacob. "Souvenirs sur Picasso contés par Max Jacob." *Cahiers d'art* (Paris), vol. 2, no. 6 (1927), pp. 199–202.

JACOB 1932
Max Jacob. "Naissance du cubisme et autres." *Les Nouvelles littéraires* (Paris), April 30, 1932, p. 7.

JACOB 1953
Max Jacob: Correspondance, vol. 1: *Quimper–Paris, 1876–1921*. Edited by François Garnier. Paris: Éditions de Paris, 1953.

JACOB 1956
Max Jacob. *Chronique des temps héroïques*. Illustrations by Picasso. 1936–37. Paris: Louis Broder, 1956.

JACOB 1964
Max Jacob. "Fox" (1931). *Les Lettres françaises* (Paris), no. 1051 (October 22–28, 1964), pp. 1, 11. Reprinted in *La Nouvelle Critique* (Paris), no. 64 (May 1973), pp. 47–49.

JACOB 1986
Hélène Henry and Jean-Claude Roda, eds. *Max Jacob à la Bibliothèque Municipale d'Orléans*. Foreword by Henri Sauguet. Orléans: Imprimerie Municipale, 1986.

JACOB 1989
Max Jacob. *Les Propos et les jours*. Edited by Annie Marcoux and Didier Gompel-Netter. Saint-Léger-Vauban (Yonne, France): Zodiaque, 1989.

JANNEAU 1929
Guillaume Janneau. *L'Art cubiste*. Paris: Charles Moreau, 1929.

JEWELL 1937A
Edward Alden Jewell. "Picasso's Pictures Placed on Display." *New York Times* (New York), November 2, 1937, p. 31.

JEWELL 1937B
Edward Alden Jewell. "In the Realm of Art: November." *New York Times* (New York), November 7, 1937, p. 10.

JOHN 1941
Augustus John. "Fragment of an Autobiography, IV." *Horizon* (London), vol. 4, no. 20 (August 1941), pp. 121–30.

JOHN 1952
Augustus John. *Chiaroscuro: Fragments of Autobiography—First Series*. London: Jonathan Cape, 1952.

JOHNSON 1975
Ron Johnson. "Primitivism in the Early Sculpture of Picasso." *Arts Magazine* (New York), vol. 49, no. 10 (June 1975), pp. 64–68.

JOHNSON 1976
Ron Johnson. *The Early Sculpture of Picasso, 1901–1914*. New York and London: Garland, 1976 (Ph.D. dissertation, University of California, Berkeley, 1971).

JOHNSON 1980A
Ron Johnson. "The *Demoiselles d'Avignon* and Dionysian Destruction." *Arts Magazine* (New York), vol. 55, no. 2 (October 1980), pp. 94–101.

JOHNSON 1980B
Ron Johnson. "Picasso's *Demoiselles d'Avignon* and the Theater of the Absurd." *Arts Magazine* (New York), vol. 55, no. 2 (October 1980), pp. 102–13.

JOUBIN 1930
André Joubin. "Le Studio de Jacques Doucet." *L'Illustration* (Paris), vol. 88, no. 4548 (May 3, 1930), pp. 17–20.

JOUFFROY 1988
Jean-Pierre Jouffroy. "Ces *Demoiselles* ont une histoire." *Humanité Dimanche* (Paris), February 5, 1988.

KAHNWEILER 1916
Daniel Henry [Kahnweiler]. "Der Kubismus." *Die Weissen Blätter* (Zurich and Leipzig), vol. 3, no. 9 (September 23, 1916), pp. 209–22.

KAHNWEILER 1920A
Daniel Henry [Kahnweiler]. "Werkstätten." *Die Freude: Blätter einer neuen Gesinnung* (Burg Lauenstein), vol. 1 (1920), pp. 153–54.

KAHNWEILER 1920B
Daniel-Henry Kahnweiler. *Der Weg zum Kubismus*. Munich: Delphin, 1920.

KAHNWEILER 1948
Daniel-Henry Kahnweiler. "Negro Art and Cubism." *Horizon* (London), vol. 18, no. 108 (December 1948), pp. 412–22. Translated by Peter Watson from "L'Art nègre et le cubisme." *Présence africaine* (Paris and Dakar), no. 3 (March–April 1948), pp. 367–77. Reprinted in Kahnweiler, *Confessions esthétiques*. Paris: Gallimard, 1963.

KAHNWEILER 1949A
Daniel-Henry Kahnweiler. "Naissance et développement du cubisme." In *Les Maîtres de la peinture française contemporaine*, ed. Maurice Jardot and Kurt Martin. Baden-Baden: Woldemar Klein, 1949. Translation of Kahnweiler, "Ursprung und Entwicklung des Kubismus." In *Die Meister Französischer Malerei der Gegenwart*, ed. Maurice Jardot and Kurt Martin. Baden-Baden: Woldemar Klein, 1948. Text from a conference at Freiburg im Breisgau, October 23, 1947.

KAHNWEILER 1949B
Daniel-Henry Kahnweiler. *The Rise of Cubism.* Translation by Henry Aronson of *Der Weg zum Kubismus* (Kahnweiler 1920b) for the Documents of Modern Art series, ed. Robert Motherwell. New York: Wittenborn, Schulz, 1949.

KAHNWEILER 1952
Daniel-Henry Kahnweiler. "Huit Entretiens avec Picasso." *Le Point* (Souillac and Mulhouse), vol. 7, no. 42 (October 1952), pp 22–30.

KAHNWEILER 1953A
Daniel-Henry Kahnweiler. "Naissance du cubisme." *Art d'aujourd'hui* (Boulogne-sur-Seine), vol 4, nos. 3–4 (May–June 1953), pp. 3–8. Excerpt from Kahnweiler, *Juan Gris: Sa Vie, son oeuvre, ses écrits,* 1946.

KAHNWEILER 1953B
Daniel-Henry Kahnweiler. "Picasso et le cubisme." In Madeleine Rocher-Jauneau, *Picasso.* Lyons: Musée de Lyon, 1953.

KAHNWEILER 1955A
"Du temps que les cubistes étaient jeunes: Un Entretien au magnétophone avec Daniel-Henry Kahnweiler." Interview with Georges Bernier. *L'Oeil* (Paris and Lausanne), no. 1 (January 15, 1955), pp. 27–31.

KAHNWEILER 1955B
Daniel-Henry Kahnweiler. "Cubism: The Creative Years." *Art News Annual* (New York), vol. 24 (1955), pp. 107–16, 180–81.

KAHNWEILER 1961
Daniel-Henry Kahnweiler. "Pablo Picasso et son temps." *La Nouvelle critique* (Paris), special issue devoted to Picasso, no. 130 (November 1961), pp. 32–39.

KAHNWEILER 1963
Daniel-Henry Kahnweiler. *Confessions esthétiques.* Paris: Gallimard, 1963. Includes "La Montée du cubisme," translation by Denise Naville of the revised and corrected edition of *Der Weg zum Kubismus* (Kahnweiler 1920b), published by Gerd Hatje, Stuttgart, in 1958.

KAHNWEILER 1969
Daniel-Henry Kahnweiler. *Juan Gris: His Life and Work.* Translated by Douglas Cooper. New York: Abrams, 1969. First published as *Juan Gris: Sa vie, son oeuvre, ses écrits.* Paris: Gallimard, 1946.

KAHNWEILER 1971A
Daniel-Henry Kahnweiler. *My Galleries and Painters.* New York: Viking; London: Thames & Hudson, 1971. Translation by Helen Weaver of *Mes Galeries et mes peintres: Entretiens avec Francis Crémieux.* Paris: Gallimard, 1961. Eight interviews broadcast over channel France III of the R.T.F., May–June 1961.

KAHNWEILER 1971B
Daniel-Henry Kahnweiler. *Der Gegenstand der Ästhetik.* Introduction Wilhelm Weber. Munich: Heinz Moos Verlag, 1971. First publication of Kahnweiler's 85-page typescript written in 1915.

KAHNWEILER / PARMELIN 1955
Daniel-Henry Kahnweiler and Hélène Parmelin. "Petite Histoire des toiles." Preface to *Oeuvres des musées de Leningrad et de Moscou (1900–1914) et de quelques collections parisiennes.* Paris: Cercle d'Art, 1955.

KIMMELMAN 1992
Michael Kimmelman. "Modern to Show New Picasso Tomorrow." *New York Times,* February 10, 1992, p. C13.

KLEIN 1937
Jerome Klein. "New Exhibitions Follow Lifeline of Modern Art." *New York Post* (New York), November 6, 1937, p. 15.

KLÜVER 1986
Billy Klüver. "A Day with Picasso." *Art in America* (New York), vol. 74, no. 9 (September 1986), pp. 96–107, 161–63.

KLÜVER 1993
Billy Klüver. *Ein Tag mit Picasso.* Stuttgart: Edition Cantz, 1993 (original manuscript in English). Published in French as *Un jour avec Picasso. Le 12 août 1916. Photographies de Jean Cocteau.* Translated from the English by Edith Ochs. Paris: Hazan, 1994.

KLÜVER / MARTIN 1989
Billy Klüver and Julie Martin. *Kiki's Paris: Artists and Lovers, 1900–1930.* New York: Abrams, 1989.

KOSTENEVICH / SEMYONOVA 1993
Albert Kostenevich and Natalya Semyonova. *Collecting Matisse.* Paris: Flammarion, 1993.

KOZLOFF 1973
Max Kozloff. *Cubism/Futurism.* New York: Charterhouse, 1973.

KRAMÁŘ 1921
Vincenc Kramář. *Kubismus.* Brno: Nakladem Moravsko Slezské Revue, 1921.

KRAMER 1984
Hilton Kramer. "The 'Primitivism' Conundrum." *The New Criterion* (New York), vol. 3, no. 4 (December 1984), pp. 1–7.

KRAUSS 1988
Rosalind E. Krauss. "Editorial Note." *October* (New York), no. 44 (Spring 1988), pp. 3–6.

KULVA 1981
Tomas Kulva. "The Artistic and the Aesthetic Value of Art." *British Journal of Aesthetics* (Oxford), vol. 21, no. 4 (Autumn 1981), pp. 336–50.

LAESSØE 1987
Rolf Laessøe. "A Source in El Greco for Picasso's *Les Demoiselles d'Avignon.*" *Gazette des beaux-arts* (Paris), series 6, vol. 110, no. 1425 (October 1987), pp. 131–36.

LAESSØE 1990
Rolf Laessøe. "Fra klassisk tragedie til moderne ikon: Et triptykon af Francis Bacon." *Argos: Tidsskrift for Kunstvidenskab, visuel kommunikation og Kunstpaedagogik* (Odense, Denmark), nos. 7–8 (1990), pp. 117–36.

LAKE / ASHTON 1991
Carlton Lake and Linda Ashton. *Henri-Pierre Roché: An Introduction.* Austin, Tex.: Harry Ransom Humanities Research Center, University of Texas at Austin, 1991.

LAUDE 1968
Jean Laude. *La Peinture française (1905–1914) et "l'art nègre": Contribution à l'étude des sources du fauvisme et du cubisme.* 2 vols. Paris: Klincksieck, 1968.

LAUDE 1973
Jean Laude. "Picasso et Braque, 1910–1914: La Transformation des signes." In *Le Cubisme.* Saint-Étienne: Université de Saint-Étienne, C.I.E.R.E.C., 1973. Proceedings of a colloquium held November 19–21, 1971.

LAUDE 1975
Jean Laude. "Le Cubisme." In Jean Cassou, *Pablo Picasso.* Paris: Somogy, 1975.

LÉAL 1988
Brigitte Léal. *Picasso: Les Demoiselles d'Avignon—A Sketchbook.* London: Thames & Hudson, 1988. French ed., *Picasso: Les Demoiselles d'Avignon—Carnet de Dessins.* Paris: Réunion des Musées Nationaux, Éditions Adam Biro, 1988.

LEFORT 1988
Rosine and Robert Lefort. "*Les Demoiselles d'Avignon* ou la passe de Picasso." *Ornicar* (Paris), no. 46 (1988), pp. 81–92.

LEGROS 1985
Dominique Legros. "Les Demoiselles d'Avignon de Picasso et les pièces africaines contemporaines du tableau: Esthétique émancipatrice ou répressive?" *Sociologie et société* (Montreal), vol. 17, no. 2 (1985), pp. 71–81.

LEIGHTEN 1989
Patricia Leighten. *Re-Ordering the Universe: Picasso and Anarchism, 1897–1914*. Princeton, N.J.: Princeton University Press, 1989. Revised version of "Picasso: Anarchism and Art, 1897–1914," Ph.D. dissertation, Rutgers University, The State University of New Jersey, New Brunswick, 1983.

LEIGHTEN 1990
Patricia Leighten. "The White Peril and *L'Art Nègre:* Picasso, Primitivism, and Anticolonialism." *The Art Bulletin* (New York), vol. 72, no. 4 (December 1990), pp. 609–30.

LEIRIS 1966
Michel Leiris. *Brisées*. Paris: Mercure de France, 1966.

LEJA 1985
Michael Leja. "'Le Vieux Marcheur' and 'Les Deux Risques': Picasso, Prostitution, Venereal Disease, and Maternity, 1899–1907." *Art History* (Oxford), vol. 8, no. 1 (March 1985), pp. 66–81.

LEJEUNE 1990
Jean-Marc LeJeune. "Sous l'influence de la gravitation, une gamme d'excentricité. I: Avec Picasso dans un bordel d'Avignon" (Ph.D. dissertation, under the direction of Costin Miereanu). Paris: Panthéon Sorbonne, 1990.

LEMAS 1980
Suzanne Lemas. "Éléments pour une biographie de Jacques Doucet." *Hommage à Jacques Doucet*, issue of *Bulletin du bibliophile* (Paris), no. 1 (1980), pp. 5–25.

LEMOYNE DE FORGES 1966
Marie-Thérèse Lemoyne de Forges, Geneviève Allemand, and Michèle Bundorf. *Collection Jean Walter–Paul Guillaume: Orangerie des Tuileries*. Paris: Réunion des Musées Nationaux, 1966.

LEONARD 1970
Sandra E. Leonard. *Henri Rousseau and Max Weber*. New York: Richard L. Feigen, 1970.

LEVEL 1928
André Level. *Picasso*. Paris: G. Crès, 1928.

LEVEL 1959
André Level. *Souvenirs d'un collectionneur*. Paris: Alain C. Mazo, 1959.

LEVY 1937
R[obert] M. L[evy]. Foreword to *Twenty Years in the Evolution of Picasso, 1903–1923*. New York: Jacques Seligmann, 1937.

LICHTENSTERN 1981
Christa Lichtenstern. "Von den *Demoiselles d'Avignon* zu Picassos 'rythmischen Figurenbildern' von 1907–1908." In *Pablo*

Picasso in der Staatsgalerie Stuttgart. Stuttgart: Staatsgalerie Stuttgart, 1981.

LIPTON 1976
Eunice Lipton. *Picasso Criticism, 1901–1939: The Making of an Artist-Hero*. New York and London: Garland, 1976 (Ph.D. dissertation, New York University, June 1975).

LOMAS 1993
David Lomas. "A Canon of Deformity: *Les Demoiselles d'Avignon* and Physical Anthropology." *Art History* (Oxford, U.K., and Cambridge, Mass.), vol. 16, no. 3 (September 1993), pp. 424–46.

LUBAR 1994
Robert S. Lubar. "Picasso, El Greco, and the Body of the Nation." In Jonathan Brown, ed., *Picasso and the Spanish Tradition*. New Haven, Conn., and London: Yale University Press, [forthcoming].

MAHAUT 1930
Henri Mahaut. *Picasso*. Paris: G. Crès, 1930.

MAKARIUS 1988
Michael Makarius. "Picasso au bordel." *Politix* (Paris), no. 1 (1988), pp. 34–35.

MALRAUX 1974
André Malraux. *La Tête d'obsidienne*. Paris: Gallimard, 1974. English ed., *Picasso's Mask*. Translated by June Guicharnaud, with Jacques Guicharnaud. New York: Holt, Rinehart & Winston, 1976.

MARKOV 1919
Vladimir Markov. *Iskusstvo Negrov*. Petrograd: Izo Narkompros, 1919. Translated by Jacqueline and Jean-Louis Paudrat in "L'Art des nègres," *Travaux et mémoires du CRHRAEC*, Université de Paris I, Panthéon-Sorbonne, I (1976), pp. 29–39. Reprinted in *Cahiers du Musée National d'Art Moderne* (Paris), no. 2 (1979), pp. 319–27.

MARTENSEN-LARSEN 1985
Britta Martensen-Larsen. "When Did Picasso Complete *Les Demoiselles d'Avignon?*" *Zeitschrift für Kunstgeschichte* (Munich), vol. 48, no. 2 (1985), pp. 256–64.

MAYER 1980
Susan Mayer. "Ancient Mediterranean Sources in the Works of Picasso, 1892–1937." Ph.D. dissertation, New York University, June 1980.

McBRIDE 1937
H. McB[ride]. "Twenty Years of Picasso: Examples from the Doucet Collection at Seligmann's." *New York Sun*, November 6, 1937, p. 30.

McCAUSLAND 1944
Elizabeth McCausland. "November 7, 1937." In

McCausland, *Picasso*. New York: ACA Gallery, 1944. Article previously published in the *Springfield Union and Republican* (Springfield, Mass.), November 7, 1937.

McCULLY 1982
Marilyn McCully, ed. *A Picasso Anthology: Documents, Criticism, Reminiscences*. Princeton, N.J.: Princeton University Press, 1982. First published, London: Arts Council of Great Britain, 1981.

MELLOW 1974
James Mellow. *Charmed Circle: Gertrude Stein and Company*. London: Phaidon; New York: Praeger, 1974.

MEYER 1976
Franz Meyer. *Picasso aus dem Museum of Modern Art, New York, und Schweizer Sammlungen*. Basel: Kunstmuseum Basel, 1976.

MILHOU 1981
Mayi Milhou. *Ignacio Zuloaga (1870–1945) et la France*. Saint-Loubes: Le Bouscat, 1981. (Ph.D. thesis, Université de Bordeaux, 1979).

MILHOU 1991
Mayi Milhou. *Du Moulin Rouge à l'Opéra: Vie et oeuvre de Maxime Dethomas, 1867–1929*. Bordeaux: Mayi Milhou, 1991.

MIX 1988
Miguel Rojas Mix. "Las Señoritas de Avignon." *Arte en Colombia Internacional* (Bogotá), no. 37 (September 1988), pp. 56–59, 147–50.

MOLLET 1947
Jean Mollet. "Les Origines du cubisme." *Les Lettres françaises* (Paris), January 3, 1947, pp. 1, 7.

MOLLET 1963
Jean Mollet. *Les Mémoires du baron Mollet*. Preface by Raymond Queneau. Paris: Gallimard, 1963.

MoMA SYMPOSIUM 1992
Picasso and Braque: A Symposium. Organized by William Rubin, moderated by Kirk Varnedoe, proceedings edited by Lynn Zelevansky. Includes essays by Theodore Reff, David Cottington, Edward F. Fry, Christine Poggi, Yve-Alain Bois, Mark Roskill, and Rosalind Krauss, appendices by Pierre Daix and Pepe Karmel, and transcripts of discussions. New York: The Museum of Modern Art, 1992.

MONOD-FONTAINE 1984a
Isabelle Monod-Fontaine et al. *Donation Louise et Michel Leiris: Collection Kahnweiler-Leiris*. Paris: Musée National d'Art Moderne, Centre Georges Pompidou, 1984.

MONOD-FONTAINE 1984b
Isabelle Monod-Fontaine et al. *Daniel-Henry*

Kahnweiler, marchand, éditeur, écrivain. Paris: Musée National d'Art Moderne, Centre Georges Pompidou, 1984.

MUGNIER 1985
Marcel Billot et al., eds. *Journal de l'abbé Mugnier (1879–1939).* Paris: Mercure de France, 1985.

NADELMAN 1985
Cynthia Nadelman. "Broken Premises: 'Primitivism' at MoMA." *Art News* (New York), vol. 84, no. 2 (February 1985), pp. 88–95.

NASH 1974
John M. Nash. *Cubism, Futurism, and Constructivism.* London: Thames & Hudson, 1974.

NORTH 1991
Percy North. "Max Weber: The Cubist Decade." In *Max Weber: The Cubist Decade, 1910–1920.* Atlanta: High Museum of Art, 1991.

OLIVIER 1965
Fernande Olivier. *Picasso and His Friends.* New York: Appleton-Century, 1965. Translation by Jane Miller of *Picasso et ses amis.* Paris: Stock, 1933. Excerpts previously published in *Le Soir* (Paris), September 9–14, 1930, and in several issues of *Mercure de France* (Paris), 42ème année: "Picasso et ses amis," no. 789, t. 227 (May 1, 1931), pp. 549–69; "La Naissance du cubisme," t. 228 (June 15, 1931), pp. 558–88; and "L'Atelier du Boulevard de Clichy,"no. 794, t. 229 (July 15, 1931), pp. 352–68.

OLIVIER 1988
Fernande Olivier. *Souvenirs intimes: Écrits pour Picasso.* Edited by Gilbert Krill. Paris: Calmann-Lévy, 1988.

OTERO 1974
Roberto Otero. *Picasso: An Intimate Look at His Last Years.* Translated by Elaine Kerrigan. New York: Abrams, [1974].

OXENHANDLER 1964
Neal Oxenhandler. *Max Jacob et "Les Feux de Paris."* Berkeley and Los Angeles: University of California Press, 1964.

PACH 1938
Walter Pach. *Queer Thing, Painting: Forty Years in the World of Art.* New York and London: Harper & Brothers, 1938.

PALAU I FABRE 1981
Josep Palau i Fabre. *Picasso vivant (1881–1907).* Paris: Albin Michel, 1981. French translation by Joëlle Guyot and Robert Marrast of *Picasso vivent.* Barcelona: Polígrafa, 1980. English edition, *Picasso: The Early Years, 1881–1907.* New York: Rizzoli, 1981.

PALAU I FABRE 1990
Josep Palau i Fabre. *Picasso: Cubism, 1907–1917.* New York: Rizzoli, 1990. Translated by Susan Branyas, Richard-Lewis Rees, and Patrick Zabalbeascoa from the Catalan, *Picasso: Cubism, 1907–1917.* Barcelona: Polígrafa, 1990.

PANDROT ET AL. 1988
Iseult Pandrot, Louis de Tranpt, Paul Ditterson, and Laurent Dispot. "La Confiture et les cochons." *James Joyce* (Paris), March 1988, pp. 180–85.

PAPINI / SOFFICI 1991
Giovanni Papini and Ardengo Soffici. *Carteggio, I: 1903–1908—Dal "Leonardo" a "La Voce."* Edited by Mario Richter. Rome: Storia e Letteratura, 1991.

PARIS 1908
Société du Salon d'Automne. *Catalogue de la 6ᵉ exposition.* Paris: Grand Palais des Champs-Élysées, October 1–November 6, 1908.

PARMELIN 1969
Hélène Parmelin. *Picasso says . . .* Translated by Christine Trollope. London: Allen & Unwin, 1969. French edition, *Picasso dit . . .* Paris: Gonthier, 1966.

PARMELIN 1980
Hélène Parmelin. *Voyage en Picasso.* Paris: Robert Laffont, 1980.

PAUDRAT 1984
Jean-Louis Paudrat. "From Africa." In William Rubin, ed., *"Primitivism" in Twentieth-Century Art: Affinity of the Tribal and the Modern,* vol. 1. New York: The Museum of Modern Art, 1984.

PENROSE 1973
Roland Penrose. *Picasso: His Life and Work.* New York: Harper & Row, 1973. First published, London: Victor Gollancz, 1958.

PENROSE 1974
Roland Penrose. "Picasso's Portrait of Kahnweiler." *The Burlington Magazine* (London), vol. 116, no. 852 (March 1974), pp. 122–33.

PEREZ-ORAMAS 1992
Luis Perez-Oramas. "Le Détour des demoiselles." *Traverses* (Paris), no. 2 (Summer 1992), pp. 76–83.

PETERS / VON WIESE 1987
Hans Albert Peters and Stephan von Wiese. *Alfred Flechtheim, Sammler, Kunsthändler, Verleger.* Düsseldorf: Kunstmuseum Düsseldorf; Münster: Westfälisches Landesmuseum für Kunst und Kulturgeschichte, 1987.

PETROVÁ 1981
Eva Petrová. *Picasso v československu.* Prague: Odeon, 1981.

PICARD 1988
Denis Picard. "Les Demoiselles et le vieux peintre." *Connaissance des arts* (Paris), no. 432 (February 1988), p. 11.

PICASSO 1948
Pablo Picasso. *Desire: A Play.* New York: Philosophical Library, 1948. Translated from the French by Bernard Frechtman. First published as "Le désir attrapé par la queue." *Messages* (Paris), no. 2 (1944). Written January 14–17, 1941.

PICASSO 1973
Pablo Picasso. *Le Désir attrapé par la queue.* Paris: Gallimard, 1973. First published 1945.

PICASSO / APOLLINAIRE 1992
Pierre Caizergues and Hélène Seckel, eds. *Picasso/Apollinaire: Correspondance.* Paris: Réunion des Musées Nationaux; Gallimard, 1992.

PLEYNET 1981
Marcelin Pleynet. "Picasso, peintre d'histoire?" *Tel Quel* (Paris), no. 90 (Winter 1981), pp. 21–37.

PLEYNET 1990
Marcelin Pleynet. *Les Modernes et la tradition.* Paris: NRF Gallimard, 1990.

PODOKSIK 1989
Anatoly Podoksik. *Picasso: The Artist's Works in Soviet Museums.* New York: Abrams; Leningrad: Aurora, 1989.

PONTOISE 1979
Éloge du petit format: Collection Pierre Bourut. Pontoise: Musée de Pontoise, 1979.

POORE 1936
Charles Poore. "The Enraging Old Master of Modernity." *New York Times Magazine,* November 29, 1936, pp. 10–11.

PREZZOLINI / SOFFICI 1977
Giuseppe Prezzolini and Ardengo Soffici. *Carteggio, I: 1907–1918.* Edited by Mario Richter. Rome: Storia e Letteratura, 1977.

PRIDEAUX 1968
Tom Prideaux. "The Terrible Ladies of Avignon." *Life* (New York), vol. 65, no. 26 (December 27, 1968), pp. 50–63.

RAASCHOU-NIELSEN / SANDBERG / VILLADSEN 1993
Inge Vibeke Raaschou-Nielsen, Jens Henrik Sandberg, and Villads Villadsen. *Picasso + Braque: Kubisme, 1907–1914.* Copenhagen: Statens Museum for Kunst, 1993.

RAPHAEL 1913
Max Raphael. *Von Monet zu Picasso*. Munich: Delphin, 1913.

RAPHAEL 1980
Max Raphael. *Proudhon Marx Picasso: Three Essays in Marxist Aesthetics*. Translated from the German by Inge Marcuse. Edited by John Tagg. 1933; [Atlantic Highlands], New Jersey: Humanities Press, 1980. (Also London: Lawrence and Wishart, 1981).

RAPHAEL 1985
Max Raphael. "Erinnerungen um Picasso." Chapter 1 of *Aufbruch in die Gegenwart: Begegnungen mit der Kunst und den Künstlern des 20. Jahrhunderts*. Frankfurt am Main and New York: Edition Qumran im Campus Verlag, 1985. Reprint of the article originally published in *Davoser Revue* (Davos), vol. 6, no. 11 (August 15, 1931), pp. 325–29.

RAYNAL 1922
Maurice Raynal. *Picasso: Avec cent reproductions hors texte*. Paris: G. Crès, 1922. First published in German (translated from the French manuscript), Munich: Delphin, 1921.

RAYNAL 1952
Maurice Raynal. "Panorama de l'oeuvre de Picasso." *Le Point* (Souillac and Mulhouse), vol. 7, no. 42 (October 1952), pp. 4–21.

RAYNAL 1953
Maurice Raynal. *Picasso: Biographical and Critical Studies*. Geneva: Skira, 1953. Translated by James Emmons from *Picasso: Études biographiques et critiques*. Geneva: Skira, [1953].

RAYNAL 1991
Ancienne collection Maurice Raynal (auction catalogue). Paris: Drouot Montaigne, November 28, 1991.

READ 1935
Herbert Read. "Pablo Picasso." In *Men of Turmoil: Biographies by Leading Authorities of the Dominating Personalities of Our Day*. New York: Minton, Balch, 1935. Also published as *Great Contemporaries: Essays by Various Hands*. London: Cassel, 1935.

RÉBÉRIOUX 1988
Madeleine Rébérioux. "Ces Demoiselles." In Alain Buisine, Norbert Dodille, Claude Duchet, eds., *L'Exotisme: Actes du colloque de Saint-Denis de la Réunion*. Cahiers CRLH-CIRAOI, no. 5. Paris: Diffusion Didier Érudition, 1988.

REFF 1973
Theodore Reff. "Themes of Love and Death in Picasso's Early Work." In Roland Penrose and John Golding, eds., *Picasso in Retrospect*,

1881–1973. New York and Washington, D.C.: Praeger, 1973. British edition, *Picasso, 1881–1973*. London: Paul Elek, 1973. A version of the Reff article was published in *Artforum* (New York), vol. 11, no. 9 (May 1973), pp. 64–73. German translation, "Liebe und Tod in Picassos Frühwerk." In Ulrich Weisner, ed., *Picasso: Todesthemen*. Bielefeld: Kunsthalle, 1984.

REVEL 1961
Jean-François Revel. "Jacques Doucet, couturier et collectionneur." *L'Oeil* (Paris and Lausanne), no. 84 (December 1961), pp. 44–51, 81, 106.

REVERDY 1924
Pierre Reverdy. *Pablo Picasso et son oeuvre*. Paris: NRF, 1924. Reprinted in the collection of his works *Nord-Sud, Self-defence et autres écrits sur l'art et la poésie, 1917–1926*, ed. É.-A. Hubert. Paris: Flammarion, 1975.

RÉVOLUTION SURRÉALISTE 1925
La Révolution surréaliste (Paris), vol. 1, no. 4 (July 15, 1925) The *Demoiselles* is reproduced on p. 7.

RICHARDSON 1987
John Richardson. "Picasso's Apocalyptic Whorehouse." *The New York Review of Books* (New York), vol. 34, no. 7 (April 23, 1987), pp. 40–47.

RICHARDSON 1991
John Richardson, with Marilyn McCully. *A Life of Picasso*, vol. 1: *1881–1906*. New York: Random House, 1991.

RICHARDSON 1993
John Richardson. "Picasso Among Thieves." *Vanity Fair* (New York), vol. 56, no. 12 (December 1993), pp. 198–205, 224–27.

RICHTER 1969
Mario Richter. *La Formazione francese di Ardengo Soffici, 1900–1914*. Milan: Vita e Pensiero, 1969.

RICHTER 1975
Mario Richter et al. *Ardengo Soffici: L'Artista e lo Scrittore nella cultura del '900*. Florence: Centro Di, 1975.

RODRIGUEZ 1984–85
Jean-François Rodriguez. "Picasso à la Biennale de Venise, 1905–1948: Sur deux lettres de Picasso à Ardengo Soffici." *Atti dell'Istituto Veneto di Scienze, Lettere ed Arti* (Venice), vol. 143 (1984–85), pp. 27–63. Also published as *Picasso alla Biennale di Venezia, 1905–1948: Soffici, Paresce, De Pisis e Tozzi, intermediari di cultura tra la Francia e l'Italia*. Padua: Cooperativa Libreria Editrice Università di Padova, 1993.

ROJAS 1984
Carlos Rojas. *El mundo mítico y mágico de Picasso*. Barcelona: Planeta, 1984.

ROSENBLUM 1973
Robert Rosenblum. "The *Demoiselles d'Avignon* Revisited." *Art News* (New York), vol. 72, no. 4 (April 1973), pp. 45–48.

ROSENBLUM 1974
Robert Rosenblum. *Cubism and Twentieth-Century Art*. Rev. ed., New York: Abrams, 1976. First published, London: Thames & Hudson, 1960.

ROSENBLUM 1984
Robert Rosenblum. "The Fatal Women of Picasso and de Kooning." *Art News* (New York), vol. 84, no. 8 (October 1985), pp. 98–103. Originally published as "Notes sur Picasso et de Kooning." In Claire Stoullig, ed., *Willem de Kooning*. Paris: Musée National d'Art Moderne, Centre Georges Pompidou, 1984.

ROSENBLUM 1986
Robert Rosenblum. "The *Demoiselles*: Sketchbook No. 42, 1907." In Arnold Glimcher and Marc Glimcher, eds., *Je suis le cahier: The Sketchbooks of Picasso*. New York: Pace Gallery, 1986.

ROSENSHINE C. 1964
Annette Rosenshine. "Life's Not a Paragraph" (typescript of unpublished memoirs; written c. 1964). Annette Rosenshine Papers, The Bancroft Library, University of California, Berkeley.

ROTHENSTEIN 1931–40
William Rothenstein. *Men and Memories: Recollections*. Vol. 1: *1872–1900*, London: Faber & Faber, 1931–40. Vol. 2: *1900–1922*, London: Faber & Faber, 1931–40. Vol. 3: *1922–1938*. New York: Macmillan, 1940.

RUBIN 1972
William Rubin et al. *Picasso in the Collection of The Museum of Modern Art*. New York: The Museum of Modern Art, 1972. The text on the *Demoiselles* is reprinted from Barr 1946.

RUBIN 1977
William Rubin. "Cézannisme and the Beginnings of Cubism." In Rubin, ed., *Cézanne: The Late Work*. New York: The Museum of Modern Art, 1977.

RUBIN 1979
William Rubin. "Pablo and Georges and Leo and Bill." *Art in America* (New York), vol. 67, no. 2 (March–April 1979), pp. 128–47.

RUBIN 1980
William Rubin, ed. *Pablo Picasso: A*

Retrospective. Chronology by Jane Fluegel. New York: The Museum of Modern Art, 1980.

RUBIN 1983
William Rubin. "From Narrative to 'Iconic' in Picasso: The Buried Allegory in *Bread and Fruitdish on a Table* and the Role of *Les Demoiselles d'Avignon.*" *The Art Bulletin* (New York), vol. 65, no. 4 (December 1983), pp. 615–49.

RUBIN 1984
William Rubin. "Modernist Primitivism: An Introduction" and "Picasso." In Rubin, ed., *"Primitivism" in Twentieth-Century Art: Affinity of the Tribal and the Modern,* vol. 1. New York: The Museum of Modern Art, 1984.

RUBIN 1988
William Rubin. "La Genèse des *Demoiselles d'Avignon.*" In Seckel 1988 (*Les Demoiselles d'Avignon,* 2 vols., Paris: Réunion des Musées Nationaux, 1988). A revised version appears in the present volume.

RUBIN 1989
William Rubin. *Picasso and Braque: Pioneering Cubism.* Documentary Chronology by Judith Cousins. New York: The Museum of Modern Art, 1989.

RUSSELL 1981
John Russell. *The Meanings of Modern Art.* London: Thames & Hudson, 1981. Published in twelve monthly installments by the Book of the Month Club and The Museum of Modern Art, 1974–75.

RUSSELL 1988
John Russell. "Art View: A Treasure Trove Worthy of a Pulitzer." *New York Times,* April 24, 1988, p. 37.

SABARTÉS 1946
Jaime Sabartés. *Picasso: Portraits et souvenirs.* Translated by Paule-Marie Grand and André Chastel. Paris: Louis Carré and Maximilien Vox, 1946.

SACHS 1987
Maurice Sachs. *Au temps du Boeuf-sur-le-toit.* 1934; Paris: Grasset, 1987.

SALLES 1927
Georges Salles. "Réflexions sur l'art nègre." *Cahiers d'art* (Paris), vol. 2, nos. 7–8 (1927), pp. 247–54.

SALMON 1912
André Salmon. "Histoire anecdotique du cubisme." In Salmon, *La Jeune Peinture française.* Paris: Société des Trente, Albert Messein, 1912.

SALMON 1918A
André Salmon. "La Semaine artistique." *L'Europe nouvelle* (Paris), vol. 1, no. 13 (April 6, 1918), p. 631.

SALMON 1918B
André Salmon. "La Jeune Peinture française." *L'Europe nouvelle* (Paris), vol. 1, no. 24 (June 22, 1918), pp. 1155–56.

SALMON 1919A
André Salmon. "La Semaine artistique: Cubisme—'Exposition Metzinger,' Galerie Rosenberg." *L'Europe nouvelle* (Paris), vol. 2, no. 3 (January 18, 1919), pp. 139–40.

SALMON 1919B
André Salmon. "Mouvement des idées: Origines et intentions du cubisme." *Demain* (Paris), no. 68 (April 26, 1919), pp. 485–89.

SALMON 1920A
André Salmon. *L'Art vivant.* Paris: G. Crès, 1920.

SALMON 1920B
André Salmon. "Picasso" (May 1920). *L'Esprit nouveau* (Paris), vol. 1, no. 1 (October 1920), pp. 61–81.

SALMON 1922
André Salmon. *Propos d'atelier.* Paris: G. Crès, 1922.

SALMON 1926
André Salmon. "L'Anniversaire du cubisme." *L'Art vivant* (Paris), no. 36 (June 15, 1926), pp. 444–45.

SALMON 1931
André Salmon. "La Jeunesse de Picasso." *Les Nouvelles littéraires* (Paris), July 11, 1931, p. 8.

SALMON 1944
André Salmon. *Odeur de poésie.* Marseille: Robert Laffont, 1944.

SALMON 1945
André Salmon. *L'Air de la Butte.* Paris: La Nouvelle France, 1945.

SALMON 1955
André Salmon. *Souvenirs sans fin: Première époque (1903–1908).* Paris: Gallimard, 1955.

SALMON 1956
André Salmon. *Souvenirs sans fin: Deuxième époque (1908–1920).* Paris: Gallimard, 1956.

SALMON 1961
André Salmon. *Souvenirs sans fin: Troisième époque (1920–1940).* Paris: Gallimard, 1961.

SALTO 1917
Axel Salto. "Pablo Picasso." *Klingen* (Copenhagen), no. 2 (November 1917), n.p.

SAMALTANOS 1984
Katia Samaltanos. *Apollinaire: Catalyst for Primitivism, Picabia and Duchamp.* Ann Arbor, Mich.: UMI Research Press, 1984. (Revised edition of Ph.D. dissertation, University of Virginia, 1981).

SAMALTANOS-STENSTRÖM 1987
Katia Samaltanos-Stenström. "If the Wages of Sin Is Death." *Critica d'arte* (Florence) vol. 52, no. 15 (October–December 1987), pp. 63–70.

SAUCIER 1980
Roland Saucier. "Lettre à François Chapon." *Bulletin du bibliophile* (Paris), 3 (1980), pp. 428–30.

SCHAWELKA 1991
Karl Schawelka. "Das Primitive als Kulturschock: Pablo Picasso." In Monika Wagner, ed., *Moderne Kunst: Das Funkkolleg zum Verständnis der Gegenwartskunst,* vol. 1. Reinbeck bei Hamburg: Rowohlt Taschenbuch, 1991.

D. SCHNEIDER 1947–48
Daniel E. Schneider. "The Painting of Pablo Picasso: A Psychoanalytic Study." *College Art Journal* (New York), 7 (1947–48), pp. 81–85.

P. SCHNEIDER 1984
Pierre Schneider. *Matisse.* Translated from the French by Michael Taylor and Bridget Streveus Romer. New York: Rizzoli, 1984. Revised edition, Paris: Flammarion, 1992.

P. SCHNEIDER 1988
Pierre Schneider. "Picasso: Le Lupanar transfiguré." *L'Express* (Paris), February 12–18, 1988, pp. 98–100.

P. SCHWARTZ 1971
Paul Waldo Schwartz. "Towards Cubism: Picasso and *Les Demoiselles d'Avignon.*" Chapter 2 of Schwartz, *Cubism.* Praeger World of Art series. New York: Praeger, 1971.

S. SCHWARTZ 1988
Sheila Schwartz. "Letter to the Editor: The Philosophical Brothel Revisited." *Art in America* (New York), vol. 76, no. 10 (October 1988), pp. 21, 23.

SCOLARI BARR 1987
Margaret Scolari Barr. "'Our Campaigns': Alfred H. Barr, Jr., and The Museum of Modern Art—A Biographical Chronicle of the Years 1930–1944." *The New Criterion* (New York), special issue (Summer 1987), pp. 23–74.

SEBASTIAN LOPEZ 1984
Santiago Sebastian Lopez. "El burdel filosofico o Les Demoiselles d'Avignon." In Sebastian Lopez, *El "Guernica" y otras obras de Picasso: Contextos iconográficos*. Murcia: Universidad de Murcia, Departamento Historia del Arte, 1984.

SECKEL 1988
Hélène Seckel, ed. *Les Demoiselles d'Avignon*. 2 vols. Paris: Réunion des Musées Nationaux, 1988. Spanish-language edition published in one volume in 1988 by Ediciones Polígrafa, S.A., Barcelona.

SECKEL 1992
Hélène Seckel. "Une Étude pour *Les Demoiselles d'Avignon*." *Poésie* (Paris), no. 60 (1992), pp. 121–25.

SELIGMAN 1961
Germain Seligman. *Merchants of Art, 1880–1960: Eighty Years of Professional Collecting*. New York: Appleton-Century-Crofts, 1961.

SELIGMANN 1937
Twenty Years in the Evolution of Picasso, 1903–1923 (exhibition catalogue). New York: Jacques Seligmann & Co. November 1–20, 1937.

SERANO 1916
M[arcel] S[erano]. "Une Exposition: L'Art moderne en France." *Le Bonnet rouge* (Paris), July 19, 1916, p. 2.

SEVERINI 1946
Gino Severini. *Tutta la vita di un pittore*, vol. 1: *Roma–Parigi*. [Milan:] Garzanti, 1946. Reprinted as *La Vita di un pittore*. Milan: Feltrinelli, 1983.

SIMON 1977
Linda Simon. *Alice B. Toklas*. New York: Avon, 1977. Reprinted 1984.

SMITH 1992
Roberta Smith. "One Brief and Shining Cubist Moment." *New York Times*, November 13, 1992, p. C30.

SOCIAS PALAU 1988
Jaume Socias Palau. "Cronica de Barcelona." *Goya* (Madrid), no. 204 (May–June 1988), pp. 364–65.

SOFFICI 1942
Ardengo Soffici. *Ricordi di vita artistica e letteraria*. 2nd ed., Florence: Vallecchi, 1942. The chapter concerning Picasso, "Gli Studi di Picasso," was previously published under the title "Fatti personali" in *Gazzetta del popolo* (Turin), February 9, 1939, p. 3.

SOFFICI 1968
Ardengo Soffici. *Opere*, vol. 7, part 2: *Autoritratto d'artista italiano nel quadro del suo tempo / Il salto vitale / Fine di un mondo*. Florence: Vallecchi, 1968.

SOTHEBY'S 1989
An Important Collection of Twentieth-Century Furniture: By Pierre Legrain, Eileen Gray, and Eyre de Lanux, Formed by Robin Symes, Including Pieces Designed for Jacques Doucet and Original Drawings by Pierre Legrain. New York: Sotheby's, May 6, 1989.

SPIEGEL 1988
Olga Spiegel. "*Les Demoiselles d'Avignon* se instalan en la calle Montcada." *La Vanguardia* (Barcelona), May 12, 1988, p. 60.

SPIES 1969
Werner Spies. "Picassos Herausforderung: Graphik von 1968 in der Galerie Leiris." *Frankfurter Allgemeine Zeitung* (Frankfurt am Main), no. 5 (January 7, 1969), p. 18.

SPIES 1981
Werner Spies. *Pablo Picasso: Eine Ausstellung zum hundersten Geburtstag—Werk aus der Sammlung Marina Picasso*. Munich: Prestel, 1981.

SPIES 1982
Werner Spies. "Picasso: L'Histoire dans l'atelier." *Cahiers du Musée National d'Art Moderne* (Paris), no. 9 (1982), pp. 60–77.

SPIES 1983
Werner Spies. *Picasso: Das plastische Werk*. Rev. ed., Stuttgart: Gerd Hatje, 1983. First published 1971.

SPIES 1988
Werner Spies. "Picassos rätselhafte Konfession: Zur Pariser Ausstellung der *Demoiselles d'Avignon*." *Frankfurter Allgemeine Zeitung* (Frankfurt), February 27, 1988. Also in chapter 1 of his *Kontinent Picasso: Ausgewählte Aufsätze aus zwei Jahrzehnten*. Munich: Prestel, 1988.

STALLER 1986
Natasha Staller. "Early Picasso and the Origins of Cubism." *Arts Magazine* (New York), vol. 61, no. 1 (September 1986), pp. 80–91.

STEEGMULLER 1970
Francis Steegmuller. *Cocteau: A Biography*. Boston and Toronto: Little, Brown, 1970.

DE STEFANI 1988
Alessandro de Stefani. "Matisse e il cubismo: Per una datazione del *Grand nu* di Braque." *Paragone* (Florence) no. 457 (March 1988), pp. 35–61.

G. STEIN 1938
Gertrude Stein. *Picasso*. Paris: Floury, March 12, 1938. Original French manuscript substantially revised and translated by Alice B. Toklas as *Picasso*. London: B. T. Batsford, October 1938 (reprinted, New York: Dover, 1984). The *Demoiselles* is reproduced.

G. STEIN 1961
Gertrude Stein. *The Autobiography of Alice B. Toklas*. New York: Vintage, 1961. First published, New York: Harcourt, Brace, 1933.

L. STEIN 1947
Leo Stein. *Appreciation: Painting, Poetry, and Prose*. New York: Crown, 1947.

L. STEIN 1950
Leo Stein. *Journey into the Self, Being the Letters, Papers, and Journals of Leo Stein*. Edited by Edmund Fuller. New York: Crown, 1950.

STEINBERG 1972
Leo Steinberg. "The Algerian Women and Picasso at Large." In Steinberg, *Other Criteria: Confrontations with Twentieth-Century Art*. London, Oxford, and New York: Oxford University Press, 1972. A version of this article was published in *Artforum* (New York), vol. 10, no. 2 (October 1971), pp. 44–55.

STEINBERG 1978
Leo Steinberg. "Resisting Cézanne: Picasso's *Three Women*." *Art in America* (New York), vol. 66, no. 6 (November–December 1978), pp. 114–33.

STEINBERG 1979
Leo Steinberg. "The Polemical Part." *Art in America* (New York), vol. 67, no. 2 (March–April 1979), p. 114–27. Continuation of Steinberg 1978.

STEINBERG 1988
Leo Steinberg. "The Philosophical Brothel." *October* (New York and Cambridge, Mass.), no. 44 (Spring 1988), pp. 7–74. Revised version of the essay originally published in *Art News* (New York), vol. 71, no. 5 (September 1972), pp. 22–29 (part 1); vol. 71, no. 6 (October 1972), pp. 38–47 (part 2). Published in French in Seckel 1988 (*Les Demoiselles d'Avignon*, 2 vols., Paris: Réunion des Musées Nationaux, 1988) and in Spanish.

STEINBERG 1990
Leo Steinberg. "Letter to the Editor." *Art Journal* (New York), vol. 49, no. 2 (Summer 1990), p. 207.

STORSVE 1988
Per Jonas Storsve. "*Les Demoiselles* at the Musée Picasso." *Apollo* (London), vol. 127, no. 314 (April 1988), p. 278.

SWEENEY 1941
James Johnson Sweeney. "Picasso and Iberian Sculpture." *The Art Bulletin* (New York), vol. 23, no. 3 (September 1941), pp. 191–99.

TALMEY 1954
Allene Talmey. "The Big Gamble: Thirty-three Blue Chips at The Museum of Modern Art." *Vogue* (New York), November 1, 1954, pp. 106–09.

TASSET 1988
Jean-Marie Tasset. "Casse-tête." *Le Figaro* (Paris), January 18, 1988, p. 39.

TAYLOR 1993
Patricia Taylor. "Blasphemous Altarpiece: Picasso's *Les Demoiselles d'Avignon* as Homage to the Virgin-Whore and the Transformative Power of the Feminine" (excerpts from a manuscript in progress). *Proceedings of the International Conference on Representations of Love and Hate.* Carrollton, Ga.: West Georgia College, 1993.

TÉRIADE 1931
E[mmanuel] Tériade. "Jeunesse!" *Cahiers d'art* (Paris), vol. 6, no. 1 (1931), p. 18.

TÉRIADE 1952
E[mmanuel] Tériade. "Matisse Speaks." *Art News Annual*, no. 21 (1952), pp. 70–71. Reprinted in Flam 1973.

TINTEROW 1981
Gary Tinterow. *Master Drawings by Picasso.* New York: Braziller; Cambridge, Mass.: Fogg Art Museum, 1981.

TOPOR 1975
Roland Topor. *Mémoires d'un vieux con.* Paris: Balland, 1975.

TORRE 1936
Guillermo de Torre. "Su obra: Guíon de sus épocas." In *Picasso.* Madrid: Amigos de las Artes Nuevas, 1936.

TORROELLA 1980
Santos Torroella. "Las Demoiselles d'Avignon en cuestión." *Destino* (Barcelona), no. 2226 (June 5–11, 1980), pp. 38–39 (part 1); no. 2228 (June 19–25, 1980), pp. 38–39 (part 2).

TUGENDHOL'D 1914
Jakov Tugendhol'd. ["The French Collection of S. I. Shchukin."] *Apollon* (Petrograd), nos. 1–2 (1914), pp. 5–46. Partial French translation by Lucia Popova and Dominique Moyen of the original Russian text published as "La Collection française de S. I. Scukin." *Cahiers du Musée National d'Art Moderne* (Paris), no. 4 (1980), pp. 313–18.

TURNER 1984
Elizabeth Hutton Turner. "Who Is in the Brothel of Avignon? A Case for Context." *Artibus et historiae* (Vienna), vol. 5, no. 9 (1984), pp. 139–57.

UHDE 1929
Wilhelm Uhde. *Picasso and the French Tradition: Notes on Contemporary Painting.* Translated from the German by F. M. Loving. New York: E. Weyhe; Paris: Quatre-Chemins, 1929. First published in French (translated from the German by A. Ponchont) as *Picasso et la tradition française: Notes sur la peinture actuelle.* Paris: Quatre-Chemins, 1928.

UHDE 1938
Wilhelm Uhde. *Von Bismark bis Picasso: Erinnerungen und Bekenntnisse.* Zurich: Oprecht, 1938.

VALLENTIN 1957
Antonina Vallentin. *Pablo Picasso.* Paris: Albin Michel, 1957.

VALLIER 1954
Dora Vallier. "Braque, la peinture et nous." *Cahiers d'art* (Paris), vol. 29, no. 1 (1954), pp. 13–24.

VAUXCELLES 1916
Louis Vauxcelles. "La Vie artistique: Quelques Jeunes." *L'Événement* (Paris), July 28, 1916, p. 2.

VEILLEUR 1918
[Signed "Le Veilleur"]. "Bloc-notes: Le Pont des arts." *L'Excelsior* (Paris), January 24, 1918, p. 4.

VINCHON 1924
Jean Vinchon. "Une Leçon de Guillaume Apollinaire." *Images de Paris* (Paris), vol. 5, nos. 49–50 (January–February 1924), n.p.

VLAMINCK 1931
Maurice de Vlaminck. *Poliment.* Paris: Stock, 1931.

VLAMINCK 1943
Maurice de Vlaminck. *Portraits avant décès.* Paris, Flammarion, 1943.

VLAMINCK 1961
Maurice de Vlaminck. *Dangerous Corner.* London: Elek, 1961. Translated by Michael Ross from *Tournant dangereux: Souvenirs de ma vie.* Paris: Stock, 1929.

WALLIS 1992
Brian Wallis. "Let's Make a Deal: MoMA sells Kuniyoshi to Buy a Picasso Sketch." *Art in America* (New York), vol. 80, no. 3 (March 1992), pp. 29, 31.

WARNCKE 1991
Carsten-Peter Warncke. *Pablo Picasso, 1881–1973.* 2 vols. Cologne: Benedict Taschen, 1991. French ed., 1992.

A. WARNOD 1945
André Warnod. "Matisse est de retour." *Arts: Littérature, Beaux-Arts, Spectacles* (Paris), no. 26 (July 27, 1945), p. 1.

J. WARNOD 1972
Jeanine Warnod. "The Birth of *Les Demoiselles d'Avignon*," chapter 6 of *Washboat Days.* Translated from the French by Carol Green. New York: Grossman, Orion Press, 1972.

J. WARNOD 1975
Jeanine Warnod. *Le Bateau-Lavoir, berceau de l'art moderne.* Paris: Musée Jacquemart-André, 1975.

J. WARNOD 1986
Jeanine Warnod. *Le Bateau-Lavoir.* Rev. ed., Paris: Mayer, 1986.

J. WARNOD 1988
Jeanine Warnod. "Les Coulisses d'un tableau." *Le Figaro* (Paris), January 28, 1988, p. 39.

WEBER 1958
Max Weber. "The Reminiscences of Max Weber." Oral History Collection of Columbia University, New York. Transcript of tape-recorded interviews conducted by Carol S. Gruber of the Oral History Research Office, January–March 1958.

WEEKS 1940
Henry H. Weeks. "A Nudist Appraisal of Pablo Picasso, Rated as America's Greatest Living Artist." *Sunshine and Health: The Nudist* (Mays Landing, N.J.), June 1940, pp. 11–14, 23.

WEISS 1993
Jeffrey S. Weiss. "Pablo Picasso: *Head of a Woman (Tête de femme). Head of a Man (Tête d'homme).*" In *Great French Paintings from the Barnes Foundation.* New York: Alfred A. Knopf in association with Lincoln University Press, 1993.

WESTHEIM [n.d.]
Paul Westheim, ed. "Pablo Picasso: Ein Interview," translated by Dora Benjamin, in *Kunstlerbekenntnisse. Briefe, Tagebuchblätter, Betrachtungen heutiger Künstler*, pp. 144–47. Berlin: Propyläen, n.d. [1923?].

WOLLHEIM 1987
Richard Wollheim. *Painting as an Art.* Bollingen Series XXXV, 33. Princeton, N.J.: Princeton University Press, 1987.

YAEGASHI 1972
Haruki Yaegashi. "Reconsidération sur *Les Demoiselles d'Avignon* de Picasso (I)." *Bulletin annuel du Musée d'Art Occidental* (Tokyo), no. 6 (1972), pp. 44–54.

YAU 1988
John Yau. "Please Wait by the Coatroom: Wifredo Lam in the Museum of Modern Art." *Arts Magazine* (New York), vol. 63, no. 4 (December 1988), pp. 56–59.

ZERVOS 1932
Christian Zervos. "Georges Braque et le développement du cubisme." *Cahiers d'art* (Paris), vol. 7, nos. 1–2 (1932), pp. 13–27.

ZERVOS 1938
Christian Zervos. *Histoire de l'art contemporain.* Paris: Cahiers d'Art, 1938.

ZERVOS II1 1942
Christian Zervos. *Pablo Picasso: Vol. II*— Oeuvres de 1906 à 1912.* Paris: Cahiers d'Art, 1942.

ZERVOS II2 1942
Christian Zervos. *Pablo Picasso: Vol. II**— Oeuvres de 1912 à 1917.* Paris: Cahiers d'Art, 1942. Includes a supplement on works of 1906–12.

ZERVOS VI 1954
Christian Zervos. *Pablo Picasso: Vol. VI— Supplément aux volumes 1 à 5.* Paris: Cahiers d'Art, 1954.

ZERVOS XXII 1970
Christian Zervos. *Pablo Picasso: Vol. XXII— Supplément aux années 1903–1906.* Paris: Cahiers d'Art, 1970.

ZERVOS XXVI 1973
Christian Zervos. *Pablo Picasso: Vol. XXVI— Supplément aux années 1907–1909.* Paris: Cahiers d'Art, 1973.

Films

Picasso's "Les Demoiselles d'Avignon." In "Modern Art and Modernism: Manet to Pollock" (Course A 315). Great Britain, 1983 (Broadcast on BBC1 every year until 1992). 16 mm (video), sound, color, 24". In English. Produced by B.B.C., Open University Production Television Programmes. Distributed by Open University Educ. Enterprises Ltd. (G.-B.). Produced by Nick Levinson. Written and presented by Francis Frascina.

Les Coulisses des "Demoiselles d'Avignon." France, 1988. 16 mm, sound, color, 13". In French. Directed by Laurent Truchot. Script by Noel Simsolo. Produced by Musée Picasso, Direction des Musées de France, Réunion des Musées Nationaux, Atriascop. Distributed by Réunion des Musées Nationaux. Camera: Jean-Claude Vickery. Montage: Khaddicha Bariha. Sound: Antoine Bonfanti. Narrator: Bernard Eisenschitz. Participants: Curators of the Musée Picasso. Filmed on the occasion of the Musée Picasso's exhibition "Les Demoiselles d'Avignon."

Les Demoiselles d'Avignon. France, 1988. Video, sound, color, 28". In French. Directed by Jean-Denis Bonan. Produced by La Sept, Sodaperaga, Mikros Image, FR3, and CNC. Distributed by Sodaperaga. Scenario: Pierre Daix. Award: Grand Prix de la Critique et de l'Histoire, 1989.

Les Demoiselles d'Avignon. France, 1988–89. Video, sound, color, 7". In French. Directed by Laurène L'Allinec and Jean-Pierre Mitrecey. Produced by Laurène L'Allinec, Alphascope. Distributed by Laurène L'Allinec. Scenario: Laurène L'Allinec, Jean-Pierre Mitrecey, and Alain Jacquier. Music: Terremoto de Jerez, La Nina de los Peines, Stravinsky's *Le Sacre du Printemps.* Narrator: Philippe Sollers. Award: Selected at the 2nd Biennale Internationale du Film sur l'Art, Centre Georges Pompidou, 1990.

The Women of Avignon. United States, 1990. Video, no sound, color, 2". Computer 3-D simulation. Directed by David Haxon. Produced by William Paterson College. Distributed by US–William Paterson College.

Exhibitions

Pablo Picasso. *Les Demoiselles d'Avignon*
Paris, June–July 1907
Oil on canvas, 8' x 7' 8" (243.9 x 233.7 cm)
Zervos II¹, 18. Daix 47
The Museum of Modern Art, New York.
Acquired through the Lillie P. Bliss Bequest, 333.39

Provenance
The artist
Jacques Doucet, Paris, 1924
Jacques Seligmann & Co., New York, 1937
The Museum of Modern Art, New York, 1939

Exhibitions
Paris, Salon d'Antin, 26, avenue d'Antin, July 16–31, 1916

[Possibly shown at the Matisse/Picasso exhibition, Galerie Paul Guillaume, Paris, January 23–February 15, 1918 (see Appendix)]

New York, Jacques Seligmann & Co. Gallery. "Twenty Years in the Evolution of Picasso, 1903–1923." November 1–20, 1937

New York, The Museum of Modern Art. "Art in Our Time: An Exhibition to Celebrate the Tenth Anniversary of The Museum of Modern Art and the Opening of Its New Building." May 10–September 30, 1939

New York, The Museum of Modern Art. "Picasso: Forty Years of His Art," November 15, 1939–January 7, 1940. Exhibition traveled to: The Art Institute of Chicago, February 1–March 3, 1940; City Museum of Saint Louis, March 16–April 14, 1940; Museum of Fine Arts, Boston, April 26–May 25, 1940; San Francisco Museum of Art, June 25–July 22, 1940; Cincinnati Museum of Art, September 28–October 27, 1940; The Cleveland Museum of Art, November 7–December 8, 1940; Isaac Delgado Museum, New Orleans, December 20, 1940–January 17, 1941; Carnegie Institute, Pittsburgh, March 15–April 13, 1941

New York, The Museum of Modern Art. "Large-Scale Modern Paintings," April 1–May 4, 1947

London, The Institute of Contemporary Arts. "40,000 Years of Modern Art: A Comparison of Primitive and Modern," December 13, 1948–January 29, 1949

Paris, Musée National d'Art Moderne. "Le Cubisme (1907–1914)," January 30–April 9, 1955

New York, The Museum of Modern Art. "Twenty-fifth Anniversary Exhibition: Paintings from the Museum Collection," October 19, 1954–February 6, 1955

New York, The Museum of Modern Art. "Picasso: Twelve Masterworks," March 15–April 24, 1955

Buffalo, New York, Albright Art Gallery, The Buffalo Fine Arts Academy. "Fifty Paintings, 1905–1913: The Fiftieth Anniversary Exhibition," May 14–June 12, 1955

New York, The Museum of Modern Art. "Picasso: Seventy-fifth Anniversary Exhibition," May 22–September 8, 1957. Exhibition traveled to The Art Institute of Chicago, October 29–December 8, 1957

Philadelphia Museum of Art. "Picasso: A Loan Exhibition of His Paintings, Drawings, Ceramics, Prints, and Illustrated Books," January 8–February 23, 1958

London, Tate Gallery. "Picasso," July 6–September 18, 1960

Paris, Musée National d'Art Moderne. "Les Sources du XXe siècle: Les Arts en Europe de 1884 à 1914," November 4, 1960–January 23, 1961

New York, The Museum of Modern Art. "Picasso in The Museum of Modern Art: Eightieth Birthday Exhibition—The Museum Collection, Present and Future," May 14–September 18, 1962

Toronto, The Art Gallery of Toronto. "Picasso and Man," January 11–February 16, 1964. Exhibition also presented at The Montreal Museum of Fine Arts, February 28–March 31, 1964

Paris, Grand Palais. "Hommage à Pablo Picasso," November 16, 1966–February 5, 1967

New York, The Metropolitan Museum of Art. "The Cubist Epoch," April 7–June 7, 1971. Exhibition presented earlier at the Los Angeles County Museum of Art, without *Les Demoiselles d'Avignon*

New York, The Museum of Modern Art. "Picasso in the Collection of The Museum of Modern Art," January 25–April 2, 1972

New York, The Museum of Modern Art. "Pablo Picasso: A Retrospective," May 16–September 30, 1980

New York, The Museum of Modern Art. "'Primitivism' in Twentieth-Century Art: Affinity of the Tribal and the Modern," September 19, 1984–January 15, 1985. Exhibition traveled to: The Detroit Institute of Arts, February 23–May 19, 1985; Museum of Fine Arts, Dallas, June 15–September 8, 1985

Paris, Musée Picasso. "Les Demoiselles d'Avignon," January 26–April 18, 1988. Exhibition also presented at the Museu Picasso, Barcelona, May 10–June 14, 1988

New York, The Museum of Modern Art. "Picasso and Braque: Pioneering Cubism," September 24, 1989–January 16, 1990

New York, The Museum of Modern Art. "Matisse, Picasso, and *Les Demoiselles d'Avignon*." January 23–31, 1993

Contributors

Judith Cousins is Curator for Research in the Department of Painting and Sculpture, The Museum of Modern Art.

Étienne-Alain Hubert is Maître de Conférences, Université Paris-Sorbonne.

William Rubin is Director Emeritus of the Department of Painting and Sculpture, The Museum of Modern Art.

Hélène Seckel is Conservateur en Chef at the Musée Picasso, Paris.

Index

Credits